WASSERSTROM

D1615723

The Joan Palevsky Imprint in Classical Literature

In honor of beloved Virgil—

"O degli altri poeti onore e lume . . ."

—Dante, *Inferno*

*The publisher gratefully acknowledges
the generous contribution to this book provided
the Classical Literature Endowment Fund of the
University of California Press Associates,
which is supported by a major gift
from Joan Palevsky.*

Quṣayr ʿAmra

THE TRANSFORMATION OF THE CLASSICAL HERITAGE

Peter Brown, General Editor

Quṣayr ʿAmra

Art and the Umayyad Elite in Late Antique Syria

GARTH FOWDEN

Centre for Greek and Roman Antiquity
National Research Foundation, Athens

University of California Press

BERKELEY LOS ANGELES LONDON

University of California Press
Berkeley and Los Angeles, California

University of California Press, Ltd.
London, England

Library of Congress Cataloging-in-Publication Data

Fowden, Garth.
 Quṣayr ʿAmra : art and the Umayyad elite in late antique Syria /
Garth Fowden.
 p. cm.—(The transformation of the classical heritage ; 36)
 Includes bibliographical references (p.) and index.
 ISBN 0-520-23665-3 (cloth : alk. paper).
 1. Mural painting and decoration, Umayyad—Jordan—Foreign
influences 2. Quṣayr ʿAmrah (Jordan : Dwelling) 3. Arabic
poetry—622–750—History and criticism. I. Title: Art and the
Umayyad elite in late antique Syria II. Title. III. Series.

 ND2819.J6F69 2004
 751.7′0956959—dc21 2003050133

Manufactured in the United States of America

13 12 11 10 09 08 07 06 05 04
10 9 8 7 6 5 4 3 2 1

The paper used in this publication is both acid-free and totally chlorine-
free (TCF). It meets the minimum requirements of ANSI/NISO
Z39.48–1992 (R 1997) (Permanence of Paper).⊚

For my father and mother
who introduced me to Syria
(Beirut and Jerusalem, Easter 1966)
and for Iason
who allowed himself to be introduced
(Aleppo and Beirut, Easter 1996)

Contents

Maps and Illustrations

Color versions of figures 6, 8, 10, 15, 17a–b, 20, 21, 24, 25, 29, 36, 53, 60, and 62 may be found on the internet at http://www.ucpress.edu/books/pages/9924.html.

Abbreviations

A.A.	*Archäologischer Anzeiger* (Berlin)
A.A.A.S.	*Les annales archéologiques arabes syriennes* (Damascus)
A.A.E.	*Arabian archaeology and epigraphy* (Copenhagen)
A.D.A.J.	*Annual of the Department of Antiquities of Jordan* (Amman)
A.I.O.N.	*Annali: Istituto [Universitario] Orientale di Napoli* (Naples)
A.J.	D. Homès-Fredericq and J. B. Hennessy, *Archaeology of Jordan* (Louvain 1986–89)
A.L.U.P.	A. F. L. Beeston, T. M. Johnstone, R. B. Serjeant, and G. R. Smith, eds., *Arabic literature to the end of the Umayyad period* (Cambridge 1983)
A.M.I.	*Archaeologische Mitteilungen aus Iran* (Berlin)
A.O.	*Ars orientalis* (Washington, D.C.; Ann Arbor)
A.S.	K. Weitzmann, ed., *Age of spirituality: Late antique and early Christian art, third to seventh century* (New York 1979)
Bal.	Aḥmad b. Yaḥyā al-Balādhurī, *Ansāb al-ashrāf* (see Bibliography)
B.A.S.O.R.	*Bulletin of the American Schools of Oriental Research* (Boston)
Bayt al-Maqdis 1	J. Raby and J. Johns, eds., *Bayt al-Maqdis: ʿAbd al-Malik's Jerusalem* (Oxford 1992)

Bayt al-Maqdis 2	J. Johns, ed., *Bayt al-Maqdis: Jerusalem and early Islam* (Oxford 1999)
B.E.I.N.E.	*The Byzantine and early Islamic Near East* (Princeton):
	Vol. 1, *Problems in the literary source material,* ed. Av. Cameron and L. I. Conrad (1992)
	Vol. 2, *Land use and settlement patterns,* ed. G. R. D. King and Av. Cameron (1994)
Berque	J. Berque, *Musiques sur le fleuve: Les plus belles pages du Kitâb al-aghâni* (Paris 1995)
B.G.A.	M. J. de Goeje, ed., *Bibliotheca geographorum arabicorum* (Leiden 1870–94)
B.S.O.A.S.	*Bulletin of the School of Oriental and African Studies, University of London* (London)
Bull. épigr.	"Bulletin épigraphique", published annually in *Revue des études grecques* (Paris)
C.A.	*Cahiers archéologiques* (Paris)
C.I.L.	*Corpus inscriptionum latinarum* (Berlin 1863–)
C.R.A.I.	*Comptes rendus: Académie des Inscriptions et Belles-Lettres* (Paris)
Creswell	K. A. C. Creswell, *Early Muslim architecture,* vol. 1, *Umayyads A.D. 622–750* (Oxford [1932[1]] 1969[2])
D.A.	*Dossiers d'archéologie* (Dijon)
D.A.C.L.	F. Cabrol and H. Leclercq, *Dictionnaire d'archéologie chrétienne et de liturgie* (Paris 1907–)
Da.M.	*Damaszener Mitteilungen* (Mainz am Rhein)
Derenk	D. Derenk, *Leben und Dichtung des Omaiyadenkalifen al-Walīd ibn Yazīd: Ein quellenkritischer Beitrag* (Freiburg im Breisgau 1974)
D.O.P.	*Dumbarton Oaks papers* (Washington, D.C.)
E.A.P.	A. Jones, *Early Arabic poetry* (Reading 1992–96)
E.Ir.	E. Yarshater, ed., *Encyclopaedia Iranica* (London; Costa Mesa, Calif., 1985–)

E.Is.	H. A. R. Gibb, J. H. Kramers, E. Lévi-Provençal, and J. Schacht, eds., *The encyclopaedia of Islam* (Leiden 1960–²)
F.Gr.H.	F. Jacoby, ed., *Die Fragmente der griechischen Historiker* (Berlin 1923–)
Hamilton	R. W. Hamilton, *Walid and his friends: An Umayyad tragedy* (Oxford 1988)
I.E.J.	*Israel exploration journal* (Jerusalem)
I.G.L.S.	*Inscriptions grecques et latines de la Syrie* (Paris 1929–)
I.J.M.E.S.	*International journal of Middle East studies* (Cambridge)
Is.A.A.	R. Ettinghausen, O. Grabar, and M. Jenkins-Medina, *Islamic art and architecture, 650–1250* (New Haven 2001)
Iṣf.	Abū 'l-Faraj al-Iṣfahānī, *Kitāb al-aghānī* (see Bibliography)
Jaussen and Savignac	A. J. Jaussen and R. Savignac, *Mission archéologique en Arabie* (Paris 1909–22)
J.B.M.	*Jahrbuch der Berliner Museen* (Berlin)
J.N.E.S.	*Journal of Near Eastern studies* (Chicago)
J.R.A.	*Journal of Roman archaeology* (Ann Arbor; Portsmouth, R.I.)
J.S.A.I.	*Jerusalem studies in Arabic and Islam* (Jerusalem)
J.S.S.	*Journal of Semitic studies* (Manchester)
Ḳ.ʿA.	A. Musil et al., *Ḳuṣejr ʿAmra* (Vienna 1907)
K.Is.	J. Sourdel-Thomine and B. Spuler, *Die Kunst des Islam* (Berlin 1973)
K.M.	R. W. Hamilton, *Khirbat al Mafjar: An Arabian mansion in the Jordan Valley* (Oxford 1959)
Kröger	J. Kröger, *Sasanidischer Stuckdekor* (Mainz am Rhein 1982)
L.I.M.C.	*Lexicon iconographicum mythologiae classicae* (Zurich 1981–99)
Mas.	ʿAlī b. al-Ḥusayn al-Masʿūdī, *Murūj al-dhahab* (see Bibliography)

N.E.A.E.H.L.	E. Stern, ed., *The new encyclopedia of archaeological excavations in the Holy Land* (Jerusalem 1993)
O.E.A.N.E.	E. M. Meyers, ed., *The Oxford encyclopedia of archaeology in the Near East* (New York 1997)
P.E.Q.	*Palestine exploration quarterly* (London)
P.G.	J.-P. Migne, ed., *Patrologia graeca* (Paris 1857–66)
Piccirillo	M. Piccirillo, *The mosaics of Jordan*, ed. P. M. Bikai and T. A. Dailey (Amman 1993)
P.O.	R. Graffin and F. Nau, eds., *Patrologia orientalis* (Paris 1907–)
Q.ʿA./Q.ʿA.[1]	M. Almagro, L. Caballero, J. Zozaya, and A. Almagro, *Qusayr ʿAmra: Residencia y baños omeyas en el desierto de Jordania* (Madrid 1975[1] = *Q.ʿA.*[1]; corrected and updated, but omitting some of the photographs, Granada 2002[2] = *Q.ʿA.*)
Q.D.A.P.	*Quarterly of the Department of Antiquities in Palestine* (Jerusalem)
Q.H.E.	O. Grabar, R. Holod, J. Knustad, and W. Trousdale, *City in the desert: Qasr al-Hayr East* (Cambridge, Mass., 1978)
Q.H.G.	D. Schlumberger, *Qasr el-Heir el-Gharbi* (Paris 1986) [reprint of id., *Syria* 20 (1939) (see Bibliography), with additional illustrations, and comments on subsequent restoration work added in footnotes and an appendix]
R.C.E.A.	E. Combe, J. Sauvaget, G. Wiet, et al., eds., *Répertoire chronologique d'épigraphie arabe* (Cairo 1931–)
R.E.	G. Wissowa et al., eds., *Paulys Realencyclopädie der classischen Altertumswissenschaft* (Stuttgart; Munich 1893–1980)
R.E.I.	*Revue des études islamiques* (Paris)
Rotter	G. Rotter, *Abu l-Faradsch: Und der Kalif beschenkte ihn reichlich. Auszüge aus dem "Buch der Lieder"* (Tübingen 1977)

S.Byz.Is.	P. Canivet and J.-P. Rey-Coquais, eds., *La Syrie de Byzance à l'Islam, VIIᵉ — VIIIᵉ siècles* (Damascus 1992)
Shahîd, *B.A.SI.C.*	I. Shahîd, *Byzantium and the Arabs in the sixth century* (Washington, D.C., 1995–)
S.H.A.J.	A. Hadidi et al., eds., *Studies in the history and archaeology of Jordan* (Amman 1982–)
Ṭab.	Abū Jaʿfar Muḥammad b. Jarīr al-Ṭabarī, *Taʾrīkh al-rusul wa-'l-mulūk* (see Bibliography)
Taq-i B.	S. Fukai, K. Horiuchi, K. Tanabe, and M. Domyo, *Taq-i Bustan* (Tokyo 1969–84)
Vibert-Guigue diss.	C. Vibert-Guigue, "La peinture omeyyade du Proche-Orient: L'exemple de Qusayr ʿAmra" (Diss., Université de Paris I, 1997)
Yāq.	Yāqūt al-Rūmī, Shihāb al-Dīn al-Ḥamawī, *Muʿjam al-buldān* (see Bibliography)
Z.D.M.G.	*Zeitschrift der Deutschen Morgenländischen Gesellschaft* (Leipzig)
Z.D.P.V.	*Zeitschrift des Deutschen Palästina-Vereins* (Wiesbaden)

Preface

> In the afternoon, tired, we came to Kusair el Amra. . . . In the cool
> dusk of its hall . . . we lay . . . puzzling out the worn frescoes of the
> wall, with more laughter than moral profit.
>
> T. E. LAWRENCE, *Seven Pillars of Wisdom*

It was in August 1918 that T. E. Lawrence and his men camped briefly by the
painted bath house of Quṣayr ʿAmra in the limestone desert east of ʿAmmān
in what is now Jordan. Just twenty years earlier, in June 1898, a Moravian
Czech priest and scholar called Alois Musil had become the first explorer to
set eyes upon this monument, one of the so-called desert castles that dot the
Syro-Jordanian steppe and the more arid regions to the east of it. These "cas-
tles" are in fact residences, pleasure domes, hunting lodges, and farms built
by princes of the Umayyad dynasty that ruled the Arab Empire from Dam-
ascus between 661 and 750. The frescoes of Quṣayr ʿAmra seemed extraor-
dinary and puzzling when first published in 1907, and have lost little of their
power to mystify. Study and restoration have actually increased the number
of problems associated with them, and elucidated remarkably few. One of the
most complete and interesting painted interiors that has survived from the
ancient world—and at 450 square meters one of the more extensive too—
remains relatively little known a century after its discovery, despite the stan-
dardized references to it in every introduction to Islamic art and architecture.

Although the paintings still harbor many secrets, they yield, along with
the building itself, more than enough material to explain why a bath house
came to be built in such an apparently remote setting. They also encourage
us to look beyond this particular site, not only to other "desert castles", but
also to the social and political context in which they came into being. In the
case of Quṣayr ʿAmra, this was the period when the Umayyads were losing
their grip on the caliphate, while the propaganda of their opponents, in-
cluding their eventual supplanters, the Abbasids, focused on the dynasty's
illegitimacy and the court's failure—evident at Quṣayr ʿAmra—to measure
up to Quranic standards of propriety. But this wider perspective on a single
monument forces us to engage as well with the fundamental problems that

arise from any attempt to write the early history of antiquity's last and in many ways most extraordinary product, Islam.

It seems odd in retrospect, but it was precisely a concern for "moral profit" (insofar as this is available to a historian) that brought me to the study of Quṣayr ʿAmra. I believed I had detected in one of the frescoes a depiction of Sarah and Abraham. I thought that this might symbolize early Islam's conscious appropriation not only of the Christian Sarah, Mary's antetype, but also of other significant elements in Christian culture, not to mention the whole ecumene of civilizations symbolized by the six kings on the wall next to her, who seemed to be paying homage to the woman Christian writers regarded as the *Saracens'* ancestress. Nothing remains of this beguiling idea in the present work, save a retractation in a footnote. So much for a novel approach to Islam's ecumenicity.

By the time I had seen that my hypothesis could not be sufficiently supported, I knew too much about Quṣayr ʿAmra to want to leave it alone. So I carried on "puzzling out the worn frescoes", in something closer to the spirit of Lawrence's laughing comrades. Eventually I saw that this could be more than just an antiquarian enterprise. The paintings provide, in the first place, a case study of how material and especially visual evidence can be used to eke out the deficient written record of Umayyad cultural aspiration. They also present such a cornucopia of images that they are the nearest we come to a synthesis of Umayyad court culture. They make us vividly aware how late antique this milieu was. Studying them, I came to see the Umayyads if not as late antiquity's culmination, then at least as its vigorous heirs—this much of the original project survived.

The title I have chosen is, in other words, no mere paradox. Students of the pre-Islamic world have generally assumed that the new regime imposed by the Arab armies of Islam, from the 630s onward, finally strangled the more or less flourishing (or declining) life of the Roman and Sasanian East, and ushered in the end of antiquity. Orthodox Muslim scholars concur, though for a different reason, namely their insistence on the originality of Islam. Non-Muslim students of the early caliphate concur too, because they concentrate on texts not monuments—and the Arab historians turn an almost blind eye to Syria as it was before Muḥammad. But a different interpretation of the early caliphate is increasingly being heard, and will be aired here too. It sees the Syria of the Romans and the Christians—much more than Constantinople—as retaining tremendous cultural impetus, while once the Arabs reunited the Iranian plateau and both halves of the Fertile Crescent under a single political authority, for the first time since the early Seleucids, there was also a much more direct input from Irān.

Nor were these just arbitrary debts contracted by conquerors newly arrived from an Arabian wilderness and disoriented amidst the relicts of the old empires. Arabs had been an egregious presence in Rome's eastern provinces, and on the Sasanians' westerly marches, for centuries before Muḥammad's prophecies. The Lakhmids based at al-Ḥīra on the desert edge south of Ctesiphon had defended Mesopotamia's soft Arabian underbelly. The Ghassanids had ranged the frontier zones of Roman Syria, protecting more settled lands to the west in return for the recognition, prestige, and material rewards through which Constantinople manifested its obligation and favor. Both alliances had faltered as Muḥammad grew from boy to young man. Their wavering must have seemed to many in Arabia a beckoning: in earlier centuries other Arab tribes—notably the Ghassanids themselves—had moved out of Arabia toward a more promising land. In short, the Arabs had long experience of life under surveillance by "the world's two eyes", as some called Rome and Irān. The experience had bred familiarity as well as contempt. When their hour came, they knew exactly how to go about spoiling the Egyptians. Drawing on an almost overwhelming richness of cultural traditions, the Arabs mixed whatever they liked into a distinctive if not always, to our eyes, elegant or coherent Umayyad style. Its eclectic character, distinctly lacking in Quranic asceticism, provided a target for the political opposition and became a factor—even if at times a negative factor—in the evolution of that Abbasid style and outlook, which in turn defined what Muslims and non-Muslims alike see as the "classical" moment of Islamic culture, in tenth-century Baghdād.

The historian who approaches Quṣayr ʿAmra finds himself being drawn backwards, then, into the world of late antiquity. But what is borrowed is put together in novel ways and to thoroughly contemporary ends, while our attempts to elucidate this very particular late Umayyad conjuncture would be hobbled, indeed, were it not for the Arabic historians. We find ourselves being carried forward, as well, into the "classical" Islamic world of Baghdād and the Abbasids. In lieu of contemporary written accounts of what happened as the Umayyads tottered and fell, and why, we discover an abundance of ninth- and tenth-century histories (and others still later) full of political and religious prejudice, reworkings of earlier narratives to suit the winning side. Because Muḥammad's own life (c. 570/80–632), and the careers of his immediate successors, the first four, "rightly guided" caliphs (632–61), assumed such paradigmatic significance in both the social and the private life of later Muslims, the community's early history was especially subject to this tendentious remodeling. But the Abbasids' desire to present their regime as the rule of the true faithful, in contrast to the more worldly "kingship" *(mulk)* of the Umayyads, led not a few of their historians to rewrite the history of

that period too, in the light of criticisms that had already surfaced among the more pious of the Umayyads' own contemporaries.

Our concern here will be with the later Umayyads, it is true, while the principal sources drawn on for this period by, for example, the major tenth-century historian al-Ṭabarī were composed by men such as al-Wāqidī or al-Madā'inī who were born just when the Abbasids came to power and were therefore able to interview eyewitnesses. Nothing, of course, guarantees an eyewitness's reliability; but occasional references in such sources to obscure toponyms, for example—see the entries for Qaṣr Bāyir or the Wādī 'l-Ghadaf in the index—remind us that amidst some elaboration, uninventable facts still glitter. In order to give the reader some impression of this buried historiography, the footnotes of the present work occasionally include the most notable figure in the chain of authorities *(isnād)* that many of the classical compilers provide for each section of their narrative. But one ought not to be overimpressed by such science. Even if al-Ṭabarī reproduces his sources faithfully, nobody who reads the whole of his *History* can fail to be astonished by its radical selectivity. Its geographical prejudice, for Irān and ʿIrāq in preference to "Syria"—what today we call Syria, Lebanon, Palestine, and Jordan—is flagrant.

One longs to get behind these fabricated, tendentious, or merely selective versions of Umayyad history, but it is hard to do that if there is nothing by which to test the literary narratives. Fortunately, the search for such alternatives is not completely unrewarding, though it has as yet been undertaken with less enthusiasm than one might have expected, in view of the sometimes damaging analysis to which the Muslim historians have been subjected. The most obvious need is for sources that can be dated, uncontroversially, to the Umayyads' own times, and that have undergone as little recasting as possible at later dates. In practice this means material culture, objects such as inscriptions, coins, or papyri. Already in 1957 Nabia Abbott, in the introduction to volume 1 of her *Studies in Arabic literary papyri*, concluded from her survey of the relatively few known literary papyri that there was a need for a more skeptical approach to the Abbasid sources, and a reappraisal of the Umayyads' cultural achievements. Her work opened a sudden new perspective on both the learned and the popular literary life of the eighth century.[1] Unfortunately, though, archaeological discoveries (in which I include the papyri) do not often throw so direct a light on the life of the mind.

1. Note Abbott's influence on, for example, Sezgin, *Abū Miḥnaf* 32–33, 88–89, 98; but also various modifications to this line of research, surveyed by Schoeler, *Écrire et transmettre* 6–8.

Another category of evidence that deserves to be incorporated more fully into the historical record is architecture in the widest sense: buildings that have stood continuously like the Great Mosque in Damascus, excavated sites, and of course all forms of architectural decoration. Syria is especially privileged in this respect: numerous Umayyad monuments still stand there, whereas in Egypt, for example, not a single Muslim building remains from before 750. As a perfectly preserved structure with a full set of frescoes, and painted texts in both Arabic and Greek, Quṣayr ʿAmra is in many ways the answer to a prayer. But as we shall see, the circumstances of its discovery and problems that arose in the course of its study decreased its impact on historians of the early Islamic world. A restoration of the frescoes in the early 1970s increased the area of paint surface that was visible, yet obscured its interpretation by adding numerous retouches.

Had none of these obstacles been put in the way of study of Quṣayr ʿAmra, still the bath house would not have been able to substitute for the narratives and analyses that are the literary sources' forte. Instead, the sort of information it provides, especially in its painted decoration, is more akin to the photographic technique of the poet who offers, in anything from a phrase to a whole poem, an impression of one or several moments or single scenes. Through these small windows, as we open them, further vistas are revealed. In fact, early Arabic poetry and the exegetic literature that sprouted around it has turned out to be highly relevant to the story of Quṣayr ʿAmra, whose patron was in all probability himself a poet. Despite persistent doubts about the extent to which this poetic legacy was tampered with by Abbasid editors, we are dealing with materials the Umayyads are likely to have known, in either oral or written form, in something closer to the shape in which we have them than the historical narratives transmitted, for the most part, in versions finalized in the ninth century or later. What is more, Quṣayr ʿAmra's intense concentration and variety of images provides an unusually favorable opportunity for an approach through poetry, much more so than, for example, the vast Abbasid palaces of Sāmarrāʾ in ʿIrāq, where relatively few figural images have so far been found. Although there is a certain amount of poetry that alludes to Sāmarrāʾ, it is much harder there to set up interactions between texts and monuments in the way that comes naturally at Quṣayr ʿAmra, despite the fact that no surviving poetry actually names the place.[2]

Even putting the frescoes and the poetry together, though, we can produce little more than an atmospheric evocation of an elite Umayyad milieu,

2. Cf. Scott-Meisami, *Medieval Islamic city*. Division of labor for the purpose of this "interdisciplinary approach" is partly to blame, as is implicitly accepted at 69 n.3.

or rather of its cultural pretensions. For any grasp of the social and historical context in which it made practical sense to build a bath house in the Jordanian steppe and fill it with images of courtly life, there is no alternative
to the historians, despite the fact that they too never mention Quṣayr ʿAmra
and are overwhelmingly interested in politics rather than everyday life. The
method behind the present study, then, is to read our visual and poetic materials first, to draw whatever conclusions we can from them, and after that
to turn to the narrative sources and ask to what extent they are confirmed
by our findings, or can even eke them out. As the book proceeds, it will become apparent that there is, in fact, a reassuring consonance between the
two bodies of evidence. Further comments will be offered in the appendix
on the value of each of the more significant Arabic writers.

Within the scope of what sets out to be a historical monograph that situates the particular part in relationship if not to the whole, then at least to
its immediate context, it is neither possible nor desirable to discuss every
single one of Quṣayr ʿAmra's paintings in depth, in the manner of a systematic art-historical publication. Nonetheless, I intend to treat as exhaustively as possible those frescoes that strike me as characteristic or informative. And I aspire to convey a sense of a specific and unique place. I begin
with Musil's dramatic first visit to Quṣayr ʿAmra. When the reader puts this
book down, I hope that an impression will remain of what it felt like to sit
in the hall among the princely founder's guests, to hear the poets' songs and
watch the dancers, and to know that one belonged among the lords and masters of a world that had long despised and reviled one's kith and kin for no
better reason than that they were Arabs.

> The fair singing girls in their [the Umayyads'] dwellings
> are like gazelles in an empty shallow of Rumāḥ.
> They give gifts abundantly in their evening and morning assemblies,
> they are noble lords, their clients long for their favors.
> In the evening they are like the lamps of a hermit
> at Mawzan, on whose wicks he has poured oil abundantly.
> On their way to their assemblies they walk across wondrous carpets,
> while their sandals touch the hem (of their garments), or almost.
> They are the people of the throne, to right
> and left of it close by (they stand), the elite.[3]

The publication of this book affords me an opportunity to acknowledge my
father's inspiration in taking me, aged thirteen, on a brief journey through

3. Kuthayyir ʿAzza (d. 723), *Dīwān* 79.

Lebanon and Palestine. That experience, in 1966, stirred my curiosity about Islam and Eastern Christianity. I had only to wait until 1970–71 for a chance to pursue this further, during a year spent in Palestine through the kind offices of the Reverend Antony Good and under the auspices of the Anglican Archdiocese in Jerusalem and Archbishop George Appleton. It was then that I first visited the splendid palace at Khirbat al-Mafjar near Jericho, which reflects much the same milieu as Quṣayr ʿAmra. Thanks to introductions kindly arranged by the Very Reverend Henry Chadwick, and the generous provision of a Land Rover and driver by the Jordanian Department of Antiquities, I first saw Quṣayr ʿAmra itself in 1977, before its bleakly evocative environment was ruined by electricity pylons, a highway carried across the adjacent wadi on a bridge, and a guardian's house and public toilets, the last two replaced in 1999 by a "visitors' center". I gave no more thought to the site until 1991, when Irfan Shahîd delivered a lecture on the frescoes at the Institute for Advanced Study, Princeton, while I was a member of the School of Historical Studies. This was the occasion on which Oleg Grabar first opened to me his photographic archive. Subsequently he allowed me to read his unpublished book, *The paintings at Qusayr Amrah: The private art of an Umayyad prince*, which he had prepared in 1975 for the World of Islam Festival in London. I owe an enormous debt of gratitude to him and to Glen Bowersock, not just for our many friendly discussions, but also for expressing with such gentleness their skepticism about my first attempts to make sense of Quṣayr ʿAmra.

As Musil long ago perceived, the most suggestive guide to the world of Quṣayr ʿAmra is Abū 'l-Faraj al-Iṣfahānī's *Kitāb al-aghānī*, or *Book of songs*, a compilation of early Arabic poetry and of stories about poets and princes, which in the edition I have used runs to twenty-five volumes plus two of indices, and 9,275 pages of text. In order to bring my Arabic to the point where I could venture into the *Kitāb al-aghānī* and begin to assess its value as a source, I spent five months in Aleppo in 1996 at the kind invitation of Mar Gregorios Yohanna Ibrahim, the Syrian Orthodox metropolitan of the city in which al-Iṣfahānī is traditionally held to have completed his work and presented it to the Amīr Sayf al-Dawla (945–67). I shall not forget the happy hours I spent with Ranya and Razek Syriani and Farida Boulos, but above all with Fahima Toro, who bore the brunt of my obsession with this amazingly rich text. Only a tiny fraction of the *Kitāb al-aghānī* has been translated into European languages. My quotations from this and other Arabic sources are often in my own translation; but both here and when merely referring to a passage without quoting it, I have noted the versions I am aware of, in order to help the reader who does not know Arabic to approach

this otherwise quite inaccessible literature. References to translations are provided once and for all in the bibliography when the pagination or section divisions of the Arabic text serve to orient one in the translation as well, otherwise in the footnotes too.

My work on Quṣayr 'Amra could hardly have begun, let alone been finished, without the context provided by the Centre for Greek and Roman Antiquity of the National Research Foundation in Athens, and its director, Miltiades Hatzopoulos. It has been the Centre's policy, ever since its foundation, to foster research on the peripheries of Hellenism, and this project has been the fruit of that policy. During my stay in Aleppo and other shorter visits, between 1977 and 1996, to Jordan, Palestine, Lebanon, Syria, and southeast Turkey, I have been able to inspect most of the sites mentioned in this book, as well as the relevant museums. For financial and other assistance in connection with these and more recent travels, I wish to thank the University of Oxford (Denyer and Johnson Fund and Arnold Fund); Merton College, Oxford; the Faculty of Oriental Studies of the University of Cambridge (Wright Studentship Fund); Peterhouse, Cambridge; the British Academy; the Seven Pillars of Wisdom Trust; the Society for the Promotion of Roman Studies (Donald Atkinson Fund); the Society of Antiquaries of London; the Centre for Greek and Roman Antiquity, National Research Foundation, Athens; and the Foundation for Hellenic Culture, Athens.

Other debts that especially deserve record are to Juan Zozaya in Madrid and Claude Vibert-Guigue in Paris, for the abundant information they have given me about—respectively—the Spanish mission to Quṣayr 'Amra in 1971–74 and the more recent Franco-Jordanian project to record all the frescoes; likewise for their willingness to share photographic and other unpublished materials in their possession, as a result of which I have noted some details not apparent in the published sources. Thanks are also due to Patricia Crone and Alastair Northedge for more skepticism at various stages; Peter Brown for reading the typescript's almost final version and encouraging me to take more seriously certain aspects of the Greek background; and Jean-Michel Carrié and Baber Johansen for arranging three seminars on Quṣayr 'Amra at the École des Hautes Études en Sciences Sociales, Paris, in the spring of 2001, as a result of which some of my ideas were helpfully refocused. It should also be said that my research has been much facilitated by the wonderful libraries of Athens, notably those of the École Française, whose librarian kindly secured me a microfiche copy of Claude Vibert-Guigue's thesis; the American, British and German archaeological schools; and the Goethe Institut, to whose efficient *Leihverkehr* and attentive staff

I owe so much. Hussein Qudrah went out of his way to find me copies of various Jordanian publications. In the very last stages of revision, Aziz al-Azmeh, Pierre-Louis Gatier, and Raisa Khamitova supplied me with items that were not available in Greece. At the University of California Press, Kate Toll and Cindy Fulton have done their utmost to ensure the best possible presentation of sometimes recalcitrant materials, especially the illustrations.

Finally, Elizabeth Key Fowden has shared every stage of my interest in Quṣayr ʿAmra since 1991, and her parallel researches on al-Ruṣāfa have often fertilized my thoughts. The moral profit of studying the Umayyads is indeed debatable, but there would have been less laughter in these long years of work, had she not been there to share them. Together, we also divined something of what the late Don Fowler described in his essay "The ruin of Time" as "the paradox of the monument": "Designed as a summation of memory, an omega-point in which is concentrated all the meaning that a culture wishes to preserve", its unstable polysemy ends up making of it the starting point not only for historical memory of a fixed moment in the past, but also for desire, and a new journey. The Umayyad poet-prince who, I believe, conjured Quṣayr ʿAmra into being would have found nothing strange in the reflections of the postmodern critic. For what is the classical Arabic ode if not the poet's recollection (or anticipation?) of journeyings and the loves they lead to, triggered by the sight of a camping place abandoned, yet seemingly familiar? The stories the monuments tell are our own.

Limni, Euboia, November 2003

POSTSCRIPT. Important survey work on the Umayyad monuments of Jordan and Syria has been conducted, from 2001, by Denis Genequand. His reports in the *Jahresbericht* of the *Schweizerisch-Liechtensteinische Stiftung für archäologische Forschungen im Ausland* should be consulted, as they frequently contain new information about sites discussed here:

1. www.slsa.ch/Projekte/QasrAl-HayrAl-SharqiD.pdf
2. www.slsa.ch/Projekte/QasrAl-HayrAl-SharqiD_02a.pdf
3. www.slsa.ch/Projekte/QasrAl-HayrAl-SharqiD_02b.pdf

1 Musil's Fairy-Tale Castle

Early in the morning of 8 June 1898, the members of the beduin raiding party rose in silence and made ready. As the sun came up at 4:19 A.M., Shaykh Ṭalāl b. al-Fāyiz sprang onto his riding camel. Though he said nothing, his men—some five hundred of them—had watched his every movement and mounted in unison. They set off northeastwards in a wide, thin line, sweeping the desert in line abreast.

Almost four and a half hours later the raiders dismounted to take a rest. An old man on horseback and a younger figure riding a camel immediately broke away from the party. They made off along a shallow watercourse known to them as the Wadi of the Terebinths. After half an hour they reached the point where, today, the highway from ʿAmmān to the oasis of al-Azraq crosses the Wādī ʾl-Buṭum, as it is called in Arabic, some 65 kilometers east-southeast of the center of the Jordanian capital (as a bird flies), and just under a hundred kilometers due east of the point where the Jordan River debouches into the Dead Sea (map 1). The big old terebinths that crowd the watercourse hereabouts, nourished by seasonal pools that linger after the rains, are virtually the only trees that grow naturally between ʿAmmān and al-Azraq. Still more remarkable is the perfectly preserved barrel-vaulted hall with tiny chambers leading off it that stands by the left or northern bank of the wadi (fig. 1).

The raiders, who belonged to the local Banū Ṣakhr tribe, knew the spot well and used it as a cemetery. They preferred not to linger there, especially at night. And it took courage to go inside the buildings, which belonged to an old bath house. Every wall and vault was covered with once brightly colored paintings of men and women and animals—something few had seen

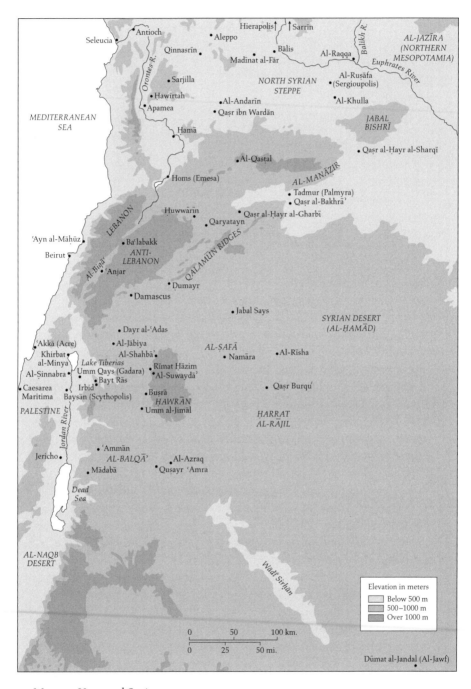

Map 1. Umayyad Syria

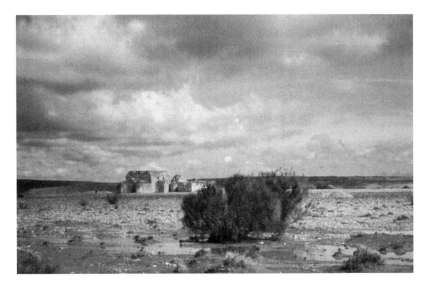

Figure 1.　Quṣayr ʿAmra, looking northwest from the Wādī ʾl-Buṭum after heavy rain (February 1974). J. Zozaya.

anywhere but here. The place was a haunt of jinns. Some maintained it had been built by King Solomon himself, who tradition held "was the first to build baths in every place under his dominion, for he had the demons subject to him",[1] especially, according to the Qurʾān, jinns who were "builders and divers".[2] What the beduin could not explain—and nobody ever has— was the name of this place: Quṣayr ʿAmra, "the little castle of ʿAmra".[3]

The older man climbed onto the roof and nervously scanned the low hills either side of the wadi. Meanwhile his companion made straight for the basalt doorway into the hall. Once inside, he examined rapidly but with extreme surprise and curiosity the darkened paintings of hunting scenes, dancing girls, and much besides. Emerging again into the intense light outside,

1. John of Nikiu, *Chronicle* 38; Soucek, *A.O.* 23 (1993) 114–17 (on the Islamic tradition).
2. Qurʾān 21.82, 38.37.
3. If it is an old name, the allusion may be to the Banū ʿAmrā tribe attested in a sixth-century Arabic inscripton from Umm al-Jimāl near the border between Jordan and Syria: *R.C.E.A.* 1. no. 4 (and note also the toponym Khirbat ʿAmra 6.5 kilometers east-southeast of Umm al-Jimāl: King, *A.D.A.J.* 26 [1982] 92). There is as yet no compelling reason to connect this common name with the ʾl ʿmrt frequently attested in much earlier Safaitic inscriptions: e.g., Khraysheh, *Syria* 72 (1995). For other still more speculative suggestions see Musil, *Ḳ.ʿA.* 1.143–44 (and cf. 148 with n. 266, but also Nöldeke's reservations, *Z.D.M.G.* 61 [1907] 230); *Q.ʿA.* 120.

he ran up a low eminence to the northwest to examine some badly ruined structures. From this vantage point he could look back eastwards along the terebinth-filled wadi toward the diminutive bath house. Then, returning to the main building, he produced a camera and had already taken a few pictures when the lookout shouted: "Enemies, Shaykh Mūsā, enemies!" The young shaykh hastily stuffed the photographic apparatus back into his saddlebag, and the two visitors hurtled off eastwards, hotly pursued by the three or four camel-riders who had appeared from the north. They were slowed down by the terrain—low, rounded hills strewn with small, sharp stones blackened as if by fire, the characteristic volcanic *ḥarra*. They felt too a growing certainty that the men following them were scouts for a larger party— and enormous relief when at last they espied Shaykh Ṭalāl with a few other riders awaiting their return.

Shaykh Mūsā—the Reverend Dr. Alois Musil of the University of Olmütz in Moravia—was destined one day to build a considerable scholarly reputation on the discovery he had made during the forty minutes he contrived to spend at Quṣayr ʿAmra that morning, just three weeks before his thirtieth birthday. But the rest of the day's events left no time for thought of matters academic. Ṭalāl now divided his men into two parties, one of which he took eastwards across the plain toward al-Azraq, while the other was sent along a nearby valley. Musil rode with Ṭalāl. After a time, they heard shots from the valley. Springing from their camels to the faster horses they had brought with them, the Arab warriors set off eastwards at a wild gallop, waving rifles and lances in the air and loudly chanting a song of battle. Musil followed as best he could on his camel, and watched the fight from a distance as it unfolded near the palm groves round the grim basalt fort of al-Azraq. Already the Banū Ṣakhr were driving off the camels they had captured from what turned out to be a caravan accompanied by members of the hostile Ruwala tribe, bearing salt from the marshes near al-Azraq. Such caravans regularly followed the old Roman road from al-Azraq to the Ḥawrān and Damascus.[4]

Shaykh Ṭalāl took his friend over to one of the springs near the castle and showed him the tomb of a tribal ancestor, Mubārak, who had lived seven years in the palm grove with a gazelle for company and its milk his only nourishment. Here around his grave, still nobody dared kill a gazelle: a wandering merchant who broke this taboo had been killed by his own bullet. Beside Musil rode a young beduin, an only son, who had acquired abundant booty on the raid and was now to take a beautiful girl, whom he loved dearly,

4. Stein, *Limes report* 261, 264; cf. Doughty, *Arabia deserta* 2.64.

into his tent. At that moment a shot rang out from the palm grove, and the young man gave a muffled cry. "I saw", Musil later wrote, "how his hands clutched the pommel of his saddle, then his mouth opened, for a while he stared lifelessly ahead, and the next moment he slid off his mount onto the ground." Ṭalāl's men launched themselves once more at the enemy lurking in the palm grove; but they were dangerously exposed if reinforcements should arrive, and soon they were retreating westwards with their booty, their wounded, and their one dead companion bound to his camel. When after an all-night ride they reached their camp Musil, who had been in the saddle since 1 March almost without respite, felt exhausted—it was a year of exceptional heat and drought. He realized that a systematic investigation of Quṣayr ʿAmra would have to be postponed. He resolved to cut short his explorations and return, after a three-year absence, to Europe.

SHAYKH MŪSĀ / ALOIS MUSIL

Alois Musil[5] was the first child, born in 1868, of an impoverished farming family from the region between Vyškov (Wischau) and Olomouc (Olmütz) in southern Moravia—the eastern part, in other words, of the present-day Czech Republic, where islands of German speakers were surrounded by a Czech-speaking majority but dominated the towns and higher education. Alois was to write in both Czech and German, while his second cousin Robert was destined for fame as a German poet. In 1887, Musil entered the Theology Faculty of the University of Olmütz, and as a student took special interest in Hebrew and the Old Testament. In 1891 he was ordained in the Church of Rome and for the next three years worked as a catechist while preparing his doctoral dissertation on the history of the diocese of Olmütz (1895). Thanks no doubt to this choice of subject, he caught the attention of the prince archbishop of Olmütz, Theodor Kohn, a converted Jew. Musil was granted a "stipendium" and so enabled, in November 1895 at the age of twenty-seven, to visit the Middle East for the first time. He participated

5. On Musil see Rypka's two articles in *Archív orientální* 10 (1938) and 15 (1946), and Bauer, *Alois Musil*. Musil himself describes his first three journeys to Quṣayr ʿAmra in various brief notes printed in the *Anzeiger der kaiserlichen Akademie der Wissenschaften, Philosophisch-historische Classe* from vol. 36 (1899) onwards, and then in *Kᵘṣejr ʿamra und andere Schlösser*; *Ḳ.ʿA.* 1.3–117 (giving the date of the first visit as 9 June); and *Arabia petraea* 1.173, 206–10, 219–32, 275–90, 400. See also Mielich's recollections of the third visit in *Ḳ.ʿA.* 1.190–92. On conditions in Jordan generally see Abujaber, *Pioneers over Jordan*, especially for its wealth of oral testimony.

in the programme of study and excursions offered by the recently opened Dominican École Biblique in Jerusalem, and he took private lessons in Hebrew and Arabic. But organized caravan travel with Baedeker in hand was not to his taste: its comfort, he observed, was in inverse ratio to its profit. He longed to penetrate as intimately as possible what he conceived to be the profoundly conservative ways of life and thought of the beduin, as a means to a more vivid contact with the writers and original readers of the Old Testament.

In the summer of 1896 Musil moved to the town of Mādabā in the hill country across the Jordan, practiced his Arabic with the farmers, and explored Moab and Edom on horseback with a local Catholic missionary. Already at this early stage he showed a propensity for ethnographical observation and mapmaking, with extreme care for the accurate rendering of place-names. It was in Moab in 1896 that Musil first heard tell of Quṣayr ʿAmra, in the anarchic region east of the Pilgrim Road from Damascus via Maʿān to Makka. There the wheel was still unknown and the tribes set at naught the authority of the Ottoman state, pursuing a camel-raising and camel-raiding way of life unchanged since before Islam. The locally dominant Banū Ṣakhr had since 1891 been constantly at war with the powerful Ruwala, and Musil found nobody prepared to accompany him, especially to the Wādī 'l-Buṭum—the eye of the storm, because of its proximity to the al-Azraq oasis. He bided his time, traveling elsewhere in the region and studying in the library of the Jesuits' Université St-Joseph in Beirut.

During these travels Musil had begun, as he wrote home to his parents in May 1898, to dress like a beduin "in big red shoes"—a notable sign of status in this mostly shoeless land—"a yellow-striped robe, a black goat-hair cloak and a striped headcloth fastened on the forehead with a black cord" (fig. 2).[6] This disguise had recently incurred the perfectly understandable suspicion of the governor of ʿAqaba, who assumed its wearer was an Egyptian spy and locked him up. Evading these attentions, Musil finally managed, in the last days of May 1898, to contact friends among the Banū Ṣakhr. Not long after that he persuaded Shaykh Ṭalāl to include him, for the sake of his medical skills, in the raid whose last act has just been described. Writing his story up some years later for the final publication of his discovery, it was still easy for Musil to recapture the danger, the frenzy, of that day he first set eyes on Quṣayr ʿAmra. His narrative has few if any rivals among accounts of the rediscovery of an ancient site—indeed, the extraordinary nature of the monument itself goes almost unnoticed amidst the din of raid

6. Bauer, *Musil* 43; Musil, Ḳ.ʿA. 1.5–6.

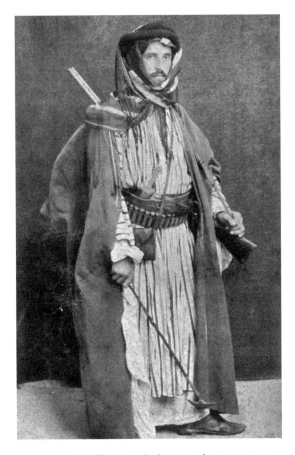

Figure 2. Shaykh Mūsā / Alois Musil (c. 1896–98).
Photograph in H. Lammens, "Ajāʾib bilād Muʾāb",
Al-Mashriq 10 (1907) opposite p. 580.

and counterattack around it. For Musil's companions, though, that day was nothing out of the ordinary. In the closing decades of the nineteenth century, Europeans were just beginning to wake up to the existence of whole tracts of the Middle East hitherto impossible to visit because the Ottoman Empire's writ did not run there. The regions of Jordan that lay east of the Pilgrim Road were truly anarchic—not even a Wild West, because there existed no concept at all of an overarching authority, only the bonds that united members of the same clan. One traveled there entirely at one's own risk, in danger of being murdered at any moment.

Having survived this experience, even the stolid, reserved Musil did not

entirely resist the temptation to impress on his colleagues the heroic character of his explorations. In late October and early November 1898 Kaiser Wilhelm II had made his theatrical, faintly ludicrous visit to Palestine, and Musil will have been aware that press reports of this event were fresh in his readers' recollection. In January 1899 he presented a report on the hitherto completely unknown Quṣayr ʿAmra paintings to the Kaiserliche Akademie der Wissenschaften in Vienna, which had helped fund his journey. The *Anzeiger* of the Academy for that year contains Musil's summary of his report, liberally sprinkled with toponyms and quotations in Hebrew, Syriac, Arabic, and Greek characters. Musil packs a great deal into two and a half pages and breathlessly concludes:

> Imprisoned by the mutaṣṣaref [governor] of Kerak [this was after his previous arrest by the governor of ʿAqaba], I escaped with my Benî Ṣaḫr friends into the regions east of the Derb el-Ḥagg [Pilgrim Road], where I found many castles, with beautiful, finely executed frescoes.... After many dangers and battles, full of the hideous sound of the Naḫâwa [war cry], and after I had also taken part in a raid [he writes this word too in Arabic], and so made intimate acquaintance with life in the wild, I returned on 17 June 1898 to Damascus.

One may compare this melodramatic passage with the terser account in a letter written that very same day, 17 June 1898, to the Jesuits of St-Joseph, and published in their new Arabic-language journal, *Al-Mashriq*. This earliest printed allusion to Quṣayr ʿAmra by someone who had actually seen it was accompanied by a drawing made from one of Musil's photographs.[7]

Unfortunately, during his headlong flight from Quṣayr ʿAmra, Musil had lost most of his photographic plates. His Viennese patrons found themselves in a quandary. What this young, unknown provincial scholar claimed to have found was of undeniable importance: an intact, frescoed building from, it seemed, late antiquity (narrowly defined as the fourth or fifth century). Nothing comparable was known at that time—not much more is today. The mid-third-century Dura Europus synagogue frescoes were not discovered until 1932, and even then Quṣayr ʿAmra remained one of the most complete programmes of painted decoration surviving from any period of antiquity after the eruption of Vesuvius in A.D. 79. It was an enviable coup. As his friend Jan Rypka was later to record, "Vienna suspected poor Musil of charlatanism".[8] Quṣayr ʿAmra was the young Moravian's "Märchen-

7. Musil, *Al-Mashriq* 1 (1898) 629, and cf. 632 for the drawing.
8. Cf. Karabacek, *Almanach der Kaiserlichen Akademie der Wissenschaften* 52 (1902) 342–43.

schloss", his fairy-tale castle.⁹ Musil felt obliged to ask that his full report be kept from the printer until he could produce tangible evidence to support his claims.

1900 TO 1909

After some time spent pursuing background research in the libraries of London, Cambridge, and Berlin, Musil went back to the Middle East in May 1900 and learned with delight that plans for a rising against the Turks had at last induced the Ruwala and Banū Ṣakhr to make peace. The Banū Ṣakhr slaughtered a sheep to celebrate Shaykh Mūsā's return. But the ride to Quṣayr ʿAmra was an anxious one, full of bad omens and fear of enemies and the lurking spirits of the desert. T. E. Lawrence and his men were to experience similar sensations during their night ride to ʿAmra in August 1918:

> As we slipped on, gradually we became aware of night-birds, flying up from under our feet in numbers, black and large. They increased, till it seemed as though the earth was carpeted in birds, so thickly did they start up, but in dead silence, and dizzily, wheeling about us in circles, like feathers in a soundless whirl of wind. The weaving curves of their mad flight spun into my brain. Their number and quietness terrified my men, who unslung their rifles, and lashed bullet after bullet into the flutter.[10]

Musil's companions were far from eager to spend long enough in the ruins' haunted environs for him to gather the data demanded by his mentors in Vienna. Normally no beduin would dream of pitching his tent there, only (as we learn from the graffiti they left) wandering smiths, tradesmen, or gypsies, who anyway were in league with the jinn.[11] The beduin were especially afraid of "the owls that haunt a man's grave"[12]—each was a jinn, and if it flew over your head you would surely die. At night they wrapped head in cloak and waited, miserable, for the dawn. Musil managed to photograph, measure, and take notes for three exhausting days before his friends prevailed on him to leave, on July 13. It was on the basis of these two brief visits that he now at last felt able to publish his first extended account (in-

9. Musil, *Ḳ.ʿA.* 1.57b, 58a; id., *Tajemná Amra* 250–51 (quoted in German translation by Oliverius, *Archív orientální* 63 [1995] 411).
10. Lawrence, *Seven pillars of wisdom* 573.
11. Musil, *Ḳ.ʿA.* 1.88.
12. Jarīr and al-Farazdaq, *Naqāʾiḍ* 387.14; Mas. 1192–93 (2.132–33 Dāghir).

cluding photographs) of Quṣayr ʿAmra. He submitted it in 1901, and it appeared in the *Sitzungsberichte* of the Vienna Academy (Philosophisch-historische Classe) for 1902. It is still worth reading, if only for a sense of how tentative (at times, plain wrong) Musil's understanding of the paintings was at this stage. The building itself is nowhere identified as a bath house. Various theories about its purpose were in circulation, including the idea that it had been a heathen cult place. That it was, in fact, a bath house was finally demonstrated by the Arabic epigrapher Joseph Karabacek in a lecture he delivered to the Vienna Academy, of whose Philosophisch-historische Classe he was secretary, in 1902.[13]

In the year 1901, the Academy also set up a special commission—called from 1902 the "Nordarabische Kommission"—to supervise Musil's work, which it was continuing to fund. And in late May the scholar-explorer returned for his third visit to the monument that had so captivated him. He was accompanied this time by an artist, Alphons Leopold Mielich (1863–1929), whose job was to copy the paintings. Mielich was already acquainted with the Levant, and it was hoped that his Impressionist leanings might enable him to redeem by speed of execution in difficult conditions whatever he might sacrifice in fidelity compared to an archaeological draughtsman.[14] No sooner had the two travelers arrived, accompanied once more by Musil's friends from the Banū Ṣakhr, than they were attacked by hostile tribesmen who abducted all their camels save one, which eagerly ran after the others and was only restrained when Musil, who had gamely hung on to its hump from behind, managed to hit its neck with his rifle and force it to turn its head in the opposite direction. Musil's party barricaded itself and the remaining camel inside the bath house and awaited in trepidation the raiders' return. It soon emerged that the incident was a misunderstanding, and the camels were returned. But before that happened, Musil and Mielich had been forced to the decision that they would stay, and even face possible murder, rather than abandon the task of copying the paintings, whose artistic merits as well as historical interest Mielich had immediately perceived.[15] The two companions had to remain on constant alert throughout the days of work that followed, as well as bearing the resentment of the Quṣayr ʿAmra vipers, the shrieking of its owls, the howling of its hyenas, the discomfort of intense heat (50.5° C at half past two on the

13. Karabacek, *Almanach der Kaiserlichen Akademie der Wissenschaften* 52 (1902) 352–55; and id., K.ʾA. 1.213, 214, 226.

14. Wickhoff, K.ʾA. 1.203.

15. Mielich, K.ʾA. 1.190.

first day of work), dust and lack of water, and the stench from beduin corpses the hyenas had half dragged from their shallow graves around the buildings.

An outbreak of cholera prevented Musil from reaching Quṣayr ʿAmra again in October 1902, in order to make a more accurate copy of the labels and texts in Arabic and Greek that occur at various points in the frescoes. As a result, crucial information was probably lost. Musil's fourth and last visit had to wait until June 1909, when, no longer in fear for his life, he was accompanied by none other than Prince Nūrī b. Shaʿlān, the leader of the Ruwala. "Veiled in thin vapors", Musil wrote,

> it appeared and reappeared as the breeze rent and rejoined the shifting mists. But how melancholy the castle looked from a distance! Standing deep in the lowland enclosed on all sides by high, gray, desolate slopes, it appeared to be a part of the hillside. Between it and the sky were vaporous exhalations from the earth, which prevented the sunbeams from penetrating to it. The castle stood as gloomy as if it were forsaken by heaven itself.[16]

"No wonder", Musil added, "the Arabs attribute such a place to none but the ghoul"—a type of jinn that haunts abandoned places in order to lead travelers astray. Since ghouls commonly assumed the appearance of women, of whom there are many depicted in Quṣayr ʿAmra's paintings, or of centaurlike creatures precisely paralleled in the zodiac fresco (fig. 10), it is easy to see why the beduin found this particular ruin so off-putting.[17] Admittedly, most published photographs of Quṣayr ʿAmra are taken in bright sunlight and show the buildings profiled against a radiant sky, so these ghoulish associations strike an unexpected note. But they are thoroughly in tune with Musil's many accounts of the place, which emphasize the grey monotony of the low, stony hills, the ashen color of the horizon even when the sky overhead is deep blue, and the difficulty of distinguishing the buildings at all—they are constructed of stone quarried on site—until one is almost upon them.

Musil continues:

> The ʿAmra paintings had suffered great damage. In the year 1901 we had to remove the patina, clean the paintings, and wash and daub them with many chemicals. Through this process the colors had been temporarily refreshed, but the particles of paint were falling off and the pictures were vanishing. The painting opposite the one we had taken

16. Musil, *Arabia deserta* 334–35.
17. Cf. Taʾabbaṭa Sharrā's *Qiṭʿa nūnīya* (E.A.P. 1.223–28); Mas. 1196–1203 (2.134–37 Dāghir).

from the wall had disappeared. Intending to take that with us too, we had plastered canvas over it, cut the canvas in sections, and by rapping the plaster had tried to get the picture off the stone of the wall. Unable to separate it, however, as our escorts urged us to hurry along, we had to leave the work unfinished, with the canvas still over the picture. The unusual sight of the surface plastered over with canvas puzzled the Bedouin herdsmen, who poked off the canvas with their daggers and lances and thus destroyed the entire painting.[18]

But Musil and Mielich had removed more than one painting from Quṣayr ʿAmra. Apart from the full-length female figure here alluded to, at least three other fragments had found their way to Vienna, and there are all together ten spots where sections of fresco can be shown to have been cut out.[19] Mielich's 1908 sale of some of the fragments to the Kaiser-Friedrich-Museum in Berlin, without Musil's knowledge, resulted in 1910 in a court case involving the two former traveling companions. Today, the Museum für Islamische Kunst possesses the female figure, an aquatic scene from beneath the throne of the prince in the alcove of the main hall, and a small part of the six kings panel from the hall's west aisle.[20]

PUBLICATION AND ITS PROBLEMS
Facsimiles and Photographs

Despite the adverse conditions under which he labored at Quṣayr ʿAmra, Mielich managed to draft preliminary copies of the frescoes, which he then worked up back at home in his studio in order to produce the (mostly) colored facsimiles that constituted an indispensable part of the formal publication planned by the Vienna Academy (e.g., figs. 19, 28, 61). *Ḳuṣejr ʿAmra* was finally issued in 1907, in two luxurious and expensive elephant folio

18. Musil, *Arabia deserta* 334–35, 346.
19. Müller, *Ḳ.ʿA.* 1.IV, VI; Musil, *Ḳ.ʿA.* 1.96, 98; Wickhoff, *Ḳ.ʿA.* 1.203; *Ḳ.ʿA.* 1.218, fig. 135; *Ḳ.ʿA.* 2. pls. XVI, XXIII; Jaussen and Savignac 3.89 n. 1 and pl. XXXIX.2; *Q.ʿA.* 56 n. 1; Bauer, *Musil* 63; Enderlein and Meinecke, *J.B.M.* 34 (1992) 143 n. 29 and pl. 6; Vibert-Guigue, *ARAM periodical* 6 (1994) 345, 346–47; Vibert-Guigue diss. 1.62–71.
20. Museum für Islamische Kunst, inv. nos I.1264, 1266, 1267 respectively. I.1265 is a fragment of floor mosaic. Berlin also received from Mielich four fragments of architectural decoration from Qaṣr al-Ṭūba (on which see below, pp. 156–58)—their inventory numbers, I.1268–71, immediately follow those of the materials from Quṣayr ʿAmra. My thanks to Jens Kröger for clarifying some of these details. Mielich sold at least one Arabic inscription (without provenance) to the Kunsthistorisches Hofmuseum in Vienna in 1915: Grohmann, *Islamica* 2 (1926) 225.

volumes. Mielich's architectural drawings and his facsimiles of the fres-
coes took up the second volume, and together they still provide the most
complete and easily usable record we have of Quṣayr 'Amra, not least be-
cause they refuse to indulge in speculative restoration. Mielich neither saw
everything that is visible now, nor published copies of everything he had
seen—for example, the hunt panel in the hall's west aisle. But still his omis-
sions, astonishingly, amount to only some 10 percent of the painted sur-
faces.[21] As for the first volume, it comprised essays by various hands. Here,
the lion's share fell to Musil himself, who chose to preface his account of
the topography and history of the area with a lengthy description of his vis-
its to the site in 1898, 1900, and 1901. Written in a lucid and compelling
German, Musil's contribution fuses travelogue, ethnographic observation,
and archaeology.

The numerous and often substantial reviews this publication elicited show
its importance was duly appreciated, at least in the German-speaking
world.[22] In particular, it was recognized that Musil was Quṣayr 'Amra's ideal
discoverer. Growing numbers of adventurous Europeans were now visiting
the Middle Eastern hinterlands, but few knew Arabic and its dialects as he
did, or had read the historical and literary sources in Hebrew, Syriac, Ara-
bic, and Greek, or could match his dedication to minute topographical, ar-
chitectural (when circumstances allowed), and above all ethnographical ob-
servation conducted while traveling and living as a beduin. Musil had an
unusual talent, too, for using these lines of research in order to contextual-
ize each other. No one type of approach was sufficient. And he was deploy-
ing these gifts just when the Ottoman government was at last pacifying the
Jordanian tribes, establishing law and order and encouraging settlement and
agriculture. The coming of the mechanical age represented by the Ḥijāz Rail-
way, which reached 'Ammān in late 1902, was destined to remove the tra-
ditional camel-herding society's motive and its means of sustenance. The
way of life Musil described in such detail was still close to what we find in
the classical Arabic poets, and to the world that produced Quṣayr 'Amra.[23]
In addition, the Vienna of the 1890s and the early 1900s was the place where
the theoretical foundations of art history as we know it were being laid,
while late antiquity had been proclaimed the last unexplored frontier. The

21. Vibert-Guigue diss. 1.99.
22. *Q.'A.* 14; Hillenbrand, *Muqarnas* 8 (1991) 25, to which add R. Geyer's lauda-
tory leading article in *Deutsche Literaturzeitung* 28 (1907), and id., *Memnon* 1
(1907). Note also the remarks in Lammens's review of *Arabia petraea* 1, in *Al-
Mashriq* 10 (1907) 577–81.
23. R. Geyer, *Memnon* 1 (1907).

infant discipline was advancing by leaps and bounds, books full of grand—sometimes wild—ideas and full-blooded polemic came out year by year, while "Byzantinists" and "Islamicists" still regarded some acquaintance with each other's materials as obligatory. In this intellectual climate, Quṣayr 'Amra was seized on with relish.[24]

It has to be admitted, though, that this level of interest failed to be sustained. The reason was not simply the outbreak of the First World War, which after all replaced Ottoman dominance of Arab lands with European or European-backed regimes that provided better conditions for scholarly exploration by passing more stringent antiquities laws and founding departments of antiquities and national museums.[25] Three of the main reasons why Quṣayr 'Amra was, in the long run, eclipsed are to be found, rather, in the at first glance impressive volumes of 1907. They have to do with the reproduction of the frescoes, their dating, and their interpretation—which was directly dependent on the way in which they had been reproduced and dated. The personalities responsible—though not in every case to blame—for the defects in these three areas were, respectively, Musil and Mielich, Karabacek, and, on the interpretative or art-historical front, Alois Riegl and Franz Wickhoff. We may begin by asking why it was that Musil, despite having discovered Quṣayr 'Amra and then written so illuminatingly about it as a philologist and historian, failed to provide the level of visual documentation that was indispensable to the art historian (which he was not).

Musil was by nature, and in all respects, a loner. Throughout his life he displayed a consistent and honest purposefulness, unwavering devotion to hard work, and no undue regard for the feelings of others. He had a strongly autarkic streak; he insisted on seeing things for himself and forming his own judgments, to which he adhered resolutely; and since he was largely self-sufficient, except financially, he felt little need to bear with fools. If he compromised—which he might for his social betters—it was only because he knew he would be proved right in the end. In 1912 Musil took Prince Sixtus of Bourbon-Parma to visit the ruins of al-Ruṣāfa near the Euphrates. The prince feared it would rain and desired to spend the night in a sheltered

24. In view of Quṣayr 'Amra's place almost at the inception of Muslim Arab figural art, it is interesting to note the first publication at Vienna, by David Müller (on whose involvement with Quṣayr 'Amra see below, pp. 16, 20 n. 41) and Julius von Schlosser in 1898, of the Sarajevo Haggadah, "vielleicht ... das älteste uns bekannt gewordene Exemplar ... der illustrierten Haggadah": von Schlosser in Müller and von Schlosser, *Haggadah* 211.

25. Vernoit, *Muqarnas* 14 (1997) 6–7.

room in one of the towers of the city wall. Musil tried to dissuade him on the grounds that sleeping in a confined place was dangerous, and anyway the floor was covered with bird droppings. The prince prevailed, and the two men were duly attacked, had to run for their lives, and spent the rest of the night guarding their beasts and baggage. Musil recounts the story with transparent satisfaction.[26]

Comparing Musil with T. E. Lawrence (whom he esteemed as a stylist), one perceives that it was precisely this autarky that permitted Musil to function so successfully in two milieux as different as the ecclesiastical and academic world of Central Europe on the one hand, and "Arabia deserta" on the other. Both men had a certain rapport with—or at least tolerance for—the beduin; both also found their loyalties tested when they became involved in Middle Eastern politics as agents of their respective countries. Musil from an early age, and throughout his life, was rooted in an ecclesiastical and academic tradition that provided ideals and a programme of work valid, for him, whatever the vicissitudes of his career and of history as it unfolded around him. By contrast, during Lawrence's sojourn among the Arabs, admittedly much greater external demands and responsibilities bore down on and eventually broke a personality lacking in the depth of self-reliance Musil had bred from scholarly discipline and faith: "How did I reach these results? By unbreakable trust in God's providence, consistent fulfillment of my duties and iron perseverance."[27] One would search Lawrence's writings in vain for any such self-assessment. "Rudderless" was his considered verdict, at the wells of Bāyir on his thirtieth birthday. From afar he idolized his commander in chief, General Sir Edmund Allenby, for his self-sufficiency.[28] The point is underscored by the way in which Musil, born a Moravian Czech, and always aware of belonging to a subject people, was able to see himself as a devoted Austrian or, once the Austro-Hungarian Empire broke up, a loyal citizen of Czechoslovakia—but above all, and always, as an Arab.[29] And an Arab, for Musil, was one who lived in everyday communion with the realities of human existence, from the struggle for survival in a hard land to the intuition, in the desert's abstract landscape, of God's simplicity. Whether

26. Musil, *Palmyrena* 154–55.

27. Musil, *Po prve v pousti* (trans. T. Smetanka, in *Journeys through desert and time* [5]).

28. Lawrence, *Seven pillars of wisdom* 564–65. Note Hourani's comparison of Lawrence with another man of faith, Louis Massignon, who was raised up by "the incursion of grace": *Islam in European thought* 121. My thanks to Robin Lane Fox for sending me this eloquent essay.

29. Bauer, *Musil* 86 (plate), 249, 282–83.

the Catholic priest may in some sense have been at heart a Muslim remains a matter for speculation.[30]

It was entirely consistent with this autarkic outlook that Musil should have preferred, when traveling in steppe or desert, the very small party's speed, flexibility, and capacity for disguise: if one was to face the perils of the desert more or less alone, it was better not to advertise one's presence. But, as one reviewer with much experience in the matter pointed out, doing without a caravan meant one had to return every so often to somewhere like Mādabā in order to resupply, and prevented one from carrying much equipment.[31] Worse still, Musil had refused to take along with him, in 1901, an expert on late antique art to help Mielich in places where the frescoes were hard to interpret. There were those in Vienna who felt, long before the final publication appeared in 1907, that Musil had compromised the scientific results of his expedition by running altogether too tight a ship. There is evidence for this view in the art historian Alois Riegl's reports on Musil's work, which were submitted to the Academy and quoted in the foreword to *Ḳuṣejr 'Amra* by David Müller, professor of Semitic languages at Vienna. Certainly Mielich's facsimiles, worked up later in his studio, fail to convey the vigor and chromatic vibrance of the originals. They were to be pronounced inadequate by a distinguished contributor to those same volumes, while Salomon Reinach enunciated posterity's considered opinion: "Il faut se défier des reproductions édulcorées de l'ouvrage de Musil."[32]

Even supposing that much of the blame for this state of affairs could be laid on Mielich's abilities, or the conditions under which he worked, still the question would remain, why the facsimiles were not supplemented by the publication of a wider range of photographs. All that was made available was a handful of fuzzy images that Musil published in his article of 1902, and then again with the account of his travels in Moab in volume 1 of *Arabia petraea* (1907). Had Musil been able to provide more informative photographs, the impact of Quṣayr 'Amra on the scholarly world would certainly have been much more direct. It is instructive to compare what happened when, in 1899, Dr. Georg Sobernheim took a beautiful photograph, using a long exposure and magnesium lighting, of the first painted tomb to

30. Segert, *Archív orientální* 63 (1995) 394; Kropáček, *Archív orientální* 63 (1995) 401.

31. Brünnow, *Wiener Zeitschrift für die Kunde des Morgenlandes* 21 (1907) 355–56.

32. Wickhoff, *Ḳ.'A.* 1.203–07; Reinach, *Répertoire* 49; and cf. Brünnow, *Wiener Zeitschrift für die Kunde des Morgenlandes* 21 (1907) 270–71; Creswell 396 ("travesties"); Brisch, *Oriens* 33 (1992) 454.

be discovered at Palmyra—where, it is not irrelevant to note, the Ottoman authorities had recently stationed a detachment of light cavalry designed to keep the tribes at bay. The "tomb of the three brothers" immediately became the starting point for a major and controversial book by Josef Strzygowski, professor of art history at Graz, to whom Sobernheim had entrusted his photograph for publication. In *Orient oder Rom* (1901), Strzygowski rejected the view championed among others by Franz Wickhoff (of whom more below) that artistic inspiration had tended to run from imperial Rome to the provinces, and asserted the East's claim to be considered the source of major developments in what was known—rather undiscriminatingly, Strzygowki thought—as "Roman imperial art".

It would be unfair, though, to blame Musil or Mielich for the inadequacy of the photographic record of Quṣayr ʿAmra. It was not that they failed to foresee the need to convince skeptical (or jealous) colleagues of the accuracy of their facsimiles. Hence their attempts to cut out and remove specimen frescoes, which seems barbarous to us today partly because we have so many opportunities for travel and autopsy. If, for example, the palatial Umayyad structure at Mushattā (fig. 3), not far from Quṣayr ʿAmra but more accessible, was vigorously debated at this very period, that was because in 1903 Kaiser Wilhelm II had, as a result of prompting initiated by Strzygowski, secured large sections of its decorated facade for the Kaiser-Friedrich-Museum (opened 1904), as a personal gift from Sultan Abdülhamit II. (The kaiser reciprocated by sending the sultan a team of black thoroughbred horses.)[33] But Musil and Mielich succeeded in removing very few pieces of the frescoes, and the only substitute was photography. Sadly, though, the frescoes had been undermined by rainwater seepage, blasted by sand-laden winds, overlaid by the soot of generations of campfires, hacked at by graffiti-scratchers, and peppered with shot from the novel firearms that the beduin acquired in large quantities during the nineteenth century. If most of the photographs Musil took in 1900 and 1901 remained unpublished, that was probably because the frescoes themselves were barely legible.[34]

In order to supplement the deficient photographic record, Fathers Antonin Jaussen and Raphaël Savignac of the École Biblique in Jerusalem made repeated visits to Quṣayr ʿAmra in 1909, 1911, and 1912, their account of

33. Enderlein and Meinecke, *J.B.M.* 34 (1992) 146–48, 161–71; Marchand, *Down from Olympus* 203–5, and 365 pl. 33 (for a view after the bombing on 3 February 1945; for the correct date see *Museum für Islamische Kunst* 6). On the spelling of Mushattā, see Ṭūqān, *A.D.A.J.* 14 (1969) 15 n. 12.

34. Cf. Wickhoff, in *K.ʿA.* 1.203. Musil's photographic archive is now held by the Regional Museum, Vyškov, Czech Republic: cf. *Journeys through desert and time*.

Figure 3. Mushattā, looking through the gateway and across the courtyard toward the throne complex (1900). G. Bell: Gertrude Bell Photographic Archive A 233, University of Newcastle.

which was published after the First World War, in 1922. Between the Dominicans and Musil, little love was lost. Musil made no particular effort to conceal the low opinion he formed of the École Biblique during his sojourn there, when the elementary Hebrew course had been taught by Jaussen, himself more or less a beginner.[35] In the third volume of their *Mission archéologique en Arabie*, Jaussen and Savignac applied themselves to the congenial task of correcting the plans and reconstructions of the "Arab castles" that Musil had made under such adverse conditions, and deplored, with reference to the Quṣayr ʿAmra frescoes, his "détestable manie de vouloir tout emporter".[36] They opined, too, that he had exaggerated the danger of travel-

35. Bauer, *Musil* 29, 35; Segert, *Archív orientální* 63 (1995) 395. The "programme de l'année scolaire 1895–1896" may be consulted in the *Revue biblique* 4 (1895) 627–28.
36. Jaussen and Savignac 3.10, and cf. 89 n. 1. On the inaccuracy of many of Musil's plans, see Gregory, *Roman army* 180, though sometimes he improved considerably on earlier travelers: see, for example, Lenoir, *Syria* 76 (1999).

ing in those parts, though their own explorations were not without incident. Yet even the Dominicans were forced to admit that it was hard to add much to Musil's account of Quṣayr ʿAmra, and that many of the most important frescoes were almost impossible to photograph. After the destructive cleaning inflicted on them in 1901, the soot of the beduin campfires had no doubt begun once more to accumulate. The frescoes made little impression on Gertrude Bell, who passed by on 2 January 1914 and devoted her brief diary entry exclusively to the structure of the dome and vaults.[37] In 1939, having just visited the complex, Sir Aurel Stein could write:

> of the famous pictures . . . nothing was to be seen now on the walls
> of the central hall. Of the scenes . . . adorning the Caliph's bath-room
> only very scanty traces were left. Wilful effacement by Arabs and the
> scribblings of visitors had done their work only too thoroughly since
> copies of the paintings were made and published for the Imperial Academy of Vienna.[38]

Chronology

The inadequacy of the visual record undoubtedly contributed to the second major shortcoming of the 1907 publication, which was its failure to speak with one voice on the crucial question of dating. Alois Riegl is quoted in the foreword as having assigned the frescoes, on purely stylistic grounds, to the "fourth or at latest the fifth century", a procedure accounted "audacious" by Franz Wickhoff in his chapter on style. Wickhoff, for his own part, after much beating about the bush, gingerly delivers himself of the view that Quṣayr ʿAmra should be assigned to "a relatively late period of Byzantine art".[39] But the scholar who had the job of elaborating formal chronological arguments was the epigrapher Joseph Karabacek, who contributed the substantial last chapter of *Ḳuṣejr ʿAmra*.

Besides being secretary of the Philosophisch-historische Classe of the Vienna Academy, Karabacek was also "Professor der Geschichte des Orients und ihrer Hilfswissenschaften" at the University, and director of the Royal Library. He had been active as a scholar since the 1860s, and by the early 1900s was a thoroughly Establishment figure, "more courtier than scholar", as C. H. Becker was to observe in an exceptionally readable obituary of the

37. Bell, *Arabian diaries* 154; and see her photographs, including some frescoes, in Gertrude Bell Photographic Archive (www.gerty.ncl.ac.uk) X 008, Y 067–76, Y 523–24. Strzygowski, *Zeitschrift für Geschichte der Architektur* 1 (1907) 62, had noted Ḳ.ʿA.'s failure to provide an adequate account of the caldarium dome.

38. Stein, *Limes report* 285.

39. Wickhoff, Ḳ.ʿA. 1.205.

"de mortuis nil nisi vere" genre.[40] But Karabacek had not become so much a "cortegiano" that he could pass up an opportunity to exercise the other side of his personality, that of "academic adventurer" ("wissenschaftlicher Glücksritter" is Becker's phrase), and on a project as prestigious for the Academy as was the publication of Quṣayr ʿAmra.[41] He was a deeply learned man, but also possessed of—or rather by—a limitless and unscrupulous imagination. The words are Becker's again; and in his obituary he provided numerous examples of preposterous hypotheses—an inscription, for example, read out from a purely decorative arabesque on a carpet—that Karabacek had foisted on colleagues hypnotized by his self-assurance. Running true to form in *Ḳuṣejr ʿAmra,* he argued that the artists who painted not only the frescoes, but also their Arabic and Greek inscriptions, were Greeks who wrote Arabic from left to right out of ignorance, and Greek from right to left out of a desire to adjust to local habits.[42] On the basis of these and other no less ingenious arguments, Karabacek produced a reading of the inscriptions that supported his proposal for a date in the mid-ninth century.

As for Musil himself, he had argued in 1902 what the Jesuit Arabist and historian Henri Lammens had already proposed in 1898,[43] namely that Quṣayr ʿAmra was built by the Ghassanid Arabs in the pre-Islamic period—an idea that was to be perpetuated in *Seven pillars of wisdom.* But by 1905 Musil seems to have come to the view that the patron had been an Umayyad prince in the first half of the eighth century, and specifically al-Walīd b. Yazīd (708/9–44), who was heir apparent throughout the reign of his uncle Hishām (724–43), and then briefly became caliph as al-Walīd II (743–44). In a summary note accompanying his topographical and historical chapter for *Ḳuṣejr ʿAmra,* which he submitted to the Nordarabische Kommission in 1905, Musil stated that in his opinion al-Walīd had lived at Quṣayr ʿAmra, and had ordered the construction of the courtyard dwelling that, as we shall see in chapter 2, stood a few hundred meters away from the bath house. Musil carefully avoided claiming that al-Walīd built and decorated the bath house.[44] But when two years later his chapter was finally published, it was perfectly clear that its author did in fact regard al-Walīd as the patron of

40. Becker, *Islamstudien* 2.491–98
41. See, for example, Bauer, *Musil* 50–51, 66. The Academy's eagerness to bathe in Musil's reflected glory, and sensitivity to perceived slights, is noted by Goldziher, *Tagebuch* 260–61 ("the sly Polack" is Rabbi David Müller).
42. Von Karabacek, *Ḳ.ʿA.* 1.215, 223.
43. Lammens, *Al-Mashriq* 1 (1898) 635.
44. Musil, *Anzeiger der kaiserlichen Akademie der Wissenschaften, Philosophisch-historische Klasse* 42 (1905) 45.

Quṣayr ʿAmra. Still he did not say so in as many words—he was unwilling to cross swords publicly with Karabacek. On the other hand, his seemingly modest insistence that his interpretation of the literary texts might be invalidated by the discovery of more "desert castles" reads like an ironic challenge to the sixty-two-year-old courtier to go out and find them.[45]

Everyone now agrees that Musil was right in broad terms, though there may still be room for debate about the particular individual who deserves the credit, either al-Walīd or some other late member of the Umayyad dynasty. The detailed arguments will be reviewed in chapter 5. But it needs to be made clear already at this early stage that the Greek labels and more substantial Arabic texts painted on the frescoes show Arabic was the primary language of the environment that produced Quṣayr ʿAmra. One of the Arabic texts also makes explicit reference to the Muslim religion.[46] It is evident, then, that Quṣayr ʿAmra was built for an Arab Muslim patron. Theoretically, this could already have been Muʿāwiya b. Abī Sufyān, who governed Syria from Damascus c. 647–61, and then ruled the whole caliphate from that same city, 661–80. The first of the Umayyads actually known to have dwelt in the Syrian steppe is Yazīd I (680–83) at Ḥuwwārīn;[47] while in about the year 690 ʿAbd al-Malik took refuge from the plague at al-Muwaqqar, close to Mushattā.[48] Once ʿAbd al-Malik finally overcame the caliphate's serious internal divisions, by 692, there will have been nothing to impede the more intensive construction of pleasure domes along the desert fringes.[49] But not after 750—the Abbasid dynasty that came to power in that year and soon moved the capital of the caliphate from Damascus to al-Anbār on the Euphrates, and eventually in 762 to Baghdād on the Tigris, did not share the Umayyads' passion for the Syrian steppe.[50] It is a shame there was no public discussion of this whole vital question of dating in the learned journals before the Academy sent its monumental volumes to the press. O. M. Dalton of the British Museum, who set out in his *Byzantine art and archaeology* (1911) to "acquaint English readers with the latest Continental research", ended up following Karabacek on page 69, and Musil on page 279.

45. Musil, *Ḳ.ʿA.* 1.158, and cf. von Karabacek, *Ḳ.ʿA.* 1.213.
46. Below, p. 126.
47. Below, p. 283.
48. The source for this little-noticed fact is the traditionist Muḥammad b. Muslim b. Shihāb al-Zuhrī (d. 741); cf. Elad, *Medieval Jerusalem* 153–57.
49. Cf. Gaube, *Ḥirbet el-Baiḍa* 133–34.
50. The contrast between flourishing al-Anbār and the "ruined" residences of the Syrian steppe—Homs, Qinnasrīn, and al-Muwwaqar—is drawn with relish by the poet Abū Nukhayla (d. 764) in Ibn Khurradādhbih, *Kitāb al-masālik* 42.

Interpretation of the Frescoes

Another shortcoming of the Vienna publication was Franz Wickhoff's fail-
ure to rise to the occasion in his disappointingly summary descriptions of
the paintings and comments on their style—he devotes 10 pedestrian pages
to what Musil had risked his life for, in three journeys recounted in 180 com-
pelling pages. Not that Wickhoff can fairly be made to bear all the blame.
The analysis of the frescoes was originally entrusted to his fellow profes-
sor ordinarius of art history at Vienna University, Alois Riegl, who is still
today numbered among the founding fathers and leading theoreticians of
the discipline.[51] Riegl's first major achievement, in his *Stilfragen (Problems
of style)* of 1893, had been the elucidation of how ornamental forms, espe-
cially vegetal motifs, evolved diachronically from Egypt, Greece, and Rome
right through to the arabesque that Muslim builders so loved, against those
who saw "die späte Antike" as a period of decline and barbarian disruption,
and ornament as somehow above—or rather beneath—historical analysis.
"In this masterpiece", as a more recent representative of the Vienna School
has noted, "the history of the acanthus scroll is turned into an epic of vast
dimensions."[52] To his interest in architectural relief carving Riegl added an
intimate familiarity with the applied arts, when he accepted an invitation
to publish late antique archaeological finds housed in the museums of the
Austro-Hungarian Empire. What issued from this project was no catalogue
of antiquities, but a treatise on the *Spätrömische Kunst-Industrie (Late Ro-
man arts and crafts)*, which Ernst Gombrich—one of Riegl's more radical
critics—has called "the most ambitious attempt ever made to interpret the
whole course of art history in terms of changing modes of perception".[53]
Both for the wide implications of its argument, and for its sympathetic treat-
ment of late antique art as a transitional phase between Greek and Roman
roots and the evolved style of mediaeval art, Riegl's book begs comparison
with Wickhoff's contribution to the volume he and Wilhelm Ritter von Har-
tel produced in 1895 on the famous late antique manuscript of Genesis pre-
served at Vienna. Wickhoff's magisterial introduction was soon translated
into English as an independent work under the lapidary title *Roman art*
(1900); and the German original offered in addition, and for the first time,
a comprehensive discussion and photographic record of the Vienna Gene-

51. See M. Dvořák's important obituary in *Mitteilungen der k.k. Zentralkom-
mission für Erforschung und Erhaltung der Kunst- und historischen Denkmale* 3e
Folge, 4 (1905); Müller, *K.'A.* 1.I–VIII; Wickhoff, *K.'A.* 1.203.
 52. Gombrich, *The sense of order* viii.
 53. Gombrich, *Art and illusion* 18.

sis manuscript, its text as well as its illuminations. Wickhoff aimed (in the words of Gombrich, once more) "to demonstrate that what had been considered the debased and slovenly style of Roman imperial art deserved such an accusation as little as did the modern impressionists, whose much-maligned paintings Wickhoff had learned to love. The art of the Romans, Wickhoff concluded, was as progressive in the direction of visual subjectivity as the art of his own time."[54]

In 1901, the year in which Musil took Mielich to Quṣayr 'Amra and the *Spätrömische Kunst-Industrie*—not to mention Strzygowski's *Orient oder Rom*—was published, Riegl fell seriously ill, at the age of only forty-three. He became deaf and suffered considerable pain. Then, in June 1905, he died. During these last four years of his life, Riegl was at once aware of the frailty of his health and eager to push his ideas forward, away from his earlier quasi-scientific fascination with pure form toward a greater interest in questions of representation, signification, and symbolism. He was also becoming aware that there was criticism of the *Spätrömische Kunst-Industrie* as well as praise for it. In particular, it was validly objected that he had tended to assert the universal synchronic validity of his analysis by somewhat arbitrarily extending conclusions built on his areas of specialization to cover other departments of late antique art, such as architecture, that he knew less well.[55] Precisely at this crucial period in his life, Riegl allowed himself to become deeply involved with two completely new causes. One was the preservation of historical monuments in Austria, an academic interest but also a bureaucratic and legislative project that absorbed enormous amounts of his time and energy. The other project was the publication of Quṣayr 'Amra. Thwarted by the state of his health (and Musil's intransigence) in his desire to accompany the third expedition, Riegl personally assisted Mielich in the production of his facsimiles. He read and reread the manuscript of Musil's contribution, though his name is conspicuously absent from the author's acknowledgments. And he made three special journeys round the museums of Europe to collect photographs of comparable materials, exhibiting no doubt the same meticulous care for the empirical evidence on which his synthesis was to be based that is so apparent in his drawings for *Stilfragen*. Despite the absolute silence about Quṣayr 'Amra maintained in everything that has been written about Riegl since he died,[56] with the sole exception of Müller's

54. Ibid.
55. Pächt, in Riegl, *Spätrömische Kunstindustrie* (reprint, 1927) 406–12.
56. On the recent efflorescence of Riegl scholarship see Scarrocchia, *Alois Riegl* 29–35.

foreword to the publication of the site, and Wickhoff's contribution to the same volume, one is bound to ask why somebody of his intellectual distinction and broad interests should have become so fascinated by the bath house in the Wādī 'l-Buṭum, when he already knew his days were numbered.

The answer lies in Riegl's conviction that Quṣayr 'Amra was a monument of the fourth or at latest fifth century, not the eighth. As he himself observed in the report he wrote in March 1901 on the materials Musil had gathered in 1900,

> Figural frescoes are in themselves a rare occurrence in late Roman art: a few late catacomb paintings in Rome are just about all we currently have in this respect. In the Roman East, these frescoes [at Quṣayr 'Amra] still, at the moment, stand in complete isolation. . . . But with their—very substantial—assistance it will now for the first time be possible to sketch a clear overall view of the development of post-Constantinian painting in the Roman Empire's Far East. In order to indicate what in my opinion gives the Kasr 'Amra frescoes truly unique value, I must refer to the fact that what we have here is the almost intact painted decoration of a large room. . . . What makes this circumstance so particularly fortunate is not so much the undeniable advantage as regards iconographical identification . . . but rather the possibility of examining purely artistic features, the composition of forms and the use of the pallet in such a large number of paintings from the same place and period. We may hope in this way to gain a much completer and surer picture of the development, characteristic features, and purposes of late Roman monumental painting, than could ever be had from isolated catacomb paintings.[57]

An intact and unknown monument of late Roman painting had been uncovered and, had it continued to be thus classified, would undoubtedly have made just the same splash in the learned world that the third-century paintings in the Dura Europus synagogue did thirty years later—except that where Dura enormously strengthened Strzygowski's Oriental view of late Roman art, Quṣayr 'Amra would have been seen as supporting Wickhoff's and Riegl's Romanocentric view of things. One suspects Riegl was misled primarily by the apodyterium paintings (e.g., figs. 19, 62), the most "Hellenistic" in style and among the very few areas of Quṣayr 'Amra's decoration that could be effectively photographed at this time.[58] Apparently, death saved Riegl from crowning a brilliant career with a resounding gaffe.

57. Quoted by Müller, *Ḳ.'A.* 1.II–III.
58. Musil, *Arabia petraea* 1.281, 283–84; cf. R. Hillenbrand, *Ḳ.Is.* 162–63. On the Riegl-Strzygowski debate and on Dura, see Elsner, *Art history* 25 (2002). I am obliged to Jaś Elsner for his comments on the present chapter.

Wickhoff stepped into his younger colleague's shoes in tragic circumstances, at the eleventh hour, and with evident misgiving,[59] having had previously only a brief involvement, in 1901, with the work of the Vienna Academy's Quṣayr ʿAmra panel. His wide-ranging yet historically focused approach to the Vienna Genesis boded well; but one has only to compare his summary description of the Quṣayr ʿAmra frescoes with his earlier work to realize that he had yet to come to grips with the unusual new discovery. Working from tracings, and photographs that were for the most part deemed unpublishable, and seriously hampered by his mistrust of Mielich's facsimiles, not to mention the uncertainty about dating, Wickhoff was also blinkered by his own Roman perspective on the art of late antiquity, and his unwillingness to engage with the Strzygowskian Orient where Quṣayr ʿAmra, from many points of view, undeniably belonged. One reviewer wondered out loud why Wickhoff had been preferred to Strzygowski, also an Austrian professor after all, when a replacement had been needed for Riegl.[60]

AFTER MUSIL

In his obituary of Karabacek, published in 1920, Becker observed of *Ḳuṣejr ʿAmra* that "despite its magnificent presentation, and even leaving Karabacek's contribution aside, the whole publication is a historical document of the mischief that can be done by a clique of possessive academics"[61]—by which he meant, *inter alia*, Karabacek's intense jealousy of Strzygowski.[62] Thanks, though, to Theodor Nöldeke's review, and to another by Becker, in which he drew on readings of the painted texts that had been communicated to him by Musil himself and by Enno Littmann before *Ḳuṣejr ʿAmra* had even been published,[63] Musil's circumstantial and impressionistic reasoning in favor of a date under the Umayyads had been rapidly replaced by much firmer epigraphical arguments, of which more will be said in chapters 5 and 7. This in turn affected the debate about Mushattā, enabling those who saw in Quṣayr ʿAmra and Mushattā products of quite different histor-

59. Wickhoff, *Ḳ.ʿA.* 1.203.

60. Van Berchem, *Journal des savants* (1909) 308–9; in similar vein Becker, *Islamstudien* 1.304–6 (first published in 1907).

61. Becker, *Islamstudien* 2.497.

62. As M. Hartmann made clear in a letter to Becker, 4 June 1907: Hanisch, *Islamkunde* 43–44.

63. Nöldeke, *Z.D.M.G.* 61 (1907); Becker, *Islamstudien* 1.287–307, esp. 297, 299 (first published in 1907).

ical milieux to accept Strzygowski's early dating for Mushattā in the fourth to sixth century, while encouraging those who thought the two buildings more or less contemporary to affirm Mushattā's Umayyad date, which is now generally accepted.[64]

Even so, the scholarly excitement generated by Quṣayr ʿAmra in the first two or three decades of the twentieth century gradually tailed off. K. A. C. Creswell visited the bath house in 1919 or 1920, as inspector of monuments to the British military authorities in Syria and Palestine, and gave a characteristically thorough account of it in part 1 of his monumental *Early Muslim architecture*, published in 1932. But whereas the first edition of *The encyclopaedia of Islam* (1913–38) contained a substantial article on "ʿAmra" by Ernst Herzfeld, who had uncovered his first fragments of Abbasid painting in the palaces of Sāmarrāʾ on the Tigris north of Baghdād only four years after the publication of Quṣayr ʿAmra, the new edition relegates the building to a short paragraph in the entry "Architecture". Although they had now been satisfactorily dated, the frescoes in particular remained profoundly puzzling. Even their—for the period—unparalleled extent could not satisfactorily explain what seemed to everyone an extreme heterogeneity of content. And like the Dura Europus synagogue frescoes, the Quṣayr ʿAmra paintings also seemed almost provocatively incompatible with the contrast that was conventionally drawn between aniconic Semites (especially Muslims) and image-loving Greeks. Quṣayr ʿAmra's impact on these preconceived ideas was so weak that when, in 1936, Daniel Schlumberger announced the first results of his excavation of Qaṣr al-Ḥayr al-Gharbī, a palatial establishment near Palmyra that was literally covered in stucco decoration including numerous human figures, there were still those who argued that the figural decoration excluded his Umayyad dating, even though he had inscriptions to back it.[65] In the early 1940s Ugo Monneret de Villard planned to compose a chapter titled "Le pitture di Quseir ʿAmra" for what was eventually published, long after his death in 1954, as *Introduzione allo studio dell' archeologia islamica;* but his executors found no such chapter among his papers. In a famous article published in 1951, André Grabar argued for the influence of Muslim courtly motifs—the enthroned prince, dancing girls, acrobats, musicians, and pages—on tenth-century Constantinopolitan art without any reference to Quṣayr ʿAmra, though it has all the above.[66]

64. Herzfeld, *Der Islam* 1 (1910) 106–8.
65. Schlumberger, *Syria* 20 (1939) 335 n. 1.
66. A. Grabar, *L'art de la fin de l'antiquité* 1.265–90, esp. 278.

Only three years later Grabar's son, Oleg Grabar, completed a doctoral dissertation for Princeton entitled *Ceremonial and art at the Umayyad court* and visited Quṣayr ʿAmra for the first time. He was no less disappointed by the main hall than Sir Aurel Stein had been, but his still often mentioned article on one of the frescoes, published that same year,[67] became the first in a series of publications notably sensitive and intuitive if compared, for example, with Creswell's approach. The frescoes themselves, though, remained dishearteningly illegible until, between the years 1971 and 1974, a Spanish team cleaned and conserved them, bringing back into view whole areas of painting that had been invisible even to Mielich—but the essential accuracy of his copies was confirmed. The Spanish team was also able, by limited excavation, to establish for the first time how exactly the bath's hydraulic system had worked. In June 1974 Oleg Grabar and the photographer Fred Anderegg spent a week studying the newly cleaned frescoes, and a number of their excellent photographs are used in the present book. The following year Martin Almagro, Luis Caballero, Juan Zozaya, and Antonio Almagro published *Qusayr ʿAmra: Residencia y baños omeyas en el desierto de Jordania*, a summary description of the complex and its decoration, together with an invaluable selection of clear photographs of the paintings after (but not before or during) the restoration. This was intended only as the forerunner of a fuller account, which has not appeared.

In the three decades that have gone by since the Spanish restoration, Quṣayr ʿAmra itself has become more accessible, while our knowledge of human activity in the wider region, and at every period of history, has broadened thanks to archaeological excavations and surveys conducted at leisure and in secure conditions unimaginable to Musil and other pioneers. At the same time, suspicions slowly began to be aired about the extent to which the Spaniards had intervened in Quṣayr ʿAmra's frescoes rather than simply cleaning them. These suspicions have now been comprehensively documented by a Franco-Jordanian team. Under the direction of Gazi Bisheh of the Jordanian Department of Antiquities, Claude Vibert-Guigue of the Institut Français d'Archéologie du Proche-Orient began work in 1989 on the production of full-size tracings of everything visible on the walls onto transparent sheets of plastic, which were then photographed at one quarter of the original size. The project was completed in 1995. The present state of the frescoes has in this way been recorded in unprecedented detail, along

67. Grabar, *A.O.* 1 (1954).

with the damaged areas and the numerous graffiti. A full publication of the tracings is also planned.[68]

As a result of this project, certain parts of the paintings that had remained obscure after the Spanish restoration can now be reconstructed. Elements of vegetal decoration, and even whole figures, can be shown to be lurking on what had seemed to be hopelessly damaged paint surfaces. So far as one can tell in advance of the final publication, our knowledge of Quṣayr 'Amra's frescoes is not about to be enlarged spectacularly. Something significant has been taken away, though, in the sense that an element of doubt has been introduced into our understanding of what we thought we could see. We now know that there has been quite frequent and extensive repainting, even if it is not usually radical enough to affect the sense of the composition. Especially in the main hall, figures whose outlines and coloring were almost obliterated, for example by rain pouring in through holes in the vaults, have been crudely resketched, particularly faces, hands, and details such as ornaments on fabrics. Already badly damaged Arabic and Greek texts have been retouched in such a way as to render them illegible or of doubtful interpretation. Only where the original paintings were in very good condition, as in the tepid chamber, or else in a seriously mutilated state, did the restorers not retouch. Hence the particular importance—as a standard by which to assess what still remains on the walls—of the three fresco fragments now in Berlin's Museum für Islamische Kunst, which were so infamously cut out by Musil and Mielich but have hardly been interfered with since,[69] and also of the damaged and unrestored panels that can be reconstructed, at least on paper, thanks to Vibert-Guigue's and Bisheh's careful tracings. Attempts to understand Quṣayr 'Amra's paintings have now of necessity to be preceded by study of the history of the bath house's very gradual discovery. This was and is an ongoing process in which two early events, Mielich's visit in 1901 and the work done by Jaussen and Savignac, can at last be more fully appreciated as the only occasions on which scholars looked—or will ever look—at the authentic Umayyad paintings in order to record what could be seen. It is worth noting that Claude Vibert-Guigue, who is in a better position to judge than anyone else, takes a notably more generous view of Mielich's work than did many of his predecessors.[70]

The most recent event in this story occurred in 1996 when Antonio Al-

68. Vibert-Guigue, *S.H.A.J.* 5 and *ARAM periodical* 6 (1994); Vibert-Guigue diss. 1.89–94, 2.310–12.

69. Vibert-Guigue diss. 1.69, 98–111.

70. Vibert-Guigue diss. 2.272–73.

magro returned to Quṣayr ʿAmra with a team from the University of Granada and "derestored" 18 square meters of frescoes in the alcove of the hall (described in chapter 4).[71] The yellowing paintwork was cleaned and "extensive" retouching was confirmed and in part removed, the criterion being the (supposed) intelligibility of the frescoes to tourists—retouched outlines of figures were therefore mostly left in place. Theoretically, at least, the possibility now exists of "derestoring" all the paintings and then retracing the whole ensemble a second time. But what is certain is that Quṣayr ʿAmra has now entered a new phase in its existence, as an evolving tourist attraction.

As for Alois Musil, he did undertake some diplomatic activity in the Middle East, on behalf of Austria-Hungary, during the First World War; but after 1917 he never again visited Arab lands. It was not until 1948, four years after his death, that the only novel he ever wrote was published, in Czech, under the title *Pán Amry (The lord of Amra)*, with illustrations by Václav Fiala.[72] The same year Czechoslovakia succumbed to a Communist putsch, and Musil's friend the foreign minister Jan Masaryk was killed in a fall from his office window, reported as suicide. Not surprisingly, *The lord of Amra* made little impression and is now exceedingly hard to come by. Full of the colorful incident that Musil had culled from his reading of Arabic poetry and history, as well as from his own travels, the book tells the story of a young Bohemian prince, Jurata, who studied architecture and painting with a teacher from the East Roman Empire. After his father is killed in battle, the young prince flees to Constantinople, where he encounters Basil, another architect and painter who is employed in the service of the caliph Hishām. With Basil, Jurata travels to Syria and meets the heir to the throne, al-Walīd b. Yazīd, who is busy building Quṣayr ʿAmra, just as Musil had suggested in his contribution to the publication of the site. Jurata becomes part of Prince al-Walīd's court at nearby Qaṣr al-Ḥallābāt. There he gets to know his fellow Bohemian Česta, an aristocratic woman who was abducted, sold into slavery, and married to a nomad prince in Syria. Jurata saves Česta's daughter Saʿada from the hands of Hishām's son Sulaymān, marries her, and leaves Syria to settle in Constantinople.

Weaving fiction once more, at the end of his life, around the building he

71. Vibert-Guigue diss. 2.310–13; and see now *Q.ʿA.* 137–44, a report on the 1996 campaign (regrettably without new photographs).

72. Two of these are included in this book (figs. 14, 37), for the sake of the insight they give into what Quṣayr ʿAmra may have looked like when it was in use. I am deeply obliged to Petr Holman (Prague) for securing me a copy of *Pán Amry*.

had once striven so mightily to prove was no mere fairy-tale castle, Musil pulled the remote ancestors of his own people into the transfiguring light of Mediterranean history. Our task is to find whether the bath house in the Wādī 'l-Buṭum may also help to impart to our understanding of its historical patron and his circle a perspective more immediate and revealing than what we read in the classical Arabic political narratives such as that of the historian al-Ṭabarī, and more reliable than al-Iṣfahānī's extraordinary compilation of literary gossip and poems, the *Kitāb al-aghānī*.

2 Luxuries of the Bath

Perhaps because of its characteristic mix of black basalts and white lime-stones, the region that is bordered to the west by the valley of the Jordan River and extends from the Wādī 'l-Zarqāʾ or even Irbid in the north as far as the Wādī 'l-Mūjib in the south was recognized by Arabs of the Muslim period to possess some intrinsic coherence—they called it al-Balqāʾ, "the piebald" (map 2).[1] Its waters drain either westwards into the Jordan or east-wards toward the Wādī Sirḥān. Of these eastward-flowing watercourses, the Wādī 'l-Buṭum is one. Collectively, they discharge themselves into the in-land drainage basin round al-Azraq,[2] in whose thickets lions once lurked.[3] Nobody has ever cared to define, though, the Balqāʾ's eastern border. This is a wasteland, and in it stands Quṣayr ʿAmra, well to the east of the tradi-tional zone of settled life and "proverbially excellent wheat"[4] in the hills of Moab, but also somewhat beyond the 100-millimeter isohyet that notion-ally divides the steppe lands from the desert.[5]

In ancient times and right up until the drawing of national frontiers in the twentieth century, al-Azraq was an important stage on the route that followed the Wādī Sirḥān between Damascus and inner Arabia. Quṣayr ʿAmra lay some 27 kilometers to the west, off the Wādī Sirḥān route, but quite close to a track from ʿAmmān that fed into it, and was said by the tenth-

1. Yāq. 1.489 s.v. "Al-Balqāʾ"; J. Sourdel-Thomine, *E.Is.* 1.997–98.
2. Sauvaget, *R.E.I.* 35 (1967) 35 fig. 2.
3. Musil, *Arabia deserta* 337.
4. Yāq. 1.489 s.v. "Al-Balqāʾ"; cf. al-Muqaddasī, *Aḥsan al-taqāsīm* 175, 180.
5. D. L. Kennedy, *Archaeological explorations* 11–15; Northedge, *ʿAmmān* 1.19–20 and figs. 6–9; Gatier, *Frontières terrestres* 442–44.

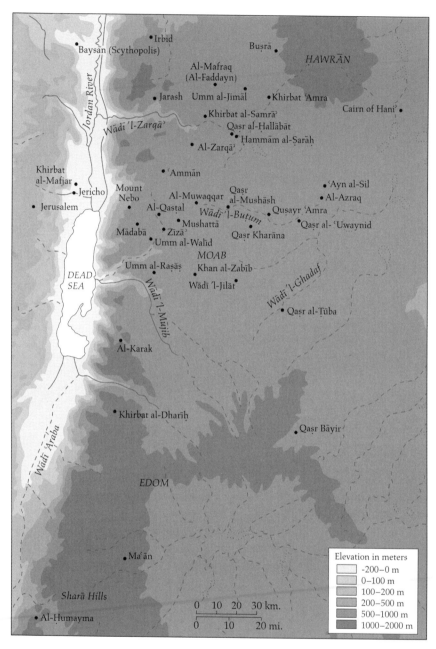

Map 2. Umayyad Jordan, especially al-Balqāʾ

century geographer al-Muqaddasī (from Jerusalem) to have been used by the Umayyad postal service.[6] There are several other Umayyad sites strung out along the probable route of this track. Fifteen kilometers southwest of the fort at al-Azraq lies Qaṣr al-ʿUwaynid. Its visible remains are hard to date—apparently mostly Roman. But al-Muqaddasī explicitly mentions it as al-ʿAwnīd, a staging post two days' distance from ʿAmmān.[7] Then comes Quṣayr ʿAmra itself, Qaṣr Kharāna (rather too far south to have been actually on the track), Qaṣr al-Mushāsh, and al-Muwaqqar, whence ʿAmmān is but a short distance.[8] All these sites have Umayyad associations. Despite its at first sight rather eccentric location amidst the "gray, desolate slopes", far from villages, let alone cities, there are, then, signs that Quṣayr ʿAmra fits into a wider pattern of Umayyad settlement in the Balqāʾ. But before we consider that possibility (in chapters 5 and 9), the complex itself needs to be described and understood, on its own terms and within its own immediate environment.

Viewed from outside, there is nothing monumental about Quṣayr ʿAmra: the internal volumes of the limestone structure are presented without disguise or adornment (figs. 4, 5, 6).[9] Its walls, of varying thickness, are built for the most part of poorly cut stones, along with a few much larger, well-squared blocks possibly taken from an earlier structure on the same site.[10] Mortar is used abundantly to smooth out the irregularities and is lime-based, as was the custom in Syria and generally in Roman architecture. Quṣayr ʿAmra makes relatively little use of gypsum, unlike other Umayyad buildings in the region, whose builders were more indebted to Mesopotamian and Iranian construction techniques. The same continuity

6. Al-Muqaddasī, *Ahsan al-taqāsīm* 250, 253; Musil, *K.ʿA.* 1.122–23; Humbert and Desreumaux, *Khirbet es-Samra* 1.86–87.

7. Jaussen and Savignac 3. pl. III; Stein, *Limes report* 272 pl. 62b, and 281 with n. 1 on the form of the name; D. L. Kennedy, *Roman army* 59–61.

8. Urice, *Qasr Kharana* 84, "postulates" that the al-Azraq–ʿAmmān route ran via Qaṣr al-Ḥallābāt and Muwaqqar—for the terminally lost?

9. For a full description of the buildings see *Q.ʿA.* 25–48, 102–8, with additional details in Bisheh, Morin, and Vibert-Guigue, *A.D.A.J.* 41 (1997). Photographs of the exterior: Jaussen and Savignac 3. pls. XXXVI–XXXIX; Gertrude Bell Photographic Archive (www.gerty.ncl.ac.uk) X 008, Y 073–74, Y 076, Y 524; Creswell pls. 70–71; *K.Is.* pl. 31; *Q.ʿA.* 12 fig. 1, 20 fig. 4, 22 fig. 5, 30–31 figs. 8–9, 35 fig. 11. Late antique and early Islamic baths and bathing: Berger, *Das Bad in der byzantinischen Zeit*; J. Sourdel-Thomine, *E.Is.* 3.139–44; Grotzfeld, *Das Bad im arabisch-islamischen Mittelalter.* The parts of the bath: Nielsen, *Thermae et balneae* 1.153–66.

10. For fragments of Greek inscriptions (presumably reused) or graffiti found at Quṣayr ʿAmra, see *Q.ʿA.* 105; Vibert-Guigue diss. 2.119, 3. pl. 131.2–3; Bisheh, Morin, and Vibert-Guigue, *A.D.A.J.* 41 (1997) 385–86; and the excavation notebooks of J. Zozaya (Madrid), who kindly showed them to me.

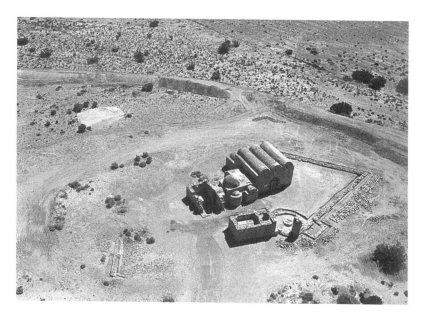

Figure 4. Quṣayr ʿAmra from the air. C. Vibert-Guigue.

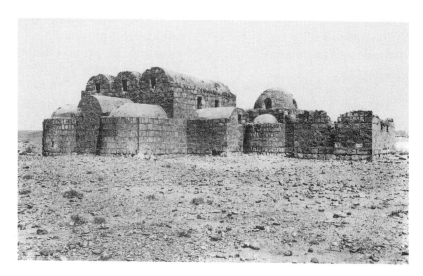

Figure 5. Quṣayr ʿAmra from the southeast (1909–12). A. J. Jaussen and
R. Savignac, *Mission archéologique en Arabie* (Paris: P. Geuthner, 1909–22;
reprint, Cairo: Institut Français d'Archéologie Orientale, 1997) 3. pl. XXXVII.

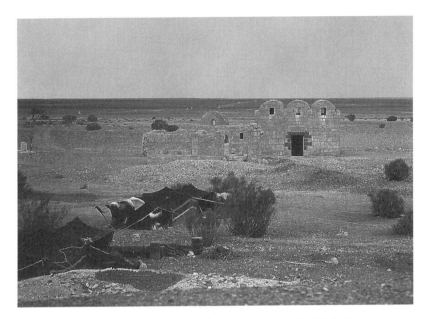

Figure 6. Quṣayr ʿAmra from the north. Oronoz Fotógrafos, Madrid.

with Roman architecture is apparent in the construction of the vaults with rubble masonry rather than the brick used at Mushattā, for example. By using brick and gypsum, with its excellent binding qualities, vaults could be constructed without the use of expensive and hard-to-come-by wood centering; but this consideration carried less weight in a small building like Quṣayr ʿAmra.[11]

The rectangular hall, oriented north-south (fig. 7), has three longitudinal tunnel vaults and eight small windows placed high in its walls close to the vaults: two in the eastern sidewall, none in the wall opposite, since the rains come from the west, and three in each of the endwalls, one for each aisle. To the southern endwall are attached three small barrel-vaulted chambers, the middle one terminating in a plain wall, while the two side chambers are provided with shallow apses (inverting, in other words, the conventional plan of a Christian basilica). The hall's external measurements, including the projecting apses, are roughly 14 meters × 10.5 meters. Opening off its east side is a sequence of three tiny rooms that make up the bath itself. The third of these rooms has an apse on its northern and southern sides and is covered with a dome lit by four arched windows. On its east side are the

11. Almagro, *S.H.A.J.* 5.

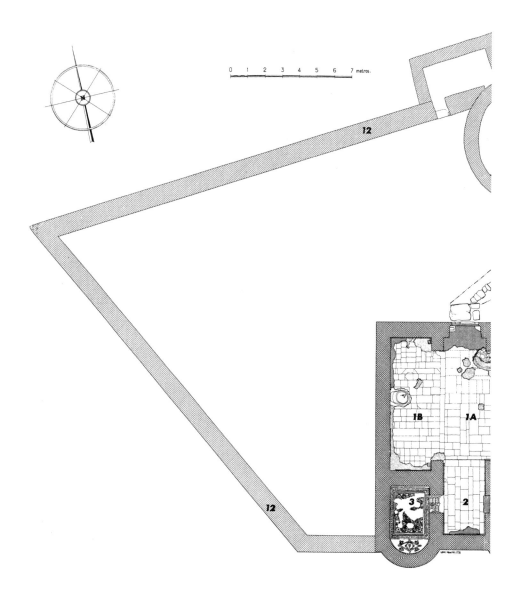

Figure 7. Quṣayr ʿAmra: plan of the bath house. 1A: Hall, central aisle.
1B: Hall, west aisle. 1C: Hall, east aisle. 2: Hall, alcove. 3–4: West and
east apsidal side rooms. 5: Apodyterium. 6: Tepidarium. 7A: Caldarium.
7B: Boiler and water tank. 8: Service area and wood store (?). 9: Cistern.
10: Well. 11: Winding installation and circular camel track. 12: Flood barrier.
J. I. L. Macarrón, in *Qusayr ʿAmra: Residencia y baños omeyas en el desierto
de Jordania*, ed. M. Almagro, L. Caballero, J. Zozaya, and A. Almagro (Madrid:
Instituto Hispano-Árabe de Cultura, 1975) fig. 4.

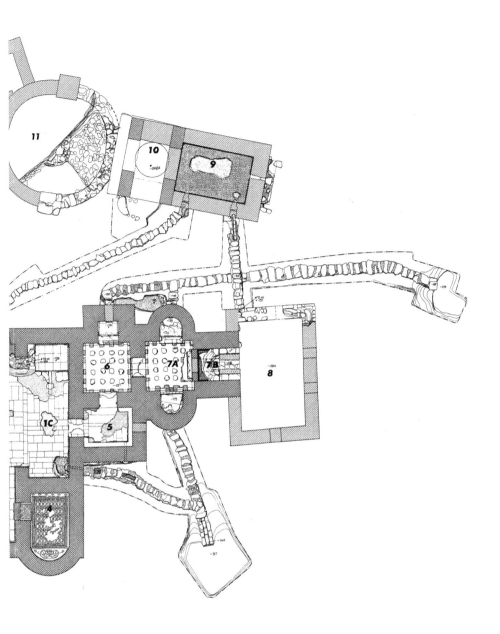

boiler and water tank, and beyond that a large walled area, the bath's east-ernmost appurtenance and now the only part that lacks a roof, if it ever had one. This appears to have been an addition to the main structure and was probably the service area and wood store for the boiler.

The complex's principal entrance is a basalt portal in the hall's northern wall. Through this doorway the sun streams in to supplement the diffused, dappled light from the high, small windows once filled with tracery and colored glass. As for the space within, it is divided lengthways (north-south) into three equal-sized, marble-paved bays by single, broad, and slightly pointed arches parallel to the hall's axis, springing from pilasters and pseudocapitals at a height of about 1.5 meters. At first glance this reminds one of a three-aisled basilica. But the use at Quṣayr ʿAmra—copying, it seems, the nearby but somewhat earlier Umayyad fort at Qaṣr Kharāna[12]—of arches supporting tunnel vaults rather than roofs made of stone slabs, represents an innovation in Syrian architecture. Here, at least, there may be an influence from Mesopotamia. What one perceives on closer inspection is "a clear interior, nearly square, without aisles, the triple division being confined to the vaulting above one's head".[13] The overall effect is one of spaciousness (fig. 8).

The furnishings are left to our imagination. The only installation of which traces remain—though they were not found until the Spanish restorers undertook a small excavation—is a marble-revetted pool (Latin *piscina*, whence Arabic *fisqīya*), measuring 1.95 × 1.40 × 0.40 meters, and situated at the northern end of the east aisle. It seems that this hall combined the functions of the entrance hall of the standard Roman bath house, and its frigidarium, where one cooled off by sitting in the shallow *fisqīya* and having cold water poured over one, after experiencing the intense heat of the inner chambers. Alternatively, the pool enabled one to freshen up before taking one's place in the hall, without going through the whole bathing process; or else it functioned as a simple air conditioner for those sitting near it.[14] Shallow pools of this sort, not designed for immersion, have been found in the halls of several late Roman and Umayyad bath houses in Syria (Sar-

12. Urice, *Qasr Kharana*, esp. 86–87, seconded by Hillenbrand, *Oriental art* 37 (1991), suggests a date before 684. This is not impossible, given that ʿAbd al-Malik is said to have resided temporarily at al-Muwaqqar (below, pp. 151–52) c. 690: Elad, *Medieval Jerusalem* 154–56.

13. Creswell 441, and cf. 444–49; Gaube, Z.D.P.V. 93 (1977) 85.

14. Cf. al-Madāʾinī in Bal. 2. fol. 726a (72, §134 ʿAthāmina) on the caliph Hishām sitting with his feet in a *birka* (pool) on a hot day; Hurgronje, *Mekka* 2.41.

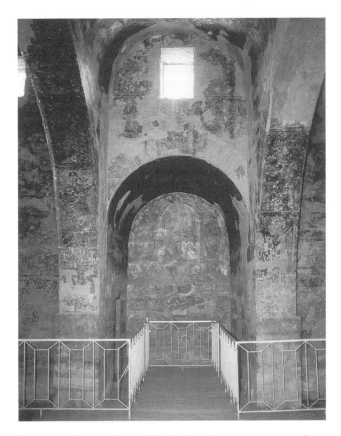

Figure 8. Quṣayr ʿAmra, hall, looking from entrance (north)
to alcove (south). C. Vibert-Guigue.

jilla, for example, Qaṣr al-Ḥayr al-Gharbī, Qaṣr al-Ḥayr al-Sharqī, and Ḥam-
mām al-Ṣarāḥ).[15]

The hall's main surfaces are divided into four zones. The first reaches door
lintel height, the second the sills of the windows, the third the spring of the
barrel vaults. The fourth zone consists of the vaults themselves. If the com-
plex's exterior is of the austerest simplicity, its interior is riotous variety
and color, paintings spreading out over every wall and vault of the hall and

15. See respectively Charpentier, *Syria* 71 (1994); Schlumberger, *Syria* 20
(1939) 215, 219, and pl. XXXIII (= *Q.H.G.* 6, 8, and pl. 51a); *Q.H.E.* 90–91; Bisheh,
Da.M. 4 (1989) 227. Compare also the apparently deeper pools in the frigidarium
of the newly discovered sixth-century bath at al-Andarīn: M. M. Mango, *D.O.P.* 56
(2002) 311.

of the smaller rooms too (fig. 9).[16] The lowest zone was taken up by a marble dado and, above it, by representations of simple wall hangings and by bands of ornament. Figural decoration begins at lintel height, that is to say, eye level (the doors being low, at least by our standards). One's attention is particularly caught by the painting of an enthroned prince that adorns the rear wall of the barrel-vaulted alcove in the middle of the south wall right opposite the entrance and provides a focus for this most public part of the bath. Here must be the spot where Quṣayr 'Amra's owner sat to receive distinguished guests. Other frescoes, of attendants and dancing girls, drop further hints at the way in which the hall was used on more formal occasions of reception and entertainment.

As for the two small, virtually unlit apsidal rooms, they are entered through low doors in the sidewalls of the alcove and are the only parts of the complex that afforded complete privacy. The architectural historian K. A. C. Creswell recorded that he did not enter the left, or east, room because "the floor was occupied by a number of desiccated corpses, presumably of Bedawīn, very neatly and carefully wrapped up in winding-sheets".[17] These rooms could have been for changing or undressing, though screens or large towels held by servants would have served this purpose just as well.[18] It would also have been possible to sleep in them, or indeed to use them for the erotic pleasures that Quṣayr 'Amra's paintings often seem to evoke.[19]

16. The frescoes of Quṣayr 'Amra have not yet all been illustrated in a single publication. See Musil's photographs in *Kᵘsejr 'amra und andere Schlösser* figs. 13–20, and *Arabia petraea* 1. figs. 118–24; Mielich's facsimiles in *Ḳ.ʿA.* 2; photographs in Jaussen and Savignac 3. pls. XXXIX.2–XLIII, XLV–LIV—note also the preliminary publication by Migeon, *Revue biblique* 11 (1914); Gertrude Bell Photographic Archive (www.gerty.ncl.ac.uk) Y 067–72, Y 075, Y 523 (including some general interior photographs); photographs taken immediately after the Spanish restoration, in *Q.ʿA.*; and photographs taken by Fred Anderegg for Oleg Grabar: *Is.A.A.* 44–49; Grabar, *C.A.* 36 (1988), *S.Byz.Is.* (all references to direction in the legends of these two articles are incorrect), and *A.O.* 23 (1993). Good color photographs from before 1971 exist only for frescoes that were legible and therefore little affected by the Spanish restoration: see below, pp. 42 n. 23, 57 n. 67. The most comprehensive verbal descriptions of the frescoes are Wickhoff, *Ḳ.ʿA.* 1.208–12; *Q.ʿA.* 49–93; Grabar's unpublished *Paintings at Qusayr Amrah;* and, in a category entirely of its own, Vibert-Guigue's massive doctoral thesis, *Peinture omeyyade.* The same author will provide comprehensive visual documentation in *Les peintures de Qusayr 'Amra,* to be published in collaboration with G. Bisheh.

17. Creswell 398 n. 6.

18. Sauvaget, *Syria* 20 (1939) 247; Dow, *Islamic baths of Palestine* 6.

19. Cf. al-Ghuzūlī (d. 1412), *Maṭāliʿ al-budūr fī manāzil al-surūr* 2.8–9 (trans. Grotzfeld, *Das Bad im arabisch-islamischen Mittelalter* 146–48); also Behrens-Abouseif, *Muqarnas* 14 (1997) 16, for an arguably similar arrangement at the Umayyad palace of Khirbat al-Mafjar near Jericho.

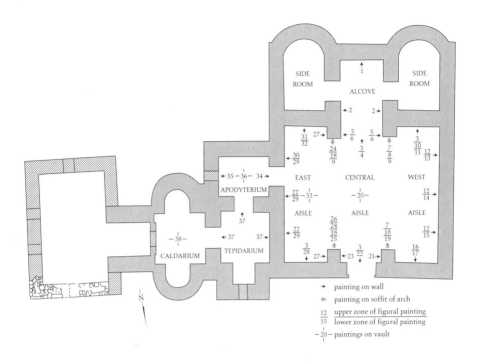

Figure 9. Quṣayr ʿAmra: key to the bath house frescoes. 1. Enthroned prince: figs. 36–37. 2. Decorative women framed by arcade: fig. 21. 3. Personifications (?) (lunette): fig. 50. 4. *Mukhannathūn* (?) (above alcove arch): fig. 20. 5. Lunging animal (spandrel): fig. 25. 6. Decorative woman framed by arch (spandrel): fig. 14. 7. Standing figure. 8. Dancing girl: fig. 17a. 9. Singer (?). 10. Dynastic icon: figs. 50–51. 11. Arabic text in *tabula ansata*: figs. 50–51. 12. Onagers pursued into net: figs. 33, 60. 13. Six kings: figs. 52, 53, 60. 14. Bathing beauty: figs. 51, 60. 15. Acrobats: fig. 60. 16. Fishes (lunette). 17. Figure with outstretched arms (labeled *ΡΩΠΑ*?): fig. 14. 18. Musician. 19. Decorative woman framed by arch. 20. Figures in various poses (32 panels): fig. 25. 21. Pensive woman with Eros (spandrel): fig. 24. 22. Erotic scene (?). 23. Male musician flanked by female dancers (spandrel): fig. 18. 24. Decorative woman in long skirt, holding up a bowl or basket: fig. 17b. 25. Decorative woman. 26. Medallion containing portrait (apex of arch): fig. 25. 27. Date palm (spandrel). 28. Slaughter of onagers in net enclosure: fig. 34. 29. Hunt with salukis: fig. 29. 30. Lion pouncing on wild ass: fig. 61. 31. Personifications of Philosophy, History, and Poetry: fig. 28. 32. Slaughter of animals (including oryx) in a woodland clearing: fig. 32. 33. Scenes from the construction industry (32 panels): fig. 61. 34. Death of Salmā (lunette): fig. 62. 35. Half nude woman, baby, nude man. 36. Musician, dancing girl, bear, monkey, "three ages of man" (?), etc. (diamond-shaped panels): fig. 19. 37. Bathing women (lunette): fig. 15. 38. Zodiac (dome): fig. 10. Based on the plan by J. I. L. Macarrón, in *Q.ʿA.*[1] fig. 4.

The walls and vaults of these particular rooms are decorated with frescoes of vines and bunches of grapes; while the interlacing curvilinear patterns of the carpetlike mosaic floors develop in an original fashion the pre-Islamic repertory of the Roman East, with which the artists at Quṣayr ʿAmra were still intimately familiar.[20]

The part of the complex that was set aside strictly for bathing is entered through a doorway in the hall's east wall. One immediately finds oneself in a tunnel-vaulted room with a bench round the walls, and a waste water outlet. It is often hard to assign specific functions to each chamber in ancient bath houses, and Quṣayr ʿAmra is no exception. The tunnel-vaulted room presents special difficulties, but by process of elimination it was most probably the apodyterium, where one undressed before the bath. It will also have eased the transition from the hot bath—by which it was indirectly heated—back to the hall. Hence a door leads straight into a cross-vaulted room that must be the tepid chamber or tepidarium, designed to allow a gradual increase in the body's temperature. It is provided with a full immersion bath in its north wall. The third, domed room is the hot chamber or caldarium, with full immersion baths in each of its two apses.[21] Both tepidarium and caldarium were heated under the floor, by hypocausts. The upper walls of the tepidarium were covered in frescoes, while those of the caldarium, an especially elegant room, were decorated with mosaics. The dome was frescoed. To this caldarium one may apply the description of the corresponding chamber in the baths of his villa, penned by a fifth-century Gallic aristocrat, Sidonius Apollinaris:

> At this point there stands the hot bath. . . . It has a semicircular end with a roomy bathing tub, in which part a supply of hot water meanders sobbingly through a labyrinth of leaden [at Quṣayr ʿAmra ceramic] pipes that pierce the wall. Within the heated chamber there is full day and such an abundance of enclosed light as forces all modest persons to feel themselves something more than naked.[22]

The "abundance of enclosed light" that floods into the caldarium at Quṣayr ʿAmra through its four windows certainly contrasts with the obliquer illumination of the hall: the zodiac painted on the dome (fig. 10)[23] stands out

20. Kessler, in Creswell; Piccirillo 50, 147, 258, 350–53, etc.

21. Creswell pl. 75b. The (late) Roman has here been preferred to the mediaeval Arabic terminology invoked in *Q.H.E.* because it and the way of life it denotes are closer to the Umayyads in time—and could have been known to them.

22. Sidonius Apollinaris, *Epistulae* 2.2.4 (trans. W. B. Anderson).

23. Cf. *K.Is.* pl. VI and *Q.ʿA.*[1] pl. XLVIII/ *Q.ʿA.* 48 fig. 20—a rare chance to compare color photographs from before and after the Spanish restoration; also Brunet, Nadal, and Vibert-Guigue, *Centaurus* 40 (1998) 99–101 figs. 1–3.

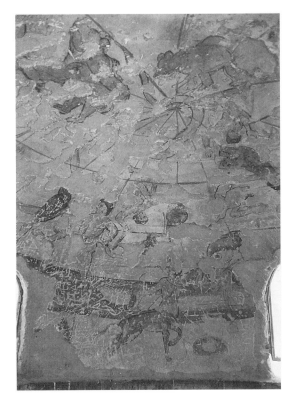

Figure 10. Quṣayr ʿAmra, caldarium, dome: Zodiac
(fresco). C. Vibert-Guigue.

as clearly as do the stars over the surrounding desert at night. "The edifice
is aglow like the vault of heaven",[24] which we know was depicted in certain
bath houses in the Greek East, though Quṣayr ʿAmra is the only example
of this convention that has actually been preserved. It has been shown that
the zodiac was painted on the dome from a model in a Greek astronomical
manuscript—once more, we find ourselves in the presence of an artist im-
mersed in the region's pre-Islamic visual traditions.[25]

Six hundred meters to the northwest of the hall and bath, on higher

24. See Leo Choirosphaktes' poetic description of a palace bath built or restored
by the East Roman emperor Leo VI (886–912), in Magdalino, *D.O.P.* 42 (1988)
116–18, line 13.

25. Saxl, in Creswell; Brunet, Nadal, and Vibert-Guigue, *Centaurus* 40 (1998);
cf. Mielich, *Ḳ.ʿA.* 1.194. For almost exactly contemporary depictions of the twelve
constellations in the Vatican gr. 1291 copy of Ptolemy's *Handy tables* (now dated

ground above the watercourse's floodplain, lie ruins of a single-storied en-
closure some 27 × 32 meters, or 32 × 33 meters with projections (fig. 11). It
is made up of chambers grouped round three sides of a courtyard, with a
single entrance in the fourth, southern wall facing toward the wadi, and two
projecting towers—or perhaps simply latrines—on the side opposite the
entrance. This is just one of a whole set of such structures, variously data-
ble between the first and eighth centuries, that can be found in the steppe
and desert. There is no evidence by which the one at Quṣayr ʿAmra might
be dated; but a close parallel, almost identical in size as well, has recently
been located among a cluster of some eighteen buildings of the seventh or
eighth century at al-Rīsha in northeastern Jordan, apparently intended to
facilitate contacts between the nomad Arabs of the region and the Umayyad
authorities. At Jabal Says, a rather more substantial settlement at the foot
of a conspicuous volcanic cone some 105 kilometers east-southeast of Dam-
ascus and known to have been favored by the caliph al-Walīd I (705–15),
there are some forty to fifty structures, not all of them necessarily Umayyad,
but again including close parallels to the Quṣayr ʿAmra courtyard dwelling,
as well as a bath house. It is interesting to note, too, that among several lo-
cal concentrations of this type of building, one is in the westward approaches
to the Wādī Sirḥān.[26] These structures seem to owe something to the do-
mestic architecture of Roman Syria, something to the caravanserais or *man-
siones* that afforded shelter to travelers on the main routes, and something
also, however imaginatively or even unconsciously, to the many Roman forts
and military camps that the Arabs became familiar with before as well as
during and after the rise of Islam.[27] The examples known to us are all in the

to the third quarter of the eighth century) see Brubaker and Haldon, *Byzantium*
37–40. Seventh- and eighth-century Syriac astronomy "seems to have been pre-
dominantly Ptolemaic", whereas the earliest Arabic astronomical texts (735 onwards)
come from the East and show strong Iranian and Indian influence: Pingree, *Journal
of the American Oriental Society* 93 (1973), esp. 34–35, 37.

26. Helms, *Early Islamic architecture* 84–102, esp. figs. 34 (reconstruction of
building C at al-Rīsha), 38 (parallels at Jabal Says); cf. Dentzer, *Syria* 71 (1994), esp.
72–73 (Wādī Sirḥān area); and the convenient collection of plans in Gregory, *Ro-
man military architecture* 1. figs. 7.17–26.

27. Arguments for and against the influence of Roman military architecture are
presented by Bettini, *Anthemon*, and Dentzer, *Syria* 71 (1994) 88–96 (for); and Gre-
gory, *Roman army* 183–88 (against). Note also (1) the *castellum* and *balneum*
constructed in A.D. 201 according to an inscription found at Qaṣr al-ʿUwaynid, not
far from Quṣayr ʿAmra, though possibly brought from elsewhere (al-Azraq?):
D. L. Kennedy, *Archaeological explorations* 122–23, 125, and *P.E.Q.* 132 (2000) 31;
(2) the defensive inadequacies of the Umayyad "desert castles" (below, p. 287), but
also of the Justinianic fortress-monastery at Sinai: Forsyth, *D.O.P.* 22 (1968) 6; (3)

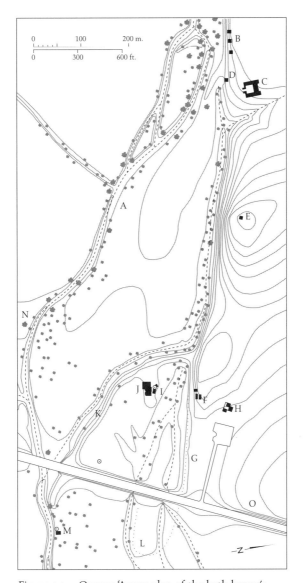

Figure 11. Quṣayr ʿAmra: plan of the bath house's environs. A: Wādī ʾl-Buṭum. B: Traces of structures. C: Courtyard dwelling. D: Cistern with central pillar. E, F, G: Remains of small structures. H: Visitors' center. I: Well in front of bath house. J: Bath house. K: Modern dyke. L: Remnants of garden wall. M: Well by wadi. N: Traces of structures. O: ʿAmmān–al-Azraq highway. T. Morin, in T. Morin and C. Vibert-Guigue, "Une structure d'accueil des visiteurs à l'entrée de Quṣayr ʿAmra", *A.D.A.J.* 44 (2000) 589.

steppe or desert of Syria or Arabia, though that does not mean that their rather obvious plan was unknown in the more settled regions, where the ruins of such undistinguished buildings were much more likely to be built over and obliterated.

During a surface survey in 2001 were discovered, 20 meters outside the courtyard dwelling's entrance, the exiguous remains of a small Umayyad mosque, with a *qibla* wall 9.45 meters long. This filled what had always seemed a rather odd gap at Quṣayr ʿAmra. Halfway between the courtyard dwelling and the baths, but still on the high ground, stood a structure some 6.80 meters square, and there are remains of what seem to be smaller dwellings too.[28] So the bath house was originally less isolated than it now appears.

A HUNTING LODGE IN THE DESERT

The use that was made of all these buildings depended, primarily, on their water supply. During rainfall, water pours off the stony hills and collects in the Wādī 'l-Buṭum, where it may form substantial pools (fig. 1). In a flash flood, the hall and bath easily fill with water,[29] which the wedge-shaped wall that bounds the complex to the west was designed to divert. Quṣayr ʿAmra also has two wells. One, just in front of the facade of the bath house, has on one side the remains of an unusually intact, recently (1996) restored winding installation *(sāqiya)* and its circular camel track, and on the other side a small cistern. This well supplied water that was piped into the bath house. Some 325 meters to the southeast, on the very edge of the wadi, is another such installation, for the irrigation of fields. North of this and east of the main structure are the remnants of a garden wall, while the wadi was dammed to allow some irrigation. The nearest constant spring, though, is at the al-Azraq oasis. Musil's description of his visit to Quṣayr ʿAmra in 1909 draws attention to the variability of the water supply:

> The neighbourhood had changed very much since I first saw it. Four years before, rain had fallen so plentifully that the Sirḥân, who were camping near the castle on both the right and the left bank of the

recent reclassification of supposed Roman *castra* as Umayyad residences: below, p. 275 n. 111; (4) the probable derivation of Arabic *qaṣr* ("desert castle") from *castrum:* below, p. 273 n. 102.

28. Morin and Vibert-Guigue, *A.D.A.J.* 44 (2000) 583 n. 10; Genequand, *A.D.A.J.* 46 (2002).

29. Musil, *Ḳ.ʿA.* 1.87–88; cf. Sauvaget, *R.E.I.* 35 (1967) 34.

Wudej al-Buṭum, cut out and burned all the bushes. Since, however, the rain had been insufficient in the next two years and almost absent during the year just past, not even annuals had grown, while perennials had either been grazed off or rooted out and burned. Consequently the vicinity now resembled an arid desert. Even the younger terebinth trees had disappeared, only the oldest ones remaining.[30]

Since Quṣayr ʿAmra lacks the large reservoirs that are so characteristic of other such sites in the steppe and desert, it is unclear to what extent its irregular water supply could be stored and spread out over dry periods. But in any case, the buildings were probably not in use for very long. In the first place, they show no sign of the alterations, extensions, and contractions that are so characteristic of the archaeological record of long-lived baths. Secondly, an expert on ancient water-lifting devices, Thorkild Schiøler, who visited Quṣayr ʿAmra in 1969, observed that "neither in the [main] well nor in the walls was there the slightest evidence of wear. There are usually heavy deposits of crustaceous lime around water tanks and wells, but I could find no trace of this either."[31] Finally, there is no evidence that the frescoes were ever repaired or repainted, as one might reasonably have expected especially in the tepidarium and caldarium.[32] The lower surfaces of the walls were admittedly protected by marble cladding, but the paintings on the upper walls, and on the caldarium dome, would have suffered had the bath been in use for a generation or two. Yet some of the best-preserved frescoes are to be found precisely in these two hottest rooms. One concludes that Quṣayr ʿAmra's heyday was brief. Even during that short period, the bath house may have been used only seasonally.

Another question concerns the extent to which the site, as we see it today, represents a completed project or one that, like others to be mentioned in chapter 5, was abandoned without ever reaching its final intended form. The reason why this seems a natural question to pose is that Quṣayr ʿAmra's combination of courtyard dwelling, free-standing bath house, cultivation, and facilities for water gathering was far from unique in the Umayyad Balqāʾ. To the west, Qaṣr al-Mushāsh on the road to ʿAmmān shows all these ele-

30. Musil, *Arabia deserta* 343; cf. Jaussen and Savignac 3.9.
31. Schiøler, *Water-lifting wheels* 96.
32. Cf. the baths west of the Great Mosque of al-Mutawakkil at Sāmarrāʾ: Herzfeld, *Die Malereien von Samarra* VII ("Die die Malereien zerstörende Feuchtigkeit der Bäder machte eine dauernde Übermalung notwendig, und es fanden sich daher bis zu 16 Schichten übereinander, wie die Jahresringe eines Baumes, von vielleicht nicht viel mehr als 16 Jahren"), 81–84, pl. LVIII; also Arnold, *Painting* 85–86 and pl. XVIIc.

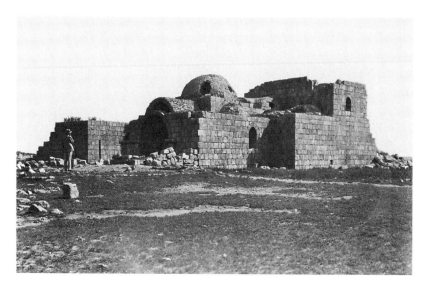

Figure 12. Ḥammām al-Ṣarāḥ as it was preserved until the early 1950s. Field
Museum, Chicago.

ments, again arranged along a wadi.[33] So does al-Qasṭal, some 25 kilome-
ters south of ʿAmmān.[34] And about 45 kilometers to the northwest lies Qaṣr
al-Ḥallābāt, a hilltop Roman frontier fort transformed under the Umayyads
into a luxurious residence adorned with carved stucco, mosaics, and frescoes
showing humans and animals.[35] Close by are to be seen a huge reservoir
and eight cisterns, a walled agricultural enclosure or *ḥayr* with an irriga-
tion system, and the remains of a cluster of dwellings. Five kilometers away
stands Ḥammām al-Ṣarāḥ (fig. 12), a bath house composed of a hall followed
by three small rooms roofed, in this order, with a tunnel vault, a cross vault,
and a dome. The general resemblance in appearance and plan but also, more
specifically, in the use of cross vaults, slightly pointed arches, and figured
frescoes all suggest a close relationship with Quṣayr ʿAmra, though Ḥam-
mām al-Ṣarāḥ's greater architectural sophistication may imply a slightly
later date.[36] Qaṣr al-Ḥallābāt (like al-Qasṭal) also has a mosque, whose ma-

33. G. R. D. King, *A.J.* 2.391–96; Bisheh, *Bilād al-Shām* 81–90.
34. P. Carlier, *A.J.* 2.458–65; and see below, pp. 152–53.
35. Bisheh, *S.H.A.J.* 2, *A.J.* 2.245–51, and *Muqarnas* 10 (1993); Piccirillo 341–51.
36. Creswell 498–502; *Q.ʿA.* 106 n. 29; Bisheh, *Da.M.* 4 (1989). For further par-
allels to the vaulting sequence see Creswell 440–41 (ʿAbda and Ruḥayba in the
al-Naqb desert; late Roman), 477 (Jabal Says; Umayyad). There is a more recent dis-
cussion of the ʿAbda bath house in Negev, *Oboda* 170–76.

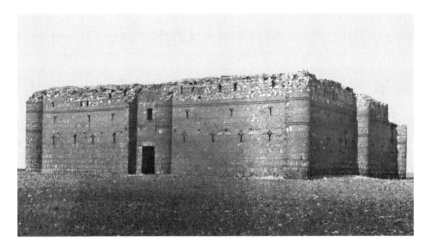

Figure 13. Qaṣr Kharāna (1913). G. Bell: Gertrude Bell Photographic Archive X 10,
University of Newcastle.

sonry links it closely to Ḥammām al-Ṣarāḥ, while its three parallel tunnel
vaults suggest that these two sites, together with Quṣayr ʿAmra, should be
treated as a group.[37] Not that Qaṣr al-Ḥallābāt and Ḥammām al-Ṣarāḥ nec-
essarily belonged to the same person as Quṣayr ʿAmra. Their patrons must
have been acquainted, though; and no doubt they exchanged artisans as well
as ideas.

Comparing, then, Quṣayr ʿAmra as it is today with Qaṣr al-Mushāsh and
al-Qasṭal and Qaṣr al-Ḥallābāt, one is struck by the imbalance between its
well-built, perfectly preserved bath house, on the one hand, and, on the other
hand, the extreme ruinousness of its courtyard residence, and the absence
of reservoirs. The same imbalance is duly reflected in the scholarly tradi-
tion, which has been fascinated by the bath house's frescoes but largely in-
different to all the other buildings on the site, and to the concept that lay
behind the complex as a whole. In particular, the close similarity between
the Quṣayr ʿAmra and Ḥammām al-Ṣarāḥ bath houses leads one to ask,
where is Quṣayr ʿAmra's equivalent to Qaṣr al-Ḥallābāt? There are two pos-
sible answers. The unassuming courtyard dwelling's dimensions of 27 × 32
meters without projections, and its lack, so far as is known, of any expen-
sive decoration, make it roughly comparable to nearby Qaṣr Kharāna (ap-
proximately 35 meters square without projections) (fig. 13)—except that it
would have had only half the height. So either the courtyard dwelling was

37. Creswell 502–5.

itself the required equivalent, but presumably much more roughly built than the bath house, in view of its state now (just a scattering of stones); or alternatively, the courtyard dwelling antedated the bath house, and something on a grander scale was planned to replace it but was never started, let alone completed. Whichever solution we choose, though, the same corollary has to be accepted, namely that Quṣayr 'Amra's patron considered it acceptable for his project to function, even temporarily, as what we see today: a dominant bath house accompanied by a few auxiliary structures.[38] In which case, we must assume that most of Quṣayr 'Amra's visitors camped out, in tents pitched round the bath house. That would in turn explain the very limited defensive value of the built structures. Their users' best defense was their mobility, and their citadels were elsewhere.[39]

Indeed, not only the soundly built stone bath house itself but also its decoration, and the resources needed if it was to be provided with water and with fuel for the boiler, all point to a capital investment, and therefore a patron, from the urban world beyond the steppe horizon. Quṣayr 'Amra did not meet local needs but rather gratified the whims of wealthy outsiders. It was conceived for occasional visits, full of pleasures one might dream of, but hardly expect, in the desert.

Some of these pleasures were simple ones, it is true, and one did not need to be rich to enjoy them. The terebinth trees, for example. Once upon a time they were more commonly encountered in the Balqā';[40] and hereabouts they still make the Wādī 'l-Buṭum, seen from the air, look like a long green ribbon unfurled across the steppe. Musil noted that they were "the only trees that I have seen east of the Pilgrim Road", and quite possibly had been planted by the hand of man.[41] Characteristically, he dwells on the beduin's fright when he comes unawares on something as odd as a tree, especially if the air is hot and makes whatever he sees dance and distort; but trees were also for the beduin a refuge, even something holy.[42] The terebinth or wild pistachio in particular, throughout its long history in the Middle Eastern landscape, has offered its unusually deep, dense shade to gods, angels, and holy men as well as to ordinary mortals.[43] Musil and Mielich lost their camels to robbers in 1901 precisely because two of their companions, in-

38. Compare Khirbat al-Mafjar: below, pp. 162–63.

39. Al-Haytham b. 'Adī in Mas. 1111 (2.97–98 Dāghir); Musil, *Palmyrena* 287–88.

40. Ṭūqān, *Al-ḥā'ir* 404.

41. Musil, *Arabia petraea* 1.222; cf. id., Ḳ.ʿA. 1.119.

42. Musil, Ḳ.ʿA. 1.56–57.

43. Mader, *Mambre* 285–88; Kislev, *P.E.Q.* 117 (1985).

stead of keeping watch, had sat down in the shade of one of the terebinths and were happily picking insects out of their clothing. Even in time of strife, Quṣayr ʿAmra's water and trees might offer brief security and relaxation: Lawrence's men, in August 1918, "stretched themselves beneath the trees, for a slumberous afternoon and evening. The aeroplanes had not found us— could not find us here."[44]

In his prose, sober with vivid flashes, Musil conveys all the place's terrors. When he visited it one last time, in a more relaxed frame of mind in 1909, it still seemed misty, grey, melancholy, even ghoulish. But he knew its magic too, even the magic of its terror. Here is his description of a desert storm, viewed from a distance:

> At about 9 o'clock in the evening [on 4 June 1901] I was sitting on the hot roof with Bakhīt , who was keeping watch. Far away on the southern horizon we saw a dark ball, the size of a fist, moving northeastward at enormous speed and constantly getting bigger. Once it had reached the middle point of the glowing southern sky, an intensely black mass—I could not immediately make out what it was—appeared in the middle of the eastward sky. It turned out to be two strange cloud formations, which were now merging together. Before they collided, both opened to reveal a vertical, flaming surface. Soon afterwards, the whole expanse of the desert boomed, as if thousands of guns had been fired. At the same moment, bright yellow tongues of fire flashed and blazed forth, lighting up the desert all round. Also it seemed to me that one of these spreading fire-serpents had touched the black ḥarra-desert and set it aflame on a front several kilometers long; and then again, I thought I saw the sand rearing up in the shape of a pyramid, becoming one with the clouds. Meanwhile the whole southeasterly sky had become completely black. All living things fell silent, and silently the desert too beheld this battle of the spirits, the jinn. A grandiose, awesome sight![45]

No doubt the wandering Arabs of the desert also came here to hunt the gazelles that were attracted to the wadi in winter and especially springtime by its standing water, and probably took advantage of it as a protected route of migration as well. In the 1960s, Guy Mountfort wrote:

> After examining the Qasr we explored the Wadi el Butm. It was full of tired migrants such as Rollers, Collared Flycatchers, Redstarts, Chiffchaffs, Lesser Whitethroats, Nightingales and Rufous Bush Chats. Swallows were passing through in considerable numbers, swooping

44. Lawrence, *Seven pillars of wisdom* 573; cf. Jaussen and Savignac 3. pl. I.1.
45. Musil, *Ḳ.ʿA.* 1.91.

down from the surrounding hills and flying close to the bed of the wadi to escape the wind.[46]

The built installations, though, were aimed at grander hunters than these—we shall shortly encounter them in the bath house frescoes, in hot pursuit of their quarry. On such occasions we may imagine the place invaded by a whole caravan of domestics and women who transformed it, however temporarily, into home from home for their masters, while cooks prepared the meat of the animals just caught, and garnished it with vegetables produced in Quṣayr ʿAmra's gardens by the skeleton staff that lived there permanently. Such large-scale expeditions into the steppe or desert were a common form of entertainment for the Umayyads. We read, for example, in various sources an account of how the caliph Hishām once went out from his preferred residence at al-Ruṣāfa in the Syrian steppe, accompanied by "his family, his entourage, his servants and his companions". He camped in a barren, stony plain, but in a year when the rain had fallen early and abundantly, so that the landscape was transformed by a mass of springtime grasses and gaily colored flowers, and all was beautiful to behold.[47] Elsewhere we glimpse al-Walīd b. Yazīd relaxing after a day's hunting "in a tent whose floor and walls were adorned with Armenian (carpets and hangings)", which were enormously prized by the Arabs,[48] while on another occasion we find him setting forth to spend some time carousing with his drinking companions and court poets in a hunting lodge he owned: the Arabic word is *mutaṣayyad*.[49] This is perhaps also the best label to attach to Quṣayr ʿAmra, at least in the shape in which it has come down to us, and without prejudice to the possibility that it was meant to be developed, eventually, into a more permanent type of settlement.

The focus of this busy scene will have been neither the courtyard dwelling nor even the welcome refreshment of the bath itself, but rather the bath house hall, where the patron received his guests. Looking farther afield, to the wider context provided by the bath houses of late Roman as well as early Islamic Syria and Palestine, one can see that the "hall-type" design followed at Ḥammām al-Ṣarāḥ and Quṣayr ʿAmra was far from innovative. From the limestone uplands of northwestern Syria, Antioch's hin-

46. Mountfort, *Portrait of a desert* 80, and cf. 60 (gazelles).

47. Iṣf. 2.129, and cf. Ibn Qutayba, *Al-imāma wa-'l-siyāsa* 2.126. Another such scene, with "caravans, trains of camels, slave girls and horses", at Ṭab. 2.211 (trans. 18.222 M. G. Morony).

48. Al-Aṣmaʿī in Iṣf. 6.101; Ahsan, *Social life* 191–92.

49. Al-Madāʾinī in Iṣf. 7.80.

terland, eastwards to the banks of the Euphrates and southwards to the al-Naqb desert, but also in much of the rest of the Mediterranean world, are still to be found numerous examples of a type of bath house that combines compact sequences of bathing rooms *strictu senso* with an often much larger social area, usually rectangular in shape. This area might either be roofed or not, and if in some places it was purely private in intention, in others it was designed for public assemblages, often social or cultural rather than strictly balneal in character.[50]

What exactly were the social acts that could appropriately be performed in a bath house, yet were of sufficient formality to require a reception hall for their setting? In whatever had to do with bathing, the Roman example counted for something, as Herod the Great had shown in his palace at Caesarea Maritima, the public half of which featured an audience hall opening onto a courtyard surrounded by stoas, while the private part was built round a large bathing pool on a promontory lapped by the Mediterranean. The palace and the pool remained in use into the sixth century and were still recognizable when Caesarea fell to the Arabs.[51] The complex's whole conception anticipates the elaborate Umayyad palace, its audience hall graced by a 19.5 × 3.4 × 1.25–meter indoor swimming pool, at Khirbat al-Mafjar in the Jordan Valley near Jericho (another place where Herod, like the Hasmoneans before him, built residences graced by baths and several substantial swimming pools designed to afford relief from the place's intolerable heat[52]). From constructing half one's palace round a swimming pool to conducting public business in the bath is but a step or two. Unfortunately it is not clear whether the "Sophianai", where the emperors of East Rome were wont, in the eighth century, to make formal receipt of the booty brought back by their conquering generals, are to be identified with the suburban Constantinopolitan palace of that name, or the very central and quite separate bath house.[53] The ninth-century Greek chronicler Theophanes does record, though, that in the same city, in the year 713, the emperor Philippicus "decided on the Saturday of Pentecost to enter the public bath house of Zeuxippus on horseback with his

50. See above, p. 39 n. 15; also Brown, *Excavations at Dura-Europus* 49–63; Yegül, in *Corinthia*; Charpentier, *TOPOI* 5 (1995). *Q.'A.* 115 fig. 78 provides comparative plans of twelve Umayyad bath houses.

51. See the sequence of articles in Raban and Holum, eds., *Caesarea Maritima* 193–247.

52. Josephus, *Antiquitates Iudaicae* 15.53–55; Lichtenberger, *Baupolitik* 55–70.

53. Theophanes, *Chronographia* 451, and cf. 243, 251, 434; Leo Grammaticus, *Chronographia* 191; Mentzu-Meimare, *Byzantinische Zeitschrift* 89 (1996) 64–66.

retinue and instruments of music, to wash himself there and breakfast with citizens of ancient lineage".[54] Another source tells us that a painted statue of Philippicus was set up in the same baths.[55] A comparable royal portrait figures among Quṣayr ʿAmra's frescoes, along with depictions of music making and an image suggestive of imperial triumph; while the social habits of the Constantinopolitan court were familiar enough to the Arab elite.

Despite the difference in scale—which is anyway compensated by the existence in the Balqāʾ of much larger late Umayyad structures like Mushattā—it is easy to imagine some such scene unfolding at Quṣayr ʿAmra (fig. 14). An Umayyad potentate—probably, as Musil suggested, a scion of the caliphal dynasty—would have sat in front of the portrait of the enthroned prince at the hall's focal point and there entertained "his family, his entourage, his servants and his companions", or (these enumerations of retinues are common in the *Kitāb al-aghānī*) "the people of his household, his clients *(mawālī)*, the poets and the ministers".[56] He would have been mindful also of the need to cultivate friendly relations with the area's tribal leaders. There were those too who of their own initiative sought out the prince in order to gain his favor. In a fragment by the early Abbasid historian al-Madāʾinī, preserved in the *Kitāb al-aghānī*, we read about Ṭurayḥ al-Thaqafī, one of al-Walīd b. Yazīd's favorites when he was still heir apparent, in the reign of his uncle, the caliph Hishām (724–43). Ṭurayḥ's enemies eventually found a way of turning al-Walīd against him and having him banned from court. He then found an ally in the doorkeeper, who gave Ṭurayḥ the following tip:

> "On such-and-such a day the *amīr* visits the bath *(ḥammām)* and orders his throne to be brought out. On that day he has no doorkeeper. I will let you know when the time comes, so that you go in to him and obtain your request. As for me, I will have my excuse ready." When the day came, al-Walīd entered the bath. He ordered his throne to be brought and took his seat on it. The people were permitted to enter his presence. Al-Walīd busied himself with his petitioners. The doorkeeper sent for Ṭurayḥ, and he drew nigh, when the place was full of people. Al-Walīd caught sight of him while he was still some way off, and *averted his gaze.* But he could not bring himself to drive him out, so Ṭurayḥ approached and greeted al-Walīd, who *did not reply.*[57]

54. Theophanes, *Chronographia* 383.
55. *Parastaseis syntomoi chronikai* 82.
56. Iṣf. 2.129, 4.311 (from al-Madāʾinī).
57. Al-Madāʾinī in Iṣf. 4.307–10. The italicized phrases indicate points at which a correct courtier would have desisted or left: al-Jāḥiẓ (attributed), *Kitāb al-tāj* 7–8.

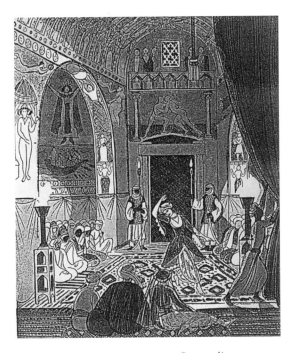

Figure 14. An entertainment at Quṣayr ʿAmra.
Drawing by V. Fiala, in A. Musil, *Pán Amry* (Prague:
Nakladatelstvi Vyšehrad, 1948) opposite p. 208.

With which the scene is set for the poem that predictably melts the *amīr's* heart.

Among the bath's more bodily pleasures, athletic exercise had long been assigned an honored place by Greeks and Romans. This, indeed, had been the bath's *raison d'être* originally, though that was largely forgotten in late antiquity, and already Aristophanes had complained that the *palaestra* was empty while the bath house was full.[58] Wrestling was one type of exercise that was commonly depicted in the decoration of bath houses;[59] and at Quṣayr ʿAmra, too, Musil thought wrestlers were shown grappling with each other in a badly damaged painting above the hall's main doorway (fig. 14), though the Spanish restorers suspected the scene was erotic.[60] Another fresco, at the north end of the west wall and full of youths wearing only

58. Aristophanes, *Nubes* 1054.
59. E.g., Pausz and Reitinger, *Nikephoros* 5 (1992).
60. *Q.ʿA.* 55–56. Vibert-Guigue diss. 1.307–9 also sees the panel as erotic.

loincloths (fig. 60),[61] has been identified as a painting of gymnasts or box-ers; but the most prominent figures seem to be about to perform cartwheels, while two others are holding on to either end of a rope,[62] so the panel prob-ably depicts the acrobats, including rope dancers, who often appeared at royal and other entertainments.[63] Syria and the East generally had long been fa-mous for their "dancers", "leapers", jugglers, mime artists, and other such performers,[64] while the Sasanian emperor Bahrām V Gūr (420–38) had sup-posedly imported thousands of musicians and other entertainers from In-dia, whose descendants, perhaps, the Dominican explorers Jaussen and Sav-ignac encountered near Mādabā in 1912:

> That evening a troupe of Nawār, oriental gypsies, put on an acrobatic
> performance in front of our tent. A woman, while singing and writhing
> her body, did her best to climb up on a rope that was attached at both
> ends to two sound posts, and rested in the middle on a stake driven into
> the earth. It was not the first time that we had encountered among the
> nomads these oriental bohemians who, as blacksmiths, circus perform-
> ers, or fortune-tellers, not to mention other less reputable professions,
> wander from one camp to the next in search of some meager sustenance
> for their miserable existence.[65]

A very cursory glance round the hall at Quṣayr ʿAmra reveals, though, that its owner's favorite form of exercise was not in any case gymnastics but hunting, and that when he was not hunting, he desired to be entertained

61. Cf. Grabar, *S.Byz.Is.* fig. 4; and details in *Q.ʿA.* 107 figs. 74–75; Vibert-Guigue, *ARAM periodical* 6 (1994) 356 fig. 10.

62. See *K.M.* fig. 50 opp. p. 95, 236–37, pl. XLIV.4–5, and *K.Is.* pl. 57 for similar figures in the late Umayyad palatial bath house at Khirbat al-Mafjar; for a very dif-ferent interpretation see Soucek, *A.O.* 23 (1993) 122 (but also *K.M.* 192).

63. Philostratus, *Vita Apollonii* 2.28; Rostovtzeff, *Yale classical studies* 5 (1935) 190–92 and fig. 31 (bone plaques from Olbia, showing court scenes); Volbach, *Elfen-beinarbeiten* pl. 9 no. 19 (diptych of Anastasius, Constantinople, A.D. 517; lower register, middle group, especially the figure at the right); Kawami, *Metropolitan Museum journal* 22 (1987) 28–29 (and figs. 6–7), 41 (early Sasanian [?] painting at Kūh-i Khwāja, Sīstān; see now Ghanimati, *Iran* 38 [2000] 145–46); Marshak, *C.R.A.I.* (2001) 235 pl. 3a (later sixth-century Chinese funerary couch, influenced by Sogdian art); Melikian-Chirvani, *Bulletin of the Asia Institute* 10 (1996) 115–24, esp. fig. 22 (seventh- or eighth-century Iranian wine cup with scenes from a Nawrūz banquet). Note also, though concerning later periods, Liudprand of Cremona, *Antapodosis* 6.9; Ettinghausen, *Islamic art and archaeology* 167–70 (Fatimid wood carving from Cairo); A. Tietze, *E.Is.* 2.442–43. It has been suggested (*Q.ʿA.* 68) that Quṣayr ʿAmra's patron is depicted at the far right of the acrobats panel.

64. Ptolemy, *Tetrabiblos* 2.3.24 (whence the words in quotation marks); W. Kroll, *R.E.* suppl. 6.1278–82; Graf with Dreyer, *A.A.S.* 42 (1996) 207–10.

65. Jaussen and Savignac 3.21; cf. Ḥamza al-Iṣfahānī, *Taʾrīkh* 43; al-Thaʿālibī, *Al-ghurar* 566–67; Pantke, *Bahrām-Roman* 182–84; J. Walker, *E.Is.* 8.138–39.

by beautiful women. The hunting frescoes will be dealt with in the next chapter. As for the patron's appreciation of women, it began from—though was by no means exhausted by—the beauty of their bodies.

NUDITY

Among the features of Quṣayr ʿAmra that has always caught the attention of art historians is the abundance of naked, mainly female flesh displayed. On the east wall of the apodyterium, for example, a nude man and a half nude woman flank the window and look at each other, the woman seen frontally, the man from behind. Between them, underneath the window, Mielich saw a third naked figure, apparently a baby in a reclining position, presumably the fruit of the couple's union.[66] In the tepidarium, heavy-buttocked women carrying buckets for drawing water bathe their children in what are probably Quṣayr ʿAmra's best-known images (fig. 15);[67] while in the main hall, in the middle of its west wall, a woman almost totally undressed emerges from a pool and is gazed at by a crowd of onlookers, for reasons to be investigated in chapter 8.

The Qurʾān exhorts women to keep themselves covered:

> Say to the believing women, that they cast down their eyes and guard their private parts, and reveal not their adornment save such as is outward; and let them cast their veils over their bosoms, and not reveal their adornment save to their husbands, or their fathers, or their husbands' fathers, or their sons, or their husbands' sons, or their brothers, or their brothers' sons, or their sisters' sons, or their women, or what their right hands own, or such men as attend them, not having sexual desire, or children who have not yet attained knowledge of women's private parts; nor let them (walk) with skipping tread of their feet, so that their hidden adornment may be known.

Men, too, were expected to "guard their private parts."[68] Also, a saying was attributed to Muḥammad according to which women might not enter bath

66. *K.ʿA.* 2. pl. XXXV; Jaussen and Savignac 3. pls. XLVI–XLVII.1; *Q.ʿA.* 86 and 92 fig. 65. Vibert-Guigue diss. 2.10, 13, is not certain the right-hand figure is male, and wonders whether the "baby" may be an Eros. Compare Balty, *Mosaïques* 342 pl. X (al-Shahbāʾ).

67. See also Jaussen and Savignac 3. pls. LI–LII; *Q.ʿA.* 47 fig. 19, 94 fig. 66, 95 fig. 67, 97 fig. 68, 129 fig. 87; Ettinghausen, *Arabische Malerei* 31, and *K.Is.* pl. X (color photographs taken before the Spanish restoration); *Mémoires d'Euphrate* 212–13; Vibert-Guigue, *D.A.* 244 (1999) 94.

68. Qurʾān 24.31 (whence the quotation, trans. A. J. Arberry, the last two phrases adjusted in the light of Luxenberg, *Syro-Aramäische Lesart* 197–99), 33.35.

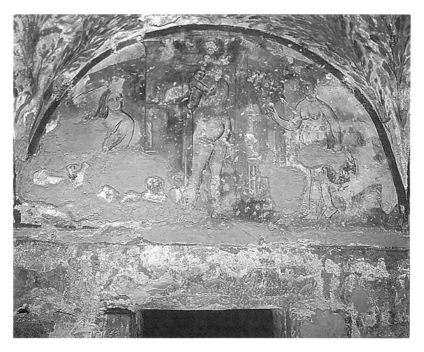

Figure 15. Quṣayr ʿAmra, tepidarium, south wall: bathing women (fresco).
Oronoz Fotógrafos, Madrid.

houses at all, and men only with their private parts covered.[69] In the light of
Musil's dating of Quṣayr ʿAmra in the earlier half of the eighth century, it is
clear that its decoration consciously flouted Muslim ethical norms. Whether
it also broke the iconographical conventions of the period is less certain. Riegl
took for granted that no nude could possibly be Muslim, and went so far as
to adduce this assumption in support of his early dating.[70] But we now know
that the Umayyads not only approved artistic representations of naked
figures, but also applied the Islamic ban on depictions of living beings only
in religious buildings. There were exceptions, of course—it was said that for
a while after its foundation in 702, the mosque at Wāsiṭ boasted a large brass
basin in the shape of a woman, from whose breasts water flowed.[71] But there
is a marked contrast between the riotous decor of the "desert castles" and

69. Lewcock, al-Akwaʿ, and Serjeant, *Ṣanʿāʾ* 501. For further traditions against
nudity see U. Rubin, *Eye of the beholder* 83–86.
70. Quoted by Müller, *Ḳ.ʿA.* 1.II.
71. Baḥshal, *Taʾrīkh Wāsiṭ* 68.

the sober avoidance of living beings in the mosaics of Jerusalem's Dome of the Rock, or at the Great Mosque in Damascus. Even within a single structure, as, for example, the palace of Mushattā, one could find a mosque decorated aniconically standing close to a throne room adorned with more-than-life-size statues of both men and women either entirely naked or draped in such a way as to emphasize rather than hide their private parts.[72]

In his taste for nudity, Quṣayr ʿAmra's patron must have been aware—at least indirectly—of the Greeks' and Romans' long tradition of mythological representation. In late antique art, it is true, nudity rarely featured in scenes from contemporary reality such as those in our Jordanian bath house. We quite often find naked athletes, especially wrestlers, in mosaics.[73] Otherwise, nudes were commonest in scenes from the lives of Old Testament figures like Adam, Jonah, or Daniel or in mythological compositions as at sixth-century Mādabā, not far from Quṣayr ʿAmra (fig. 26), and—as personifications of the Hours—in a Vatican Ptolemy manuscript, made three decades, at the most, after Quṣayr ʿAmra.[74] To judge from the Greek epigrams collected in the *Palatine anthology*, Aphrodite, Eros, nymphs, and Graces were commonly depicted in bathing establishments, and often unclothed:

> Here once upon a time young Eros stole
> the wondrous robes of Graces at their bath.
> And off he made, leaving them naked there,
> ashamed to show themselves without the doors.[75]

It may well be that the bath house was one of this artistic tradition's last refuges from Christian disapproval. In a letter already quoted, the fifth-century Gallic aristocrat—but soon to be bishop—Sidonius Apollinaris describes the decoration of his own bath house in words that make no bones about his dislike for paintings of nudes:

> Here no disgraceful tale is exposed by the nude beauty of painted
> figures, for though such a tale may be a glory to art it dishonours the
> artist. There are no mummers *(histriones)* absurd in features and dress
> counterfeiting Philistion's outfit in paints of many colours. There are
> no athletes slipping and twisting in their blows and grips. . . . There will

72. K. Brisch, *K.Is.* 184–85 (pls. 62–65); Trümpelmann, *A.A.* (1965); Altheim and Stiehl, *Araber* 1. pls. 8–9; Baer, *Da.M.* 11 (1999) 19–20. Van Reenen's rejection of R. Paret's mid-Umayyad dating of the literary traditions hostile to figural art, *Der Islam* 67 (1990) 60–70, ignores these early buildings.

73. E.g., Pausz and Reitinger, *Nikephoros* 5 (1992).

74. Piccirillo 53, 68–69, 77, 80 (Mādabā); above, p. 43 n. 25 (Vat.gr. 1291). For mythological nudes on silver vessels see Matzulewitsch, *Byzantinische Antike.*

75. *Anthologia Palatina* 9.616.

not be found traced on those spaces anything which it would be more proper not to look at.[76]

Sidonius implicitly concedes that a bath house without nudes might still in his day be thought unusual; but at Scythopolis by the river Jordan, about the year 515, statues of a naked Aphrodite and a nymph were thrown into a bath house hypocaust, where archaeologists recently found them again, lying face down in the mud.[77]

Captives taken during Sasanian campaigns in the Roman East, especially from Antioch, carried this Mediterranean taste for bath houses and the depiction of the naked body into the heart of the rival empire.[78] If we want a direct precedent or even model for the Quṣayr ʿAmra nudes, we should consider the reliefs of dancing girls and musicians on conveniently portable Sasanian silver objects, but also the depictions in mosaics from Bīshāpūr and stucco reliefs from the mansions of the Iranian elite at Ctesiphon.[79] The ultimate inspiration for these naked and diaphanously draped figures, who play instruments or hold aloft fruit or flowers, may have been Dionysiac;[80] the iconography of the Seasons and Months, and Aphrodite, also offers some parallels.[81] But in the Sasanian and *a fortiori* the Arab Muslim context, these arguably once mythological beings are happy to be taken at face value, as entertainers. The silver vessels on which they were often depicted first percolated into the Arab world as booty taken in the wars of conquest;[82] and later on we hear of al-Walīd b. Yazīd ordering, as caliph, "gold and silver ewers" to be specially made far away in the East in Khurāsān (where Sasa-

76. Sidonius Apollinaris, *Epistulae* 2.2.6–7 (trans. W. B. Anderson).

77. Tsafrir and Foerster, *D.O.P.* 51 (1997) 129–30 and figs. 37–38.

78. Bath houses: Morony, *Iraq* 266–70. Nudes (all third or fourth century): Ghirshman, *Bîchâpour* 2. pls. B, V–VII, and von Gall, *A.M.I.* 4 (1971) 193–205 (mosaics, Bīshāpūr); Daems, *Iranica antiqua* 36 (2001) 51, 133 fig. 190 (stucco figurines, Ḥājjīābād, 300 kilometers southeast of Shīrāz), and 51–52, 133 fig. 192 (bronze figurine, Tuzandejan); Harper, *Royal hunter* 145–46 (seal stone). Keall, Leveque, and Willson, *Iran* 18 (1980), regard as late Parthian the abundant stucco nudes from Qalʿeh-i Yazdigird in western Irān near Qaṣr-i Shīrīn.

79. *K.M.* 235–36; Ghirshman, *Bîchâpour* 2. pl. XXIX; Kröger 85–88, 103–7, 116–17, pls. 27–28, 41–42, 48.1; Duchesne-Guillemin, *Instruments de musique*; Goldman, *Iranica antiqua* 32 (1997) 247–49, 254–55, 258–59; Daems, *Iranica antiqua* 36 (2001) 58–59, 146–48 figs. 217–25. Note also the carved wooden dancing girl, contemporary with Quṣayr ʿAmra, from Panjikent some 70 kilometers east of Samarqand: *Oxus* 64, no. 75.

80. Ettinghausen, *From Byzantium to Sasanian Iran* 3–10 and figs. 8–9, 16, 18–22; Marschak, *Silberschätze* 251–54.

81. Harper, *La Persia nel medioevo*; M.-O. Jentel, *L.I.M.C.* 2(1).159–61.

82. Hishām b. al-Kalbī in al-Balādhurī, *Kitāb futūḥ al-buldān* 338.

nian memories had lingered longer than in the West) for use at his court.[83] Soon after this, in early Abbasid poetry, we begin to find quite detailed descriptions of the iconography of Iranian drinking cups: Kisrā himself, of course (the generic name for the Iranian monarch, taken from the last great representative of the line, Khusraw II), along with his armies and their generals; hunting scenes; and even images of Christian priests and crosses.[84] It seems possible that several of these imitations have survived—study of them reveals telltale iconographic differences from their Sasanian models.[85] One, an oval wine boat now in the Walters Art Museum, Baltimore, shows a seated king flanked by an attendant with a fly whisk, a dignitary holding a diadem, and two naked dancing girls (fig. 16).[86] Thanks to constant recycling of precious metals, and the puritan attitudes of the Muslim religious establishment, which discouraged their possession and use, no such objects have as yet turned up in Syria.[87] Still, Sasanian or post-Sasanian vessels could have provided models for Quṣayr ʿAmra's artists, in their (admittedly inept) attempts to depict nudes neither athletic nor mythic, but simply pleasure-giving, and in a courtly setting.

Literary sources can be of great assistance in our attempts to judge the precise resonances of Quṣayr ʿAmra's paintings, especially its nudes, for those who commissioned and first saw them. What did the naked female body signify at that particular time and place? The Qurʾān's exhortation to women to cover themselves represented no innovation. That was the modest—but in the dust of steppe or desert also practical—fashion in which women, including Christian women, had long since dressed.[88] And in the bath house,

83. Ṭab. 2.1765–66 (trans. 26.116–17 C. Hillenbrand), and cf. 2.1779 (trans. 26.131). For an impressive example of transfer of Iranian gold and silver objects to the Arabs through diplomatic gift-giving in the reign of Hishām, see below, p. 82.

84. Ḥammād ʿAjrad, in Iṣf. 14.332 (line 1); Wagner, *Abū Nuwās* 303–4.

85. Marschak, *Silberschätze* 276–80, 291–94.

86. Cf. Ghirshman, *Artibus Asiae* 16 (1953) 51–70 (suggesting, on pp. 53–56, that total nudity was a divergence from the Sasanian norm, possibly under Indian influence, on which see also Marschak, *Silberschätze* 266–69); Harper, *Silver vessels* 119–20, 139–41; Melikian-Chirvani, *Islamic art* 4 (1990–91) 15, 55.

87. See Ibn Rusta, *Kitāb al-aʿlāq* 66, on the figural decoration of a silver censer—given by ʿUmar b. al-Khaṭṭāb to the Prophet's mosque at al-Madīna—beaten out by an iconoclastic late eighth-century governor; various papers in Vickers, ed., *Pots and pans*; Northedge, *ʿAmmān* 1.101. Al-Walīd's order never reached Syria but was distributed among the common people of Khurāsān after his murder: Ṭab. 2.1846 (quoting al-Madāʾinī), 1855–56 (trans. 26.209, 221). Theodore of Tarsus apparently observed Iranians drinking from horns during their early seventh-century occupation of Syria: PentI 303 in Bischoff and Lapidge, *Biblical commentaries* 356.

88. Dirven, *Mesopotamia* 33 (1998) 298 figs. 1–2 (Palmyra, first century B.C. and A.D.); Barbet and Vibert-Guigue, *Peintures des nécropoles romaines d'Abila*

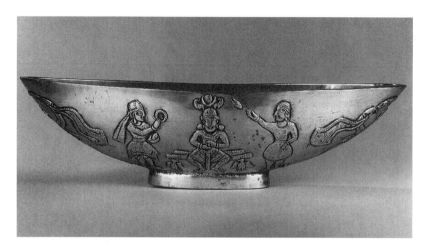

Figure 16a. Wine boat (silver, post-Sasanian). The Walters Art Museum, Baltimore, inv. no. 57.625.

women were usually segregated from men, at least when unclothed. An ascetic like Symeon of Emesa (Homs) might break into the women's bath, but only in order to prove that he was in full control of his own body. The women quite properly beat him up and threw him out.[89] Others could only dream of such escapades, for instance, the Greek epigrammatist fantasizing about Eros making off with the Graces' "wondrous robes", or the pre-Islamic poet Imru' al-Qays, whose verses

> Oh yes, many a fine day I've dallied with them [sc. women],
> and especially I call to mind a day at Dāra Juljul,
> a day I slaughtered for the virgins my riding beast,[90]

were elaborated into a fanciful tale about the poet's passionate pursuit of his cousin 'Unayza. One day, he came upon 'Unayza and her friends bathing

1.179–92, 2. pls. 106a, VI.4, VII.1 (mid-second century A.D.); Tertullian, *De virginibus velandis* 17.4 (on the Arabia of his day); Łazar P'arpec'i, *History* 110 (Armenian, late fifth century); Simeon of Beth-Arsham, *Letter G* pp. 57–59 (south Arabia, first quarter of sixth century); Pisentius of Coptos (d. 632), *Encomium on S. Onophrius* pp. 15–16; Denḥā, *History of Mārūthā of Takrīt* (d. 649) 84; Ḥassān b. Thābit (d. c. 659), *Dīwān* no. 123.7, with Shahîd's important comment, *B.A.S.I.C.* 2(1).295. Further references in the admirably learned article of de Vaux, *Revue biblique* 44 (1935). Contrast Rosenthal's assertion, *Humor* 20 n. 3, that veiling was unusual in first-century (A.H.) al-Madīna.

89. Leontius of Neapolis, *Vita Symeonis Sali* 149.3–18.

90. Imru' al-Qays, *Mu'allaqa* 10–11 (trans. Arberry, *Seven odes* 61, with adjustments).

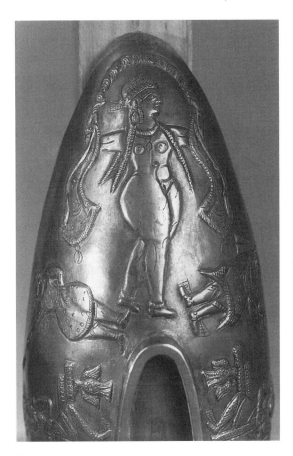

Figure 16b. Detail.

in a pool of rainwater. Hobbling his camel, he crept up and stole their clothes. They ignored his exhortations to come out and get them until, as the day wore on, they emerged one by one and reclaimed their dresses, all except 'Unayza, who begged him to throw it to her—in vain. "So she came out, and he gazed at her both in front and behind, then he returned her dress." The women's reproaches he proceeded to disarm by slaughtering his camel and treating them to a fine feast. In the form in which we have this story in the *Kitāb al-aghānī*, it is put into the mouth of none other than the Umayyad poet al-Farazdaq (died c. 728–30), who is reminded of it during a similar encounter with a pool-full of naked girls. He tries to play Imru' al-Qays's trick on them but ends up getting a mud bath from the girls, who

also steal his mule (eventually returned, with an obscene message suggesting what he could do with it).[91]

The nude bathers at Quṣayr ʿAmra busy themselves with their children and take no thought of showing off their bodies. Yet the paintings were put there to be looked at. They may not tell the story of Dāra Juljul, but they do make possible—indeed encourage—that same visual violation of their subjects that Imruʾ al-Qays imposed on ʿUnayza and her companions. The enormity—and by the same token intense transgressive pleasurableness— of this violation is best felt if we recall the deep offense the Arab was liable to take if another man was so unwise as to praise the beauty of one of his women. For example, the poet al-Nābigha al-Dhubyānī's intimate description of the wife of al-Nuʿmān III (c. 580–602) of al-Ḥīra in southern ʿIrāq had resulted in a sudden fall from grace that was long remembered.[92] It is possible to sympathize, then, with Oleg Grabar when he wonders whether Quṣayr ʿAmra's frescoes of nudes are not just erotic but "perhaps even pornographic" (though surely only by suggestion).[93] Here is an instance of how the Arabs' poetry can help us to reimagine for ourselves the allusions evoked or at least, as here, fantasies provoked by Quṣayr ʿAmra in those by and for whom it was built.

ENTERTAINERS AND DECORATIVE WOMEN

Some may feel, though, that there is a more direct erotic charge in Quṣayr ʿAmra's frescoes of female entertainers, partly because they are not completely naked. Their partial or skimpy dress hints and suggests. At the very least they seek to draw attention, while the unself-consciously nude bathers are erotic (if at all) only in the mind of the beholder.

The most conspicuous paintings of entertainers at Quṣayr ʿAmra are on the south soffits of the hall's two arches (fig. 8).[94] To the left we see "a singing girl drawing her fingers over a lute, plucked sonorously by her thumb", in the words of the poet Labīd who died in the reign of the first

91. Iṣf. 21.342–46 (trans. Weisweiler, *Arabesken der Liebe* 155–58). For variations on the same idea see the comedian Ashʿab in Iṣf. 16.155–56 (trans. Berque 322); also Iṣf. 18.43.

92. Ibn Qutayba in Iṣf. 11.17, and cf. 3.216–18, and Isḥāq al-Mawṣilī in Iṣf. 4.397. Also Abbott, *J.N.E.S.* 1 (1942) 354–55, 356; S. P. Stetkevych, *Mute immortals* 165.

93. Grabar, *Formation* 155. One need only recall the Suburban Baths at Pompeii to see how little pornographic Quṣayr ʿAmra is by those standards: Clarke, *Looking at lovemaking* 212–40 and pls. 9–16.

94. Jaussen and Savignac 3. pl. XL.3–4; *Q.ʿA.* 137 figs. 90–91.

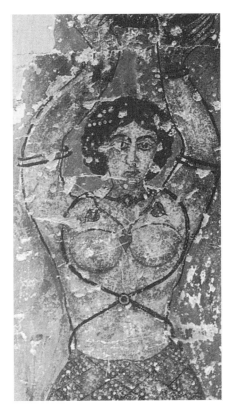

Figure 17a. Quṣayr ʿAmra, hall, west arch, south soffit: dancing girl (fresco).
Oronoz Fotógrafos, Madrid.
Figure 17b. Quṣayr ʿAmra, hall, east arch, south soffit: decorative woman. A. and
H. Stierlin.

Umayyad caliph, Muʿāwiya.[95] On the corresponding soffit of the west arch
is an awkward depiction of a female dancer clad in bikini bottom, bracelets,
armlets, anklets, a necklace, and a body chain (fig. 17a). She is like most of
the Quṣayr ʿAmra women in that she has a rather slender torso and firm
breasts, but heavy hips and fleshy thighs, calves, and arms. Her jewelery
is also typical. Especially worth noting is the body chain *(wishāḥ)*, which
rests on the shoulders and falls saltirewise to the waist, its four sections
clasped on the chest and back by a decorative broochlike element. Such
chains might be worn by ladies of rank but also by goddesses, whether fully

95. Labīd b. Rabīʿa, *Muʿallaqa* 60 (trans. Jones); cf. Isḥāq al-Mawṣilī in Iṣf.
17.164–65 (trans. Berque 184).

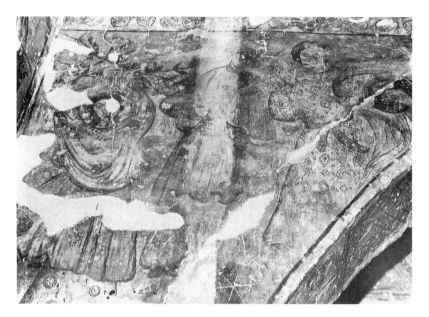

Figure 18. Quṣayr ʿAmra, hall, central aisle, northeast spandrel: male musician flanked by dancers (fresco). F. Anderegg, courtesy of O. Grabar.

clothed or naked. Either way, they gave emphasis to the breasts.[96] Aphrodite was commonly shown wearing one, as in various Roman pottery figurines found in Jordan (fig. 59),[97] and they also feature occasionally in Roman erotic art.[98] Our dancer's clownish pose is anticipated by that of another dancing girl, this time clothed, on the probably sixth-century Egyptian ivory plaque of Isis that adorns the pulpit of Henry II in Aachen Cathedral.[99]

Besides other, less well-preserved paintings of instrumentalists in the corresponding positions on the north soffits of these same arches, music making and dancing are illustrated at at least two other points in Quṣayr ʿAmra's frescoes. On the central aisle's northeast spandrel is a group consisting of a

96. Lane, *Arabic-English lexicon* 2943; K. R. Brown, *Gold breast chain* (add a late-fourth- or early-fifth-century example found in 1992 at Hoxne in Suffolk, England: C. Johns, *Jewellery of Roman Britain* 96–98, 217–18, and color pl. 6). Note also a "Safaitic" rock carving showing a woman adorned with little but armlets, anklets, and a body chain: de Vogüé, *Inscriptions sémitiques* 141.

97. Cf. Iliffe, *Q.D.A.P.* 11 (1945) pl. II.25–26; M.-O. Jentel, *L.I.M.C.* 2(1).159 no. 111; Loberdou-Tsigarida, Ὀστέινα πλακίδια 251 no. 14.

98. Clarke, *Looking at lovemaking* 168 fig. 60 and pl. 12. For further examples Roman, Coptic, and Sasanian see Baer, *Da.M.* 11 (1999) 14.

99. Volbach, *Elfenbeinarbeiten* 59–61, pl. 41 no. 72 (bottom right).

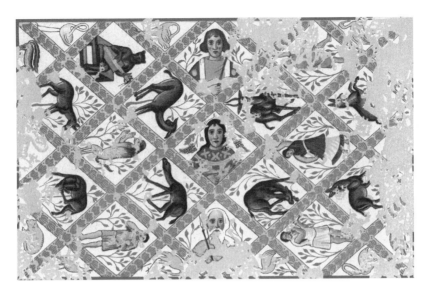

Figure 19. Quṣayr ʿAmra, apodyterium, vault: decoration (fresco). Drawing by A. Mielich, in A. Musil et al., *Ḳuṣejr ʿAmra* (Vienna: Kaiserliche Akademie der Wissenschaften, 1907) 2. pl. XXXIV.

male musician flanked by two female dancers with large, expressive eyes and fully dressed (fig. 18).[100] The one on the left twirls her hands above her head, while the one on the right wears a long-sleeved, belted shift patterned with roundels, diamonds, and flower sprigs in the elaborate Sasanian manner, and holds a tambourine. The musician plays the long-necked lute, and the fact that its neck extends up toward the right-hand dancer's face, while the middle part of the instrument has been virtually obliterated by water streaming in through the vault, caused the Spanish team to identify the woman as a flautist—and perhaps to misrestore her right hand.[101] As was remarked already in chapter 1, what we now see on Quṣayr ʿAmra's walls is to some extent the product of modern interpretation. Meanwhile, in the diamond-shaped compartments on the vault of the apodyterium, a man plays the flute while a man and a woman in a long tunic covered by a mantle dance

100. Cf. *Mémoires d'Euphrate* 218.
101. I owe this interpretation of the fresco to Oleg Grabar's unpublished book on the Quṣayr ʿAmra paintings; cf. also E. H. Peck, *E.Ir.* 5.740, 764. Vibert-Guigue diss. 1.291–94 sees, from left to right, a female dancer, a male tambourinist, a male flautist, and a hand—apparently belonging to a fourth musician—holding a cymbal. On al-Walīd b. Yazīd's interest in both short- and long-necked lutes see Ṭab. 2.1765–66 (trans. 26.116–17).

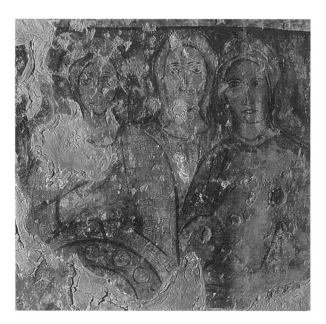

Figure 20. Quṣayr ʿAmra, hall, central aisle, south wall
above alcove arch: *mukhannathūn*? (fresco). Oronoz
Fotógrafos, Madrid.

(fig. 19). The Spanish restorers saw these figures as gypsies. Certainly they
are homelier in appearance than the entertainers in the main hall; but the
dancing woman's dress and pose—if not the clumsiness of execution—are
well paralleled in late Roman art of the highest quality. Elsewhere on the
same vault a bear plays a lute and a monkey dances, like untold generations
of animals before them in the art of the Near East, while a bystander throws
up his hands in astonishment.[102] Are these performing animals humans in
disguise? Al-Walīd b. Yazīd was said to have summoned the comedian Ashʿab
(d. 771) from al-Madīna, dressed him in monkey-skin trousers with a tail,
and set him to dance and sing.[103]

It may be that yet another group of musicians is depicted on the hall's

102. Ḳ.ʿA. 2. pl. XXXIV; Q.ʿA. 45 fig. 18, 91 figs. 61–63. With the dancing woman
compare Åkerström-Hougen, *Villa of the Falconer* 110–13 and pl. VIII. For musi-
cal animals see Spycket, *Iraq* 60 (1998).

103. Al-Haytham b. ʿAdī in Iṣf. 19.184 (trans. Rosenthal, *Humor* 90); al-Madāʾinī
in Iṣf. 7.56 (trans. Berque 123); Bal. 2. fol. 162a = p. 323 (38 Derenk). For a real per-
forming monkey belonging to Yazīd I, see Mas. 1918 (3.67–68 Dāghir); also Nadler,
Umayyadenkalifen 219–21, for the poets' mockery of this caliph's weakness for apes.
Al-Haytham b. ʿAdī is indeed a suspect source for al-Walīd (ʿAṭwān, *Al-Walīd* 151–

south wall over the alcove arch (fig. 20).[104] Especially because of the rain-
water that blew in through the window above this fresco, a great deal of
damage has been done: the faces of only five out of nine figures are more
or less clearly visible. They are variously attired and appear to be women,
though distinguishing young women from beardless young men of good
birth—or, at least, courtly function—has created problems for students of
Quṣayr ʿAmra, as we shall see in chapter 7. The whims of the Spanish re-
storers have to be taken into account here as well. One of the figures holds
in front of her a circular object with smaller round decorations or attach-
ments along its circumference. It is big enough to be a shield but cannot be,
since there is nothing remotely martial about these personages. It is prob-
ably a large tambourine or frame drum with cymbals attached;[105] and that,
together with the ambiguous gender of these figures, suggests we have to
do here with a group of *mukhannathūn*, effeminate male professional mu-
sicians.[106] The earliest recorded representative of this class, at al-Madīna,
was Ṭuways (632–710), "the little peacock", who accompanied himself with
the tambourine and never played, like his fellows, the lute.[107] We have no
other early representation of this controversial and, in the eyes of some,
scandalous class of performer.

Besides these entertainers, there are numerous women represented at
Quṣayr ʿAmra, particularly in the prince's alcove and around the arch lead-
ing into it, who may have been dancers but play no clearly definable role
save as adornments of the court—assuming all or most of the figures were
intended to correspond to people or types who actually frequented the build-
ing. Under a strip of vault decoration consisting of vases, floral designs, small
human figures, and birds,[108] the alcove's sidewalls flanking the enthroned
prince are painted with arcades and Corinthian capitals. Between the columns
stand figures singly or in groups of three against a background of drapes
and plants or trees (figs. 21, 36).[109] Above them, immediately under the

52); but does that justify Rosenthal, *Humor* 22 n. 1, in rejecting all stories about
Ashʿab and al-Walīd as "entirely legendary"?

104. Cf. *Mémoires d'Euphrate* 219.

105. Cf. Jenkins and Olsen, *Music and musical instruments* 74, 83–84, and pl.
2; Serjeant and Lewcock, eds., *Ṣanʿāʾ* 414; Gillon, *Anciennes fêtes* 40, 123 pl. 2.

106. Al-Walīd b. Yazīd no. 96/102 (trans. Hamilton 135–36; Derenk 98; Rotter
112); al-Madāʾinī in Ṭab. 2.1737 (trans. 26.80); Iṣf. 4.221; Eisener, *Zwischen Faktum
und Fiktion* 171–77; cf. Lane, *Modern Egyptians* chap. 19 ("Public dancers"); Hur-
gronje, *Mekka* 2.54–55.

107. Hishām b. al-Kalbī (among others) in Iṣf. 3.28.

108. Vibert-Guigue, *ARAM periodical* 6 (1994) 358 fig. 13.

109. Cf. Ḳ.ʿA. 2. pls. XVII–XVIII; Q.ʿA. 57 figs. 28–29 + Q.ʿA.¹ pl. IXc; Grabar, *A.O.*
23 (1993) 104 figs. 5–6.

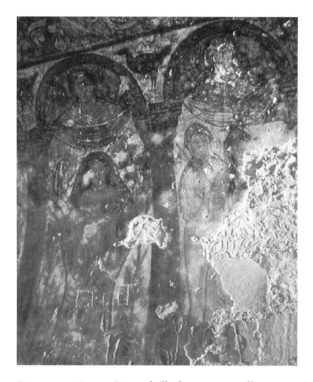

Figure 21. Quṣayr ʿAmra, hall, alcove, west wall:
decorative women (fresco). J. Zozaya.

arches, human figures of whom we see only the head and shoulders[110] hold
each one of them a cloth or kerchief *(mandīl)* weighed down, possibly with
fruit like the personifications of Earth (Gē) one finds in the somewhat ear-
lier Christian mosaics of Mādabā to the west, and in a remarkable Umayyad
painting discovered at Qaṣr al-Ḥayr al-Gharbī (fig. 22).[111] If this is the model,
then these ambiguous personages are female, like most of the standing
figures, who are elegantly but not always fully dressed. One, for example,

110. For this curious arrangement, see also the south Arabian relief published
by Honeyman, *Iraq* 16 (1954); and the Parthian or Sasanian terracotta ossuary from
Samarqand discussed by Strelkoff, *Survey* 1.452, and 7.145D for photograph.

111. Linant de Bellefonds, Ελληνισμός 233–35; Maguire, *Rhetoric, nature and
magic* VII; and cf. Ahsan, *Social life* 46–47. Mādabā: Piccirillo 38 fig. xxiii, 174–75,
178–79. Further Christian parallels: Schmidt-Colinet, *Mitteilungen zur spätantiken
Archäologie und byzantinischen Kunstgeschichte* 1 (1998).

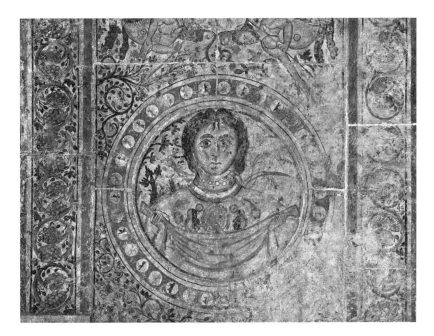

Figure 22. Qaṣr al-Ḥayr al-Gharbī: personification of Earth (fresco). National Museum, Damascus.

wears a long tunic and veil and a necklace and stands with arms uplifted in a posture similar to that in which late antique Christians customarily prayed. Another, who wears just a long skirt, a belly chain decorated with round objects like coins, a necklace, and a few bangles looks as if she might well be a dancer. She holds aloft a horn of plenty, just like similarly dressed stucco figures at Qaṣr al-Ḥayr al-Gharbī and Khirbat al-Mafjar.[112]

The arcade-and-figures motif is common enough in Mediterranean and Iranian art.[113] It is echoed at Qaṣr al-Ḥayr al-Gharbī too, in the stucco reliefs of topless women, probably dancers, who hold flasks of wine (?) and adorn the parapets of the first-floor gallery around the courtyard (fig. 23).[114] Both there and at Khirbat al-Mafjar and Quṣayr ʿAmra it is courtly luxury that is being evoked, and Plenty, the abundance that characterizes a happy

112. *Q.H.G.* pl. 67c; *K.M.* pl. LVI.9. With the belly chain compare the late-sixth- or early-seventh-century marriage belt at Dumbarton Oaks: *A.S.* 283–84.

113. See, for example, Herzfeld, *Die Malereien von Samarra* 18–21; Rostovtzeff, *Yale classical studies* 5 (1935) 190–92 and fig. 31 (bone plaques from Olbia, showing court scenes); Loberdou-Tsigarida, Οστέινα πλακίδια 251–52 nos. 16–20.

114. Cf. R. Hillenbrand, *K.Is.* 171–72.

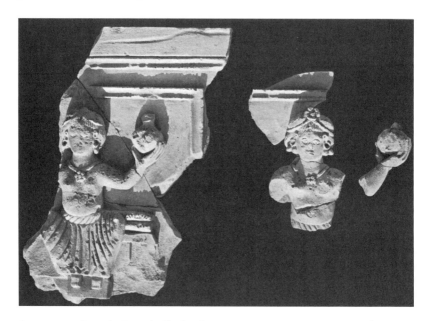

Figure 23. Qaṣr al-Ḥayr al-Gharbī: decorative women (stucco). National Museum, Damascus.

reign. One is reminded of a story told by Ḥammād al-Rāwiya (694–772/73), about how he once recited a love poem that threw al-Walīd b. Yazīd into ecstasy. The prince

> raised his head to motion to a servant who was standing there as if he were the sun. He lifted a curtain behind him, and there came forth forty pages and maids like a scattering of pearls, with jugs in their hands and napkins. He said: "Give them to drink", and all drank without exception, while I went on declaiming the poem. At daybreak he was still drinking and pressing drink on us, and we left his presence only when the attendants carried us off, wrapped in rugs [or: sleeping carpets], and deposited us in the guest house.[115]

Likewise at the court of the Armenian king Gagik (d. after 942/43), in a milieu influenced by East Rome and Irān, but also by Islam, we can imagine similar scenes unfolding. Here is how the tenth-century continuator of the historian Thomas Artsruni describes the paintings in Gagik's palace on the island of Ałtʿamar in Lake Van:

115. Iṣf. 7.79. "Pages . . . like a scattering of pearls" echoes Qurʾān 76.19, on the joys of Paradise.

(The pictures) include gilt thrones, seated on which appears the king in splendid majesty surrounded by shining young men, the servants of his festivities, and also lines of minstrels and girls dancing in an admirable manner. There are bands of men with drawn swords, and wrestling matches. There are also troops of lions and other wild beasts, and flocks of birds adorned with various plumage. If anyone wished to enumerate all the works of art in the palace, it would be a great labour for himself and his audience.[116]

This manner of courtly luxury, not always distinguishable from mythological fantasy, had become common coin in late antiquity. The abundant parallels one can observe in carvings on Coptic bone plaques, for example, or the mosaics of Mādabā[117] show it had been widely disseminated. It had reached the court of Ctesiphon too, which the Arabs had known long before they looted it, only to be enslaved in their turn by a mirage of maidens bearing flowers and fruit. Since the Sasanian court had assigned a place of such honor to these and other entertainers,[118] it was probably Quṣayr ʿAmra's patron's immediate model.

This atmosphere intensifies in the central aisle of the hall. On either side of the alcove arch, on the lower part of the southern spandrels of the hall's two arches, bejeweled but almost naked beauties stood in elaborate niches (while above them were represented lunging animals: fig. 25, at left). Sadly, neither of these attractive paintings can be seen at Quṣayr ʿAmra today. The one on the southeast spandrel was cut up by Musil and Mielich into nine pieces and borne off to Vienna and eventually Berlin, its present home.[119] The panel opposite it is the one Musil found in 1909 to have been hacked and poked at by beduin, inspired not by puritanism but by curiosity, the Austrians having left the panel covered in canvas after their botched attempt to detach it. The modest gestures of these two women, their ornaments, and even the niches they stand in recall images of Aphrodite that had been common in the Roman East.[120] Similar female figures, likewise framed in niches, preferred posies to visitors as they entered the palace at Khirbat al-Mafjar.[121]

116. Thomas Artsruni, *History* 295–96.

117. Strzygowski, *Koptische Kunst* pl. XV; Loberdou-Tsigarida, Ὀστέινα πλακίδια; Piccirillo 52, 68–69.

118. See below, p. 109 on Ṭāq-i Bustān; and al-Jāḥiẓ (attributed), *Kitāb al-tāj* 25, 28. On decorative women bearing flowers and fruit at Quṣayr ʿAmra, Qaṣr al-Ḥayr al-Gharbī, and Khirbat al-Mafjar see above, pp. 69–71; and at the Sasanian court see above, p. 60, and Abkaʿi-Khavari, *Das Bild des Königs* 70–71.

119. Museum für Islamische Kunst inv. no. I 1264; Baer, *Da.M.* 11 (1999) pl. 3a.

120. E.g., M.-O. Jentel, *L.I.M.C.* 2(1).155–56, esp. no. 31.

121. Hamilton 52–54, 56 fig. 23.

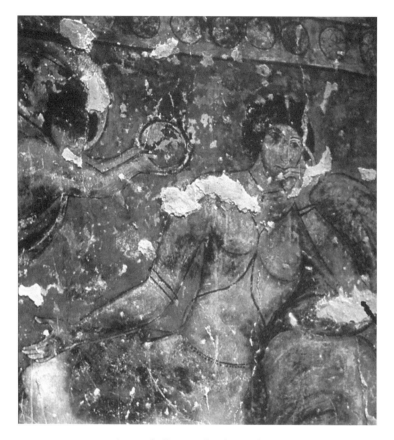

Figure 24. Quṣayr ʿAmra, hall, central aisle, northwest spandrel: pensive
woman with Eros (fresco). J. Zozaya.

At the other end of the main aisle, by the entrance, the northwest span-
drel shows a beautiful and pensive woman propping herself against a cush-
ion (fig. 24). A hovering but wingless figure, more likely in this context to
be an inept Eros than an apteral Victory,[122] hands her a crown. She wears a
long skirt but is bare from the waist up save body chain, necklace, and ban-
gles. In both appearance and dress she closely resembles the two women who
are painted standing with their arms held up above their head in the soffit

122. C. Augé and P. Linant de Bellefonds, *L.I.M.C.* 3(1).943 nos. 9–10, 949
no. 106; 3(2).669, 677; and compare the entry in the same work on "Victoria". For
Sasanian parallels, but in representations of kings, see Ghirshman, *Artibus Asiae* 16
(1953) 61 fig. 12, 66 fig. 16 (a wingless *putto*).

of the eastern arch (figs. 17b, 25).[123] Each holds a bowl or shallow basket full
of small circular objects, apparently coins; and between these, at the apex of
the arch, is a much-damaged circular medallion that contained a portrait,
possibly of a woman—hair and eyes are still discernable, but the lower part
of the face has been destroyed.[124] These fine, life-size images remind us of
the depictions of Victory (Nikē) holding up portrait medallions that were
to be seen throughout the Roman Empire, including Syria and Jordan, and
had deep roots in Greek artistic tradition (fig. 42).[125] Especially in their at-
tire, they also recall an Aphrodite in a mosaic from a sixth-century man-
sion at Mādabā (fig. 26). They make an impression even in Quṣayr ʿAmra's
crowded hall. Their significance for the patron and artists, though, is hard
to guess. Probably they evoked nothing more specific than what they sug-
gest to today's visitors, namely a courtly, opulent, and vaguely triumphal
atmosphere, with a touch of irreverence in the topless and wingless Victo-
ries. If there was an allusion to some historical individual, the reclining
woman who receives a crown, and whose undress (other than in the con-
text of bathing) virtually excludes her having been of free status, may have
been some especially prized singing girl—such female entertainers were by
definition slaves.[126] Though they resemble her, the women in the arch soffits
are elegant space fillers, not portraits.

The vault of the central aisle substitutes for the *fabrefactum lacunar*, the
"cunningly wrought coffered ceiling", that Sidonius Apollinaris was so
proud of in his bath house,[127] a cheaper solution in the form of thirty-two

123. Cf. *Q.ʿA.* 85 fig. 52, 140 fig. 93 + *Q.ʿA.*¹ pl. XXVIIIa.

124. Vibert-Guigue diss. 1.365–74, and a photograph taken in 1974 and kindly
shown me by J. Zozaya, but not reproducible. The western arch has lost much of its
corresponding decoration. What remains excludes the possibility that the women of
the eastern arch were duplicated, and that there was a medallion in the same posi-
tion as on the eastern arch, *pace* fig. 14.

125. Cf. Strzygowski, *Orient oder Rom* pl. 1, and pp. 14–17, 25–30; Volbach,
Elfenbeinarbeiten pls. 4–5, 8–9, 11; Linant de Bellefonds, Ἑλληνισμός 238–39; Spetsieri-
Choremi, *Mitteilungen des Deutschen Archäologischen Instituts, Athenische Abtei-
lung* 111 (1996).

126. Al-Jāḥiẓ, *Risālat al-qiyān* (a much more enlightening discussion than what
survives of al-Iṣfahānī's *Al-qiyān*; cf. Kilpatrick, *Book of songs* 25); Ṭab. 2.1766 (trans.
26.117), on al-Walīd II's order for female musicians, falcons, and horses from
Khurāsān; C. Pellat, *E.Is.* 4.820–24. On the freedom of behavior and dress of slave
compared to free women see Simeon of Beth-Arsham, *Letter G* pp. 55–59; *Chroni-
con ad annum Christi 1234 pertinens* 1.222–23 (from Dionysius of Tel-Maḥrē, d.
845); al-Jāḥiẓ, *Risālat al-qiyān* 23; Iṣf. 22.211 (trans. Berque 196); also the reports
according to which ʿUmar I insisted his female slaves serve guests unveiled, discussed
by Johansen, *Law and society* 79–80.

127. Sidonius Apollinaris, *Epistulae* 2.2.5 (trans. W.B. Anderson).

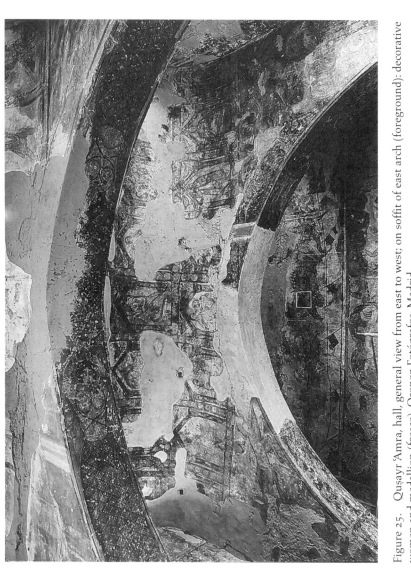

Figure 25. Qusayr 'Amra, hall, general view from east to west; on soffit of east arch (foreground): decorative women and medallion (fresco). Oronoz Fotógrafos, Madrid.

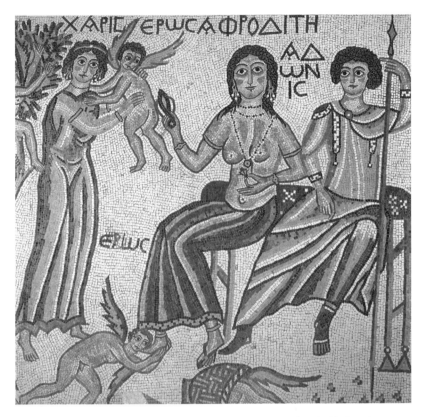

Figure 26. Mādabā, Hippolytus hall: Aphrodite (mosaic, first half of sixth century). By permission of the Department of Antiquities, Jordan.

panels arranged in four rows, each panel containing one or two figures placed under gable-shaped arches, with a bird in each spandrel (fig. 25).[128] This type of decoration was commonplace in the Roman world and had caught on in Irān too.[129] Some of the figures are naked, and some seem—the paintings are ill executed, much damaged, and extensively restored—to be erotically involved with each other. Strikingly similar scenes, including niches with the same gable-shaped arch, adorn a bronze and iron brazier of the Umayyad period recently unearthed at al-Faddayn near al-Mafraq, northwest of

128. Cf. K.ʿA. 2. pls. XX, XXII; Q.ʿA. 43 fig. 17, 54 fig. 26 + Q.ʿA.¹ pl. VIIIa; Vibert-Guigue, *D.A.* 244 (1999) 93.
129. Volbach, *Elfenbeinarbeiten* pl. 38; Forsyth and Weitzmann, *Monastery of Saint Catherine* 17 and pls. CXXXIV–CXXXV; Kawami, *Metropolitan Museum journal* 22 (1987) 27–28.

Figure 27. Al-Faddayn: brazier (bronze, Umayyad). Archaeological Museum,
ʿAmmān. By permission of the Department of Antiquities, Jordan.

Quṣayr ʿAmra beyond Qaṣr al-Ḥallābāt (fig. 27).[130] This object is also
adorned by statuettes of naked women wearing armlets, anklets, and neck-
laces and belongs to the same world as our bath house.

Abundance, relaxation, and eroticism; music making, singing, and danc-
ing; the showing off of fine clothing and jewelery by women—all these
things were, and long remained,[131] part of bath-house culture, even outside
the court milieu. Yet as with all pleasures, they took their special, intense
taste from contrast with exertion and risk, whether in the hunt, whose stren-
uousness the side aisles display, or in war, ever part of Umayyad life. That
danger and pleasure are two sides of the same coin was the main idea be-
hind the Arabs' verse battle cries, with their endless insistence that "skill
with the sword blade" would bring the admiration of "a lovely serving girl,
adorned with necklace and anklets."[132] We should keep in mind this back-

130. See below, pp. 153–54; and compare also the stucco ornament at Qaṣr
al-Ḥayr al-Gharbī: *Q.H.G.* pls. 58, 63c, 68d–e.
131. Russell, *Natural history of Aleppo* 1.137–38; Lewcock, al-Akwaʿ, and Ser-
jeant, *Ṣanʿāʾ* 514, 518, 524.
132. Ṭab. 1.3005 (trans. 15.203 Humphreys), 3014–15 (trans. 15.212–13); 2.561,
562, 617 (trans. 20.146, 148, 201).

ground rumble of strife and violence, whether external or internal. The danc-
ing girl may stand for Victory as well;[133] peace comes only after war.

SINGERS AND POETS

The poetic and musical culture these depictions of entertainers and decora-
tive women allude to was thoroughly Arab, even if it had analogues else-
where. Verse was one of the Arabs' natural means of expression, and de-
spite all the controversy that surrounds the remnants of pre-Islamic poetry,
especially the contribution of Abbasid editors,[134] this medium had reached
a high point of perfection before the writing down of the Qur'ān, with the
subsequent enormous development of Arabic as a written and literary lan-
guage. Poets were sought after wherever they went; and it was normal for
them to sing rather than recite their compositions: hence the title of the *Kitāb
al-aghānī*, the *Book of songs*.[135] This vast compilation offers a panoramic,
vivid picture of the world of the early Arab poets, who were—and often de-
picted themselves as—social marginals, but whose art spoke to the hearts
of men and women, commoners and princes.

In hope of substantial reward from these princes, who in turn aspired
to increase their own reputation for generosity, poets traveled far and wide,
even before Islam. The best were by no means averse to seeking patronage
and inspiration outside the Arab sphere, as, for example, the famous Chris-
tian poet of al-Ḥīra, 'Adī b. Zayd. For a time during the last quarter of the
sixth century, 'Adī lived in the Iranian capital of Ctesiphon, where he be-
came secretary for Arab affairs. The Sasanian monarch (exactly which one
is unclear) sent 'Adī on an embassy to the emperor of Rome, who in turn
dispatched him on a provincial tour to give him an opportunity to take in
the majesty and extent of the Roman state. He ended his travels declaim-
ing Arabic poetry in Damascus.[136] A generation or so after this Ḥassān b.
Thābit (d. c. 659), who later submitted to Islam and became one of Muḥam-
mad's elect poets, visited the Ghassanid prince Jabala b. al-Ayham, possi-
bly at al-Jābiya south of Damascus. He described the deep impression made

133. Cf. Kiss, *Το Βυζάντιο ως οικουμένη* 82, on the crown of Constantine
Monomachus.

134. For some recent comments see Montgomery, *Vagaries of the qaṣīdah* 8–9,
38–40.

135. A. Arazi, *E.Is.* 9.449b–450a; Kilpatrick, *Book of songs*.

136. Hishām b. al-Kalbī in Iṣf. 2.94–95 (trans. Horovitz, *Islamic culture* 4 [1930]
38–39); Shahîd, *B.A.SI.C.* 1.478–82.

on him by the entertainment he witnessed there, especially the "five Greek girls who sang in Greek accompanying themselves on the lute *(barbaṭ)*, and five (other girls) who sang songs of the people of al-Ḥīra".[137] Al-Ḥīra and the Ghassanids, "more directly exposed to the impact of the high cultures to the north", as has recently been pointed out, "presumably acted as channels (and at the same time as filters) through which musical influences spread southwards, and may well have been in the vanguard of musical change".[138]

Once Islam united this whole Middle Eastern world,

> luxury and prosperity came to (the Arabs), because they obtained the spoils of the nations. They came to lead splendid and refined lives and to appreciate leisure. The singers (now) left the Persians and Byzantines. They descended upon the Ḥijāz and became clients of the Arabs. They all sang accompanied by lutes, pandores, lyres and flutes. The Arabs heard their melodious use of sound, and they set their poems to music accordingly.[139]

It became common to meet, on the highway between one city and another, men such as Saʿīd b. Misjaḥ, who flourished in the later seventh century. Of this black singer from Makka, the *Kitāb al-aghānī* reports that he visited both Syria and Irān in order to absorb the local musical traditions, and in Syria also familiarized himself with the music of the Romans, in other words the local Christian populations. Returning to the Ḥijāz, he created a mixed music out of Arab, Roman, and Iranian elements, which became popular and was widely imitated.[140] Alongside these cosmopolitan poets and singers, the traditional storytellers of the nomadic Arabs also remained in demand. We catch a glimpse, for example, of the caliph Hishām feeling ill and malcontent one night in his palace at al-Ruṣāfa, and summoning one of these *muḥaddithūn* to recite the familiar old poems of the desert as he reclined with candles flickering in front of him and his women eagerly following the performance behind a thin curtain.[141]

Women poets were rare before and after Islam; but women singers were common. And Arab lovers of women and song could, of course, hardly be

137. Al-Wāqidī in Iṣf. 17.169–70 (trans. Nicholson, *Literary history* 53). On the *barbaṭ*, a characteristically Iranian type of lute, see J. During, *E.Ir.* 3.758–59. On al-Jābiya see Conrad, *Byzantine and modern Greek studies* 18 (1994) 46–47; Shahîd, *B.A.SI.C.* 2(1).96–104.
138. Wright, in *A.L.U.P.* 437.
139. Ibn Khaldūn, *Muqaddima* 2.360 (trans. Rosenthal).
140. Iṣf. 3.273 (trans. Berque 147), cf. Kilpatrick, *Book of songs* 51.
141. Iṣf. 10.190–93, esp. 191.

immune to the indispensable third member of the triad, the fruit of the grape, under whose influence they, like the Arabs of pre-Islamic times, imagined themselves to be incomparably nobler and more generous than when they were sober. Wine made them feel like kings, in fact.[142] They called it "the daughter of the grape",[143] a conceit they were far from having thought up for themselves, and which may indeed help explain the taste in Irān, up to Sasanian times and even beyond, for wine bowls decorated with images of naked women amidst vines, or wine horns that terminated in female busts.[144] The Qurʾān forbade consumption of wine, but not a few of the Umayyad family were passionate drinkers, none more so than al-Walīd b. Yazīd. A characteristic "wine, women, and song" passage from the *Kitāb al-aghānī* tells us how al-Walīd was offered for sale a Greek slave girl who had been brought up at al-Kūfa in ʿIrāq. He bade her sing. And she, whose name was Suʿād, responded with this:

> I am enchanted now by one among you, a young gazelle,
> finely reared, plaintive of voice, dark-eyed,
> a noble girl, well rounded her thighs and slender of waist,
> while her anklets and bracelets nestle in her fleshiness.[145]

So bewitched was al-Walīd that he called for twenty drinking bowls of wine, had Suʿād sing the piece again, and happily paid her price without haggling. "She became for ever after his favorite."

Al-Walīd's drinking bouts have nearly always been understood by scholars as pure hedonism and were certainly censured by some contemporaries as frivolity;[146] but he was far from unique among the Umayyads,[147] and there was a system and almost a grandeur to his imbibing that makes one wonder whether perhaps there was also an idea behind it. It is recorded, for example, that he propagated among his courtiers not only a taste for the wines of Irān—the wines, as he himself called them, of Kisrā[148]—but also a certain specifically Iranian drinking custom that had previously been unknown

142. Goldziher, *Muslim studies* 1.27–38.
143. E.g., al-Walīd b. Yazīd no. 8/5 (trans. Hamilton 164; Blachère, *Analecta* 397–98; Derenk 101; Gabrieli 24; Rotter 113).
144. Melikian-Chirvani, *Bulletin of the Asia Institute* 10 (1996) 107–12.
145. Isḥāq al-Mawṣilī in Iṣf. 7.30–31 (author's translation; cf. that of Derenk 106–7).
146. See, for example, al-Madāʾinī in Bal. 2. fol. 156a = p. 311 (8–9 Derenk), and Ṭab. 2.1742 (trans. 26.89–90).
147. Al-Jāḥiẓ (attributed), *Kitāb al-tāj* 151–52. On this text's tendency to exaggerate out of dislike of Arabs see, though, ʿAṭwān, *Al-Walīd* 219.
148. Al-Walīd b. Yazīd no. 95/98 (trans. Hamilton 119; Gabrieli 29).

among the Arabs.[149] One might wonder, too, for what reason al-Walīd had his "gold and silver ewers" specially made in faraway Khurāsān. Syria, after all, could boast a perfectly respectable tradition of silver work.

But Irān had something more, an ideal of kingship with which these luxury objects were closely linked. And among the grand, eagerly anticipated events of the Sasanian court year had been the formal audience and banquet, or *bazm*, that was celebrated twice a week, but with special magnificence on the new year and spring festival of Nawrūz, when the king's reign was renewed in harmony with the natural order, and also on the lesser winter festival of Mihrjān.[150] On these two special occasions the King of Kings enthroned in all his regalia had solemnly and for up to three days in succession feasted and drunk wine from vessels of gold or silver in the company of his ministers and generals, for it was felt that a king was most truly a king when he entertained, received gifts and bestowed gifts in return, and could be beheld in glory like the sun (whose imagery occurs frequently in our sources) by all his guests assembled. The *bazm* continued to be performed in ex-Sasanian lands until the Mongol invasions.[151] It is recorded, also, that in the year 738 the governor of Khurāsān, Asad b. ʿAbd Allāh al-Qasrī, attended a Mihrjān festival at Balkh, and that he sat in state on a throne while Arab and Iranian nobles vied in the lavishness of their gifts to him: "a fortress of silver, a fortress of gold, pitchers of gold, pitchers of silver, and large dishes of gold and silver . . . a ball of gold" and garments of silk. All these gifts Asad immediately distributed among his followers.[152] The full Zoroastrian significance of this event will have been, at best, a matter of indifference to the Arab conquerors. Nor is it recorded whether wine was consumed on this particular occasion: it seems improbable that a governor would expose himself to such an obvious accusation. But as a manifestation of kingly magnificence and generosity the *bazm* could hardly be bettered. When al-Walīd drank ceremoniously, accompanied by the great men of his state, his poets, his servant "like the sun", and his forty pages and maids "like a scattering of pearls",[153]

149. Iṣf. 7.73 (trans. Hamilton 130), though note the different version of the story in Mas. 2247 (3.216–17 Dāghir).

150. Al-Jāḥiẓ (attributed), *Kitāb al-tāj* 101, 146–50, 159–60; Melikian-Chirvani, *Banquets d'Orient*; Abkaʿi-Khavari, *Das Bild des Königs* 77–84.

151. Al-Yaʿqūbī, *Taʾrīkh* 2.218; Melikian-Chirvani, *Banquets d'Orient*; J. Calmard, *E.Is.* 7.18–19; and note especially the verses of the caliph al-Maʾmūn (813–33) quoted by Mas. 3503 (4.245–46 Dāghir), alluding to the *khusrawānī* (i.e., "Kisran", royal) wine that is drunk on the festival of Mihrjān.

152. Ṭab. 2.1635–38 (trans. 25.167–69).

153. See above, p. 72.

he was surely following consciously, if somewhat informally, an example set long ago at Ctesiphon of how kings might most effectively be seen to be kings.[154]

To return, though, to Suʿād. Singing girls were by definition young and beautiful, and mixed unveiled (when it suited them) with Arab men in whose poetic culture they were well versed, and whose "free" wives were veiled or confined to the domestic quarters.

> My boon companions are white as stars, and a singing wench
> comes to us in her striped garment or her saffron robe;
> wide the opening of her collar, delicate her skin
> to my companions' fingers, tender her nakedness.
> When we say, "Let's hear from you", she advances to us
> chanting fluently, her glance languid, in effortless song.[155]

Suʿād herself surely embodied the ideal of feminine beauty her song extolled. Al-Walīd's encounter with her recalls the occasion on which his father Yazīd b. ʿAbd al-Malik had first caught sight of his own favorite, Ḥabāba, when she was brought to court wearing "a veil *(izār)* [the sort that covers the whole body as well as the head] with a double train" and flinging a tambourine in the air, then catching it, while singing the song of an old pre-Islamic poet about his beloved Mulayka, in which he tells how he longs to caress her beautiful body that night, with only the stars for company.[156] And this reflectivity of song and singer is still further reinforced at Quṣayr ʿAmra by the paintings on the wall, which exemplify the same aesthetic and erotic ideal. One is reminded of a much later writer's observation about how the scenes of lovemaking depicted on the mosaic floor of a Baghdād bath house added to the intensity of the erotic encounters experienced in that very room by the owner of the bath.[157]

154. This idea was already adumbrated by Grabar, *Studies in memory of Gaston Wiet* 58–59. With the "Pharaonic cup" alluded to by one literary source in the context of the Iranian wine ritual (Melikian-Chirvani, *Banquets d'Orient* 102), and the crescent-shaped vessels apparently used on these occasions (ibid., 95 n. 2), compare al-Walīd's long, curved drinking bowl (or wine horn) known as "Pharaoh's phallus": Ḥammād al-Rāwiya in Iṣf. 2.204 (trans. Berque 125); al-Aṣmaʿī in Iṣf. 6.89.

155. Ṭarafa (sixth century), *Muʿallaqa* pp. 32–33 (trans. Arberry, *Seven odes* 85–86). Cf. the remarkable photograph of a young singer-tambourinist in Serjeant and Lewcock, eds., *Ṣanʿāʾ* 414. Amidst the uniformly veiled women of Ṣanʿāʾ, the presence of such girls in public life presents an open provocation.

156. Isḥāq al-Mawṣilī in Iṣf. 15.119 (trans. Berque 192–93). Singing while walking and accompanying oneself with a tambourine was a Hijazi habit al-Walīd was to imitate: Iṣf. 9.314.

157. Al-Ghuzūlī, *Maṭāliʿ al-budūr* 2.8–9 (trans. Grotzfeld, *Das Bad im arabisch-islamischen Mittelalter* 146–48); cf. Muth, *Erleben von Raum* 311–12, 320–21, and

"A young gazelle": the metaphor is standard in Arabic poetry. There are two sorts of hunting going on at Quṣayr ʿAmra. The implied pursuit of the beautiful woman was ideally combined with wine and song. The pursuit of herds of gazelle or other wild beasts across the steppe, a fully explicit theme of our frescoes, required—by contrast—sobriety, discipline, and silence. We should not underestimate, though, the extent to which the one hunt might be seen in terms of the other. With Imruʾ al-Qays's "suspended ode", already quoted above for the incident at Dāra Juljul, the patron of Quṣayr ʿAmra will beyond any doubt have been intimately familiar:[158]

> Out I brought her, and as she stepped she trailed behind us
> to cover our footprints the skirt of an embroidered gown.
> But when we had crossed the tribe's enclosure, and dark about us
> hung a convenient shallow intricately undulant,
> I twisted her side-tresses to me, and she leaned over me;
> slender-waisted she was, and tenderly plump her ankles,
> shapely and taut her belly, white-fleshed, not the least flabby,
> polished the lie of her breast bones, smooth as a burnished mirror.
> She turns away, to show a soft cheek, and wards me off
> with the glance of a wild doe of Wajra, a shy gazelle with its fawn;
> she shows me a throat like the throat of an antelope, not ungainly
> when she lifts it upwards, neither naked of ornament.[159]

Heliodorus, *Aethiopica* 4.8, on a fair-skinned baby conceived just when its mother, an Ethiopian queen, happened to be looking at a painting of naked, white Andromeda.

158. Cf. Ishāq al-Mawṣilī in Iṣf. 8.197–206 (trans. Berque 201–7); Iṣf. 7.46; Arberry, *Seven odes* 39–41.

159. Imruʾ al-Qays, *Muʿallaqa* 28–33 (trans. Arberry, *Seven odes* 62–63).

3 The Hunt

The same ode just quoted, Imru᾽ al-Qays's *Muʿallaqa*, begins with the following lines:

> Halt, friends both! Let us weep, recalling a love and a lodging
> by the rim of the twisted sands between al-Dakhūl and Ḥawmal,
> Tūḍiḥ and al-Miqrāt, whose trace is not yet effaced
> for all the spinning of the south winds and the northern blasts.[1]

Most modern analyses of the classical Arabic ode, the *qaṣīda*, divide it into three sections, with appeal to the authority of the ninth-century critic Ibn Qutayba—who actually mentions four.[2] First comes the *dhikr al-aṭlāl*, echoing Imru᾽ al-Qays's evocation of an abandoned camping place and those who once dwelt in it. Linked to the *aṭlāl* according to Ibn Qutayba, and subordinating it in the opinion of the moderns, we find a declaration of the poet's yearning for his absent or perhaps long-lost beloved: the *nasīb*. Many critics have regarded not only the incident at Dāra Juljul and the "wild doe at Wajra" section, but also Imru᾽ al-Qays's *aṭlāl* just quoted, as belonging to his poem's *nasīb*.

Next—though in practice much less predictably—comes a section in which the poet describes something he is specially proud of, usually his camel, in which case he may also recall some long, exhausting journey they once made together. This part of the ode, called the *raḥīl*, was especially popular in the Umayyad period. Often, the qualities of the mount are compared

1. Imru᾽ al-Qays, *Muʿallaqa* 1–2 (trans. Arberry, *Seven odes* 61).
2. Wagner, *Grundzüge* 1.83–115, esp. 114–15; cf. Ibn Qutayba, *Kitāb al-shiʿr wa-'l-shuʿarā᾽* 20–21 (trans. Nicholson, *Literary history* 77–78).

to those of undomesticated animals such as the wild ass, the ostrich, or the eagle, and in this way the *raḥīl* may come to include also an evocation of the hunt.

The ode culminates in its fourth—or, if there is no *raḥīl*, third—part, which may be either a *fakhr*, in which the poet boasts about himself and his tribe; a *madīḥ*, in which, though lovesick and travel-worn, he flatters the prince before whom he is performing his composition and whose generosity he counts on; or else a *hijā'*, an invective. The *fakhr* too might contain a description of a hunt; or else it might dwell on the joys of wine and women. In Imru' al-Qays's *Muʿallaqa* the two erotic sections quoted in the last chapter, whether or not they belong to his *nasīb*, are obvious examples of this sort of sexual bragging.

Nothing stopped the poet from omitting one or more of these sections or changing their order. But the ideal sequence outlined by the critics, whether we think of it as tripartite with the moderns or quadripartite (recognizing the autonomy of the *dhikr al-aṭlāl*) with Ibn Qutayba, was extremely familiar and, perhaps not entirely surprisingly, turns out to be a felicitous organizing principle for the description of Quṣayr ʿAmra. By beginning with its architecture and archaeology, and going on to consider the luxuries of the bath, especially those pleasures associated with women, the previous chapter reflected the characteristic preoccupations of the *dhikr al-aṭlāl* and the *nasīb* (though in Quṣayr ʿAmra's as well as Imru' al-Qays's frankly hedonistic approach to women there is something of the *fakhr* too). Moving now gradually outward from the bath house itself, the present chapter will enquire why it was built in the Wādī 'l-Buṭum and not somewhere else. That reason—which cannot be fully elucidated unless we use the internal evidence of the building itself, and in particular its frescoes—has to do with animals and hunting, the subject of the *raḥīl*. And only when we have considered the architecture and the use of the bath, as well as the rationale of the site, will it be possible to go on, in chapter 5, to ask who was the patron of this building, which despite its anonymity sings unmistakably the praises *(madīḥ)* of a pleasure-loving prince.

Beyond this happy coincidence between the structure of the Arabic ode and the logical necessities of a scholarly investigation, there is also the patent fact that the preoccupations of Quṣayr ʿAmra and the *qaṣīda* are identical. Women and sex are important to both; so is the manly exhibitionism of the hunt. Self-advertisement, even boasting, is no fault, while generosity is constantly hymned in the poetry, and exuded too by the luxury and extravagant decor of our bath house. Most of what Ignaz Goldziher described as *murūwa*, the manliness or "virtue" of the traditional Arab, in his famous essay "Mu-

ruwwa and dīn",[3] is lauded in the poetry and illustrated, or at least implied, at Quṣayr ʿAmra. As for Muḥammad's ascetic religion, *dīn*, it undeniably influenced many Umayyad poets; but the pull of pre-Islamic ideals, of the desert (however idealized) against the city, remained strong as well, imparting a nostalgic mood to much of the poetry of this period.[4] It is this transitional mental world that Quṣayr ʿAmra too reflects, though less enthusiastically even than the poets. Our bath house, as will gradually appear in the course of this study, is Arab to the core, but only patchily Muslim.

Poetry provides, then, a key to understanding Quṣayr ʿAmra.[5] By the same token, the bath house furnishes a hoard of images illustrative of the *qaṣīda*. These conclusions do not emerge solely from comparison of the *qaṣīda*'s subject matter with that of the frescoes. They are also directly signaled by the paintings themselves. High up on the southern end wall of the east aisle, immediately under the barrel vault and on either side of the window, are three standing figures, barefoot and bareheaded but clad in flowing robes (figs. 28, 32). They look like the personifications one finds in mosaics of the Roman period, such as the early fourth-century floor from al-Shahbāʾ in the Ḥawrān representing Philosophy, Maternity, and Justice, now in the Damascus Museum.[6] As in this mosaic, so too in our fresco, each figure— presumably female, like most personifications—is labeled in Greek. In blueish-white letters on a blue ground we read, from left to right, *CKEΨH*, *ICTOPIA*, and *ΠΟIHC(H)*.[7] In other words, Inquiry or Philosophy, His-

3. Goldziher, *Muslim studies* 1.11–44.

4. Cf. Montgomery, *Vagaries of the qaṣīdah* 209–53.

5. A proposition questioned by Grabar, *A.O.* 23 (1993) 95, on the grounds that poetry is evanescent and architecture permanent. Yet much Umayyad poetry remained in circulation for generations, when Quṣayr ʿAmra had long been abandoned; while the tenth-century *Kitāb adab al-ghurabāʾ* attributed to al-Iṣfahānī is built on the idea that a poem that starts life as a graffito can transcend the evanescence of its architectural medium once it is copied and circulated as literature *(adab)*. Note also Fowler's reflections on the unstable polysemy of monuments and their small success, compared to poetry, in fixing memory: *Roman constructions* 193–217. The historian may legitimately treat both as expressions of a particular moment or period, and therefore as at least potentially capable of throwing light on each other. Grabar concedes that architectural decoration may be somewhat more amenable to an approach through poetry.

6. *L.I.M.C.* 3(2).278.

7. *Q.ʿA.* 2. pl. XXIX; Vibert-Guigue, *D.A.* 244 (1999) 94; and cf. Mielich, *K.ʿA.* 1.199a (on the *E* of *CKEΨH*, which is now barely if at all recognizable, according to C. Vibert-Guigue, letter of 2 April 2000); Jaussen and Savignac 3. pl. LV.6–7; *Q.ʿA.* 76–80; Grabar, *A.O.* 23 (1993) 106 fig. 11; Vibert-Guigue diss. 3. pl. 166. Bowersock's preference, *Selected papers* 152–53, for the rare form *CKEΨ* (i.e., σκοπός/ή) seems arbitrary in view of the coherence of these three intellectual personifications,

Figure 28. Quṣayr ʿAmra, hall, east aisle, south wall: Philosophy, History, and Poetry (fresco). Drawing by A. Mielich, in *Ḳ.ʾA.* 2. pl. XXIX.

tory, and Poetry were activities of the mind that our princely patron pretended to.

We should resist, though, the temptation to see in these figures just an off-the-peg trio of personifications designed to intimate a smattering of Greek culture. In the first place, the personification of Skepsis is probably unique in what we know of late antique art,[8] so one suspects some thought has gone into the choice of these particular disciplines for representation. And secondly, it is most unlikely that *Greek* poetry was what was intended. Rather, iconographical conventions borrowed from the Greek world (in the widest sense) are here being put to work in the very different cultural sphere of the Arabs. To *murūwa* and *dīn* may be added, then, another polarity in the transitional mental world of Quṣayr ʿAmra, that between Hellenism and Arabism. Of the role of Greek language and culture at Quṣayr ʿAmra, there will be more to say in later chapters.

not to mention the presence of an *H* at the end of the word. I propose *ΠΟΙΗϹ(Η)* not *ΠΟΙΗϹ(ΙϹ)*, by analogy with *ϹΚΕΨΗ*. The assimilation of third-declension types ending in -ις to the first declension in -η had begun many centuries before this: Niehoff-Panagiotidis, *Koine und Diglossie* 74–75, and cf. Mitchell, *Anatolian studies* 27 (1977) 92–96. (I am obliged to J. Niehoff-Panagiotidis and A. Panagiotou for help with this point.) *Pace* Becker, *Islamstudien* 1.292, there is no sign of or room for a sigma at the end of *ϹΚΕΨΗ*.

8. J. C. Balty, *L.I.M.C.* 7(1).791.

THE ART OF THE HUNT

The Greeks and Romans too had assigned the hunt, together with bathing, a prominent place among mankind's favorite diversions. "Hunting, bathing, having fun, laughing, that's the life!" proclaims a graffito on the paving stones of the forum at Timgad in Algeria.[9] Roman art, like that of the Iranians, was full of images of the hunt, which might also adorn bath houses.[10] Even as late as the eighth century, paintings or mosaics with depictions of the hunt (as well as horse races and scenes from the hippodrome and theater) were still a perfectly familiar sight in the Roman Empire.[11] In this preoccupation, then, as well as in their depictions of music making and dancing, the Quṣayr ʿAmra artists were addressing themes of universal interest. The product of their labors could hardly be impervious to the great imperial iconographical traditions of the past. One has only to consider a late Sasanian silver-gilt bowl now in the Cleveland Museum of Art, with its miniatures of musicians and wrestlers as well as a hunter trying to spear a bear in a net, to sense an atmosphere, or a combination of passions, extremely close to Quṣayr ʿAmra's.[12] But the air Quṣayr ʿAmra's patron breathed—and perforce his artists too, even if at second hand in the case of non-Arabs—was that of Arabic poetry. In attempting to interpret the paintings, some reference to the imperial traditions will be appropriate. If, though, we would grasp the hunt's place within the broader spectrum of Arab mentality and life, we must keep in mind the poetry as well.

For this reason, it may not be inappropriate to reproduce at this point part of Sir Charles Lyall's free but evocative translation of one of the greatest and most moving of Arabic poems, an elegy in which Abū Dhuʾayb, a contemporary of Muḥammad, uses images of the hunt in order to come to terms with the death of his five sons, all carried off by the plague in the same year. First, the hunt of the wild ass:

> Time sweeps away all things on earth in its changeful stream:
> nought stands: not he, the wild ass, his mates a dry-uddered four.
> . . .
> He has grazed the lush long grass: a slim-bodied mate beside

9. *C.I.L.* 8.17938: "venari lavari ludere ridere occ est vivere"; cf. Dunbabin, *Papers of The British School at Rome* 57 (1989) 6–7 esp. n. 3.

10. E.g., J. B. Ward-Perkins and Toynbee, *Archaeologia* 93 (1949) pls. XLII–XLIII (Hunting Baths, Lepcis Magna, second–third century); Drandaki, Μουσείο Μπενάκη 2 (2002) (late antique bath buckets decorated with hunting scenes).

11. Stephen the Deacon, *Vita Stephani Iunioris* 26.

12. Cleveland Museum of Art, inv. no. 1966.369; see Harper, *Royal hunter* 53–54.

sticks close: the pasture has filled him full of fresh wantonness.
There in the hollows shine the pools which unfailing showers
 keep brimming, ever renewed from clouds that have no surcease.
So long they played and together romped in the lusty mead:
 at times his play had a will behind, pure mirth at times.
Till at last the drought sucked up the waters throughout the land—
 how soon set in the ungrateful change in that world of joy!
"To the springs", thought he, "down must we go"; and a gloomy cloud
 drew o'er his soul, as his Fate advanced that had dogged his steps.
 . . .
So down they came to the water, while in the starry vault
 shone bright Capella, a watcher posted above the Belt.
Down went their lips to the streamlet's marge, where sweet and clear
 flowed cool the flood, and their feet were hidden, both shank and
 knee.
As they drank, they heard as it were a sound from the height behind
 and a noise suspect, as though something struck upon another thing,
and the rustle where one girt himself for the chase, in hand
 harsh-twanging bow of a *nab‘* bough and an arrow-pack:
what it was they knew not, and terror seized them, and long of neck
 close pressed a she-ass, the chief of four, to her mate's big breast.
Then the hunter shot, and the arrow pierced from side to side
 her well-nourished frame, and came out, its feathers all clung with
 blood;
when she fell, the side of her mate was bared as he turned to flee
 in his haste, and swift from behind the hunter an arrow drew;
then sped it, piercing the he-ass's flank with the far-flung shaft,
 one of Ṣa‘da's best, and the ribs shut close on the death within.
So among them all he scattered bane—one fled as best
 life's last remains gave strength, another in stumbling died:
their legs beneath slipped where the blood from the cruel shafts
 dyed deep the ground, as if clad in striped stuff from Tazīd.

And after the onager comes the turn of the oryx:

Yea, Fortune strikes with an equal fate the swift-footed steer
 full of youth and strength—but the dogs have smitten his heart with
 dread—
trained hounds—he knows them, and sinks his spirit as paling East
 leads in the day, true dawn at last, though it bring but fear.
Night-long he sought in the thorn brake for a shelter-nook
 from the pelting rain and the chilling blasts that had vexed him sore.
With his eyes he searches the hollows round, and to see more clear
 draws close the lids; and his eyes confirm what his ears report.
As he stands in sunlight to warm his back, there close at hand
 break forth the first of the hounds, held back till their fellows join.

In his fright he turns to escape, and finds that the way is blocked
 by dogs well trained, two with hanging ears, crop-eared the third.
With their teeth they grip him, but stoutly thrusts he the hounds away,
 a defender sturdy of leg, his long sides streaked with brown;
sideways he turns to bring into play horns sharp as steel—
 on them the blood shines red and bright as Socotra's dye:
 . . .
Till at last, when all of the pack were checked, a good handful slain,
 and the rest dispersed this way and that, yelping with pain,
stood forth the Master to save his hounds, in his hand a sheaf
 of slender arrows with shining points, feathers cut close;
then he shot, if haply the remnant scape: and the arrow sped,
 and the bitter shaft transfixed the bull from side to side:
headlong he crashed, as a camel-stallion falls outworn
 in the hollow ground: but the bull was fairer and goodlier far.[13]

As for the visitor to our Quṣayr ʿAmra hunting lodge, what he first no-
tices as he steps into the main hall is the enthroned prince in the alcove
straight ahead, or the long-skirted, bare-breasted women in the soffit of the
left-hand arch. But it takes no more than a few seconds to realize that one
is surrounded by hunting scenes as well, all along the east and west walls,
but also on the endwalls of the eastern aisle. At first glance, one may be struck
by narrative parallels between Abū Dhuʾayb's evocation of the hunt of the
wild ass and oryx and these painted images from about a century later. They
will have acted as backdrop, perhaps even provocation, for the recitation of
this and other similar poems. One may also note the dissimilarities, such as
the absence from the paintings of the landscape contexts so skillfully hinted
at by the poet. And the emotional punch the poem packs, even to the unini-
tiated modern reader—this is not lacking at Quṣayr ʿAmra, though it may
seem less direct, given the need to decipher the visual codes that once upon
a time, though, were surely perfectly familiar.

We may begin in the east aisle, which in fact contains all but one of
Quṣayr ʿAmra's hunting frescoes. In the right-hand panel of the east wall's
upper zone, a depiction of a lion pouncing on a wild ass (fig. 61), which made
an indelible impression on Musil, is surely not there merely to remind us
that hunting is as much part of life in the animal kingdom as it is a diver-

13. Abū Dhuʾayb, *Marthiya* 14, 16–20, 25–42, 44/45–47/48 (trans. Lyall, with
minor alterations; cf. *E.A.P.* 2.206). On Umayyad hunting poetry see Wagner,
Grundzüge 2.46–58. For a prose description of a hunt contemporary with Quṣayr
ʿAmra and addressed to a caliph, presumably Marwān II, see ʿAbd al-Ḥamīd al-Kātib,
letter 23. Note the use of falcons here as well as dogs, and the detailed evocation of
the landscape and weather.

sion for humankind.[14] The motif was immensely familiar, but a masterful Umayyad mosaic in an apsidal chamber adjacent to the bath house at Khirbat al-Mafjar, and depicting a lion pouncing on a gazelle under a fruit tree while two other gazelles graze nearby, stands out among the hundreds of such scenes that have been preserved.[15] Even a passing familiarity with the Arabic poetry of the period soon convinces one that the meaning of these scenes is erotic, for the lion often stands for the strong, impulsive lover, while the gazelle is the fair maiden pursued.[16] Similarly erotic, in all probability, are the other two panels in this upper zone, featuring humans.

In the lower zone on the same wall, toward the left, a solitary huntsman lets loose a pack of at least fifteen saluki dogs (fig. 29):[17]

> The hounds wear collars and are trained especially for the task, alike in appearance and invariably hungry and very lean; this makes them all the more eager for the chase and their long muzzles and necks stretch forward, their tails carried high, covering the ground with their long strides.

This recent evocation of salukis in full cry, based on passages culled from early Arabic poetry,[18] may also serve as a description of the scene at Quṣayr ʿAmra. On the right of the panel the quarry—six of them—turn to confront their assailants with an oddly languid air, almost of unconcern. There has been little agreement about what these ineptly drawn animals were meant to be, but the most competent authority identifies them as wild asses.[19] If, to us, their ears seem too large, that may reflect not so much on the artist's fidelity as on the confusion of equid taxonomy both ancient and modern.[20] What is important for present purposes, though, is that "for as long as hunt-

14. *Q.ʿA.*[1] pl. XXVIIIa; Musil, *Palmyrena* 290.

15. *K.Is.* pl. XIV. For a stucco relief of a panther pursuing a gazelle, recently found in an Umayyad residence at Umm al-Walīd, southeast of Mādabā, see Bujard and Trillen, *A.D.A.J.* 41 (1997) 361 fig.17.

16. Behrens-Abouseif, *Muqarnas* 14 (1997).

17. Cf. *Q.ʿA.* 49 fig. 21, 99 fig. 69 + *Q.ʿA.*[1] pls. XXVIIIa, XXIXb; Grabar, *C.A.* 36 (1988) 82 fig. 12.

18. Allen and Smith, *Arabian studies* 2 (1975) 133, and 111 for photographs. On the collars, see also *E.A.P.* 2.185–86. There are more collared hunting dogs in the Umayyad decoration at Qaṣr al-Ḥayr al-Gharbī (Schlumberger, *Syria* 25 [1946–48] pl. B: fresco) and Khirbat al-Mafjar (*K.M.* pls. XLIX.2: stucco, XCVI.2: ink sketch on marble), and in the church at Dayr al-ʿAdas, south of Damascus (fig. 30, and cf. Farioli Campanati, *Arte profana*), on whose date see below, p. 95 n. 27.

19. Jabbur, *Bedouins* 106, 182; cf. Strommenger and Bollweg, *Collectanea orientalia*. The quarry in the Dayr al-ʿAdas mosaic (previous note) is also impressionistically drawn and hard to identify: Donceel-Voûte, *Pavements* 50.

20. Hauben, *Ancient society* 15–17 (1984–86).

Figure 29. Quṣayr ʿAmra, hall, east wall: hunting scene, detail (fresco). Oronoz Fotógrafos, Madrid.

ing has been known among the Arabs, the wild ass, or onager, along with the 'wild cow' [or oryx], has been the quarry most highly prized by hunters in the desert".[21]

The Quṣayr ʿAmra artist's technique is to sketch bold and undeniably vigorous outlines of his subjects, and fill them with ochre tones; but he neglects to model them very much.[22] Nor does he communicate to his composition, as a whole, any sense of depth. For Abū Dhuʾayb's careful description of the physical environment, he substitutes that monochrome blue background so typical of Quṣayr ʿAmra, and of all the art of the East since long before the coming of the Greeks.[23] (It can be observed also in the Umayyad fresco fragments found at Khirbat al-Mafjar and al-Ruṣāfa.[24]) This method of painting is quite common at Quṣayr ʿAmra, and it is worth noting that

21. Jabbur, *Bedouins* 105.

22. This style of painting is sensitively described in Nordhagen's account of the frescoes in S. Maria Antiqua in Rome from the first decade of the eighth century, contrasting their linearity with the softly modeled features of mid-seventh-century paintings in the same church: *Frescoes of John VII* 106–10.

23. Ainalov, *Hellenistic origins* 212–14; Keall, Leveque, and Willson, *Iran* 18 (1980) 8.

24. Grabar, *K.M.* 309 and pls. XCVII, XCVIIA; Ulbert, *Da.M.* 7 (1993) 224.

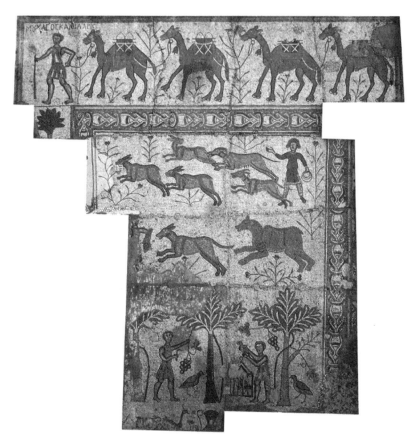

Figure 30. Dayr al-ʿAdas: hunting scene (mosaic, seventh century?). Buṣrā Castle.

there was clear evidence for it *before* the Spanish restoration,[25] which often involved emphatic redrawing of outlines but not restoration of flesh (or fur) tones, with the result that some figures now have a starker, still less illusionistic appearance than originally.[26]

Although not unparalleled in the Christian art of the region, as, for example, in a possibly seventh-century mosaic from Dayr al-ʿAdas south of Damascus, depicting a single hunter on foot loosing two dogs on three hares

25. R. Hillenbrand, *K.Is.* (published in 1973) 159a, 163b, 164b.
26. Vibert-Guigue, *ARAM periodical* 6 (1994) 348, 355.

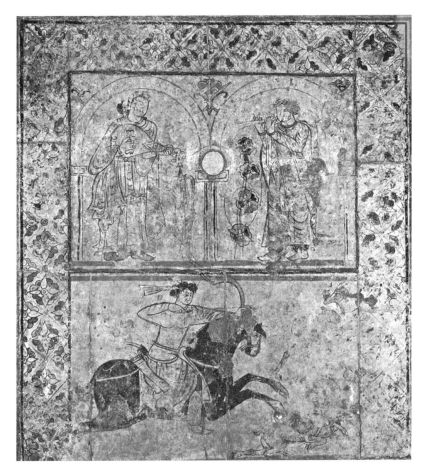

Figure 31. Qaṣr al-Ḥayr al-Gharbī: hunting scene (fresco). National Museum, Damascus.

in a schematically indicated landscape (fig. 30),[27] the scene on our hall's east wall puts one in mind of a Sasanian hunting fresco found at Susa, and datable perhaps to the early fourth century.[28] A remarkable Umayyad hunting fresco found at Qaṣr al-Ḥayr al-Gharbī, though more obviously Sasanian in man-

27. Cf. above, p. 92 nn. 18–19. The date 722 usually assigned to this figural nave mosaic is in fact supplied in another panel in the north aisle: cf. Gatier, "Témoignage."
28. Ghirshman, *Iran* 183 and pl. 224.

ner than this Quṣayr 'Amra panel, demonstrates the same preference for a graphic rather than painterly technique (fig. 31).[29]

The Sasanians were known for stocking their residences with hunting art. The Roman soldier-historian Ammianus Marcellinus, who died at the end of the fourth century and had campaigned against the Iranians in Mesopotamia, was struck by the way in which pictures of the king killing wild beasts (such appears to be the subject of the Susa fresco) were very common "in every part of [their] houses".[30] Al-Ṭabarī, an Arabic historian but of Iranian origin, recorded in the tenth century a tradition about how Bahrām Gūr—"the wild ass"—had once, before he came to the throne (420–38), killed a lion and an onager with a single shot and immortalized his achievement by having it painted on the wall of one of his residences.[31] His hunting exploits were to become a common theme in Iranian interior decoration, both in Sasanian times and under Islam.[32] It is no surprise, then, to find 'Ubayd Allāh b. Ziyād, governor of 'Irāq from 675/76 to 683/84, decorating his residence in al-Baṣra with pictures—presumably paintings—that included "a fierce lion, a barking dog and a butting ram". This is the earliest Umayyad hunting scene reported in our sources, and we may assume it was Sasanian in inspiration, as was so much else about 'Ubayd Allāh's administration.[33] Until recently, actual surviving examples of Sasanian painting were almost too exiguous to merit discussion.[34] For this reason, there may be more Sasanian echoes in our Quṣayr 'Amra bath house than we yet have ears to hear. But some possibilities have already been noted in chapter 2; and new evidence gradually accumulates. The fourth-century Sasan-

29. Cf. R. Hillenbrand, *K.Is.* 174–75, esp. 174a; M. L. Carter, in Harper, *Royal hunter* 77–78. Mode, *Sogdien und die Herrscher der Welt* 116 and n. 364, argues that the mounted hunter's carefully depicted weaponry and quiver are Sogdian. For further parallels see (1) a Sogdian-style later sixth-century Chinese funerary couch depicting Hephthalite (?) horsemen: Marshak, *C.R.A.I.* (2001) 242, 243 pl. 9b; (2) the armed rider painted on a shield from the Sogdian fortress on Mount Mugh, east of Panjikent, and probably contemporary with its capture by the Arabs in 722–23: *L'Asie des steppes* 97, and cf. C. E. Bosworth, *E.Is.* 5.854; and (3) another armed rider of the same period from Panjikent: *Oxus* 61–64, no. 74. For an Umayyad woman's passion for Sogdian jewelry see al-Balādhurī, *Kitāb futūḥ al-buldān* 413.

30. Ammianus Marcellinus, *Res gestae* 24.6.3.

31. Ṭab. 1.857 (trans. 5.85–86).

32. Hishām b. al-Kalbī in Ibn al-Faqīh, *Kitāb al-buldān* 213 (trans. 216); al-Tha'ālibī, *Al-ghurar* 543–44, and *Thimār al-qulūb* pp. 179–80; Fontana, *Bahrām Gūr* 13–17, and *Haft qalam* 28–32.

33. Yāq. 1.530 s.v. "Al-Bayḍā'"; C. F. Robinson, *E.Is.* 10.763–64.

34. Kröger 88–89, and 219, for the possibility that the hunting reliefs at Ṭāq-i Bustān (see below, p. 109) were originally painted.

Figure 32. Quṣayr ʿAmra, hall, east aisle, south wall: hunting
scene (fresco). F. Anderegg, courtesy of O. Grabar.

ian residence excavated not long ago at Ḥājjīābād, 300 kilometers southeast
of Shīrāz, is especially suggestive in this respect, with its paintings and stuc-
coes depicting nobles, scenes of mounted combat (?), women both dressed
and naked, Erotes, and animals, either real or fabulous.[35]

 To the right of the panel showing dogs and onagers, and at a right angle
to it, on the southern endwall of this eastern aisle, is depicted what must be
intended as its sequel (fig. 32). In a woodland clearing, perhaps amid the Wādī

35. Azarnoush, *D.A.* 243 (1999). Note also how, only a couple of generations af-
ter Quṣayr ʿAmra, the caliph al-Amīn (809–13) decorated a reception hall with im-
ages, especially of animals, copied from ruined Sasanian palaces: see the commen-
tary on Abū Nuwās's *Dīwān* by that connoisseur of the Iranian tradition, Ḥamza

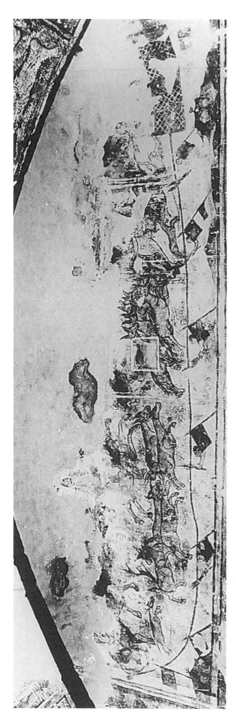

Figure 33. Quṣayr ʿAmra, hall, west wall: hunting scene (fresco). F. Anderegg, courtesy of O. Grabar.

'l-Buṭum's terebinths, a bearded central figure and two assistants are busy slitting the throats and disemboweling the carcasses of their prey—some of them oryx, to judge from their long, straight horns.[36]

The most memorable of the hunting scenes occupies the upper zone of the west wall, an enormous space some 7 meters long and 1.5 meters high (fig. 33, 60).[37] It is an energetic and confidently drawn painting of a herd of onagers being pursued at full tilt from left to right into a trap by three mounted hunters riding bareback, one of whom is falling from his horse (an unusual theme,[38] whether used here by way of allusion to a specific incident,[39] for the sake of artistic variety, or as a joke at the expense of Arab opponents of the new-fangled stirrup,[40] we can only guess). The trap is made of a net held up by stakes, while the quarry is directed toward the enclosure thus formed, at the right of the composition, by a guide rope supported by spears driven blade upwards into the ground. To each spear is attached at least one black pennant or cloth, and by each spear lurks a beater or net man, a precise detail to which a rare parallel may be found on a Sasanian silver plate, the Tcherdyne plate in the Hermitage Museum, where the profiled heads of beaters and salukis alternate round the scalloped rim formed by the outline of the net.[41] The beaters at Quṣayr ʿAmra follow the stampede of the onagers with rapt attention, each clasping in outstretched arm a burning torch. Their markedly coarse features, contrasting with the often effeminate beauty of other male figures in the frescoes, indicate servile sta-

al-Iṣfahānī (d. after 961), in Istanbul MS Fātiḥ 3774, fol. 269b–270a (trans. Wagner, *Abū Nuwās* 146; analysis of the commentary in Wagner, *Akademie der Wissenschaften und der Literatur in Mainz, Abhandlungen der Geistes- und Sozialwissenschaftlichen Klasse* [1957] 316–22).

36. *Ḳ.ʿA.* 2. pl. XXIX; Vibert-Guigue diss. 1.419–20; Harrison and Bates, *Mammals of Arabia* 188–91.

37. Cf. *Q.ʿA.* 75–79, figs. 40–48; Grabar, *C.A.* 36 (1988) 78–79 figs. 5–9; id., *A.O.* 23 (1993) 103 fig. 2.

38. Cf. Kleemann, *Satrapen-Sarkophag* 142–44; Talbot Rice, ed., *Great Palace* 124–25 and pl. 45.

39. Cf. Mas. 2250 (3.217–18 Dāghir).

40. Cf. Nicolle, *War and society* 17–19. For representations of stirrupped hunters or other riders roughly contemporary with Quṣayr ʿAmra see fig. 31 (Qaṣr al-Ḥayr al-Gharbī); *K.M.* 238 and pl. XXXVI.2 (Khirbat al-Mafjar); Harper, *Silver vessels* 88, 139–40 with fig. 46 (Pur-i Vahman plate, Hermitage Museum); *Oxus* 61–64, no. 74 (Panjikent); Muthesius, *Byzantine silk weaving* 68–69, pl. 24B (Mozac hunter silk). For literary allusions (of what value it is hard to tell) to Umayyad riders' use of stirrups from the late 680s onwards see Ḥammād al-Rāwiya in Iṣf. 6.85 (trans. Hamilton 76); also Ṭab. 2.785, 799 (trans. 21.156–57, 173), 1265 (trans. 23.213), 1546 (trans. 25.83), quoting Hishām b. al-Kalbī, al-Madāʾinī, and others.

41. Harper, *Silver vessels* 79–81, pl. 27.

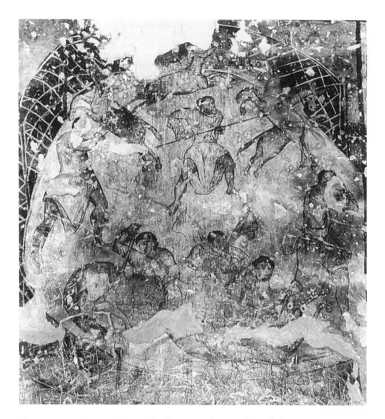

Figure 34. Quṣayr ʿAmra, hall, east aisle, north wall: hunting scene (fresco). F. Anderegg, courtesy of O. Grabar.

tus.[42] Though we see only their heads and arms, we may be sure they wore the short belted tunic that was the characteristic dress of men of their station.[43] Black beduin tents, the tip of their main poles adorned with double crescents (possibly imaginative restorations, and not lightly to be taken as symbols of Islam), are positioned at the beginning of the guide rope and by the mouth of the net, in other words at the far left and right of the panel. In the right tent we discern the faces of three onlookers, conceivably women.

42. On the physiognomy of the free and servile see the comedian al-Ashʿab in Iṣf. 16.156 (trans. Berque 323); Jarīr, *Diwān* p. 130.1: "If you should meet the tribe of Taym with their slaves, you would ask which of them were the slaves" (trans. Jayyusi, *A.L.U.P.* 413).
43. Cf. figs. 30, 61; Schlumberger, *Syria* 25 (1946–48) pl. B; Oddy, *Numismatic chronicle* 151 (1991) 61 fig.1, 65; E. H. Peck, *E.Ir.* 5.763 (and cf. *Taq-i B.* 4.96, 111 fig. 46).

At the left of the composition a single onager senses what lies in store for it and, still running, glances back over its shoulder. It is a gesture rich in resonance, artistic as well as emotional. The animal reminds us of another onager facing its end in a late second-century A.D. wall painting from a private house at Dura Europus on the Euphrates frontier between Rome and Irān. This, in turn, vividly recalls the famous hunting sculptures, some eight or nine centuries older, from the North Palace of Ashurbanipal at Nineveh, now in the British Museum. We are in the presence of a durable artistic motif that has no need of Greek or Roman parallels to illuminate it.[44] It depicts a moment of peculiar poignancy, that moment when, for Abū Dhu'ayb's onager,

> a gloomy cloud
> drew o'er his soul, as his Fate advanced that had dogged his steps.

"It is said", according to Musil, "that the gazelles even dream of the narrow opening [of the trap] through which they rush to certain destruction. If a Bedouin wishes to stop a gazelle in flight, he shouts: 'A narrow opening is in front of thee, O gazelle!', and the gazelle at once stops and looks round."[45] But others may identify with the animal's predicament: an aged poet, of the early Arabs, compared himself to "the gazelle who has escaped, yet death still awaits him when he is caught in the nets".[46]

This scene too has its sequel, on the northern endwall not of this west aisle, which would have balanced the other pair of paintings too neatly for Quṣayr 'Amra's quirky designer, but of the east aisle. (Still, the two pairs of paintings create a clockwise progression, which may even have been intended—with the enthroned prince at 12 o'clock.) In this sequel we see the gory scene inside the net enclosure once all the animals have entered (fig. 34).[47] Six hunters dispatch onagers with spear or sword or cut them up; while those they have not yet killed run in a frenzy round the edge of the enclosure, trying to escape. More than the other scene of slaughter opposite it, this one recalls parallels in late Roman art, particularly in mosaics and ivory diptychs, though usually set in the wild or in an amphitheater[48] and not, as here, in a net hunting trap.[49]

44. Rostovtzeff, *Yale classical studies* 5 (1935) 273–78, and figs. 71, 75; Barnett, *North Palace* pls. LI–LII. For parallels from the Mediterranean world see Schlunk, *Centcelles* 23 fig. 6, 103–6.

45. Musil, *Rwala* 27.

46. Arṭāt b. Suhayya (d. c. 705) ap. Iṣf. 13.39 (trans. Berque 302).

47. Cf. Ḳ.'A. 2. pl. XXXII; Q.'A. 79 fig. 49, 83 fig. 51 + Q.'A¹ pl. XXXa.

48. Cf. Lavin, *D.O.P.* 17 (1963) figs. 7, 21, 110, 120–21; Volbach, *Elfenbeinarbeiten* pls. 20, 31, 32.

49. Cf. Lavin, *D.O.P.* 17 (1963) figs. 76, 128.

One's eye is caught, particularly, by a bearded figure in the upper center of this panel, who is thrusting a lance into the belly of an onager as it rears on its hind legs. His features are reminiscent of the bearded central figure in the other scene of slaughter on the wall opposite; and he wears the aristocrat's long tunic,[50] hitched up to leave his legs free. The Arabic verb that describes this action, *shammara*, also denotes vigorous and decisive action generally;[51] while the *shammarī* is characterized by the Arabic lexicographers as one who is clever and skillful, and expert in the conduct of business. Certainly this is no common beater; and it has been suggested that he may be none other than Quṣayr ʿAmra's princely patron.[52] Yet we are at a certain distance from the heroic hunts of the Umayyads' Sasanian predecessors—roughly as far, in fact, as were al-Walīd's drinking parties from the *bazm*s of the lord of Ctesiphon.

HUNTING WITH NETS

Although hunting with nets was a standard subject in Greek and Roman art,[53] not seen as something to be ashamed of, still Plato had denounced traps as the resort of the indolent,[54] while princes preferred, unsurprisingly, to be depicted face-to-face with a pouncing lion or charging boar rather than hacking at a beast helplessly entangled in a trap. Even the enclosed game parks, or *paradeisoi*, favored by the Iranians were dismissed by some Greek writers as fit only for the unmanly.[55] This was not wholly fair—in the sort of net traps shown at Quṣayr ʿAmra, and *a fortiori* in the vast Iranian *paradeisoi*, the animals were not yet necessarily tangled up, but free to run around and seek an escape route, so still dangerous to confront. Nonetheless, viewing the Quṣayr ʿAmra paintings from the perspective of the ideal heroic hunter, whether Herakles or Bahrām Gūr, or even from that of the grandiose Sasanian hunting reliefs at Ṭāq-i Bustān, which were probably executed only a century before Quṣayr ʿAmra,[56] one's first reaction is that princely vaingloriousness could have been better served.[57] As indeed it was

50. Cf. the poem by Kuthayyir ʿAzza quoted above, p. xxvi.
51. E.g., al-Wāqidī in Ṭab. 2.848 (trans. 21.228).
52. Q.ʿA. 73, 76; and cf. 68 (acrobats panel on west wall). Did the same figure appear among the three (now damaged) riders in the hunting scene on the west wall?
53. Fowden, *Roman and Byzantine Near East*, esp. 132.
54. Plato, *Leges* 823d–824c.
55. Dio Chrysostom, *Oratio* 3.135–38; cf. Xenophon, *Cyropaedia* 1.4.5–15.
56. See below, p. 109.
57. A similar development in East Roman imperial art of the eleventh century was attributed to Muslim influence by A. Grabar, *L'art de la fin de l'antiquité* 1.280–

at the Umayyad residence and, no doubt, hunting lodge of Qaṣr al-Ḥayr al-Gharbī near Palmyra, where the high-quality monumental painting already mentioned (fig. 31), measuring 12.12 meters by 4.35 meters, depicts a quite possibly royal archer dressed in elegant Sasanian style galloping in hot pursuit of a gazelle that looks back over its shoulder at its persecutor. In a separate panel just above this scene a man plays the flute and a woman the lute, both dressed, again, in the luxurious manner of the Sasanian court[58]—or, more exactly, of the Sasanian court as it was remembered and imagined once it had ceased to exist.[59]

It is, though, in its relatively unpretentious hunting scenes that Quṣayr ʿAmra's patron becomes most clearly visible to us and is least indebted to the stereotypes of palace art. It would be surprising, after all, if he had had no say in what went on the walls. That the artists carried earlier models in mind as they worked, we may hardly doubt. But there is also some local input here—if the Arabs traditionally knew about something, it was not bath houses or dancing girls, but animals and how to catch them. At Quṣayr ʿAmra, they were too excited by the prospect of creating images of what was most familiar to them—the informal hunt of the steppe—to worry about the conventions of other people's imperial hunts, the solemn panoply of the Sasanian *paradeisos*.

Lifeless though the steppe and the desert may be today, now that the wild animals that once roamed it have been exterminated, Quṣayr ʿAmra once lay amidst prize hunting lands. The proof is still there to be seen—most easily from the air—in the hundreds of stone hunting enclosures, or *maṣāyid* in Arabic, that cluster especially round the al-Azraq oasis, whose permanent pools and safe thickets of vegetation were a magnet—much more so than the Wādī 'l-Buṭum's few terebinths and seasonal waters—to all the animals of the steppe, including gazelles, onagers, and even, once upon a time, lions.[60] Typically these traps consist of roughly circular, quadrangular, or polygonal

81. Earlier Roman imperial art had glorified the emperor as hunter, but our evidence is much thinner than for Irān: cf. A. Grabar, *Empereur* 57–62, 133–44.

58. To the references above, p. 96 n. 29, add Schlumberger, *Syria* 25 (1946–48) 97–98; E. H. Peck, *E.Ir.* 5.763–64.

59. Cf. Harper, *Iran* 17 (1979) 59.

60. On the *maṣāyid*, discussed in this and the following paragraphs, see Fowden, *Roman and Byzantine Near East*, esp. 124 fig. 6 (al-Azraq). Although the Wādī 'l-Buṭum was a migration route for birds (above, pp. 51–52), while the Umayyads were enthusiastic falconers (ʿAbd al-Ḥamīd al-Kātib, letter 23, *risāla fī waṣf al-ṣayd*; al-Ghiṭrīf b. Qudāma al-Ghassānī, *Kitāb dawārī al-ṭayr*; Ṭab. 2.1766 [trans. 26.117]; Oddy, *Numismatic chronicle* 151 [1991]; above, p. 75 n. 126), not one of the 129 birds depicted at Quṣayr ʿAmra is either hunter or hunted.

dry-stone enclosures about a meter and a half in height, with hides for the hunters attached to their circumference, like coins hanging from a necklace. There is only one, narrow entrance, and the animals are funneled toward it by long guide walls that straggle across the landscape, but not aimlessly—the *maṣāyid* round al-Azraq, for example, are mostly oriented on the oasis, a reservoir of wildlife waiting to be decanted into these death traps.

One of the so-called Safaitic rock drawings, on a stone found in the grave cairn of one Hani' in northeastern Jordan, and probably to be dated like most of these graffiti in the first century B.C. or A.D., shows just such a hunting enclosure, but with ropes supported on lines of stakes—or, as at Quṣayr 'Amra, spears—leading toward its mouth, not the usual stone guide walls. (Interestingly enough, another of Hani''s friends drew a naked woman playing the flute on a stone found near the same cairn.)[61] When the *maṣāyid* were placed on migration routes or close to water, as was often the case, the inflexibility of the stone enclosure was no disadvantage: there was always a supply of animals. But clearly it was found that there was some profit to be had in fine-tuning the catchment area, in other words the guide walls. In other situations, though, especially when herds were being hunted across wide open spaces for sport, fully portable net traps were the only practical solution. That is what we have at Quṣayr 'Amra; and though there are no specimens of such nets surviving from antiquity to place alongside the stone traps, there are parallels to our frescoes in the literary sources, as well as in the artistic representations alluded to at the beginning of this section.

The painting on the west wall at Quṣayr 'Amra is, in fact, a particularly careful depiction of a form of hunting that was intimately familiar to the artist. To such details as the pennants or cloths attached to the spears there are very few ancient parallels, and the most striking one, in mosaic, comes from a fourth-century A.D. Roman villa at Centcelles near Tarragona on the northeast coast of Spain.[62] Such comparisons, remote in both place and time, can be of no decisive usefulness to the student of Quṣayr 'Amra, whose paintings so obviously relate to local experience. It is worth, though, quoting one literary account of this form of hunting, in order to make clear what is happening at Quṣayr 'Amra, and to underline how familiar this form of hunting was, in Syria especially.

The passage in question can be found in a third-century A.D. verse treatise on hunting, the *Cynegetica* by Oppian of (Syrian) Apamea, often also known as Pseudo-Oppian. Toward the end of his work Oppian describes lion

61. Lankester Harding, *A.D.A.J.* 2 (1953) 30–33 and pl. VI.
62. Schlunk, *Centcelles* 23 fig. 6, and pls. 5–7, 38–40.

hunting as it was practiced along the Euphrates, and bear hunting as con-
ducted by the river Tigris and in Armenia.[63] If we put these two rather sim-
ilar accounts together, they yield the following picture. First, nets are dis-
posed in a crescent, attached to strong stakes. At the tips and in the middle
of the crescent, hunters lie in ambush "under piles of ashen boughs".

> From the wings themselves and the men who watch the entrance they
> stretch on the left hand a well-twined long rope of flax a little above
> the ground in such wise that the cord would reach to a man's waist.
> Therefrom are hung many-colored patterned ribbons, various and
> bright, a scare to wild beasts, and suspended therefrom are countless
> bright feathers. . . . On the right hand they set ambushes in clefts of
> rock, or with green leaves they swiftly roof huts a little apart from
> one another, and in each they hide four men, covering all their bodies
> with branches.

Beaters drive the animals toward the trap;

> and each man of them holds a shield in his left hand—in the din of
> the shield there is great terror for deadly beasts—and in his right hand
> a blazing torch of pine; for, above all, the well-maned lion dreads the
> might of fire and will not look on it with unflinching eyes.

The beasts, terrified by the torches and the din of shouting men and clang-
ing shields and "swinging feathers whistling shrill", and by "the ribands
waving aloft in the air", charge into the net and are there ensnared. Musil
too speaks of hunting gazelle by driving them between two fires—not for
illumination, as the hunt he took part in was conducted by daylight, but in
order to scare the animals into running in a particular direction.[64]

Since Pseudo-Oppian continued to be read in the East Roman Empire,
while the oldest manuscript, of the eleventh century, is illustrated with
scenes from the hunt that have been thought to derive from late antique
and perhaps Syrian models,[65] it is possible that Quṣayr ʿAmra's artists drew
on some such source, as they did also for the zodiac in the caldarium dome.[66]
Yet their paintings do not in fact resemble those so far known from either
this or the later Pseudo-Oppian manuscripts; nor indeed is it necessary to
assume strict adherence to any such prototype, when everyday life around
the Wādī 'l-Buṭum provided inspiration in abundance.

63. Oppian of Apamea, *Cynegetica* 4.112–46, 354–424.
64. Musil, *Ḳ.ʿA.* 1.18.
65. Kádár, *Greek zoological illuminations* 91–109, 118–20, pls. 138–85; but see
also J. C. Anderson, *D.O.P.* 32 (1978) 195–96.
66. See above, p. 43.

WOMEN AT THE HUNT

The hunting frescoes at Quṣayr ʿAmra make sense, then, and may stand on
their own, as documents of the princely expeditions that made a bath house
such a convenience in this particular place. They celebrate a pastime that
was dear to the Arabs above most others. They also, we may surmise, pro-
claim the patron's wealth and his ability to organize large-scale hunts that
required coordination of numerous men and mounts. A third level of mean-
ing is apparent in the paintings of what seems at first sight like unvarnished
butchery on the endwalls of the east aisle. Mention has been made already
of parallels to these scenes that can be found on late Roman consular dip-
tychs.[67] There they illustrate the honorand's openhandedness, especially in
the organization of circus games. The message conveyed at Quṣayr ʿAmra
is identical. The act of slaughtering animals *(jazr)* would immediately have
struck the Arab visitor as a manifestation of the generosity one expected of
princes. A late-seventh-century governor of al-Baṣra who, on taking up his
post, announced that he intended to be known as "The Slaughterer", was
making not a threat but a promise.[68] Whatever the hunting scenes seem to
lack in princely heroism, they make up for by underlining the patron's abil-
ity to reward his followers.

There is, finally, a fourth level of meaning to Quṣayr ʿAmra's hunting fres-
coes, which becomes apparent, though, only when we cease to consider them
in isolation, and recognize that they are juxtaposed with a variety of other
images. Apart from hunting, the other dominant theme that runs through
this extraordinary gallery is, unmistakably, the charm and beauty of women.

To the eye of many hunters in the ancient world, there would have seemed
to be a tension implicit here. "Every kind of animal was susceptible to his
power, although he could not wield it over women": Carlo Levi's observa-
tion about the aged grave-digger and wolf-tamer he befriended in a south-
ern Italian village[69] reflects—although in an unusually absolute form—a
widespread and ancient belief that, whenever in his life this becomes nec-
essary, a man must choose whether he wishes to deploy his most vital en-
ergies in subduing animals or women. So it was that when Gilgamesh and
the unnamed hunter resolved to tame the wild man Enkidu, who lived at
one with the animals and set them free from the hunter's traps, they sent
him the harlot Shamhat:

67. See also below, pp. 133–34.
68. Al-Madāʾinī in Ṭab. 2.717, with note ad loc. in the trans., 21.84; and cf. Ṭab.
3.30 (trans. 27.154, with n. 379) on Abū ʾl-ʿAbbās al-*Saffāḥ*, the first Abbasid caliph.
69. C. Levi, *Cristo si è fermato a Eboli* 60 (trans. Frenaye 71).

Shamhat unclutched her bosom, exposed her sex, and he took in her
 voluptuousness.
She was not restrained, but took his energy.
She spread out her robe and he lay upon her,
she performed for the primitive the task of womankind.
His lust groaned over her;
for six days and seven nights Enkidu stayed aroused,
and had intercourse with the harlot
until he was sated with her charms.
But when he turned his attention to his animals,
the gazelles saw Enkidu and darted off,
the wild animals distanced themselves from his body.[70]

To hunt is, then, to abstain from intercourse with women.[71] And since the
mere presence of the fair sex was a temptation, women came to be excluded
from participation. A virgin goddess might break the rule, especially if she
hunted alone, like Homer's "arrow-showering Artemis" striding "over lofty
Taygetus or Erymanthus, delighting in boars and swift-running hinds".[72] So
too might Amazons, or semimythical queens such as Semiramis, Dido, or
Zenobia, who as al-Zabbā' grew into a central figure in Arab storytelling and
generated numerous expressions that became Arabic proverbs.[73] But Procris,
who was possessed by sexual jealousy of Cephalus, and spied on him as he
hunted alone on Hymettus, died by her husband's own spear. These Greek
myths were part of Quṣayr 'Amra's wider cultural background. A late fifth-
century mosaic found in 1982–83 at Sarrīn near the Euphrates in northern
Syria alludes to the tragic love of the hunters Meleager and Atalanta and in-
cludes powerful images of both Artemis and Aphrodite.[74] And a sixth-cen-
tury mosaic uncovered in the same year, 1982, but this time at Mādabā, il-
lustrates the story of Phaedra, who longed to hunt alongside her chaste
beloved, and Hippolytus, who fell victim to Aphrodite's jealousy of his all-
exclusive devotion to the divine huntress.[75] Artemis and Aphrodite, the hunt
and the pleasures of heterosexual sex, are eternally juxtaposed as in Quṣayr
'Amra's paintings, but often at odds with each other too, even fatally.[76] An

70. *Epic of Gilgamesh* 1.170–80.
71. Cf. Serjeant, *South Arabian hunt* 82–83.
72. Homer, *Odyssea* 6.102–4.
73. Hishām b. al-Kalbī in Ṭab. 1.757–67 (trans. 4.139–48).
74. Balty, *Mosaïque de Sarrîn*; ead., *Mosaïques* 262; cf. Raeck, *Patron and pavements*; Brands, *Jahrbuch für Antike und Christentum* 45 (2002) 131–32.
75. Piccirillo 51, 66.
76. Cf. Aristophanes, *Lysistrata* 785–95 (on Melanion); and further references in Anderson, *Hunting* 90–91. By contrast, the hunt was, at least in ancient Greece,

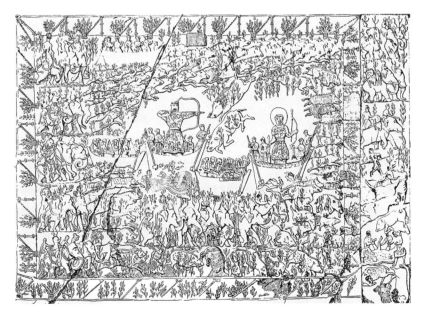

Figure 35. Ṭāq-i Bustān, large grotto: left-hand hunting scene (relief). E. Flandin and P. Coste, *Voyage en Perse* (Paris: G. Baudry et J. Baudry, 1851) pl. 10.

Arab woman who insisted on going hunting was well advised to dress as a man, and mind her behavior.[77]

To this taboo on women at the hunt, Irān and the wider East were recognized to be an exception—a laxity that Greeks pointed to, along with polygamy, incest, and exposure of the dead,[78] as proof that the Iranians were the polar opposite of their "civilized" values. "When he went out hunting, his concubines too went out with him", exclaims the fourth-century B.C. historian Heraclides of Cyme in his disapproving account of the Iranian monarch's luxurious lifestyle;[79] while the diplomat Megasthenes tells how the great Indian king Chandragupta ("Sandracottus": c. 324–300 B.C.) would indulge in "a sort of Bacchic hunt" surrounded by heavily armed women in chariots or mounted on horses and elephants. "Such things are quite alien to our cus-

a natural prelude to homosexual courtship, as we see in archaic vase paintings of lovers offering hares, in particular, to the beloved: Schnapp, *Le chasseur et la cité* 247–57, 325–32, 345–50 (vases), 454–56 (myth).

77. Ḥammād al-Rāwiya in Iṣf. 11.175–77 (trans. Weisweiler, *Arabesken der Liebe* 132–34).

78. Agathias, *Historiae* 2.23–24, 30.

79. Heraclides of Cyme, *Persica* fr. 1.

toms", observes the prim Greek.[80] Presumably it is again Chandragupta that the first-century A.D. Roman writer Quintus Curtius Rufus has in mind in his history of Alexander the Great, when he recounts the decadent habits of an Indian king who, "amid the prayers and songs of his concubines", enjoyed shooting at animals kept specially for that purpose in a game park.[81]

But even in this exotic East, the role of women in the hunt seems usually to have stopped well short of the kill. Assyrian royal hunting reliefs of the seventh century B.C. show women as spectators and musicians;[82] while on the two famous Sasanian hunting reliefs at Ṭāq-i Bustān commonly assigned to the reign of Khusraw II (590–628), and much more realistic in style than the rather symbolic hunting scenes common on Sasanian silverware, the King of Kings is attended by bevies of women who play the harp, clap, and perhaps sing as well (fig. 35).[83] A probably post-Sasanian silver plate shows a king feasting with his queen on the meat of wild boar killed during a day's hunting.[84]

Ṭāq-i Bustān lies just east of Kirmānshāh, a town in western Irān on the so-called High Road that led from Mesopotamia through the central Zagros Mountains to Khurāsān, the crucially important Central Asiatic frontier of Arab conquest.[85] It had been carved out of the mountainside rather more than a century before the most likely date for Quṣayr ʿAmra, and became familiar to the Umayyad armies as they passed this way, especially on account of its splendid sculpture of Khusraw's favorite horse Shabdīz, which the Arabs accounted one of the wonders of the world and whose name they applied to the whole site.[86] If we view the hall at Quṣayr ʿAmra, with its equally realistic hunting scenes and its many decorative women, as an artistic whole, it is hard to deny a general similarity of atmosphere—which will be further discussed in chapter 4—as well as obvious differences, such as the overwhelming prominence given to the hunter-monarch at Ṭāq-i

80. Megasthenes, *Indica* frs. 32 and 27b.
81. Quintus Curtius Rufus, *Historiae Alexandri Magni* 8.9.28.
82. Barnett, *North Palace* 37 and pl. VI, 39 and pl. XIV.
83. *Taq-i B.* 1 and *Splendeur des Sassanides* 85–86 (photographs); *Taq-i B.* 3. pl. XI (photogrammetric elevation of left-hand hunt); 4.83–95, 135–36, 192 (description). On the date see Herzfeld, *A.M.I.* 9 (1938); Mode, *Sogdien und die Herrscher der Welt* 64–70.
84. Ghirshman, *Artibus Asiae* 16 (1953) 63–66.
85. Note the letter of ʿUmar II quoted by Ṭab. 2.1366 (trans. 24.95).
86. Ibn Khurradādhbih, *Kitāb al-masālik* 19–26, describes the road and mentions (19) Shabdīz (as Shibdāz), and also the Dukkān (see below, pp. 216–17). See further Ibn al-Faqīh, *Kitāb al-buldān* 423–29 (trans. 259–62), and Yāq. 3.319–21, s.v. "Shibdāz". Ibn Khurradādhbih 162 underlines how much Ṭāq-i Bustān was admired. On Umayyad Syrians in Irān see Northedge, *ʿAmmān* 1.103.

Bustān. Quṣayr 'Amra's women are not excluded from the general vicinity of the hunt—it has even been suggested that some of the onlookers who watch on the west wall from the safety of their tent are female.[87] Nor is it easy for the modern viewer to know whether women may implicitly be present even where they are most visually absent. Besides alerting him to the patron's generosity, the scenes of solemn butchery on the endwalls of the east aisle will have put a late Umayyad observer in mind, once more, of that verse in "the most famous, the most admired and the most influential poem in the whole of Arabic literature",[88] where Imru' al-Qays has slaughtered his camel for the girls he has tormented,

> and the virgins went on tossing its hacked flesh about
> and the frilly fat like fringes of twisted silk.[89]

As recently as 731 a poet had claimed, while lamenting a general's neglect at the Battle of the Defile near Samarqand against the Turgesh Turks:

> You abandoned us like pieces of a slaughtered beast
> which the slaughterer *(al-jāzir)* divides for a round-breasted girl.[90]

Despite, then, the indisputable fact that women do not participate actively in its hunting scenes, Quṣayr 'Amra may nonetheless be said to suggest, by artful juxtaposition, the relaxed Iranian approach to the question of women at the hunt, rather than the absolute exclusion favored by other ancient peoples.

Not that Iranians were unaware of the danger when a woman took an active part in the hunt, especially if that woman enjoyed an erotic relationship with the male hunter. Hence the famous tale of Bahrām Gūr (the Sasanian emperor Bahrām V, 420–38) and the beautiful Greek slave girl and lyre player Āzāda.

According to the classic version of this tale in the *Shāhnāma* of the Iranian poet Firdawsī (c. 940–1020), Bahrām became so enamoured of Āzāda that he took her out hunting without his retinue. She rode behind him on his racing camel, and when they spotted two pairs of gazelles, the young man complacently asked her which she would prefer him to shoot. " 'My lion-hearted prince,' she mockingly replied, 'men of war do not go in chase of gazelles.' " Still, she bade him make the female of the first pair a buck, and the doe a male, and then with a single arrow pin the hind leg of one of the

87. Q.'A. 68 and 79 fig. 48.
88. Arberry, *Seven odes* 41.
89. Imru' al-Qays, *Mu'allaqa* 12 (trans. Arberry, *Seven odes* 61).
90. Ibn 'Irs al-'Abdī in Ṭab. 2.1557 (trans. Blankinship, *Jihād state* 159).

other pair to its ear—"'if you would like me to call you the most brilliant
[archer] in the world'". So Bahrām, eager to oblige, turned to the first pair
of gazelles, shot off the buck's horns, and lodged two more arrows in the
doe's head, so that it acquired horns. Then, pursuing the second couple, he
shot a pebble into the ear of one of them.

> The gazelle immediately scratched its ear. At that moment he fixed
> an arrow into his bow and with it pinned together the creature's head,
> ear and hind leg. Āzāda's heart burned with grief for the gazelle, and
> Bahrām said to her,
> "How is it, my pretty one, that you release such a stream of
> tears from your eyes?"
> "This is not a humane deed", she replied. "You are no man;
> you have the spirit of a demon."
> Putting out his hand, Bahrām dashed her from the saddle headlong
> to the ground and drove the camel over her, bespattering her head, her
> breast and her arms and the lyre with her blood. . . .
> The girl died beneath the camel's feet, and never again did he take
> a girl with him when hunting.[91]

In Sasanian times and long afterward, Iranian artists loved to depict
Bahrām hunting on camelback, while Āzāda perched behind him with her
lyre,[92] a single and distinctly invasive singing girl to contrast with the ranks
of harpists who laud the Ṭāq-i Bustān hunter from a respectful distance.
Clearly these artists were attracted more by the story's romantic beginning
than its tragic conclusion. Eventually, a version with a happy ending had to
be supplied.[93] But the tragic version, as told by Firdawsī, had long before
that taken root in the Arab tradition too.[94] Bahrām had after all been raised,
and taught in particular the art of hunting, at the court of the Lakhmid rulers
of al-Ḥīra,[95] while the prophet Muḥammad himself had been forced to com-
pete, at Makka, with storytellers such as al-Naḍr b. al-Ḥārith, who "had been
to al-Ḥīra and learnt there the tales of the kings of Persia, the tales of Rus-
tum and Isbandiyār".[96]

The popularity of this story is proof that it can be enjoyed and interpreted

91. Firdawsī, *Shāhnāma* 6.382–84 (Warner), pp. 299–300 (Levy, whose trans-
lation I use here).

92. See above, p. 96 n. 32.

93. As by the twelfth-century Iranian poet Niẓāmī, *Haft paykar* 25–26.

94. E.g., Ibn Qutayba, *'Uyūn al-akhbār* 1.273, and Ibn al-Faqīh, *Kitāb al-buldān*
521–23 (trans. 309–11); cf. Pantke, *Bahrām-Roman* 134 n. 4, 138–39; Fontana,
Bahrām Gūr 79–81, 103–20, and *Haft qalam* 15–27.

95. Ṭab. 1.855–57 (trans. 5.82–86).

96. Ibn Isḥāq, *Sīrat rasūl Allāh* 191, 235 (Wüstenfeld)/1.337, 395–96 (al-Saqqā)
(trans. Guillaume 136, 162–63); 256, p. 182 (Ḥamīdullāh).

in many different ways. Arguing from a variant reading in certain manu-
scripts that has Āzāda exclaim to Bahrām Gūr:

"You are Ahriman. Were it not so, how could you have shot thus?"

one scholar has even suggested that the prince was punishing her for break-
ing a Mithraic taboo on pronouncing the name of the Hostile Spirit.[97] But
less esoteric interpretations are more likely to explain why the story
achieved such a wide resonance. The eleventh-century Arabic writer al-
Thaʿālibī introduces it as a straightforward tale of greed: Bahrām Gūr de-
sired to enjoy all at once the pleasures of the chase, of music, of wine, and
of his lover's company.[98]

There is a structurally somewhat similar anecdote in the biography of the
Prophet by Ibn Isḥāq (c. 704–c. 767), an exact contemporary of Quṣayr ʿAmra.
Toward the end of his life, Muḥammad sent Khālid b. al-Walīd against Ukay-
dir, the Christian ruler of Dūmat al-Jandal, modern al-Jawf at the southern
end of the Wādī Sirḥān. When Khālid came within sight of Ukaydir's castle,

> it was a moonlit summer night and Ukaydir was on the roof terrace
> with his wife. The wild cows [oryx] had been scratching the palace gate
> with their horns all night. His wife asked him if he had ever seen any-
> thing like that, and he said, "No indeed". Then she said, "Who would
> allow this?" He responded, "No one". He then came down and called
> for his horse, which was saddled. A group of men from his family,
> among them his brother Ḥassān, took their hunting spears, mounted
> (their horses), and rode off. On their way they encountered the cavalry
> of the Messenger of God, and (Ukaydir) was seized and his brother
> Ḥassān was killed. Ḥassān was wearing a silk brocade gown woven
> with gold in the form of date palm leaves. Khālid stripped him of it
> and sent it to the Messenger of God before his arrival.[99]

Ibn Isḥāq goes on to recall how the Prophet had told Khālid in advance that
he would find Ukaydir hunting oryx—the animals were, in other words, in-
struments in a divine plan to bring over to Islam this strategically crucial
and powerfully fortified oasis and market on the highway from Inner Ara-
bia to Damascus. It takes little imagination to see the words of Ukaydir's
wife as part of the same scheme, another example of woman's fatal curios-
ity, and of her power—sometimes even despite herself—to tempt men into
behavior they know to be inappropriate.

97. Bivar, *Mélanges Gignoux* 32–33.
98. Al-Thaʿālibī, *Al-ghurar* 541.
99. Ibn Isḥāq, *Sīrat rasūl Allāh* 903 (Wüstenfeld)/4.180 (al-Saqqā), quoted
by Ṭab. 1.1702 (trans. 9.58–59 I. K. Poonawala). On Dūma cf. Shahîd, *B.A.SI.C.*
2(1).283–86.

A century or so later, and not far from the other end of the Wādī Sirḥān, Quṣayr ʿAmra's owner must have spent more than one such moonlit night relaxing with his women, both he and they gorgeously dressed, and absorbed in tales from olden times, stories of the Arabs but assuredly also of the heroes of Irān. On the walls of his hall, as in the painting of a hunting scene with musicians (one male and one female) from Qaṣr al-Ḥayr al-Gharbī, already mentioned more than once, women and scenes of the hunt were placed in suggestive, if apparently chaste, juxtaposition. If, beyond the inscrutable workings of God, any lesson was to be drawn from the stories of Bahrām Gūr and Ukaydir, an obvious one was that male appetites, which can hardly be suppressed, must at least be held in balance. Pleasures by nature irreconcilable must not be mixed. It is not women as such that are the problem, but men's tendency to be distracted by them, and led into excess. Probably, therefore, Āzāda's end would not have struck the Sasanian or Umayyad audience as especially regrettable, since it provided the necessary proof that the central male and princely figure had reasserted control of himself after a lapse of judgment, and known how to overcome the temptation to imbalance and excess that would otherwise have destroyed him and compromised the authority he symbolized. It was all very well, as a poetic conceit, to portray the pursuit of the beloved in terms derived from the hunting of animals. But to associate women with a real hunt, even in poetry, was to flirt with the virile man's age-old temptation to put together what ought to be kept apart, and to pose with Bahrām Gūr the self-satisfied question:

"What think you of the feat you've seen?"[100]

Better, with old-fashioned Xenophon, to think of the hunt as a school in which young men might learn to be "self-controlled, and just".[101]

In his "suspended ode" that has already been quoted, Imruʾ al-Qays too comes close to breaking the taboo—a game to which his extraordinary poem owes much of its hold over us. His *nasīb*, to use the critics' language, is full of deliberately provocative anticipations of *raḥīl*—both journey and hunt—as when, straight after the allusion to Dāra Juljul, he recalls

> . . . the day I entered the litter where ʿUnayza was
> and she cried, "Out on you! Will you make me walk on my feet?"
> She was saying, while the canopy swayed with the pair of us,
> "There now, you've hocked my camel, Imruʾ al-Qays. Down with
> you!"

100. Niẓāmī, *Haft paykar* 25.37.
101. Xenophon, *Cynegeticus* 12.7.

> But I said "Ride on, and slacken the beast's reins,
> and oh, don't drive me away from your refreshing fruit."[102]

Following this erotic journey comes the erotic hunt, as the poet pursues his "wild doe at Wajra" in the dunes—a legitimate thing for a hunter to do, only this particular wild doe is accomplice as well as quarry. After all this, it is hardly surprising to discover that the ode lacks a true *raḥīl* section.

Imruʾ al-Qays, as everyone knew, came to a terrible end, treacherously murdered in exile by his host, the emperor of Rome, apparently in the middle of the sixth century. It was not an inappropriate fate for one whose whole life had been marked—according to the traditional accounts—by an extraordinary impetuousness, notably in the self-destructive intemperance with which he pursued his duty to avenge the murder of his father, Ḥujr, the last king of the Kinda.[103] The ideal remained, perforce, a creative balance, and if a tension, then a pleasurable one, between not only sex and the hunt, but all the appetites that impel men to make pastimes out of necessities, and even to become criminals and outcasts. Such is the ideal of ordered pleasure that lies behind the paintings of Quṣayr ʿAmra, in implicit response to the example of disordered pleasure offered by Bahrām Gūr. So too the poet must show equal ability in the quite different subgenres of *nasīb* and *raḥīl*, conveying their differences but at the same time integrating them into a satisfying whole.[104] To attain this balance in one's life was the mark of the man who was wise as well as virile, and therefore deserving of what all sought most, the admiration and praise of their fellows. As for the poet, he could expect monetary reward as well. It is to the panegyric—the *madīḥ* in poetical terms, and the portrait of the prince in terms of Quṣayr ʿAmra's paintings—that we must now turn.

102. Imruʾ al-Qays, *Muʿallaqa* 13–15 (trans. Arberry, *Seven odes* 61–62).
103. Iṣf. 9.93–126.
104. On the emergence from the *qaṣīda* of whole separate genres of love, wine, and hunting poetry, precisely under the Umayyads, see J. Stetkevych, *Tradition and modernity*, and *Journal of Arabic literature* 30 (1999). Quṣayr ʿAmra's paneled decoration (see below, pp. 308–10) might, *à la rigueur*, be read as acknowledging at least some of these developments; but it seems more natural to treat the hall, at least, as a single albeit variegated composition, in the manner of the classic pre-Islamic ode. Another index of Quṣayr ʿAmra's conservatism may be its neglect of falconry, to which poets had already turned their attention by the middle Umayyad period: J. Stetkevych, *Journal of Arabic literature* 30 (1999) 121–23, and above, pp. 103 n. 60.

4 "O God, Bless the *Amīr*"

After the domesticity of Quṣayr ʿAmra's bathing scenes, and its studiously unheroic depictions of the hunt, the fresco of the prince enthroned in the alcove at the hall's focal point allows a glimpse of that courtly splendor in which the Umayyads cloaked themselves, when they desired to show forth the caliphate's full dignity. The sequence in which the paintings are discussed in the present book has so far been determined by a convenient ordering of the bath house functions (bathing, entertainment, hunting) to which they relate, and analogies drawn with the structure of the Arabic ode. But even within this externally imposed scheme of things, the prominence of entertainers, dancers, and musicians has already pointed unmistakably to a courtly milieu. If we now choose instead to follow the building's—and therefore the paintings'—own layout, then the portrait of the prince is among the first images the eye discerns as it accustoms itself to the hall's gentle light after the glare of the limestone desert outside. Despite the alcove's relatively poor lighting, neither the bathing nor the hunting scenes are allowed such immediate impact on the first-time visitor, as he is drawn in along the main north-south axis of the hall.

The impetuous, liminal, transgressive poet-prince Imruʾ al-Qays has seemed, at several points in the last two chapters, an appropriate source to invoke in order to throw light on the mentality of those who produced Quṣayr ʿAmra. But even our first glimpse of the enthroned prince reassures us that history has moved on: the Arabs are no longer the plaything of foreign powers, however great their emotional attachment may yet be to that pre-Islamic Arabian ethos so eloquently, powerfully expressed by "the wandering king" of Kinda. Where Imruʾ al-Qays died in a robe woven of gold

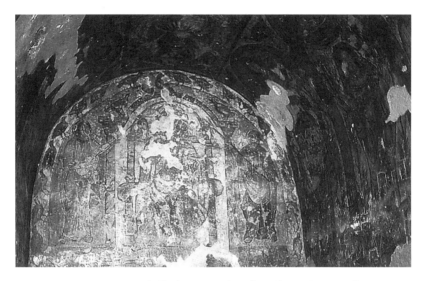

Figure 36. Quṣayr ʿAmra, hall, alcove, south wall: enthroned prince (fresco).
C. Vibert-Guigue.

and soaked in poison, a gift from the emperor of Rome, Quṣayr ʿAmra's prince
flaunts finery neither borrowed nor bestowed, but his by conqueror's right.

The prince and, we may assume, the bath house's owner, stares out at us
from a substantial throne with a high, rounded back, which in turn stands
under a round arch each of whose flattened extremities rests on a spiral-
fluted column (fig. 36, 37).[1] We are reminded of the similar architectural
frame in the fourth-century Madrid *missorium*'s depiction of the emperor
Theodosius I, and the seventh-century David Plates adorned with scenes
from the life of an Old Testament prince widely regarded as an exemplar of
Christian kingship.[2] Arches stood for royal authority, and Arab tradition
had that of Khusraw II's palace at Ctesiphon collapse just at the time of
Muḥammad's birth.[3]

Atop each column perches a sandgrouse *(qaṭā)*, a type of bird smaller
than a partridge, somewhat like a ptarmigan, which dwelt in large flocks in
the deserts of Arabia and is much alluded to in early Arabic poetry.[4] Avian

1. Cf. *Ḳ.ʿA.* 1.215 fig. 132 (and cf. 213), 2. pls. XV–XVI; *Q.ʿA.* 145 fig. 94 + *Q.ʿA.*[1]
pls. Xb–XI; *Is.A.A.* 44 pl. 50.
2. *A.S.* 74–76, 475–83.
3. Wahb b. Munabbih in *Ṭab.* 1.1010 (trans. 5.332).
4. Dozy, *Supplément* 2.386; *E.A.P.* 1.163–67, 178; Iṣf. 8.266–75. The third bird
that has been perching on top of the arch since the 1970s is an imaginative Spanish

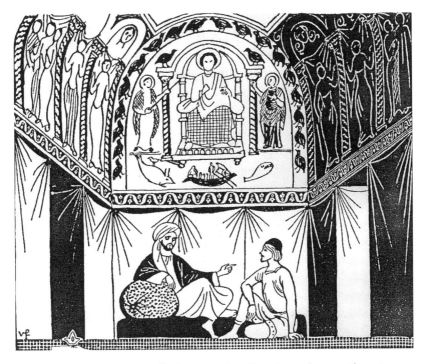

Figure 37. Quṣayr 'Amra, hall, alcove, south wall: enthroned prince (fresco). Drawing by V. Fiala, in Musil, *Pán Amry* 176.

"supporters"—to borrow a term from heraldry—were common in the art of the Roman East, though apparently not in Sasanian territory. Portraits of royal, holy, or otherwise distinguished personages, along with the canon ta-bles at the beginning of gospel books such as the sixth-century Rabbula Gospels from northern Mesopotamia, were quite often framed by an arch or some similar structure on which birds perched, usually two large ones *en face*.[5] At Quṣayr 'Amra, though, this honorific convention, with its intimation of

restoration of a black blotch according to Vibert-Guigue diss. 2.311. It is not shown in Mielich's facsimile, *Ḳ.'A.* 2. pl. XV.

5. Colledge, *Art of Palmyra* 49, 50 fig. 30 (rock carving dated A.D. 147 from near Palmyra); *A.S.* 31–32, 330–32 and pl. IX, 547, 618–19; Cecchelli, Furlani, and Salmi, *Evangeliarii syriaci ornamenta*; Farioli Campanati, *Felix Ravenna* 145–48 (1993–94) figs. 7, 9, 10, 11, 14; Richardson, *Isles of the north* 180–81 (marble inlay panel showing edicule containing cross, Hagia Sophia, Constantinople), and cf. 182, 183 fig. 11. The model was diffused as far as Ireland: see the portrait of Christ in the probably early ninth-century Book of Kells fol. 32v (Meehan, *Book of Kells* 56).

Paradise gardens[6] or of the celestial vault, has been vulgarized and is also used to adorn the hangers-on who crowd the prince's alcove,[7] or the various figures, some naked, some perhaps amorously involved with each other, who inhabit the thirty-two panels into which the central vault is divided.[8]

More sandgrouse, twenty of them all together, can be seen processing along a painted frieze that follows the curve of the alcove vault—to be precise, two processions encounter each other at the midpoint of the curve. Double avian processions of this sort were occasionally employed as a framing device in Syriac art, as, for example, in the Rabbula Gospels.[9] Single rows of birds occur commonly enough in Sasanian art,[10] while similar sandgrouse processions—this time in painted stucco—wended their way round various parts of the Umayyad palace at Khirbat al-Mafjar. It has recently been proposed that their symbolism is erotic.[11] But perhaps the nearest parallel—in conception if not execution—is the so-called Qazwīn silver plate in Teheran, thought to have been made during the century and a half following the fall of the Sasanian dynasty (fig. 38). Here the monarch is shown standing in front of his throne under a substantial arched structure, the facade of which is decorated with birds in roundels, seven on each side.[12]

At least, then, as regards these peripheral elements of the composition, the portrait of the prince seems to be of eclectic inspiration, combining a distinctly Roman-style architectural frame with avian supporters from the Roman East and an avian procession that is more Sasanian in manner. As for the pair of richly appareled servants who stand flanking the prince, they are a standard framing element in East Roman depictions of eminent personages (fig. 42) and are not unknown in Sasanian art either (fig. 16a, 38). As the ninth-century writer al-Jāḥiẓ explains,

6. Nordenfalk, *Studies* 31.
7. Grabar, *A.O.* 23 (1993) 104 figs. 5–6.
8. See above, p. 77.
9. Cecchelli, Furlani, and Salmi, *Evangeliarii syriaci ornamenta* fols. 10b, 11a.
10. Kröger 177–78; and cf. Esin, *Kunst des Orients* 9 (1973–74) 82 figs. 29–30, 83–84 (Varakhsha near Bukhārā, and Sāmarrāʾ).
11. K. Brisch, *K.Is.* 181–82 (pl. XV); Baer, *I.E.J.* 24 (1974); Behrens-Abouseif, *Muqarnas* 14 (1997) 16; cf. Jahhur, *Redouins* 124–25.
12. Cf. von Gall, *A.M.I.* 4 (1971) 225; Harper, *Silver vessels* 115–17 and pl. 34. Birds in roundels also inhabit the frame of a painting of Melchisedek (?) enthroned, from the apse of the church of the priest Wāʾil at Umm al-Raṣāṣ (mosaics dated 586; building still in use under Umayyads): Acconci, *Bisanzio e l'Occidente*. According to Wahb b. Munabbih (654–728/32), *Kitāb al-tījān* 162–63, when Solomon desired to visit Queen Bilqīs he sat on his throne and commanded the wind to carry him and the birds to shade him.

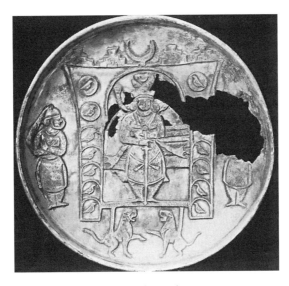

Figure 38. The Qazwīn plate (silver, post-Sasanian).
Irān Bāstān Museum, Teheran, inv. no. 904.

A caliph, or someone else in a comparable position of power and
influence, used never to be without a slave girl standing behind him
to wave fly whisk and fan, and another to hand him things, in a public
audience in the presence of other men.[13]

At Quṣayr ʿAmra, these particular servants seem to be male—but there are
plenty of women close at hand on the alcove's sidewalls. Dressed alike, in a
long tunic or shirt *(qamīṣ)* with a high neckline either beaded or embroi-
dered, a long, loose mantle or wrap *(ridāʾ)* covering it, elaborately patterned,
and slippers, the two attendants look quite like the musicians in the hunt-
ing fresco at Qaṣr al-Ḥayr al-Gharbī, which breathes a distinctly Iranian at-
mosphere (fig. 31).[14] On the other hand, male costume in the late Sasanian
Ṭāq-i Bustān hunting reliefs, whether the king's or his servants', is differ-
ent, involving heavy, stiff, tight-fitting and embroidered caftans with belts,
and the traditional Iranian leggings (fig. 35).[15] As for the long fans wielded

13. Al-Jāḥiẓ, *Risālat al-qiyān* 20 (trans. Beeston).
14. See above, p. 96 n. 29.
15. Cf. *Ṭaq-i B.* 4.96–111; Peck, *E.Ir.* 5.749–51; Goldman, *Iranica antiqua* 28
(1993), esp. 222–29.

with both hands, they are a rarity in courtly iconography—usually we find fly whisks held in one hand only.[16]

The prince himself appears to be attired little differently from his attendants. His long tunic or shirt, and his mantle, must correspond to the *izār* and *ridāʾ*, both of deep saffron, that the caliph al-Walīd II wore when seated on his throne.[17] It is rather by posture and gesture that the prince is marked out. He is seated on a voluminous cushion placed upon his throne. Together with the arch immediately above it, and the semicircle of the vault, the throne's rounded headpiece provides a triple frame for the prince's head, which was set against a halo too. Much of this central part of the fresco is badly damaged. We cannot discern any longer the prince's face, and though we see that his right forearm is positioned in front of his chest, it is not clear whether he is holding a cup, as kings often do on Sasanian and post-Sasanian silverware,[18] or raising his hand in the royal gesture of triumph and benediction that was customary in both Rome and the pre-Sasanian East.[19] Overall, what this panel most recalls is the frontal portrait of the Roman emperor that became current from the late third century onward and was particularly popular in the mid-eighth century,

16. Loberdou-Tsigarida, Ὀστέινα πλακίδια 253 nos. 26–27 (Coptic bone plaques); Ghirshman, *Artibus Asiae* 16 (1953) 52 and figs. 1–2 (frontispiece) (post-Sasanian silver); *K.Is.* pl. 106 (ivory casket from Córdoba, dated 1004); cf. Mas. 622 (1.292 Dāghir) (portrait of Khusraw I); Ṭab. 3.306 (trans. 28.278) (al-Manṣūr the Abbasid).

17. Ḥammād al-Rāwiya in Iṣf. 2.203, and al-Aṣmaʿī in Iṣf. 6.88; cf. Dozy, *Noms des vêtements* 24–25 (on the wide meaning of *izār* in early Islam), and Ahsan, *Social life* 34–39 (also on the *qamīṣ*, perhaps a more accurate term for the tunic illustrated at Quṣayr ʿAmra). Al-Walīd is also mentioned as wearing, on different occasions, a saffron shirt (Ḥammād al-Rāwiya in Iṣf. 7.56) or a brocaded gown gleaming with gold (Iṣf. 3.305) or else (the singer Ḥakam al-Wādī in Iṣf. 6.295, 13.305) a gown, mantle, and boots, all of brocade or patterned fabric (*washī*—which might be woven with gold thread: Ahsan, *Social life* 52–55). See also al-Haytham b. ʿAdī in Bal. 2. fol. 167a = p. 333 (59 Derenk); al-Madāʾinī in Ṭab. 2.1802, 1806 (trans. 26.156, 160). The statue of a caliph, probably al-Walīd, found at Khirbat al-Mafjar shows him wearing a long Sasanian-style belted coat and trousers, both of red: fig. 46; *K.M.* 229. On Hishām's dressing in red silk gown and turban see Khālid b. Ṣafwān b. al-Ahtam in Iṣf. 2.129; Ḥammād al-Rāwiya in Iṣf. 6.85 (trans. Hamilton 76); Ibn Khallikān, *Wafayāt al-aʿyān* 2.208 (trans. 1.471).

18. Ghirshman, *Artibus Asiae* 16 (1953). Certain Umayyad caliphs were in the habit of drinking even while seated on their throne during a formal audience: Grabar, *Studies in memory of Gaston Wiet* 58; and see also above, pp. 81–83, on the Umayyads' adoption of the Iranian *bazm*.

19. Rome: Brilliant, *Gesture and rank*, esp. 204–11; also Piccirillo 96, 98, a mosaic from Mādabā, dated 578, showing the Sea personified, and surrounded by fishes and marine monsters. Pre-Sasanian East: Ghirshman, *Iran* 27 pl. 36, 55 pl. 68, 94–95 pls. 105–6, etc. In Sasanian art, this gesture was used only as a sign of reverence to deities: Choksy, *Iranica varia*.

Figure 39. Qaṣr al-Ḥayr al-Gharbī:
enthroned prince, Sasanian-style
(stucco). National Museum, Damascus.

and the closely related iconography of the enthroned Christ.[20] This debt
to the Roman tradition is further underlined if we compare the Quṣayr
ʿAmra prince with the two late Umayyad princely images in stucco that
were recovered from the excavation of Qaṣr al-Ḥayr al-Gharbī. One, from
the gatehouse's outer arcade, is Sasanian especially in his posture (knees
apart, heels together); his dress and earrings also contribute to the orien-
tal style he exudes (fig. 39). The other, from the gatehouse's courtyard fa-

20. Emperor: Brilliant, *Gesture and rank* 204–8; A. Grabar, *Empereur* 24–25,
196–200; *A.S.* 31, for an early-sixth-century ivory diptych leaf, probably showing
the empress Ariadne. Christ: A. Grabar, *Empereur* 196–200; Volbach, *Elfenbeinar-
beiten* 104 no. 161 and pl. 82; Cecchelli, Furlani, and Salmi, *Evangeliarii syriaci or-
namenta* fol. 4b; Sörries, *Studien.*

Figure 40. Qaṣr al-Ḥayr al-Gharbī: enthroned
prince, Roman-style (stucco). National Museum,
Damascus.

cade, is Roman (fig. 40).[21] The idea of depicting a prince—presumably the
same prince—in more than one guise of quite different cultural resonance

21. Cf. Strika, *A.I.O.N.* 14 (1964) 730–43; R. Hillenbrand, *K.Is.* 163–64 (pl. 38);
K. Brisch, *K.Is.* 182–83 (pl. 59); *Q.H.G.* 14–15, 22; E. H. Peck, *E.Ir.* 5.763a. The Sasa-
nian prince is identifiable as such chiefly by his posture: Harper, *Iran* 17 (1979)
50. On the oriental male's taste for earrings see *Taq-i B.* 4.61–62; Abkaʿi-Khavari,
Das Bild des Königs 63, 64–65; Tyler-Smith, *Numismatic chronicle* 160 (2000)
155–56; Nicephorus of Constantinople, *Breviarium* 12; al-Aswad b. Yaʿfur al-
Nahshalī, *Qaṣīda dālīya* 23; Ṭab. 1.2642, 2880–81 (trans. 14.11, 15.86–87). Jus-
tinian wears them in the mosaic at San Vitale, Ravenna. Martinelli, *San Vitale (At-
lante)* 220–21, 224–25. The Sasanian prince's loosely fitting garb, though plainly
oriental, differs from the stiffer costume shown in two seventh-century monu-
ments from the Iranian cultural zone that are plausibly supposed to depict late
Sasanian monarchs, namely Ṭāq-i Bustān and Afrāsiyāb (above, p. 119; below, pp. 220–
21). This presumably authentic style is echoed by the statue of the late Umayyad
patron at Khirbat al-Mafjar (below, p. 163), but ignored in the six kings panel at
Quṣayr ʿAmra, where Kisrā is attired in the manner of Constantinople (below, pp.
200–201). Evidently the Umayyads were uninterested in fashion history (cf. their

within a single artistic scheme is striking, and there may, as we shall see in chapter 6, be a partial parallel to this at Quṣayr ʿAmra. But the prince in his alcove is, first and foremost, a reflection of the late Roman iconography of *imperium*.

The prince's feet rest on a footstool; and below that, in an area of painting hard to decipher since Musil and Mielich removed part of it, was depicted among other themes an aquatic scene (now in Berlin) including birds, fishes, and four or five fishermen in a boat that also contained amphoras.[22] One is reminded of the Nilotic scenes that became especially popular in the art of Palestine and Syria during the fifth and sixth centuries.[23] But this painting is more than just standard bath house decor;[24] and anyway it is not freestanding, but part of a larger composition. It may, then, represent the mighty rivers—Tigris, Euphrates, and Nile—that watered the caliphate's richest regions,[25] or else the Ocean that embraces the Earth, underneath Heaven's vault symbolized by the arc of birds that touches the aquatic scene at its left and right extremities. This was appropriate imagery with which to frame a world ruler,[26] as had long been recognized in the Roman Empire.[27] Indeed the poet al-Farazdaq, in encomiastic mode, not only envisaged al-Walīd II seated under a dome that represented the heavens (as does that of Quṣayr ʿAmra's caldarium), but also emitted the conceit that al-Walīd was himself "the sky of God".[28] By another poet, the same Ṭurayḥ al-Thaqafī

unreliable depictions of Sasanian crowns: below, pp. 202–3), except as a source for sartorial eclecticism.

22. Museum für Islamische Kunst, Berlin, inv. no. I.1266; *Ḳ.ʿA.* 2. pl. XVI.

23. Balty, *Mosaïques* 245–54; also Piccirillo 160–61 pl. 209, and "Mosaici", in *Umm al-Rasas* 1.142–43, with Baumann, *Spätantike Stifter* 152–55, for similar compositions from Mount Nebo (A.D. 557) and Umm al-Raṣāṣ (borders of nave mosaic, church of S. Stephen).

24. Dunbabin, *Papers of The British School at Rome* 57 (1989) 25–29.

25. Al-Aḥwas (d. 728/29) in Bal. 1. fol. 381a = p. 761 (158, §442 ʿAbbās) (trans. Nadler, *Umayyadenkalifen* 123).

26. *Letter of Tansar* p. 29; Ettinghausen, *Arabische Malerei* 32.

27. Corippus, *In laudem Iustini Augusti* 3.194–200 (the canopy over Justin II's throne compared to the heavenly vault); Maguire, *Earth and ocean* 73–80; and Williams, *Numismatic chronicle* 159 (1999) 310–13 (note especially the positioning of personifications of Earth or Ocean under the ruler's feet)—though for a rabbinic doubt, whether the Roman emperor may be said to rule, as does God, over sea as well as land, see Urbach, *Sages* 80–81. See also below, pp. 129–30, on the al-Mundhir building at al-Ruṣāfa; and, on the Iranian sphere, Marshak, *Arts asiatiques* 49 (1994) 18.

28. Al-Farazdaq, *Dīwān* 1.12 (extract trans. Jamil, *Bayt al-Maqdis* 41). Van Reeth, *Le ciel*, supposes the Quṣayr ʿAmra zodiac was a setting for al-Walīd II's "apotheosis". Note the tradition according to which the caliph Sulaymān (715–17) had, on

already encountered in chapter 2, al-Walīd was said to be able to command the waves to do whatever he liked—an original notion even in the uberous world of Umayyad panegyric.[29] And if the caliph's power was supposed to be cosmic, it was also expected that his generosity would prove to be Oceanic, or at least Nilotic.[30]

In the Umayyad milieu, it was the Euphrates that provided the more usual simile for that princely openhandedness of which poets dreamed, and with which so many of the *Kitāb al-aghānī*'s anecdotes culminate.[31] Here, for example, is how the Christian poet al-Akhṭal addressed himself to the caliph ʿAbd al-Malik—an illustration at once of the Euphrates simile, and more generally of the panegyrical *madīḥ* section of the classical Arabic ode, to which Quṣayr ʿAmra's princely portrait corresponds:

> To a man whose gifts do not elude us, whom God has made victorious,
> so let him in his victory long delight!
> He who wades into the deep of battle, auspicious his augury,
> the caliph of God through whom men pray for rain.[32]
> When his soul whispers its intention to him it sends him resolutely forth,
> His courage and his caution like two keen blades.
> In him the common weal resides, and after his assurance
> no peril can seduce him from his pledge.
> Not even the Euphrates when its tributaries pour seething into it

his accession, received his subjects under one of the domes in the Ḥaram al-Sharīf in Jerusalem: Mujīr al-Dīn, *Al-uns al-jalīl* 249 (trans. Sauvaire 57–58); and cf. Ibn ʿAsākir, *Taʾrīkh madīnat Dimashq* (selection ed. al-Munajjid, *Muʿjam Banī Umayya*) 67; Gil, *Palestine* 104. Was this the Dome of the Chain, whose function has yet to be explained, and which probably dates from the reign of ʿAbd al-Malik (Rosen-Ayalon, *Art et archéologie* 36–38; Busse, *Z.D.P.V.* 107 [1991] [1992] 148; Bieberstein and Bloedhorn, *Jerusalem* 3.154–56)? In which case the axiality implied by a throne under a dome was underlined by two considerations: (1) that Jerusalem was considered to be the earth's center (Nau, *Journal asiatique* 5 (1915) 256, 267, again with reference to Sulaymān); (2) that the Dome of the Chain marks the geometrical center of the Ḥaram al-Sharīf. Note also the recent suggestion that the Dome of the Rock was designed for the throne of God in the Last Days: Elad, *Bayt al-Maqdis* 51–52, and *Medieval Jerusalem* 162–63, Flood, *Great Mosque* 09–90, 243 n. 12. The possibility clearly exists that the Dome of the Chain was designed to shelter the caliph's throne on state occasions—and at the Last Judgment?

29. Al-Madāʾinī in Iṣf. 4.310 (trans. Nadler, *Umayyadenkalifen* 265).

30. Cf. Al. Cameron, *Zeitschrift für Papyrologie und Epigraphik* 139 (2002) 289; Thābit b. Qays b. al-Shammās in Ṭab. 1.1496 (trans. 8.38), on Muḥammad.

31. On the frequency of this theme: Nadler, *Umayyadenkalifen* 22–26.

32. A topos in this genre: cf. ʿImrān b. ʿIṣām in Ṭab. 2.1166 (trans. 23.110); al-Farazdaq in Ṭab. 2.1339 (trans. 24.64); Iṣf. 22.24.

and sweep the giant swallow-wort from its two banks into the middle
of its rushing stream,
and the summer winds churn it until its waves
form agitated puddles on the prows of ships,
racing in a vast and mighty torrent from the mountains of the Greeks,
whose foothills shield them from it and divert its course,
is ever more generous than he is to the supplicant
or more dazzling to the beholder's eye.[33]

We may recall too the story that fascinated endless generations of Arabs, about how al-Nuʿmān b. Imruʾ al-Qays, king of al-Ḥīra, had one day looked down from his famous palace of al-Khawarnaq across his prosperous possessions to the Euphrates with its "mariners, pearl divers and fishermen" and then that very night abandoned all this earthly glory for the life of a mendicant.[34]

Earthly omnipotence and generosity may not, though, have been the only ideas our image evoked. Later in the present chapter, parallels will be adduced from the Christian iconography of Adam and of Christ himself, which imply a religious resonance in the fresco before our eyes. Something similar is hinted at, from a remoter distance, by a probably fourth- or early fifth-century painting recently discovered in an Afghan cave, apparently showing the Avestan god Tištrya enthroned, with his feet resting on an ornamental footstool, under which fish swim in a lake or sea.[35] As for any Muslim who entered the hall at Quṣayr ʿAmra, he would likewise have sensed an allusion to sacred tradition in the fresco before his eyes. He would have remembered the Quranic verse, "His throne encompasses the heavens and the earth, and their preservation is no burden to Him."[36] That same divine throne was conceived of as having stood, ever since the very beginning of creation, amidst the waters.[37] And because the aquatic scene is positioned

33. Text and translation (slightly adapted) in S. P. Stetkevych, *Journal of Arabic literature* 28 (1997). On the Euphrates simile see Montgomery, *Vagaries of the qaṣīdah* 191–94, and cf. 161 n. 220. Kaʿb b. Maʿdān al-Ashqarī in Ṭab. 2.1130 (trans. 23.75) evokes Euphrates and Nile together, under ʿAbd al-Malik. On water symbolism more generally in Umayyad panegyric, see Jamil, *Bayt al-Maqdis* 32–37, esp. n. 110.

34. ʿAdī b. Zayd in Ṭab. 1.853–54 (trans. 5.81); Ḥamza al-Iṣfahānī, *Taʾrīkh* 79–80.

35. Lee and Grenet, *South Asian studies* 14 (1998).

36. Qurʾān 2.255.

37. Wahb b. Munabbih (see below), *Kitāb al-tījān* 10; various sources in Ṭab. 1.34–37 (trans. 1.203–7); Mas. 34, 36 (1.38, 39 Dāghir); cf. *Daniel* 3.55. This is presumably not what inspired ʿAbd al-Malik's brother and governor of Egypt, ʿAbd al-ʿAzīz b. Marwān, to build a glass throne (ʿarsh) over an artificial pool (birka) at Ḥulwān in Egypt. Apparently he was pursuing a cure for leprosy. See Saʿīd b. al-Biṭrīq, *Kitāb al-taʾrīkh* (Eutychius of Alexandria, *Annales*) 2.40 (trans. Pirone 362).

immediately below and to each side of the prince's footstool, we should in addition bear in mind Wahb b. Munabbih's assertion:

> "The heavens and the earth and the oceans are in the *haykal,* and the *haykal* is in the footstool. God's feet are upon the footstool. He carries the footstool. It became like a sandal on His feet." When Wahb was asked: "What is the *haykal?*", he replied: "Something on the heavens' extremities that surrounds the earth and the oceans like the ropes that are used to fasten a tent."[38]

Wahb (654–728/32) was a polymath and one of the principal channels through which Jewish and Christian materials entered the Muslim literary tradition. He was appointed chief judge of Ṣanʿāʾ c. 717 and, whether or not he ever visited Damascus, was well known there for his erudition.[39]

The close relationship between the prince and God—in other words, God's protection of the prince—is also impressed on us by the Arabic text, white Kufic letters carefully and elegantly painted on a blue ground, that runs along the face of the arch above his head. The French epigrapher Frédéric Imbert has recently offered, with all due caution, a fuller version of this text than was previously available. He reads:

> O God, forgive the heir apparent (?) of the Muslim men and women . . . well-being from God and mercy![40]

With this prayer, which happens to contain one of the earliest epigraphical occurrences of the name "Muslim",[41] our investigation of the bath house frescoes moves for the first time into the realm of historical specificity—or at least the hope of it. It was his highly imaginative detection of the patron's name amidst these few words that misled Karabacek into dating Quṣayr ʿAmra in the mid-ninth century. In fact, little can be deduced, except that the patron may have been an heir apparent rather than a ruling caliph. But this is potentially an important piece of information; and fortunately it is

38. Wahb b. Munabbih in Ṭab. 1.38 (trans. 1.208 F. Rosenthal).
39. R. G. Khoury, *Wahb b. Munabbih* 189–98.
40. *Allāhu[mma] i[ghfir] ?li-walī [ʿa]hd? al-muslimīn wa-ʾl-[mus]lima* (sic) . . . *ʿāfiya min allāh wa-ra[ḥ]ma:* Imbert, *Inscriptions arabes.* Musil's and Mielich's copies of the text are reproduced by von Karabacek, *K.M.* 1.214–15, figs. 131–33. See also Jaussen and Savignac 3.96–97 and pls. LV.1–2, LVI. If Imbert's reading is correct, this is the earliest known epigraphical attestation of the title *walī al-ʿahd:* cf. A. Ayalon, *E.Is.* 11.125–26. The expression *al-muslimīn wa-ʾl-muslimāt* occurs once in the Qurʾān, 33.35, along with the commoner *al-muʾminīn wa-ʾl-muʾmināt.* The latter is attested in an Umayyad inscription from Sinai (Sharon, *I.E.J.* 43 [1993] 55–56), which displays the same omission, normal in this early period, of the long *alif.*
41. Cf. Hoyland, *J.S.A.I.* 21 (1997) 87.

confirmed by a three-line Arabic acclamation in Kufic letters similar to those
used in the prince's portrait, positioned high up above the south window in
the east aisle:

> O God *(Allāhumma)*, bless the *amīr* as you blessed David and Abraham
> and the people of his [i.e., Abraham's] community [i.e., the Muslims] . . .
> gift . . . [42]

The title *amīr* was commonly employed to designate the heir apparent.[43] It
was also used of provincial governors. We can be sure, in other words, that
Quṣayr ʿAmra's patron did not, at the time this text was executed, hold the
office of *amīr al-muʾminīn*, that is, Commander of the Faithful or caliph[44]—
though he probably looked forward to assuming it in the not-too-remote
future.

. . . IN THE IMAGE OF ADAM

These texts, and the portrait of the prince as world ruler, positioned at the
hall's focal point, impart a note of tremendous solemnity to the scene.
Alphons Mielich expressed particular admiration for the disposition and ex-
ecution of the paintings throughout the whole alcove.[45] And although por-

42. *Allāhumma bārik ʿalā al-amīr kamā bārak[ta ʿalā] d[ā]wū[d wa-]ibrāhīm* (sic) *wa-āl millatihi . . . ʿaṭīya . . . al-* . . . : Imbert, *Inscriptions arabes*. See also Jaussen and Savignac 3.98 and pl. LV.3; Sauvaget, *Journal asiatique* 231 (1939) 14; Vibert-Guigue diss. 3. pl. 165. On the meaning of *milla* here see F. Buhl [-C. E. Bosworth], *E.Is.* 7.61. I am obliged to Frédéric Imbert for communicating his readings of these two inscriptions, and Irfan Shahîd for discussing them with me.

43. Gaube, *A.D.A.J.* 19 (1974) 97 and pl. XXXI.1 (Qaṣr Burquʿ inscription, dated 700; al-Walīd b. ʿAbd al-Malik); Bashshār b. Burd 15–16 (Arabic), 63–64 (transla-tion) in Beeston's selection (Sulaymān b. Hishām); Ṭab. 2. 1890–91 (trans. 27.2) (Marwān II). Only in unambiguous contexts might one call the caliph *amīr*, as in a letter in which one had already used the fuller title: Baramki, *Q.D.A.P.* 8 (1939) 53. Otherwise, it was a sign of nonrecognition: al-Madāʾinī in Ṭab. 2.1875 (trans. 26.247). On calling the *amīr* caliph, see below, pp. 150–51.

44. That the prince apparently wears no diadem proves nothing, since Umayyad use of the *tāj* is rarely attested: see iconographic evidence in fig. 39 (Qaṣr al-Ḥayr al-Gharbī; also *Q.H.G.* 15, 22), and *K.Is.* pl. 72e (coin from Tlemcen, c. 700); and for ref-erences in Umayyad poetry, Nadler, *Umayyadenkalifen* 60–61, to which add Thābit Quṭna in Iṣf. 14.268 line 11 (cf. van Ess, *Theologie und Gesellschaft* 1.167). According to the *Chronicon Maroniticum* 71, "Muʿāwiya did not wear a crown like other kings in the world" (trans. Palmer, *Seventh century* 32). Al-Walīd b. Yazīd no. 68/123 (Ṭab. 2.1782, trans. 26.133 C. Hillenbrand) boasts of wearing a *tāj* "which will not be re-moved"; but this poem may be a defamatory invention, as Ṭab. points out.

45. Mielich, *Ḳ.ʿA.* 1.195b, 196b.

traits of princes—plaster statues rather than paintings—have been found in other Umayyad structures, at Khirbat al-Mafjar (fig. 45) as well as Qaṣr al-Ḥayr al-Gharbī (fig. 39, 40), they seem to have been positioned high up in niches, as a type of architectural decoration without ceremonial function.[46] At Quṣayr ʿAmra, by contrast, the portrait of the prince marks the exact spot where he would have sat to receive his petitioners, as described in the story about Ṭurayḥ al-Thaqafī quoted in chapter 2. On such occasions the alcove may initially have been closed off with a curtain of the sort often mentioned in the *Kitāb al-aghānī*, and depicted in Quṣayr ʿAmra's own paintings. This would have been drawn back, by slave girls or other servants, when the moment came for the prince to show himself.[47] The same moment of drama is still achieved today in the liturgies of the Eastern Orthodox Churches, which also culminate in the manifestation of a king to his people, with the help of a curtain hung from the chancel arch or the central door of the icon screen in front of the altar, the throne of Christ.[48]

This manner of presenting the prince as if he were a sacred object reflects absolutist and indeed theocratic conceptions that were given memorable expression in the letter by which al-Walīd II bestowed rights of succession on two of his sons—an episode of which more will be said in chapter 6:

> God appointed His caliphs to follow in the path of Muḥammad's prophetic ministry. . . . The caliphs of God succeeded each other as sovereigns over that which God had made them inherit from His prophets and that which he had entrusted to them. No one contests the right of the caliphs without God striking him down. . . . No one treats their authority lightly and challenges the decree of God vested in them without God granting them mastery and power over such a person and making an example of him and a warning to others. . . . It is in showing obedience to those whom God has appointed to rule on earth that there lies happiness for those whom God inspires thereto.[49]

46. *K.M.* 98–103, 228–32, pl. LV.1, 5; *Q.H.G.* 15 and nn. 120, 123.

47. Al-Jāḥiẓ (attributed), *Kitāb al-tāj* 31–33; Iṣf. 1.61–62, 3.306, 7.54 (trans. Hamilton 45–46, 37, 110, respectively), 7.79 (quoted above, p. 72; the latter two passages are from Ḥammād al-Rāwiya); *Ḳ.Ā.* 2. pls. XVII–XVIII; Vibert-Guigue, *S.H.A.J.* 5,109 fig. 7; Hillenbrand, *Art history* 5 (1982) 9–10. Compare the Sasanian monarch's curtain (al-Jāḥiẓ [attributed], *Kitāb al-tāj* 28–29), the *velum* of the Roman emperor or empress (Eberlein, *Apparitio regis* 13–48), and the *ḥujub* in front of God's throne (*Ḥadīth Dāwūd* 19.22–25).

48. Trempelas, Τρεῖς λειτουργίαι 71 n. 19.

49. Ṭab. 2.1756–64, esp. 1758–59 (trans. 26.106–15, esp. 108–9 C. Hillenbrand). Cf. also al-Walīd's letter to Hishām, in Bal. 2. fol. 157a = p. 313 (13–14 Derenk); Ṭab. 2.1746 (trans. 26.95); and an earlier expression of similar ideas in Ṭab. 2. 1231 (trans.

The future Marwān II (744–50) had recently expressed himself in similar terms, when as governor of Armenia he had written to congratulate al-Walīd on his accession:

> The Commander of the Faithful . . . has assumed responsibility for matters which God has judged him competent to decide, and he stands confirmed in absolute control of the charge which has been laid upon him . . . God has singled him out from His creatures to rule, for He sees their circumstances. God has invested him with the caliphal ornament hanging round his neck and has bestowed on him the reins of the caliphate and the torque of authority. Praise be to God Who has chosen the Commander of the Faithful for His caliphate and to maintain the firm foundations of His religion! He has preserved him from the evil designs of the wicked; and He has elevated him and has brought them low. Anyone who persists in such base actions destroys his soul and angers his Lord, but anyone whom repentance directs to the true course, abstaining from what is wrong and turning to what is right, will find God ever disposed to forgive and be merciful.[50]

Just a few years after this, Marwān had his chief secretary 'Abd al-Ḥamīd b. Yaḥyā address a letter of exhortation to princely virtue to his son and heir. The letter's emphasis is, naturally enough, more on the prince's duty than his subjects' obedience; but still that duty is performed in response to a choice made by God, not the people.[51] The dissemination of such ideas was, in the Arab world, very much a product of the new, Islamic revelation, or rather of the political dispensation to which it had given rise. Through a vivid anecdote, al-Ṭabarī suggests that the first caliph to insist on explicit recognition of them had been the proud and tyrannical al-Walīd I.[52]

Pre-Islamic kings had, it is true, worn modest diadems.[53] The Ghassanid al-Mundhir (570–c. 581) had even held audience seated in a custom-built structure at al-Ruṣāfa (Sergioupolis) near the Euphrates. The building still

23.178). For this religious understanding of the caliphate see Tyan, *Institutions* 1.439–73; Crone and Hinds, *God's caliph* 24–42; van Ess, *Theologie und Gesellschaft* 1.24–25, 74, and 4.425 n. 1; al-Azmeh, *Muslim kingship* 62–79; Donner, *Narratives* 40–43; Jamil, *Bayt al-Maqdis* 30–45; U. Rubin, *Method and theory*; also below, pp. 138–41.

50. Ṭab. 2. 1752–53 (trans. 26.102 C. Hillenbrand).

51. 'Abd al-Ḥamīd al-Kātib, letter 21 (trans. Schönig, *Sendschreiben* 17–73; summarized by Latham, *A.L.U.P.* 167–72). On 'Abd al-Ḥamīd generally, as a spokesman for the late Umayyads' sacral idea of kingship, see al-Qāḍī, *Saber religioso*. Cf. additionally al-Madāʾinī in Bal. 2. fol. 728a (82–83, §158 'Athāmina) (on Hishām); and, on the same idea in Umayyad poetry, Wagner, *Grundzüge* 2.23–24.

52. Ṭab. 2.1232–34 (trans. 23.179–81).

53. 'Athāmina, *Al-qanṭara* 19 (1998).

stands, and, in a Greek inscription located just underneath a frieze decorated with marine animals that runs round the apse, proclaims: "The fortune of Alamoundaros conquers." The building looks remarkably like a church and is situated close to the martyr shrine of one of the Christian Arabs' favorite saints, Sergius, which was chosen, about the year 575, as the setting for the negotiations and oath taking that ended a period of estrangement between al-Mundhir and the Roman emperor Tiberius, after the latter had ineptly attempted to have his Arab ally assassinated. In view of the fact that churches were not infrequently the venue for audiences and other official business, it looks as if al-Mundhir was using either an actual church or else a hall with a distinctly ecclesiastical air about it, in order to convey a (barely) subliminal message about his own status.[54]

Since al-Ruṣāfa remained an important center under the Umayyads and indeed became the more or less permanent residence of the caliph Hishām (724–43),[55] Quṣayr ʿAmra's patron can hardly have been unaware of al-Mundhir's building atop its knoll just outside the city's north gate. Its general layout, the emphasis its inscription placed on the idea of victory, whose role at Quṣayr ʿAmra will be discussed in chapters 6 and 7, and perhaps even its frieze of marine animals may have been in his mind—along with recollections of various Syrian bath houses he had visited—when he commissioned his own project. It would be idle, though, to pretend that pre-Islamic Arab tradition offered more than an embryonic precedent for the high view of their caliphate espoused by the Umayyads. These were accordingly forced, to a large extent, to borrow ideas, images, and architectural forms from their neighbors, especially from those who had had their own experience of expressing a vision of universal and divinely sanctioned empire. As we have already seen, a much more developed and therefore easily assimilable language of royalty was available from al-Mundhir's patron, Rome—and from Sasanian Iran, whose influence on our princely portrait was less than Rome's, but whose prestige cast a spell over the later Umayyads to which Quṣayr ʿAmra is only one testimony among many. Quṣayr ʿAmra is, though, our main concern here; and the most instructive place to compare

54. Brands, *Da.M.* 10 (1998); E. K. Fowden, *Da.M.* 12 (2000). It was perfectly normal to honor the sovereign at a church's focal point, the apse. See, for example, the medallion portrait of Justinian I thinly disguised as David (with a cross atop his crown!) directly beneath Christ in the Transfiguration mosaic at S. Catherine's, Sinai: Forsyth and Weitzmann, *Monastery of Saint Catherine* 15 and pls. CLXX, CLXXIV.

55. On the Umayyads and al-Ruṣāfa see the sources gathered by Kellner-Heinkele, *Resafa* 4.

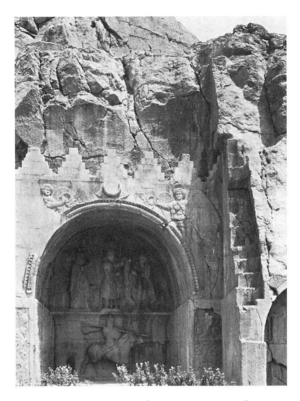

Figure 41. Ṭāq-i Bustān, large grotto, external view.

it with in the Sasanian world is, as already intimated in the last chapter, the early seventh-century monument at Ṭāq-i Bustān.[56]

Apart from a grotto and a rock relief ordered by Sasanian monarchs of the fourth century, Ṭāq-i Bustān's main feature is a second, much larger round-arched and "barrel-vaulted" grotto cut into the rock, with a flat rear wall bearing a frontal relief-portrait of a standing monarch—thought to be Khusraw II—as the central figure in an investiture scene (fig. 41). The formal similarity to Quṣayr ʿAmra's alcove is intensified by the fact that the king is flanked by two figures, though here they are gods—Ahuramazdā and Anāhitā—each of whom proffers him a diadem. The specific theology on display here would of course have been perfectly alien to any Umayyad; but the image's basic structure and intention, as a statement of imperial au-

56. Above, p. 109; also Shepherd, *Cambridge history of Iran* 3(2).1085–88.

thority, are the same as those of our princely portrait, which is also, as has already been hinted and will shortly be demonstrated, a religious image.

Just as the side walls of Quṣayr ʿAmra's hall are decorated with large-scale hunting scenes, so too at Ṭāq-i Bustān the sides of the arched recess are given up, as noted in the last chapter, to two great reliefs of the hunt, dominated by repeated representations of the emperor. Singing girls laud his heroic exploits (fig. 35). Neither the girls nor the hunt are diversions from the serious business of exercising power. Both contribute directly to its representation and propagation, and Ṭāq-i Bustān helps us to see clearly that this must be the case at Quṣayr ʿAmra too. Outside, on the carefully smoothed face of the mountain, the arch of the alcove vault is framed by an enormous royal diadem with flying ribbons attached to each end, and by reliefs of hovering Victories also bearing diadems, in a style highly reminiscent of the Roman tradition.[57] Before the alcove stood a statue of the emperor protected by an edicule.

The actual function of this unfinished installation—assuming it had one, other than declaration or advertisement—must have been connected with enthronement: perhaps the Sasanian monarch intended to receive there, either before or more probably after the hunt. The Qazwīn plate (fig. 38) shows a prince standing in front of his throne under a vault or *iwan* just like Ṭāq-i Bustān's (fig. 41), also with stepped crenellations and a relief of a large crescent moon in the middle.[58] Remains of a *paradeisos* in the plain before Ṭāq-i Bustān show where the deer hunt depicted on the right-hand wall took place. (The boar hunt from boats, depicted on the left wall [fig. 35], was conducted in another *paradeisos*, 30 kilometers to the east near Bīsutūn, which could be flooded by a nearby river.[59]) In this functional respect too, there is a parallel with Quṣayr ʿAmra, whose hall sheltered and entertained the prince and his companions, when they had had their sport with the animals of the desert and the steppe. As already remarked in chapter 3, many Umayyad armies passed by Ṭāq-i Bustān, on their way to campaign in Khurāsān, for example. So a specific reminiscence of this monument at faraway Quṣayr ʿAmra is certainly on the cards. Ṭāq-i Bustān, with its intense emphasis on the divine origin of the Sasanian monarchy, could have been part of the se-

57. See especially *Taq-i B.* vols. 1–2 (photographs of the site generally, the investiture scene, and the Victories); 3. pls. I–II (photogrammetric elevations of the investiture scene and one of the Victories). Compare the mosaic angels on the triumphal arch at S. Catherine's, Sinai (Justinianic): Forsyth and Weitzmann, *Monastery of Saint Catherine* 13 and pls. CXXIIB, CXXIIIB, CLXXIV.

58. Cf. von Gall, *A.M.I.* 4 (1971) 216 (on Ṭāq-i Bustān "als Felsumsetzung eines Thronbaldachines").

59. Kleiss, *Bisutun* 108–13.

ries of conscious or unconscious references that flickered through the mind
of the Umayyad beholder, when he contemplated the princely portrait.[60]

Muslim antipathy to use of images in religious contexts admittedly did
not facilitate the work of an artist required to portray a monarch who de-
rived his authority from God. He could depict the prince's outward appear-
ance; but the source of his power could only be hinted at. No Ahuramazdā
or Christ could be seen to invest or bless him. Still, an image or a whole en-
vironment that was reminiscent of Ṭāq-i Bustān might, in the informed be-
holder, conceivably evoke the idea of personal divine investiture, which we
know was current because we have contemporary Arabic literary evidence
for it.[61] Such a process cannot be excluded at Quṣayr ʿAmra. It may, though,
be objected that there are at least as many differences as resemblances be-
tween our bath house and Ṭāq-i Bustān. The parallels to Quṣayr ʿAmra's
royal iconography that are to be found if we look on the Roman side of the
frontier are indeed much more striking. Two groups of images especially
stand out, one a product of the Greek and Roman tradition, the other Jew-
ish and Christian in inspiration.

The late antique Roman iconography of power is amply documented in
the many ivory consular diptychs that have survived (e.g., fig. 42).[62] Most
belong to the fifth century and the first half of the sixth, and a number of
them may have been produced in Syria or Egypt. The Umayyads or their
artists could conceivably have been aware of these valuable and eminently
transportable objects, and even if they were not, the diptychs display a range
of costume and accoutrements that long remained familiar in the East Ro-
man world.[63] They portray ceremonially attired consuls enthroned within
an architectural framework or arch, from which curtains sometimes hang
and on which two large birds may perch. The great man's feet rest on a foot-
stool. Lictors or other ceremonial or symbolic figures usually flank him, and
often Victories too, who brandish portrait medallions. Depictions of Gē
holding a kerchief weighed down with fruit are also encountered. Above the
consul's head, often on the arch itself, runs an inscription that identifies him.
Beneath the consular footstool, slave boys may be glimpsed pouring rivers
of gold coin from capacious sacks. Acrobats and other entertainers perform,

60. Cf. Ettinghausen, *From Byzantium to Sasanian Iran* 64–65, for a parallel
line of thought. For possible influence of decorative motifs from Ṭāq-i Bustān on
the Dome of the Rock see Creswell 286–90 (but also Raby, *Bayt al-Maqdis* 144).

61. Marwān (II) b. Muḥammad in Ṭab. 2.1752–53 (trans. 26.102), quoted above,
p. 129.

62. For a range of examples see Volbach, *Elfenbeinarbeiten* pls. 1–37.

63. Breckenridge, *Justinian II* 37–45.

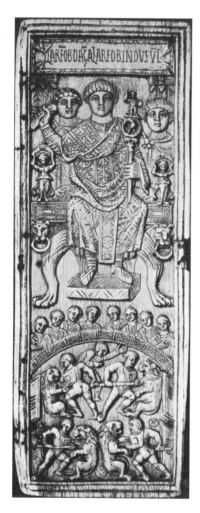

Figure 42. Consular diptych of Areobindus (ivory, Constantinople, A.D. 506). Schweizerisches Landesmuseum, Zurich, inv. no. A-3564.

and combats with wild beasts are much favored too, especially the spearing of them in arenas. Merely to enumerate all these features makes plain the many points of contact between the consular diptychs and Quṣayr ʿAmra's frescoes. There is here a substantially shared conception of what a royal iconography should be. But for royal images that were definitely familiar to the Umayyads we have to turn to Syria's mosaic art, not until recent times deemed portable (except as heaps of recyclable tesserae[64]).

64. Al-Wāqidī in Ṭab. 2.1194 (trans. 23.142); Ibn ʿAsākir, *Taʾrīkh madīnat Dimashq* 1(2).42–43.

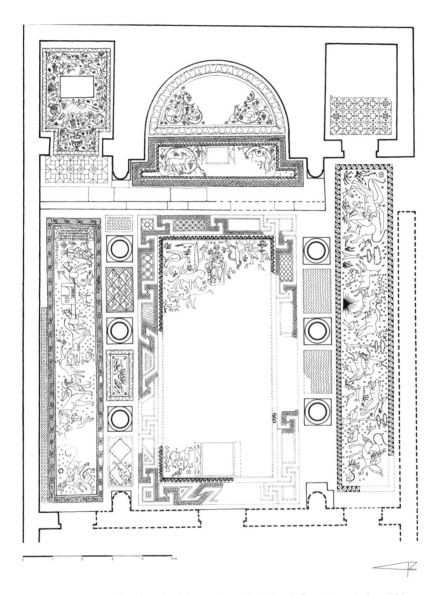

Figure 43. Ḥawīrtah, Church of the Archangel Michael, floor (mosaic, late fifth century). Drawing by F. Laroche, in P. Canivet and M. T. Canivet, *Ḥūarte: Sanctuaire chrétien d'Apamène (IVᵉ–VIᵉ s.)*, Institut Français d'Archéologie du Proche-Orient, Bibliothèque archéologique et historique 122 (Paris: P. Geuthner, 1987) 2. plan X.

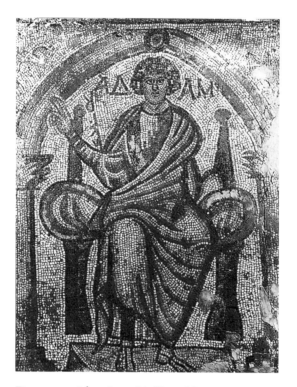

Figure 44. Adam (mosaic). Ḥamā Museum.

The church of the archangel Michael in the abandoned village of Ḥawīr-
tah, 15 kilometers north of Apamea in Syria, recently yielded to its exca-
vators a fine mosaic floor of the late fifth century (fig. 43).[65] In the place of
honor just in front of the sanctuary step, and facing the visitor who enters
from the west, Adam was depicted naming the animals as they throng
around him. Seated majestically on a thick cushion reposing on a backless
throne, he raises his right hand in blessing or a gesture of speech, while in
the other he holds a book. His head is flanked by two birds facing each other.
Above him is inscribed his name, in Greek. Behind in the sanctuary stood
the altar, the throne of Christ the heavenly king, of which Adam's throne
acts as a direct visual precursor, just as Adam himself—who is fully clothed
and not, as more commonly before the Fall, naked—prefigures Christ.[66]

65. Canivet and Canivet, *Ḥuarte* 1.54–56, 133–40, 142, 207–25, 258–59, 296–98;
2.pls. CXII–CXVII, CXX–CXXVIII, and plan X; Donceel-Voûte, *Pavements* 102–16.
66. Ephraem the Syrian, *Hymns on the Nativity* 1.16, 41.

Flanking Adam, in the basilica's side aisles, are scenes of wild animals attacking each other, the hunting party's antecedent and parallel in the world of nature. Presumably from another church not far away, and probably from the same position in it, is now preserved in the Ḥamā Museum a similar mosaic that depicts Adam seated on a cushion, upon a throne that this time has a back and stands under a round arch supported on two columns (fig. 44).[67] He holds no book but raises his right hand in blessing. His feet rest on a footstool. His name is inscribed clearly in Greek and maladroitly in Syriac. The resemblance between this panel and the Quṣayr 'Amra fresco is particularly striking.

A third such panel, of the fifth or sixth century and said also to be from northern Syria, was acquired in 1970 by the National Museum, Copenhagen.[68] As at Ḥawīrtah, Adam is seated on a backless throne and rests his feet upon a footstool. His right hand is raised. His name appears above his head, in Greek. But unlike the other two panels, this one shows Adam's head surrounded by a nimbus. Evidently the prototype of earthly royalty[69] (though, being the first man, he naturally lacks the attendants a contemporary prince found indispensable) will have been frequently encountered by members of the Muslim Arab elite during the visits they loved to make to the churches and monasteries in which their newly won possessions abounded.[70] And the common ancestor had a special significance for Muslims, since it is recorded in the Qur'ān that God made him his deputy *(khalīfa)* and taught him the name of each created being. "I will place on the earth a *khalīfa*", so God declared to his angels;[71] and the only other man of whom God says this in the Qur'ān is David, who, as we have seen, is also invoked at Quṣayr 'Amra in connection with the prince.[72] God then had his angels prostrate themselves before Adam; only Satan (Iblīs) refused.[73] According to Jewish and Christian noncanonical traditions that may go back

67. Canivet and Canivet, *Ḥūarte* 1.259–60; Donceel-Voûte, *Pavements* 487.

68. Inv. no. 15061: Canivet and Canivet, *Ḥūarte* 1.259, 2. pl. CXVIII.2; Rasmussen, *Byzantium* 63–65.

69. John Chrysostom, *Homiliae in Genesin* 2.13.4; Michael the Syrian, *Chronicle* 1.4 (trans. Chabot 1.5); Maguire, *Rhetoric, nature and magic* IV.368 n. 33; Cosentino, http://utenti.lycos.it/augustocosentino/Viaggistorici.htm, on treatment of Adam in the East, according to apocryphal texts, as a model of sanctity rather than the original sinner.

70. E.g., Bal. 2. fol. 726a (p. 70, §129 'Athāmina); Hamilton 86–91; D. Sourdel, *E.Is.* 2.198.

71. Qur'ān 2.30–33.

72. Qur'ān 38.26.

73. Qur'ān 2.34; Wahb b. Munabbih, *Kitāb al-tījān* 15; various sources in Ṭab. 1.82–86, 91–94 (trans. 1.253–57, 263–66).

as early as the first century A.D., the first to adore the image God had made
of himself was the archangel Michael, who then bade the other angels fol-
low suit.[74] Adam's presence in the Michaëlion at Ḥawīrtah is therefore easy
to understand. So too is the unmistakable visual allusion to his standard por-
trait at Quṣayr ʿAmra, for as God's first caliph, directly and unambiguously
nominated, he was the ultimate symbol of legitimacy.

That the Umayyad court milieu was ready for such an image is suggested
by an anecdote the ninth-century historian al-Balādhurī preserved, accord-
ing to which the caliph Hishām once bade his courtier and advisor, the or-
ator Khālid b. Ṣafwān, "Preach a sermon, and be quick about it!" Khālid rose
to the challenge with the following:

> You are set over creation, and there is none over you save God Himself.
> You are proceeding towards God; therefore fear God.[75]

Now, at Quṣayr ʿAmra, an ingenious iconographical suggestion evokes the
first half, at least, of Khālid's minisermon, by reminding the visitor of Adam
the ruler of all creation and God's own appointed caliph. There is, though,
a still closer parallel to the princely portrait in the letter, from which a pas-
sage has already been quoted, whereby al-Walīd II bestowed rights of suc-
cession on two of his sons and drew a this time explicit parallel with God's
designation of Adam as his deputy on earth.[76] The full significance of this
passage emerges only if one considers that Quranic exegetes active under
the Umayyads, when called upon to explain the polyvalent and in many
ways obscure word *khalīfa* as applied to Adam, never—with one possible
exception—suggested any connection between this term and the head of
the Islamic state![77] It was, then, as a defiant comment on the Muslim Es-
tablishment's refusal to legitimize the excessively "kingly" Umayyads[78]
by associating them with the Quranic Adam that al-Walīd chose to invoke
Adam when proclaiming his heirs, and Quṣayr ʿAmra's patron to have him-
self depicted as Adam in the hall's focal fresco.[79]

We should bear in mind as well that even the relatively narrow circle of
habitués, mostly people attuned to the patron's habits of thought, will have
included individuals who saw the Adamic portrait at Quṣayr ʿAmra through

74. Awn, *Satan's tragedy* 20–22; Canivet and Canivet, *Ḥūarte* 1.299–300.
75. Bal. 2. fol. 726b (74, §141 ʿAthāmina).
76. Ṭab. 2.1759 (trans. 26.108–9).
77. Al-Qāḍī, *Gegenwart als Geschichte;* this reference courtesy of Baber Jo-
hansen.
78. See below, pp. 171–72.
79. Even though, according to the text painted above his head, he was not yet
himself caliph: see above, pp. 126–27.

the lens of Genesis as well as the Qurʾān. For them, Adam had not only been set over the whole of terrestrial creation, including the fish of the sea and the birds of heaven, but was also made in the very image of God. And just as at Ḥawīrtah the image of Adam anticipated the throne of Christ, that is to say, the altar that stood in the apse behind the mosaic, so too at Quṣayr ʿAmra it is conceivable that the prince's borrowings from the iconography of Adam evoked in the subconscious at least of certain viewers, such as the recent converts who frequented the Umayyad court, feelings of awe similar to those felt by the Christian who stood—or had once stood—before the altar of his Lord. Even the attendants with their fans recalled the two deacons similarly equipped, who flanked the celebrant bishop and priests and "discretely chased away the small flying insects".[80] Already by the sixth century these fans no longer had a purely practical function and had come to symbolize the six-winged cherubim.[81] On the stone *ciborium*, the canopy that protected the holy table, might be represented not only these liturgical *flabella* but also peacocks perching on its rising arch,[82] just like the sandgrouse on the arch that shelters our prince. And on the apse's semidome behind the altar, our hypothetical visitor to Quṣayr ʿAmra might also have seen a mosaic or fresco portrait of Christ enthroned above the waters of Paradise and their abundant shoals of fish.[83]

It is admittedly hard to judge the degree of Christian culture one may reasonably suppose in Quṣayr ʿAmra's creators and audience. But at S. Catherine's, Sinai, which was situated at the heart of the Arab world and was widely familiar because of the many pilgrims who visited it, there is a striking parallel to our painting. At the very center of the apse, directly below the figure of Christ in the Transfiguration mosaic generally held to be part of Justinian's original benefaction, the central portrait in a set of medallions of prophets depicts King David arrayed in purple chlamys and a crown topped off with a cross![84] There is a distinct resemblance to the famous portrait of Justinian at San Vitale, Ravenna—if Constantinopolitan, both mosaicists will surely have seen the emperor in the flesh. If nothing else, this

80. *Constitutiones apostolorum* 8.12.3; cf. Denḥā, *History of Mārūthā of Takrīt* (d. 649) 74—my thanks for this latter reference to E. K. Fowden.

81. Braun, *Das christliche Altargerät* 642–45.

82. For both images, see the Perugia *ciborium*: L'Orange, *Cosmic kingship* 138 fig. 99, and cf. Leclercq, *D.A.C.L.* 5.1617 fig. 4468.

83. Ihm, *Apsismalerei*, pls.; also the large aquatic scene under Christ enthroned in the apse of the Monte della Giustizia oratory, Rome: Ihm, *Apsismalerei* 16 fig. 1, 149–50.

84. Forsyth and Weitzmann, *Monastery of Saint Catherine* 15 and pls. CLXX, CLXXIV.

medallion proves that the basic idea of displaying a ruler in the guise of a prophet at the focal point of a hall or basilica need not have been pure inspiration on the part of al-Walīd or his artists.

No knowledge at all of Christianity was required, though, for one to be put in mind at Quṣayr ʿAmra of the mosaic of Christ enthroned that occupied the vault above the emperor's throne in the famous Chrysotriclinus audience hall at Constantinople.[85] The image was removed or covered at some point—we know not when exactly—during the period of iconoclasm. But the Umayyad elite will have known of it and may have had it in part to thank for the urge they felt to substitute an image modeled on Christ's antecessor Adam in similar relation to the ruler. Just in the period when the iconoclast emperors of East Rome were refusing any association of their own image with that of Christ,[86] an Umayyad prince was neatly circumventing the obstacle Islam had placed in the way of depictions of divine sanction or investiture, by alluding to an icon that was widely known in late antique Syria and depicted the common father of all mankind, whom God had created in his own image.[87]

To return, finally, to the Muslim resonances of the princely portrait, it is worth recalling that any royal place of honor, such as the apse of al-Mundhir's building at al-Ruṣāfa, was called in the Arabic of that period *al-miḥrāb*—a term destined, under Islam, to be used for the one indispensable focal feature of every mosque throughout the world.[88] Quṣayr ʿAmra's alcove is clearly also, in the earlier sense of the word, a *miḥrāb*.[89] Since it is in a bath house, it can hardly have been meant to be a *miḥrāb* in the Islamic

85. *Anthologia Palatina* 1.106–7; Breckenridge, *Justinian II* 52–56.

86. A. Grabar, *Empereur* 113–14; Auzépy, *EYΨYXIA*.

87. For a bath house in Constantinople decorated c. 900 with mosaics or paintings showing, among other things, the emperor Leo VI apparently in the guise of the kingly Adam, and aquatic scenes, see Magdalino, *D.O.P.* 42 (1988), esp. 106–7. Shortly afterwards, the Armenian king Gagik (see above, pp. 72–73) had his (still surviving) palatine church on the island of Aḵt'amar in Lake Van decorated with reliefs and frescoes that proclaimed his acceptance of Adam as a paradigm of kingship: Jones, *Eastern approaches*.

88. Qur'ān 34.13, 38.21 (cf. Paret, *Der Koran: Kommentar und Konkordanz* 66); *Ḥудud Ḍuwul* 13.11, 20; 14.18; 15.4; 16.6, 10, 17, 21, 22; 26.4, 15, 17 (misleadingly translated "Gebetsnische" by Khoury); G. Fehérvári, *E.Is.* 7.7; Whelan, *I.J.M.E.S.* 18 (1986) 206–7; Troupeau, *Le miḥrāb*; Robin, *Revue du monde musulman et de la Méditerranée* 61 (1991) 152–55.

89. Cf. the allusion by the poet Kuthayyir ʿAzza (d. 723), *Dīwān* 340, to "al-Qasṭal in the Balqāʾ [an Umayyad complex near the Pilgrim Road], with its *maḥārib* [i.e., *maḥārīb*, plural of *miḥrāb*]". On *miḥrāb* as a synonym for *qaṣr* generally, with special reference to the height of the structure, see N. N. N. Khoury, *I.J.M.E.S.* 30 (1998) 10 and n. 77, 12.

sense as well.[90] Nevertheless, it was common in the Umayyad and early Abbasid world to give palaces and even whole cities the same orientation as their mosques. The Umayyad palace of Mushattā is one example; the town of al-Raqqa, Hārūn al-Rashīd's capital by the Euphrates, is another.[91] The accuracy of their orientation on Makka might leave much to be desired[92]—as was the case at Quṣayr ʿAmra too, if this was what was intended. But the point of such orientation was not the provision of an accurate direction for prayer. Rather it served to underline the sacred character of the Islamic polity. It was the same essentially poetic purpose that the Umayyad panegyrists had in mind when they declared in their verses that the caliph was himself the prayer direction, the *qibla*.[93] When ʿAbd al-Malik dreamed that he made water four times in a *mihrab*, the interpretation came easily to such flatterers that four of his sons would rule the empire.[94]

90. Cf. *Q.ʿA.* 112, 124–25.
91. Enderlein and Meinecke, *J.B.M.* 34 (1992) 141 (Mushattā), 142 (Qaṣr al-Ṭūba: cf. below, pp. 156–58); Meinecke, *Mitteilungen der Deutschen Orient-Gesellschaft zu Berlin* 128 (1996) 159–67 (al-Raqqa).
92. On the whole subject of fixing the prayer direction in early times, see Hoyland, *Seeing Islam* 560–73; Wheatley, *Places where men pray* 476 n. 52.
93. Examples in Jamil, *Bayt al-Maqdis* 43. Note also Wheatley's speculations, *Places where men pray* 229–30, 335, on why the governor's residence was often built against the *qibla* wall of a city's principal mosque.
94. Ibn Khallikān, *Wafayāt al-aʿyān* 2.378 (trans. 1.567).

5 The Princely Patron

THE PATRON'S IDENTITY

Is it now possible to be more precise about the identity of the prince who is the subject of the genial portrait described in the last chapter?

It has already been indicated that the inglorious collapse of the Umayyad dynasty and the coming of the Abbasids, in 750, marks a point after which it becomes less likely that a princely bath house would have been built in the Balqāʾ.[1] Not that Jordan suddenly fell off the map in 750—indeed, Abbasid Jordan is becoming one of the new frontiers of Middle Eastern archaeology, thanks to revision of traditional periodizations triggered by a realization, growing since the late 1980s, that pottery types formerly regarded as "late Umayyad" in fact remained in use into the ninth century.[2] What is more, we know that some representatives of the Umayyad clan continued to live on estates in the Balqāʾ decades into the Abbasid period—one of them rebelled against the caliph al-Maʾmūn (813–33).[3] Members of the early Abbasid elite, even caliphs, visited Syria quite frequently, for it lay athwart the route from ʿIrāq to the West and shared a disputed frontier with infidel Rome. Hārūn al-Rashīd actually established his capital there.[4] Nevertheless, Quṣayr ʿAmra lacked the water and the economic potential that might have attracted either continued occupation by the Umayyads or their kin, or a takeover by

1. Above, p. 21.
2. De Vries, *Umm el-Jimal* 20–21; Walmsley, *Long eighth century* 329–31 and *Céramique byzantine* 305–13; cf. Avner and Magness, *B.A.S.O.R.* 310 (1998).
3. Ibn Ḥazm, *Jamharat ansāb al-ʿarab* 85; Ibn ʿAsākir, *Taʾrīkh madīnat Dimashq* (selection ed. al-Munajjid, *Muʿjam Banī Umayya*) 53 = Yāq. 4.240–41 s.v. "Al-Faddayn" (trans. Grabar, *Eretz-Israel* 7 (1964) 44*); and cf. Imbert, *Archéologie islamique* 3 (1992) 56–59; Northedge, *ʿAmmān* 1.53.
4. Abiad, *Culture et éducation* 103–38.

(or at least under) the Abbasids.[5] If, as seems certain, Quṣayr 'Amra was a princely foundation, it remains hard to imagine that it was erected after 750.

It has also been suggested that Quṣayr 'Amra would have made more sense after 'Abd al-Malik reimposed order on the caliphate in the early 690s and found leisure to occupy himself with major construction projects such as the Dome of the Rock in Jerusalem, whose foundation inscription bears the date A.H. 72 (A.D. 691–92).[6] A milestone in this process was, incidentally, the fall of al-Kūfa in southern 'Irāq in October or November 690 or 691, which 'Abd al-Malik marked with a grand banquet held in the nearby Sasanian-Lakhmid residence of al-Khawarnaq, originally built for Bahrām Gūr.[7] It was said of this building—celebrated for its own sake but also for the beauty, especially in springtime, of the surrounding countryside and the nearby Euphrates—that "no governor could visit al-Kūfa without adding something to it".[8] Certainly al-Khawarnaq will have been present to the mind of all Umayyad patrons and architects of "desert castles". So too its decoration, which in the light of what we know of Sasanian and then Umayyad interior design, can hardly not have depicted Bahrām's hunting exploits,[9] and of course the story of Āzāda. It is tempting to see in 'Abd al-Malik's celebratory gathering at al-Khawarnaq an early symptom of the later Umayyads' taste not only for luxury building on the desert's fringe, but also that mixing of women and the hunt that is so distinctive a feature of Quṣayr 'Amra's frescoes. Indeed, the literary sources credit 'Abd al-Malik with such a strong interest in country residences that he may well be seen as the first establisher of this taste, rather than its forerunner.[10]

5. For examples of continued use see al-Balādhurī, *Kitāb futūḥ al-buldān* 129, 143–44; *Q.H.E.* 155, 157–59; Whitcomb, *B.A.S.O.R.* 271 (1988); Waheeb, *A.D.A.J.* 37 (1993) 15. If only as a beduin shelter, Quṣayr 'Amra continued in use after 750 and until the twentieth century. Consciously or not, the historian tends to exclude such later phases of occupation from his account (though *Q.H.E.* makes an exemplary attempt to give Qaṣr al-Ḥayr al-Sharqī's later phases their due weight). Quṣayr 'Amra's abundant graffiti are seen more as an obstacle to study of the frescoes than as a historical record in their own right. Yet graffiti on palace (and other) walls were seen as a worthy object of study by a tenth-century man of letters identified as al-Iṣfahānī, in the *Kitāb adab al-ghurabāʾ*. And see now Betts, *A.A.E.* 12 (2001).

6. Above, p. 21; Blair, *Bayt al-Maqdis*, esp. 77 n. 56, 84.

7. Ṭab. 2.819–21 (trans. 21.195–96); cf. Hoyland, *Seeing Islam* 553–54, 648–49.

8. Al-Haytham b. 'Adī in Ibn al-Faqīh, *Kitāb al-buldān* 214 (trans. 216). On the beauty of al-Khawarnaq's environs see above, p. 125; Khālid b. Ṣafwān b. al-Ahtam in Iṣf. 2.130; Musil, *Middle Euphrates* 105–6.

9. As stated by the twelfth-century Iranian poet Niẓāmī, *Haft paykar* 13.18–22, 14.69–71 (but on what authority?). See also above, p. 96.

10. See below, p. 159, on his seasonal migrations between Lake Tiberias, the Damascus region, and Lebanon; pp. 151 n. 54, 152, on properties in al-Balqāʾ; and Yazīd

But if we anticipate a conclusion that can be deduced from evidence to be presented in chapter 7, it is possible to propose a somewhat later date for Quṣayr ʿAmra's earliest possible construction, or at least decoration. The fresco of the six kings on the west side of the hall includes a depiction of the last Visigothic ruler of Spain, Roderic, who was vanquished and probably killed by the Berber general Ṭāriq b. Ziyād in 711 or 712. Ṭāriq's superior Mūsā b. Nuṣayr, the governor of Ifrīqiya (Africa), set out from Spain at some point between 712 and 714, accompanied by Visigothic prisoners and carrying with him gold, silver, jewels, "ointments to kindle women's desire", and much else. He arrived in Damascus shortly before the death of al-Walīd I on 24 February 715.[11] Although the bare news of the conquest will obviously have reached Damascus long before this, due appreciation of its importance, and especially of the economic and indeed symbolic significance of the treasures it had yielded,[12] will have taken time to sink in. Yet such appreciation is presupposed by the six kings fresco, which ranks Roderic alongside the Roman and Sasanian emperors, among the most powerful rulers the world had ever known. The year 715 is, in other words, the very earliest that one could imagine the impression made by Ṭāriq's and Mūsā's achievement having already resulted in a building in Syria being adorned with a portrait of Roderic; while the Visigoth king's enduring fame among the Arabs, for reasons to be discussed in chapter 7, relieves the pressure some scholars have felt to date Quṣayr ʿAmra as near as possible to the year of his fall. These considerations—as well as the fact that the patron was an *amīr*— exclude the much-canvassed possibility that al-Walīd I was responsible for Quṣayr ʿAmra.[13] And 750 is once again indicated as the bath house's latest possible date of construction, if we suppose that an Abbasid patron would have been unlikely to advertise so exclusively Umayyad a conquest as that of Spain—which continued under Umayyad rule even after the rise of the Abbasids.

We need, then, to find between 715 and 750 an Umayyad prince or heir

b. Abī Muslim, secretary to ʿAbd al-Malik's governor of ʿIrāq, al-Ḥajjāj b. Yūsuf al-Thaqafī, in Ibn Khallikān, *Wufayāt al-aʿyān* 4.106 (trans. 2.392), on a *muntazah* (park) at Dūmat al-Jandal.

11. *Mozarabic chronicle of 754* 56–57 (trans. Wolf); al-Wāqidī in al-Balādhurī, *Kitāb futūḥ al-buldān* 231; Eisener, *Zwischen Faktum und Fiktion* 57–63; Collins, *Arab conquest* 28–31, 39.

12. See below, pp. 213, 224.

13. Supporters of al-Walīd I are listed by Grohmann, *Arabische Paläographie* 2.73a n. 3, to which add, for example, Strika, *A.I.O.N.* 17 (1967); *Q.ʿA.* 112; Gaube, *Z.D.P.V.* 95 (1979) 204; Bacharach, *Muqarnas* 13 (1996) 27–28, 33.

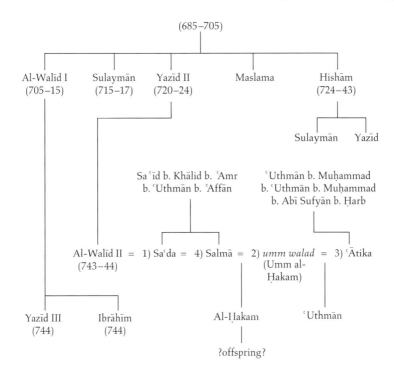

Figure 45. Select later Umayyads.

apparent—not a reigning caliph—who enjoyed women and the hunt or at least was not an ascetic like 'Umar II. One would also feel more comfortable assigning a structure as nonautonomous as a hunting lodge to a prince who can be shown to have had a more general interest in the Balqāʾ—Quṣayr 'Amra is unlikely to have been its patron's sole investment in the region. In fact, the ideal candidate will have spent several years in the Balqāʾ as *amīr*, in order to leave room for the suggestion made by some students of Quṣayr 'Amra that the frescoes may not all have been executed at the same time.[14] There is also a theoretical possibility that the structure of the bath house was completed some time before the frescoes were applied. But the arguments already advanced in chapter 2 against an extended period of use,[15] taken together with the short period of thirty-five years between the earliest possible date for the frescoes and the latest probable date for such a project

14. Jaussen and Savignac 3.87; R. Hillenbrand, *K.Is.* 158a; cf. also Urice, *Qasr Kharana* 87, and below, pp. 189–90.

15. Above, p. 47.

in this particular region, tend to favor the frescoes' contemporaneity with the building they adorn.

Al-Walīd's *amīr* and successor, Sulaymān (715–17), enjoyed the reputation of a vain voluptuary, who created such a rage for brocaded fabrics *(washī)* that even his cook affected them.[16] He is not, though, said to have shown above-average interest in the Balqāʾ. The closest we get is the assertion in a later Syriac chronicle (which preserves the *History* of the ninth-century Syrian Orthodox patriarch Dionysius of Tel-Maḥrē) that he built "citadels, gardens and mills" down in the Jordan Valley near Jericho—perhaps a forerunner of Khirbat al-Mafjar.[17] Sulaymān is anyway excluded as patron of Quṣayr ʿAmra before 715 by the same argument that excludes al-Walīd, and after 715 by the fact that he was no longer *amīr*.[18] It was said that in al-Walīd's day people could talk only about building projects, in Sulaymān's reign about food, slave girls, and sexual intercourse, and under ʿUmar II, Sulaymān's successor (717–20), nothing but prayer and fasting.[19] So ʿUmar can be excluded too, and not just for being such an abnormally ascetic Umayyad, but also because he became caliph without having previously served as *amīr*.

But it was his successor, Yazīd b. ʿAbd al-Malik (Yazīd II, 720–24), who was responsible for issuing the infamous edict of 721 against images wherever they might be found. A statue of a female beauty in an al-Fusṭāṭ bath house was said to have been one of its victims.[20] It has been suggested that Quṣayr ʿAmra ought to be dated after 721, because its paintings show no sign of iconoclast interference.[21] Archaeology indicates, though, that the iconoclastic activity that did occur in Jordan (whether at Yazīd's behest or some-

16. Al-Madāʾinī in Ṭab. 2.1337–38 (trans. 24.62–63); Mas. 2154 (3.175 Dāghir); and cf. Iṣf. 4.337–49, summarized by Kilpatrick, *Book of songs* 156–57.

17. *Chronicon ad annum Christi 1234 pertinens* 1.327. According to Ibn ʿAsākir, *Taʾrīkh madīnat Dimashq* (selection ed. al-Munajjid, *Muʿjam Banī Umayya*) 67, Sulaymān was in al-Balqāʾ when he heard of his accession; but Ṭab. 2.1282 (trans. 24.3) has al-Ramla. Cf. Eisener, *Zwischen Faktum und Fiktion* 39, 79, 148, 156 n. 42; al-Maʿīnī, *Al-Balqāʾ* 1 (1992) 155–56.

18. Given that Quṣayr ʿAmra was constructed over a certain period of time, and that the hall's west aisle was perhaps finished last (below, p. 190), it would be possible to argue that Sulaymān started the project before 715 as *amīr* and completed it—in particular the six kings panel on the west wall—as caliph. But his lack of interest in the Balqāʾ, compared to Yazīd II or al-Walīd II (see below), remains a strong argument against him. For a recent attempt to read Sulaymān's name in a painted text in the hall's west aisle, see below, p. 178 n. 6.

19. Al-Madāʾinī in Ṭab. 2.1272–73 (trans. 23.221).

20. Vasiliev, *D.O.P.* 9–10 (1956); Ibn ʿAbd al-Ḥakam, *Futūḥ Miṣr* 113–14, and al-Kindī, *Taʾrīkh Miṣr wa-wulātihā* 71–72 (verses trans. Arnold, *Painting in Islam* 85), for the statue.

21. King, *B.S.O.A.S.* 48 (1985) 276–77.

one else's) was aimed mainly against Christians.[22] And since Yazīd was not otherwise noted for his Muslim piety, while evidence for iconoclastic activity is unevenly distributed geographically, it may be that his edict was an aberrant action of only short-term effect. In any case it would not have been so inconceivable for Yazīd to have enjoyed, in the relative privacy of Quṣayr ʿAmra, images that in some public pronouncement he had condemned. If he commissioned them as *amīr*, that would in any case have been between 717 (when Sulaymān named him in his will as heir to ʿUmar[23]) and 720.

On the basis of several of the criteria listed above, including the most specific one, namely association with al-Balqāʾ, Yazīd in fact seems a rather strong candidate for Quṣayr ʿAmra's patron. Our evidence about him deserves closer attention. And it makes sense to consider at the same time his son al-Walīd b. Yazīd, Musil's favored candidate,[24] and the inheritor of his father's properties in the Balqāʾ.

Father and son had, it seems, much in common. However large the pinch of salt with which one takes certain of the Abbasid literary sources on the Umayyads, whose salacious readability betrays their design to discredit,[25] still Yazīd and al-Walīd emerge with a reputation for unabashed extravagance and hedonism that contrasts markedly with both ʿUmar II's piety and Hishām's parsimony. We have already encountered Yazīd's beloved singing girl Ḥabāba, at the moment when as *amīr* he first set eyes upon her.[26] As caliph he gave himself up to the company of Ḥabāba and another slave girl called Sallāma, and gained the reputation of one who much preferred poetry and drinking in the company of these two beautiful women to busying himself with affairs of state.[27] On one occasion, he thought to test the truth of the popular saying that no man can pass a day and a night without some unhappiness or misfortune befalling him.[28] He was at Bayt Rās, ancient Capitolias near Irbid at the northern edge of the Balqāʾ, a hilltop residence

22. Schick, *Christian communities,* esp. 205–19, 223.
23. Ṭab. 2.1342 (trans. 24.70–71).
24. Above, pp. 20–21.
25. Cf. ʿAṭwān, *Al-Walīd* 35, 38, on Yazīd and Ḥabāba; also (e.g.) 201–8 on al-Walīd, noting the relative respectability of reports by al-Madāʾinī (mediated, for example, by al-Balādhurī). ʿAṭwān does not question (72–89) the romantic story of al-Walīd and Salmā (below, pp. 186–88), for which there is good evidence in al-Walīd's own poetry.
26. Above, p. 83; also al-Madāʾinī in Ṭab. 2.1464 (trans. 24.194–95).
27. Al-Madāʾinī in Ṭab. 2.1464–66 (trans. 24.194–96); Mas. 2197–205, 2211 (3.196–99, 202 Dāghir); Iṣf. 8.347–65, 15.119–42; and cf. Hamilton 63–73.
28. Iṣf. 15.139–40; Ibn al-Athīr, *Al-kāmil* 3.306; and on Bayt Rās see Ṭab. 2.1463 (trans. 24.193–94); Mas. 2196 (3.195 Dāghir); Yāq. 1.520 s.v. "Bayt Raʾs"; Conrad, *Byzantine and modern Greek studies* 18 (1994) 44–46.

famous for its wine. He gave orders that he was not to be troubled with news
or dispatches. Then he shut himself away with Ḥabāba, and they spent the
day eating—until she choked to death on a grape or a pomegranate seed
that Yazīd had entertainingly tossed into her mouth. Inconsolable, the caliph
too died a few days later.

Only his namesake Yazīd I (680–83), and Sulaymān, had somewhat an-
ticipated Yazīd II's concern with "his belly and his private parts"; and al-
though the Umayyads' opponents condemned them all except ʿUmar, the
reasons given were various, including tyranny, blood lust, devouring for-
bidden property, and so on.[29] Al-Walīd, though, was evidently impressed
by his father's example and became a fervent seeker of pleasure, above all
in poetry, music, wine, and women.[30] He was also handsome,[31] a fine horse-
man and athlete of great physical strength,[32] a hunter, especially of the wild
ass that is so much depicted at Quṣayr ʿAmra,[33] and something of a practi-
cal joker.[34] Nor did he entirely neglect more serious pursuits. Besides his
passion for poetry, and the many invitations he addressed to leading poets
and singers and literary scholars, who competed for his favors, including sub-
stantial cash handouts,[35] al-Walīd also took an amateur's passionate inter-
est in the history of the times before Islam, "collecting the records, poems,
historical traditions, genealogies and dialects of the Arabs".[36] Since much
of the Arabs' historical memory was transmitted in their poetry, as one can

29. See the anti-Umayyad sermon delivered in the late 740s by Abū Ḥamza al-
Mukhtār b. ʿAwf, reconstructed and translated by Crone and Hinds, *God's caliph*
129–32.

30. Derenk, *Al-Walīd*, provides a brief account of al-Walīd's life and (like Rot-
ter, *Abu l-Faradsch* 100–127) a partial German translation of our most abundant
source, Iṣf. 7.5–97. Hamilton, *Walid*, incorporates English translations or summaries
of the same material in an entertainingly anecdotal narrative. The most compre-
hensive treatment, with important critical remarks on Abbasid manipulation of the
literary sources (cf. above, p. 147 n. 25; below, pp. 330 n. 8, 332 n. 10), is ʿAṭwān, *Al-
Walīd;* see also Blachère, *Analecta* 379–99; Abbott, *Studies* 3.90–103.

31. *Mozarabic chronicle of 754* 87 (Alulit [=Ἀλουλιτ, an attested variant of the
more usual Ἀλουλιδ: Bell, *Aphrodito papyri* 539 s.v.] *pulcher Emir Almuminim*); Iṣf.
4.392, 10.101, 19.142; and further references in ʿAṭwān, *Al-Walīd* 172.

32. Bal. 2. fol. 163a = p. 325 (42 Derenk); Ṭab. 2.1811 (trans. 26.164); Mas. 2248–51
(3.217–19 Dāghir); Iṣf. 7.31 (trans. Derenk 108).

33. Hishām b. al-Kalbī in Iṣf. 7.58 (partial trans. Derenk 118); al-Haytham b. ʿAdī
in Bal. 2. fol. 160b = p. 320 (31 Derenk); al-Madāʾinī in Ṭab. 2.1775–76 (trans. 26.127)
and Iṣf. 7.56 (trans. Berque 123), 80, 87 (trans. Rotter 122); and cf. Bal. 2. fol. 155a =
p. 309 (4 Derenk); Iṣf. 7.114–16.

34. Iṣf. 7.70–71; and above, p. 68.

35. E.g., Iṣf. 6.80–81, 7.111–14; cf. ʿAṭwān, *Al-Walīd* 182–209.

36. Ibn al-Nadīm, *Kitāb al-fihrist* 103 (trans. Dodge 197–98).

see from the inordinate amounts of verse contained even in a work such as Ibn Isḥāq's *Life of the Prophet*, these interests are two sides of the same coin.[37] One is reminded of the personifications of Poetry and History in Quṣayr ʿAmra's east aisle.

All these tastes and skills al-Walīd had abundant opportunity to refine and enjoy, because Yazīd II had entrusted the reins of state to his brother Hishām, reserving to his own son only the right of succession on Hishām's death. As it turned out, Hishām reigned for nineteen long years, from 724 to 743. Being a sober, diligent, and tight-pursed ruler, he took no pleasure in his playboy nephew. Hishām's attempts to restrain al-Walīd's expenditure, including his building projects, made for a tense atmosphere at al-Ruṣāfa, and eventually caused al-Walīd to leave altogether, after which Hishām cut off his allowance.[38] The crown prince waited out the remaining years of Hishām's reign on his properties in the Balqāʾ. He celebrated Hishām's eventual demise in characteristic fashion, with wine and a singing girl,[39] but was to enjoy his throne only for fifteen months after that (743–44), until he was assassinated during a revolt led by members of other branches of the Umayyad clan. Al-Walīd's accession had thwarted numerous ambitious cousins; his way of life had offended somewhat wider circles. But with his assassination, the first of a reigning caliph since 661, a fatal blow was struck at the plausibility of the Umayyad dynasty itself, and at the cohesion of its power base, Syria.

If al-Walīd had one powerful motivation besides pleasure, it was the desire to shock. Our literary sources are full of outrageous stories, some no doubt apocryphal,[40] and of poems in similar vein attributed to al-Walīd, not a few of them spuriously, one suspects—though neither apocrypha nor spuria commonly attach to nonentities (any more than do plagiarists, of whom al-Walīd was to know a few). According to one story already mentioned in passing, al-Walīd had the jester Ashʿab dressed up as a monkey and adorned with bells, then exposed his erect penis, and had the "monkey" bow down before it;[41] according to another, al-Walīd, hearing the muezzin's call as he withdrew from the singing girl Nawār, sent her in dis-

37. Abbott, *Studies* 1.14–19.
38. Al-Madāʾinī in Ṭab. 2.1743–50 (trans. 26.91–99); Bal. 2. fol. 157a–b = pp. 313–14 (13–16 Derenk). There is an indirect reference to al-Walīd's buildings in Iṣf.'s version of Hishām's letter, 7.20 (trans. Derenk 94); but the problem is also alluded to in the *Khuṭba Yazīd;* and cf. *History of the patriarchs of Alexandria* pp. 368–69.
39. Iṣf. 7.23 (trans. Derenk 97–98).
40. See above, p. 147 and n. 25.
41. See above, p. 68.

guise to preside at prayers in his place.[42] There is the unforgettable image of al-Walīd using a copy of the Qurʾān for target practice, and declaiming verses in which he places himself proudly among the damned.[43] In another poem, he professes to be ready for the flames of hell, if only he can become, for a moment, the cross he has just seen a pretty girl reverencing in church.[44] Contemporaries who moved in the same circles seem to have perceived al-Walīd as one who was deliberately placing himself beyond the bounds of Islam.[45]

In one respect, though, al-Walīd differed from his father: his genuine talent for poetry—itself a potentially impious taste, in the eyes of the strict.[46] Among contemporaries, his reputation was backed up by his prodigious skill and energy as a musician;[47] and he is still esteemed today in Arabic literary circles for the delicacy of his wine and love poetry.[48] Because his verse was a direct expression of his way of life (or, at least, could plausibly be represented as such), all sorts of anecdotes gathered around the poems in order to explain their content and context, just as stories were woven round each verse of the Qurʾān, to show why and on what occasion it had been revealed. The long chapter on al-Walīd in the *Kitāb al-aghānī* is an excellent specimen of this genre of poetic-biographical commentary. Its colorfulness has attracted the attention not only of literary historians but also of students of Umayyad politics and art, with the result that al-Walīd has come to bulk somewhat larger than his brief reign alone can justify in accounts of the Umayyad dynasty, and especially of its contribution to Arab culture.

Even after his succession to the caliphate, al-Walīd seems to have stayed mostly in the Balqāʾ and pursued his pleasures.[49] It is hard to see much difference between the stories in the *Kitāb al-aghānī* that call him *amīr* and

42. Al-Madāʾinī in Bal. 2. fol. 162b = p. 324 (40 Derenk) and Iṣf. 7.57 (trans.Berque 124); al-Iṣfahānī, *Al-qiyān* 16–17.

43. Iṣf. 7.59–60 (trans. Rotter 119).

44. Al-Walīd b. Yazīd no. 32/127 (trans. Hamilton 165).

45. Al-Madāʾinī in Bal. 2. fol. 156a = p. 311 (8–9 Derenk); Bal. 2. fol. 719a (23, §41 ʿAthāmina) and Ṭab. 2.1747 (trans. 26.96); Ṭab. 2.1742, 1838 (trans. 26.89–90, 190), Iṣf. 7.6, 10 (trans. Derenk 76 77, 81).

46. Cf. Iṣf. 7.90 (trans. Rotter 125). For the Qurʾān's view of poets see 26.224–27.

47. Iṣf. 9.314.

48. See Blachère's sensitive essay in *Analecta* 379–99; also Jacobi, *Festschrift Ewald Wagner*.

49. This may be deduced from Bal. 2. fol. 166a = p. 331 (55 Derenk); Ṭab. 2.1743, 1776 ad init., 1795, 1819 (trans. 26.91, 127, 148, 174); and cf. Bal. 2. fol. 163b = p. 326 (45–46 Derenk); *History of the patriarchs of Alexandria* pp. 368–69.

those in which he is *amīr al-muʾminīn*.[50] For him the caliphate was not so much a responsibility as an opportunity to indulge his longing for

> ripe girls like statues, slaves, and mounts to hunt,
> and dizzy wine.[51]

He gathered poets around him, especially those of the Ḥijāz school, who had long suffered for their reputation as libertines.[52] And their shared pleasures nourished his own poetry, imparting to the Arabic wine song a new subtlety, of which the great Abū Nuwās was soon to be the heir:

> God and the holy angels hear me speak,
> and all the righteous worshippers of God.
> These are my heart's desire: a cup of wine,
> the sound of music, and a pretty cheek
> to bite; a noble friend to drink with me,
> a nimble serving man to fill my bowl,
> a man of wit to talk; an artful minx
> with round young breasts in jeweled necklaces.[53]

Al-Walīd had inherited his affection for the Balqāʾ from his father. In fact, although some of the earlier Umayyads had owned properties in the lands south and east of the Ḥawrān that we call Jordan,[54] Yazīd and his son are the only members of the clan after al-Walīd I (705–15) who are known to have built anywhere in this region. Yazīd's attachment to al-Balqāʾ extended beyond his tragic association with Bayt Rās. For example, only 45 kilometers west of Quṣayr ʿAmra, at al-Muwaqqar on the road to ʿAmmān, an Arabic inscription states that in A.H. 104 (A.D. 722–23) he ordered the construction

50. He may even be addressed as Caliph in stories that clearly took place under Hishām; see, for example, the comedian al-Ashʿab in Iṣf. 3.344–45.

51. Al-Walīd b. Yazīd no. 15/16 (trans. Hamilton 20–21; cf. Derenk 92; Gabrieli 28).

52. See Ḥammād al-Rāwiya in Iṣf. 22.106 for a characteristic list.

53. Al-Walīd b. Yazīd no. 22/24 (trans. Hamilton 149; cf. Derenk 106).

54. E.g., Abū Sufyān (d. c. 653), the father of the caliph Muʿāwiya, who owned a village in al-Balqāʾ (al-Balādhurī, *Kitāb futūḥ al-buldān* 129; Yāq. 1.472 s.v. "Biqinnis"); ʿAbd al-Malik, who owned an unidentified property in Jordan called Qaṣr Khālid (Ibn ʿAsākir, *Taʾrīkh madīnat Dimashq* 2[1].133; not to be identified with al-Faddayn *pace* G. Bisheh in Delmont, ed., *Jordanie* 161–62, who confuses Khālid b. ʿAmr b. ʿUthmān, owner of al-Faddayn, with Khālid b. Yazīd b. Muʿāwiya, who received Qaṣr Khālid from ʿAbd al-Malik) and resided on at least one occasion at al-Muwaqqar (see below): Elad, *Medieval Jerusalem* 155; and al-Walīd I (705–15), who built something (as yet undetermined) at Qaṣr Burquʿ in northeast Jordan in A.H. 81 (A.D. 700–701) according to an inscription (above, p. 127 n. 43). On the administrative and economic history of Umayyad Jordan see Northedge, *ʿAmmān* 1.48–52.

there of a reservoir for water—which is still in use.[55] Perhaps he was also responsible for building the residence, outbuildings, tower, and dams whose remains are to be seen at this hilltop site with its wide views "out over the harvested plains", "a gracious country".[56] References to al-Muwaqqar in panegyrics on Yazīd by Kuthayyir ʿAzza (d. 723) and in a poem by Jarīr (d. c. 729)[57] prove that the place was well known by the 720s; but it had already been used by ʿAbd al-Malik c. 690, as a hideaway from the plague.[58] It is worth noting that the numerous decorated capitals found at al-Muwaqqar are unusually varied and inventive in their decoration. Not only does each capital differ from all the others, but also the sides of the same capital, or the two halves of the same side, may be quite different. Clearly this was no ordinary residence. Similarities that have been observed between al-Muwaqqar's construction and decoration and those of other buildings in the Balqāʾ, including Quṣayr ʿAmra, that are commonly assigned to al-Walīd,[59] can be attributed either to continued work at al-Muwaqqar by al-Walīd or to the involvement of the same craftsmen in the projects of both father and son, over a period of intensive construction work and therefore stable employment prospects that can hardly have exceeded thirty years, c. 717 to 744.

We owe to Kuthayyir ʿAzza the observation that al-Qasṭal as well as al-Muwaqqar belonged to Yazīd.[60] Al-Qasṭal was a large and luxurious courtyard residence whose ruins may still be inspected beside the ʿAmmān–al-ʿAqaba highway, some 25 kilometers south of the modern capital and close to Mushattā.[61] Next to the palace stood a mosque with what appears to be the earliest surviving purpose-built minaret in all Islam. There was also a bath house, an audience hall with exceptionally fine mosaic floors and an alcove with flanking rooms very like Quṣayr ʿAmra and Ḥammām al-Ṣarāḥ in layout, a dam across the nearby Wādī ʾl-Qasṭal, and a reservoir. In the settlement's cemetery, gravestones have recently been discovered, which

55. Creswell 493–97, pls. 81–82; C. E. Bosworth, *E.Is.* 7.807; cf. Yāq. 5.226 s.v. "Al-Muwaqqar".

56. Lawrence, *Seven pillars of wisdom* 571, and Bell, *Arabian diaries* 156, respectively; cf. Najjar, Azar, and Qusous, *A.D.A.J.* 33 (1989).

57. Kuthayyir ʿAzza, *Dīwān* 340, 344, 349; Jarīr and al-Farazdaq, *Naqāʾid* 997.6. For further references in poetry to al-Muwaqqar see al-Maʿīnī, *Abḥāth al-Yarmūk* 9 (1991), and *Al-Balqāʾ* 1 (1992) 145–52.

58. Above, p. 21.

59. Creswell 495 (Qaṣr al-Ṭūba and Quṣayr ʿAmra), 496 (Mushattā); R. Hillenbrand, *K.Is.* 162 (Mushattā and Khirbat al-Mafjar).

60. Kuthayyir ʿAzza, *Dīwān* 340, 349.

61. Carlier and Morin, *Archiv für Orientforschung* 33 (1986); Imbert, *Archéologie islamique* 3 (1992); Piccirillo 352; Bisheh, *Liber annuus* 50 (2000).

may commemorate descendants of al-Walīd who continued to live here under the early Abbasids. The relative infrequency of references to al-Qasṭal in contemporary poetry suggests it was far from being as important as al-Muwaqqar.[62] Nonetheless, the occasional references in our sources to al-Walīd residing during his caliphate at "al-Qasṭal"[63] must concern the site in the Balqāʾ and not the residence of the same name between Homs and Palmyra, because the latter was one of the main centers where al-Walīd's cousins hatched the plot that led to his downfall.[64]

The early Abbasid historian al-Madāʾinī records how on one occasion Yazīd went to spend some time in the country at a place called al-Faddayn,[65] which lies just north of al-Mafraq, a town of the Balqāʾ roughly as far southeast of Bayt Rās and Irbid as it is northeast of ʿAmmān. What Yazīd's living arrangements were at al-Faddayn we do not know; but we learn that the settlement included a qaṣr. Qaṣr (pl. quṣūr) is often translated "castle" in English, but in the Arabic of the steppe or desert, according to Charles Doughty, "has commonly the sense . . . of 'stable habitation', whether clay or stone, and opposite to *bayt shaar*, the hair-cloth booth, or removable house, of the nomads".[66] This qaṣr—which can hardly, as Musil thought, be Qaṣr al-Ḥallābāt, some 25 kilometers distant[67]—belonged to Saʿīd b. Khālid b. ʿAmr b. ʿUthmān b. ʿAffān (a great grandson, in other words, of the third caliph), whose daughter Saʿda was married to the young prince al-Walīd, fifteen years old when his father died in 724. Hither, then, al-Walīd would come to visit both his father and his father-in-law. On one particular occasion, when Saʿīd was ill, he also caught sight for the first time of Saʿda's sister Salmā, and immediately fell in love with her.

62. Al-Maʿīnī, *Al-Balqāʾ* 1 (1992) 145 (al-Muwaqqar: 14; al-Qasṭal: 3).

63. Saʿd b. Murra b. Jubayr, in Iṣf. 7.32 (trans. Derenk 109); al-Azdī, *Taʾrīkh al-Mawṣil* 52.

64. Ṭab. 2.1784 (trans. 26.137), 1896 (trans. 27.8); Haase, *Untersuchungen* +37.

65. Al-Madāʾinī and Abū 'l-Yaqẓān al-Nassāba in Bal. 2. fols. 157b–158a = pp. 314–15 (16–17 Derenk); al-Madāʾinī in Iṣf. 7.33–34 (trans. Derenk 111), reading "Qurayn" ("Fartanā" at Iṣf. 7.36 [trans. Derenk 114; likewise from al-Madāʾinī] must also be al-Faddayn); cf. Yāq. 4.240 s.v. "Al-Faddayn", and Sauvaget, *R.E.I.* 35 (1967) 47 n. 5. Yāqūt's spelling is adopted here, but in more modern usage the toponym has been Fudayn (with or without the article: Musil, *Northern Arabia* h4; Lammens, *Études* 339 n. 6; Ṭūqān, *Al-ḥāʾir* 404), which means the same as Quṣayr. *Mutabaddiyan* (from *tabaddā*) is a common expression, also used of al-Walīd's withdrawal from al-Ruṣāfa to the privacy of al-Aghdaf: al-Madāʾinī in Iṣf. 7.7 (trans. Derenk 79), and see below, p. 156.

66. Doughty, *Arabia deserta* 1.147; cf. 2.634. On the word qaṣr see further below, pp. 273–74.

67. Musil, *Palmyrena* 283.

Al-Madāʾinī's story has acquired even more interest since 1986, when a French archaeologist, who thought that al-Faddayn with its cyclopean masonry would be a wonderful site at which to study the North Jordanian Iron Age, found himself excavating an Umayyad mansion complete with bath house, mosque, and various nonfigural wall paintings. The plan of the bath house is not unlike that of Quṣayr ʿAmra; but most interesting of all is the collection of luxury household objects that was found in the mansion. Apart from the magnificent bronze and iron brazier already mentioned in chapter 2, adorned with erotic scenes like those on the central vault of Quṣayr ʿAmra (fig. 27), there were also unearthed a bronze incense burner and incense pourer; various ivory objects, including a palette with incised decoration showing a she-camel with its young on one side, and on the other a palm tree and an arch with a hanging lamp; an iron lamp stand with a steatite lamp shade adorned with arcades and hanging lamps, and geometrical designs; ten decorated steatite containers, some of them inscribed in Arabic with a woman's name; ten glass bottles for water or wine; and two bronze molds, representing a ram and an elephant; also some fragments of stucco decoration with vegetal motifs.[68]

More domestic utensils of the Umayyad period have recently been excavated at Umm al-Walīd—"Mother of al-Walīd"—southeast of Mādabā and 16 kilometers from Mushattā. There are remains at this site of no fewer than three Umayyad *quṣūr*, together with a mosque, bath house, two large dams, and an associated village.[69] Given that al-Walīd was so closely linked with the Balqāʾ, it is tempting to associate these *quṣūr* with his mother; and since she was a niece of ʿAbd al-Malik's noted governor of ʿIrāq, al-Ḥajjāj b. Yūsuf al-Thaqafī, one may also wonder whether Umm al-Walīd is the family *mazraʿa*—a country estate or farm—to which al-Walīd's disgraced governor of ʿIrāq, Yūsuf b. ʿUmar al-Thaqafī (a cousin of al-Ḥajjāj), retreated after his patron's assassination.[70] (The Umayyads' greatest modern student, Julius Wellhausen, was moved to call this repellent and sadistic individual

68. Humbert, *Liber annuus* 36 (1986); *Voie royale* 267–70; Humbert, *Contribution française*; Bienkowski, *Art of Jordan* 92 pl. 109, 106 pl. 120, Delmont, *Jordanie* 180–68; *Omeyyades* 51–52, 68–69; cf. Humbert, *A.J.* 2.221–24; and Vibert-Guigue diss. 2.149–50, *Q.ʿA.* 115 fig. 78, for the unpublished bath house, mosque, and paintings found by the Jordanian Department of Antiquities in 1993. On braziers see Ahsan, *Social life* 185–86. *Is.A.A.* 308 n. 145 treats the al-Faddayn brazier as "pre-Islamic", without explanation.
69. Bujard and Trillen, *A.D.A.J.* 41 (1997); Bujard, *D.A.* 244 (1999) 88–99 (domestic utensils); *Omeyyades* 51, 81–83, 92.
70. Ṭab. 2.1840–42 (trans. 26.200–203); and cf. Bisheh, *S.H.A.J.* 3.195–96.

both a troll and—on the same page—a toad.[71]) Even if Umm al-Walīd is not the exact *mazraʿa* in question, still its name may suggest that it was one of the no doubt numerous properties the al-Thaqafīs owned in this fashionable area.

Together, al-Faddayn and Umm al-Walīd evoke the Umayyad clan's concentric circles. We may also recall another *qaṣr* far to the south, "on the hill of Maʿān", and known only from a literary source that speaks of "a green garden next to a wide wadi opposite the *qaṣr*". The estate is said to have belonged to "one of the Banū Umayya", too obscure, it seems, for his name to have been remembered.[72] There were the hangers-on as well: individuals or families linked to the ruling dynasty through shared interests and perhaps one or more of the innumerable marital alliances by which friends were gained and power maintained; and senior officials who aspired to emulate their masters' way of life.[73] Even a poet who had caught the ear of a prince might aspire to own a *ḥiṣn*, or fort, in the Balqāʾ.[74] The provinces were squeezed and squeezed again for taxes to pay for the handouts and pensions absorbed by these transient (and all the greedier for that) beneficiaries of the regime.[75] And they in turn were drawn to the Balqāʾ, with its abundant waters and fertility, its once more extensive forests and the cover they gave animals (as round al-Faddayn, for example),[76] and its proximity to the winter warmth of the Jordan Valley. It offered, as well, convenient access to Damascus, but also to Makka and al-Madīna, the Umayyad world's religious and cultural nerve center.[77] By the same token it might be used as a retreat when the plague made life dangerous in the city of Damascus and in the ring of Ghūṭa suburbs and country estates—it was in this greater Damascus area that most members of the Umayyad elite had their primary residence.[78] We may see in the Balqāʾ's abundance of high-profile luxury properties one of

71. Wellhausen, *Das arabische Reich* 230.
72. Ibn ʿAsākir, *Taʾrīkh madīnat Dimashq, Tarājim al-nisāʾ* 520. The anecdote as here related concerns one of al-Walīd b. Yazīd's invitations to poets to visit him from al-Madīna.
73. Cf. below, p. 277 n. 118.
74. Yāq. 2.51 s.v. "Tanhaj".
75. See the letter by al-Walīd II quoted in Ṭab. 2.1779 (trans. 26.130); cf. Blankinship, *Jihād state* 82.
76. Ṭūqān, *Al-ḥāʾir* 404.
77. On the crucial importance of these north-south routes, see King, *Proceedings of the seminar for Arabian studies* 17 (1987).
78. See above, p. 21, on ʿAbd al-Malik retreating to al-Muwaqqar; and on the residences of the Umayyads Ibn ʿAsākir, *Taʾrīkh madīnat Dimashq* 2 (1).141 and passim, especially the selection ed. al-Munajjid, *Muʿjam Banī Umayya*.

the end products of those massive transfers of capital from one province to another, of which al-Walīd's subjects were to complain so bitterly, and which were to be one of the reasons for his downfall.[79]

We find al-Walīd in residence at al-Faddayn on at least one further occasion, and again in connection with Salmā. Having divorced Saʿda in order to marry her sister, al-Walīd had incurred the displeasure of their father. It was only when he became caliph, in 743, that Saʿīd's objections, partly of a legal nature, could be surmounted. It is in this connection that we find a reference to al-Walīd's summoning experts in the law from al-Madīna to visit him at al-Faddayn and provide an opinion on a controversial point concerning divorce.[80] In the long years that had intervened since he first met Salmā, Hishām's accession and his own assumption of the role of crown prince had compelled him to move to al-Ruṣāfa. His final falling out with Hishām took place only after he led the Pilgrimage to Makka in A.H. 116 (A.D. 735),[81] and possibly not until the death in 738 of a moderating influence, Hishām's half brother, the famous general Maslama b. ʿAbd al-Malik, mentioned in one passage of the *Kitāb al-aghānī* just before the final rupture between the caliph and his heir.[82] But this unpleasant row at least gave al-Walīd an excuse to return to his beloved Balqāʾ, where he lost no time in establishing himself, according to al-Ṭabarī, "at al-Azraq between the territory of the Balqayn and the Fazāra (tribes) at a watering place called al-Aghdaf", in an area of *rīf*, that is to say, cultivation or at least pasture.[83]

Al-Aghdaf may be Qaṣr al-Ṭūba by the Wādī 'l-Ghadaf some 70 kilometers south and a little west of al-Azraq and still today—for all the "development" of the wilderness and degradation of the environment of most of its Umayyad monuments—a genuinely remote place. Musil reported two wells there, and signs of gardens long since abandoned.[84] Al-Walīd was not the man to be put off by the logistical problem of conveying workers, building materials, and supplementary food and water to such an isolated spot. Even shortly before his assassination he was said to have been preoccupied

79. *Khuṭba Yazīd.*

80. Yāq. 4.240 s.v. "Al-Faddayn".

81. Al-Madāʾinī in Ṭab. 2.1741–43 (trans. 26.88–91) and Iṣf. 7.7 (trans. Derenk 78–79); Bal. 2. fol. 155b = p. 310 (7 Derenk).

82. Al-Madāʾinī and others in Iṣf. 7.11, 13–14 (trans. Derenk 83, 84–86), quoting al-Walīd's laments. Iṣf. may well be following al-Madāʾinī's ordering of events.

83. Al-Madāʾinī in Ṭab. 2.1743, 1795–96 (trans. 26.91, 148–49 C. Hillenbrand), and Iṣf. 2.233, and 7.14 (trans. Derenk 86), reading "al-Azraq" for "al-Abraq"; cf. Bal. 2. fol. 156b = p. 312 (10 Derenk), 158b = 316 (20 Derenk); Sauvaget, *R.E.I.* 35 (1967) 40 n. 1.

84. Musil, *Ḳ.ʿA.* 1.111.

by a canal he was having dug (though apparently far to the west, in the Jordan Valley), ignoring the pressing news that kept on arriving about the uprising against him and the evolving situation in Damascus.[85] It was a question, after all, of his pleasures—heaven for him was the desert, its night sky, and wine enjoyed in the company of his poets and singing girls.[86] If "Abāyin", which he visited one spring as caliph, according to the *Kitāb al-aghānī*, is Qaṣr Bāyir by famous, much-used wells where an old track to the Wādī Sirḥān crosses one of the roads that linked Damascus to Western Arabia, then he penetrated the Jordanian desert well to the south of al-Ṭūba.[87] An Egyptian Christian source preserves an awed account of al-Walīd's building projects in the desert, without naming them.[88]

The enormous complex at Qaṣr al-Ṭūba was planned to consist of two roughly 70-meter-square courtyard dwellings with projecting semicircular towers clearly intended for decoration rather than defense. Each had its own main entrance, but the two dwellings were constructed side by side with a shared wall and were linked via an internal corridor.[89] The scale seems to be appropriate to a princely dwelling; yet it is not clear whether Qaṣr al-Ṭūba possessed the audience hall or elaborately decorated reception rooms that are often found in Umayyad palaces.[90] That it is "at al-Azraq" only in the broadest sense we may put down to our literary sources' understandable tendency to attach well-known toponyms to whole regions; but the fact that

85. Al-Madāʾinī in Ṭab. 2.1803 (trans. 26.157). This project was regarded as highly extravagant: cf. the *Khuṭba Yazīd* (reading "canal" for "river" at Ṭab. trans. 26.194). See also *The secrets of Rabbi Simon ben Yōḥay*, a Jewish apocalypse of early Abbasid origin (allusion to murder of Marwān II and kin), quoted by B. Lewis, *Studies in classical and Ottoman Islam* V.326, and cf. 309, 327–28; King, *S.H.A.J.* 4.374; Khamis, *B.S.O.A.S.* 64 (2001) 174. For the Sasanians, digging canals was a characteristic and necessary royal activity: Mas. 661 (1.313 Dāghir); Northedge, Wilkinson, and Falkner, *Iraq* 52 (1990) 131–34, on a late Sasanian palace and canal at Sāmarrāʾ. For ascetic Muslims, on the other hand, "digging canals and planting trees" was to evoke the very opposite of their vocation: Goldziher, *Introduction* 129 n. 39.

86. Al-Walīd b. Yazīd nos. 14/15 (trans. Rotter 121), 66/70 (trans. Gabrieli 2; Rotter 126); Mas. 2240 (3.214 Dāghir); Iṣf. 7.72–73 (trans. Hamilton 130).

87. Iṣf. 2.303–4; Nöldeke, *Z.D.M.G.* 61 (1907) 226; Bell, *Arabian diaries* 48–49, 163–64; Gertrude Bell Photographic Archive (www.gerty.ncl.ac.uk) Y 183–95; Creswell 642–43; King, *Proceedings of the seminar for Arabian studies* 17 (1987) 91, 95–97; Gyssens and al-Khraysheh, *A.D.A.J.* 39 (1995). Strategic position of Bāyir: Lawrence, *Seven pillars of wisdom*, index s.v. "Bair".

88. *History of the patriarchs of Alexandria* pp. 368–69.

89. Creswell 607–13, pls. 137–38.

90. Carlier and Morin, *A.D.A.J.* 28 (1984) 380. Hence King's suggestion, *Proceedings of the seminar for Arabian studies* 17 (1987) 96, 99, that al-Ṭūba was a khan rather than a residence. The many roads he has converge on this site (map 2, p. 105) are hypothetical but not implausible.

al-Ṭūba never came anywhere near being completed is more worrying, especially since al-Iṣfahānī's authorities, including al-Madāʾinī, state that al-Walīd lived at al-Aghdaf from when he left al-Ruṣāfa until Hishām's death,[91] a period of possibly as much as eight years. Pending further investigation of Qaṣr al-Ṭūba, we should perhaps envisage al-Walīd based there, using tents as well as the completed part of the *qaṣr*, during the spring, when the desert comes alive after the winter cold and rains, and there is abundant water in the pools of the Wādī ʿl-Ghadaf.[92] He may conceivably have possessed or at least planned a residence at al-Azraq too, though its mosquitoes used to be notorious.[93] Arguably Umayyad remains have recently been discovered there, including basalt carvings that depict birds, fishes, and animals of the chase such as the onager, gazelle, lion, lioness, saluki dog, mountain goat, and hare. The carvings adorned an enclosure wall that was designed to control the water supply and perhaps to create a garden or hunting enclosure.[94]

In general, al-Walīd "disliked inhabited places . . . kept on the move, and was often hunting", according to al-Ṭabarī, writing with particular reference to the period when he was caliph.[95] If Qaṣr al-Ṭūba was indeed his, he may also have been responsible for Mushattā, which resembles it in scale and—very closely—in construction technique and decoration, as well as in having never been finished, but is much nearer to reliable supplies of water and permanently inhabited territory (fig. 3).[96] It is also an infinitely more exhibitionistic building than Qaṣr al-Ṭūba: one can imagine its splendid, ri-

91. Iṣf. 2.233.

92. Musil, *Ḳ.ʿA.* 1.123. Imbert, *Arabica* 47 (2000) 385–86, imaginatively suggests that an Umayyad inscription found not far from Qaṣr al-Ṭūba and containing Qurʾān 43.88–89, against unbelievers, may have been provoked by al-Walīd's presence in those parts. This is more plausible than Enderlein's interpretation of al-Ṭūba's double layout as a residence for al-Walīd's two sons and heirs (see next chapter), al-Ḥakam and ʿUthmān: *Islam* 78.

93. On the noxiousness of the mosquitoes and fevers of the oases, see the poet Ibn Mayyāda addressing al-Walīd at "Abāyin" (cf. above, p. 157): Iṣf. 2.305 lines 2–3.

94. Sauvaget, *R.E.I.* 35 (1967) 39–40; Bisheh, *A.D.A.J.* 30 (1986) 12–14 and pls. 11–18; *Omeyyades* 162–63; Kennedy, *ARAMCO world* 51(3) (2000) 45 (aerial photograph); Watson and Burnett, *Near Eastern archaeology* 64(1–2) (2001). For a probably quite similar structure at Makka, designed as a reservoir and constructed of large carved blocks by an Umayyad governor no later than 717 see al-Azraqī, *Akhbār Makka* 2.107.

95. Al-Madāʾinī in Ṭab. 2.1776 (trans. 26.127).

96. Creswell 578–606, 614–41; cf. 607–13, 623, and Moraitou, Μουσείο Μπενάκη 1 (2001) 161–63, for similarities with Qaṣr al-Ṭūba; Enderlein and Meinecke, *J.B.M.* 34 (1992) 137–46, esp. 145–46 on new evidence suggesting a late Umayyad date. Grabar, *D.O.P.* 41 (1987), prefers to see Mushattā as an early Abbasid "formal building of power rather than . . . a château". Unlike the ʿAmmān citadel though (see below),

otously decorated audience hall and the elaborate, delicately wrought
stonework of its facade arousing Hishām's ire and envy, but also providing
an excellent setting for warm-weather entertainments after the relative aus-
terity and isolation of the winter months. Perhaps al-Walīd imitated the sea-
sonal migrations of his grandfather ʿAbd al-Malik between al-Ṣinnabra by
the southern end of Lake Tiberias for the winter, al-Jābiya and Damascus
until it became too hot, and Baʿlabakk in Lebanon for the summer.[97] Al-Walīd
would have moved up to Mushattā from al-Ṭūba or Qaṣr Bāyir or wher-
ever else in the steppe he had spent the spring, in order to pass the summer
months in the relative coolness of the Balqāʾ highlands. Then in the winter,
which is not always so mild at the altitude of Mushattā,[98] al-Walīd would
have taken "his camp, his treasures and his women"[99] to bask down in the
warmth of the Jordan Valley, where Khirbat al-Mafjar was graced at some
point in Hishām's reign with another flamboyant palace alongside a no less
palatial bath house.[100] This palace—also incomplete, though to a much lesser
degree—boasted a considerable series of figural, possibly historical frescoes,
known only from fragments, but which would certainly have borne com-
parison with Quṣayr ʿAmra.[101] Not surprisingly, Khirbat al-Mafjar too has
been attributed to al-Walīd (but as *amīr*, in the reign of Hishām).[102]

the site had neither military value nor a population to overawe; and are we to at-
tribute al-Ṭūba to the Abbasids as well? Grabar's subsequent reticence about his ar-
gument (*A.O.* 23 [1993] 100 n. 6), along with Enderlein and Meinecke and the par-
allels with al-Ṭūba, are all ignored by Whitcomb, *Archaeology of Jordan* 507–8, who
argues from "parallels in size, orientation, and hierarchical arrangement" between
Mushattā and the ʿAmmān citadel palace that the latter too must be Abbasid. But
parallels in size and hierarchical arrangement are legion in structures of this type,
while Whitcomb adjusts the north-northwest—south-southeast orientation (with ex-
tramural off-axis mosque) of the ʿAmmān palace to make it correspond to Mushattā's
north—south orientation (and intramural mosque). Whitcomb also asserts, *Archae-
ology of Jordan and beyond* 511, that "the only carved stone decoration" in the "desert
castles" is to be found at Mushattā and ʿAmmān—forgetting the wonderful speci-
mens from al-Ṭūba (see, for example, *Omeyyades* 111).

 97. Al-Madāʾinī in Bal. 200 (Ahlwardt).
 98. Cf. al-Muqaddasī, *Aḥsan al-taqāsīm* 179; al-Maʿīnī, *Abḥāth al-Yarmūk* 8
(1991) 114–15.
 99. Bal. 2. fol. 166a = p. 331 (56 Derenk).
 100. Creswell 545–77. For resemblances between Khirbat al-Mafjar and Mu-
shattā, see Hamilton 172. Though Ettinghausen argues at length, *From Byzantium
to Sasanian Iran* 17–65, that the great hall adjacent to Khirbat al-Mafjar's bathing
installations is a "throne hall" not a "bath hall", the distinction hardly bothered late
antique patrons: above, pp. 53–55.
 101. Grabar, *K.M.*, esp. 313–14.
 102. E.g., *K.M.* 232. The discovery, apparently in surface scatter outside the
southeast corner tower of the uncompleted palace, of a piece of marble with a letter

If al-Walīd was indeed the patron of so many unfinished projects,[103] the reason for their incompletion would not be far to seek, either in his loss of his allowance from Hishām while still crown prince[104] or in his sudden assassination after just over a year as caliph. As for their numerousness: bearing in mind that Hishām left a full treasury,[105] while, for part of his tenure as heir apparent and the whole of his reign as caliph, al-Walīd did without the facilities of Damascus or other large cities, it should not seem strange if he initiated several rather grandiose projects in his preferred place of residence. In addition to the sites already mentioned, it is worth noting that the large palace, parts of which still stand on the citadel of 'Ammān and display markedly Iranian taste in architectural decoration, has been dated to this period. As caliph, al-Walīd is known to have imprisoned Hishām's son Sulaymān at 'Ammān, presumably in its citadel; and 'Ammān was the nearest administrative, religious, and market center to many of the Umayyad residences in al-Balqā'.[106]

As satellites of these major structures, one would expect to find some lesser amenities too, both public and private. For example, just a short ride from Mushattā, at a staging post called Zīzā' on the *ḥajj* road, al-Walīd

> would feed for a period of three days people returning from the pilgrimage. He would give fodder to their riding animals and would refuse nothing that was asked of him.[107]

addressed to Hishām written on it in ink (Baramki, *Q.D.A.P.* 8 [1939] 53), implies Hishām was still alive during the last construction phase. My thanks to Jeremy Johns for discussion of this evidence.

103. Note also the canal project mentioned above, pp. 156–57. Against Mielich, *Ḳ.ʿA.* 1.191a, 194a, C. Vibert-Guigue believes that Quṣayr 'Amra was completed: personal communication, 28 November 2001.

104. This supposed penury leads Bisheh, *Archaeology of Jordan and beyond* 59, 63 n. 2, to doubt any link between al-Walīd and Khirbat al-Mafjar. But al-Walīd was already a mature man by contemporary standards (see below, p. 183) when he embarked on his nineteen-year stint as heir apparent to Hishām at the age of fifteen in 724. Between that date and his rupture with Hishām in c. 735–38 he had at least eleven years—and abundant resources—to get Khirbat al-Mafjar under way. Even once he lost his annuity, he still enjoyed the properties he had inherited from his father, access (presumably) to the state's corvée system for concentrating labor forces (see below, pp. 254–55), and—more important than cash in hand to artisans not covered by the corvée—the imminent prospect of becoming caliph, when he could be expected to favor those who had stood by him.

105. Al-Madā'inī in Ṭab. 2.1732–33 (trans. 26.75).

106. Northedge, *'Ammān* 1.51, 88, 96–98, 156. On Sulaymān b. Hishām see al-Madā'inī in Bal. 2. fols. 163b, 168b = pp. 326, 336 (46, 67 Derenk), and Ṭab. 2.1776, 1825 (trans. 26.127, 183).

107. Ṭab. 2.1754 (trans. 26.103–4).

For his own personal use, what more natural than somewhere to relax with friends and guests after a day's hunting had carried them far from al-Ṭūba or Mushattā or al-Muwaqqar, to the environs of the Wādī 'l-Buṭum?

Even excluding hypothetical associations such as Mushattā and Khirbat al-Mafjar, al-Walīd's close personal ties—from his childhood—with the Balqāʾ alone suffice to make him the strongest candidate, among the late Umayyads, for our hunting lodge's patron. And he trumps his father too, who spent only three years as *amīr* or heir apparent, compared to al-Walīd's nineteen—more than enough time to account for either hypothetical or observed discontinuities in the process of construction and decoration. For there is no reason to assume that Quṣayr ʿAmra was built all at once, or even that it was necessarily commissioned after al-Walīd's departure from al-Ruṣāfa c. 735–38. He will have stayed in touch with his father's properties in the Balqāʾ throughout Hishām's early years. There are, though, certain clues that combine to suggest a date for the beginning of the construction phase round about 735. For example, several reasons were already given in chapter 2 why the buildings may not have been in use for a long period, or at least very often.[108] Besides suggesting a date well into al-Walīd's tenure as *amīr*, this point also counts against Yazīd as builder of Quṣayr ʿAmra, since in that case it would have been visited quite often by al-Walīd too, during the years he resided in the Balqāʾ. Admittedly, it has been argued that the very shallow points of the arches in Quasyr ʿAmra's hall, compared to neighboring structures such as Ḥammām al-Ṣarāḥ or Mushattā, imply a relatively early date for our bath house.[109] But even within so confined a geographical area, such arguments presuppose an improbably high degree of consistency and coherence in the building trade. They also ignore the fact that, without increasing the height of the building, it was impossible to give much of a point to the extremely wide arches that were chosen at Quṣayr ʿAmra, in order to achieve an overall effect of spaciousness.[110] So the degree of pointedness at Quṣayr ʿAmra is probably irrelevant as a chronological indicator. As it happens, though, the likewise only slightly pointed arches of the Qaṣr al-Ḥayr al-Sharqī mosque[111] are dated by an inscription to 728,[112] so we are under no obligation to put Quṣayr ʿAmra before that, even though al-Walīd had become heir apparent four years earlier, at the already mature age of fifteen.

108. Above, p. 47.
109. Creswell 502.
110. Compare the much fussier effect of the arcaded bath house hall at Qaṣr al-Ḥayr al-Sharqī: *Q.H.E.* ill. 44D.
111. Creswell 532.
112. Below, pp. 166, 255.

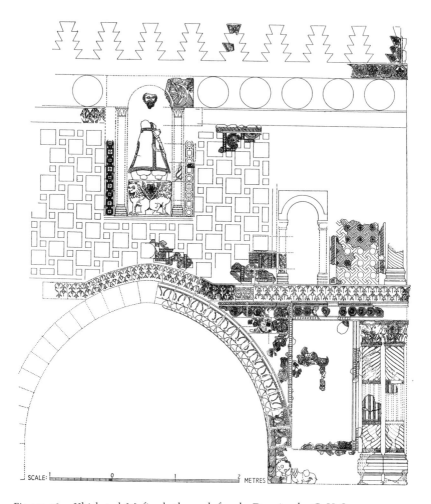

Figure 46. Khirbat al-Mafjar, bath porch facade. Drawing by G. U. Spencer Corbett, in R. W. Hamilton, *Khirbat al Mafjar: An Arabian mansion in the Jordan Valley* (Oxford: Clarendon Press, 1959) 99 fig. 52; by permission of Oxford University Press—© Oxford University Press, 1959.

It would then be perfectly reasonable to imagine the foundations of Quṣayr ʿAmra being dug in the early to mid-730s.

The same lack of wear and tear, which suggests a relatively brief period of use, has also been noticed in the palace—though not the bath house—at Khirbat al-Mafjar.[113] In other words, the Khirbat al-Mafjar bath house

113. *K.M.* 8, 27, 45, 244–45; and Hamilton, *Levant* 1 (1969) 61–63.

was built first and for a time stood alone like the one at Quṣayr ʿAmra. (Given the crucial *majlis* or reception hall aspect of these bath houses, we may extend the comparison to Mushattā, whose hall was completed, but not its flanking wings.) Another feature of Quṣayr ʿAmra that bears comparison with Khirbat al-Mafjar and implies a date toward the end of al-Walīd's life at least for their decoration is the Adamic splendor of the princely portrait, paralleled in the distinctly caliphal appearance of the Sasanian-style stucco statue—presumably depicting the patron—that stood in a niche over the entrance to the Khirbat al-Mafjar bath house, flanked (again as in the Quṣayr ʿAmra portrait) by "courtiers dressed like their master in the finery of Persia" (fig. 46).[114] Assuming that both these images do indeed depict al-Walīd, it would be possible, in the case of Khirbat al-Mafjar, to suppose that the statue was executed after he became caliph.[115] But at Quṣayr ʿAmra, the Arabic text on the arch above the enthroned figure's head appears to identify him as heir apparent—a point that, as we have seen, is confirmed by another text in the east aisle.[116] It is possible, then, that both these images—Khirbat al-Mafjar's as well as Quṣayr ʿAmra's—reflect the unseemly impatience that crept up on the long-frustrated heir, as the years dragged by and Hishām still occupied the throne.[117] Al-Madāʾinī recorded how, even before he left al-Ruṣāfa, al-Walīd on one occasion took the place of honor in Hishām's *majlis* and barely moved aside even when the caliph himself came in.[118]

THE BUILDING A MIRROR OF THE MAN?

Despite, though, the probability that al-Walīd b. Yazīd was Quṣayr ʿAmra's patron, the subject of its princely portrait,[119] it needs to be emphasized that some of the arguments rehearsed above are worth more than others. In particular, the point about al-Walīd's intense interest in the Balqāʾ bears considerable weight, whereas the notion that distinctive aspects of his lifestyle are so closely reflected in the decoration of certain buildings, including

114. *K.M.* 232, and cf. 98–103, 228–32, pl. LV.1, 5; E. H. Peck, *E.Ir.* 5.760–61.
115. Cf. Hamilton, *Levant* 1 (1969), and Hamilton 172–75.
116. Above, pp. 126–27.
117. Cf. *K.M.* 232.
118. Al-Madāʾinī in Bal. 2. fol. 156a = p. 311 (9 Derenk) and Iṣf. 7.10–11 (tr. Derenk 81–82).
119. Scholars who have accepted Musil's suggestion are listed by Grohmann, *Arabische Paläographie* 2.73a n.3. For criticism of details of Musil's argument see Nöldeke, *Z.D.M.G.* 61 (1907) 227, and Hillenbrand, *Art history* 5 (1982) 22 n. 13.

Quṣayr ʿAmra, that they must have been his[120] is more debatable. It is reasonable to doubt that somebody as religious as ʿUmar II would have bothered with Quṣayr ʿAmra; but one did not need to be flagrantly immoral, or even an "exuberant aesthete",[121] in order to paint dancing girls on one's walls. This argument can be much reinforced if we turn now to our evidence for Hishām, the most historically significant of the late Umayyad caliphs, and the one whose reign covered nineteen of the thirty-five years (715 to 750) during which, according to our original hypothesis, Quṣayr ʿAmra could have been constructed.[122]

Unlike ʿUmar II, Hishām is said by certain of our historical sources to have shown a normal interest in women, entertainments, and luxurious living.[123] A contemporary account, by the literary scholar Ḥammād al-Rāwiya, conveys the brilliant impression made on a visitor by Hishām's court, and by the caliph himself.[124] As for his wives, ʿAbda left jeweled clothing that the caliph al-Mahdī (775-85) could bestow on his son's bride safe in the knowledge that "the like of it had not been seen in Islam"; while Umm Ḥakīm was remembered by posterity for her heroic drinking habits and her large cup of glass and gold, still to be seen in the Abbasid treasury a century and a half later.[125] Archaeology corroborates this picture, up to a point.

Qaṣr al-Ḥayr al-Gharbī consisted of a palace, a bath, an irrigated garden, and another building that may have been a caravanserai (fig. 47, 64, 67). It stood where the road from Palmyra westwards to Qaryatayn crosses the north-south route from Homs to faraway al-Jawf. An inscription over the entrance to the caravanserai (?) declares that it was erected by command of Hishām in the year 727;[126] while the homogeneous architectural style of

120. E.g., Hillenbrand, *Art history* 5 (1982) 1.

121. Hamilton 9.

122. Al-Walīd's successors are excluded as possible patrons of Quṣayr ʿAmra because Yazīd III (744) and Marwān II (744–50) took power by force so never served as *amīr*, while Ibrāhīm (744) was *amīr* for only five months, and caliph for two. Besides, Marwān adopted faraway Ḥarrān in northern Mesopotamia as his permanent residence: Ṭab. 2.1892, 1946; 3.9–10 (trans. 27.4, 57, 131–32).

123. Bal. 2. fol. 726a (71, §132 ʿAthāmina); Ṭab. 1.2816 (trans. 15.21); further references in ʿAṭwān, *Al-Walīd* 167–70, 181–82. See also below, p. 239.

124. Ḥammād al-Rāwiya in Iṣf. 6.85 (trans. Hamilton 76) and Ibn Khallikān, *Wafayāt al-aʿyān* 2.208 (trans. 1.471)—with the carpet, compare the vast and splendid specimen that had belonged to Hishām and over a century later was still the best the caliphal furniture store possessed: al-Shābushtī, *Diyārāt* 150.

125. Al-Shābushtī, *Diyārāt* 156; Iṣf. 16.298–301.

126. *R.C.E.A.* 1. no. 27, with drawing in Mordtmann, *Sitzungsberichte, Akademie der Wissenschaften zu München* (1875: 2.4), fold-out sheet; Creswell 506–7 and pl.

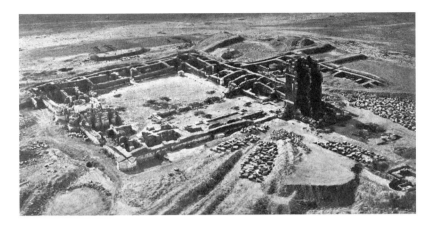

Figure 47. Qaṣr al-Ḥayr al-Gharbī from the air. Armée Française du Levant,
in M. Dunand, *De l'Amanus au Sinai : Sites et monuments* (Beirut: Imprimerie
Catholique, 1953) 142

the buildings confirms that Hishām was responsible for the whole project.
By its very form, unique in early Islam, the inscription reveals what im-
portance the caliph attached to this undertaking. Instead of being carved di-
rectly into the marble of the antique lintel that, together with two mono-
lithic doorposts, forms the building's portal, an old Roman practice has been
followed, of casting the letters in bronze and attaching them to the stone
with pegs. Their sockets, and the shallow grooves for the letters, are all that
now remains of this extremely elegant piece of work.

To its excavator, Daniel Schlumberger, Qaṣr al-Ḥayr al-Gharbī yielded a
wide range of figural decoration in the form of both stucco carvings and
paintings. It would richly have deserved the epithet *al-manqūsh*, "orna-
mented with sculpture or color", that was applied to the palace Hishām's
governor al-Ḥurr b. Yūsuf built in Mosul at exactly the same period.[127] The
decoration of Qaṣr al-Ḥayr al-Gharbī has been reassembled (along with the
inscribed portal) in the Damascus Museum. Besides the two ruler portraits
mentioned in the last chapter, we are also put in mind of Quṣayr ʿAmra by

85c; Enderlein and Meinecke, *J.B.M.* 34 (1992) 150 pl. 15. On the complex generally
see Ṭūqān, *Al-ḥāʾir* 151–79; *Q.H.G.* Northedge, *Entre Amman et Samarra* 47–48,
points out that there is no clear evidence for a caravanserai. (My thanks to the au-
thor for allowing me to read this unpublished dissertation.)

127. Al-Azdī, *Taʾrīkh al-Mawṣil* 24–25; cf. Robinson, *Empire and elites* 75, 80.

representations of women dancing, attending, carrying baskets of fruit, or simply bare of breast (fig. 23).[128] Hunting and music making are the subject of one of the two large fresco panels that adorned the stairwells that gave access to the caliph's reception rooms (fig. 31); while the other has in its central medallion a painting of Earth (Gē) and its abundant fruits (fig. 22) that is highly reminiscent of some of the figures painted on the sidewalls of the alcove at Quṣayr 'Amra.[129] A fragment of another fresco shows a very beautiful young woman wearing a head scarf.[130] Schlumberger even found carefully painted Greek letters on two or three other fresco fragments, one of which he thought might have depicted a historical scene.[131] None of this suggests great austerity.

Other residences associated with Hishām are more restrained. For example, an unspecified part of the much larger complex at Qaṣr al-Ḥayr al-Sharqī, east of Palmyra, is dated to the following year, 728, by an inscription worded similarly to that at Qaṣr al-Ḥayr al-Gharbī (fig. 48).[132] A glance at a map reveals a close strategic relationship between the two establishments. Both dominate major north-south routes through the low chain of mountains that tends northeastwards from near Damascus to the Euphrates. These routes were of crucial importance to Hishām, who lived at al-Ruṣāfa. They were also bottlenecks on the migration routes of the gazelle, and therefore prime vantage points for the hunter.[133] Yet Qaṣr al-Ḥayr al-Sharqī has yielded relatively little decoration, while what there was eschewed human forms and only once, so far as is known, depicted animals.[134]

As for al-Ruṣāfa itself, an Umayyad residence has been excavated to the south of the walled Roman city. It uses the same roughly 70-meter-square enclosure with projecting semicircular towers, living rooms arranged in self-contained suites round the central courtyard, a grandiose gatehouse, and the show rather than the reality of defensive capability that were deployed at Qaṣr al-Ḥayr al-Gharbī and the smaller of the two enclosures at Qaṣr al-Ḥayr al-Sharqī, as also at al-Qasṭal and Qaṣr al-Ṭūba, among other

128. Cf. above, p. 71; *Q.H.G.* pls. 64–70 (esp. 67c), 81–82; Trümpelmann, *A.A.* (1965) 257–58 and pl. 26.

129. Above, pp. 69–71.

130. Muratore, *Da Ebla a Damasco* 346–47 no. 252; *Q.H.G.* pl. 37, and cf. p. 14.

131. *Q.H.G.* 14; cf. Muratore, *Da Ebla a Damasco* 346–47 no. 253.

132. *R.C.E.A.* 1. no. 28 (and cf. below, p. 255); Creswell 532; *Q.H.E.* 191 and passim. Ṭūqān's account of the site, *Al-ḥāʾir* 181–201, appeared a year after *Q.H.E.*

133. *Q.H.E.* 156–57; Fowden, *Roman and Byzantine Near East* 108, 123. Note also Sauvaget, *Syria* 24 (1944–45) 110–12 (and cf. Lenoir, *Syria* 76 [1999] 229–34), on residences of Hishām at the southern end of the Dumayr—Qaryatayn corridor as well.

134. *Q.H.E.* 152–53, 175–79.

Figure 48. Qaṣr al-Ḥayr al-Sharqī from the air.
V. Shahinian.

later Umayyad sites.[135] These were altogether more impressive establish-
ments than the smaller courtyard dwellings evoked earlier, in chapter 2, in
connection with the ruined structure near the bath house at Quṣayr
ʿAmra.[136] The reception rooms of the specimen at al-Ruṣāfa were richly dec-
orated with stucco and wall paintings. It seems reasonable to assume that,
along with at least five other such residences known to have existed in this
3-square-kilometer area, and some thirty smaller buildings, it formed part
of the caliphal complex or rather city where Hishām, his sons,[137] his

135. For plans, and tabulation of characteristic features, see Carlier and Morin,
A.D.A.J. 28 (1984) 379–83.
136. Above, pp. 43–46.
137. Cf. Ṭab. 2.1751 (trans. 26.100) on Maslama b. Hishām's *manzil;* al-Bakrī,
Muʿjam mā istaʿjam 580 (trans. Kellner-Heinkele, *Resafa* 4.144).

Figure 49. Al-Ruṣāfa from the air, with the ruins of the Christian city in the distance, and to the south of them clear traces of Hishām's development. Armée Française du Levant, in Dunand, *De l'Amanus au Sinai* 140.

ministers,[138] and for a time his successor designate al-Walīd lived amidst gardens adorned with pleasure pavilions (fig. 49). But except perhaps for some hard-to-interpret fragments from one of these pavilions, no figural ornament has yet been found.[139]

The simplicity of Qaṣr al-Ḥayr al-Sharqī's decoration may be explicable in terms of the complex's function: perhaps it was not meant to be a residence as formal as Qaṣr al-Ḥayr al-Gharbī.[140] As for the absence of figural ornament at al-Ruṣāfa, one gets the feeling Hishām may have been avoiding offense to Muslim sensibilities at his capital, while indulging personal— or rather family—tastes at Qaṣr al-Ḥayr al-Gharbī. There is clear support for this interpretation in the literary record. A suggestive story depicts him longing to invite the comedian Ashʿab from al-Madīna, but eventually de-

138. Cf. al-Ḥarīrī, *Durrat al-ghawwāṣ*, quoted by Ibn Khallikān, *Wafayāt al-aʿyān* 2.208 (trans. 1.471), on the Īwān al-aḥmar (Red Hall) belonging to Yūsuf b. ʿUmar, who served as governor of ʿIrāq; also Iṣf. 10.191 on the residences of Sulaym b. Kaysān al-Kalbī, whose sons were to back al-Walīd II against his enemies (Ṭab. 2.1802 [tr. 26.156]) and ʿAmr b. Bisṭām al-Taghlibī.

139. Otto-Dorn, *A.O.* 2 (1957); Northedge, *ʿAmmān* 1.164; Ulbert, *Da.M.* 7 (1993), esp. 224; C.-P. Haase, *E.Is.* 8.631a; and, with an up-to-date plan of the area, Sack, *Zehn Jahre Ausgrabungen* 90–93, and Sack and Becker, *Stadt und Umland*.

140. *Q.H.E.* 32–33 argues that the smaller of Qaṣr al-Ḥayr al-Sharqī's two enclosures was a caravanserai. Northedge, *ʿAmmān* 1.163, 165, and *B.E.I.N.E.* 2.235–37, prefers to see it as a residence.

ciding not to for fear of the disgrace if word got round.[141] In our historical sources Hishām more often comes over as an austere, miserly puritan and born accountant than as a *bon viveur*.[142] We are told that once when he encountered a man who was said to keep singing girls, wine, and a lute *(barbaṭ)* at home, Hishām had the lute broken over his head. On another occasion, while on pilgrimage (725), he came across some effeminate musicians *(mukhannathūn)*, each with his *barbaṭ*, and straightway had them locked up, and their instruments sold.[143]

Apparently Hishām often felt the need to look upon his subjects with a threatening mien. Part of it, no doubt, was a wish to seem to emulate the asceticism of Muḥammad and his immediate successors; his carefulness with money may also have been imposed by the vast expense of the military campaigns he was forced to wage. But a certain hypocrisy was involved. This came out in his quarrel with al-Walīd, who resented being criticized for construction projects and playboy habits by a man who was busy building luxury residences for himself.[144] Hishām's was a complex character. The building most often adduced, in this and the three previous chapters, as a source of parallels to Quṣayr ʿAmra is Qaṣr al-Ḥayr al-Gharbī; yet its decoration offers a far more partial set of correspondences to what the literary souces tell us about its patron than is the case with Quṣayr ʿAmra and al-Walīd.

141. Bal. 2. fol. 718a (14, § 22 ʿAthāmina). For a family of entertainers that consorted with Yazīd II and returned to Syria in 743 to amuse his son but sat out Hishām's reign in al-Madīna see al-Iṣfahānī, *Al-qiyān* 16.

142. Al-Madāʾinī in Ṭab. 2.1730–37 (trans. 26.72–80) and Iṣf. 7.7–8 (trans. Derenk 78–80); Ḥammād al-Rāwiya in Iṣf. 4.87.

143. Al-Madāʾinī in Bal. 2. fol. 725b (67, §§123–24 ʿAthāmina) and Ṭab. 2.1737, 1733 (trans. 26.80, 76).

144. Bal. 2. fol. 156a = p. 311 (8–9 Derenk), quoted below, 240–41. Note in this passage, too, Hishām's antipathy toward lutes, already conspicuously manifested for Meccan consumption during the *ḥajj* of 725 (see above), yet followed soon after by the commissioning at Qaṣr al-Ḥayr al-Gharbī of a fresco depicting a lutenist and a flautist (fig. 31). On Hishām's palaces and public works, the latter a major theme of his panegyrists, see Jarīr, *Dīwān* pp. 11.6–7, 118.3–9 (trans. Strika, *A.I.O.N.* 30 [1970] 500, 504); Nadler, *Umayyadenkalifen* 259–62; *Secrets of Rabbi Simon ben Yōḥay* (see above, p. 157 n. 85), quoted by B. Lewis, *Studies in classical and Ottoman Islam* V.326, and cf. 309, 327; *Chronicon anonymum pseudo-Dionysianum vulgo dictum* (compiled in 775: Palmer, *Seventh century* 53–54) 2.171; Theophanes, *Chronographia* 403; al-Balādhurī, *Kitāb futūḥ al-buldān* 180; Robinson, *Empire and elites* 78–79, 84–85, 87 (on Mosul); Khamis, *B.S.O.A.S.* 64 (2001) 174–76; Madelung, *J.S.S.* 31 (1986) 171. Inscriptions: al-Rīḥāwī, *A.A.A.S.* 11–12 (1961–62) 106 (Arabic section)/207–8 (French section) (cistern at Rīmat Ḥāzim near al-Suwaydāʾ); Khamis, *B.S.O.A.S.* 64 (2001) (market building at Scythopolis/Baysān).

If, then, two characters as different as Hishām and al-Walīd could pro-
duce buildings as similar in their decorative themes, their hedonism, and their
eclectic allusions to Roman and Sasanian art as are Qaṣr al-Ḥayr al-Gharbī
and Quṣayr ʿAmra, those common denominators must primarily reflect a cur-
rent style rather than individual taste. The current style reflected by Qaṣr
al-Ḥayr al-Gharbī and Quṣayr ʿAmra can best be characterized as that of the
court's more intimate milieux. Sulaymān and Yazīd II will have absorbed it
just as easily as did Hishām and al-Walīd. Only ʿUmar II must have found
it unacceptable. Qaṣr al-Ḥayr al-Gharbī, Quṣayr ʿAmra, and, of course, Khir-
bat al-Mafjar all represent a courtly style that might be adopted by individ-
ual rulers of quite different character—just as, in the ninth century, the Ab-
basids decorated their palaces at Sāmarrāʾ with themes, such as bare-breasted
dancing girls, quite reminiscent of the Umayyads whose decadence they so
loved to denounce.[145] No doubt, had al-Walīd spent more time in Damascus,
even he would have found advisable a less sensually iconic throne room than
that which he allowed himself at remote Quṣayr ʿAmra.

As an eccentric's folly, Quṣayr ʿAmra would anyway be of only limited
interest to the historian. It may indeed owe at least part of its relatively low
impact on the study of early Islamic art, during the century after its dis-
covery, precisely to Musil's proposal that it be attributed to the notoriously
eccentric al-Walīd—a reasonable proposal that was founded, though, as
much on al-Walīd's attachment to the Balqāʾ as on his extravagant lifestyle.
The absence of a comprehensive presentation of Qaṣr al-Ḥayr al-Gharbī's
stucco decoration, to place alongside Robert Hamilton's thorough (but also
witty and refreshingly literate) publication of Khirbat al-Mafjar, has been
another obstacle to proper appreciation of Quṣayr ʿAmra's context. In real-
ity, its decor is far from unique among the Umayyad buildings of Syria. It
is a representative specimen of a later Umayyad courtly style, and a wor-
thy parallel in stone and paint to the classical Arabic ode's concluding sec-
tion, whether panegyric, *madīḥ*, or self-praise, *fakhr*.[146]

At the same time—and to conclude—it would be perverse to deny Quṣayr
ʿAmra any intimation of its patron's personality. We may, if we wish, see in
its paintings just as much *fakhr* as *madīḥ* and detect in at least some of its
images that edge of incitement (to pleasure) and defiance (of Islam) that a re-
cent critic has detected in al-Walīd's poetry.[147] And the elegant courtiers and

145. Herzfeld, *Die Malereien von Samarra* 29–32 and pls. XX–XXVIII; cf.
Is.A.A. 59.
146. For a useful reign-by-reign survey of the Umayyad *madīḥ* see Strika,
A.I.O.N. 16 (1966), drawing on the visual evidence too.
147. P. F. Kennedy, *Wine song* 25.

entertainers on the alcove walls have not stepped out of just any *majlis* (reception hall), even though they stand in two orderly lines before the throne—as al-Walīd's court did too, in its soberer moments.[148] Rather they seem to be denizens of al-Walīd's more intimate circle, which a slightly later writer calls a *majlis al-lahw*, "assembly for distraction",[149] and whose proceedings the prince himself was at times concerned to veil from publicity.[150]

Al-Walīd's, too, was a subtle personality. It was a characteristic conceit, to have himself depicted in the guise of Adam, the peak of creation and symbol of true religion. Likewise, in the letter quoted in chapter 4 by which he bestowed rights of succession on two of his sons, he made a point of drawing a parallel with God's designation of Adam as his deputy—his caliph—on earth.[151] Both the painting and the letter may have been responses to accusations that the Umayyads had perverted the caliphate into autocratic kingship, that *mulk* with which Satan had successfully tempted God's very first caliph.[152] Although the Umayyads themselves, and their courtiers, were wholly at ease with the vocabulary of kingship,[153] the noted al-Madīna jurist Saʿīd b. al-Musayyab (d. c. 712) was on a quite different wavelength when he observed that Muʿāwiya was the first who made the caliphate into *mulk*.[154] A recently discovered document that may date from shortly after Saʿīd's death reveals that adherents of the politico-religious tendency known as the Murjiʾa denounced the Umayyads as sinful kings from whom one should disassociate oneself;[155] while the ascetic Ḥasan al-Baṣrī (d. 728) questioned

148. Ṭab. 2.1820 (trans. 26.175); Iṣf. 7.111; and cf. Mas. 1830 (3.28 Dāghir) (Muʿāwiya I), and Iṣf. 18.220 (trans. Berque 127) (Hārūn al-Rashīd).

149. Hishām b. al-Kalbī in Iṣf. 5.123.

150. Ibn Qutayba, *ʿUyūn al-akhbār* 2.136; Bal. 2. fol. 161b = p. 322 (35 Derenk); Iṣf. 1.63 (trans. Hamilton 46), 9.314.

151. Ṭab. 2.1759 (trans. 26.108–9).

152. Qurʾān 20.120 and, for the caliphate-kingship tension more generally, 2.30 and 38.26, with the interesting discussion of this Islamic theme in the context of the Old Testament and East Rome by Dagron, *Empereur et prêtre* 68–73. Note though that in the Qurʾān *mulk* is usually a neutral concept, being frequently attributed to God as well; and it continued to be so used under the Umayyads: Tyan, *Institutions* 1.380–84.

153. Nadler, *Umayyadenkalifen* 37–42, 51, 58–63, 274–75; cf. the *Khuṭba Yazīd*, and Khālid b. Ṣafwān b. al-Ahtam (d. 752) in Iṣf. 2.130. Al-Yaʿqūbī, *Al-taʾrīkh* 2.232, asserts that Muʿāwiya called himself "first among kings".

154. Al-Yaʿqūbī, *Al-taʾrīkh* 2.232; and cf. below, p. 173 n. 165. The pure politics of power denoted by the term *mulk* is fully analyzed, with reference to Muʿāwiya, by Polat, *Umwandlungsprozess*, esp. 143–58.

155. *Sīrat Sālim b. Dhakwān* 8–12, edited, translated into English, and discussed by Cook, *Early Muslim dogma* 161–62, 24–25, 33–36 respectively; cf. van Ess, *Theologie und Gesellschaft* 1.174.

whether the caliph was owed absolute obedience, and held that the Umayyads should confine themselves to exercising governmental power *(sulṭān)* "for the protection of religion", and not conflate the two.[156] As a leading exponent of the doctrine of free will *(qadarīya)*, al-Baṣrī naturally resisted the Umayyads' view that they were an "act of God" and therefore owed the same unquestioning obedience his creator had demanded for Adam. (Here was another reason for al-Walīd, a committed anti-Qadarite like nearly all the later Umayyads, to paint himself as Adam on the wall.) It must also be significant that, as pointed out in the previous chapter, Quranic exegetes active under the Umayyads, when called upon to explain the polyvalent and in many ways obscure word *khalīfa* as applied to Adam, never—with one possible exception—suggested any connection between this term and the head of the Islamic state.[157]

One can appreciate, then, the political considerations that led al-Walīd to associate himself with Adam. Whether he also did so out of piety, we may doubt. Al-Walīd's shows of piety were usually precisely that. Quoting in one of his poems a verse from the Qurʾān in order to justify a petty posthumous revenge he had taken on Hishām, he rubbed in the calculated tastelessness of his gesture by adding:

> It was not out of innovation that we did so,
> but the Distinguishing Book fully permitted it to us.[158]

Nor was this the only time he gave in to his ironic urge to sanctify license with a Quranic tag. Elsewhere he flaunts his wine bibbing with the assistance of a scriptural allusion:

156. Ibn Khallikān, *Wafayāt al-aʿyān* 2.71–72 (trans. 1.371).

157. Above, p. 138. In writers who lived partly or wholly under Abbasid rule, accusations of *mulk* became predictably more frequent, e.g., Hishām b. al-Kalbī, al-Madāʾinī, and others, in Bal. 1.fols. 350a–b, 355a, 378b = pp. 699–700, 709, 756 (24, §78; 47, §170; 147, §§416–18 ʿAbbās) (trans. Pinto and Levi della Vida 16, §35; 45–46, §126; 159–60, §§368–70), on Muʿāwiya; Sibṭ b. al-Jawzī in Elad, *Bayt al-Maqdis* 54 (text), 35 (translation), reporting a tradition derived from Muḥammad b. al-Sāʾib al-Kalbī (d. 763; father of Hishām), quoting an opinion expressed by the anti-caliph ʿAbd Allāh b. al-Zubayr (d. 692) about Muʿāwiya and ʿAbd al-Malik; Madelung, *J.S.S.* 31 (1986) 144–47, on Muʿāwiya and the Umayyads generally in traditions from Homs; Abū Mikhnaf in Ṭab. 2.266, 367 (trans. 19.59, 162), referring to the reign of Yazīd I. Note also the sermon preached at the inauguration of the Abbasid caliphate, and quoted by Ṭab. 3.31 (trans. 27.155), with its denunciation of the autocratic character of Umayyad rule, which it sums up as the accumulation of silver and gold, the building of castles and the digging of canals (on which last see above, p. 169 n. 144, and below, p. 280).

158. Al-Walīd b. Yazīd no. 55/54 (Ṭab. 2.1752, trans. 26.101 C. Hillenbrand; cf. Hamilton 135; Derenk 100; Gabrieli 10; Rotter 113).

Would that today my share of all
 the livelihood and provisions which I have were to consist in
a wine on which to spend
 my newly acquired wealth and then my inheritance;
so that because of it my heart *could wander*
 distractedly in every wadi.
Therein lies my piety,
 my salvation and my right guidance.[159]

Al-Walīd was not one to refuse to preach a sermon when it was his duty to do so, nor was he any novice in theology; but he might not resist the urge to undermine the performance, for example by doing it all in light verse.[160] One can see how the rumor arose, that he had once sent a girl straight from his bed, in disguise, to take his place presiding at prayers in the mosque.[161] And one wonders whether al-Walīd/Adam may not also on occasion have been tempted to see himself as Iblīs or Satan, who sat "on his throne in the deep green sea like the throne that had been upon the water",[162] or as Pharaoh, who countered Moses's signs by bragging: "Are not mine the sovereignty *(mulk)* over Egypt, and these rivers flowing under me?"[163] Here is another—perhaps no less legitimate—way of reading the aquatic scene beneath the patron's footstool. At the end of his reign, al-Walīd's enemies denounced him as, precisely, a reckless rebel against God, a corrupter of religion and society;[164] and they circulated a *ḥadīth* according to which the Prophet had criticized those who called their children al-Walīd (the name, in the early Muslim tradition, of the pharaoh Moses had confronted), adding: "Verily, a man with the name al-Walīd will come who will be more injurious to my community than Pharaoh ever was to this people."[165] Yet for al-

159. Al-Walīd b. Yazīd no. 36/32 (trans. Kennedy, *Wine song* 27; cf. Blachère, *Analecta* 397). The italicized phrase alludes to Qurʾān 26.225, a condemnation of poets.

160. Al-Walīd b. Yazīd no. 37/115 (Iṣf. 7.68–69).

161. Al-Madāʾinī in Bal. 2. fol. 162b = p. 324 (40 Derenk) and Iṣf. 7.57 (trans. Berque 124).

162. Wahb b. Munabbih in Ṭab. 1.727 (trans. 4.115 M. Perlmann).

163. Qurʾān 43.51. Ibn Khurradādhbih, *Kitāb al-masālik* 161, recalls that "the four rivers which flowed under his [Pharaoh's] throne" had been visible at Memphis; cf. U. Haarmann, *E.Is.* 6.412a. Al-Walīd was said to have possessed a long, curved drinking bowl or wine horn known as "Pharaoh's phallus": above, p. 83 n. 154.

164. *Khuṭba Yazīd,* echoing criticisms of earlier Umayyads attributed to the family and followers of ʿAlī: e.g., Abū Mikhnaf in Ṭab. 2.300 (trans. 19.95–96).

165. Reported from Saʿīd b. al-Musayyab (d. c. 712) in the *Kitāb al-ʿuyūn wa-ʾl-ḥadāiq* 112, and originally applied to al-Walīd I, then transferred during the revolt against al-Walīd II; cf. Ṭab. 1.444–45 (trans. 3.31–32).

Walīd himself, Iblīs may well have been the lord not of darkness but of pleasure. It is more than likely—we have only fragments of his poetry—that he anticipated the next generation of libertine, irreligious poets who, under the early Abbasids, proudly made of Iblīs the inventor of musical instruments, an inspiration to singers, and patron of the *jund Iblīs*, Satan's army of hedonists.[166]

166. Bal. 2. fol. 161a = p. 321 (32 Derenk) (cf. C. Pellat, *E.Is.* 1.45–46); Chokr, *Zandaqa* 242, 280–81. Van Reeth, *Studies*, sees mainly hedonism behind al-Walīd's dabblings in non-Muslim cult.

6 Maintaining the Dynasty

A FAMILY PORTRAIT

Although the prince occupies Quṣayr ʿAmra's focal point, on the back wall of the alcove, he is not the only enthroned figure depicted in the hall. No less immediately visible to visitors who enter through the main doorway is a large painting on the southern endwall of the west or right-hand aisle (fig. 50, 51).[1] Even when Musil and Mielich were at Quṣayr ʿAmra, it was clear that this panel depicted a richly dressed woman reclining under an awning and flanked by two standing figures with two young persons to the right of her. Further details were revealed by the Spanish restoration. Not only from the composition itself, but also from the similarity between its positioning and that of the prince's portrait, one deduces that one is in the presence of a royal personage.

In the top left and right corners of the panel are two Greek labels, or one label composed of two words.[2] The right-hand word, *NIKH*, the Greek for "victory", was painted in white onto the panel's blue background, according to Mielich's facsimile. Creswell was unable to distinguish anything. Since the mid-1970s, though, the letters have been plainly visible once more, but in black, for reasons that will be discussed.[3] Vibert-Guigue has expressed the opinion that the original color of the letters was red. The left-hand word

1. Cf. Ḳ.ʿA. 2. pl. XXV; Q.ʿA. 64–65 figs. 35–36, 73–74 figs. 38–39; Grabar, R.E.I. 54 (1986) 131 (= fig. 50) –32 (photographs taken *after* the Spanish restoration *pace* Baer, Da.M. 11 [1999] 17); Vibert-Guigue diss. 3. pl. 34 (for a restoration); Betts, A.A.E. 12 (2001) 98–99 figs. 1–2.

2. See previous note; also Jaussen and Savignac 3. pl. LV.5; Creswell 397 n. 3; Q.ʿA. 65; Vibert-Guigue diss. 1.215.

3. Cf. Mielich, Ḳ.ʿA. 1.195a: "Schwarz findet . . . nur an wenigen Stellen Verwendung, wie etwa als Haarfarbe."

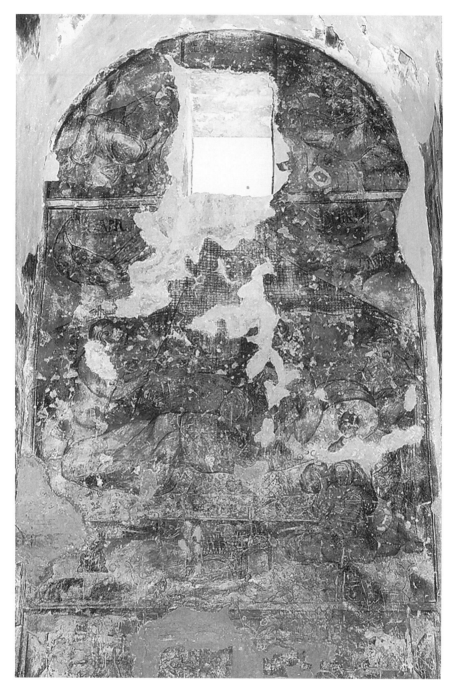

Figure 50. Quṣayr ʿAmra, hall, west aisle, south wall: dynastic icon (fresco).
F. Anderegg, courtesy of O. Grabar.

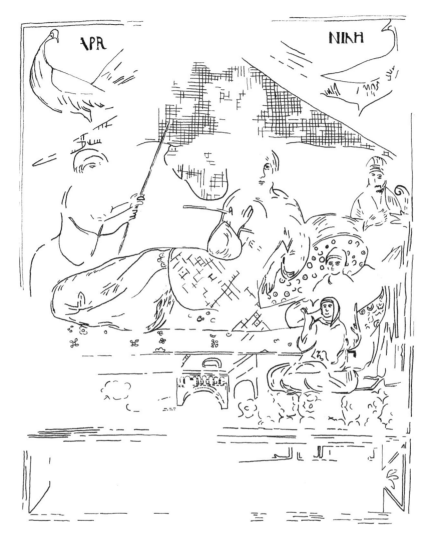

Figure 51. Quṣayr ʿAmra, hall, west aisle, south wall: dynastic icon (fresco).
Based on tracing by C. Vibert-Guigue.

has been visible, also in black, only since the restoration. It is problematic, and discussion of it too may be postponed.

A three-line Arabic text below the painting is enclosed in a special type of frame, a *tabula ansata*, which will have been familiar to both artists and patron from countless pre-Islamic inscriptions in the region.[4] Unfortunately it is wholly illegible, apart probably from an initial *bismi 'llāh* ("In the name of God").[5] Above the panel, on either side of the window, are unlabeled figures, presumably personifications corresponding to those on the southern endwalls of the central and eastern aisles; while between the window and the vault is another Arabic text, of three lines, which at first sight looks better preserved than the longer one below but was repainted by the Spanish restorers in such a way as to extinguish what dim hopes there ever were of reading it.[6] It is unlikely, though, that either of these texts contained information directly relevant to the interpretation of our panel, since this has a frame round it, and they stand outside that frame, the upper text at a considerable physical remove as well. At Quṣayr ʿAmra, labels are always painted straight onto the frescoes they refer to. So is the prayer for the enthroned prince. We should bear in mind also that since one of the two Greek words on the panel itself means "victory", it is likely that the other one was equally banal, and the identity of the people depicted deemed self-evident.

For us, then, interpretation requires an effort to identify, and then think ourselves back into, the circumstances of Quṣayr ʿAmra's creation. No wonder its students have been reticent about this particular painting. Since the first part of its Greek label is hard to understand, it seems wise to start with a full description of the iconography. Only after this has been provided will it be reasonable to ask what the painting may tell us about the patron. What-

4. The same borrowing occurs at Ḥammām al-Ṣarāḥ (Bisheh, *Da.M.* 4 [1989] pl. 60b); also in the inscription from ʿAyn al-Māḥūz, north of Beirut, attributed to al-Walīd II as caliph by Sauvaget, *Syria* 24 (1944–45) 96–100. Christian workers in the quarries opened by al-Walīd I in al-Biqāʾ Valley in Lebanon also used the *tabula ansata* for the inscriptions they left behind them: Mouterde, *Mélanges de l'Université Saint Joseph* 22 (1939). Already, the Arabic inscription from Namāra dated A.D. 328 had been framed by a *tabula ansata*: Calvet and Robin, *Arabie heureuse* 265–69.

5. Imbert, *Inscriptions arabes*.

6. Imbert, *Inscriptions arabes*; and cf. Jaussen and Savignac 3.98–99; *Q.ʿA.* 73 fig. 38; Vibert-Guigue, *ARAM periodical* 6 (1994) 348–49; Vibert-Guigue diss. 3. pl. 162. In the light of Imbert's painstaking inspection of this text in 1989 and his conclusion that, apart from an initial *allāhumma*, not a single word can be read, Fernández-Puerta's claim (*Q.ʿA.* 149–50) to have deciphered the name "[Su]laymā[n] b. ʿAbd al-Malik" (caliph 715–17) must be rejected. It may be noted that he has studied the painting only in its "restored", post-1974 state.

ever we make of the label, it should elaborate, rather than itself determine, our reading of the image.

While all the other women we have so far encountered in Quṣayr ʿAmra's hall are there for decoration or to entertain, and are often more or less undressed, the woman who provides the focal point of our panel has a grave demeanor and is fully, indeed elaborately dressed, a figure of power or at least prestige. Her face, though damaged, appears to be that of a mature adult. She wears a mantle decorated with a diamond pattern, which reaches (given her reclining position) to just above the knee, and under that a long tunic or, conceivably, baggy *sirwāl* or trousers down to her feet.[7] Her left elbow she rests on a large, well-stuffed cushion, while her right hand is raised, the palm seeming to face inwards at breast height. What is perhaps intended is the traditional gesture of royal triumph and benediction, with raised palm facing outwards;[8] but an inept draughtsman (or restorer) has depicted the hand the wrong way round, with the thumb on its outer rather than inner side.

The couch upon which the woman reclines, and the cushion or possibly cushions, all covered in rich fabrics, provide an almost unique iconographical confirmation of something already well known from our literary sources,[9] namely the Umayyads' adoption of the luxurious and expansive couch thrones with cushions that had been favored by the Sasanians.[10] Sometimes the prince might almost disappear from sight amidst the cushions.[11] Our princess's reclining not sitting posture and the voluminous rather than flat,

7. Long tunic and mantle: compare *Q.ʿA.* 91 fig. 63; Goldman, *Iranica antiqua* 32 (1997) 253 A16, 254 A20, 273 a10; and see above, 120 n. 17. Trousers: E. H. Peck, *E.Ir.* 5.764a; Goldman, *Iranica antiqua* 32 (1997) 274 a23 (Qaṣr al-Ḥayr al-Gharbī); Ahsan, *Social life* 45–46, 66–68. The mantle might also be extended over the head as a veil, as perhaps in *Q.ʿA.* 57 fig. 29. In general, men's and women's dress was quite similar.

8. Above, p. 120 n. 19.

9. Al-Haytham b. ʿAdī in Bal. 2. fol. 719a (23, §42 ʿAthāmina); al-Madāʾinī in Ṭab. 2.1739 (trans. 26.82); Isḥāq al-Mawṣilī in Iṣf. 6.81 = 16.22; Ibn Qutayba, *Al-imāma wa-ʾl-siyāsa* 2.126; Ṭab. 2.1285 (trans. 24.7), 1451 (trans. 24.181), 1615 (trans. 25.150); Grabar, *Studies in memory of Gaston Wiet* 54 n. 16; Sadan, *Mobilier* 32–51, 99–120. For another Umayyad image showing such a couch see fig. 23.

10. On Sasanian thrones see Ṭab. 1.963, 1048–49 (trans. 5.262, 385–86) and 2270, 2274 (trans. 12.66, 70); Ghirshman, *Bîchâpour* 2.69 fig. 8; von Gall, *A.M.I.* 4 (1971) 207–35; Harper, *Iran* 17 (1979) (with a conclusion [64] that would have benefited from knowledge of the Quṣayr ʿAmra painting); Shaked, *J.S.A.I.* 7 (1986) 77–82; Abkaʿi-Khavari, *Das Bild des Königs* 72–77. For Sasanian use of expensive cushions as precedence markers at court and as diplomatic gifts, see Sebeos (attrib.), *Armenian history* 101; Adontz, *Armenia* 337* s.v. *Gahnamak*, 398* s.v. *gah*.

11. See references in n. 9 above. Compare the remarkable photographs of a Qajar shah giving audience, in Soucek, *A.O.* 23 (1993) 133 figs. 6–7. Note also the cur-

square type of cushion suggests, admittedly, that Palmyrene funerary reliefs may have provided the immediate iconographical model[12]—though stripped of the association with death, which the Umayyad artists may not even have recognized. Nonetheless, Irān bulked much larger than Palmyra in the imagination of the Arabs. The scene may have been designed as a deliberate counterbalancing of the portrait of the prince in the alcove, which, we may recall, is more Roman in style, just as the two princely images at Qaṣr al-Ḥayr al-Gharbī, though admittedly not directly juxtaposed, are presented, one in the Roman manner and the other in the Sasanian.[13] The Arabs, once despised by both empires, now enjoy the luxury of plundering either at will.

In front of the couch or rather throne stands a footstool or low table, or a brazier like the one recently excavated at al-Faddayn, a symbol of hospitality and generosity to parallel the aquatic scene beneath the prince's footstool, as interpreted in chapter 4. In a story retailed in the *Kitāb al-aghānī*, a poet who has just declaimed to the caliph's satisfaction demands as his reward the magnificent brazier standing in front of the throne.[14]

As for the awning that shades the couch and its occupant, it appears to be made of some sort of netting, or of material with a netlike pattern. Perhaps it is a sunshade,[15] or a mosquito net or *killa*, of the sort—as we learn from the tenth-century polymath al-Masʿūdī—that a woman might sit under in a mosque while praying.[16] Its lower edge hangs down in what looks like an irregular fold. The overall effect is also a bit reminiscent of the beduin's tent in the heat of high summer, when he dispenses with the sections of material that constitute the walls, for the sake of a through breeze.[17] The orange-red color of the awning puts one in mind of the ceremonial tent, or *qubba*, that a shaykh might use, and that was also thought appropriate for the protection of holy persons or objects.[18] A tent might also stand metaphorically for the caliphate itself,[19] which was certainly part of the rea-

tain before the throne (cf. above, p. 128), and the parallel lines of courtiers or supplicants (cf. above, p. 171).

12. Colledge, *Art of Palmyra* 136, 157–58, with pls. 100–102, 150, and esp. 107 (a rare representation of a woman in this pose).

13. Above, pp. 121–23.

14. Iṣf 15.141.

15. Sayf b. ʿUmar in Ṭab. 1.2287 (trans. 12.82).

16. Mas. 1732 (2.412 Dāghir).

17. Musil, *Rwala* 73.

18. Dirven, *Mesopotamia* 33 (1998) 298 fig. 1, 299, 301; van Ess, *Theologie und Gesellschaft* 3.424, 4.396.

19. See the verses by al-Kumayt b. Zayd al-Asadī (d. 743/44) in Bal. 2. fol. 720a (28, §49 ʿAthāmina) and Ṭab. 2.1742 (trans. 26.90), and by ʿImrān b. ʿIṣām (under ʿAbd al-Malik) in Ṭab. 2.1166 (trans. 23.110).

son why al-Walīd planned to set up a *qubba*, probably open all round, on the roof of the Kaʿba when he led the Pilgrimage to Makka in 735. His idea was to sit under it with his friends, sipping wine and enjoying seeing and being seen.[20] After all, had not God given Adam a tent to dwell in, and pitched it on the very spot where later the Kaʿba was built?[21] Fearing though that they would all be lynched, the *amīr*'s drinking companions managed to dissuade him from pursuing this particular idea.

With such a playful patron, one must be ready for the unexpected. In this panel, particularly, one constantly feels one is treading on unfamiliar ground, with no obvious and enlightening parallels to be drawn, as between the princely portrait and the Adam mosaics. It is a nonstereotyped image tailor-made to convey a specific message.

Apart from the objects that surround her, the princess's status is further underlined by the other figures depicted in this panel. Two peacocks perch rather improbably on the awning or tent, back to back but turning their heads to look inwards. This sort of avian "supporter" has already been touched on in connection with the prince's portrait. Below these birds, flanking the princess, are a man and a woman. The woman, to the left, is young, wears her mantle drawn over her head to cover her hair,[22] and wields a long fan that she holds with both hands. The man, to the right, is a mature, noble-looking figure with a mustache and beard. He wears a round, ribbed hat, slightly pointed, and long robes; and he clasps a staff, whose crozier-shaped head was perhaps an inspiration of the Spanish restorers. The hat is a "low" *qalansuwa* or *qalansīya*, as worn by senior Sasanian officials and affected by their Umayyad successors.[23]

The two young persons are positioned in front of this man and beside the couch, therefore a little to the right of the reclining female. One squats in front and wears a sort of head scarf, not unlike a *kūfīya*;[24] the other stands or perches behind and wears a *qalansuwa*. What we have, then, in this painting is a woman who is being accorded special honor, center stage; a distinguished-looking male who is probably her spouse, and who is effacing him-

20. Al-Madāʾinī in Ṭab. 2.1741 (trans. 26.88–89).

21. Wahb b. Munabbih in al-Azraqī, *Akhbār Makka* 1.37.

22. See above, p. 179 n. 7.

23. Sayf b. ʿUmar in Ṭab. 1.2025, 2037 (trans. 11.13–14, 27); Ettinghausen, *From Byzantium to Sasanian Iran* 30–34; Ahsan, *Social life* 30; and cf. *Chateaux omayyades de Syrie* 33, 42 (Qaṣr al-Ḥayr al-Gharbī); Creswell pl. 120 (Mushattā); Muthesius, *Byzantine silk weaving* pls. 25A–B, 79B (hunter silks).

24. For possible adult use of this type of head covering at this period see Miles, *Museum notes (American Numismatic Society)* 13 (1967) 212, 216 and pls. XLVI–XLVII.

self somewhat for the purposes of this portrait; and two youngsters who, one might assume, are their offspring, the elder marked out by his more eminent position and by the similarity of his headgear to that of his father. The junior of the two is young enough to have been taken for a girl;[25] but at Quṣayr ʿAmra even grown men have been thought to be women (a problem that will be discussed in chapter 7), while one wonders under what circumstances it could have been thought necessary, let alone interesting, to depict a female minor. In all probability, both are boys.

At this point it is worth forestalling prejudices that are as strong today as ever, by pointing out that the sort of Arab Muslim who considered building a bath house and decorating its walls with representational art would not have found anything strange in the idea that an adult woman, even an Arab woman, might be depicted in such a prominent fashion, in the company of the princes and governors of this world. He would have been familiar with great women from the past like al-Zabbā (Zenobia), the brave and ambitious queen of Mesopotamia, and, from the Qurʾān, Bilqīs, the queen of Sabaʾ (Sheba), who "has been given of everything, and possesses a mighty throne",[26] not to mention Mary, the mother of Jesus, images of whom will have been seen by any Arab who had been brought up in or enjoyed contact with the Christian milieu. Even Muḥammad was said to have ordered the preservation of a painting of her that he had found in the Kaʿba at Makka.[27] In addition, any Arab who had seen Sasanian rock reliefs, visited Constantinople, or merely heard tell of these places would know that empresses and other women of the court were not uncommonly portrayed in public.[28] Part of the liberated if not necessarily always libertine atmosphere of Quṣayr ʿAmra is to take for granted such things, which might seem questionable to one bred in a narrowly Muslim environment.

It is, in other words, rather the subordination of the male than the prominence of the female that causes the viewer to sense a certain tendentiousness in this family portrait. The tendentiousness itself, though, is unmistakable and provides a clue to the panel's meaning—if we accept that the building's patron was indeed al-Walīd II.

25. *Q.ʿA.* 64–65; Vibert-Guigue diss. 1.214.
26. Qurʾān 27.23 (trans. Arberry).
27. Al-Azraqī, *Akhbār Makka* 1.168–69.
28. E. H. Peck, *E.Ir.* 5.743; John of Ephesus, *Historia ecclesiastica* 3.3.24.

THE SUCCESSION TO AL-WALĪD II

All Umayyad caliphs were preoccupied by the question of who should suc-
ceed them. There were two guiding principles that might be invoked.[29] The
more traditional one favored the appointment of the senior member of the
clan available when the ruling caliph died, or at least the right of senior mem-
bers, acting as a consultative council *(shūrā)*, to elect a successor. That per-
son might also be designated in advance—it was in this way that Hishām
had succeeded Yazīd II, with al-Walīd relegated to the position of second in
line. But there was also the more narrowly hereditary principle, according
to which the succession ought to pass from father to son. Fathers and sons
had a natural weakness for this form of succession, but minors and incom-
petents were a recurrent problem. Al-Walīd had vigorously resisted Hishām's
attempts to transfer the right of succession to his own offspring; but within
four months of his accession, he showed himself no less eager to secure this
right for his son al-Ḥakam, with al-Ḥakam's half brother ʿUthmān second
in line.[30] Although al-Ḥakam was already married and according to one re-
port, elsewhere contradicted, had offspring,[31] he must have still been very
young: precocious paternity (at the age of eleven or twelve) was not with-
out precedent in these circles.[32] And ʿUthmān had reached puberty only two
years before.[33] Both, then, were still young enough to be regarded by the ill-
disposed as not of age,[34] even though in Islamic law puberty, which entails
legal majority, is determined by physical signs or by the sole declaration of
the person concerned.[35] Hishām's sons will certainly have taken al-Walīd's
measure as a direct attack on their position—especially the experienced gen-
eral Sulaymān, who, as if this were not enough, was thrown into prison by
al-Walīd, as also was his brother Yazīd.[36]

29. Mas. 1829–30 (3.28–29 Dāghir); Tyan, *Institutions* 1.320–24, 375–76; ʿAṭwān,
Al-Walīd 368–69; Eisener, *Zwischen Faktum und Fiktion* 233–40, esp. 235–36; C. E.
Bosworth, *E.Is.* 9.504–5.
30. Ṭab. 2.1755–64 (trans. 26.104–15), quoting contemporary correspondence.
On al-Walīd's fifteen sons, see ʿAṭwān, *Al-Walīd* 70, 90–94.
31. Ṭab. 2.1807, 1891 (trans. 26.160, 27.2); cf. Ibn Ḥazm, *Jamharat ansāb al-
ʿarab* 91.
32. Cf. Lecker, *B.S.O.A.S.* 52 (1989) 30.
33. Ṭab. 2.1891 (trans. 27.2).
34. Al-Madāʾinī in Bal. 2. fols. 163b–164a = pp. 326–27 (46 Derenk), Ṭab. 2.1776–
77, 1827 (trans. 26.128, 185), and Iṣf. 7.82.
35. Abū Mikhnaf in Ṭab. 2.372–73 (trans. 19.166–67), 739 (trans. 21.107); *E.Is.*
1.993.
36. Al-Madāʾinī in Ṭab. 2.1776 (trans. 26.127–28).

Equally insulting, in those days, was the fact that al-Ḥakam's mother was unfree, and therefore non-Arab. Writing in the first century of Abbasid rule, by which time virtually all caliphs had slave mothers, the musician Isḥāq al-Mawṣilī observed that "al-Walīd was the first to have the oath of allegiance given to the son of a slave concubine".[37] Although this was perfectly consistent with Islam's egalitarian tenets, it went counter to traditional Arab ideals of genealogical purity, which remained strong.[38] Hishām had famously insisted on them, just a few years earlier, in order to rebuff the caliphal aspirations of the Prophet's great-great-grandson Zayd b. ʿAlī b. Ḥusayn.[39] Several of the most notable men of the day made no secret of their disapproval of al-Walīd's step, and in doing so incurred the caliph's intense wrath.[40] Hardly surprisingly, both the boys were murdered soon after their father's fall, to prevent them or anyone else from asserting their claim to the throne.[41]

Al-Ṭabarī reproduced, in his account of al-Walīd's reign, the full text of the letter in which he communicated to his provincial governors the arrangements for the succession. It is a lucid statement of the God-given nature of the caliphate, part of which has already been quoted in chapter 4.[42] We may readily imagine that attempts to convince his subjects of the wisdom of his decision and the legitimacy of his heirs took up not a little of al-Walīd's time thereafter. And it seems highly likely that this preoccupation has spilled over into the frescoes of Quṣayr ʿAmra, which are much concerned with what it means to be a prince, albeit emphasizing the office's pleasures rather than its responsibilities.

It may be suggested, then, that the reclining woman in our painting is the mother of al-Walīd's designated heir, al-Ḥakam.[43] The literary sources

37. Isḥāq al-Mawṣilī in Iṣf. 7.83–84 *(li-'bn surrīyat amma)*; and cf. the poem attributed to al-Ḥakam in Ṭab. 2.1891 (trans. 27.3). ʿAṭwān, *Al-Walīd* 373–74, 375, argues that in appointing al-Ḥakam his father was making an egalitarian gesture in favor of the *mawālī* (see below, p. 262). But he may simply have felt al-Ḥakam was the most capable of his sons.

38. Ṭab. 2.1674 (trans. 26.11); Goldziher, *Muslim studies* 1.115–20.

39. Al-Madāʾinī in Bal. 2. fol. 728b (85–86, §163 ʿAthāmina); Ibn Qutayba, *ʿUyūn al-akhbār* 1.312–13; Ṭab. 2.1676 (trans. 26.12–13); Ibn Khallikān, *Wafayāt al-aʿyān* 3.266–69 (trans. 2.209–11); cf. Tyan, *Institutions* 1.370–74; ʿAṭwān, *Al-Walīd* 371; Bashear, *Arabs and others* 36–40, 118.

40. Al-Madāʾinī in Bal. 2. fol. 164a = p. 327 (46–47 Derenk), Ṭab. 2.1776–77 (trans. 26.128), Iṣf. 7.82, and Ibn ʿAsākir, *Taʾrīkh madīnat Dimashq* (selection ed. al-Munajjid, *Muʿjam Banī Umayya*) 124.

41. Theophanes, *Chronographia* 418–19; al-Madāʾinī and others in Ṭab. 2.1830, 1841–42, 1877–79 (trans. 26.189, 202, 251–53).

42. Above, p. 128.

43. That the central female figure in this panel is the patron's wife or favorite had been suspected: Q.ʿA. 66; Grabar, *R.E.I.* 54 (1986). It is the more precise identi-

do not record her name, only that she was an *umm walad*, "mother of a son", that is to say, a slave who had borne her owner's child.[44] But we may henceforth call her Umm al-Ḥakam. Al-Ḥakam himself is the elder of the two boys, the one who wears a *qalansuwa* just like his father, who is said to have worn one regularly.[45] The caliph stands proudly and discretely at the right of the composition and holds the staff of the Prophet *(qaḍīb* or *'aṣā)* that was one of the symbols of his office,[46] and that may already have been represented, for a brief period, on some Umayyad coins.[47] If one hypothesis may be allowed to support another, then we may add that the mustache, beard, and general appearance of the figure whom we identify here as al-Walīd all seem to correspond well enough to those of the handsome, bearded principal hunter in the two scenes on the endwalls of the east aisle, whose identity with Quṣayr ʿAmra's patron has already been mooted.[48]

Logically the younger boy—the one some have taken for a girl—must then be ʿUthmān, al-Ḥakam's half brother and the son, just two years into puberty, of ʿĀtika bint ʿUthmān b. Muḥammad b. ʿUthmān b. Muḥammad b. Abī Sufyān b. Ḥarb[49]—an Arab woman with a genealogy, not just an *umm walad.*[50] The slave girl to the left balances the composition and underlines at once its relation to the princely portrait with its two attendants, and the honor now accorded to the future caliph's mother. The awning—or rather caliphal tent—and the peacocks echo the arch and sand grouse that frame the prince in his alcove. As a contemporary depiction of a caliphal family, rather than the caliph alone, this panel is unique in Umayyad art. Its primary purpose must have been to strengthen Umm al-Ḥakam's position—

fication that is new. I withdraw the hypothesis offered in *Empire to commonwealth* 143–49, in view of the uncertainty of the reading there proposed for the panel's Greek legend, and because it is easier to imagine the patron revealed by Quṣayr ʿAmra's paintings being preoccupied by personal and political ambitions than by theories of ethnogenesis tinged with theology.

44. Bal. 2. fol. 155b = p. 310 (6 Derenk).

45. Iṣf. 7.41, 104, 105.

46. Al-Wāqidī in Ṭab. 1.2982 (trans. 15.183) (Abū Bakr, ʿUmar, ʿUthmān), 2.92 (trans. 18.101) (Muʿāwiya), 2.1467 (trans. 25.2) (Hishām); al-Walīd b. Yazīd no. 86/85 (trans. Derenk 101–2) and Iṣf. 7.24 (trans. Derenk 99) (al-Walīd II); also the poem attributed to al-Ḥakam in Ṭab. 2.1891 (trans. 27.2), in which the *ʿaṣā* stands for al-Walīd himself; Theophanes, *Chronographia* 429 (s.a. 753–54); Jamil, *Bayt al-Maqdis* 53–54; U. Rubin, *Method and theory* 96–97. A governor might also carry a *qaḍīb*: Iṣf. 20.382.

47. Bates, *Schweizerische Numismatische Rundschau* 65 (1986) 243, 263 pl. 31.4.

48. Above, p. 102.

49. Ibn Ḥazm, *Jamharat ansāb al-ʿarab* 91.

50. *Pace* Wellhausen, *Das arabische Reich* 225.

especially if, as is possible, she had now been enfranchised and become a wife rather than a concubine[51]—and hence to legitimize the right of succession recently bestowed on her son, against those who questioned it on the grounds of his servile descent.[52] There were such doubters even in al-Walīd's innermost circle, exactly the sort of men who went hunting with him and might easily have found themselves camping a night or two at Quṣayr ʿAmra.

It may be deduced from our painting that al-Walīd was a typical specimen of the male Umayyad, and no doubt of the male Arab generally, in his touchiness on matters of parentage and descent. The later Arab historians preserve a couple of stories that well illustrate this point with specific reference to al-Walīd and his immediate relations.[53] As for the doubts expressed about the youthfulness of al-Ḥakam and his half brother, al-Walīd himself had been only eleven years old when his father designated him second in line to the caliphate.[54] Clearly the artists were under no pressure to depict the heirs as older than they really were. Their father was, after all, thirty-four years of age when he announced his plans for the accession in 743, and had reason to hope that he would reach at least his fifties, like Hishām.[55] Indeed, this is probably meant to be one of the painting's subliminal messages. Another—not so subliminal, in fact—was aimed at the *ḥarīm*. But to understand how and why, it is necessary to go back to the days when al-Walīd's father, Yazīd, was still alive.

In chapter 5 we glimpsed al-Walīd visiting the father of his wife Saʿda when he was sick in his mansion at al-Faddayn, at a time when Yazīd too was staying in the same area.[56] It was on this occasion that he first caught sight of Saʿda's sister Salmā, with whom he immediately fell hopelessly in love. As soon as his father died, al-Walīd divorced Saʿda, who had borne him a son,[57] in order to marry Salmā, simultaneous marriage to two sisters be-

51. Cf. Ibn Khallikān, *Wafayāt al-aʿyān* 3.269 (trans. 2.211).

52. Compare Heraclius's provision that his niece and second wife, Martina, mother of the younger of his two sons and heirs, be acknowledged "as mother and empress" by *both* the half brothers, plainly in order to counteract disapproval of her uncanonical marriage: Nicephorus of Constantinople, *Breviarium* 27–28. The two sons are shown flanking Heraclius on coins imitated by ʿAbd al-Malik (fig. 65a).

53. Al-Madāʾinī in Bal. 2. fol. 156a = p. 311 (8–9 Derenk) and (with others) Iṣf. 7.9–11 (trans. Derenk 80–82).

54. Al-Madāʾinī in Bal. 2. fol. 155b = p. 310 (6 Derenk).

55. Al-Wāqidī in Ṭab. 2.1729 (trans. 26.71).

56. Al-Madāʾinī and Abū ʾl-Yaqẓān al-Nassāba in Bal. 2. fol. 157b–158a = pp. 314–15 (16–17 Derenk); al-Madāʾinī in Iṣf. 7.33–34 (trans. Derenk 110–12).

57. Ibn Ḥazm, *Jamharat ansāb al-ʿarab* 91–92, where Saʿda is called Umm ʿAbd al-Malik.

ing illegal;[58] but their father, pressurized by Hishām, refused to allow the match. For the rest of Hishām's reign, then, al-Walīd pined for Salmā and wrote love poems to her, notably this one inspired by an incident that occurred one day while he was out hunting:

> We caught and would have killed an antelope
> that ran auspicious from the right.
> But then it gently turned its eyes and looked—
> the very image of your look!
> We let it go. And know: but for our love
> for you, it surely would have died.
> Now, little antelope, you're free and safe.
> So off you go,
> happy among the other antelopes.[59]

This sympathy with the hunted animal cannot but remind us of Abū Dhuʾayb's elegy quoted in chapter 3, and of the gazelle that glances over its shoulder as it is stampeded into the net trap, on Quṣayr ʿAmra's west wall.

Salmā, in the meantime, had been living in al-Madīna. Once Hishām was dead and al-Walīd caliph, his top priority was to seek her no longer very youthful hand.[60] But in a fit of rage with her father, back in 724, al-Walīd had sworn that, should he ever marry Salmā, he would immediately divorce her three times—the most conclusive form of repudiation—even if he were still in love with her.[61] Al-Walīd was now reminded of this inconvenient oath. After taking legal advice he concluded that it would be better, given the office he held, to proceed as if his threat had the same legal status as an actual divorce—a fascinating illustration of the way in which the Umayyads' theoretically unlimited sacral authority was constrained in practice by the social cost of creating precedent that others might then follow.[62] This meant that Salmā had to contract another marriage before she could "return" to al-Walīd.[63] One of the caliph's nephews then assumed the formal role of

58. Qurʾān 4.23.
59. Al-Walīd b. Yazīd no. 24/20 (trans. Hamilton 168; cf. Derenk 118; Gabrieli 27).
60. Al-Madāʾinī and others in Bal. 2. fol. 155b, 160a–b = pp. 310, 319–20 (6, 28–30 Derenk), and Iṣf. 7.38–39, 40 (trans. Derenk 115–16), 43 (trans. Derenk 117–18), 77 (trans. Derenk 116–17); and cf. ʿAṭwān, *Al-Walīd* 74–75.
61. Note especially al-Madāʾinī in Iṣf. 7.34 (trans. Derenk 111). Hishām too used the weapon of marriage followed immediately by divorce, in his case to avenge his favorite wife Umm Ḥakīm against an ex-rival for another man's affections: Iṣf. 16.298.
62. Cf. Crone and Hinds, *God's caliph* 48–49, on other Umayyads who consulted lawyers; and 57: "One suspects that al-Walīd II's letter [quoted above, p. 128] had an outmoded ring to it already at the time of its publication".
63. Qurʾān 2.230. On the divergent interpretations of threefold *ṭalāq* and its consequences at this period, see J. Schacht, *E.Is.* 10.152–53. It is clear that Salmā had not

marrying her, consummating the marriage[64] and divorcing her, and al-Walīd punctiliously observed the legal requirement that she menstruate three times before remarrying.[65] The wedding was a high point of his life. The evening before it, he compared himself in verse to Solomon the wise king, the rightful heir of David, who is also invoked by the Arabic text painted in Quṣayr ʿAmra's east aisle:

> You son of David! Hear the merry sound
> of friendly cheer next door! Will not the bride
> so long imprisoned now come forth? Day breaks!
> Its getting light! And she's not dressed! Ah, now
> she comes! A new moon in a lucky night!
> No inauspicious star is seen; but five
> high-breasted maidens come with her, and she's
> the noblest of the five.[66]

Yet within either "seven" or "forty" days of their wedding, or that very night, according to reports that differ in details, Salmā tragically died. Al-Walīd was left to compose, once more, mournful poetry about her and tried to channel his hopes for the future in another direction. If we prefer the symbolic "seven" to the no-less-suspect "forty" and assume al-Walīd sought Salmā's hand immediately after his accession, which took place in February 743, probably early in the month,[67] then there was enough time for all these dramatic events to flit by before the proclamation of al-Ḥakam on May 21 of the same year.[68]

married since 724, *pace* Ibn ʿAsākir, *Taʾrīkh madīnat Dimashq* (selection ed. al-Munajjid, *Muʿjam Banī Umayya*) 213, who claims she was one of Hishām's wives (!).

64. This was the hardest bit for al-Walīd to swallow: al-Madāʾinī and others in Bal. 2. fol. 160b = p. 320 (29 Derenk). It is not clear whether al-Walīd's legal consultations at al-Faddayn "about divorce before intercourse" (Yāq. 4.240 s.v. "Al-Faddayn") concerned his own premature threat of divorce, or his nephew's chances of bedding Salmā before he divorced her. Most legal authorities required this: J. Schacht, *E.Is.* 10.153.

65. Y. Linant de Bellefonds, *E.Is.* 3.1010–11. Al-Balādhurī's emphasis on the canonical delay may allude to some initial impatience on al-Walīd's part, especially since under the Umayyads the delay was not yet that canonical: cf. Motzki, *Origins* 85, 88, 133–36, rather than Schacht, *Origins* 181 (erroneously adducing the birth—before Islam—of the poet Arṭāt b. Suhayya).

66. Al-Walīd b. Yazīd no. 51/50 (trans. Hamilton 148; cf. Derenk 115–16; Rotter 115–16). On David and Solomon as touchstones of Umayyad legitimacy see Crone and Hinds, *God's caliph* 153 s.v. "David".

67. Al-Wāqidī in Ṭab. 2.1740 (trans. 26.83). Al-Walīd died on 15 April 744 and was held to have ruled for between fourteen and fifteen months: Bal. 2. fols. 155a, 168b = pp. 309, 336 (4, 66 Derenk).

68. Ṭab. 2.1764 (trans. 26.115). Bal. 2. fol. 160b = p. 320 (30 Derenk), mentions the proclamation straight after the death of Salmā. Some reports indicate a longer

Al-Walīd's regulation of the succession issue, and the Quṣayr ʿAmra painting too, should be seen therefore in the context of his final and this time irreversible loss of Salmā as both romantic dream and the potential mother of children. Al-Walīd had to make the best of the sons he already had, and decided to appoint al-Ḥakam his heir, regardless of the fact that he had been born to a slave concubine. Al-Ḥakam's position had, accordingly, to be bolstered against his own brothers and against rivals in the wider Umayyad clan; and that, in turn, meant that respect for his mother also had to be enforced in the *ḥarīm*, for other wives or even concubines—starting with ʿUthmān's mother—will have been eager to undermine her position and that of her son, aware as they were that even the formal proclamation of an order of succession was not definitive and could be reversed at the caliph's discretion.[69]

While on the subject of chronology we should recall the observation made in chapter 4, that according to the Arabic text in the hall's east aisle, and probably the one over the seated prince as well, the patron of Quṣayr ʿAmra was still heir apparent, not yet caliph. We have also noted that the bath house appears to have enjoyed only a short period of use. What seems to have happened is that the longed-for but—when it actually came—unexpected news of Hishām's death arrived while the frescoes were being executed or even when work had been suspended for some time, perhaps as a result of al-Walīd's loss of his allowance from Hishām. What was already finished, including the alcove and east aisle, was left as it was; while in the as-yet-undecorated west aisle account could be taken—quite possibly by the same artists—of the new situation. In other words, we are now in a position to offer a clear-cut date for at least the final phase of Quṣayr ʿAmra's frescoes, namely 742–43, or approximately the year 125 of the Muslim era (4 November 742—24 October 743), though no doubt taking in part of the year 126 as well.

Some of Claude Vibert-Guigue's observations on iconography and painterly technique at Quṣayr ʿAmra are of interest in this context. First of all, there are obvious differences between the paintings in the bath house proper (with its apodyterium, tepidarium, and caldarium) and those in the hall. In the former, figural scenes are confined to the lunettes and vaults. This may be just to protect them from water damage, but that would not explain why they contain no monumental figures; little frontality; none of the hangings,

cohabitation, but al-Walīd's own poetry gives them the lie: ʿAṭwān, *Al-Walīd* 75, 86–87.

69. See al-Walīd's proclamation, quoted by Ṭab. 2.1764 (trans. 26.115).

curtains, and fabrics generally that adorn the hall; and much less elaborate settings and clothing. There are also no texts or labels. In general the small rooms are less formal, more intimate than the hall, and not just because of their size.[70] Secondly, there are variations in painterly technique as well. Throughout Quṣayr 'Amra there is evidence of more than one hand at work. The preparation of the plaster is the same everywhere, but some areas of fresco are smooth to the touch, while on others thick brush strokes impart a certain relief to the paint surface. Although this variety is omnipresent, it intensifies as one moves westwards. And it is not attributable to the restorers.[71] Vibert-Guigue resists the conclusion that Quṣayr 'Amra was painted in two stages;[72] but equally, the historical information revealed by the frescoes makes plain they were not all executed at the same time. We may propose that the focal and most flattering composition, the enthroned prince, was completed first—it put al-Walīd's stamp of ownership on the whole project. The east aisle, which still alludes to the patron as heir, came soon after, whereas the paintings in the west aisle are particularly complex, as we have already seen when examining the hunting scenes. It follows that this space, with its reference to the succession issue as well, was decorated relatively late, when the artists were gaining in confidence. The bath house proper was handled separately, apparently by a different artist. We shall see in chapter 9 that one of the apodyterium paintings alludes to the death of Salmā, which puts it at very much the same date as the Umm al-Ḥakam panel.

We may now return briefly to the contents of the *tabula ansata* immediately underneath this composition.[73] With its monumental aspect and large letters, and positioned as it is relatively low on the wall for legibility, it was meant to be noticed and must have alluded to the patron. Indeed, it may well be the bath house's foundation "inscription", kept until the project's end. Its three lines, and the size of the letters of the initial *bismi 'llāh* (which itself may indicate an official text), show that it was shorter than foundation inscriptions put up by the caliph Hishām, for example,[74] and closer in

70. Vibert-Guigue diss. 2.244–45.
71. Ibid. 2.186–87, 245.
72. Ibid. 2.243–44.
73. Above, p. 178; and Imbert, *Inscriptions arabes.*
74. E.g., *R.C.E.A.* 1. nos. 27 (Qaṣr al-Ḥayr al-Gharbī; 33 words), 28 (Qaṣr al-Ḥayr al-Sharqī; 35 words); al-Rīhāwī, *A.A.A.S.* 11–12 (1961–62) 106 (Arabic section)/ 207–8 (French section) (Rīmat Ḥāzim near al-Suwaydāʾ; 28 words); Khamis, *B.S.O.A.S.* 64 (2001) (Scythopolis/Baysān; fragmentary double inscription, c. 45 words); and cf. the inscription from 'Ayn al-Māhūz, north of Beirut, attributed to al-Walīd as caliph by Sauvaget, *Syria* 24 (1944–45) 96–100.

length to building inscriptions placed by al-Walīd I (before he became caliph) at Qaṣr Burquʿ,[75] and at Buṣrā in A.D. 745/46 by the otherwise unattested *amīr* ʿUthmān b. al-Ḥakam, evidently a member of the ruling family.[76] At Quṣayr ʿAmra, the opening pious formula will have been followed by the bald statement that the *amīr al-muʾminīn* (no longer just *amīr*) al-Walīd ordered the bath house to be built in such-and-such a year.[77]

GRACE (?) AND VICTORY

It is easy to imagine the psychological boost Umm al-Ḥakam received from seeing or at least hearing about her portrait on the wall at Quṣayr ʿAmra. Our sources tell us nothing about her, but it is likely she was a Greek captive who had been carried off during a raid into Asia Minor, one such as those evoked by Bashshār b. Burd in a panegyric of Hishām's son Sulaymān:

> The daughters of Leo [III], after his [Sulaymān's] return,
> being shared out as booty among the fellow soldiers, seemed does—
> donatives for which he who wins them is envied,
> choicest of the captives of Rūm, virgins and matrons.[78]

His taste for *rūmīyāt*—Greek slave girls—was one of several supposed frivolities or weaknesses for which al-Walīd, together with his father, was taunted by his uncle Hishām and his cousins the sons of al-Walīd I (705–15), one of whom, Yazīd, was to overthrow and succeed him.[79] Such needling, which probably did not stop with al-Walīd's accession, will have seemed particularly obnoxious if his principal intended heir had been born of a *rūmīya*. It was not, after all, necessary to go so far as to call a Christian woman's offspring a "son of a clitoris" (in other words, of an uncircumcised woman)[80] in order to be offensive—"ibn al-Naṣrānīya" ("son of a Christian woman")

75. Gaube, *A.D.A.J.* 19 (1974) 97 and pl. XXXI.1 (19 words in 3 lines).
76. Sauvaget, *Syria* 22 (1941) 56–58 (18 words). Note also the 17-word inscription al-Walīd (II) b. Yazīd placed on the two crescent moons he dedicated in the Kaʿba: al-Wāqidī in al-Azraqī, *Akhbār Makka* 1.224. (Even if the date A.H. 101 = A.D. 719–20 given by al-Azraqī is correct, the donor still cannot have been al-Walīd I, *pace R.C.E.A.* 1. no. 26.)
77. The inscription will have run roughly as follows: *bismi ʾllāh al-raḥmān al-raḥīm amara bibunyān hādhā al-ḥammām ʿabd allāh al-walīd amīr al-muʾminīn fī sanat khams waʿishrīn wa-māʾa.*
78. Bashshār b. Burd 16 (Arabic), 64 (translation), in Beeston's selection.
79. Al-Madāʾinī in Bal. 2. fol. 156a = p. 311 (8 Derenk); Iṣf. 7.9 (trans. Derenk 80).
80. Al-Madāʾinī in Bal. 2. fol. 156a = p. 311 (8 Derenk); Iṣf. 7.9 (trans. Derenk 80), 22.20; cf. *E.Is.* 4.913.

was quite sufficient.[81] The implied religious and often also racial slur, added to the likelihood that a *rūmīya* mother had been a captive, was a potent cocktail in an age when female captives of non-Arab origin were increasingly popular as concubines, with obvious consequences for Arabs' pride in the purity of their descent and even, in the opinion of some, for the general cohesiveness of the Muslim community *(umma)*.[82] Patrilineal formulation of genealogies was a fortunate face-saver, but everybody knew it told only half the story.

No doubt our painting's Greek legend was intended as a compliment, in her own language, to its principal subject. The key position she occupies in the composition cannot, though, have been meant just to flatter her, despite the prominence Quṣayr ʿAmra generally accords to women. After all, it was al-Ḥakam, not his mother, who was to be his father's heir. Rather, she is intended as the centerpiece of an image of dynastic succession. She stands, representatively, for all the caliph's wives and symbolizes the dynasty's ability to regenerate itself, and so to continue in power. We may, then, expect the Greek legend to refer not just to the panel's central figure, but to the composition's wider meaning.

This legend poses a particularly thorny problem to the interpreter of Quṣayr ʿAmra.[83] It apparently consists of two separate words—there are no other examples in our frescoes of words being divided for the sake of symmetricality, though if there is not enough space, one or more letters may be broken off and placed adjacently, as in the labels of the personifications in the east aisle. The second half of the legend, *NIKH* or "Victory", was read easily enough by Musil and Mielich; and even though it is now black rather than white as in Mielich's facsimile, the reading may be regarded as certain. The first word, though, is much harder to make sense of. Like the face of Umm al-Ḥakam, it has suffered damage from beduin campfires, vandalous visitors, and rain from the winter storms that blow in through the window above, on the building's exposed southwesterly corner. One can trace the progress of the water as it streamed down the wall, entirely effacing, among other things, the legend's initial letter.

At first glance we read *APA*, and the Spaniards thought they could dis-

81. E.g., al-Madāʾinī in Ṭab. 2.1780 (trans. 26.132). For seventh-century examples of resistance to intermarriage even with well-born non-Arab women, see Morony, *Iraq* 238–39.

82. Cf. the letter attributed to the caliph ʿUthmān and quoted by Ṭab. 1.2803 (trans. 15.7); Abbott, *Studies* 3.70–71, and the same writer's erudite survey of Umayyad wives and concubines, *J.N.E.S.* 1 (1942) 341–68; Madelung, *J.S.S.* 31 (1986) 161–62.

83. For the basic references, see above, p. 175 n. 2.

cern an initial Θ, giving Θ*APA*. But already at a second perusal one is struck by the awkwardness of the final *A*, which looks more like a Latin R. The letters are also notably fuzzy compared to the regular, neat lettering of *NIKH*. What appears to have happened is that the original white (or red)[84] paint of the lettering was blackened by the smoke of campfires lit in the hall by visitors, including the foreigners who became increasingly numerous in the aftermath of Musil. Describing his fourth visit in 1909, Musil himself remarked on the recent deterioration in the condition of the paintings. Eventually the blackened pigments will simply have fallen off the wall, as has also happened, since Musil's day, to one of the personification labels in the east aisle. All that was then left was a shadow or negative of the original letter, with more or less indistinct edges.[85] The restorers apparently decided to fill the whole of this shadow, so far as they could discern it, with black paint, chosen no doubt to match *NIKH*, whose letters had likewise become blackened since Musil's day.[86] The persistence of old surface scratches and pitting on *NIKH*, and the darker hue of the rectangular area of paint immediately around it, clearly apparent on photographs taken soon after the restoration by Fred Anderegg, suggests the restorers prudently left this part of the legend more or less alone. Possibly, therefore, the blackness of *NIKH* is due to discoloration of the original pigments rather than repainting.[87] But the absence of such surface scratches from the first half of the legend makes it likely that, here, some retouching was indeed undertaken.[88]

This reconstruction of what happened during the restoration is speculative, an attempt to contact those directly responsible having failed. But we may at least acquit the Spaniards of any inventiveness inspired by knowledge of Greek: in their publication they reproduce a Greek word taken from Creswell's discussion of Quṣayr ʿAmra, complete with a compounded version of a glaring typographical error that had occurred when the word was printed in Creswell's book.[89]

Although the restorers' hesitation about the Θ, and their failure to restore either it or the left stroke of the first *A*, which is missing, implies some

84. Above, p. 175.
85. Above, p. 11; Vibert-Guigue, *S.H.A.J.* 5.107–8; Vibert-Guigue diss. 3. pl. 166f.
86. Creswell 397 n. 3.
87. It is disquieting that the drawing in Jaussen and Savignac 3. pl. LV.5 lacks the serifs now visible; but serifs were used in the labels of the six kings: Ḳ.ʿA. 1.218–19 figs. 135–36.
88. Note also the sloping rather than level bar of the alpha on the Berlin fragment of the six kings panel, which has definitely not been tampered with: Vibert-Guigue, *D.A.* 244 (1999) 93.
89. Creswell 397; Q.ʿA. 76.

exercise of restraint and even discrimination, the fact that the second *A* di-
verges completely in execution from the regularity of the first proves that
their intervention here—whether in the shape of actual repainting, or sim-
ply of a decision about which areas of discoloration to clear off, and which
to leave—resulted in a deformation of whatever evidence was visible when
they started. If, as has been suggested, what appears to be a second *A* was
originally *C*, a lunate sigma,[90] then our confidence in what we see on the
wall now can scarcely be greater here than in the case of the nearby Arabic
text just above the window, which has, as noted earlier, been rendered il-
legible by exactly the same process of blackening the shadows left by the
peeled-off paint of the original lettering. Nonetheless the reading *XAPIC*,
"Grace", whose meanings ranged between physical attractiveness[91] and di-
vine favor, may tentatively be retained as at least a possibility.[92]

By analogy with the personifications in the east aisle, "Grace" and "Vic-
tory" together might suggest that two of the figures in the scene below were
intended as representations of these abstract qualities. *Charis*, in particular,
was in late antiquity an attribute frequently ascribed to buildings; while the
Charites, or Graces, were often depicted in bath houses.[93] But neither of these
usages seems relevant to the iconography of this particular panel. There is
also the practical problem that our painting contains five figures, while the
labels, if such they are, stand in close spatial relationship to none of them,
unlike labels elsewhere at Quṣayr ʿAmra, in the east aisle and on the six kings
panel. Positioned as it is, symmetrically at the top of the panel, the legend
looks much more like a title for the whole composition, something not oth-
erwise attested in these paintings—but the whole picture is unique, and not
only at Quṣayr ʿAmra.

Victory and Grace—in the sense of God's blessing, or even the *charis* of
Adam in Paradise[94]—are certainly desirable attributes in a ruler, and *a for-
tiori* a dynasty, if this panel is to be taken as a symbolic proclamation of the
Umayyad house generally, of the divine grace and favor shown to it, of the
regularity and legitimacy of the succession, and of the victoriousness that

90. Bowersock, *Selected papers* 152.
91. Note the paragon of youthful feminine grace labeled *Charis* in a sixth-
century mosaic at Mādabā: fig. 26.
92. One might, by analogy with *CKEΨH* and *ΠOIHC(H)* (above, p. 87), have
expected *XAPH*. The fluctuation (if real) is another straw in the wind of evidence
for a certain differentiation between the paintings that adorn the hall's eastern and
western aisles. Grabar, *A.O.* 23 (1993) 102 n. 33, withdraws his earlier suggestion of
APIC[TO]NIKH.
93. Mentzu-Meimare, *Byzantinische Zeitschrift* 89 (1996) 71–73.
94. Cf. Lampe, *Patristic Greek lexicon* 1517b.

ideally, and often actually, marked its dealings with other powers. To all that al-Ḥakam would, it was hoped, one day fall heir. The opposite of *charis* was *phthonos*, envy;[95] and this pair is not uncommonly encountered in Roman bath houses, whose inscriptions show due awareness that where too much beauty and good fortune is concentrated, a fall may be just around the corner.[96] Hence the use of apotropaic symbols and brief texts such as "Builder! Envy will not vanquish you" ([κ]τίστα· σε φθόνος οὐ νικήσι), or "Envy does not vanquish fortune" (ὁ φθόνος τύχην οὐ νικᾷ).[97] Victory, then, is a theme that occurs naturally in this context. Against the Greek background, "Grace" and "Victory" at Quṣayr 'Amra can be seen to go well together, and this thought world was clearly still familiar to the artists. As for the patron, the very speed with which al-Walīd published his arrangements for the succession showed how aware he was that merely by naming al-Ḥakam and 'Uthmān, he could be signing their death warrant—as turned out to be the case.[98] Victory might be required against unusual odds, so the sooner the heir set about securing his position against challengers, the better. A later historian asserts that the Umayyad clan was in general opposed to the succession of concubines' sons, "because they believed that the passing of their kingdom would come about in the reign of the son of a concubine".[99]

It ought to be underlined, though, that no other painting at Quṣayr 'Amra gives such prominence to the dynastic idea. Overwhelmingly, the frescoes are about the patron, not his family. Even the dynastic icon discussed in this chapter was bound to be understood, by those who were privileged to see it, as—ultimately—an expression of the ruler's personal will. As he pointedly observed in his proclamation of al-Ḥakam and 'Uthmān, his was the right to remove them too, and to substitute another of his sons, or even somebody from outside his family, should he see fit.[100] His decision to favor a politically powerless concubine, rather than a wife drawn from an influential family or tribe, was an implicit assertion of this absolute power and self-sufficiency. In al-Walīd's eyes, the only truly weighty considera-

95. Note also one of the imperial acclamations shouted at the Council of Chalcedon (451): "May envy not touch your rule!" (ἀπείη φθόνος τῆς ὑμῶν βασιλείας): *Acta conciliorum oecumenicorum* 2.1.2, p. 155.

96. Dunbabin, *Papers of The British School at Rome* 57 (1989) 12, 17, 33. The Sarjilla bath house inscription is *I.G.L.S.* 4.1490.

97. Roueché, *Aphrodisias* 126–36.

98. The problem was familiar at Constantinople too: Dagron, *Empereur et prêtre* 42–43.

99. Al-Mas'ūdī, *Kitāb al-tanbīh* 325 (trans. Carra de Vaux 420). For the same idea, but in a legal rather than political context, see Bashear, *Arabs and others* 42–43.

100. Ṭab. 2.1764 (trans. 26.115).

tion was the child's paternity. And he wrote a poem to this effect in which, after recalling his own legitimate succession to Hishām, he added the following boast:

> I made as an heir to succeed me at my death
> one most excellent in his childhood and his youth.
> He is my son, lord of the Quraysh,
> the best of lords, and the best of them in his ancestry.[101]

In these lines, the idea implicit in the dynastic icon is restated in still firmer tones. No wonder Yazīd b. al-Walīd, once he had eliminated his cousin, started dropping hints about reviving the consultative council or *shūrā* as a means of deciding the succession—though he could not resist mentioning as well that his genealogical claim was no weaker than al-Walīd's.[102]

What was the source of this legitimizing power inherent in the caliph himself? His pedigree, his dynastic claim, is of course indispensable and so obvious that Quṣayr ʿAmra does not underline it. But this particular caliph, al-Walīd, had a claim that was still more personal, namely his unquestioned virility. Though not a warrior, he was notably handsome, strong and athletic, the father of fifteen boys. The story about how he displayed his erect penis to one of his courtiers, that he might bow down before it,[103] may well have been intended to satirize a potency al-Walīd was felt by some to have shown off once too often.[104] His prominent role in the hunting scenes at Quṣayr ʿAmra speaks likewise of confidence verging on self-advertisement. But as long as his armies' and courtiers' patience lasted, the caliph might continue to present himself as the hunter par excellence, pursuit of the swift onager the proof of his manliness, and that of the delicate gazelle its reward.[105]

101. Al-Walīd b. Yazīd no. 86/85 (trans. Derenk 101–2; note the variant version in Bal. 2. fol. 159b = p. 318 (24 Derenk)). Derenk is clearly wrong to identify the son in question as ʿUthmān; the correct identification is given by ʿAṭwān, *Al-Walīd* 374. Al-Madāʾinī (reported by al-Iṣfahānī) must also be wrong to state that the poem was written as soon as the news of Hishām's death reached al-Walīd.

102. See the *Khuṭba Yazīd*, and his letter quoted by Ṭab. 2.1844 (trans. 26.206).

103. Above, p. 149.

104. Compare the "acclamations" directed by the people of Constantinople at the sexual exploits of their emperors, including al-Walīd's contemporary Constantine V: Dagron, *Constantinople imaginaire* 178–80.

105. Were it not for the plainly family/dynastic character of our panel, one might be tempted to take *Charis-Nikē* as a telegraphic assertion that "the sexiest girl gets the prize", flaunting the arbitrary character of al-Walīd's rule. Such an interpretation would indeed fit well the painting of a reclining beauty being crowned, on the northwest spandrel of the main aisle: above, p. 74.

7 The Six Kings

A ROYAL DELEGATION

Immediately to the right of the dynastic icon, and at right angles to it, in other words at the southern end of the west wall, are to be seen the degraded remains of the famous painting of the six kings (fig. 52, 53). Of all the frescoes, this one has attracted most attention since the publication of the Vienna Academy's volumes in 1907. Several of the reviews that appeared shortly afterwards, by such as Carl Becker, Rudolf Brünnow, Max van Berchem, and Theodor Nöldeke, already contributed to the elucidation of the panel's Arabic and Greek labels, and by extension to the controversial question of the dating of the structure in which they stood.[1] It was an opportunity for scholars to collaborate in order to resolve a specific problem. But since then, as in general with the study of Quṣayr ʿAmra, only desultory progress has been made. The present discussion starts from the assumption that these portraits of six great rulers, with their careful labeling in both Arabic and Greek, will have attracted the particular attention of Quṣayr ʿAmra's visitors and stimulated a variety of reactions. The panel may, then, have no one "correct" interpretation. Rather, it will have evoked a spectrum of associations and conveyed a variety of "meanings", just as ʿUbayd Allāh b. Ziyād's hunting decor in his palace at al-Baṣra was meant, no doubt, to impress and divert, but to an Arab of the desert who happened to see it appeared rather to contain a prophecy, that the governor (d. 686) was about to lose his job.[2] Our task, then, is to conjure forth as many meanings as possible, whether evi-

1. See above, p. 144. Ignaz Goldziher, writing to Nöldeke as soon as he had read the latter's review (18 May 1907), confessed himself convinced and assumed Karabacek would recant: Simon, *Ignác Goldziher* 303.
2. Yāq. 1.530 s.v. "Al-Baydāʾ".

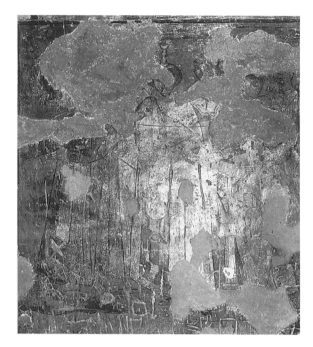

Figure 52. Quṣayr ʿAmra, hall, west wall: six kings
(fresco). F. Anderegg, courtesy of O. Grabar.

dent or hidden. The six kings are symbolic figures who stand for the whole
political and cultural heritage of the world the Arabs had now inherited.

Thanks in part to Musil's and Mielich's attempts to remove it, this panel
is in a piteous state,[3] while both garments and faces have been extensively
restored.[4] We can discern, though, that the six kings stand erect and con-
front the viewer in two ranks, simāṭān, as was the custom of the dignitaries
who clustered round the throne of both Umayyad and Abbasid caliphs.[5] Each
king stretches out both hands, palms turned upwards in a gesture that tra-
ditionally denoted supplication or at the very least the rendering of honor,[6]

3. Jaussen and Savignac 3.89 n. 1 and pl. XXXIX.2. For reproductions see, apart
from figs. 52–53, Ḳ.ʿA. 2. pl. XXVI (= K.Is. pl. VIII); Q.ʿA. 50 fig. 22, 135 fig. 89, 139
fig. 92; Is.A.A. 45 pls. 53–54; Omeyyades 122; and the drawings by Nicolle, in War
and society 77, nos. 8A–B.

4. Vibert-Guigue diss. 1.242.

5. Ṭab. 2.1820 (trans. 26.175); Iṣf. 18.220 (trans. Berque 127).

6. Cf. John Chrysostom, De inani gloria 4 (the crowd stretches forth its hands
to a benefactor generous as the Nile); A.S. 575 (sixth-century pyxis showing stand-
ing pilgrims who extend their hands toward S. Menas).

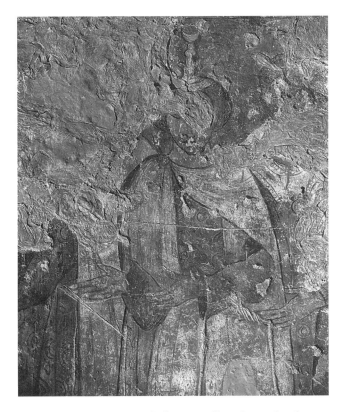

Figure 53. Quṣayr ʿAmra, hall, west wall: six kings, detail
of Kisrā (fresco). Oronoz Fotógrafos, Madrid.

toward his right, our left, in the direction, that is, of the immediately adja-
cent dynastic icon, which is placed somewhat higher on the wall but still is
the most obvious recipient of the kings' gesture (it can be addressed only
indirectly to the prince enthroned out of sight in his alcove). The faces that
can still be seen are, contrary to what one might expect, young and beard-
less. Indeed Riegl, before the labels were deciphered, took the kings for
women,[7] a curious echo of a mistake said to have been made by the tradi-
tionist Muslim b. Ṣubayḥ (d. c. 718) when he visited a friend's house, saw
there an image of Kisrā, and mistook it for Maryam, the mother of the
Prophet ʿĪsā (Jesus).[8]

7. Riegl, quoted by Müller, *Ḳ.ʾA.* 1.VI; also von Karabacek, *Ḳ.ʾA.* 1.217, 220a; and
cf. Becker, *Islamstudien* 1.297.
8. Van Reenen, *Der Islam* 67 (1990) 45, 63–64, 76.

In the art of the late antique East, young men were in fact quite often presented in a way that seems to us to make them look effeminate, in order to underline social, cultural, or even moral distinctions that were important to the artist or patron. One thinks, for example, of the seventh-century mosaic in the church of S. Demetrius at Thessalonica, in which a youthful, beardless S. Demetrius is flanked by a strikingly hirsute and wrinkled bishop and governor.[9] A cameo portrait depicting a Theodosian empress was recycled as an icon of a soldier martyr, S. Bacchus, just by adding a label.[10] Even imperial hunters are depicted, on a silk at the Vatican, as "clean shaven . . . with large eyes, lengthy fine noses and small mouths".[11] Peter Brown's observation, in his study of the late antique body, that "indeterminacy of any kind was disturbing to late antique persons",[12] reflects accurately enough the ascetic's wariness of effeminate youths[13] but ignores the artist's habit of distinguishing sanctity and worldliness, or noble and base pedigrees, by employing facial types that subordinate the vocabulary of sex and age to a primarily symbolic grammar.[14] At Quṣayr ʿAmra the six kings are marked off, by their unrealistically soft appearance, both from obvious social inferiors such as the beaters in the hunting scene above them and from the bearded *amīr* in the hunting scenes in the east aisle, who seems manlier and more vigorous than them. This softness of the six kings identifies them as representatives of an older, more sophisticated but also less dynamic civilization than that of the Arabs.

The kings' robes are not easily understood from Mielich's frequently reproduced facsimile, and the damage that has been inflicted on this panel means that only the left and middle figures in the front row can be described with some confidence. Both wear two full-length garments: a dark blue inner tunic, richly patterned and presumably of silk, and a white outer mantle fastened at the right shoulder with a brooch or fibula—these are respectively the *chitōn* or *dibētēsion* and the *chlamys* of the Greek sources. The central figure wears red slippers. The neckline of the inner tunic is cov-

9. *A.S.* 554–55.
10. E. K. Fowden, *Barbarian Plain* 35, 36 fig. 5.
11. Muthesius, *Byzantine silk weaving* 62.
12. P. Brown, *Body and society* 438.
13. E.g., *Apophthegmata patrum*, *P.G.* 65.176; Cyril of Scythopolis, *Vita Euthymii* 16.
14. On youthful appearance as a symptom of sanctity—both covered in later Greek by the concept *charis*—see Rostovtzeff, *Yale classical studies* 5 (1935) 237; Kádár, *Acta antiqua Academiae Scientiarum Hungaricae* 40 (2000); Kazhdan, *History* 155; Mas. 89 (1.63 Dāghir). God might be conceived of in early Islam as a handsome young man, but never as a bearded *shaykh*: van Ess, *Theologie und Gesellschaft* 4.380–82.

ered by the mantle, so we cannot tell whether it is beaded or embroidered, like those of the enthroned prince's attendants. And whereas the mantles of these two richly clad servants rest loosely on their shoulders without a clasp and lie in folds on their arms as they raise them to wield their fans, the kings' mantles fall straight to their feet, which suggests that they are of a heavier material, possibly wool. One recalls Procopius's description of the robes bestowed by the Roman emperor Justinian (527–65) on native rulers set over parts of Armenia:

> There was a cloak *(chlamys)* made of wool, not such as is produced by sheep, but gathered from the sea. The creature on which this wool grows is called a *pinnos*. The part where the purple should have been, that is, where the insertion of purple cloth is usually made, was of gold. The cloak was fastened by a golden brooch, in the middle of which was a precious stone from which hung three sapphires by loose golden chains. There was a tunic *(chitōn)* of silk adorned in every part with decorations of gold which they are wont to call *ploumia*. The boots were of purple colour, and reached to the knee. They were of the sort which only the king *(basileus)* of the Romans and (the king) of the Persians are permitted to wear.[15]

This heavier outer garment is depicted, with the inner tunic visible too, in mosaics in the church of S. Demetrius at Thessalonica that cannot all be securely dated but certainly belong between 600 and 900, and in the sixth-century icon of Mary with SS. Theodore and George (or possibly Demetrius), at the monastery of S. Catherine, Sinai (fig. 54).[16] Though their *chlamys* lacks the characteristic inserted embroidered panel or *tablion* mentioned by Procopius, the six kings are attired, broadly speaking, in the manner of the East Roman court.

This should not surprise us, as the court of Constantinople was the late Umayyads' most plausible remaining rival, and its cultural prestige still enormous. The fabrics that evoked these privileged associations had become all the rage with the Umayyads. The example set by the caliph Sulaymān was followed by Hishām and, of course, al-Walīd b. Yazīd.[17] The only ele-

15. Procopius, *De aedificiis* 3.1.19–23 (trans. H. B. Dewing, emended); cf. Corippus, *In laudem Iustini Augusti* 2.100–25, with Cameron's commentary.

16. For the Thessalonica mosaics see Kourkoutidou-Nikolaïdou and Tourta, Περίπατοι 160–70. The at first sight comparable lay figures on the left of the seventh-century Privilegia mosaic in Sant' Apollinare in Classe, Ravenna, are not original: Deichmann, *Ravenna* 1.342, 2(2).273–80, esp. 276. The difficulty of distinguishing successive restorations from what is original in this mosaic puts the problems of Quṣayr ʿAmra in perspective.

17. Sulaymān: above, p. 146. Hishām: Mas. 2219 (3.205 Dāghir). Al-Walīd: above, p. 120 n. 17, and Iṣf. 7.70, on his changes of costume several times each day.

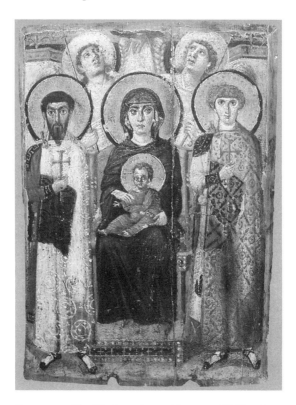

Figure 54. The Virgin enthroned between SS. Theodore
and George/Demetrius (icon, sixth century). Monastery
of S. Catherine, Sinai.

ment of the six kings' costume that would not have been so familiar, except
in images on coins, fabrics, silverware, and other portable objects, was their
headgear. Mielich's facsimile shows each monarch differently adorned in this
respect; and on a fragment of the fresco removed by Musil and Mielich, now
in Berlin, one can still see part of the crowns of the first and second figures
from the left, who (as will shortly be demonstrated) are respectively the Ro-
man emperor in a jeweled and knobbed helmet differing from those attested
on the coins only in its lack of a plume, and the Visigothic king in a plainer
helmet.[18] On the wall itself, all that now remains is the remarkable insignia
on the head of the third figure from the left, that is to say, the middle figure
in the front row. It resembles a rather fancy candlestick whose topmost el-

18. Museum für Islamische Kunst, Berlin, inv. no. I.1267; Vibert-Guigue, *D.A.*
244 (1999) 93. East Roman imperial headgear: Grierson, *Byzantine coins* 74–75, 82.

ement is a crescent moon, its tips pointing upwards. In Mielich's facsimile there are also wings curving up on either side. Although the central feature, as we see it today, is entirely the product of restoration, the wings have surprisingly been allowed to disappear, apart from a few faint traces.[19] Still, one's impression that this device is meant to look like a Sasanian crown,[20] or rather to reflect the imprecise post-Sasanian, including Umayyad, understanding of what Sasanian crowns had been,[21] is confirmed by the label immediately above.

The kings' names (or titles) are painted above their heads in blueish-white letters on a blue background, the Greek version on top, the Arabic underneath.[22] This part of the fresco was already fragile when Musil and Mielich set about recording it, some of it was lost in their efforts to clean it,[23] and further damage was done when they tried to detach sections of the painting. One fragment, containing the right-hand side of the first label from the left, the far left-hand end of the second, and, as just mentioned, part of the crown of each of the figures to which the labels refer, made it to Vienna and eventually Berlin, where it now resides in the Museum für Islamische Kunst.[24] The rest of the second name from the left, which also provided the most explicit evidence for dating Quṣayr ʿAmra, was apparently destroyed during the attempt to remove it from the wall.[25] Remains of the third and fourth names are still visible *in situ* but have been repainted and rendered, practically speaking, useless.[26] We know next to nothing about the labels that identified the two figures on the right of the panel.[27] What we now have to go on, then, apart from the Berlin fragment, is Mielich's tracing and Musil's much more interpretative copy, both made on the spot;[28] the fac-

19. Vibert-Guigue diss. 1.233. Since *Q.ʾA.* 67 takes the wings' existence as given, one deduces that the Spanish restorers forgot to sketch them in again.

20. For a selection of which see Göbl, *Sasanidische Numismatik* tables I–XIV.

21. Ghirshman, *Artibus Asiae* 16 (1953) 53; Harper, *Iran* 17 (1979) 50; Kröger 186a, 256a; also the eighth- or ninth-century East Roman silk at S. Ursula's, Cologne: Muthesius, *Byzantine silk weaving* 70–71, 174 (M 32), and pls. 80A, 100A.

22. Vibert-Guigue diss. 1.67–68. Bilingual labels are not uncommon in the art of the Roman East: see, for example, above, p. 99 n. 44 (hunting scene from Dura Europus), and fig. 44 (mosaic of Adam, Ḥamā Museum).

23. Mielich, *Ḳ.ʾA.* 1.199b.

24. Museum für Islamische Kunst, inv. no. I.1267; von Karabacek, *Ḳ.ʾA.* 1.217, 218–19 figs. 135–36; Vibert-Guigue, *D.A.* 244 (1999) 93 (an impressively legible reconstruction of traces hard to photograph—my thanks to Jens Kröger of the Museum für Islamische Kunst for arranging the production of a slide, April 2002).

25. Jaussen and Savignac 3.97 and pl. XXXIX.2.

26. *Q.ʾA.* 135 fig. 89; Vibert-Guigue diss. 1.68, 234.

27. Van Berchem, *Journal des savants* (1909) 367 n. 1; Vibert-Guigue diss. 1.234.

28. *Ḳ.ʾA.* 1.220 figs. 137–38; Vibert-Guigue diss. 1.237.

simile Mielich worked up later;[29] a verbal description by Mielich;[30] and one further drawing made by Jaussen and Savignac a few years later, during an examination of the fresco that yielded a better reading of the fourth name and hinted at what might have been done to improve Musil's and Mielich's readings of the label they destroyed.[31] Musil's sketch is nonetheless especially valuable, as it took account of letters that were destroyed in the process of cleaning.

On the basis of this evidence, one can be reasonably sure about the following readings, from left to right:

1. . . .] Ç *A P*
 q—y—ṣ [
2. *POΔOPIK^C*
 l / r ?]—ū—d / dh—r—ī (?)—q

or, assuming no lost initial letter, and reading the first preserved letter as *rā'* not *wāw*:

 r—d / dh—r—ī (?)—q[32]
3. *XOCΔPOIC*
 k—s—r—ā[33]
4. *NI/HΓO*
 . . .] sh—ī

In other words, four of the kings represented were Caesar (in Greek *KAIΣAP* / Kaisar, in Arabic Qayṣar), Roderic (*POΔOPIKOΣ* / Rodorikos in Greek, but elsewhere attested only in the form *POYΔEPIXOΣ*/ Rouderichos;[34] Lūdhrīq or Lud(h)rīq in the ninth-century Arabic geographers[35]),

29. *Ḳ.'A.* 2. pl. XXVI.
30. Mielich, *Ḳ.'A.* 1.199b.
31. Jaussen and Savignac 3.97–98 and pl. LV.4.
32. Cf. Nöldeke, *Z.D.M.G.* 61 (1907) 225; Becker, *Islamstudien* 1.297. Littmann, *Z.D.M.G.* 105 (1955) 288, claimed to have detected on Kisrā's robe a graffito reading "Lūdhrīq". This was presumably written out by someone to whom the name was unfamiliar, at a time when the label was better preserved than it was in Musil's day. Compare the inscription left by a visitor to Qaṣr Burquʿ in A.D. 1409–10, immortalizing his decipherment of "this Kufic inscription"—the one that records the activity there of the Umayyad *amīr* al-Walīd b. ʿAbd al-Malik: Shboul, *A.D.A.J.* 20 (1975).
33. Cf. Nöldeke, *Z.D.M.G.* 61 (1907) 224; Becker, *Islamstudien* 1.294; Jaussen and Savignac 3.97. The *alif maqṣūra* is written, as often in manuscripts, with *alif* not *yā'*.
34. Procopius, *De bellis* (mid-sixth century) 7.5.1, 7.19.25, 7.19.34. My thanks to Irfan Shahîd for kindly drawing these passages to my attention.
35. Ibn Khurradādhbih, *Kitāb al-masālik* 90, 157, and Ibn al-Faqīh, *Kitāb al-buldān* 134–35 (trans. 101; de Goeje 82–83 vowelized the *dhāl* with *fatḥa*). Al-Wāqidī

Khusraw (*ΧΟΣΡΟΗΣ* / Chosroēs or *ΧΟCΔΡΟΗΣ* / Chosdroēs[36] in Greek,
Kisrā in Arabic), and the Negus (not elsewhere attested in Greek; in Arabic
Najāshī).

The Arabic labels correspond to names that were used generically in Ara-
bic for *all* the rulers of a given land or dynasty: the Roman emperor was al-
ways or very often called Qayṣar, the Visigothic king Lū/udhrīq, the Sasa-
nian monarch Kisrā, and the ruler of Aksum Najāshī.[37] Only in the case of
the Visigothic king, who even in the decades immediately after the conquest
of al-Andalus occupied a less prominent place than the others in the Arab
worldview,[38] is it probable that our panel makes a personal reference, in this
case to the last Visigothic ruler, who was overwhelmed by Ṭāriq b. Ziyād in
711 or 712 and was called Roderic. His name was adopted as generic by the
Arabs, presumably for the simple reason that they had never come into con-
tact with any other ruler of the Visigoths.

As for the Greek labels, until the time of Heraclius (610–41) Roman em-
perors normally called themselves *autokrator kaisar* in Greek, *imperator
caesar* in Latin. Heraclius replaced this formula with the title *basileus*, al-
ready long familiar in literary texts; and thenceforth sons and heirs of em-
perors, and even leading personalities at court or foreign rulers might be
called *kaisar*, but not emperors (except in Latin).[39] The Sasanians had tra-
ditionally addressed the Roman emperor as *kaisar* but from 591, at least,
began to use *basileus* as well.[40] The Arabs too, in due course, became aware
of the new title but appear not to have adopted it.[41] They stuck to Qayṣar,
or *Qayṣar malik al-Rūm*, "Qayṣar king of the Romans", a formula com-
monly found in Ibn Isḥāq's eighth-century biography of the Prophet. The
most probable explanation is that this title had become familiar to the Arabs
through common usage long before Islam and then had been in a way con-
secrated thanks to the pious stories that circulated about the letter Muḥam-

(d. 823) in Ṭab. 2.1235 (trans. 23.182) gives Adrīnūq; al-Yaʿqūbī (d. 897), *Taʾrīkh* 2.285,
has Adrīq. See also Becker, *Islamstudien* 1.297.
 36. Nöldeke, *Z.D.M.G.* 61 (1907) 224.
 37. Qayṣar, Kisrā, Najāshī: Ibn Khurradādhbih, *Kitāb al-masālik* 16–17; Mas. 397,
714 (1.182, 339 Dāghir); Lū/udhrīq: Mas. 398, 474, 701, 747 (1.182, 213, 334, 358
Dāghir).
 38. By al-Ṭabarī's day, the conquest of al-Andalus could be dismissed in a few
lines: 2.1235, 1253–54 (trans. 23.182, 201).
 39. Rösch, *ONOMA ΒΑΣΙΛΕΙΑΣ* 36–37, 159–71.
 40. Rösch, *ONOMA ΒΑΣΙΛΕΙΑΣ* 155–56, to which add Nicephorus of Con-
stantinople, *Breviarium* 12.57: still under Heraclius the Roman emperor assumed
that his Iranian counterpart would call him *Kaisar*.
 41. Ibn Khurradādhbih, *Kitāb al-masālik* 16.

mad had supposedly addressed to the Qayṣar Heraclius, exhorting him to accept Islam.[42] And this usage appears to have been so deeply rooted that it did not occur to the Quṣayr ʿAmra artists to offer *basileus* as the Greek version of Arabic Qayṣar. Perhaps they also wished to maintain as close a parallelism and harmony as was possible between the Greek and Arabic titles.

Their command of Greek—certainly sufficient to have permitted them to write *basileus*, had they wanted to—is amply demonstrated by the other three surviving labels. Chosdroēs was a perfectly acceptable Greek form of the Iranian name Khusraw, with, in this case, a normal substitution of iota for ēta, *i* for *ē*. As for Rodorikos derived from the Latin Rudericus, and Ni/ēgos from the Geʿez *negus* or *nāgāsī*, these names or titles are unlikely to have been widely current in Greek during the eighth century, when not only Constantinople but also Greek speakers elsewhere were almost completely out of touch with both Aksum and Spain. So either our artists were using current but rare terminology or they were creating new forms, and avoiding—be it noted—the temptation to derive them from the Arabic.[43] Either way, they were demonstrating a certain rough-and-ready[44] competence in the Greek language. It has nonetheless been suggested that *kaisar* is merely a transliteration from the Arabic, and that the artists therefore knew no Greek.[45] It is indeed undeniable that their choice of *kaisar* may have been influenced by the currency in Arabic of the title Qayṣar. But it is also conceivable that they were aware of this title's former currency in Greek. They may even have been familiar with the Sasanians' preference for it, once upon a time. In any case, the other three labels were plainly not devised by people ignorant of the Greek language.

The last two kings are squeezed in at the right of the panel, and there is less room for their names, of which even Musil found no useful traces. But they can hardly have been just space fillers, as Becker suggested.[46] If Max

42. See below, pp. 211, 225.

43. *Pace* Gatier, *Syr.Byz.Is.* 148: "La forme grecque transcrit simplement le terme arabe."

44. Rodorikos being a less literary form than Procopius's Rouderichos (above, p. 204 n. 34).

45. Becker, *Islamstudien* 1.293–94. It has also been held that the Arabic texts at Quṣayr ʿAmra were confidently painted, whereas preliminary outlines or even stencils had to be used for the Greek labels: Mielich, *Ḳ.ʿA.* 1.196b, 199b, followed by (among others) Becker, loc. cit., and Creswell 409. This is now rejected by Vibert-Guigue diss. 1.67, 235–36, and 2.220–21, who holds that the labels in both languages were executed with equal confidence, and that outlines were usually done in a light color, whereas the traces visible at Quṣayr ʿAmra may reflect a change of mind about the best color to use for the lettering.

46. Becker, *Islamstudien* 1.298.

van Berchem was right, and the artist placed emperors in the front row and lesser rulers in the back, while working from west (left) to east (right), then the two figures on the right may well have been in the front row the Khāqān—a title the Arabs applied to the heads of various groupings of Turkic peoples—or even the emperor of China, and then at the far right some Turkish or perhaps Indian prince.[47] With the rulers of these Asiatic regions, as with the Visigoths, the Umayyads had entered into a particularly intensive phase of diplomatic and military contact during the reign of al-Walīd I. But that does not compel us to assume that this caliph was Quṣayr ʿAmra's patron.[48] Of the power of the Central Asiatic khanates the Arabs were especially conscious in the reign of Hishām, under whom the Khazars took by storm, using mangonels, the military stronghold of Ardabīl and contracted what for a "barbarian" was a most unusual royal marriage alliance, between the Khāqān's daughter and the Roman emperor Leo III's son.[49] As we shall see, Roderic and the Khāqān continued, alongside Caesar and Khusraw, to play a part in the Arabs' imaginative world long after the disappearance of the Umayyads.

KHUSRAW, CAESAR, THE NEGUS, RODERIC . . .

The six kings are shown presenting their respects to the figures in the dynastic icon on the endwall, to which Caesar, on the left of the panel, stands closest (and the dynastic character of which is implicitly underlined by the artist's vision of the kings as symbolic and representative rather than individualized figures). But their gaze is fixed straight ahead. Although the status of the three preeminent members in the front row is not otherwise differentiated, the most natural interpretation is that the middle one, Khusraw, is the leader of the delegation, albeit only as *primus inter pares*.

Khusraw and Caesar, Kisrā and Qayṣar, bulked large in the Arab imagination at this time and were often mentioned together. According to one of his earliest biographers, skeptics had mocked Muḥammad, saying that his new religion was as plausible as the idea that "the treasures of Kisrā and Qayṣar will be opened to him".[50] Even some of his followers had their doubts

47. Van Berchem, *Journal des savants* (1909) 367–70, and cf. Creswell 401. On the Central Asiatic khanates in the late Umayyad period, and their relations with China, and also on India, see Blankinship, *Jihād state* 108–12.

48. *Pace* Herzfeld, *Die Malereien von Samarra* 5.

49. Blankinship, *Jihād state* 124–25, 150, 153–54; cf. Bashear, *Arabs and others* 104–11.

50. Ibn Isḥāq, *Sīrat rasūl Allāh* 175 and 448 (Ḥamīdullāh).

and complained about how "Muḥammad promises us that we shall enjoy
the treasures of Kisrā and Qayṣar, whereas it is not safe for one of us to go
to the privy!"[51] The Prophet's favorite poet, Ḥassān b. Thābit, was said to
have replied to doubters:

> Be not like a sleeper who dreams that
> he is in a town of Kisrā or of Qayṣar![52]

To this day a village preacher in Jordan or anywhere else in the Muslim world
may recall, with every expectation of being understood, "the cleaving of
Kisrā's palace and the splitting of Qayṣar's seat" on the night of the
Prophet's noble birth in the land of Makka the venerable.[53]

Although the Sasanian dynasty had been defeated by the armies of Is-
lam, and its empire eliminated as an independent political entity, still Kisrā
had left in the Arabs a fond, lingering envy of a ruler who had made so much
of this world's wealth and beauty attend his smallest whim.[54] In Kisrā's con-
quest they could feel pride unalloyed, while flattering themselves on the
obeisance that mighty prince would have done God's caliph, had he but been
saved. For this reason alone we should resist the temptation to see in Quṣayr
'Amra's Kisrā one of those last pathetic Sasanians after Khusraw II, merely
because, unlike their forebears, they are shown beardless even on their own
coinage.[55] As already noted, Kisrā's boyish appearance here denotes so-
phistication and cultural superiority, not effeminacy. He stands, in particu-
lar, for the two mighty warriors who had given the Sasanian monarchs their
generic name in Arabic, namely Khusraw I Anūshirwān, "of the immortal
soul" (531–79), and Khusraw II Parwīz, "the victorious" (591–628).

Precisely because of the spectacular reversal of roles brought about by
the rise of Islam, the Arabs liked to dwell on Kisrā's dealings with the desert
tribes along his western frontiers. It was poignant, with one eye on the
present, to contrast the extreme luxury of the Sasanian court with the mis-
erable existence—in those days—of the Arabs. The early Abbasid poet Abū
Nuwās, for example, could sing of

51. Ibn Isḥāq, *Sīrat rasūl Allāh* 357, 675 (Wüstenfeld)/2.135, 3.245 (al-Saqqā)
(trans. Guillaume 243, 454). In pre-Islamic Arabia houses lacked privies. One went
outside the settlement, preferably at night, to relieve oneself. Ibn Isḥāq, *Sīrat rasūl
Allāh* 733 (Wüstenfeld)/3.327 (al-Saqqā), quoting the Prophet's wife 'Āisha.
52. Ḥassān b. Thābit in Ibn Isḥāq, *Sīrat rasūl Allāh* 303 (Wüstenfeld)/2.64 (al-
Saqqā) (trans. Guillaume 207).
53. Antoun, *Muslim preacher* 158, 161.
54. Hishām b. al-Kalbī in Ṭab. 1.1041–42 (trans. 5.376–78).
55. *Pace* Nöldeke, Z.D.M.G. 61 (1907) 225, 233; Becker, *Islamstudien* 1.295–96;
Herzfeld, *Der Islam* 21 (1933) 235. Cf. Göbl, *Sasanidische Numismatik* 14, and pl.
14.225–27.

a place where Kisrā built his palaces,
 free from uncouth beduins—
no thorny Arab foods there,
 no bitter acacia leaves!
Rather there was pomegranate blossom, streaked
 with myrtle, garlanded with roses and lilies.
If you breathe of its spirit,
 [the fragrance] of basil breathes into your nostrils.[56]

Kisrā also impressed by his extraordinary knowledge of humankind. From the vantage point of his international court, populated by men who, like the Hiran poet ʿAdī b. Zayd,[57] had traveled throughout the world and gathered information wherever they went, Kisrā could make comparisons between far-flung peoples that were beyond even the imagination of the Arab in his lonely camp, its scattered stones soon to be remembered only in the poet's lament. And with such knowledge came the power also to expand the influence and even the borders of his empire. This threat lurks just below the surface of a story told by the early Abbasid polymath Hishām b. al-Kalbī (d. 819/21) about a visit made by al-Nuʿmān III b. al-Mundhir (c. 580–602) to the court at Ctesiphon. There the king of al-Ḥīra had encountered other delegations from different nations. When all had had their say, Kisrā (Khusraw II) addressed them as follows:

> I have thought about the question of Arabs and other nations. . . .
> The Romans, I find, are distinguished by their unity, the territorial
> extent of their kingdom, their many cities and their great monuments.
> They have a religion which distinguishes the licit from the illicit and
> punishes the sinner. . . . India I likewise found their equal in wisdom
> and medicine, a country of plentiful rivers and fruit trees, amazing
> craftsmanship, spices, exact mathematics and great population. The
> Chinese, too, I found to be distinguished by their unity, their military
> craftsmanship, iron industries, chivalry, sense of purpose and a king-
> dom which unites them. Even the Turks and the Khazars, despite their
> wretched existence . . . have kings who unite their furthest regions. . . .
> But I have seen no marks of virtue among the Arabs in matters of
> religion or state, no wise policy and no strength. Further proof of their
> lonely and abject condition is provided by their homeland with its wild
> beasts and birds of prey. They kill their own children because of poverty
> and resort to cannibalism when there is need.[58]

56. Abū Nuwās, *Dīwān* 3.324–25 (trans. P. F. Kennedy, *Wine song* 263).
57. See above, p. 79.
58. Hishām b. al-Kalbī in Ibn ʿAbd Rabbihi, *ʿIqd* 2.4–5 (trans. Khalidi, *Arabic historical thought* 103).

Many such anecdotes were in circulation—sometimes they ended with Kisrā recognizing that the Arabs, whatever else they might lack, were at least endowed with some primitive virtue or even wisdom.[59] A century and more after the rise of Islam, when the political map of Asia and Africa had changed beyond recall, and Muslim armies were penetrating Europe as well, the six kings on the wall at Quṣayr ʿAmra will have provoked some to tell these tales again, and not just for the sake of recalling a very different past, but also in order to point the same fatalistic moral about human glory and pride that ʿAdī b. Zayd had long ago expressed in his verses:

> Where now is Kisrā, Kisrā of the kings,
> Anūshirwān? Or where Sābūr before him?
> The pale-faced noble race of kings of Rūm—
> not one of them today is on men's tongues.[60]

This poem remained extremely popular under Islam, and the mere sight of Kisrā and Qayṣar on the wall at Quṣayr ʿAmra will have brought it to the mind of visitors. Hishām once became enraged with a guest who foolishly recited it during a caliphal picnic[61]—which will have endeared it to al-Walīd.

By late Umayyad times, though, ʿAdī's assimilation of Qayṣar's position to Kisrā's must have seemed distinctly tendentious. For the ruler of Constantinople had in the end fallen much less far than his brother the lord of Ctesiphon. He still stood for the mighty empire of Rome, whose defeats in the early seventh century at the hand of Irān the Quranic *sūra* known as "The Greeks" alludes to (according to the more probable interpretation), but only to add that "after their vanquishing, they shall be the victors in a few years".[62] Rome went on to survive even the high water mark of Arab expansion and in 718 saw the armies of Islam, and all its naval forces too, retire in disarray from the shores of the Bosphorus, which—with a brief exception in 782—they were not to see again for many centuries, and then under Turkish auspices. Above all, Rome's cultural prestige remained intact, even at the court of the caliphs whose holy book accused Christianity of departing from the straight path of true belief. And Rome had remained one, while the Church had split irrevocably. The influence of its cultural supremacy has already been noticed in the portrait of the prince. Here, in the six kings panel, it is openly acknowledged in the person of its political head and representative.

59. Iṣf. 13.229–31 (trans. Berque 95–97).
60. Iṣf. 2.131 (trans. Hamilton 84).
61. Hishām b. al-Kalbī in Bal. 2. fol. 722a (45–46, §85 ʿAthāmina), with copious references to other quotations of these verses in the note ad loc.
62. Qurʾān 30.1–5 (trans. Arberry 2.105).

We have already learned, by now, to expect little conventional Muslim piety at Quṣayr ʿAmra; but if we would gauge what resonances a portrait of Caesar might have for a mid-eighth-century Arab, we must recall that part of this monarch's fascination lay precisely in his dogged survival, and so in the hope that he might yet submit to God's fullest revelation. Hence the popularity then and down the ages of the story, already alluded to, of how Muḥammad wrote to the Caesar of his own day, Heraclius, and bade him recognize the new revelation; and of how that emperor wished to do so, but the great men of his realm prevented him.[63] A similar tale was told of a correspondence between the caliph ʿUmar II (717–20) and the emperor Leo III (717–41), though on this occasion, too, without the result the Muslims desired.[64] Quṣayr ʿAmra's Caesar, then, is in no wise a defeated enemy of Islam, but rather a prestigious competitor whose submission might still be hoped for—and his culture, in the meantime, enjoyed.

In short, not only Kisrā but Qayṣar too remained potent symbols of the age before Islam, the world, according to Greek writers, whose "two eyes" they had been.[65] Less predictably, the Negus also occupied a special position in Muslims' view of history and contemporaneity. He continued, after all, along with the kings of Nubia, to act as a political representative or at least symbol of non-Chalcedonian Christianity, which was the dominant form of that religion in all the lands from Ethiopia in the south to Armenia in the north, with large communities spreading eastward into Irān as well.[66] Non-Chalcedonians accounted for a significant portion of all the caliphate's non-Muslim subjects, so toward a non-Chalcedonian king beyond their frontiers Muslims were bound to feel a certain wariness, mingled with the hope of conversion. Hence the Negus figured alongside Caesar in the story of the exhortation to Islam that Muḥammad addressed to various rulers in Arabia and adjoining lands.[67] In the case of the ruler of Aksum, the Prophet's hopes were not unreasonable, for the Negus al-Aṣham or Maṣhama (and other variants) had afforded shelter and protection to certain of Muḥammad's followers when, in the early days of his preaching, they had been forced to flee Makka. We are even told that he inclined to embrace Islam,

63. Ibn Isḥāq in Ṭab. 1.1565–67 (trans. 8.104–6).
64. Hoyland, *Seeing Islam* 490–501.
65. Fowden, *Empire to commonwealth* 18 n. 21.
66. Fowden, *Empire to commonwealth*, esp. 118–19, 131–33, 135–36, accepting a sixth-century origin for Ethiopia's national epic, the *Kebra Nagast*. This, or related compositions or ideas, may have influenced Christian writers under the Umayyads: Reinink, *S.Byz.Is.* 83–84 esp. n. 37; Johnson, *Peace and war* 206–8.
67. Ibn Isḥāq in Ṭab. 1.1569–71 (trans. 8.108–10).

though in the end he did not.[68] Ibn Ishāq (d. 767), the earliest biographer of the Prophet of whose work substantial parts have survived, dwells at length on this story and treats the Najāshī favorably; while subsequent Ethiopian rulers remained beyond the reach of Islam's victorious armies.

In other words, the Negus was very much a part of the early Muslim worldview. He enjoyed sufficient honor to make any crudely triumphalist interpretation of the six kings panel seem improbable. And since Aksum had been the nearest major royal court to early Islamic Makka, it did not seem so unrealistic to mention the Negus in the same breath as the Sasanian and Roman emperors.[69] When our artist makes a point of depicting the Negus in a soft golden bonnet or head cloth, in contrast to the much solider headgear of Qaysar, Roderic, and Kisrā, he is doing so because he knew that was exactly what the Negus wore, as we can see for ourselves on Aksumite coins. A sixth-century Roman ambassador to the Ethiopian court likewise recorded that the king wore "a turban *(phakiolin)* made of linen interwoven with golden thread".[70] As for the curious fact that the Ethiopian monarch is as white of skin at Quṣayr ʿAmra as the other five kings who stand beside him, we may, if we wish, put that down to the idealizing tendency that was already noted at the beginning of this chapter. But there is also a chance that it reflects if not direct knowledge of Aksumite society, then at least an awareness of the anecdotes that circulated among Muslims about the self-exile of some of the earliest members of their community to the Christian kingdom beyond the Red Sea. As Ibn Ishāq recalls:

> My father Isḥāq b. Yasār said: "I saw Abū Nayzar, the Negus's son. Never have I seen a man, Arab or foreign, larger or taller or more handsome than him. . . . " I asked my father if (Abū) Nayzar was a black man like the Ethiopians, and he replied that had I seen him I should have said that he was an Arab.[71]

68. Ibn Ishāq, *Sīrat rasūl Allāh* 208–24 (Wüstenfeld)/1.358–79 (al-Saqqā), 281–301 (Ḥamīdullāh).

69. Ibn Ishāq, *Sīrat rasūl Allāh* 745 (Wüstenfeld)/3.343 (al-Saqqā), 293 (Ḥamīdullāh).

70. Munro-Hay, *Aksum* 151–54; John Malalas, *Chronographia* 18.56 (a summary of the ambassador's first-person account, to judge from Malalas's single lapse from third-person narrative).

71. Ibn Ishāq, *Sīrat rasūl Allāh* 296 (Hamīdullāh) (trans. [emended] Guillaume, *New light* 46). According to Raven, *J.S.S.* 33 (1988) 198–209, a number of stories about the Negus that circulated in the first century or two of Islam had an implicitly anti-Umayyad bias. Conceivably this is relevant to the six kings panel: the patron was countering his enemies' annexation of the Negus, or the stories arose because the Umayyads were known to be sympathetic to this kingly figure of rather

In the end, though, if Qaysar and Kisrā had been vanquished by the Arabs, who could hope to stand against them?[72] Certainly not the likes of the Negus or Roderic. The Christian Mesopotamian chronicler who rhetorically enquired, probably in the late 680s,

> Who can relate the carnage they [the Arabs] effected in Greek territory, in Kush [Nubia or Ethiopia], in Spain and in other distant regions . . . ?[73]

had a sound political sense and, rather than being too fast off the mark, was probably just using "Kush" and "Spain" as general indicators of "Deep South" and "Wild West". If, in the end, Aksum was allowed to survive, that was presumably because the Umayyads felt not just that it was too mountainous to conquer, but also that it had passed its apogee and no longer represented a political or military threat—an estimate with which historians of ancient Ethiopia concur.[74] As for Roderic, for all his remoteness he was given no choice but to die with dignity, going out to meet Ṭāriq b. Ziyād "on the king's throne, wearing his crown, his gloves, and all the adornments kings used to wear", according to the Iranian al-Ṭabarī's laconic report (from al-Wāqidī ?) of a faraway campaign whose booty, though, was later to become the stuff of elaborate legend. When posterity remembered Roderic, it was not least for the sake of "the table of Solomon the son of David, containing God knows how much gold and jewels", that the Arab conquerors had found in the city of Toledo and sent back with much other plunder to the caliph al-Walīd in Damascus.[75]

Roderic also had another claim on the Arabs' attention, and unless we are to regard it as the figment of a later imagination, Quṣayr ʿAmra's patron will have been aware of it. For "Roderic"—in the sense of the Visigothic kings generally—had been a great hunter, like the earlier inhabitants of Spain. (The late fourth-century Latin compilation known as the *Historia Augusta* remarks of the Palmyrene queen Zenobia that she "hunted with the greed of a Spaniard".[76]) In particular, writers on hunting maintained that it was the Visigothic king Euric (466–84) who had introduced the much-

ambiguous relationship with the Prophet. On the Umayyads accused of being kings not caliphs, see above, pp. 171–72.

72. Sayf b. ʿUmar in Ṭab. 1.2587 (trans. 13.170).

73. John Bar Penkāyē, *Rīš Melē* 14.142* (trans. Brock 58).

74. Munro-Hay, *Aksum* 90–95; cf. Blankinship, *Jihād state* 115–16.

75. Al-Wāqidī and others in Ṭab. 2.1235, 1253–54 (whence the quotations, trans. 23.182, 201 M. Hinds); al-Yaʿqūbī, *Taʾrīkh* 2.285; Ibn Khurradādhbih, *Kitāb al-masālik* 156–57; Ibn al-Faqīh, *Kitāb al-buldān* 134–35 (trans. 100–101); Ibn Khallikān, *Wafayāt al-aʿyān* 5.327–29 (trans. 3.483–85).

76. *Historia Augusta, Tyranni triginta* 30.18.

prized art of falconry into both Spain and the Maghrib.[77] Indeed, apart from
a few "philosophers" such as Apollonius of Tyana and Galen, kings were
considered to be the best authorities on the techniques of hunting with birds.
In al-Masʿūdī's summary of hunting lore, compiled in the mid-tenth cen-
tury, a *khāqān* of the Turks is quoted on how to use the goshawk; Kisrā
Anūshirwān and Qayṣar are adduced in support. A philosopher called Ar-
sitjānus (Archigenes of Apamea, a famous Syrian doctor who worked in
early second-century Rome) is quoted from a book that had been sent by
an East Roman notable called Michael the son of Leo to the Abbasid caliph
al-Mahdī (775–85); and straight after this we are told how the emperor Con-
stantine was led by a falcon to the site where he was to found Constantinople.
Although falconry is curiously absent from Quṣayr ʿAmra's frescoes, the
contribution of three at least among the six kings to the art of hunting, so
graphically depicted immediately above them, is unlikely to have been ig-
nored completely. What is more, al-Masʿūdī's main source was none other
than al-Ghiṭrīf b. Qudāma al-Ghassānī, who served as master of the hunt
to al-Walīd II and almost certainly knew Quṣayr ʿAmra's painting of the six
kings at first hand.[78]

FROM THE DUKKĀN TO DAMASCUS

As already mentioned at the start of the previous section, these six kings
are in reality seven, their gesture of supplication or honor implying a re-
cipient, who in this context can only be the caliph—or, strictly speaking,
the dynasty. In order to probe, then, the background of Quṣayr ʿAmra's
iconographically unparalleled image of six kings, it makes sense to ask where,
in oriental legend or literature, we find mention of six kings gathered round
a seventh. The answer is Irān, where an evidently Sasanian tradition pre-
served by later writers in both Arabic and Persian speaks of Irān as situated
at the earth's center, surrounded by six geographical regions or *aqālīm* (sing.
iqlīm), which, unlike the Ptolemaic *klimata* from which they derived their
Arabic name, corresponded also to political units. These were variously listed,
but apart from Irān itself one might expect to find India with al-Sūdān (Black
Africa); Arabia; North Africa from Egypt westwards, including Spain; Rūm,

77. Mas. 474, 701 (1.213, 334 Dāghir).
78. Mas. 466–73 (1.210–13 Dāghir); and cf. one of al-Masʿūdī's main sources, al-
Ghiṭrīf b. Qudāma al-Ghassānī, *Kitāb ḍawārī al-ṭayr* 2, with Möller, *Falknereiliter-
atur* 34–35.

including Syria; the Turkic lands of Central Asia; and China.[79] Comparing this list with the Quṣayr ʿAmra painting, one notes that Irān and Rome are both present, while the Negus represents India and al-Sūdān, Roderic North Africa, and the implied caliph Arabia. This leaves the Turkic lands and China to be represented by the two kings whose name has disappeared from the Quṣayr ʿAmra panel.

Since the six kings are painted together in a compact group, it is implied that, on at least one occasion, they all met together. Such improbable or impossible gatherings were a popular conceit in late antiquity: one recalls, for example, the ancient sages who were supposed to have gathered round Alexander the Great's coffin to swap aphorisms, a Greek genre known to have been already familiar, in Arabic translation, at the court of Hishām, where one might also have heard tell of a three-day concert at Makka during which the stars of Umayyad musical life had performed together, though they were not all contemporaries.[80] There was, too, the iconographical theme, known to us from the Roman period, of the Seven Sages, who could never in historical reality have met in the same place and at the same time. A variant on this was the Seven Doctors, a theme exemplified in two different versions at the beginning of the great sixth-century Dioscorides codex at Vienna.[81]

As for our kings, there is a complex of Iranian and Arabic narratives about how the rulers of the world—not necessarily seven in number—had once gathered to do homage to the greatest among them, the Iranian *shāhanshāh*. Our sources are mainly the encyclopaedic writers of the Abbasid period— but some of these were Iranians, and enjoyed access to the oral and written traditions of their homeland. Sometimes the kings assemble in person, as in the probably late Sasanian *Book of deeds of Ardashir son of Papak*.[82] In other versions they send ambassadors—as in the story already quoted from Hishām b. al-Kalbī—or just letters.[83] Some writers even supply details about seating arrangements and protocol.[84] The Quṣayr ʿAmra painting shares with these

79. Mas. 189 (1.102 Dāghir); A. Miquel, *E.Is.* 3.1076–78; Pantke, *Bahrām-Roman* 167–72. For other late antique lists of great empires, see Monneret de Villard, *Annali Lateranensi* 12 (1948) 144 and n. 1; Fowden, *Empire to commonwealth* 12–13.

80. Grignaschi, *Le muséon* 80 (1967), esp. 228–39, 261–64; cf. Kilpatrick, *Book of songs* 69 and n. 73, 116.

81. Gerstinger, *Dioscurides* 28–30 and pls. 20–21, on both sages and doctors.

82. *Book of deeds of Ardashir son of Papak* 13.20–21: rulers of Rome, Kabul, India, and the Turks.

83. *Letter of Tansar* (early or mid-Sasanian) 28; Mas. 620–24 (1.291–93 Dāghir), mentioning *inter alia* letters from the rulers of China, India, and Tibet.

84. Ibn al-Balkhī, *Fars-nāma* 97, esp. 13–14 (trans. Christensen, *Iran* 411–12): rulers of China, Rome, and the Khazars; Abū ʾl-Baqāʾ Hibat Allāh al-Ḥillī, *Kitāb al-*

stories the concept of a gathering of monarchs or their representatives to honor one of their number who is recognized as of preeminent prestige. But it would hardly be possible to use what, in the form in which we have them, are mainly Abbasid literary traditions, in order to elucidate the genesis of an Umayyad painting, were it not for the fact that one of our sources, and among the earlier in date, ties the story to a particular monument, and in doing so provides coordinates in space, and to some extent in time as well, for the genesis of a tradition that helps explain the painting as well as the texts.

Writing in Arabic in the year 902/3, the Iranian geographer Ibn al-Faqīh has the following to say about the town of Qarmāsīn, better known as Kirmānshāh in Irān:

> At Qarmīsīn is the Dukkān, where the kings of the earth gathered together to Kisrā Abarwīz, among them Faghfūr the King of China, Khāqān the King of the Turks, Dāhir the King of India, and Qayṣar the King of Rome among them. [The Dukkān] is a four-sided platform made of stone, so carefully constructed and held together with iron clamps that no space can be detected between any two blocks. Anyone who sees it thinks that it is made of a single piece of stone.[85]

Since Ibn al-Faqīh was a native of Hamadhān (Ecbatana), somewhat to the east of Kirmānshāh, and wrote about a century and a half after the fall of the Umayyads, it is reasonable to assume that local traditions along these lines had indeed been passed down and went back not just to the age of the Umayyads, but to that of the Sasanians themselves. And as was already pointed out in chapter 3 in connnection with nearby Ṭāq-i Bustān, Kirmānshāh lay on the High Road from Mesopotamia to Khurāsān, one of the focal points of the Umayyads' *Drang nach Osten*.[86] Just as Ṭāq-i Bustān turned out to be of some help in illuminating the imaginative world and cultural references of Quṣayr ʿAmra, so too it is likely that the Dukkān and its associated traditions were

manāqib al-mazyadīya 43–46 (partly trans. Shaked, *J.S.A.I.* 7 (1986) 79): rulers of the Turks, Rome, India, and China. Note also the report by Sayf b. ʿUmar in Ṭab. 1.2446–47 (trans. 13.26–27) according to which there was found amongst the Arabs' spoils from the capture of Ctesiphon a collection of coats of mail that had formerly belonged to various Iranian rulers, Heraclius, the Khāqān, the Dāhir (an Indian prince), and the last Lakhmid king of al-Ḥīra. A similar list of powers with which Kisrā might reasonably be supposed to have come in contact underlies Ṭab.'s account, 1.863–71 (trans. 5.94–106 Bosworth) of the foreign relations of Bahrām Gūr: Khāqān, India, Rome, and "the land of the blacks, in the region of Yemen" (presumably including Aksum). Ḥamza al-Iṣfahānī, *Taʾrīkh* 6, describes Irān as placed at the center of the world, surrounded by the six other major empires of China, the Turks, India, Rūm, al-Sūdān, and the Berbers.

85. Ibn al-Faqīh, *Kitāb al-buldān* 429 (trans. 262).
86. See above, p. 109.

familiar, at first hand or by report,[87] to our bath house's patron or artists. We have no reason to doubt that it was a real and still, in those days, conspicuous monument. It is frequently mentioned by the Arabic geographers as a halt on the road from Kirmānshāh to Hamadhān, and remains of it were identified in the 1960s by the archaeologist Leo Trümpelmann.[88]

Once we have tied our story to a Sasanian monument, it becomes reasonable to suppose that the physical object gave rise, perhaps from the very outset, to a variety of aetiological speculations or "explanations". And it is attractive, though not absolutely essential, to surmise that the catalogue of kings that became an essential part of these stories had its origin in some inscription, or a labeled image carved, painted, or in mosaic, that was preserved on the spot.[89] Indeed, Ernst Herzfeld convinced himself that the Dukkān had sheltered an image that directly inspired that of the six kings at Quṣayr ʿAmra, and proposed our panel for the then nonexistent and still now exiguous corpus of evidence for Sasanian painting.[90] The discovery in 1965 at Afrāsiyāb (Old Samarqand), far to the east yet still within the Iranian cultural sphere, of what seems to have been a royal reception hall with mid-seventh-century frescoes depicting ambassadors from various Asiatic

87. Use of sketches or plans in Umayyad architecture and decoration can hardly be doubted, *pace* among others Bakirer, *Muqarnas* 16 (1999) 52. A graffito found at Quṣayr ʿAmra (*Q.ʿA.* 105, and further information from J. Zozaya) may be an architectural plan, and there is a less debatable specimen from Qaṣr al-Ḥayr al-Gharbī (Soler and Zozaya, *III congreso de arqueología* 267, 274 fig. 3f). See also Khamis, *B.S.O.A.S.* 64 (2001) 165, on Hishām's marketplace at Scythopolis/Baysān; and (from other periods) the 1:1 plans for the nave arches inscribed on the floor of basilica A at al-Ruṣāfa: Bayer, *Resafa* 2.155–59; and the sketches of architectural decoration found at the Jawsaq al-Khaqānī in Sāmarrāʾ by E. Herzfeld: *Die Malereien von Samarra* 97, 99. Sibṭ b. al-Jawzī in Elad, *Bayt al-Maqdis* 54 (text), 35 (translation), reports a tradition derived from Muḥammad b. al-Sāʾib al-Kalbī (d. 763; father of Hishām) about a preliminary plan of the Dome of the Rock drawn "in the courtyard of the mosque". Al-Madāʾinī in Ṭab. 2.1636 (trans. 25.168) mentions models of fortresses in silver and gold given to an Umayyad governor of Khurāsān, who had built "arched halls *(īwānāt)* in the deserts", in 738. The detailed but purely decorative paintings of buildings (mosques?) in a recently discovered Ṣanʿāʾ Qurʾān manuscript may be of Umayyad date, as argued by von Bothmer in von Bothmer, Ohlig, and Puin, *Magazin Forschung* (1999, fasc. 1) 44–46 (including new C-14 dating); cf. *Is.A.A.* 74. (Such paintings were not previously attested in an early Qurʾān, but the Syriac Rabbula Gospel of A.D. 586 starts with comparable full-page architectural designs: Cecchelli, Furlani, and Salmi, *Evangeliarii syriaci ornamenta*.) For further, non-Umayyad references see Creswell 109–11.

88. Trümpelmann, *A.A.* (1968); cf. Herzfeld, *Die Malereien von Samarra* 6.

89. Cf. the reliefs of Mithridates II at Bīsutūn (Ghirshman, *Iran* 52 pl. 65), and Shapur II and Shapur III at Ṭāq-i Bustān (*Taq-i B.* 4.143, 163–66), with inscriptions in Greek and Pahlavi respectively.

90. Herzfeld, *Die Malereien von Samarra* 5–6; id., *Der Islam* 21 (1933) 235.

peoples, confirmed the taste for such themes—which are also alluded to in Chinese literary sources on Central Asia—and helped to fill in the general background of the Quṣayr ʿAmra painting.[91] Yet the relaxed, naturalistic grouping of these emissaries from Irān (according to a recent interpretation), China, Tibet, and even as far away as Korea bears little relation to the rigidly paratactic, frontal stance of the Quṣayr ʿAmra kings. Herzfeld too had to admit that the most relevant surviving corpus of evidence, namely the Sasanian royal rock carvings, offers no very close parallels to the frontality of the Umayyad painting, and was reduced to arguing—from little evidence—that this style became commoner toward the end of the Sasanian period. This seems unlikely. Usually, both in the rock carvings and elsewhere, it is only the *shāhanshāh* who is depicted frontally; and in that case he is more commonly seated than standing, while his courtiers and petitioners are shown in profile.[92]

Certainly the Umayyads produced some very close copies of Sasanian royal portraits, in the shape of the so-called Arab-Sasanian coinage issued during the second half of the seventh century.[93] Under ʿAbd al-Malik, these images were replaced by a thoroughly Arabic, epigraphic coinage; but members of the Umayyad clan might still pursue more privately an interest in Sasanian culture and art, if they wished. We happen to know, for example, that in the year 731, not long before the construction of Quṣayr ʿAmra, the caliph Hishām ordered to be translated from the Middle Persian an illustrated biographical dictionary of the Sasanian dynasty, with paintings of twenty-seven rulers, two of them women. Each entry listed the principal events that occurred and monuments erected during the reign in question; and each prince was depicted either standing if a warrior or seated if better known as an administrator, but in either case in full regalia, after original portraits that had been deposited in the Sasanian treasury.[94] (The fact that

91. Mode, *Sogdien und die Herrscher der Welt.*
92. Schlumberger, *La Persia e il mondo greco-romano;* Ghirshman, *Iran,* e.g., 184 pls. 225–26.
93. Morony, *Iraq* 41–51.
94. Al-Masʿūdī, *Kitāb al-tanbīh* 106–7 (trans. Carra de Vaux 150–51). This work is frequently quoted by Ḥamza al-Iṣfahānī, *Taʾrīkh* 38, 39, etc., as the *Kitāb ṣuwar mulūk Banī Sāsān;* cf. Schaeder, *Jahrbuch der preuszischen Kunstsammlungen* 57 (1936). Similar reading material was favored by Marwān II: Mas. 2288 (3.241 Dāghir). For a carpet in existence by the year 861 and decorated with medallion portraits of both Sasanian and Umayyad rulers identified by labels in Persian see Mas. 2980–82 (4.46–47 Dāghir). A similar sequence of portraits, perhaps in a book, must underlie the brief physical descriptions of Umayyad and Abbasid caliphs provided by Sāʿid b. al-Biṭrīq, *Kitāb al-taʾrīkh,* and by al-Masʿūdī in the latter part of his *Kitāb al-tanbīh.*

Quṣayr ʿAmra's patron is apparently depicted both standing in some of the hunting scenes and seated on his throne acquires additional significance in the light of this.) It is, in short, undeniable that some Umayyads were capable of an almost antiquarian interest in Sasanian royal iconography and probably would have commissioned a faithful copy of any painting or relief of the kings of this world from the Dukkān, had it existed. It is by no means self-evident, though, that the six kings panel at Quṣayr ʿAmra is such a copy.

In interpreting this or any other painting, it is much preferable to start from what we know for sure, however little that may be. Taking, then, on the one hand the painting of the six kings and on the other hand the traditions that accumulated around the Dukkān, which are too suggestive to be ignored, one may indeed accept that the former is likely to have been inspired by the latter. One may also reasonably surmise, with Herzfeld, that there had been preserved at the Dukkān (until when, though, we cannot say) some document, quite possibly an image with labels that named the kings individually. When Quṣayr ʿAmra's patron proposed this theme, though, he very probably had mainly in mind the various stories that were in circulation, and knew of the place and the (hypothetical) image only by hearsay; while what his artists produced was determined by their own visual vocabulary, which, for all its eclecticism, was closer to Roman than to Iranian tradition.

This is why the six kings ended up looking so strikingly East Roman, especially in their frontality. The parallels that immediately spring to mind are a perhaps Constantinopolitan sixth-century icon preserved at Mount Sinai (fig. 54), mosaics of the sixth century at Ravenna and of the same period or later at Thessalonica,[95] and wall paintings in the Apa Apollon monastery at Bawīṭ, now dated after the Arab conquest.[96] In the late sixth-century Syrian gospel book written by the scribe Rabbula, there is a depiction of Mary flanked at Pentecost by the apostles, six in front and six behind, making hand gestures that recall those of the six kings (fig. 55).[97] Heraclius's coins showing him flanked by his two sons, all standing, were well known in the Muslim world; in the 690s, ʿAbd al-Malik's mints imitated them (fig. 65a). There is also a Coptic codex in Naples, perhaps written as early as the fifth century, which contains part of the Book of Job, and on the back of its last leaf an ink drawing of an emperor, quite possibly Heraclius again, with to the

95. Above, p. 201 and n. 16; Martinelli, *San Vitale (Atlante)* 220–37 (the Ravenna Justinian and Theodora mosaics; note especially the soldiers and ladies in waiting).
96. Severin, *Ägypten* 336–37.
97. Cf. *A.S.* 495–96.

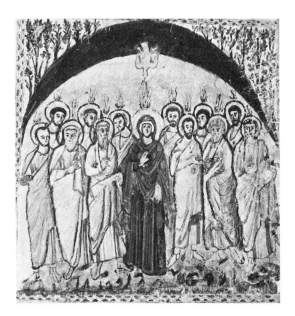

Figure 55. Rabbula Gospels: Virgin and apostles
at Pentecost (manuscript illumination, A.D. 586).
Biblioteca Medicea Laurenziana, Florence, MS Pluteus
I.56, fol. 14v. By permission of the Ministero per i
Beni e le Attività Culturali.

right of him likewise frontal depictions of what appear to be his empress
and two daughters, all gesturing with their right hand *away* from the
prince.[98] Further comparisons for the six kings are offered by two frescoes
from Caesarea Maritima, found close to each other and both dated, on in-
ternal grounds, to the late sixth or early seventh century. One shows orant
saints frontally disposed, stylistically quite reminiscent of the Rabbula
Gospels, and identified by Greek labels positioned on either side of their
haloes. The other depicts Christ flanked by the twelve apostles ranged
frontally on either side of him and gesturing toward him (fig. 56).[99] Given
the dearth of evidence for monumental painting in the sixth- to eighth-cen-
tury East, it is notable that both these recently discovered frescoes offer par-
allels with the six kings. If, on the other hand, one compares Quṣayr ʿAmra's
Kisrā with two seventh-century monuments from the Iranian cultural zone
that are plausibly supposed to depict late Sasanian monarchs, namely the

98. *A.S.* 35–36.
99. Cf. T. Avner, *Caesarea papers*.

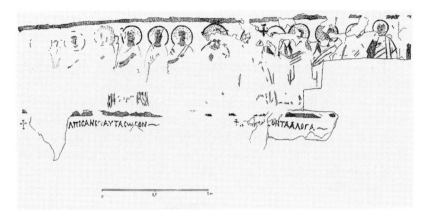

Figure 56. Caesarea Maritima: Christ and the twelve apostles (wall painting, late sixth or early seventh century). B. Haimov, in T. Avner, "Early Byzantine wall-paintings from Caesarea", in *Caesarea papers*, vol. 2, ed. K. G. Holum, A. Raban, and J. Patrich (Portsmouth, R.I.: Journal of Roman Archaeology, 1999) 120 fig. 15; courtesy of J. Patrich.

hunting reliefs at Ṭāq-i Bustān (fig. 35) and one of the frescoes at Afrāsiyāb, one has to admit that the belted vestments, soft cap, and facial hair of these figures differentiate them considerably from what we see at Quṣayr ʿAmra.[100]

These iconographical considerations have their own interest and even importance, as evidence for the Umayyads' relationship to the pre-Islamic cultural world. Of this there will be more to say shortly. But a gathering of six kings naturally makes one think first of politics rather than culture. Indeed, the possibility of a political message has already become clear from our discussion of the princely portrait in chapter 4 and, especially, the dynastic icon in chapter 6. The presence of Roderic in the six kings panel turns this possibility into a certainty. For if the Negus's territory impinged on the Sasanian sphere of influence in South Arabia and might have justified his appearance at the Dukkān (though in fact he is not mentioned), the Visigothic kings lay well beyond Ctesiphon's political horizon—but not Damascus's. Whatever Quṣayr ʿAmra's debt to the Dukkān, there has been some updating here, in the light of recent political history.

A far more significant political message is conveyed, though, by the initial choice of subject matter that preceded the secondary decision about exactly which monarchs should be included. What captured the Umayyad

100. *Taq-i B.* 4.109 fig. 44, 138 fig. 64; Mode, *Sogdien und die Herrscher der Welt* 58–71, 205 fig. 15 (and cf. *Taq-i B.* 4.117 fig. 50—the figure at the right).

patron's imagination was not the celebration of triumphs over captive kings, as in the mosaics that decorated the entrance to Justinian's palace;[101] or the vanquished ruler groveling in the dust before his conqueror, as in a number of well-known Sasanian rock reliefs;[102] or even subjects such as Khusraw I's siege of Antioch, which adorned the Sasanians' famous reception hall, the Īwān Kisrā at Ctesiphon.[103] Rather it was the idea of a peaceful acquiescence in the *shāhanshāh*'s rule, which was what the Dukkān had been designed to promote. Peaceful acceptance of their own rule the Umayyads did not necessarily take for granted, witness the apocalyptic anxieties revealed by prophecies circulating in late Umayyad Homs about conflict with Rūm, Turks, Berbers, Ethiopians, and the Abbasid revolutionaries in the Iranian East.[104] But if it were to be brought about, peaceful acceptance would be based on one or more of at least three concepts. There was, for example, the idea of the family—or better, perhaps, fraternity[105]—of kings, which the Quṣayr 'Amra panel has often been said to represent.[106] Secondly, there was the concept—already discussed—of the six *aqālīm* gathered round the central *iqlīm*, that of Irān. And thirdly, there was conceived to be an international hierarchy that linked all rulers, and to the *shāhanshāh*'s preeminent position in which the caliph was considered to have fallen heir. This idea is clearly expressed in later Arabic writings, as, for example, by the tenth-century historian al-Mas'ūdī, who asserts that the kings of China, the Turks, and India, among others, recognize the preeminence of the king of Babylon or rather the King of Kings *(shāhanshāh)*, who is as the moon amidst the stars on account of the rich and noble territory he rules. "Or such at least were the kings of this land"—he means the caliphs too, including the Abbasids—"in times gone by. One can hardly say the same in our day, in the year 332 [A.D. 943–44]." After Kisrā came the king of India, on account of that land's reputation for wisdom; then the king of China, because of the perfection of

101. Procopius, *De aedificiis* 1.10.16–18; cf. also Corippus, *In laudem Iustini Augusti* 1.285–86, for Justinian represented on golden vessels and his own funeral vestment, loading the Vandal king with chains or trampling his neck (with further parallels in Cameron's commentary, 119–20, 140–41, 142).

102. Ghirshman, *Iran* 153–61, 190–91

103. Al-Qazwīnī, *Athār al-bilād* 454–55; and cf. the painting in the palace at Panjikent, possibly depicting the Arabs' capture of Samarqand, some 70 kilometers to the west, in 712: Mode, *Sogdien und die Herrscher der Welt* 111.

104. Madelung, *J.S.S.* 31 (1986) 155–78, and 180 on the date.

105. Cf. Mas. 610 (1.285 Dāghir): Hārūn al-Rashīd beats a slave who has spoken ironically about the king who set up the Īwān Kisrā, on the grounds that "kingship (establishes) an affinity, and kings are brothers. Honour requires me to chastise this man, that kingship be preserved and kings maintain their solidarity".

106. Grabar, *A.O.* 1 (1954), and *Formation* 45.

his administrative system. In fourth position came the ruler of the Turks, the Khāqān, because of the ferocity of his warriors; and after him the king of Rome, for the beauty of his subjects. The remaining kings were all more or less each other's equal but constituted a category plainly inferior to the five just enumerated.[107] On whose authority al-Masʿūdī here depends is not made clear, though we have seen similar ideas expressed in the passage from Hishām b. al-Kalbī quoted earlier in this chapter, and it is easy to imagine that lists such as these had enjoyed perennial popularity.

This notion of hierarchy is reflected in the visual subordination of the six kings, who are placed physically lower down on the west wall than the dynastic icon of the Umayyad lords of Babylon—and so much else—on the adjacent endwall. It is proclaimed also in the gesture of supplication or honoring that they make with their outstretched hands. Within the group, the front row of emperors is given greater prominence than the back row of kings. And as in the old system, so too here, Kisrā in the middle of the front row occupies center stage—though now, of course, under the caliph. But if this is meant as a hierarchical blueprint for contemporary international relations, to be compared to that promoted, at least within the Christian sphere, by the East Roman state, and so abruptly called into question by Charlemagne's coronation in Rome in the year 800,[108] how does it come to include the not merely defeated but wholly defunct empire of the Sasanians and kingdom of the Visigoths?

If one were inclined to accept Herzfeld's suggestion that the Quṣayr ʿAmra panel was closely modeled on a Sasanian painting, one would have to assume, as he did, that Kisrā was left in it, at its focal point, by some oversight.[109] But the Negus's presence, and more particularly Roderic's, forbids this interpretation. It is clear that the painter's choices were deliberate. Once again it becomes apparent that this is no conventional image of military victory and political subordination. There is a broader understanding of triumph at play here, characterized—like al-Masʿūdī's explanation of the international hierarchy of kings—by a marked sensitivity to the cultural factor. The *NIKH* or Victory advertised on the endwall, and toward which the kings make obeisance, has been achieved not just by force of arms, but also by a "spoiling of the Egyptians". If, for example, Kisrā's Irān is recognized to be every bit as alive as Qayṣar's Rome, and just as deserving of a

107. Mas. 395–97 (1.181–82 Dāghir); and cf. 344 (1.161–62 Dāghir) for the same list in a slightly different order, attributed to the king of China.

108. Ostrogorsky, "Die byzantinische Staatenhierarchie", *Zur byzantinischen Geschichte* 119–41.

109. Herzfeld, *Der Islam* 21 (1933) 235.

place among the six kings, that is because it was still a cultural force to be reckoned with in late Umayyad times. And there must be a similar explanation for the presence of Roderic, who not only symbolized the Umayyads' military and political expansion into the farthest western reaches of the world, but was also a noted hunter. In addition he had been the steward of a part, at least, of Solomon's treasures, whose significance had to do not only with the fate of monarchy (for those treasures had long been connected with certain beliefs about the foreordained end of empires[110]), but also with the history of monotheism. The Negus too, as a leading representative of non-Chalcedonian Christianity, meant more to the Muslim world than he could to the Romans, for whom he was merely a remote heretic. In short, the significance of several of our kings, in the context in which they find themselves at Quṣayr 'Amra, is cultural at least as much as political. That is perhaps the reason why they are all attired in court not military dress.

Finally, the obverse of Quṣayr 'Amra's sensitivity to the cultural legacy of the pre-Islamic world is a certain ambiguity about Islam itself. In the alcove portrait al-Walīd does, admittedly, present himself in the guise of God's first caliph, Adam. This is a powerful image and Quranic allusion, not to be ignored. It is reinforced by the explicit reference to Islam in the text on the arch that frames the princely portrait. One should recall too the text in the east aisle that alludes to Abraham and David (though Islam had no monopoly on them), and the dynastic icon that shows al-Walīd holding the Prophet's staff. But the princely portrait may also, as noted at the end of chapter 5, deliberately encourage associations of ideas that subvert its apparent piety. What was more, any Muslim, on entering a room decorated with depictions of women playing music or dancing with almost no clothes on, would either have thought of Paradise or—more realistically in a bath house—understood that these were ostentatiously non-Islamic pleasures, to be contrasted with such pursuits as reading the Qur'ān, fasting, and religious conversation.[111] In fact, Quṣayr 'Amra is a perfect specimen of that richness of embellishment the Qur'ān repeatedly dismisses as the mere worldling's pleasure and

110. See above, p. 213 n. 75; also Procopius, *De bellis* 4.9.1–9, asserting that Justinian sent to Jerusalem the Solomonic treasures Belisarius captured from the Vandals, because certain Jews told him that keeping them in the palace at Constantinople would bring ill-fortune. It may have been for a similar reason that al-Walīd I's successor Sulaymān (715–17), according to a short historical note contained in a Syriac manuscript, "gathered together all the treasures of the Saracens [perhaps including Solomon's table from Toledo, which our sources associate with prophecies of Visigothic Spain's fall to the Arabs], assembled them and installed them in a public treasury in the city of Jerusalem": Nau, *Journal asiatique* 5 (1915) 256, 267.

111. Hishām b. al-Kalbī in Ṭab. 2.396 (trans. 19.190); cf. Kister, *J.S.A.I.* 23 (1999).

delusion, the Arabic word for which, *zukhruf*, appears to be derived from the Greek *zōgraphos/zōgraphia*, "painter"/"painting".[112]

There are also features of the bath house's decoration that could have been presented in a more explicitly Islamic fashion, had the patron desired. A politico-militarily triumphalist presentation of the six kings would have meshed well with the idea of Islam as a new revelation that superseded and entailed the disappearance, through *jihād* if necessary, of all that had gone before. That was what many among the Umayyads' Muslim subjects expected in the public or, for that matter, private declarations of their masters. Hishām and al-Walīd were, it is true, personally unwarlike,[113] and on the frontiers things were not going well by the early 740s.[114] But that was no reason not to claim victory if victory was what one's religion required. And everyone knew that the caliphate would never have come into being in the first place without the force of Islam to propel it. Apart, though, from the sacral element in the princely portrait, there is little else in the paintings at Quṣayr ʿAmra to remind us of this debt. The six kings, in particular, are rather to be admired than pitied, and the implication is that their cultural legacy is of more interest than their spiritual subjection (or that of their peoples) to Islam.

One may recall—and contrast—the popular tales about how Muḥammad had written to the kings of the world requesting they submit to Islam. Our earliest surviving source for the Prophet's life, Ibn Isḥāq, writing not so far in time from the date of Quṣayr ʿAmra, named the following as recipients: the rulers of Yamāma, al-Baḥrayn, and ʿUmān in Arabia; Muqawqis, the ruler (i.e., Chalcedonian Christian patriarch) of Alexandria; Qayṣar, that is, Heraclius; the ruler of the Ghassanid Arab confederation in Syria; the Negus; and Kisrā.[115] Though Heraclius is said to have been favorably disposed, nobody accepted Muḥammad's offer, and only the Negus even bothered to send a civil reply. But the point of the story was that, in return for confirmation in their office and responsibilities, the Prophet had expected the kings of the world to accept his revelation. At Quṣayr ʿAmra there is no such expectation. Rather, the six kings are shown in all the glory of their secular *mulk*, and the Umayyad patron, far from imposing his revelation on them, instead annexes their political and cultural prestige. He will hardly have been unaware that religious opponents of his regime were singling out

112. Qurʾān 6.112, 10.24, 17.93, 43.35; cf. Shahîd, *B.A.SI.C.* 2 (1).65.
113. Al-Wāqidī in al-Balādhurī, *Kitāb futūḥ al-buldān* 186.
114. Blankinship, *Jihād state* 199–222.
115. Ibn Isḥāq in Ṭab. 1.1560–75 (trans. 8.99–115).

precisely this kingly aspect of Umayyad rule as one of their principal reasons for denying its legitimacy.[116] But he seems content to present himself in a fashion akin to that in which Christian writers of the period portrayed Muḥammad: merely as the first king of the Arabs, and the successor of Roman and Iranian emperors.[117] If in the princely portrait he lays claim—for those with eyes to see—to the prophetic aura of a true caliph as well, it is through an allusion to Adam, who was as acceptable to Jews and Christians as to Muslims, and whose title of *khalīfa* contemporary Quranic exegetes studiously avoided connecting in any way with the ruling dynasty.[118] This image too is, in fact, very much a glorification of the caliph's kingly majesty, a far cry from the ascetic, indeed hagiographic verbal portraits of the Prophet's immediate successors, especially Abū Bakr and ʿUmar, that were evolving at this very time in the works of religious scholars.

116. See above, pp. 171–72.

117. Brock, *Syriac perspectives* VIII.14, 20; Hoyland, *Seeing Islam* 393–99, 458, 558–59; Wolf, *Conquerors and chroniclers* 41–44. One of the Prophet's Jewish contemporaries was said to have referred to him contemptuously as "king of the Ḥijāz": Ibn Isḥāq, *Sīrat rasūl Allāh* 763 (Wüstenfeld)/3.366 (al-Saqqā), and cf. 669 (Wüstenfeld)/3.237 (al-Saqqā). Others hesitated whether he was just a king or truly a prophet (e.g., Ibn Isḥāq, *Sīrat rasūl Allāh* 815 [Wüstenfeld]/4.53 [al-Saqqā] [*mulk-nubūwa*], 949–50 [Wüstenfeld]/4.235–36 [al-Saqqā])—an earlier discussion that helps contextualize the accusation of *mulk* thrown at the Umayyads.

118. See above, p. 138.

8 A Captive Sasanian Princess

PORTRAIT OF A BATHING BEAUTY

Adjacent to the six kings and contrasting oddly with them, in the very center of the hall's west wall, a tall and beautiful woman, almost entirely naked, stands in a bathing pool amidst an impressive architectural setting (fig. 57).[1] Much better preserved than the six kings, and a more striking, focused composition than the acrobats in the third, right-hand panel on this wall, our painting now dominates the west aisle. But whereas part of the meaning of the six kings panel yields itself more or less at first glance, while even the more complex image of dynastic succession on the endwall plainly depicts an eminent person enthroned, and echoes the princely portrait in the alcove, the reason why our artists chose to place a bathing beauty right next to the six kings is not apparent to the modern visitor.

The architectural space depicted is enclosed by a high colonnade joined by three round arches. The perspective in which this arcade is drawn, though awkward, makes plain that we are viewing a polygonal structure, which could have been covered by a dome. Between the two columns that support the left-hand arch extends a lower and more closely spaced colonnade supporting a gallery with a decorative parapet. The fresco's inadequate perspective makes it hard to tell, but the colonnade and gallery may link the main arch's two columns in a straight line, as at Hagia Eirene in Constantinople;[2] or they may be on a second plane behind that of the arch, making a double aisle whose outer half (against the building's external wall) bears the gallery, as

1. Cf. Q.'A. 50 fig. 22, 103 figs. 72–73, 122 fig. 84, 125 fig. 85, 127 fig. 86; *Mémoires d'Euphrate* 217.

2. Krautheimer, *Early Christian and Byzantine architecture* 251 fig. 209.

Figure 57. Quṣayr ʿAmra, hall, west wall: bathing beauty (fresco). F. Anderegg, courtesy of O. Grabar.

at S. Demetrius in Thessalonica.[3] But Hagia Eirene and S. Demetrius are basilicas, whereas the structure depicted at Quṣayr ʿAmra is centrally planned. In all probability, then, what the artist had in mind was a double-shell domed octagon like SS. Sergius and Bacchus at Constantinople (fig. 58) or San Vitale at Ravenna,[4] in which the low colonnades linking the main columns (as they are depicted at Quṣayr ʿAmra—really they should be piers) may either be straight or else billow into the enveloping ring but in either case bear galleries that look directly onto the building's central space rather than being buried (as at S. Demetrius) in a double ambulatory. Aisled poly-

3. Cf. Sotiriou, Βασιλικὴ τοῦ Ἁγίου Δημητρίου pl. 1β, 2α.
4. Martinelli, San Vitale (Atlante) 123–27.

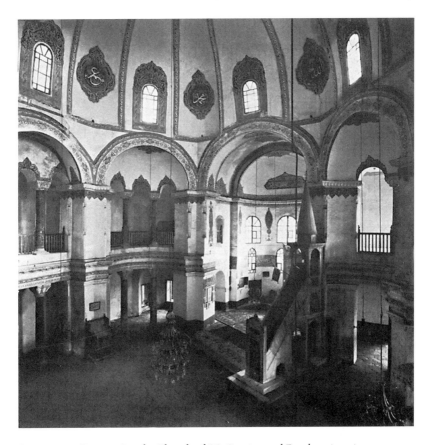

Figure 58. Constantinople, Church of SS. Sergius and Bacchus, interior.
J. Powell, in R. Krautheimer (rev. R. Krautheimer and S. Ćurčić), *Early Christian and Byzantine architecture* (Harmondsworth: Penguin Books, 1986⁴) 224 ill. 182.

gons had been popular in the eastern provinces of the Roman Empire, but also in the West, at least since the time of Constantine (306–37).[5] Domed "single-shell" octagons—that is, without ambulatories—are known to have been incorporated in bath houses, and to have featured centrally sited bathing pools. Part of one still stands outside Viterbo near Rome; and the type was well known in Syria, as, for example, at Antioch and Buṣrā.[6] The bath house of the late Roman villa at Lufton, Somerset, England, culminated

5. Kleinbauer, *D.O.P.* 41 (1987); Holum, *Caesarea papers* 28 fig. 13 (the recently discovered martyrium at Caesarea Maritima).
6. Yegül, *Baths and bathing* 326–28, 387–89.

in an octagonal frigiderium *with* ambulatory.[7] In the reign of Constantine the octagonal plan also began to be used for the construction of baptisteries, often with an octagonal font too, in the center of the building.[8]

From the gallery in the painting at Quṣayr 'Amra, a crowd of onlookers— probably female,[9] though their lack of facial hair does not absolutely impose this—looks through the high colonnade into the central space and watches the bathing beauty. The arch to the right of the composition is narrower and rests on the carved lintel of a doorway closed by a white curtain. Above the lintel and framed by the arch, perhaps in a gallery over the entrance to this grand chamber, can be discerned the head and shoulders only of another, this time solitary observer, beardless and wearing a necklace, but quite possibly a high-class male (in the manner of the six kings) rather than a female.[10] A woman attendant stands next to the pool and gestures toward the bather.

Although Quṣayr 'Amra's paintings quite often seem to recall particular iconographical types from the art of the Roman East, we cannot always be certain that the debt is specific and conscious, partly because we are as yet imperfectly informed even about the vocabulary of late Roman art, let alone the sources and procedures of artists employed by the Umayyads. For example, until a few years ago it would have been impossible to draw the parallel proposed in chapter 4 between Quṣayr 'Amra's enthroned prince and Christian depictions of Adam, because the particular Christian iconographical type in question was unknown. The origins of our bathing beauty, though, are self-evident: she is a late but powerful avatar, at the very heart of the Muslim caliphate, of a standard image of Aphrodite, the eastern provinces' best-loved Greek goddess, and ever at home in the bath house. A ceramic statuette found near 'Ammān could almost have served as a model for the Quṣayr 'Amra artist: a tall and striking figure, both arms half raised, and completely naked save for a body chain, a necklace, armlets, and bracelets (fig. 59).[11] The Quṣayr 'Amra bather wears the skimpiest of bikini bottoms, a turban, and a necklace. Instead of a body chain, a

7. Cf. Rossiter, *J.R.A.* 15 (2002) 627 with fig 1

8. Krautheimer, *Early Christian and Byzantine architecture* 176–78.

9. On the traditional Arab association between women and upper rooms see N. N. N. Khoury, *I.J.M.E.S.* 30 (1998) 22 n. 46.

10. Necklaces were part of the well-off male's wardrobe: *Taq-i B.* 4.109 fig. 44; Iṣf. 7.70 (al-Walīd b. Yazīd); and cf. Hishām b. al-Kalbī in *Ṭab.* 1.754–55 (trans. 4.136–37) on 'Amr b. 'Adī, the first Lakhmid king of al-Ḥīra and the first Arab man to wear a necklace.

11. Cf. M.-O. Jentel, *L.I.M.C.* 2(1).159 no. 111.

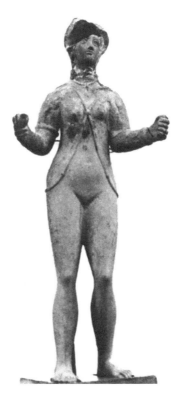

Figure 59. Aphrodite (ceramic statuette, found near ʿAmmān). Archaeological Museum, ʿAmmān, inv. no. J 12940. By permission of the Department of Antiquities, Jordan.

pendant hangs between her breasts, though this is not unparalleled in images of Aphrodite.[12]

Certain aspects of our bather's pose and appearance are strange. For example, she raises her left hand to the level of her face not, as Aphrodite often does, to gather her hair that is wet from the bath, or to balance herself as she removes her sandal, but in order to pull back a curtain which hangs, though, behind her. This must be pure ineptness on the part of the artist. Much odder, because clearly not an artist's mistake, is the gesture the bather makes, index and small figure extended, with her right hand as it hangs at

12. M.-O. Jentel, *L.I.M.C.* 2(1).165 no. 244, 2(2).169. For a statue of a female beauty, quite possibly Aphrodite, preserved in an al-Fusṭāṭ bath house until it was destroyed in the reign of Yazīd II, see above, p. 146 and n. 20.

her side. It resembles but can hardly have the same meaning as the "allo-cution" gesture used, for example, by saints, but then with an outstretched hand, in Syrian Christian iconography.[13] A third peculiarity of this painting is the turban the bather appears to be wearing, with a round ornament on its front. Aphrodite, whatever she wore on her head, had never allowed her beautiful hair to be hidden, while the rare occasions when Arabic literature mentions females wearing turbans—deliberate deceptions designed to pass women off as fighting men or hunters[14]—amply confirm the general rule that they never did.[15] Because of her incongruous turban, then, and the "allocution" gesture as well, it was recently suggested that our bather is a man, in fact the caliph himself, ei-ther in the act of addressing his court or wage bargaining with his subjects![16] Luckily, artistic motifs at Quṣayr ʿAmra have not often suffered such rad-ical decontextualization. One simply has to accept that certain aspects of this painting cannot as yet be explained, and that one of the reasons for this is perhaps the rather speculative restoration they have undergone, which may be the explanation for any or all of the three peculiarities just mentioned. At least there is no doubt that our bather does allude to icono-graphical types of Aphrodite, perhaps in particular to images that show the goddess at her bath with an attendant holding her clothes.[17] And who-ever the woman pictured on the wall at Quṣayr ʿAmra may be, one senses that she is no less aware of her own beauty than Aphrodite was. She is de-sirable but too ideal to be attainable, as her rather impassive gaze half intimates.

Besides this iconographical parallel, there are one or two other observa-tions that ought to be made before an interpretation is offered. The visual centrality of this panel is particularly notable. True, one finds oneself face-to-face with the enthroned prince as soon as one enters the hall from out-side, through its main doorway; but he is on the back wall of a low and rather dark alcove. The family portrait is better lit but is positioned to one side of the hall's main axis. If, though, we take the hall's other, east-west axis, as it appears to one who emerges into it through the room's second doorway,

13. Dodd, *Arte medievale* 6 (1992) 123–24.
14. Ḥammād al-Rāwiya in Iṣf. 11.175–77 (trans. Weisweiler, *Arabesken der Liebe* 132–34); al-Wāqidī in al-Balādhurī, *Kitāb futūḥ al-buldān* 186; al-Azdī, *Ta'rīkh al-Mawṣil* 149 (trans. Robinson, *Empire and elites* 135); Mas. 1648 (2.370 Dāghir). It is possible that one of the *mukhannathūn* (?) depicted over the alcove arch (fig. 20) also wears a turban.
15. Dozy, *Noms des vêtements* 311.
16. Dodd, *Arte medievale* 6 (1992) 123–24.
17. E.g., Baur, *Excavations at Dura-Europus* 279–82 and pl. XLIII.

from the apodyterium, then the bathing beauty lies straight ahead on the opposite wall, a commanding single—if not wholly solitary—figure to contrast with the many more or less equally weighted persons in the six kings and acrobats panels to the left and right of her (fig. 60). That it is the only scene in the bath house hall that actually represents somebody taking a bath also suggests that our painting's purpose is not to illustrate the building's function, but to make some other point, no doubt relevant to the rest of the hall's decoration.

Something else that strikes one about this painting is that it bears no explanatory label, either in Arabic or in Greek. One can only deduce that, to those who built and used Quṣayr ʿAmra, the scene was comprehensible at a glance. It stood for an idea or represented an event that was familiar to all. Unfortunately, this mental key to the painting has long since been lost, and modern students of Quṣayr ʿAmra have been left to speculate. Could our bathing beauty be, for example, that 7-cubit-tall slave girl of great beauty who was sent as a gift to the Sasanian monarch Khusraw I "of the immortal soul", Anūshirwān (531–79), by a king of India?[18] But that would make this the only painting in the hall that has nothing whatever to do with the Arab world. It seems too whimsically chosen a theme—and certainly not recognizable at a glance—for a context where everything else relates so closely to the life of an Umayyad prince.

Perhaps, in that case, the bathing beauty is one of the patron's favorite singers or dancers?[19] There is, though, no shortage of such women in the hall, and the others want to get on in the world by performing and pleasing. By contrast, the subject of our fresco benefits from a striking backdrop and an attentive audience yet shows no disposition to entertain, whether with dance or song.[20] She seems oddly aloof, given that, so far as one can tell, her only reason for being here is to show off the charms of her almost naked body. There is something awkward about the scene; while the impression one has that the onlookers in the gallery to the left are all women, and only the solitary and perhaps somewhat furtive observer at the right is a man, gives the male visitor to Quṣayr ʿAmra a sense of being a voyeur, of looking at something not intended for him. Could it be that this woman is not a slave entertainer, but free, or else a free woman reduced suddenly to captivity and now displayed at the conqueror's court?

18. Mas. 623 (1.293 Dāghir); cf. Grabar, *A.O.* 1 (1954) 187 n.17.
19. Grabar, *Formation* 154–55.
20. Her left arm is in the same position as that of the dancer on the south soffit of the hall's west arch (fig. 17). But otherwise her body is static.

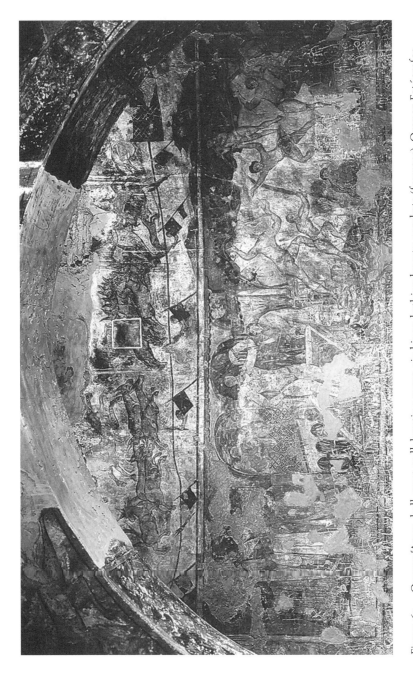

Figure 60. Qusayr ʿAmra, hall, west wall: hunting scene, six kings, bathing beauty, acrobats (frescoes). Oronoz Fotógrafos, Madrid.

BEAUTY CONTESTS AND DISPLAYS

That the artist had some particular occasion in mind, we should not doubt. The strange gesture the bather makes and her turban point in this direction. So too do her carefully drawn features. Hers is a more finished, less schematic portrait than many others in this hall, comparable with the prince as shown in the hunting scenes or the family portrait or with Umm al-Ḥakam, rather than with the entertainers or the beaters in the net hunting scene.[21] As for the elaboration of the architectural setting, it makes the framing elements in the princely and family portraits look perfunctory. The scene seems to be set in the bath house of a palace, not of a mere hunting lodge like Quṣayr ʿAmra. The excavation of the palatial, domed hall of the bath house at Khirbat al-Mafjar, with its large pool reached by a flight of four steps,[22] and more recently of part of a massive and splendid bath house in a palace complex near the al-Aqṣāʾ mosque in Jerusalem,[23] has provided a salutary reminder how grand and inventive, yet indebted to Mediterranean tradition,[24] Umayyad domestic architecture could be; while the Dome of the Rock in Jerusalem is a spectacular example of the Umayyads' adoption of the octagon—with ambulatory but no galleries—from the architectural tradition of East Rome,[25] and for a building that, while religious, is not a mosque. The Quṣayr ʿAmra bathing beauty panel now more or less obliges us to suppose that the Umayyads deployed a similar plan in one or more of their grander baths.[26] Perhaps our fresco depicts the bath house of the caliphal palace (Qaṣr al-Khaḍrāʾ) in Damascus. Unfortunately, almost nothing is known about the appearance of this building, but it is likely that it was influenced by East Roman models, not least because either it or a previous building on the site had served as the residence of the city's Roman governor. A story was told, apocryphal no doubt, but psychologically plausible, of how Muʿāwiya, having "built" (meaning perhaps rebuilt or extended) al-Khaḍrāʾ in brick, asked a visiting East Roman en-

21. The bathing beauty has been thought to resemble both the pensive woman offered a crown by a wingless Eros in the central aisle (Linant de Bellefonds, Ἑλληνισμός 235–37) and Umm al-Ḥakam (Q.ʿA. 67). The second comparison is the more plausible, but the bather looks much younger, and we do not know how much either portrait was retouched by the Spanish restorers.

22. *K.M.* pls. LXXVIA, CIV.

23. M. Ben-Dov, *N.E.A.E.H.L.* 2.793–94; cf. Raby, *Bayt al-Maqdis* 169–73.

24. Yegül, *Baths and bathing* 341–49.

25. Creswell 101–9; *Is.A.A.* 17–19.

26. Two Umayyad *quṣūr* have already yielded remains of centrally planned pavilions with octagonal elements and associated with bath houses: Haase, *ARAM periodical* 6 (1994) 252–53, 257 fig. 4 (Madīnat al-Fār near the river Balīkh); Hamilton 55–63 (Khirbat al-Mafjar).

voy for his opinion, only to be informed that the upper part was good for birds and the lower for rats. Mu'āwiya dutifully demolished the palace and rebuilt it, this time in stone.[27] The Dome of the Rock, then, is the most striking testimony, still standing today, to the Umayyads' admiration for Christian Roman material culture, of which the Constantinopolitan court was the ultimate distillation. And this disposition to emulate their neighbors will have extended not only to the architectural form of the octagonal, domed golden audience hall, the Chrysotriclinus at the heart of the imperial palace,[28] but also to the rituals performed within it, if only in order to impress Roman ambassadors when they visited Damascus.

To the beholder of this nude yet unmistakably distinguished woman being shown off in a palace bath house, the conclusion that occurs with least effort is that our fresco depicts a bride show. Assuming more recent customs are something to go by, we can be fairly sure that only once in an ordinary free Arab woman's life was she taken to the bath house and washed in front of a crowd of (female) onlookers, and that was just before her wedding.[29] As for the element of presentation and display—not just the washing and merrymaking of the ordinary bridal bath—that is so marked a feature of our fresco, this seems to point to customs well documented at the court of Constantinople, though not at that of the Umayyads.

Much scholarly interest has recently been attracted by the five bride shows that were held for Roman emperors or their sons at Constantinople between the years 788 and 882—but there is also less certain evidence for something similar as early as the end of the fourth century, as well as a clear precedent in chapter 2 of the Book of Esther.[30] An especially detailed account survives of the last of the known bride shows, the one held in 882 for the benefit of Leo, the son and coemperor of Basil I.[31] It was preceded by an

27. Ibn ʿAsākir, *Taʾrīkh madīnat Dimashq* 2(1).133–34, and cf. 138; a slightly variant version in Bal. 1. fol. 378b = p. 756 (147, §418 ʿAbbās) (trans. Pinto and Levi della Vida 159–60, §370). But it is unlikely that such a building would have been constructed of brick in Damascus. The story may have been intended as a subtle criticism of Umayyad *mulk* or, more especially, Caesarism *(qayṣarīya)*: cf. Conrad, *Quest for understanding* 266–67; Crone and Hinds, *God's caliph* 115; Shboul, ΚΑΘΗΓΗ-ΤΡΙΑ 114. For a general discussion of the al-Khaḍrāʾ see Flood, *Great mosque* 147–59.

28. Krautheimer, *Early Christian and Byzantine architecture* 77–78, 230–31.

29. Grotzfeld, *Das Bad im arabisch-islamischen Mittelalter* 102–3 (and see the next paragraph).

30. Bibliography in Dagron, *Empereur et prêtre* 67–68. Along with Dagron and *pace*, most recently, Afinogenov, *Eranos* 95 (1997) (reference courtesy of Peter Brown), I accept the historicity of the bride shows. Beauty contests always attract gossip; the anecdotal nature of the evidence is hardly surprising.

31. *Vita S. Theophano* 8–10.

empire-wide search for eligible girls conducted by officials sent out from the imperial palace. The "candidates" were brought to the capital, and after a screening process in which Eudocia, Basil's consort, was closely involved, twelve semifinalists were assembled in the imperial apartments of the Magnaura Palace. The Augusta Eudocia then picked three finalists, whom she made trial of in the bath (ἐν γυμνασίῳ). The winner, the future S. Theophano, was clothed in imperial garments and proclaimed by the senior emperor, before being presented to Leo, who had no say in the process but was afraid of his father so did what he was told. He had to endure some fifteen years of marriage to the holy Theophano until, after her premature death, he was able to marry Zoë, his mistress of many years' standing.

While it would have made sense to commission portraits of potential brides from the provinces who were not personally known to the imperial family,[32] it is not very likely that the bride shows themselves, least of all the proceedings in the bath house, were commemorated in paint. As for the Umayyad court, the Arabs' taboo on depicting free women even in words, let alone images,[33] makes it particularly hard to imagine that a woman eligible to marry into the caliphal family would ever have been painted nude on a bath house wall unless—a possibility we should not dismiss out of hand—offense was intended.

If, then, our bathing beauty is, in all probability, neither a free bride-to-be like Salmā nor a servile performer like the singer Suʿād we encountered at the end of chapter 2, there remains only one other option—she must, as we also supposed in the case of Umm al-Ḥakam, have been a captive taken in war. The position of such women, who might have been raised in great luxury, was especially delicate, though far from uncommon. The Muslim armies' successes on the field of battle ensured an abundant supply. As for the demand, it was generated not only by the laws of economics, but also by a distinctive social system. If Christian Rome was a monogamous society, whose Church viewed even a second marriage as an occasion for penance, while concubinage *(pallakeia)* existed, to be sure, but was legislated against, the caliphs, by contrast, could be married to four women at any one time, and divorce and remarriage were easy. Al-Walīd I was said to have taken and dismissed sixty-three wives during his ten-year reign.[34] Muslim men might also enjoy as many concubines as they could. Opportunities not only for bride shows, but also for beauty contests for concubines, were correspond-

32. Or of imperial princesses for display to potential bridegrooms among foreign potentates: Nicephorus of Constantinople, *Breviarium* 12.

33. Above, p. 64, and p. 75, esp. n. 126.

34. Abbott, *Studies* 3.77.

ingly numerous. Here as in much else, the Sasanians set an example the Umayyads followed, perhaps in part because the later Sasanian kings' model of perfect beauty had been none other than an Arab girl.

In al-Ṭabarī's great *History*, but also in the *Kitāb al-aghānī*, we read how al-Mundhir III, the Lakhmid Arab ruler of al-Ḥīra (505–54) and ally of the Iranians, gave as a present to Khusraw I (the same fortunate monarch who had been sent the tall Indian beauty) a girl whom he had won when he was raiding the Ghassanid Arab leader al-Ḥārith b. Jabala (c. 528–69), Rome's ally on its eastern frontier against the Lakhmids and Iranians. With the girl, al-Mundhir sent a letter in rhymed prose, a characteristic specimen of Arabic lexical exhibitionism, in which he described her body in the following words:

> (She is) of medium build and clear complexion with good teeth. (Her skin is) white, gleaming like the moon, her lashes are long, the deep black of her large eyes (contrasts with) their intense whites *(daʿjāʾ hawrāʾ ʿaynāʾ)*. Her nose is high and aquiline, her eyebrows are arched and perfectly spaced, her cheeks are smooth, her mouth is inviting, her hair luxuriant, her head noble, and her neck long, so that her earrings hang freely (from her lobes). Her chest is broad, her breasts are full, the bones of her shoulders and elbows are sturdy, her wrists comely, her hands delicate, her fingers long. She is lean of belly, and so slender of waist that her body chain *(wishāḥ)* hangs loosely from her. Her hips are heavy, her buttocks are well rounded, her thighs are plump, her seat fleshy, her haunches ample, her knees large, and her calves so fleshy that they fill her anklets, though her ankles and feet are dainty. Her steps are slow, she is drowsy even in the morning, and her skin is tender, even on those parts of the body that are usually exposed.

And al-Mundhir continues in this vein, lauding in no less fulsome terms his captive's virtuous character. Khusraw accepted the gift, so we are told, and ordered that al-Mundhir's letter be registered in the royal archive. It was passed down from generation to generation, and Khusraw's heirs would send out copies of it to their subordinates, whenever they required women for their court or wives for their sons.[35]

Because, for reasons that do not need to be explained here, this story became part of the prehistory of the famous armed encounter at Dhū Qār,

35. Ṭab. 1.1025–26 (trans. 5.353–54; Nöldeke 326–28); Iṣf. 2.113–16 (trans. Horovitz, *Islamic culture* 4 [1930] 61–62: a slavish English translation by M. Pickthall of an unpublished German version little different from Nöldeke's). The translation offered here is from Ṭab. emended where necessary from Iṣf. (who differs only in a few words) and was made by the author with kind assistance from Farida Boulos and Fahima Toro.

which took place at some point between 604 and 611 and was the first occasion on which Arab tribesmen succeeded in vanquishing a Sasanian force in pitched battle,[36] the Ghassanid captive maiden became a well-known character in the history of the Arabs before Islam. In their turn, the Umayyads took up with enthusiasm the idea of mail-order restocking of the ranks of singing girls and concubines at court. 'Abd al-Malik sent his governor of 'Irāq, al-Ḥajjāj, a demand for thirty women described in such *recherché* terminology that neither the governor nor his entourage had a clue what it meant. Eventually the riddle was solved by a notorious rabble-rouser and drunkard, one of the Arabs of the desert, who had to be extracted from the al-Kūfa jail specially for this purpose.[37] The story illustrates the esteem in which the Arabic of the nomads was held, and urbanized Umayyads' loss of touch with it. Hishām too sent out letters describing female slaves to be bought on his behalf: two of these missives have been preserved.[38]

In trying to envisage exactly how captives and "mail-order" slave girls would have been presented at court, we get precious little help from the literary sources. Apart from the situation we have already encountered, in which a prince falls for a performer during a presentation by a broker or slave dealer,[39] the most likely parallel is provided by the Sasanian monarch's wives and concubines, who might, on the occasion of the Nawrūz or Mihrjān festival, present their lord and master with an especially favored slave girl. According to the mid-ninth-century *Kitāb al-tāj* attributed to al-Jāḥiẓ,

> If one of them possessed a slave girl she knew the king loved and took
> pleasure in, she brought her to him (adorned) in all her jewellery and
> (wearing) her finest clothes and (in general) looking her best. And
> when she had done this, it was the king's duty to give her precedence
> over his other wives, advance her rank, show her more esteem, and bear
> in mind that she had acted selflessly . . . in making him a present few
> women could bring themselves to offer with a joyful heart.[40]

Such gifts were not unknown at the Umayyad court. Al-Madā'inī relates how the caliph Sulaymān criticized Yazīd b. 'Abd al-Malik's extravagant purchase of the singing girl Ḥabāba and forced him to return her. After Yazīd became caliph, his wife Su'da asked him whether there was anything he still desired.

36. Ṭab. 1.1015–37 (trans. 5.338–81); L. Veccia Vaglieri, *E.Is.* 2.241.
37. Naṣr b. Muzāḥim in Mas. 2097–101 (3.149–51 Dāghir).
38. 'Abd al-Ḥamīd al-Kātib, letters 7, 15 (197, 208 'Abbās); cf. al-Qāḍī, *B.E.I.N.E.* 1.229–31.
39. Above, pp. 80–81, 83, on Su'ād and Ḥabāba.
40. Al-Jāḥiẓ (attributed), *Kitāb al-tāj* 148.

He said: "Yes there is: Ḥabāba." Suʿda therefore sent a man who purchased Ḥabāba for four thousand dīnārs. Suʿda made her up and adorned her so that she would not look travel weary, and then she brought her to Yazīd and placed her behind a curtain. She asked: "O Commander of the Faithful, is there anything in the world that you still desire?" He replied: "Yes. Didn't I tell you when you asked me this question previously?" Then she lifted up the curtain and said: "Behold! Ḥabāba." Suʿda stood up, leaving Ḥabāba alone with the caliph. This act endeared Suʿda to Yazīd, who was generous with her and gave her many presents.[41]

Lacking evidence specifically about captives, we are forced to assume they were treated in much the same way as slave girls acquired on the internal market—who often had started out as prisoners of war anyway. We are almost equally ignorant of procedures on the Roman side of the frontier, though it is worth recalling something already mentioned in chapter 2, namely that the emperors were in the habit of making formal receipt of booty brought back by their victorious generals in the Sophianai—either the palace or the bath house of that name—at Constantinople.[42] Among the booty there will have been captives; and among the captives, beautiful young women were undoubtedly given pride of place—though they happen not to be referred to in our sources, at least in those that deal with events in the eighth century.

SHĀH-I ĀFRĪD

The picture the Greek sources suggest is largely confirmed by the Arabic evidence and corresponds well enough to what we see in our fresco. The woman is taken to the palace to be bathed and adorned and is then kept behind a curtain until the moment of revelation. If we are still not very close to identifying the particular individual in question, some more common-sense observations may help. First, any captive woman who ended up being painted on the walls of a princely hunting lodge, in a particularly prominent position without a label or any sign of interest in singing or dancing, must have been a concubine of a member of the Umayyad dynasty. Sec-

41. Al-Madāʾinī in Ṭab. 2.1464–65 (trans. 24.195–96 D. S. Powers).

42. Above, p. 53. Part of this ceremony was called a *maïoumas;* and Blazquez, *Archivo español de arqueologia* 54 (1981) 169–76, suggested the Quṣayr ʿAmra bathing beauty panel depicts the late antique water festival of that name, celebrated in honor of Dionysus and Aphrodite (John Malalas, *Chronographia* 12.3). It seems, though, that by the eighth century *maïoumas* meant just the bestowal of largesse.

ondly, that member was unlikely to have been the patron, since even a con-
cubine would hardly be displayed naked by her master in a semipublic place.
Al-Walīd himself was quite capable of stripping naked if carried away by a
poem during a private audience, but he was also well aware that such be-
havior might be misinterpreted by those unfamiliar with the ways of his
court.[43] It is hard to imagine that he would deliberately have exposed to pub-
lic gaze a woman whose portrait he would not have ordered for a place where
he held audience, had he not esteemed her. Probably, then, the bathing beauty
belonged to one of the patron's kin with whom he was at odds. And gener-
ally speaking one insulted one's relations—or anyone else—by alluding to
their mother rather than their concubine, though one man's mother might
well, of course, be another's concubine.

At this point it will be instructive to quote two anecdotes from the his-
torian al-Madāʾinī, whose lifetime covered most of the first century of Ab-
basid rule. These stories have already several times been alluded to for the
light they throw on the habits and atmosphere of the late Umayyad court.
The first runs as follows:

> Hishām was constantly finding fault with al-Walīd and disparaging him.
> (Al-Walīd) called on him one day, and found him with a gathering of
> (members of) the Marwānid branch (of the Umayyad clan). Before al-
> Walīd's arrival they had been picking fault with him and saying: "He's
> a fool." Al-ʿAbbās b. al-Walīd [the caliph al-Walīd I] b. ʿAbd al-Malik
> called out to him: "Abū ʿAbbās [al-Walīd's patronymic], how are you
> getting on with your beloved Greek girls *(rūmīyāt)*? I remember how
> keen your father was on them too." Al-Walīd retorted: "Yes, I like them
> a lot. How shouldn't I, so long as they go on producing the likes of you?"
> For al-ʿAbbās's mother was a Greek. Al-ʿAbbās countered: "It takes more
> than the seed of an outstanding man to produce someone like me!" Al-
> Walīd: "Son of a whore [literally: son of an uncircumcised woman]!"[44]
> Al-ʿAbbās: "Are you still preening yourself, Walīd, because of what was
> cut off your mother's clitoris?" Hishām asked al-Walīd on another oc-
> casion: "What do you drink?" He replied: "The same as you, Comman-
> der of the Faithful." Hishām got up in a rage. (Later) he remarked: "They
> say he's a fool, but he's not. Something tells me he's not of our faith."

Al-Madāʾinī's second story has the same setting, in the palace at al-
Ruṣāfa:

43. E.g., Iṣf. 1.61–62 (trans. Hamilton 45–46). Al-Jāḥiẓ (attributed), *Kitāb al-tāj*
31–32, distinguishes between Umayyads who would strip only in front of their slaves,
and al-Walīd and his father who showed themselves naked to their drinking com-
panions and singers as well.

44. See above, pp. 191–92.

One day, al-Walīd entered Hishām's reception hall *(majlis)*. Among
those present were Saʿīd b. Hishām b. ʿAbd al-Malik, and Ibrāhīm b.
Hishām b. Ismāʿīl al-Makhzūmī the maternal uncle of Hishām b. ʿAbd
al-Malik [whom al-Walīd was to have tortured to death], and Abū 'l-
Zubayr, a client *(mawlā)* of the Banū Marwān [and Hishām's chamber-
lain[45]]. Hishām b. ʿAbd al-Malik himself was not present. Al-Walīd
turned to Saʿīd b. Hishām and asked: "Who are you?", though he knew
him perfectly well; and he replied: "Saʿīd, the son of the Commander
of the Faithful." Al-Walīd said: "Greetings to you." Then he addressed
himself to Abū 'l-Zubayr: "Who are you?" He answered: "Abū 'l-
Zubayr." Al-Walīd: "Nisṭās [Abū 'l-Zubayr's original Greek name
Anastasius], greetings to you." Next was the turn of Ibrāhīm b. Hishām.
"Who are you?" "Ibrāhīm b. Hishām." "Who is Ibrāhīm b. Hishām?"
He knew him full well, of course. He replied: "Ibrāhīm b. Hishām b.
Ismāʿīl al-Makhzūmī." Al-Walīd: "And who was Ismāʿīl al-Makhzūmī?"
Ibrāhīm: "My (grand)father, whom your (grand)father took no notice
of until my father gave him his daughter in marriage." Al-Walīd: "You
son of a whore!" And they came to blows. But Hishām was drawing
near, and was announced: "The Commander of the Faithful!" So they
separated and returned to their places. Hishām entered, but al-Walīd
barely stirred from the place of honour in the reception hall, he just
shifted a bit to one side, and Hishām sat down. He asked: "How are you,
Walīd?" "Alright." Hishām: "And how are your lutes *[barābiṭ[46]]*?" Al-
Walīd: "They get a lot of use." Hishām: "What about your drinking
companions?" Al-Walīd: "God damn them if they're any worse than
your lot!" And he rose. Hishām exclaimed: "You son of a whore! Break
his neck!" But instead they just pushed him around, not too hard.[47]

What is especially worth retaining from these two anecdotes is the in-
tense hostility that grew up between al-Walīd and his cousins, the sons of
the caliphs al-Walīd I and Hishām. As al-Ṭabarī records:

> The sons of Hishām and of al-Walīd charged him with being an unbe-
> liever and with having debauched his father's concubines. . . . His de-
> tractors also accused him of being a free-thinker *(bi-'l-zandaqa)*. The
> most vociferous of the critics of al-Walīd was Yazīd b. al-Walīd b. ʿAbd
> al-Malik.[48]

And it was this same Yazīd who was to start the revolt against al-Walīd that
led to the caliph's shocking murder, and his own six-month occupancy of the

45. Ṭab. 2.1817 (trans. 26.172).
46. See above, p. 80 n. 137.
47. Al-Madāʾinī in Bal. 2. fol. 156a = p. 311 (8–9 Derenk), and Iṣf. 7.9–11 (trans.
Derenk 80–82).
48. Ṭab. 2.1777 (trans. 26.128–29 C. Hillenbrand, emended); and cf. Ṭab. 2.1775
(trans. 26.127), and Wellhausen, *Das arabische Reich* 225.

throne as Yazīd III. Yazīd will have been especially sensitive to al-Walīd's taunts, because like al-ʿAbbās he too was the son of an *umm walad*, indeed the first such to become caliph (and succeeded, even more briefly, by another, his half brother Ibrāhīm).[49] Nor should we suppose, just because al-Walīd wanted one of his own sons by an *umm walad* to succeed him, that he re-frained from using such birth as a stick with which to beat others when it suited him—indeed, the passage quoted above from al-Balādhurī specifically excludes such a supposition. In this family warfare, no holds were barred.

Besides the dynastic icon discussed in chapter 6, the six kings panel also touched, by implication, on this delicate relationship between the pure ge-nealogies on which true Arabs were supposed to pride themselves, and the adulterated descent that was the everyday reality of a court swamped with concubines. If Umm al-Ḥakam was a *rūmīya*, Qayṣar was not merely a for-eign ruler, but a presence in the *ḥarīm* or even, by poetic license, an ances-tor.[50] *A fortiori* Kisrā—for Yazīd's mother had not been just any *umm walad*, but Shāh-i Āfrīd bint Fīrūz[51] b. Yazdajird b. Shahriyār b. Kisrā, in other words a Sasanian princess, granddaughter of the last Sasanian monarch, Yazdigird III (632–51), and great-great-granddaughter of Khusraw II. While cam-paigning beyond the Oxus River in the region of Samarqand, on the account of al-Ḥajjāj, governor of ʿIrāq, Qutayba b. Muslim had captured Shāh-i Āfrīd and sent her back to al-Ḥajjāj, who in turn forwarded her to his master the caliph, al-Walīd I.[52] The arrival at the Damascus court of this prestigious captive will have been a singular event. Shāh-i Āfrīd was added to al-Walīd's collection of concubines and in due course bore him a son, Yazīd.

What little we know about Shāh-i Āfrīd induces curiosity our sources do not satisfy. But even if she was no longer alive in the 740s, her memory

49. Mas. 2262 (3.226 Dāghir).

50. Cf., for example, al-Iṣfahānī in Ibn Khallikān, *Wafayāt al-aʿyān* 3.308 (trans. 2.251): verses praising a vizier's son by a Greek concubine as an offspring of the Caesars.

51. "Al-Mukhdaj" ("The Deformed") according to al-Madāʾinī in Ṭab. 1.2873 (trans. 15.79). Justi, *Iranisches Namenbuch* 55 s.v. "Bābūnah", and 420, mistakenly connects this passage with al-Madāʾinī in Ṭab. 1.2887 (trans. 15.92), to make Yazīd III's mother Bābūnaj, a Sasanian woman captured much earlier, in 651–52. Justi 272 s.v. "Šāhafrīd" also erroneously makes Shāh-i Āfrīd the mother of the caliph Ibrāhīm. For further critical comment on scholarly treatment of Shāh-i Āfrīd see Sprengling, *American journal of Semitic languages and literatures* 56 (1939) 214–20.

52. Hishām b. al-Kalbī in Ibn al-Faqīh, *Kitāb al-buldān* 417 (trans. 253); al-Madāʾinī in Ṭab. 2. 1246–47 (trans. 23.195), 1874 (trans. 26.243). According to Ṭab. 2.1874, differing traditions had Yazīd die aged forty-six, thirty-seven, or thirty. Since Qutayba's campaigns in the East started in 705, forty-six is excluded. Thirty fits well with Ṭab.'s own assertion, 2.1246–47, that Shāh-i Āfrīd was captured in 712.

was certainly fresh and even controversial, as the male members of the Umayyad clan jockeyed for position toward the end and in the aftermath of Hishām's long reign. If in a devilish moment al-Walīd decided to commission for the wall of his new bath house a painting of Shāh-i Āfrīd's arrival at the court of Damascus, and an implicit visual violation of her, in her nakedness, that could only evoke a strongly negative reaction from her male relatives,[53] then he will have intended, obviously, to put Yazīd in his place. But he may also have had a more constructive motive in mind.

We are not specifically told that Yazīd was among those who openly criticized al-Walīd's proclamation of al-Ḥakam as his successor. If he did, he may have felt that his own *umm walad* mother was a cut above other concubines, on account of her ancestry. But his general hostility to al-Walīd was a given, and al-Walīd will have seized on any opportunity to remind his cousin that those who live in glass houses should not throw stones. If our bathing beauty is indeed Shāh-i Āfrīd, the painting's subtext is that these days quite a lot of us (though not al-Walīd) are "sons of the uncircumcised", and that criticism on these grounds of plans for the succession cannot therefore be taken seriously. This blunt message is delivered, though, with a certain grace.[54] Shāh-i Āfrīd is depicted at a moment of exposure and humiliation, but also of triumph as a new Aphrodite. And her identity, although presumably self-evident to most visitors to Quṣayr ʿAmra from her face alone, was not actually spelled out.

Al-Walīd was also, we may suppose, well aware that coins have two sides. The craze for concubines might make for divisions in the ruling family, but concubines of royal lineage could be viewed as a source of strength too, even of legitimation. Yazīd, for one, needed no lessons about how to make virtue out of necessity. He flaunted his mixed ancestry in a verse that came to be much quoted:

> I'm the son of Kisrā, my father is Marwān.
> One grandfather is Qayṣar, the other's the Khāqān.[55]

In the six kings panel, we see al-Walīd thinking along closely similar lines. Rather than humiliating the rulers of the old empires, and trampling their

53. See above, p. 64.
54. This no doubt evaporated once Yazīd declared open revolt: cf. Bashear, *Arabs and others* 40 n. 64.
55. Ṭab. 2.1874 (trans. 26.243—but my translation differs somewhat from that of C. Hillenbrand); Mas. 2262 (3.226 Dāghir); Ibn al-Athīr, *Al-kāmil* 3.425. Not entirely "an imagined ancestry", *pace* Grabar, *A.O.* 1 (1954) 185, and *Formation* 45.

face in the dust as the Sasanians had, we must invite them to our court and treat them with honor. We may even bask in their reflected glory. Far from being an incongruous neighbor for the six kings, which is the viewer's first reaction, Shāh-i Āfrīd is a natural extension of their message. In the 1920s and 1930s, eminent Orientalists spilled some ink debating whether one of the six kings is in fact a queen.[56] But not a single word was said about the scene right next to them.

Beyond, then, the patron's immediate desire (and need) to teach his cousins their place, there is in both the Shāh-i Āfrīd and the six kings panels an element of conciliatoriness—just what one would expect, in fact, at the start of the new reign, when the foundations of al-Walīd's long-awaited authority had to be laid as firmly as possible. And al-Walīd, who—as Hishām perceived—was no fool, may even have understood that the time had come to accept and promote a broader-based understanding of the Umayyad dynasty's mission, which could not for ever be to guarantee the privileges of a closed Arab elite impervious to new blood, whether of captives from beyond the frontiers or of converts from within.[57] A good symbolic place to start was the six kings, but as the central section of a triptych, whose wings were a Roman and an Iranian *umm walad*, Umm al-Ḥakam to the left, and Shāh-i Āfrīd to the right. The legacy of the six kings was political and cultural, that went without saying, but it was now becoming genealogical too. Al-Walīd, who took more than a passing interest in the genealogies of the Arabs,[58] was especially qualified both to make this point and to appreciate its revolutionary long-term implications.

Al-Walīd was also, like many others at the Umayyad court, a connoisseur of the female body. That was not necessarily a reason for putting Shāh-i Āfrīd rather than someone else on the wall at Quṣayr ʿAmra, unless we suppose, as we have no particular reason to do, that the Sasanian princess was a famous beauty. But once the painting, no doubt somewhat idealized, was there, it took on a life and role of its own. Some may have interpreted it as yet another variation on the "How are the mighty fallen!" theme: the Sasanian dynasty, which had plundered its subjects of their womenfolk, was now providing concubines for the court of caliphs sprung from the despised Arabs. For most, though, no justification was needed for contemplating the beauty of women. If it is possible for a universal truism to be truer in some places and at certain times than others, then perhaps the milieu we catch sight of

56. See, for example, Herzfeld, *Der Islam* 21 (1933) 233–34.
57. See above, p. 184 n. 38.
58. Above, p. 148.

at Quṣayr ʿAmra deserves special mention, in comparison, say, with the court of "Caesar". The East Roman bride shows offer, it is true, a brief glimpse of men's eternal preoccupation with the female form, and of the manner of its satisfaction at the court of Constantinople. An early-ninth-century life of a martyr to the iconoclast policies of Constantine V (741–75) caricatures that prince as a Satanic wine-bibber, an addict of music and the hunt, and a slave of women[59] in a way that parallels many Abbasid writers' view of al-Walīd. But the Greek literature of this period lacks anything remotely resembling the *Kitāb al-aghānī*,[60] while the ease with which Muslim men might marry or divorce meant that far greater resources were deployed by the caliphate to secure beautiful women for the court.

Here, once again, Quṣayr ʿAmra (not to mention Khirbat al-Mafjar, Mushattā, and Qaṣr al-Ḥayr al-Gharbī) offers valuable confirmation and illustration of tastes that are also abundantly attested in classical Arabic literature, though the fact that most of these texts reached their present form under the Abbasids often undermines one's confidence in their authenticity as sources for the Umayyad period. We cannot know, for example, to what extent the story of the Ghassanid girl at the court of Khusraw I was worked up to meet the tastes of a later age.[61] And the one text we have that was definitely in circulation more or less exactly when Quṣayr ʿAmra was being built, because it is preserved on a mid-eighth-century papyrus, is notably more restrained in its description of the ideal woman's physical attributes, though this may be because the subject is free women rather than slave girls.[62] Fascination with the female body is nonetheless implicit or explicit throughout early Arabic poetry. The erotic poetry of the Umayyad period in particular offers abundant and precise parallels with the supposed letter of al-Mundhir.[63] Even religious literature might draw on such materials.[64] And the story already alluded to, of al-Ḥajjāj and his court scratching their heads

59. Stephen the Deacon, *Vita Stephani Iunioris* 14, 27, 63, 65, 66.

60. Beck, *Byzantinisches Erotikon*, makes the most of what there is, while on the immediate previous period's "Kultur eines voyeuristischen Delektierens" see Muth, *Erleben von Raum* 310–16.

61. For example, the phrase *ḥawrāʾ ʿaynāʾ* echoes Qurʾān 44.54, 52.20, on the joys of Paradise—and incidentally gives the lie to Luxenberg's assertion, *Syro-aramäische Lesart* 232, that the purity of the eyes' whites was not for the Arabs a mark of beauty.

62. Abbott, *Studies* 3.43–78, esp. 44.

63. See Blachère's essay on "la poésie érotique au siècle des Umayyades", in his *Analecta*, esp. 348–61.

64. E.g., Ibn Isḥāq (d. 767), *Sīrat rasūl Allāh* (quoting Ḥassān b. Thābit, d. c. 659) (Wüstenfeld)/3.19–20 (al-Saqqā).

over 'Abd al-Malik's description of the women he wanted, until an Arab of the desert enlightened them, hints at the banter that would have been heard at Quṣayr 'Amra, under the enigmatic gaze of Shāh-i Āfrīd, as the dancers and the singing girls performed. The wine was passed round, and love poetry was recited, not least the patron's own verses. The fleshy beauties of Arabia, the dream of the nomad who could hardly find enough food to keep his children from starvation,[65] were compared with the girls of the Rūm, the Berbers, the Iranians, and no doubt many other races too.[66] At such moments the sober—if there were any—might take full stock of the advantages brought the Arabs by their Prophet. But even the sober may have been only subliminally aware of the long history of men's love affairs with images of Aphrodite. Christianity had not stifled these erotic impulses, and nor did Islam. Echoes of them may still be heard in the literature of Umayyad Spain.[67]

Finally, it would not have been surprising had Shāh-i Āfrīd's appearance on the wall at Quṣayr 'Amra evoked stories about other princesses too. The twelfth-century Iranian Niẓāmī tells in his famous poem the *Haft paykar* how, returning one day from the hunt, the Sasanian prince Bahrām Gūr found in his castle of al-Khawarnaq a locked chamber that turned out to be adorned with portraits of seven princesses, the daughters of the rulers of India, China, Khwārazm, Slavonia, the Maghrib, Rūm, and Irān. He sent messengers to seek their hand in marriage, and when they arrived, each told him a tale of love and its vicissitudes. Although the story as we have it appears to be Niẓāmī's own invention,[68] still one wonders, given the Arabs' fascination with Bahrām Gūr and al-Khawarnaq,[69] whether it had not been longer in the making. Quṣayr 'Amra, and especially its painting of the six kings, allows us a glimpse of the atmosphere in which this part of the Bahrām Gūr legend could have evolved.[70] Al-Khawarnaq itself, beloved of the Umayyads as already pointed out at the beginning of chapter 5, would have provided a still stronger impulse for such romantic elaborations.

65. Besides the description of the Ghassanid girl quoted above, see such representative passages as Ibn 'Abd Rabbihi, *'Iqd* 6.108; Iṣf. 1.225 (trans. Rotter 62), 11.183–84, 20.382 (trans. Berque 328, 318); and cf. *K.M.* 233–36.

66. See, for example, 'Abd al-Malik b. Marwān reported by Ibn 'Abd Rabbihi, *'Iqd* 6.103, and cf. 108; also the anonymous verses in Ṭab. 2.1765 (trans. 26.116). Baer, *Da.M.* 11 (1999) 16, perfectly reasonably points out that the Arabs were not alone in their predilection for corpulent women.

67. Olmos, *Kotinos*, esp. 265–66.

68. Pantke, *Bahrām-Roman* 91, 99–100.

69. Würsch, *Wiener Zeitschrift für die Kunde des Morgenlandes* 88 (1998).

70. Compare the suggestion, made at the close of chapter 3, that Quṣayr 'Amra itself may have been in part a response to the Bahrām Gūr legend.

9 Quṣayr ʿAmra Contextualized

FROM INNER COHERENCES TO CONTEXTS

Entering Quṣayr ʿAmra's hall through the doorway in its northern wall, we find ourselves standing before the prince enthroned in his alcove, flanked by lines of courtiers framed in arcades (fig. 8). The central aisle offers to our eyes a variety of images often arranged in pairs on opposite walls, and we have a sense of moving along a short processional way. Life-size human figures adorn the soffits of the arches that divide the hall into three aisles— we can still discern well the long-skirted, bare-breasted women on the east arch, who act as "supporters" of a portrait medallion now frustratingly illegible. Lower down on the south soffit of each arch we see a singing girl on the left, a dancer on the right. Bejeweled, almost naked beauties stand in elaborate niches on either side of the alcove arch; above them, animals lunge at unseen prey. Elsewhere, on the spandrels of the arches and even on the vault, beautiful people sing or dance, recline or embrace.

The two arches' demarcation of the space in which we stand into three aisles is, to tell the truth, more theoretical than real. The hall feels as if it was conceived as an undivided whole, and it seems the artists agreed, since they helped tie the space together by painting human figures on either side of five of the six windows that open just under the barrel vault, in the end-wall of each aisle (e.g., fig. 28, 32, 50–51).[1] Only on the south wall of the

1. Above, pp. 87–88 (south wall, east) (= figs. 28, 32). Q.ʿA. 57 and Q.ʿA.¹ pl. IIIb (south wall, center). Q.ʿA. 66, 73–74 figs. 38–39; Grabar, A.O. 23 (1993) fig. 4; Vibert-Guigue, S.H.A.J. 5.107 fig. 5; above, p. 178 (south wall, west) (= fig. 50). Q.ʿA. 74 (north wall, east). Q.ʿA. 56 (north wall, center). The sixth lunette appears to be decorated with fishes: Vibert-Guigue diss. 1.264–66 (north wall, west). See also Vibert-Guigue diss. 1.468–70.

east aisle are these figures indisputably intended to be personifications—
here they are actually labeled, in Greek (fig. 28). But their general resem-
blance to each other knits the whole room together, as on closer inspection
do the small and—even when originally painted—rather hard-to-read Ara-
bic texts that were crammed in between most (perhaps all) of the windows
and the curve of the vault.[2]

From where we are standing in the central aisle facing the enthroned
prince, we can easily see the flanking paintings on the southern endwalls of
the side aisles. To the left, in the eastern aisle, the princely patron appears
to be depicted as hunter, and to the right, in the western aisle's dynastic icon,
as head of the Umayyad clan. An image of kingly, indeed Adamic splendor
is flanked, in other words, by two testimonials to the prince's virility. If we
now turn to look at either of the hall's sidewalls, we will find that the hunt-
ing theme is there greatly elaborated, as also on the north wall of the east
aisle. In other respects, though, the two side aisles cultivate rather different
atmospheres. Women, for example, are largely absent from the east aisle
but prominent on the hall's western side, where we have the captive Sasa-
nian princess as well as the dynastic icon. And just as scenes from the hunt
are grouped in the side aisles, so too purely decorative women, and female
entertainers, are concentrated in the central aisle and the alcove. This ten-
dency to associate themes and spaces is further pursued on the endwalls (in-
cluding the alcove), which constitute a privileged field for the depiction of
the prince and his family, and in the three small chambers of the bath proper,
which is the only part of Quṣayr ʿAmra where women—and in one instance
a man too—are shown entirely naked.

One's first impression is still, admittedly, of a variegated and even con-
fusing mass of figures, human and animal, especially on the hall's west wall.
Despite, for example, the relationship that has been suggested between the
paintings of the six kings and the bathing beauty, these are linked only very
loosely to the hunters and the acrobats, by a general intention to glorify the
patron and the entertainments he offers. But these first impressions do then
begin to evolve through a perception of recurrent themes—the pleasures
of the bath (above, chapter 2) and of the hunt (chapter 3), together with the
royal imagery of the Umayyad clan (chapters 4 to 8)—into an appreciation
of certain coherences not just in the allocation of particular subjects to dis-
tinct areas of the hall, but also in the decorative scheme as a whole. In view

2. Above, p. 127 (south wall, east). Q.ʿA. 57 (south wall, center). Above, p. 178
(south wall, west). Vibert-Guigue diss. 1.380–82 (north wall, east: illegible), 265
(north wall, west: destroyed).

of the tendency that exists to view Quṣayr ʿAmra's paintings as irre-
deemably heterogeneous (of which more in chapter 10), this perception
ought to be given due weight. It helps us make sense of an overall concept
hardly amenable to the comparative iconographical approach followed by
many art historians, based on the assumption that an image's meaning is
best elucidated by comparing it with other similar images. For some of
Quṣayr ʿAmra's paintings are entirely without parallel, while none can be
perceived now with anything like the sensitivity to historical context that
came naturally to the patron, his circle, and their visitors.

To illustrate this last point we may take what has just been called the
royal imagery. Nobody can miss the durable late antique iconography of
kingship deployed in the princely portrait and the six kings panel. This is
territory highly favorable to the traditional art-historical approach. But the
dynastic icon and the bathing beauty are more allusive. No doubt they were
easy to decipher when they had just been unveiled, but they became rap-
idly more opaque thereafter, as memory receded of the particular succes-
sion problem that al-Walīd had been obliged to deal with. And whereas the
dynastic icon would have been comprehensible, at least to the politically in-
formed, if set up in a public place, the bathing beauty was strictly for the
clan's consumption. Identification of the central figures in these panels as,
respectively, Umm al-Ḥakam and Shāh-i Āfrīd is speculative compared to
our discussions of the princely portrait and the six kings. But these varying
levels of transparency do no more than reflect the realities of any histori-
cal situation, in which some factors are diachronic, others transitory. With-
out a contextualizing approach to the specific historical moment when
Quṣayr ʿAmra was built, it will always be tempting to pronounce its deco-
ration merely confused. With the help of the literary sources, though, the
paintings' meaning becomes clearer. The visitor to Quṣayr ʿAmra who en-
tered its hall having recently heard al-Walīd's succession proclamation would
easily have recognized, in front of him on the south wall, his master en-
throned in the glory of Adam, to whom (as the proclamation recalled) the
very angels had done obeisance; to his right the dynastic icon foreground-
ing Umm al-Ḥakam and the two boys; and to the left "The Kill," in which,
we may reasonably suppose, the font of all this legitimacy, al-Walīd him-
self, shows off that "abundant manliness" that the proclamation had
identified as a *sine qua non* in one who would be caliph.[3] Had our visitor
then penetrated as far as the caldarium, the fresco on its dome could for its

3. Ṭab. 2.1759 (Adam), 1763 *(jazālatu 'l-murūʾa)* (trans. 26.108–9, 114
C. Hillenbrand).

part have reminded him, in the words of an almost contemporary Greek astrologer at the court of the Abbasids, that the science of the stars is the preserve of "world-ruling and victorious dynasties."[4] At Quṣayr ʿAmra, we have seen, even the dancing and singing girls may denote victory as well as pleasure.

The time has now come, though, to turn away from the introverted contextualization that has permitted us to probe the meaning of the frescoes as an end in itself, and instead attempt a more extroverted contextualization, in which Quṣayr ʿAmra becomes the means by which wider historical problems may be addressed. The interpretations of individual paintings that have been offered in the foregoing seven chapters need to be put to work in the cause of social and cultural history so that conclusions can at last be drawn about "art and the Umayyad elite in late antique Syria". The purpose of the present chapter is to bridge the gap between our iconographical studies and our hoped-for historical conclusions by examining those aspects of our monument that can tell us not just about the identity and ideas of the patron, but about the social and intellectual milieu in which that patron lived and sought to communicate with his fellow men. The evidence will continue to be drawn directly from the monument; but our aim will now be not so much the elucidation of images (though there will still be some of that) as the contextualization of Quṣayr ʿAmra's creator and of the artisans and artists on whom he depended. Two very different but equally suggestive paintings—in the first case, a whole set of them—which have not yet been discussed will be examined in the immediately ensuing subsections. Then there will be something to say about the linguistic environment, and about other comparable structures—a matter already selectively broached in chapter 5.

PATRONS, ARTISANS, AND ARTISTS

One of the most unusual and unpredictable features of Quṣayr ʿAmra is the east vault of its hall. The paintings on the west vault have disappeared; those on the central vault seem to depict scenes of relaxation and pleasure, in harmony with the rest of the decoration of this aisle. The east vault, consistently with this part of the hall's general emphasis on virile pursuits and its almost complete lack of female figures, is given over in its entirety to images of the construction industry—they could have been "photographed"

4. Stephanus the Philosopher, *De arte mathematica* 182; cf. Pingree, *D.O.P.* 43 (1989) 238–39.

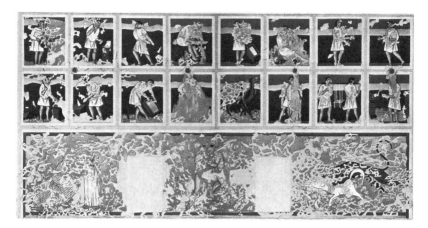

Figure 61. Quṣayr ʿAmra, hall, east aisle, vault: scenes from the construction industry (frescoes). Drawing by A. Mielich, *K̇.ʾA.* 2. pl. XXX.

from the construction of Quṣayr ʿAmra itself (fig. 61).[5] Once more there are thirty-two panels arranged in four rows. We may note paintings of stone-masons squaring blocks, loading them onto camels, and building walls; a blacksmith at his anvil; carpenters making ready their wood; and building workers preparing mortar. They all wear a short tunic reaching to just above the knee, with sleeves of varying length; and they go barefoot. It is the characteristic and practical dress of the working man.[6]

Such depictions had not been uncommon in Roman art. One thinks, for example, of the masons, carpenters, and painters, all represented as *putti*, in the eight compartments around the portrait of that great early-sixth-century church builder, the princess Anicia Juliana, at the beginning of the Vienna Dioscorides codex.[7] But the sequence of thirty-two paintings at Quṣayr ʿAmra is exceptionally rich: together, they make up a far from inconspicuous part of the overall decoration. Even supposing the patron

5. Cf. *K̇.ʾA.* 2. pl. XXVIII; *Q.ʾA.* 85–89 figs. 52–58, 113 figs. 76–77; Piccirillo 353 fig. 784; Vibert-Guigue diss. 1.426–65.

6. See above, p. 100 n. 43.

7. Gerstinger, *Dioscurides* 34–35. See also Reinach, *Répertoire de peintures* 251–52; Zimmer, *Römische Berufsdarstellungen*, esp. 66–67; A. Grabar, *Premier art chrétien* 223–24 pls. 246–47 (hypogeum of Trebius Justus, Rome); Sörries, *Buchmalerei* 23–25 and pl. 2 (fol. 4r) (building of Solomon's temple in the probably fourth-century Quedlinburger Itala); Pentz, *Invisible conquest* 48 fig. 14 (Syrian mosaic, now in National Museum, Copenhagen, showing a mosaicist at work); Maranci, *Gesta* 40 (2001) 109 (busts of figures apparently holding masons' tools in the relief decoration of the mid-seventh-century Zuartʿnocʿ cathedral, Armenia); fig. 30 (various workers including a camel driver in a mosaic from a church at Dayr al-ʿAdas, south of Damascus).

confined himself to ordering so many square meters of vault fresco, without further specification, still he could apparently be relied on not to object to a mass intrusion of the lower orders into his private space. This raises a question that has not so far been addressed head-on, though it has frequently been alluded to: what was the relationship between Quṣayr ʿAmra's patron and his architect, artists, and artisans—especially the artists, whose work is modestly omitted from the anthology on the east vault?

It seems to be generally—and reasonably—held that the role of the patron in late antiquity, including the Umayyad period, might be quite active, assuming he or she possessed a certain education. In particular, impetus toward innovation was more likely to come from patrons than artists, who unless interfered with tended to stick with what they knew.[8] It is true that the Muslim Arab conquerors were intruders from the peripheries of the Roman and Sasanian worlds, few of whom can have had more than a nodding acquaintance with or appreciation of the artistic vocabulary and techniques that had evolved in such ancient and sophisticated lands as ʿIrāq or Syria.[9] Ziyād b. Abīhi, for example, Muʿāwiya's governor of ʿIrāq, wished to endow al-Kūfa with the tallest mosque ever seen but had no idea how to solve the technical problems. When a plan was proposed by an architect trained under the Sasanians, Ziyād's response (freely rendered) was "That's just what I wanted, but I couldn't put it into words."[10] Other Arabs were famously indifferent to the splendid courtly objects they carried off as booty, or even despised them as a matter of religious principle.[11] But the process of aesthetic awakening is captured by a curious story about how Aws b. Thaʿlaba al-Taymī from al-Baṣra, one of the leaders of the Bakr b. Wāʾil in Khurāsān, had passed through Palmyra and composed some verses about a sculpture of two young women he saw there. He declaimed them to the caliph Yazīd I (680–83), probably in his residence at Ḥuwwārīn, and was complimented for showing a sensitivity no Syrian had ever exhibited.[12] As for al-Walīd b.

8. Cf. Dunbabin, *Mosaics of Roman North Africa* 24–26, 47–48, 51–52, 228–29; Asimakopoulou-Atzaka, Τὸ ἐπάγγελμα τοῦ ψηφοθέτη 74–76; Hamilton 21, on the patron of Khirbat al-Mafjar. But note also, in favor of the artisan's creativity, Hunt, *P.E.Q.* 126 (1994) 122–23.

9. Whelan, *I.J.M.E.S.* 18 (1986) 205, questions this assumption but might have assessed Mecca's cosmopolitanism more conservatively could she have known P. Crone's *Meccan trade*. And whatever the merits of her reinterpretation of the *miḥrāb*'s origins, it is relevant to the second or third generation after the conquest, not the first.

10. Sayf b. ʿUmar in Ṭab. 1.2492 (trans. 13.73).

11. Sayf b. ʿUmar in Ṭab.1.2452–54 (trans. 13.31–34 G. H. A. Juynboll).

12. Hishām b. al-Kalbī in al-Balādhurī, *Kitāb futūḥ al-buldān* 355; Ibn al-Faqīh, *Kitāb al-buldān* 160–61 (trans. 135); al-Madāʾinī in Yāq. 2.17–18 s.v. "Tadmur"; cf. G. Levi della Vida, *E.Is.* 10.400–401.

Yazīd's generation, it had grown up not exclusively in Arabia, but amidst
the very remnants of the ancient empires. In fact, some members of the Arab
elite must by this time have possessed a breadth of experience and cultural
reference that could hardly have been matched by any artist of their day.
What may have been the consequences of such an encounter between
artists with the limitations that came from having been trained in a partic-
ular tradition, and a patron who dreamed of depicting a new political and
cultural reality that was without precedent, we have already seen in our
analysis of the six kings panel; for there it seems likely that an idea derived,
presumably by the patron, from Iranian traditions known to us only from
literary contexts was given visual expression by an artist whose idiom was
East Roman and who had no access to, or perhaps interest in, possible Sasa-
nian models. If despite that he created something to our knowledge unique,
he had only his patron to thank. Nor is the six kings panel by any means
the only painting at Quṣayr ʿAmra that apparently lacks convincing paral-
lel in what we know of ancient art. The same can be said of the dynastic
icon, the bathing beauty, and the acrobats—making a whole row of unique
compositions (whatever the iconographic debts of their constituent parts)
lined up along the walls of the west aisle. All this suggests an original, imag-
inative mind at work. In view, particularly, of the personal nature of the ref-
erences contained in some, at least, of these paintings, that original mind is
likely to have been the patron's rather than the artist's.

Of the contents of the patron's mind, there will be more to say in the
next section. But before that, it is worth asking where he found the builders
and decorators he needed in order to give concrete form to his ideas. Cer-
tainly there was no shortage of choice: the Umayyads—al-Walīd I in
particular—are known to have brought workers both specialized and un-
skilled from various regions, notably Egypt, to work on major projects in
Damascus and Jerusalem, and in Lebanon's al-Biqāʿ Valley as quarriers of
stone for some project that can no longer be identified.[13] Al-Walīd I also

13. Mouterde, *Mélanges de l'Université Saint Joseph* 22 (1939), 44 (1968); Küch-
ler, *Z.D.P.V.* 107 (1991); Morelli, *Tyche* 13 (1998). Note also Flusin, *Bayt al-Maqdis*
1.25–26, 30–31 (Anastasius the Sinaite on Egyptians clearing the Jerusalem temple
esplanade under Muʿāwiya); Elad, *Bayt al-Maqdis* 1.54 (text) and 35 (translation) (Sibṭ
b. al-Jawzī reporting a tradition derived from Muhammad b. al-Sāʾib al-Kalbī [d. 763]
on ʿAbd al-Malik assembling "craftsmen and architects from all regions" in Jeru-
salem); *Secrets of Rabbi Simon ben Yōḥay* (see above, p. 157 n. 85), quoted by Lewis,
Studies in classical and Ottoman Islam V.326 (and cf. 309, 327–28), on al-Walīd's
bringing "distant men from strange lands" to divert the river Jordan; *History of the
patriarchs of Alexandria* pp. 368–69 (on the building activities of al-Walīd II in the
desert, using workers gathered "from everywhere"—evidently including Egypt);

sent "eighty Greek and Coptic artisans from Syria and Egypt" to rebuild the mosque in al-Madīna.[14] It has even been maintained that the extraordinarily varied sources of Umayyad architectural and artistic style, sometimes observable within one and the same structure, are explicable in terms of parallel work executed in different sections of the same building site by just such levies drawn from scattered regions of the caliphate.[15] It may be possible to see some evidence for this hypothesis in the inscription from Qaṣr al-Ḥayr al-Sharqī[16] that dates the construction of "this (fortified) settlement/residence" (the feminine noun *madīna*, hard to translate "town" in this particular context[17]) to the reign of Hishām but then goes on to declare that "this" (unspecified, but masculine this time) "is one of the things that the people of Homs made", alluding to whatever the inscribed stone formed part of, but evidently not to the whole project.[18]

Applied indiscriminately to artistic analysis, though, the corvée hypothesis tends to underplay the ability of the Umayyads' artists to evolve eclectic styles without division of labor.[19] Especially when dealing with a building as small and architecturally unadorned as the Quṣayr ʿAmra bath house, it is wiser to assume that most of the workforce was (as, in part, at Qaṣr al-Ḥayr al-Sharqī) local. We cannot, it is true, exclude the possibility that the architect, for example, had been influenced by Mesopotamian roofing techniques,[20] or that the artists, whose work was of such direct consequence for

and Northedge, *ʿAmmān* 1.101 (on the probability that Qaṣr Kharāna was built by workers from ʿIrāq). Leontius of Neapolis, *Vita Ioannis Eleemosynarii* 20, asserts that Patriarch John the Almsgiver of Alexandria (610–19) sent a thousand Egyptians to rebuild churches burned by the Iranians in Jerusalem; but on this see Mango, *Bayt al-Maqdis* 5.

14. Al-Balādhurī, *Kitāb futūḥ al-buldān* 7.

15. Herzfeld, *Jahrbuch der Preuszischen Kunstsammlungen* 42 (1921) 131–33, adducing *inter alia* Quṣayr ʿAmra, on which see immediately below; Schlumberger, *Syria* 20 (1939) 359–60 (= Q.H.G. 24); Sauvaget, *Syria* 24 (1944–45) 100–102 (on ʿAnjar); Almagro, Jiménez, and Navarro, *A.D.A.J.* 44 (2000) 439, 440 (ʿAmmān citadel).

16. *R.C.E.A.* 1. no. 28.

17. Cf. below, p. 273 n. 103.

18. Cf., on a similar formula in an Umayyad inscription from Buṣrā, Sauvaget, *Syria* 22 (1941) 58. The Qaṣr al-Ḥayr al-Sharqī inscription is accordingly mistranslated and misinterpreted in Q.H.E. 150, 191, where it is assumed that the whole *madīna* was built by the people of Homs. Note also the suggestion, made on strictly archaeological grounds, that the brickworkers came from Mesopotamia: Q.H.E. 152–53.

19. Cf. Rogers, *Muqarnas* 8 (1991) 52–54, on Creswell's "fatally atomistic" concept of decorative style in his analysis (following Herzfeld) of Mushattā.

20. Cf. above, p. 38.

the impression the building made on visitors, were sought farther afield. Mielich and Vibert-Guigue, both of whom studied the frescoes in intimate detail, came away with a high opinion of their creators' self-confidence, inventiveness, and subtlety.[21] Whatever mistakes or inelegances they committed are extenuated by the fact that they were executing orders that required them to innovate, and working at speed in true fresco[22] under conditions that cannot have differed much from those experienced by Mielich and Musil. It is possible, then, indeed intrinsically probable, that the patron sought out the best painters he could find. The stylistic and qualitative differences some—but not all—students of Quṣayr ʿAmra have detected between the frescoes in the hall and those in the apodyterium, tepidarium, and caldarium[23] may, furthermore, indicate two distinct groups of painters at work. But it seems unlikely that so compact a site could have accommodated, at the same time, distinct levies of workers from separate regions.[24]

Moreover the abundance, competence, and thematic richness of the mosaics found over the last century or so at Mādabā, and at Umm al-Raṣāṣ, some 30 kilometers to the southeast, show that the settled lands to the west of Quṣayr ʿAmra were well endowed with artistic talent not just in the sixth century, whose remains are outstanding, but throughout the Umayyad period and on into the first years of the Abbasids as well. The recently discovered Phaedra and Hippolytus mosaic at Mādabā reveals the continuing vitality of mythological art—and some familiarity too with the literature that inspired it—even in the sixth century (fig. 26);[25] and if, thereafter, we are confined for the most part to the neutered repertoire of the ecclesiastical mosaicist, still he might show admirable skill and verve in executing scenes from the hunt or the agricultural year. These time-worn themes of villa decoration had been annexed by the Church or were deployed by patrons of churches to underline their own social standing,[26] but at Quṣayr

21. Mielich, *K.ʿA.* 1.190a, 194b, 195b; Vibert-Guigue, *ARAM periodical* 6 (1994) 348, and *S.H.A.J.* 5.108. R. Hillenbrand, *K.Is.* 164, is less enthusiastic.

22. Vibert-Guigue, *S.H.A.J.* 5.108 (against Pollak and Wenzel, *K.ʿA.* 1.200; *Q.ʿA.* 93).

23. E.g., *Q.ʿA.* 93–102; and above, pp. 189–90. *Contra:* Mielich, *K.ʿA.* 1.193a, 194b.

24. *Pace* Rosen-Ayalon, *Archiv orientální* 63 (1995) 461. Hamilton, *K.M.* 42–43, 292, 344, assumes local masons and decorators, working, though, in an eclectic style, even at the much larger palace of Khirbat al-Mafjar. To judge from graffiti found on site, they were Christians and Muslims, with possibly some Jews as well.

25. Cf. Piccirillo 25–26, 51, 66. John of Damascus (d. c. 750) could still compose a metrical drama on Susanna "in the manner of Euripides": Eustathius of Thessalonica, *Interpretatio hymni pentecostalis* 508B.

26. The positions of, respectively, Ognibene, *Umm al-Rasas* 67–72, and Baumann, *Spätantike Stifter*, esp. 5, 87–89, 97, 162–63, 186.

ʿAmra they emerged once more in their traditional secular setting.[27] The chances are, then, that Quṣayr ʿAmra's patron did not need to look far in order to find artisans and artists reasonably capable of giving built and painted form to his—or his advisors'—ideas.

It is worth adding, finally, something that is obvious but should not be left unmentioned, namely that many of the artisans and artists of both pre- and post-conquest Syria were of Semitic and quite possibly Arab origin, like the mosaicists Salamanios (Sulaymān), who conspicuously signed one of his compositions in Greek at Mādabā in the year 578–79,[28] and Staurakios, son of Zada (i.e., Zayd), who worked on the floor of the church of S. Stephen at Umm al-Raṣāṣ in the year 756.[29] But whether such men felt a particular cultural affinity with Syria's new Muslim masters from Arabia we simply do not know. They may just as easily have felt a special antipathy for them, founded not least on religious difference. Either way, though, we may assume that knowledge of Arabic was widespread, by the eighth century, among those who stood to profit by it; and that certainly included everyone in the building trade. If nothing else, this will have eased problems of communication between the patron and his employees.

MYTHOLOGICAL THEMES?

Another group of frescoes that has so far been neglected is the decoration of the three small chambers of the bath house proper—the hall has absorbed all our attention. Several of the most important paintings have been briefly noted, such as the zodiac on the dome of the caldarium (fig. 10) or the bathers in the tepidarium (fig. 15). A naked man and half-naked woman flank the apodyterium window, reminding us somewhat of the figures around the win-

27. For general comparisons between secular and ecclesiastical decoration under the Umayyads, cf. Piccirillo 47, and Farioli Campanati, *Arte profana*, against Finster, *Gegenwart* 388 (comparing Quṣayr ʿAmra with ivories hypothetically assigned to Syria by K. Weitzmann). A comparison between Quṣayr ʿAmra and the nave mosaic of S. Stephen's, Umm al-Raṣāṣ, might be rewarding (cf. above, p. 123 n. 23); but it cannot be taken for granted, *pace* Piccirillo, *Umm al-Rasas*, that the late date (718) given in a neighboring panel refers to the whole nave composition. My thanks to Pierre-Louis Gatier for discussion of this problem.

28. Piccirillo 96, 98; *I.G.L.S.* 21. no. 142.

29. Piccirillo, "Iscrizioni", *Umm al-Rasas* 1.243, inscription 1b; cf. Shahîd, *Byzantium and the Arabs in the fifth century* 323 n. 9. While Christian sources, whether pre-Islamic or later, often mention the name of at least the architect, Umayyad Muslim sources unfortunately tend to name only the official in charge of the project: Monneret de Villard, *Introduzione* 303–6.

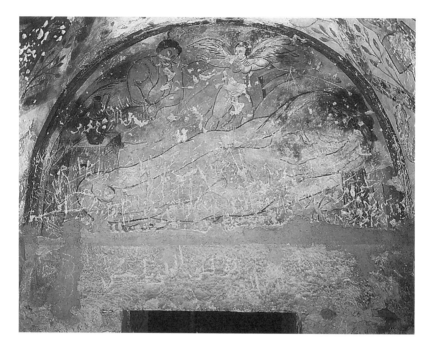

Figure 62. Quṣayr ʿAmra, apodyterium, lunette over door into hall: death of Salmā (fresco). Oronoz Fotógrafos, Madrid.

dows in the main hall. On the vault of this same room humans—and animals too—play music and dance (fig. 19).[30] What we have not so far noticed, though, is a painting that has been among the most frequently discussed at Quṣayr ʿAmra. It occupies the lunette over the door that leads from the apodyterium into the hall (fig. 62).[31] In the upper left part of the composition we see, apparently amidst a landscape of rounded rocks, a pensive young man – visible only from approximately his navel up – resting head on hand while mournfully contemplating what Musil believed was a shrouded corpse,[32] while Jaussen and Savignac thought they saw two bodies lying side by side.[33] A small, naked, winged Eros[34] hovers in the upper central area of the lunette and gestures towards—or perhaps rather beckons—the young man.

30. Cf. above, pp. 42–43 (zodiac), 57 (bathers, couple), 67–68 (vault).
31. Cf. Jaussen and Savignac 3. pl. XLV; *Q.ʾA.* 92 fig. 64; Winkler-Horacek, *Da.M.* 10 (1998) pl. 73a.
32. Musil, *Ḳᵘsejr ʿamra und andere Schlösser* 39.
33. Jaussen and Savignac 3.91.
34. C. Augé and P. Linant de Bellefonds, *L.I.M.C.* 3(1).948 no. 90.

In art of the Roman period, representations of Eros were quite often deployed in funerary contexts;[35] and a funerary interpretation of this image might be made to cohere satisfyingly with other paintings in the apodyterium: the naked youth, half-naked woman, and baby in the lunette opposite, if that is what they are,[36] and the three busts that form a line linking these two paintings across the middle of the vault and have been thought to represent the three ages of man: youth at the east end, maturity in the middle, and old age at the west end (fig. 19).[37] If we put all five paintings—thus interpreted—together, they make a neat sequence, the three ages parenthesized by birth on the east wall and death on the west. It would be a mistake to assume that this is an inappropriate theme, just because bath house decorations tended to strike a joyous—or at least active rather than reflective—note. Baths are for the care of the body, and each body has its own history, never more obviously than when unclothed, as were all those that passed through this room.

Latterly, a more specific interpretation of the painting over the door has been advanced. All the apodyterium paintings are redolent—markedly so even by Quṣayr ʿAmra's standards—of the art of the late antique Mediterranean;[38] and the tympanum fresco has been seen as alluding to a well-known episode in Greek myth, namely Dionysus's discovery of Ariadne, abandoned sleeping on a Naxian strand by the faithless Theseus.[39] Dionysus immediately bears her off and marries her. This story had been treated frequently in Greek and Roman art—the Quṣayr ʿAmra Eros, in particular, looks exactly like the Eros who was often part of this scene, and the general disposition of the figures conforms well to what one expected of "Dionysus discovering Ariadne" (fig. 63).[40]

Not only the tale of Ariadne, but the whole Dionysiac cycle, had been enormously popular—and what is more, well understood—in pre-Islamic

35. Hermary, *L.I.M.C.* 3(1).929–31, 938–39.

36. See above, p. 57.

37. Cf. *Q.ʾA.* 45 fig. 18, 90 fig. 59. Vibert-Guigue diss. 2.27 is doubtful about the three ages, but himself proposes, 2.328–30, an interpretation of the apodyterium, tepidarium, and caldarium frescoes that adds up to much the same thing (couple with Eros in apodyterium lunette: fertility; bathing scenes in tepidarium: infancy; zodiac in caldarium: adulthood).

38. R. Hillenbrand, *K.Is.* 162–63; Farioli Campanati, *XXXIX corso di cultura* 292–94, on the rhombus-shaped decorative compartments of the vault (but also Kröger 82–83, for an Iranian parallel).

39. Winkler-Horacek, *Da.M.* 10 (1998).

40. Cf. Reinach, *Répertoire* 112–13; Winkler-Horacek, *Da.M.* 10 (1998) pl. 74; Loberdou-Tsigarida, Ὀστέινα πλακίδια 255 no. 38.

Figure 63. Seleucia, House of Dionysus and Ariadne:
Dionysus and Ariadne (mosaic, Severan). Antakya
Museum. By permission of the Department of Art
and Archaeology, Princeton University.

Syria. It was treated in mosaics, which have survived abundantly, but also
no doubt in fresco too, and certainly in more portable media: ivory, silver-
ware and textiles.[41] Not far from Quṣayr ʿAmra, at Mādabā, local mosaicists
were producing images rich in explicit, labeled mythological content until
at the very least well into the sixth century.[42] And just as the Mādabā Hip-
polytus mosaic evokes—and presupposes familiarity with—a whole mytho-
logical world, so too, in the literary sphere, do the sixth-century Antioch-
ene chronicler John Malalas and Pseudo-Nonnus's mythological scholia on
the orations of Gregory of Nazianzus, whose Greek original seems to have
been composed in sixth-century Syria, and was then translated into Syriac

41. C. Augé and P. Linant de Bellefonds, *L.I.M.C.* 3(1).514–31, esp. 524–26.
42. Piccirillo 69, 76–77; and above, p. 256.

and revised at least twice during the seventh century—our earliest manuscript of the Syriac version was written in 734 at a monastery near Antioch.[43]

Against this background, Quṣayr ʿAmra's deployment of a classical image of Aphrodite comes as less of a surprise, while the personifications of Philosophy, History, and Poetry in the hall's east aisle suggest that the literary and imaginative tradition signalled by these Greek images may also have continued to be at least partly familiar. The zodiac, in particular, witnesses to its creator's considerable skill in depicting on a hemispherical cupola the whole night sky visible in a given place. A number of technical adjustments were required, and the artist had to erase and redo several parts of his composition; in other words, he was interested in accuracy, not just aesthetic effect.[44] We have to do with artists who spoke Greek and whose frame of cultural reference was far from being exclusively biblical.

We may safely assume, then, that the image of "Dionysus discovering Ariadne"—and very probably its explanation too, whether in Greek or Syriac—was familiar or at least available to the artisans employed at Quṣayr ʿAmra. But to what extent was this knowledge shared by their new, Muslim Arab masters?

One would certainly expect the Semitic population of Syria, and to a certain extent of Arabia as well, to have been aware of the iconography of the Greek gods; so it is easy to believe al-Wāqidī when he reports that the Prophet himself envisaged the Arab Aphrodite, al-ʿUzzā, as a naked woman—admittedly an Ethiopian—bedecked with jewels.[45] Nonetheless, until the 1960s Quṣayr ʿAmra itself was virtually the only direct evidence available for early Muslim knowledge of "classical" (as distinct from Christian) Greek art and perhaps even letters. And it was ambiguous evidence, because there was always a suspicion that the patron ordered images in the Greek style so as to show off a culture he did not possess. Then, in the mid-1960s, Mario Grignaschi drew attention to an Arabic version of a series of letters presumably composed originally in Greek and supposed to have been exchanged by Alexander the Great and his teacher Aristotle.[46] Grignaschi argued that the original Greek text was probably compiled in the mid-sixth

43. Pseudo-Nonnus, *In IV orationes Gregorii Nazianzeni commentarii:* see the editions listed in the bibliography, especially the introductory matter and indices s.vv. "Dionysus", "Ariadne".

44. Brunet, Nadal, and Vibert-Guigue, *Centaurus* 40 (1998).

45. Al-Wāqidī in Ṭab. 1.1648 (trans. 8.187), though the jewels are not mentioned by al-Wāqidī in the parallel account in his *Kitāb al-maghāzī* 873–74; and cf. F. Zayadine, *L.I.M.C.* 2(1). 167–69, 2(2).169–70.

46. Grignaschi, *Bulletin d'études orientales* 19 (1965–66); id., *Le muséon* 80 (1967); id., *Problematics of power;* cf. Latham, *A.L.U.P.* 154–64.

century, while the Arab editor was Sālim Abū 'l-ʿAlāʾ, one of the caliph Hishām's secretaries and most intimate collaborators at al-Ruṣāfa.[47] He was a *mawlā* (an Arab's non-Arab client, usually but not necessarily a Muslim;[48] pl. *mawālī*), and (if we provisionally accept Grignaschi's theory) quite possibly of Iranian origin, since the editor of our text is exceptionally well informed about matters Sasanian. Adopting for himself the persona of Aristotle, Sālim's intention is evidently to convey tactful advice on government and warfare to his master Hishām/Alexander. (The correspondence's detailed references to Central Asian campaigns are among the stronger arguments for assigning the work to the reign of Hishām, when such matters were uppermost in the mind of the Umayyad elite.) Besides the basic framework of the Alexander story, the letters and connecting text allude frequently to ancient Greek literature and quote by name from such as Homer—in fact, pseudo-Homer—and Euripides. Grignaschi also pointed out that Sālim understood enough Greek mythology to be able to substitute references to the Sibyl and the Tower of Babel in passages where his original alluded, respectively, to the Delphic oracle or the story of the Aloadae, who sought to reach heaven by piling mountain on mountain.[49]

Sālim evidently did not expect his readers to be as informed about things Greek as he was. But even if we assume that what we have in this apparently rather early specimen of Arabic prose represents the sum total of his Greek erudition, and that among the late Umayyad secretaries—anyway a very small group[50]—nobody else shared his tastes, still we now have a figure who will certainly have been acquainted with al-Walīd b. Yazīd in his al-Ruṣāfa years and is known to have composed the letter that apprised al-Walīd of Hishām's death and his own succession,[51] while he was also capable of

47. Ibn al-Nadīm, *Kitāb al-fihrist* 131 (trans. Dodge 257–58); and cf. al-Madāʾinī in Ṭab. 2.1649 (trans. 25.179), 1729–31 (trans. 26.71–74), and ʿAbbās, *ʿAbd al-Ḥamīd* 28–32. Manzalaoui, *Oriens* 23–24 (1974) 156–57, 162–64, 192, 193, 218, 241, questions some of the arguments in favor of a pre-Abbasid date for the Arabic version of the letters but in the end allows that Grignaschi's theory may not be so improbable.

48. Crone, *Slaves on horses* 49, esp. n. 358.

49. Grignaschi, *Bulletin d'études orientales* 19 (1965–66) 47–48.

50. Al-Masʿūdī, *Kitāb al-tanbīh* 323 (trans. Carra de Vaux 417); Blankinship, *Jihād state* 81.

51. I follow ʿAbbās, *ʿAbd al-Ḥamīd* 30, in assuming that the Sālim b. ʿAbd al-Raḥmān referred to by al-Madāʾinī in Bal. 2. fol. 716b, 717a (4, §5 and 8, §11 ʿAthāmina) and Ṭab. 2.1750 (trans. 26.99) is the same as Sālim Abū 'l-ʿAlāʾ. Note also that while Bal. §5 calls him a *mawlā* of Saʿīd b. ʿAbd al-Malik b. Marwān, al-Madāʾinī in Ṭab. 2.1649 (trans. 25.179) gives his patron's name as ʿAnbasa b. ʿAbd al-Malik. It is clear from the context of these two passages, though, that we are dealing with one and the same person.

translating a Greek literary text and adapting it with intelligence and sensitivity. If Iḥsān ʿAbbās is right to suppose that the mysterious "Samāl" identified by al-Ṭabarī as the author of al-Walīd's letter bestowing rights of succession on al-Ḥakam and ʿUthmān was in fact Sālim,[52] then Hishām's secretary apparently worked for al-Walīd as well[53] and may therefore have known Quṣayr ʿAmra at first hand and even been actively involved in the latter phases of its design.[54] It will not have been beyond the capacity of such a man to inspire al-Walīd with an interest in the story of Dionysus, of all Greek divinities the most congenial to the young *amīr*'s personal inclinations, and in particular to his love of wine. Indeed, the legend of Dionysus has left a distinct imprint on the *Letters of Aristotle to Alexander*.[55]

Nor was Sālim's interest in things Greek by any means unique in the environment of the last Umayyads. Another *habitué* of the court at al-Ruṣāfa, and a benevolent influence on the relationship between the caliph and his crown prince, was Hishām's half brother Maslama b. ʿAbd al-Malik. He was sufficiently inspired by stories of Alexander's travels to take time off from his campaigns and try to visit the famous Cave of Darkness that the conqueror alone had penetrated, at the sources of the Tigris River.[56] It seems that the Greek *Romance of Alexander* by pseudo-Callisthenes may already have been translated into Arabic by this time.[57] Another, even more tantalizing figure is al-Ghiṭrīf b. Qudāma al-Ghassānī, who served as master of the hunt to both Hishām and al-Walīd and drew extensively on Greek sources in his influential *Book on birds of prey*.[58] Like Sālim, al-Ghiṭrīf is exactly the sort of person one can imagine accompanying al-Walīd on his expeditions to Quṣayr ʿAmra. Together these three, especially Sālim and al-Ghiṭrīf, begin to suggest the existence if not exactly of a Hellenizing coterie

52. See Ṭab. 2.1764 (trans. 26.115), and the note on p. 311 of ʿAbbās, *ʿAbd al-Ḥamīd*.
53. Note that the interpolated list of caliphal secretaries at Ṭab. 2.835–43 (trans. 21.213–23) declares baldly that Sālim was al-Walīd's secretary, not Hishām's (838). Al-Jahshiyārī (a younger contemporary of al-Ṭabarī), *Kitāb al-wuzarāʾ* 59, 65, states that Sālim was secretary to both Hishām and al-Walīd.
54. According to al-Madāʾinī in Ṭab. 2.1649 (trans. 25.179), Sālim's deputy, Bashīr b. Abī Thalja, was from Jordan.
55. Grignaschi, *Bulletin d'études orientales* 19 (1965–66) 40–41, 69–72.
56. Al-Muqaddasī, *Aḥsan al-taqāsīm* 20, 136, 146. On the location of the Birkleyn caves between Diyarbakir and Bingöl, and their association with Alexander, see further Markwart, *Südarmenien* 57–60, 232–39; Sinclair, *Eastern Turkey* 3.274–77, 282, with map facing 406; Bagg, *Assyrische Wasserbauten* 112–16.
57. Abbott, *Studies* 1.50–56; Grignaschi, *Le muséon* 80 (1967) 224.
58. Al-Ghiṭrīf b. Qudāma al-Ghassānī, *Kitāb dawārī al-ṭayr*, esp. p. 2; and cf. Möller, *Falknereiliteratur* 29–36, on the extremely complex textual history of this work.

at the late Umayyad court, then at least of a permeability to Greek culture on the part of individual members of the elite.

Not that a scholarly knowledge of ancient Greece, such as Sālim's, was necessary for either the design or the appreciation of Quṣayr ʿAmra's frescoes. The foregoing observations merely indicate the maximum involvment attested, in these circles, by the available evidence. It seems quite likely, then, that Quṣayr ʿAmra's patron and some of his friends, along with, of course, the educated *mawālī* of Greek origin who abounded at the Umayyad court, would indeed have been able to recognize and even understand a Greek zodiac if they saw one,[59] and likewise an allusion to a romantic story from mythology. But it is also true that somebody with al-Walīd's intelligence and sensitivity could have become familiar with the forms of Greek art just by keeping his eyes open, without necessarily understanding anything of their mythological meaning.[60] And it does in fact seem that our apodyterium painting's relationship to its Greek prototype is of this strictly visual variety.[61] The vital clue is provided by Musil's neglected observation that at Quṣayr ʿAmra Ariadne, whom ancient art had usually shown amidst an abundance of drapery, has been hidden in a shroud. This excludes the possibility that the painting was intended as an illustration of the myth. What perhaps had happened, instead, was that al-Walīd (or Sālim or somebody else) noticed how "Dionysus discovering Ariadne" had often been deployed in funerary contexts, for instance on sarcophagi. Mistaking reclining, sleeping Ariadne for a corpse, he saw in her a visual expression of his grief for the dead Salmā and resolved to incorporate it in the bath house frescoes now

59. Their practical familiarity with the night sky was of course a given. Cf. the poem by al-Walīd's friend ʿAbd al-Ṣamad quoted by Ṭab. 2.1744 (trans. 26.92).

60. Proof that specific monuments of the polytheist past remained visible to the Umayyads is rarely available. See though above, p. 253, and the recently excavated Nabatean temple at Khirbat al-Dharīḥ southeast of the Dead Sea, that served as a barn under the Umayyads until it collapsed in an earthquake. Falling architectural reliefs of the old gods crushed several cows, to which soft landing they doubtless owe their excellent state of preservation: Egan and Bikai, *American journal of archaeology* 103 (1999) 502–5, including figs. 14–16.

61. The general fate of Greek artistic motifs as they travelled into Asia: "It is the visual image that is borrowed, not the concept" (Boardman, *Classical art* 14 and passim, reference courtesy of Robin Lane Fox). Note also Philostratus, *Vita Apollonii* 1.25, on tapestries in the palace of Babylon depicting Orpheus, "perhaps out of regard for his peaked cap and breaches, for it cannot be for his music or the songs with which he charmed and soothed others" (tr. F. C. Conybeare); Bowersock, *Selected papers* 154–55, for a similar suggestion with regard to a Syrian mosaic of Romulus, Remus and the she-wolf, dated 511; Breckenridge, *Justinian II* 56–59, and Dagron, *Constantinople imaginaire* 133, on the difficulty of interpreting the use made of classical imagery even at Constantinople itself by the 690s; and above, 60, 230.

nearing completion. Musil's hunch that our image shows a shrouded corpse is confirmed not only by the young man's pensive air but also by the water jug on a stand at the left of the composition, indicating that the burial preparations have just been completed. The young man resembles neither Dionysus nor al-Walīd. He seems to be no more than a generic image of grief. A more realistic depiction would have been too painful.[62]

ARABIC AND GREEK

Despite the progress that has been made in their interpretation, Quṣayr ʿAmra's iconographical borrowings from the Greek world are still debatable evidence for cultural affinity or even comprehension, at least as far as the patron is concerned. Conceivably they betray no more than an attraction to certain physical forms, though the artists' relationship with the Greek tradition is likely to have been closer. Study of Quṣayr ʿAmra's use of texts and labels in the Arabic and Greek languages offers, on the other hand, hope of a more explicit approach to the problem of cultural contextualization. Whereas there was no need for the patron to recognize the origin of an iconographical form—for example, the type of the Greek Aphrodite that underlies the bathing beauty on the west wall—providing it appealed to him, it is inconceivable that he did not know which language the labels were written in. And if he accepted, or demanded, the use of a language other than Arabic in the project he had commissioned, this must have been because he intended that language—or perhaps just its alphabet, irrespective of what the words meant—to be itself part of the message.

On the other hand, the appeal of Greek was felt by a much more specialized audience at the end of Umayyad rule than had been the case at its inception, when Greek must still have been widely spoken in Syria. We can best measure the distance traveled under the Umayyad dynasty by comparing Quṣayr ʿAmra, where Greek is used sparingly and only for labels,

62. "Dionysus discovering Ariadne" on sarcophagi: M.-L. Bernhard, *L.I.M.C.* 3(1).1063–64. The interpretation sketched here is further developed in Fowden, "Greek myth and Arabic poetry at Quṣayr ʿAmra" (forthcoming). The naked bathers in the tepidarium have also been suspected of Dionysiac allusion, though with less plausibility than the apodyterium tympanum: Winkler-Horacek, *Da.M.* 10 (1998) 276–83. Vibert-Guigue diss. 1.273–80 detects allusion to the myth of Achilles on Scyrus in various panels of the hall's west aisle, notably the dynastic icon and the bathing beauty, and indeed regards Greek mythology as a "fil conducteur" for understanding Quṣayr ʿAmra's many references to nature, femininity, and fertility: 2.246, 288, 317–19, 323. Even in the light of Grignaschi's work, this seems exaggerated for the period and audience in question.

while all texts that require continuous prose are in Arabic, with the bath house recently excavated at the hot springs of al-Ḥamma below Gadara (Umm Qays) near Lake Tiberias. There, a monumental and carefully cut nine-line Greek inscription, discovered *in situ* in a semicircular alcove in the middle of the west wall of the Hall of Fountains, informs us that the bath was thoroughly restored in the reign of the caliph Mu'āwiya (661–80).[63] The text starts with a cross, and there is no equivalent of the *bismi 'llāh*, though this was soon to become common in documents written in Greek.[64] But rather than trying to make a point, the official responsible was just carrying on an epigraphic tradition. The stone maintains both the conventions and even the letterforms and general aesthetic of the bath house's immediately pre-Islamic inscriptions. The name and title of the caliph and the name of the local governor are carefully transliterated from the Arabic, while the governor's title is translated. The date—662—is given according to the indiction and the local (Gadarene) era as well as that of the *hijra*. On either side of the alcove where our text was placed, two sixth-century Greek verse inscriptions recording extension or restoration of the complex continued to be displayed during the Umayyad period.[65] Viewed together, as was plainly intended, the three stones proclaim not so much a change of regime as the careful preservation of an epigraphic—and of course balneal—culture. It is perfectly clear that no need was felt for a parallel Arabic version of the inscription of 662.

Between the restoration of the al-Ḥamma bath house and the decoration of Quṣayr 'Amra, one would expect the consolidation of Arab rule and the spread of Islam to have resulted in a decline in use of the Greek language in Syria. And this does indeed appear to have been the case, so far as one can tell from the relatively few inscriptions and papyri that have been retrieved from patchy archaeological investigations. Tombs are subject to fashion like anything else; and for reasons unclear, the latest more or less securely datable Greek funerary inscriptions so far found in Syria belong to the decade after Mu'āwiya's death. At about the same time was drawn up the latest dated Greek document in the cache of papyri found at Nessana in the al-Naqb desert.[66] Nevertheless, stone quarriers employed by al-Walīd I in the Biqā' Valley in Lebanon left at least one inscription in Greek alongside many more in Syriac;[67] while we find workers employed on the con-

63. Di Segni, *Hammat Gader* 237–40 (no. 54); cf. Gatier, *S.Byz.Is.* 153.

64. Cf. Kraemer, *Nessana* nos. 56, 60–67; Küchler, *Z.D.P.V.* 107 (1991) 134 n. 59.

65. Di Segni, *Hammat Gader* 235–37 (nos. 52–53); cf. 187 fig. 1, for the original position of the three inscriptions.

66. Gatier, *S.Byz.Is.* 146–47, 152.

67. Mouterde, *Mélanges de l'Université Saint Joseph* 22 (1939) 98–99.

struction of Khirbat al-Mafjar casually writing messages and documents on discarded fragments of marble as late as the reign of Hishām, in Greek as well as Arabic.[68] Workmen left Greek graffiti on the old wooden ceiling of the al-Aqṣā mosque in Jerusalem, whose much disputed date lies somewhere between ʿAbd al-Malik or al-Walīd I and c. 780 but is most probably Umayyad.[69] Greek letters were commonly employed as masons' marks.[70] And lamps continued to be produced with Greek (Christian) inscriptions at the same time as lamps with Arabic (Muslim) inscriptions were making their appearance. One remarkable specimen from Jordan proclaims "The light of Christ is the resurrection" in Greek round its filling hole and nozzle, and on its base, in Arabic, "In the name of Allāh, the gracious, the merciful".[71] Other lamps adorned with mostly unintelligible assemblages of Greek letters are particularly hard to date, though some seem pre-Islamic, and one has an inscription saying it was made in A.H. 211 (A.D. 826–27).[72] Farther afield, Ernst Herzfeld found masons' marks in Greek, along with graffiti and sketches for architectural decoration in the Greek manner, while excavating in al-Jawsaq al-Khāqānī (the Khāqānī Palace) at Sāmarrāʾ, which was started in 836.[73]

Usually, our evidence can be made to tell us no more than that somebody somewhere could use Greek either more or less effectively at a time that may be specified but usually is not. A remarkable bilingual fragment of Psalm 78 does, though, allow us to witness the process of Greek's supplanting. The piece of parchment in question was discovered at the beginning of the twentieth century in the treasury of the Great Mosque in Damascus but must originally have been designed for use in the city's cathedral or some other church. Both the Greek and the Arabic texts are written in Greek characters, and the system of transliteration from Arabic to Greek is deliberate and, presumably, revealing of the pronunciation of Damascus Arabic at that time. This document belongs to a period when previously Hel-

68. Schwabe, *Q.D.A.P.* 12 (1946); Gatier, *S.Byz.Is.* 151 n. 3. For fragments of marble with Greek lettering found at Quṣayr ʿAmra, see above, p. 33 n. 10; but these are probably of earlier date.

69. Hamilton, *Structural history* 92–95; Hillenbrand, *Bayt al-Maqdis* 273–77. On the separate question of the date of the earliest mosque on the site, see Elad, *Medieval Jerusalem* 29–39 (Muʿāwiya).

70. Monneret de Villard, *Introduzione* 310 (Mushattā, Khirbat al-Mafjar). Each of the disks that compose the hypocaust pillars in the bath house of the *qaṣr* at al-Faddayn bears a Greek letter: Vibert-Guigue diss. 2.149–50.

71. Khairy and ʿAmr, *Levant* 18 (1986), esp. 152 no. 15.

72. C. A. Kennedy, *Berytus* 14 (1961–63) 85–86; Wilson and Saʿd, *Berytus* 32 (1984) 63, 87 fig. 18; Khairy and ʿAmr, *Levant* 18 (1986) 150 no. 12.

73. Herzfeld, *Die Malereien von Samarra* 96–99.

lenophone Christians were starting to use Arabic in church but could not as yet read it with much fluency. When was that period? Estimates have ranged from the late seventh to the late eighth century.[74] The most natural moment for such texts to have come into the possession of the mosque authorities would have been after the demolition of the church of S. John that stood on the site until the caliphate of al-Walīd I.[75] But given the conservatism of liturgical language, the later date is much more realistic. The convert poet al-Nābigha al-Shaybānī, in a poem addressed to al-Walīd himself, observed that during the period when the Christians had still shared the sanctuary, they did *not* pray in Arabic.[76] The role of Arabic was not really fully accepted until the tenth century. Only at the isolated monastery of S. Catherine, Sinai, was there perhaps less resistance, though there too the earliest specimens of liturgical Arabic are of the eighth century.[77]

As for literary composition in Greek, we know that the ecclesiastical elite—or rather, its pro-Chalcedonian sector—continued to write in that language until at least the end of the eighth century. Its most famous representative was John of Damascus, a scion of a civil service dynasty who became one of the great teachers of the Greek Church and appears to have died toward the middle of the eighth century.[78] Others carried on the tradition of theological composition in Greek for another generation or two.[79] Until (on present evidence) the 760s, formal public inscriptions in churches might also be in Greek, as is apparent from examples found at Mādabā and Mount Nebo in the Balqāʾ.[80] But public inscriptions have in many cultures employed languages no longer in daily use by ordinary people. Nor, in any case, was the linguistic split something Islam had introduced to Syria, since Chalcedonian congregations had long included speakers of Syriac, "Melkite Aramaic", and Arabic as well as Greek.[81] By the second half of the eighth century even ecclesiastical writers were going over to Arabic. The earliest Christian texts in Arabic, whose date of composition can be determined with

74. Violet, *Orientalistische Litteratur-Zeitung* 4 (1901) 429–30; Haddad, *S.Byz.Is.*

75. Sourdel-Thomine and Sourdel, *R.E.I.* 33 (1965) 84–85.

76. Al-Nābigha al-Shaybānī, *Dīwān* 53.1 (trans. Nadler, *Umayyadenkalifen* 231).

77. Nasrallah, *Mouvement littéraire* 2(2).183–84.

78. Hoyland, *Seeing Islam* 480–84; Conticello, *Dictionnaire des philosophes antiques* 3.1001–3.

79. C. Mango, *Scritture*; cf. Schick, *Christian communities* 98–100.

80. Bull. épigr. (1996) no. 504. For a difficult inscription recording the construction of a martyrium, possibly in 788, see *I.G.L.S.* 21.115.

81. Rubin, *Sharing the sacred* 155–57; Humbert and Desreumaux, *Khirbet es-Samra* 1.1–17, 435–521; cf. Daniel, *XXII congresso internazionale di papirologia*.

reasonable accuracy, belong to the period immediately after the death of John of Damascus.[82] John's ardent admirer Theodore Abū Qurra (c. 750-c. 825) became the first significant Chalcedonian theologian to write in Arabic—and possibly rarely or never in Greek, whereas John himself had never written in Arabic.[83] The linguistic transition is summed up by a Sinai Arabic manuscript (no. 154), a quintuple palimpsest, in which an eighth- or early ninth-century Arabic text is superimposed on Umayyad Arabic superimposed on seventh-century Greek uncials superimposed on two layers of Syriac—"all by itself virtually a complete stratigraphic record of the Christian literary history of Palestine to the early Arabic period".[84]

The other milieu in which Greek remained current under the Umayyads was the caliphal administration. Men familiar with the ways of the old East Roman bureaucracy continued to find a market for their skills in the mints and the accounting and tax offices,[85] in part because systems of numerical calculation were better developed in Greek,[86] while governors could more easily demand honesty of the subject peoples than of fellow Arabs, whom it might be politically costly to accuse of financial malpractice.[87] Until ʿAbd al-Malik's currency reform in 697–99 several mints, including that of Damascus, stamped their name on coins in Greek as well as Arabic—a parallel, but half a century earlier, to the bilingual labels on the six kings panel.[88] And it was only gradually, starting in ʿIrāq in 697 and then one by one in the other provinces, finishing with Khurāsān as late as 742, that orders were given for Greek, Middle Persian, and other "local" languages to be replaced by Arabic in the civil service offices or *dīwāns*.[89] In practice, neither the coinage nor the tax registers were immediately purified of the alien tongues. Private mints continued to produce imitations of the so-called Arab-Byzantine coinage well into the eighth century, while weights maintained the East Ro-

82. Griffith, *D.O.P.* 51 (1997) 25.

83. Griffith, *Arabic Christianity* II.162, VII.34–36.

84. Griffith, *D.O.P.* 51 (1997) 26.

85. For remarkable specimens of the documents they produced, in Greek but concerned exclusively with dealings by Arabs with Arabs, see Kraemer, *Nessana* nos. 92–93.

86. Theophanes, *Chronographia* 376, 431.

87. Al-Madāʾinī and others in Bal. 1. fol. 441b = p. 882 (410, §1060 ʿAbbās) and Ṭab. 2.457–58 (trans. 20.36–37), with reference to ʿIrāq, but probably true of the ex-Roman provinces too.

88. Milstein, *Israel numismatic journal* 10 (1988–89); Qedar, *Israel numismatic journal* 10 (1988–89) 33–34. Compare an Umayyad balance found recently at Scythopolis in Palestine, with gradations incised on the beam in pairs of letters, both Greek and Arabic: Tsafrir and Foerster, *Excavations and surveys in Israel* 9 (1989–90) 127.

89. A. A. Duri, *E.Is.* 2.324.

man metrological system and its characteristic markings with Greek letters right up to the end of the Umayyad period.[90] Christian scribes trained in Greek turned out to be less easily dispensable than some had hoped, as the East Roman chronicler Theophanes reports with some malice.[91] But gradually, and at varying speeds in different places, the process of attenuation of Greek and transition to Arabic was effected.

If, then, we except the ecclesiastical milieu, it becomes clear that Quṣayr ʿAmra does stand close to the end of a linguistic epoch. Its few Greek labels will not have struck anyone as utterly exotic, and those who actually wrote them showed signs of possessing a native speaker's linguistic instinct: they preferred first declension endings in ēta to the more formal iota—sigma, and they devised plausible ways of writing names or titles as rare in eighth-century Greek as Roderic and the Negus.[92] Yet all texts designed to convey more than just a single name or concept were written in Arabic. For whose benefit, in that case, were the Greek labels intended?

Part of this question's interest is that it recalls to one's mind the fact that most of Quṣayr ʿAmra's frescoes do without labels. Even the bathing beauty in the west aisle and the typanum painting in the apodyterium, which give us pause, were considered self-explanatory then. Some longer Arabic texts were provided, such as the originally (not just now) hard-to-read texts painted above the windows on the north and south walls, and the *tabula ansata* below the dynastic icon. But these are boxed off from the frescoes and apparently conceived of as independent of them. Only a minority of the frescoes were thought to require direct verbal embellishment or comment, and that was provided exclusively in Arabic on the portrait of the prince, and in Arabic and Greek together on the six kings panel. That leaves only the dynastic icon and the quintessentially Hellenic personifications bearing labels in Greek alone.[93]

The best clue to the intended audience is in the dynastic icon's procla-

90. Private mints: Bates, *ARAM periodical* 6 (1994), esp. 393–95. Weights: Khamis, *Journal of the Royal Asiatic Society* 12 (2002).

91. Theophanes, *Chronographia* 376, 431, and cf. also 416 ad fin. (with Hoyland, *Seeing Islam* 354–60); Ṭab. 2.1470 (trans. 25.7); al-Jahshiyārī, *Kitāb al-wuzarāʾ* 43 (Ibn Baṭrīq), 56 (Tādharī b. Aṣaṭīn al-Naṣrānī), 57–58, and cf. 64–65; Blankinship, *Jihād state* 38, 80; Hoyland, *Seeing Islam* 112, 287; Shboul and Walmsley, *Mediterranean archaeology* 11 (1998) 258. In the year 2000, the Tunisian bureaucracy had still not completed the transition from French to Arabic.

92. Above, pp. 87 n. 7, 206.

93. Musil reported seeing the letters *PΩΠA* next to the figure—now hard to discern—on the north endwall of the west aisle: von Karabacek, *Ḳ.ʿA.* 1.237 n. 75. Vibert-Guigue diss. 1.266 reports traces of another Greek text in the lunette above this panel.

mation of the Umayyads' victoriousness, their *NIKH*, and in the six kings panel. Umm al-Ḥakam and al-Walīd's other Greek concubines no doubt taught their master a few words of their native tongue. And the ability he thus acquired, to decipher the writings on the wall, will have been particularly useful to him when receiving ambassadors from the emperor of East Rome (or his rivals). We read in the *Chronicle* of Theophanes:

> In this year Oualid . . . became ruler of the Arabs. Both Constantine [V] and Artabasdus [a usurper] sought his alliance by dispatching to him, the former the *spatharios* Andrew, the latter the logothete Gregory.[94]

Such men will have appreciated a little hunting during the intervals of diplomatic negotiation, which can have been conducted only in the Balqāʾ, where al-Walīd permanently resided. When the day's exercise was over, Victory and the six kings will have provided them with matter for political rumination. But culture—not least that of ancient Greece and Rome, however filtered—was a no less significant area of competition, as already noted at the end of chapter 7. Recalling the historian al-Masʿūdī's admiring allusion to the East Roman ambassador-monk John, whom he had himself encountered in 946 and found to be well versed in Greek and Roman philosophy as well as history, a perceptive recent student has remarked how "when imperial envoys showed their familiarity with the figures of the Greco-Roman past and general knowledge of ancient philosophy, they demonstrated the fundamental antiquity and continuity of their political order and—irrespective of changes in religious creed—its consequent legitimacy".[95] Yet the personifications of History, Poetry, and Philosophy on the wall of Quṣayr ʿAmra's hall were meant to raise a question mark against this legitimacy, or rather its exclusivity. The caliphal court was ever eager to impress official visitors from Constantinople. Its representatives may even have gone so far as to pretend they knew less Greek than they did, in order to overhear their guests' awed reactions (it was hoped) to the monuments they saw.[96] In Abbasid times it could be complacently imagined that an emperor of East Rome had so far reciprocated this interest as to inscribe in his audience chamber some Arabic verses that had caught his fancy.[97]

Quṣayr ʿAmra's patron and his circle were, in short, far from being a linguistically Greek milieu. They did, though, admire Greek culture from afar

94. Theophanes, *Chronographia* 416 (trans. C. Mango and R. Scott).

95. Al-Masʿūdī, *Kitāb al-tanbīh* 194 (trans. Carra de Vaux 261); Shepard, *Porphyrogenita* 98.

96. Cf. Ibn ʿAsākir, *Taʾrīkh madīnat Dimashq* 2(1).43–44.

97. Al-Iṣfahānī (attributed), *Kitāb adab al-ghurabāʾ* 54–55, §34 (with the note of Crone and Moreh ad loc.).

and wish to be associated with it. What they knew of Hellenism came mainly in the form of images—a category that included, so far as most were concerned, the mysterious Greek letters.[98] A few may, like the secretary Sālim, have been considerably better informed, for example about the content and even meaning as well as the iconography of certain Greek myths. Such men will have helped to design Quṣayr ʿAmra's decorative scheme. But they will not have been typical of the bath house's everyday "customers". One may recall a tale told about the early fourth-century Sasanian prince Hormizd, preserved by a later Greek historian:

> When his father was king of the Persians, and was celebrating his birthday as is the Persian custom, Hormisdas came into the palace laden with kill from the hunt. But the guests at the banquet did not honor him by standing up as was their duty. Hormisdas was furious, and threatened to make them suffer the fate of Marsyas. Most of those present did not know this foreign tale, but one of the Persians, who had spent some time in Phrygia and had heard the story of Marsyas, explained the meaning of Hormisdas's threat to the others who were sitting there.[99]

QUṢŪR

We may move on now beyond the avenues of contextualization suggested by the frescoes and the texts inscribed upon them, to consider the problem from the perspective of the whole site—which is where we started, at the beginning of chapter 2. We should note, first of all, that this next phase of our argument is fully implicit in the frescoes that have been our focus up to this point. These do not allude just internally to the denizens of the bath house and the activities that took place within its walls; they also refer in realistic fashion to the outside world, through not only the six kings, but also the excitements of the hunt whose drama unfurled across the Balqāʾ's stony hills and along the wadis that punctuate its austere landscape. This external allusiveness, which has its parallels in the decoration of Qaṣr al-Ḥayr al-Gharbī as well, or Khirbat al-Mafjar, provides the cue for an investigation of the whole category or set of Umayyad buildings in the steppe and desert[100]

98. Cf. Franklin, *Byzantium-Rus-Russia* XII.81; but also, on Constantinople itself, Dagron, *Constantinople imaginaire* 153–56.
 99. Zosimus, *Historia nova* 2.27.1–2. Elizabeth Key Fowden kindly drew my attention to this parallel.
 100. Cf. the Arabic expression *mimmā yalī al-barr*, "that which adjoins the desert", used, for example, by al-Masʿūdī, *Kitāb al-tanbīh* 322 (al-Ruṣāfa), 324 (al-Bakhrāʾ near Palmyra) (trans. Carra de Vaux 416, 419).

of Syria and Jordan.[101] Such an investigation could easily make another book. What is intended here is a brief comment on the subject from the perspective of Quṣayr ʿAmra, its main goal the insertion of our hunting lodge into a set of structures, in such a way that the particular is illuminated by being placed in a wider but functionally and stylistically still related context. This set we may for brevity's sake call *quṣūr*, the plural form of the Arabic noun *qaṣr*.[102] Although not attested in Umayyad inscriptions,[103] the word *qaṣr* does occur in pre-Islamic and early (pre-750) Islamic poetry,[104] in the Qurʾān,[105] and in Ibn Isḥāq, who died in 767 and whose linguistic habits, broadly speaking, reflect late Umayyad usage.[106] It denotes a royal palace, the substantial residence of an eminent person, or any structure deemed impressive either for beauty or size. In the classical texts, *qaṣr* retains the same

101. There were Umayyad-period *quṣūr* outside Syria and Jordan. Al-Kūfa: Sayf b. ʿUmar in Ṭab. 1.2489–94 (trans. 13.69–74) and below, p. 300 n. 33. ʿIrāq generally: Finster and Schmidt, *Baghdader Mitteilungen* 8 (1976); Northedge, *Entre Amman et Samarra* 54–56; id., *Céramique byzantine* 209. Farther east: al-Madāʾinī in Ṭab. 2.1637 (trans. 25.168 Blankinship) on "arched halls (*īwānāt*) in the deserts" of Khurāsān, built under Hishām; Brentjes, *Syrien*, on Akhyrtash near Dzhambul (Kazakhstan); Karev, *Studia iranica* 29 (2000), and *Bulletin: Fondation Max van Berchem* 15 (2001), on a palace in process of excavation on the citadel of Samarqand, and dated to the 740s/750s (both these structures being related in plan to the Syrian *quṣūr*). But the Umayyads' predilection for the lands within striking distance of Damascus endowed the Syrian *quṣūr* if not always with a common style then at least with a shared social milieu, which makes them a more or less coherent object of study.

102. Against Conrad's derivation of this word from the Arabic root *q-ṣ-r* rather than Greek *kastron* or Latin *castrum*, *Al-abhath* 29 (1981) 8–10, see Shahîd, *B.A.SI.C.* 2 (1).67–75.

103. Cf. *R.C.E.A.* 1. nos. 27 (ʿamal: Qaṣr al-Ḥayr al-Gharbī), 28 (madīna: Qaṣr al-Ḥayr al-Sharqī). On the semantic equivalence of *madīna* and *qaṣr* in early times, see *Q.H.E.* 80–81; also Kubiak, *Al-Fustat* 50–55, 128; Robinson, *Empire and elites* 68.

104. E.g., al-Aswad b. Yaʿfur al-Nahshalī, *Qaṣīda dālīya* (*E.A.P.* 2.138–54) 9; Ḥassān b. Thābit, *Dīwān* nos. 105.2, 123.2 (trans. Conrad, *Byzantine and modern Greek studies* 18 [1994] 18, 30), and cf. Shahîd, *B.A.SI.C.* 2 (1).69; Abū Qaṭīfa (d. before 693) in Iṣf. 1.13–14 (trans. Kilpatrick, *Book of songs* 371 n. 83): famous verses about a *qaṣr* by a palm grove, more desirable than the delights of Damascus; al-Farazdaq, *Dīwān* 1.366: general reference to the *quṣūr* of Syria. Cf. also the prose narrative attributed to Jarīr in Iṣf. 8.88–89 (trans. Berque 253). For further references see Ṭūqān, *Al-ḥāʾir* 39–42.

105. Qurʾān 7.74, 22.45, 25.10, 77.32. But the Quranic *qaṣr* is either antique or paradisal or a simile. In the one allusion to fortified dwellings that existed in the Prophet's own day, the word used is *ḥuṣūn*: 59.2.

106. Ibn Isḥāq, *Sīrat rasūl Allāh* 903 (Wüstenfeld)/4.180 (al-Saqqā) on Ukaydir's *qaṣr/ḥiṣn* at Dūmat al-Jandal (al-Jawf); 102, 106 (Wüstenfeld)/1.195, 202 (al-Saqqā) and 28, p. 22, and 33, p. 28 (Ḥamīdullāh), on the "*quṣūr* of Buṣrā/Syria" (indicating generally a place far from Makka, but presumably also alluding specifically to what Damascius, in the first quarter of the sixth century, had called Buṣrā's "ancient walled fort", φρούριον παλαιὸν ἐπιτετειχισμένον: *Vita Isidori* 196 (*Epitoma*

range of meanings and is in particular the standard word for a fortified house
in a village or rural area,[107] a synonym, as in Ibn Isḥāq, for *ḥiṣn*.[108] Con-
ventionally rendered into English as "(desert) castle", the word might per-
haps more appropriately be translated, in the contexts that here interest us,
as "(country) residence".[109]

Photiana)—which shows that *qaṣr* might, on occasion, mean "castle"); 450, p. 268
(Ḥamīdullāh), on the old royal residence, *al-qaṣr al-abyaḍ*, at Ctesiphon; and cf. Hebbo,
Fremdwörter 88–90 *(ḥiṣn)*, 298–99 *(qaṣr)*. (It should be borne in mind, though, that
the *Sīra's* original text is lost. We depend on abridged or truncated editions later in
date than Ibn Isḥāq himself: Schoeler, *Écrire et transmettre* 8, 75–77, 84–86.) The word
qaṣr appears only in Bal.'s summary of the *Khuṭba Yazīd's* promise to refrain from
the building projects so favored by al-Walīd II, not in the full text.
 107. Sauvaget, *R.E.I.* 35 (1967) 46–47. Note also, with specific reference to
Umayyad-period rural structures: al-Haytham b. ʿAdī in Bal. 2. fol. 155a = p. 309
(4 Derenk) on al-Walīd b. Yazīd growing up in his father's *qaṣr* (Bayt Rās? al-
Muwaqqar?), and Abū 'l-Yaqẓān al-Nassāba in Bal. 2 fol. 158a = p. 315 (17 Derenk)
on the *qaṣr* (also called a *manzil*) of al-Walīd's father-in-law at al-Faddayn; Bal. 2.
fol. 721a (37, §68 ʿAthāmina) and al-Madāʾinī in Ṭab. 2.1738 (trans. 26.81) on the two
*qaṣr*s Hishām built at al-Ruṣāfa, and cf. Abū 'l-Yaqẓān al-Nassāba in Iṣf. 4.414; al-
Bakrī, *Muʿjam mā istaʿjam* 130, on the Abbasid clan's *qaṣr* at al-Ḥumayma; Ibn
ʿAsākir, *Taʾrīkh madīnat Dimashq* 2(1).133, on ʿAbd al-Malik's Qaṣr Khālid in Jordan;
id., *Tarājim al-nisāʾ* 520, on an Umayyad *qaṣr* at Maʿān. Al-Balādhurī, *Kitāb futūḥ
al-buldān* 143, Iṣf. 21.118–19, Agapius of Manbij, *Kitāb al-ʿunwān* p. 266, and Yāq.
2.17 s.v. "Tadmur" (among many other passages) refer to urban Umayyad-period
quṣūr at al-Ramla (Palestine), ʿAmmān, Ḥarrān, and al-Baṣra respectively.
 108. Bal. 2. fol. 166a = p. 331 (56 Derenk), on al-Bakhrāʾ. But cf. above, p. 273 n.
105; and note that al-Samhūdī (d. 1506) reports Muʿāwiya's conversion of two *qaṣr*s
at al-Madīna into *ḥiṣn*s, in order to make them more siege-proof: Lecker, *Muslims,
Jews and pagans* 11–12. Other synonyms for *qaṣr* were *dār* (al-Madāʾinī in Bal. 2.
fol. 166b = p. 332 [58 Derenk] and Ṭab. 2.1799–1800 [trans. 26.153]), *madīna* (above,
p. 273 n. 103), and *manzil* (above, p. 274 n. 107). *Manzil* is used in apposition to *ḥiṣn*
by Maymūn b. Qays al-Aʿshā, *Qiṣṣat al-Samawʾal* (*E.A.P.* 2.155–63) 7.
 109. On the similar understanding of the word in more recent Arabic cf.
Doughty's definition quoted above, p. 153; Musil, *Rwala* 160 ("*Kaṣr* is the name of
any house built of stone or mud bricks. A desert *kaṣr* forms a square courtyard en-
closed with a high wall, against which abut the dwellings of the several families. Thus
the whole kin lives together"), and *Arabia deserta* 370 (a *qaṣr* "resembles a quad-
rangular fortress, enclosed by high walls that are strengthened at every corner by
a tower. The gate ordinarily is either in the corner by the tower or else it is fortified
by a smaller tower of its own. It opens into a large yard flanked with small, flat-
roofed dwellings"); N. N. Lewis, *Nomads and settlers* 139, 147, 231 n. 30; and fur-
ther references in Conrad, *Al-abhath* 29 (1981). Conrad, in deemphasizing the ele-
ment of luxury often held to be implicit in the word *qaṣr*, draws heavily on
nineteenth- and twentieth-century travelers' descriptions of relatively humdrum
structures considered by their inhabitants to be *quṣūr*. Although *qaṣr* has indeed al-
ways designated a wide range of structures, including humble ones, it should be borne
in mind that, in seventh- and eighth-century Arabia and Syria if ever, there was an
abundance of buildings at the upper end of the market as well, which was not equaled

Numerous *quṣūr* are now known to scholarship,[110] and their number increases as archaeologists excavate fresh sites, such as al-Faddayn, or reassess visible remains long known that have hitherto tended to be classified as Roman fortifications,[111] and in general struggle to keep one step ahead of the present generation's return to a level of exploitation of steppe and desert not seen since 750. The number of *quṣūr* that has been studied is now large enough for generalizations about their significance and use under the Umayyads to have some chance of being realistic. Not that earlier generations failed to offer such broad analyses—but their database had to a large extent been determined by the interests of historians of architecture and art, and by museum treasure-seekers, with the result that spectacular buildings such as Mushattā and even Quṣayr ʿAmra enjoyed disproportionate prominence. Nowadays, various less exciting sites have been added to the list and thoroughly worked over by archaeologists, and current understanding of their original functions duly reflects all the sherds catalogued and animal bones classified. A wide range of *quṣūr* has already been touched on in chapters 2 and 5, particularly in the course of discussing the identity of Quṣayr ʿAmra's patron.

In some respects, Quṣayr ʿAmra is a representative member of this set of *quṣūr*—to such an extent, indeed, that one could actually deduce the existence of certain other parts of the set even if Quṣayr ʿAmra were the only member of it that had survived. Hunting lodges tend, after all, to be satellites of a permanent residence, which in this instance could have been in the nearby al-Azraq oasis, where remains of Umayyad structures have been discovered,[112] or at the natural fortress of ʿAmmān. Even were the latter not today crowned by one of their palaces, one might still surmise that the

again until the later twentieth century, and then only in Arabia, not Syria. Marwān II's *qaṣr* at Ḥarrān cost 10 million dirhams according to Mas. 2297 (3.245 Dāghir), which is the same order of magnitude as the cost of the vast ninth-century Abbasid palaces at Sāmarrāʾ: Yāq. 3.175 s.v. "Sāmarrāʾ". With the fall of the dynasty, the Umayyad *quṣūr* declined (the one at Ḥarrān, for example, was demolished), while the name that designated them lost its prestige: see, for example, above, p. 142, and below, p. 287, on al-Faddayn and Zīzāʾ.

110. For recent lists see Ṭūqān, *Al-ḥāʾir* 60–105 (including sites attested only in literary sources); Northedge, *ʿAmmān* 1.169 (Jordan only), and *Entre Amman et Samarra* 61–63.

111. See, for example, Bujard and Trillen, *A.D.A.J.* 41 (1997), on Umm al-Walīd and Khān al-Zabīb; Lenoir, *Syria* 76 (1999), reclassifying as a Ghassanid or Umayyad "résidence palatiale" what had passed for generations of scholars as a Roman *castrum* at Ḍumayr near Damascus.

112. Above, p. 158. Though it is too humble for Quṣayr ʿAmra's patron, note also the Umayyad farmhouse with small bath and olive plantation recently excavated at

Umayyads had used the ʿAmmān citadel, as also that there must have been a halting place (or hunting lodge or residence) between it and Quṣayr ʿAmra, some 65 kilometers distant. Al-Muwaqqar and Qaṣr al-Mushāsh correspond perfectly, as it happens, to this need.[113] Quṣayr ʿAmra's stripped-down architectural aesthetic is likewise suggestive. Apart from ensuring one will be caught off-balance by the frescoes, which are hardly modest, it may also signal that its owner's real architectural credentials are on view elsewhere.

Quṣayr ʿAmra is also less exceptional than was originally thought as regards the hedonistic parts of its decoration, which are now paralleled, though mostly in stucco, at Qaṣr al-Ḥayr al-Gharbī and Khirbat al-Mafjar. On the other hand, it is relatively unusual in being primarily a hunting lodge *(mutaṣayyad)* rather than a residence; and it is still unique for the sheer range and variety of its decoration—greater even than that of Qaṣr al-Ḥayr al-Gharbī—and of course for its state of preservation. In short, being neither wholly predictable nor utterly unique, Quṣayr ʿAmra is well placed to benefit from—and contribute to—the process of contextualization that the existence of the set *quṣūr* makes possible.

An impression of the average *qaṣr* has already been given in chapter 5 but may here be recalled and expanded somewhat.[114] In the first place, it was a roughly 70-meter-square enclosure. This does not mean that more compact—or more expansive—*quṣūr* were unknown. There was Qaṣr al-Ḥallābāt, for instance, or the even smaller Qaṣr Kharāna, which was evoked in chapter 2 as an analogue, at least with respect to size, of the courtyard dwelling at Quṣayr ʿAmra. This structure can in turn be compared with a whole group of courtyard dwellings of similar dimensions, a set not unrelated to the large *quṣūr,* but lacking their pretensions.

The perimeter walls of the square enclosure were punctuated by projecting semicircular towers. Inside, living rooms (with latrines) were arranged in self-contained suites round the central courtyard. There was a grandiose gatehouse with provision for waiting petitioners, and a show—rather than the

ʿAyn al-Sil, 1.75 kilometers northeast of the castle of al-Azraq: G. Bisheh, *A.J.* 2.150–54, and *Bilād al-Shām* 90–93.

113. Above, pp. 151–52 and 47–48 respectively.

114. The distinctive features of the *qaṣr* are tabulated by Carlier and Morin, *A.D.A.J.* 28 (1984) 379. See also Bujard and Trillen, *A.D.A.J.* 41 (1997) 357–63, 368–70. Another representative specimen of the genre, at al-Khulla south of al-Ruṣāfa, has been published by Ulbert, *Resafa* 5, though this cannot be Hishām's al-Zaytūna, which was in the Jazīra near the Euphrates, probably in the al-Raqqa area: al-Yaʿqūbī, *Al-taʾrīkh* 2.316; Sauvaget, *Syria* 24 (1944–45) 103; C.-P. Haase, *E.Is.* 8.631a.

reality—of a defensive capability. This last point is underlined by the *qaṣr's* location, which is nearly always in a flattish area or a plain[115] and never, except at ʿAmmān, in an especially elevated, defensive position. Evidently much more important than considerations of security was the problem of water. Some *quṣūr* lacked even Quṣayr ʿAmra's modest on-site supply; and most were obliged to store water for the dry season, so needed dams, water channels, and reservoirs. Either adjacent to the focal structure, or actually inside it, one usually finds a mosque, and often a bath house. Nearly all the *quṣūr* have at least a garden, if not some larger area of cultivation. And since agriculture required labor, there is usually a village too, somewhere in the environs.

It was already remarked in chapter 2 that the smaller type of courtyard dwelling must have been constructed in the more fertile areas too but is not much attested archaeologically, having fallen victim to the process of robbing, recycling, and redevelopment. In the same way, the larger type of *qaṣr* must also have been built in fertile and indeed urban areas, not just the steppe and desert, though only a few of these sites are now known. Remains of the palace in the ʿAmmān citadel have always been visible, it is true;[116] but Khirbat al-Mafjar, for example, in the irrigated area round the oasis of Jericho, or Khirbat al-Minya on the northwest shore of Lake Tiberias,[117] or the grand *quṣūr* that were constructed just outside the southwest corner of the Temple area in Jerusalem,[118] had to be reclaimed from oblivion by excavation. Nonetheless, the construction of so many *quṣūr* in arid areas demands an explanation. It is hard to imagine the Umayyads building with such gusto in the Syrian steppe and desert purely by default, without positive motivation. Some factors that need to be taken into account and have already been mentioned in chapter 5 are: the Umayyad ruling class's taste for relaxation in the steppe or desert; the need to be close to Damascus; the attraction of the al-Balqāʾ climate (in seasonal combination with that of the Jordan Valley), along with the emptiness of the desert and the hypnotic clarity of the night sky; fear of the plague; and of course the intense thrill of the hunt. The potential importance of such factors to

115. Exceptions: above, pp. 151–52 (al-Muwaqqar), 155 (Maʿān).
116. B. Ward-Perkins, *Levant* 28 (1996).
117. E. Baer, *E.Is.* 5.17.
118. Bieberstein and Bloedhorn, *Jerusalem* 3.388–90, 392–94; cf. above, p. 235 and n. 23; also the reservations of Brisch, *Oriens* 33 (1992) 450; Bahat, *History of Jerusalem* 72 nn. 204–5, 77 n. 234; and Grabar, *Shape of the holy* 129–30. Note additionally al-Azdī, *Taʾrīkh al-Mawṣil* 24–25, 27 (quoted by Robinson, *Empire and elites* 80), on the governor's elaborately decorated *qaṣr* at Mosul, c. 725–26; and al-Jahshiyārī, *Kitāb al-wuzarāʾ* 29, 56, on residences built by or for two Umayyad secretaries in al-Fusṭāṭ and ʿAkkā respectively.

any attempt to explain the Umayyads' taste for building *quṣūr* in the steppe and desert is easier to grasp if one has seen the buildings and the landscape or is familiar not just with classical Arabic prose and poetry, but also with the deep hold of poetry on the Arab imagination in those days, and with the way in which poetry wore itself into the everyday texture of people's lives, including many members of the Umayyad elite. The *Kitāb al-aghānī*, in particular, was made much of by early Arabist students of the *quṣūr* such as Musil, in his contribution to the Vienna publication of Quṣayr ʿAmra, and also his contemporary and acquaintance Henri Lammens S.J., of the Université St-Joseph in Beirut. Enthused by the connections that could be made between the colorful texts and the monuments that were being brought once again to light, both Musil and Lammens interpreted the *quṣūr* as essentially pleasure domes.[119]

A new post-First World War generation of scholars benefited from the ever-growing body of material evidence about the *quṣūr* but was eager to show itself hard-nosed about so-called romantic sensibilities. Brought up, no doubt, to be more interested in five-year plans than in the arts and pleasures of princes, such individuals preferred to see the *quṣūr* as agricultural enterprises. What now attracted attention—in particular that of the French Islamicist Jean Sauvaget (d. 1950)[120]—were the facilities for water gathering and irrigation that were often associated with the *quṣūr*, along with any signs of cultivation or of accommodation for cultivators that could be found in their environs (fig. 64). When in the 1970s the authenticity of the classical historical literature as a source for the earlier periods of Islamic history began to be questioned, the hand of the archaeologists was still further strengthened. Sauvaget's ideas continued to be elaborated or modified by participants in the discussion he had provoked. Some, for example, argued that the Umayyads' agricultural enterprises had merely built on and expanded an infrastructure that already existed thanks to colonization and

119. Lammens, *Al-Mashriq* 10 (1907) 578–79, and *Études* 325–50 ("La 'bādia' et la 'ḥīra' sous les Omayyades", originally published in 1910). Musil's acerbic criticisms of this article in *Palmyrena* 277–97 dealt with details, not the main thrust of the argument. Lammens's conclusions were largely followed by Creswell 402–6, against whom Ṭūqān, *A.D.A.J.* 14 (1969) and *Al-ḥāʾir* 115–44, pointed out that many *quṣūr* were not in the steppe or desert, and that the Umayyads' reasons for building them went beyond hunting, including servicing a peripatetic way of life and diplomatic dealings with the various sections of Arab society. This phase of the discussion is summarized by Sauvaget, *R.E.I.* 35 (1967) 5–8, and criticized 8–13, with particular attention to Lammens's habit of citing the *Kitāb al-aghānī* in support of statements that have little or nothing to do with the text adduced.
120. See especially Sauvaget, *R.E.I.* 35 (1967) (posthumous publication).

Figure 64. Qaṣr al-Ḥayr al-Gharbī: reconstruction of Umayyad irrigation works and gardens. O. Callot, in Y. Calvet and B. Geyer, *Barrages antiques de Syrie*, Collection de la Maison de l'Orient Méditerranéen 21 (Lyon: Maison de l'Orient Méditerranéen, 1992) 91 fig. 49.

cultivation of marginal lands in the steppe between the fourth and sixth centuries, or even earlier.[121] Others pointed to evidence both literary and archaeological for decline in the cultivation of marginal lands under the Umayyads compared to the fifth and sixth centuries.[122] Others were prepared to see improvements in water gathering as aimed as much at pastoralism as agriculture.[123] The Umayyad dating of some of the sites in the Wādī ʿAraba that

121. Monneret de Villard, *Introduzione* 21–22, 240–44; Grabar, *Medieval Islamic art* III; Gaube, *Ḥirbet el-Baiḍa* 122–23. On the late antique background see Gaube, *Z.D.P.V.* 95 (1979) 187–92. He rejects Sauvaget's assumption that the Umayyad installations were economically profitable. Ḥamza al-Iṣfahānī, *Taʾrīkh* 89–96, lists *quṣūr*, monasteries, and irrigation works constructed by the Ghassanids; cf. Shahîd, *B.A.S.I.C.* 2 (1). 306–45, 364–74, a maximalist case for his fundamental reliability. See also de Vries, *Umm el-Jimāl* 229–41, on the great agricultural prosperity of Umm al-Jimāl and its region, in the sixth century especially; Foss, *D.O.P.* 51 (1997) 252–58, on the flourishing economy of the Ḥawrān's southern fringes at least as far south as Qaṣr al-Ḥallābāt, into the Umayyad period; and B. Geyer, *Archéologie aérienne*, on the agricultural development of the region between Aleppo and Palmyra in the fifth and sixth centuries, and the Umayyads' dynamic exploitation of marginal lands in the region.

122. Ṭab. 1.1007 (trans. 5.326–27); al-Muheisen and Tarrier, *ARAM periodical* 6 (1994) 338–40. The evidence presented by Humbert and Desreumaux, *Khirbet es-Samra* 1, on Khirbat al-Samrāʾ between al-Zarqāʾ and al-Mafraq, appears to indicate decreased activity in the seventh century. Although Hamarneh, *Topografia cristiana* 213–30, denies any sudden decline from the sixth-century peak of prosperity in the settled areas of Jordan, her evidence is very thin by the eighth century.

123. King, Lenzen, and Rollefson, *A.D.A.J.* 27 (1983) 392, on Qaṣr al-Mushāsh. For post-Sauvaget agricultural interpretations of specific sites, at varying levels of conviction, see, for example, Grabar *Q.H.E.* 157, 162–65 (Qaṣr al-Ḥayr al-Sharqī); Bisheh, *S.H.A.J.* 2 (Qaṣr al-Ḥallābāt); Najjar, Azar, and Qusous, *A.D.A.J.* 33 (1989)

Sauvaget discussed has been rejected recently on the basis of an archaeological survey.[124]

What can under no circumstances be denied is the Umayyads' eagerness to irrigate and plant, in various parts of their dominions. To what extent this gave impetus to the long-term development of agriculture in Islamic lands is not clear,[125] but the effort invested is undeniable. We are quite well informed about, for example, improvements the Umayyads made to the irrigation of the Damascus oasis,[126] and there is a group of dams in the Ṭāʾif region of al-Ḥijāz, one of which bears an inscription stating that it was constructed under Muʿāwiya I.[127] Hishām's canal-building projects and plantations are often mentioned with admiration in the literary sources,[128] and a Jewish apocalyptic text of the period could say of him that "he will plant young trees and build ruined towns and burst open the abysses to raise the water to irrigate his trees".[129] He derived an enormous income from these projects and was criticized too, on the grounds that they were meant for his own profit.[130] As for the individual *quṣūr*, most possessed their own hydraulic installations. It was recently shown, as well, that several dams located in the Wādī 'l-Jilāt, some 26 kilometers south-southwest of Qaṣr Kharāna in the Jordanian steppe, were in use during the Umayyad period, whether or not they were actually built then.[131]

Still, the major Umayyad irrigation works were in Mesopotamia, not Syria, which simply did not have enough water. It cannot just be taken for granted that every *qaṣr* was attached to an estate capable of producing a marketable surplus in addition to meeting the needs of occasional and permanent residents. If Qaṣr al-Ḥayr al-Sharqī was surrounded by an enclosure

11 (al-Muwaqqar); Bujard and Trillen, *A.D.A.J.* 41 (1997) 372–73 (Umm al-Walīd and Khān al-Zabīb).

124. King, Lenzen, Newhall, King, Deemer, and Rollefson, *A.D.A.J.* 33 (1989) 208.

125. Lapidus, *Islamic Middle East*. The Umayyad contribution is not well brought out by Watson, *Agricultural innovation*, esp. 103–11 on irrigation.

126. Ibn ʿAsākir, *Taʾrīkh madīnat Dimashq* 2(1).145–52.

127. Grohmann, *Expédition Philby—Ryckmans—Lippens* 56–58 (Z 68), and cf. 94–95 (Z 152); Khan and Al-Mughannam, *Atlal* 6 (1982). Note also Mas. 238, on the draining of marshes in ʿIrāq.

128. Above, p. 169 n. 144; and cf. al-Balādhurī, *Kitāb futūḥ al-buldān* 151, 294, on Hishām's half brother Maslama b. ʿAbd al-Malik.

129. *Secrets of Rabbi Simon ben Yōḥay* (see above, p. 157 n. 85), quoted by B. Lewis, *Studies in classical and Ottoman Islam* V.326, and cf. 309, 327.

130. Al-Madāʾinī in Ṭab. 2.1732 (trans. 26.74–75); Blankinship, *Jihād state* 91. Criticism: Nadler, *Umayyadenkalifen* 259–61; above, p. 172 n. 157.

131. King, Lenzen, and Rollefson, *A.D.A.J.* 27 (1983) 392–98, 406 fig. 4; A. N. Garrard, *O.E.A.N.E.* 3.247–48.

that contained over 7 square kilometers of cultivable land, the gardens at Qaṣr al-Ḥallābāt and Quṣayr ʿAmra were much smaller,[132] and both their size and their remoteness from significant permanent settlements precluded their acquiring commercial value. Sometimes not even visitors could be properly fed. When al-Walīd II, confronted by the revolt that was to cost him his life, took refuge near Palmyra at Qaṣr al-Bakhrāʾ, which was not one of his own properties, he immediately bought up the village's supply of standing corn as fodder for the use of the riders who were with him. But "the soldiers said: 'What can we do with green corn? It will make our animals ill.'"[133] Under circumstances less abnormal than the last days of a regime, the proprietor of a *qaṣr* would, of course, know better than to turn up with a large force of retainers when the crops were not yet in.

We need, then, to scrutinize the easy assumptions on which Sauvaget built his hypothesis. For example, the homogeneities of the *quṣūr* are easy to exaggerate when one starts from what is shared rather than from an assessment of each building on its own terms, and merely asks whether a given site does or does not possess a particular feature. Different combinations put together in different ways—and in different environments—even from a quite restricted pool of basic elements can result in widely divergent end products, as is obvious if one compares, say, the tropical grandeur of Khirbat al-Mafjar with the still elegant but distinctly more austere atmosphere and smaller scale of some of the residences across the Jordan, such as al-Qasṭal or Qaṣr al-Ḥallābāt. Sauvaget was more interested in agricultural activity than in any of the other features that are shared by a majority of the *quṣūr*; but that was purely his preference. He openly admitted that he privileged Jabal Says in his presentation of the *quṣūr* because it illustrated with unusual clarity the agricultural exploitation he had chosen as the activity in the light of which he wished to discuss the whole set.[134] Yet Jabal Says is exceptionally remote and therefore self-supporting out of necessity. The fact that there is evidence for cultivation at most if not all *quṣūr* is not in itself sufficient justification for the assertion that agricultural activity was their *raison d'être*,[135] when one might as legitimately argue, at least in some cases, that feeding residents of or visitors to the *quṣūr*—who may or may not have

132. Sauvaget, *R.E.I.* 35 (1967) 28, 33; *Q.H.E.* 98; Bisheh, *S.H.A.J.* 2.
133. Al-Haytham b. ʿAdī in Bal. 2. fol. 167a = p. 333 (59–60 Derenk); al-Madāʾinī in Ṭab. 2.1802–3 (trans. 26.156 C. Hillenbrand), whence the quotation.
134. Sauvaget, *R.E.I.* 35 (1967) 25. Note the trenchant criticisms by Gaube, *Ḫirbet el-Baiḍa* 22–24, 119–27, questioning in particular the false dilemma Sauvaget posed "zwischen Lustschloss und Wirtschaftsanlage".
135. Sauvaget, *R.E.I.* 35 (1967) 46.

been "mere" pleasure seekers—was the *raison d'être* of the agricultural activity. Syria and adjacent lands had known a long tradition of gardens planted by kings in arid places for pleasure and the demonstration of their power as well as for profit.[136] As any visitor to Shīrāz can still sense, there is something at once impressive and poignant about such a variegated efflorescence of trees, bushes, and flowers set against the backdrop of a rocky mountainside. The Umayyads were not insensitive to these aesthetic and symbolic aspects of the garden, witness the mosaics they placed in the Damascus mosque, and their well-attested delight in the monastic gardens of Syria.[137]

We may also note a rare example of a *qaṣr* that has not only been excavated but to which it is possible to find more than bare allusions—in fact, a group of quite informative references—in our literary sources. Al-Ḥumayma lies amidst the Sharā Hills in the far south of Jordan, not otherwise known for *quṣūr*, and is Umayyad in date but not at heart—for it belonged to the Umayyads' supplanters, the Abbasid clan.[138] The property was developed by the patriarch of the family, ʿAlī b. ʿAbd Allāh b. al-ʿAbbās, after he left Damascus as the result of a conflict with al-Walīd I.[139] Besides its abundant water-gathering installations and its adjacent village and mosque, one feature of this residence that the texts especially remark on is the garden, which contained five hundred trees, apparently olives.[140] Yet it is hard to imagine that ʿAlī exiled himself to al-Ḥumayma in order to cultivate his garden. He chose it, presumably, because it was at once remote from the intensely Umayyad atmosphere of Damascus and its satellite *quṣūr*, and well placed, right by the road that linked the port of Ayla (al-ʿAqaba) by way of Maʿān to Damascus, for the gathering of news and gossip and, eventually, the dissemination of an alternative vision of the caliphate.[141] Distinguished guests were received in an audience hall with nonfigural frescoes and sumptuously furnished, to judge from recent discoveries of numerous fragments of ivory paneling with images of standing warriors, animals, and plants. The

136. Besnier, *Ktema* 24 (1999).
137. Cf. above, p. 137.
138. Pre-Islamic phase, including water supply: Graf, *Rome and the Arabian frontier* VII. Arabic literary sources: Schick, *B.E.I.N.E.* 2.150; and note especially Ṭab. 2.1975, 3.25 (trans. 27.84, 149), on the village and mosque. Excavation: Oleson, ʿAmr, Foote, Logan, Reeves, and Schick, *A.D.A.J.* 43 (1999), esp. 412, 436–43; *Omeyyades* 193–96.
139. Al-Bakrī, *Muʿjam mā istaʿjam* 130; Sharon, *Black banners* 121–25; but cf. Abiad, *Culture et éducation* 96.
140. Bal. 1. fol. 284b = p. 568 (87 al-Dūrī); al-Yaʿqūbī, *Taʾrīkh* 2.290; cf. Sharon, *Black banners* 140.
141. Sharon, *Black banners* 159–61.

garden made possible the provision of basic hospitality to wayfarers and pilgrims traveling to or from the Holy Cities, but also served to feed the large group of relatives, concubines, and clients *(mawālī)* who made up al-Ḥumayma's extended household.[142] Although crucial to the *qaṣr*'s viability, cultivation was by no means its *raison d'être*.

Of late there has been a tendency to look farther afield for explanations of the *quṣūr*, and even to discard to some extent Sauvaget's basic prejudice against the pleasure factor.[143] As understanding of the late antique road network grows, there is more interest in looking at the *quṣūr* in relation to communications. One notes, for example, how each of the three main passes through the chain of hills that tends northeastward from Damascus to the Euphrates was adorned with an Umayyad country residence: Yazīd I's seat at Ḥuwwārīn[144] and Hishām's foundations at Qaṣr al-Ḥayr al-Gharbī and Qaṣr al-Ḥayr al-Sharqī,[145] not to mention Palmyra between these two latter, with its well-developed Umayyad *sūq*.[146] The passes facilitated human contact, which undeniably included commerce based on agriculture. But they were also animal migration routes, favored sites, in other words, for hunting lodges and for traps such as those depicted in Quṣayr ʿAmra's paintings, or else more permanent ones made of stone.[147]

Likewise, in the region between ʿAmmān and al-Azraq that is our principal concern, al-Muwaqqar, Qaṣr al-Mushāsh, and Qaṣr al-ʿUwaynid all mark stages along the post route from ʿAmmān and ultimately Damascus to the Wādī Sirḥān artery into Arabia. Qaṣr Kharāna and Quṣayr ʿAmra itself lie a few kilometers off the probable line of this road, Quṣayr ʿAmra, though, in a wadi that either attracted animals for the sake of its own water and vegetation or funneled them down to the oasis of al-Azraq.[148] ʿAmmān also marked a stage on an even more important route, the Pilgrim Road to the Holy Cities of al-Madīna and Makka. Along this well-traveled trail—or

142. Ṭab. 3.26, 34, 391 (trans. 27.149–50, 158; 29.93); Ibn Khallikān, *Wafayāt al-aʿyān* 3.278 (trans. 2.220) on ʿAlī's "more than twenty sons" born at al-Ḥumayma.
143. E.g., Hillenbrand, *Art history* 5 (1982). Kennedy too, *The Prophet and the age of the caliphates* 375–77, looks farther afield but still underestimates pleasure as a motive. And his division of the *quṣūr* into urban centers of government, agricultural estates, and desert palaces takes insufficient account of their multifunctionality. My thanks for this reference to Iason Fowden.
144. Haase, *Untersuchungen* +19–+20; Sourdel, *E.Is.* 3.645; and cf. above, p. 166 n. 133.
145. Above, pp. 164–66.
146. Walmsley, *Long eighth century* 276–79.
147. Fowden, *Roman and Byzantine Near East.*
148. Above, pp. 31–33, 51–52.

branches of it—lay such *quṣūr* as al-Qasṭal, Zīzāʾ, Maʿān,[149] and al-Ḥumayma. As a group the *quṣūr* are insufficiently homogeneous, while some individual examples are far too elegant, to have been primarily conceived as part of a road system,[150] or for ordinary travelers whose needs were, in the nature of things, fairly uniform.[151] On the other hand, the grander *quṣūr* will have made good hotels for travelers who belonged to the Umayyad elite, or whom members of that elite wished to pamper,[152] while some were large complexes well able to embrace a caravanserai as well as a residence.[153] At Zīzāʾ, al-Walīd b. Yazīd is known to have provided free hospitality for returning pilgrims,[154] while at al-Ḥumayma hospitality to pilgrims will surely have been a concern for the pious Abbasids.

Of this communicative function of the *quṣūr*, a specialized but highly important aspect was their role in diplomacy, as centers from which to cultivate relations with—or spy on—Syria's turbulent tribes, a point that has been emphasized in recent scholarship.[155] The tribes' loyalty was crucial to Umayyad dominance of the caliphate's Syrian heartland, but control over them could probably not have been maintained by purely military measures, which have never been of much avail with nomads or transhumants—and anyway, the army itself was largely made up of tribesmen.[156] Nor, perhaps, was traditional feuding the only source of tension with the tribes. The Umayyads' efforts to cultivate the steppe and desert may well

149. See above, p. 155.

150. As suggested by Bisheh, *Near East in antiquity* and *O.E.A.N.E.* 4.398, treating the *quṣūr* between ʿAmmān and al-Azraq as "watering places for caravans"; and King, *Proceedings of the seminar for Arabian studies* 17 (1987) 100: "coherent planning by a regime concerned to improve and ease travel".

151. For a description attributed to ʿUmar II of Muslim travelers' needs and how they might ideally be met, see Ṭab. 2.1364 (trans. 24.94).

152. E.g., Ibn al-ʿAsākir, *Taʾrīkh madīnat Dimashq, Tarājim al-nisāʾ* 520, on al-Walīd b. Yazīd's invitation to the singer Maʿbad and the poet al-Aḥwaṣ to travel to his court "in comfort and at their leisure".

153. There is little agreement, though, on which *quṣūr* may have contained caravanserais. For doubts about Qaṣr al-Ḥayr al-Gharbī see above, p. 164 n. 126; Urice, *Qasr Kharana* 83–84, categorically rejects the possibility that Qaṣr Kharāna was a caravanserai (both courtyard and water supply too small); while for Northedge's objection to the view that the small enclosure at Qaṣr al-Ḥayr al-Sharqī was a caravanserai see above, p. 168 n. 140. Yet Walmsley, *Long eighth century* 285–90, treats all these as caravanserais, and therefore as firm evidence for Umayyad economic development of the steppe and desert.

154. Above, p. 160.

155. E.g., Gaube, *Z.D.P.V.* 95 (1979); *Q.H.E.* 156–57; Urice, *Qasr Kharana* 84–87; King, *S.H.A.J.* 4.370–72. See in general Goldziher's essay "The Arab tribes and Islam": *Muslim studies* 1.45–97.

156. Blankinship, *Jihād state* 42–46.

have contributed, for similar conflicts of interest caused by Muʿāwiya's building and agricultural projects had already, in 683, led to a violent clash with the residents of al-Madīna.[157] There were several reasons, then, for the Umayyads' constant concern with the tribal power balance, and the fondness some showed for marrying into the dominant clans.[158] In considering this diplomatic aspect of the *quṣūr*, which is not directly attested but seems a secure hypothesis, one soon realizes how difficult it is to classify them as "public" or "private" spaces. The same Umayyads who made little or no distinction between their personal fortunes and the state's finances[159] will also have been acutely aware that the best way to flatter and cajole a tribal shaykh was by admitting him to the studied privacy of the country house. Foreign ambassadors too might be received in the same surroundings—indeed, had to be, when that was where the prince spent all his time.[160]

Besides being a place of encounter and communication, the *qaṣr* might be perceived and used—though not necessarily actually built—as somewhere to withdraw to. Al-Walīd, for instance, will have seen his country residences at least in part as retreats from the prying eyes of those who condemned his way of life, especially his love of wine;[161] while others might use a *qaṣr* as a convenient refuge from the outbreaks of plague that so often made Damascus a dangerous place to live,[162] though that did not stop the Umayyads and their favorites from maintaining numerous urban palaces too.[163] And when the evil day came, as it usually did sooner or later, for officials who had got rich too fast or for princes on the wrong side of one of the internal feuds that constantly split the Umayyad clan, a country estate was a sensible retreat, as for ʿAlī b. ʿAbd Allāh b. al-ʿAbbās at al-Ḥumayma, or al-Walīd's disgraced governor of ʿIrāq, Yūsuf b. ʿUmar al-Thaqafī, who

157. Kister, *Studies* XV, esp. 41–43.
158. See, for example, Ṭab. 2.204 (trans. 18.215) on the two wives Muʿāwiya I married from the Banū Kalb (to Maysūn is attributed a famous poetic comparison between the constrictions of *qaṣr* life—but presumably in the urban Qaṣr al-Khaḍrāʾ in Damascus—and the liberties of tent life [text and translation in Nadler, *Umayyadenkalifen* 123–24], a reminder of how rarely we glimpse the Umayyad court through female eyes); al-Madāʾinī in Bal. 1. fol. 410b = p. 820 (290, § 779 ʿAbbās) on his son Yazīd's wife from the Banū Ghassān; Ibn Qutayba, *ʿUyūn al-akhbār* 4.99, on Hishām's wife from the Kalb.
159. Blankinship, *Jihād state* 85–91.
160. Cf. above, p. 271.
161. See above, p. 171; also Bal. 2. fol. 164a = p. 327 (47 Derenk).
162. Above, p. 21; al-Madāʾinī in Ṭab. 2. 1738, 1784, 1789 (trans. 26.80–81, 137, 142); Musil, *Palmyrena* 278; Conrad, *Quest for understanding* 269–71.
163. Above, p. 155 n. 78.

retreated to a country estate in the Balqāʾ after his master's assassination,[164] or al-Walīd himself after he fled from al-Ruṣāfa. A *qaṣr* might also offer a relatively safe base from which to plot against one's enemies: one thinks again of the Abbasids at al-Ḥumayma, or the conspiratorial visits made by al-Yazīd b. Walīd to his half-brother al-ʿAbbās on his estate at al-Qasṭal between Homs and Palmyra, in the last days of al-Walīd II's regime.[165]

Beyond, though, the advantage that individuals might at moments of crisis derive from withdrawal to a country estate, it is possible that many of the *quṣūr* also reflected a more general response on the part of the Arab Muslim invaders to the basic facts of Syria's human geography—not a withdrawal, of course, but quite possibly a decision to avoid the drawbacks of the settled lands, while exploiting the strategic advantages the steppe always offered those capable of controlling it, in their dealings with those who dwelt in the villages and cities. The conveniently habitable portion of Syria was, after all, only a narrow strip of land, blocked to the west by high inhospitable mountains fringed by a coast still occasionally exposed to Roman attack or at least the fear of it,[166] while eastwards it opened out defenselessly onto an ever drier steppe, and beyond it a harsh and largely waterless desert. Even if it did not, as has been rather improbably supposed,[167] respect pre-Islamic property rights to such an extent that it had little choice but to settle in the steppe,[168] still the new Arab Muslim ruling elite, which was mostly of urban or desert background, will hardly have relished the prospect of coexistence in such a confined space with an agricultural and Christian population for whose mentality and way of life they felt scant sympathy.[169] In the cultivated areas of Syria, then, the conquerors probably settled only on lands their former owners had abandoned.[170]

164. Ṭab. 2.1840–42 (trans. 26.200–3); and cf. Bisheh, *S.H.A.J.* 3.193 n. 4, 195–96.
 165. Bal. 2. fol. 164b = p. 328 (49 Derenk); al-Madāʾinī in Ṭab. 2.1784 (trans. 26.137).
 166. Cf. the inscription, probably of al-Walīd II, published by Sauvaget, *Syria* 24 (1944–45) 96–100; Ṭab. 2.1814–15 (preferring Blankinship's interpretation, *Jihād state* 170, to C. Hillenbrand's translation, 26.169); Conrad, *B.E.I.N.E.* 1.338–40; Bashear, *Journal of the Royal Asiatic Society* 1 (1991).
 167. E.g., Gaube, *Ḫirbet el-Baiḍa* 124.
 168. An assertion to this effect by al-Balādhurī, *Kitāb futūḥ al-buldān* 178, refers only to the period of Muʿāwiya's governance of Syria before he became caliph. Cf. Robinson, *Empire and elites* 60.
 169. Cf. Hishām b. al-Kalbī in Mas. 231; Abbott, *Studies* 3.84–86; Fiey, *Mélanges de l'Université Saint-Joseph* 51 (1990); and Bashear, *Arabs and others* 79–80, 125, on the "Nabaṭ".
 170. Al-Balādhurī, *Kitāb futūḥ al-buldān* 152, 173, 180; Donner, *Early Islamic conquests* 247–50. On how the Umayyads took over agricultural property in al-

In addition, the war lords thanks to whom the armies of Islam had been assembled in the first place faced, during the conquest of Syria and on a permanent basis thereafter, the pressing problem of how to house, feed, and keep together their bands of retainers, which varied in size between a handful and a few thousand.[171] Spreading them around the cities of Syria as garrison troops was part of the answer,[172] but building in the open lands to the east had its attractions too.[173] The personal bonds between fighters and their individual leaders were reinforced, and the problem of space alleviated: not just for housing and cultivation, but also for military exercises. The scene with which this book began would have been inconceivable in a landscape of crops and ditches. It is true, and has often been remarked upon, that the *quṣūr* were of no value in actual warfare. With the exception of the palatial structure on the ʿAmmān citadel, they were all set in plains or on gently undulating terrain, with fortifications—if any—that were purely for show.[174] In connection with al-Walīd's last stand at the *qaṣr* of al-Bakhrāʾ, we are told that its walls were scaled by an agile man leaping from horseback.[175] A later member of the Umayyad clan who raised a rebellion against the caliph al-Maʾmūn (813–33) could do nothing to prevent his fortresses of al-Faddayn and Zīzāʾ from being razed by the army sent against him.[176] But the warfare of tribesmen had never revolved round sieges of fixed points. The *quṣūr* were meant as residences not citadels, and the plains around them offered precisely the field of battle that the mounted Arab warrior most desired.

As regards, finally, the precise nature of the living arrangements, certain *quṣūr* possessed formal apartments intended for the establishment's owner during either visits or more extended periods of residence. The smaller rooms were often arranged as self-contained suites, with perhaps a pair of chambers on either side of a larger, communal space, making up a five-room apartment usually furnished with a latrine and often referred to in the scholarly

Naqb (purchase; annexation of abandoned or ex-crown lands), see Mayerson, *I.E.J.* 46 (1996) 104–7.

171. E.g., Ṭab. 2.1839, 1940–41 (trans. 26.199, 27.51); cf. Crone, *Slaves on horses* 53–57.

172. Donner, *Early Islamic conquests* 245–47; Whitcomb, *ARAM periodical* 6 (1994).

173. Cf. Northedge, *B.E.I.N.E.* 2.242–44.

174. Contrast the Umayyad frontier fortresses in al-Andalus, some of which may have been built in the later eighth century: Sénac, *Castrum* 4.

175. Bal. 2. fol. 167a = p. 333 (61 Derenk); al-Madāʾinī in Ṭab. 2.1806 (trans. 26.160).

176. Above, p. 142.

literature as a *bayt* (pl. *buyūt*). These would have been ideal for family use and were perhaps intended for the non-Arab clients *(mawālī)* who were responsible for the day-to-day running of Umayyad estates.[177] Some could also have been used by the owner's armed retainers, ten to fifteen of whom were, at this period, expected to sleep in a two-up, two-down house, in other words a space only slightly smaller than the standard *bayt*.[178] Some of these fighters of nomad background no doubt preferred, though, to live in tents outside the walls. Finally, the cultivators will have lived in the small villages that were often associated with *quṣūr* and in some cases considerably predated them.[179]

To summarize:[180] the typical Syrian or Jordanian *qaṣr* served primarily as the residence of a prosperous man, his family, retainers, and fighters, either on a permanent basis like Hishām's al-Ruṣāfa (which was actually a whole complex of *quṣūr*) and the Abbasids' al-Ḥumayma, or seasonally. It afforded easy access to the capital (to the extent that Damascus could be regarded as the capital when the caliph was permanently resident at al-Ruṣāfa or in the Balqāʾ), combined with space for military exercises, a change of air and pace, and a refuge in times of plague or political eclipse. It was also a symbol of status, and a relatively secure way of investing the cash the regime handed out to Umayyad family members, senior officials, poets,[181] and other hangers-on. Among these beneficiaries of the ruling house's largesse, certain individuals were particularly inclined to savor the *qaṣr*'s hedonistic aspects, and the delicious paradox of being able to enjoy singing girls and wine amidst the arid wilderness an earlier poet had seen—understandably—as

177. Kister, *Studies* XV.44–47 (under Muʿāwiya); and al-Madāʾinī (mainly) in Bal. 2. fols. 717a, 720a (6, §8 and 29–30, §53 ʿAthāmina) and Ṭab. 2.1734, 1732 (trans. 26.77, 74–75) (under Hishām). Note also the Abbasids' *mawālī*, called al-Sharawīya after the Sharā Hills around al-Ḥumayma: al-Yaʿqūbī, *Kitāb al-buldān* 243; and cf. Yāq. 3.332 s.v. "Al-Sharā".

178. Al-Wāqidī in al-Balādhurī, *Kitāb futūḥ al-buldān* 187, and Ibn al-Faqīh, *Kitāb al-buldān* 163 (trans. 138–39), though *bayt* here means a single room, as also— to judge from the archaeological remains—in the inscription of al-Walīd b. ʿAbd al-Malik at Qaṣr Burquʿ: Gaube, *A.D.A.J.* 19 (1974) and pl. XXXI.1.

179. King, *Bilād al-Shām* 77–78. That some *quṣūr* had only a small mosque need not imply that the resident nominally Muslim population was small. Arabs of nomad background were notoriously resistant to formal observance, while congregations might easily, then as now, spill over into the area immediately round the mosque; cf. al-Muqaddasī, *Aḥsan al-taqāsīm* 198–99.

180. For a similarly "multifunctional" view of the *quṣūr*, see Helms, *Early Islamic architecture* 27–30.

181. See above, p. 155.

their polar opposite.[182] The *qaṣr* was an ideal base too for hunting expeditions, sometimes thanks to its location on or near animal migration routes, but always because it provided a supply of locally grown vegetables and fruit secured by a permanent staff. In some cases this agricultural aspect undoubtedly acquired commercial dimensions. But one is on safer ground imagining scores of hungry fighting men sitting down to eat every day or local tribal leaders being unstintingly entertained after an energetic day's hunting, in the state rooms of a residence that had been conceived from the outset as a convenient political meeting place close to a major road or permanent supply of water.[183] Even if their commercial aspect was secondary, though, it should not be assumed that the *quṣūr* were a drag on the local economy. Both their construction and their maintenance required money, most of which was generated outside the Balqāʾ, and workers, many of whom we may assume were locals. So, "the *quṣūr* and their occupants were supporting the local economy, rather than vice versa".[184]

But although the set *quṣūr* impresses by its ability to perform a wide range of functions,[185] we cannot expect to find all of them catered for at each individual *qaṣr*. This is particularly the case at Quṣayr ʿAmra, which, in the shape in which it has come down to us, is, as pointed out in chapter 2, more like a hunting lodge for occasional use than a full-blown *qaṣr*, though there were *quṣūr* that were seasonally inhabited too—one has only to think of ʿAbd al-Malik's annual migrations from al-Ṣinnabra to Baʿlabakk and back again via al-Jābiya and Damascus.[186] It is not only that Quṣayr ʿAmra lacks the substantial reservoirs one has every reason to expect. Other suggestive features are its relative remoteness from major routes, and the omnipresence of women in its decoration. Besides its primary function as a hunting lodge, one wonders whether it did not also serve the married man's occasional need for privacy. There is a tale in the *Kitāb al-aghānī* about how Zayd, the grandson of the caliph ʿUthman, decided to accompany the caliph Sulaymān when he performed the *hajj* as head of state in the year 716.

182. Taʾabbaṭa Sharrā in Mas. 1585 (2.335 Dāghir). Compare Mielich's sensitive comment, *K.ʾA.* 1.190, on the contrast between the exterior and interior of the Quṣayr ʿAmra bath house: "Aussen grösste Einfachheit, glatte ungegliederte Massen, nackte Flächen, innen üppiger Farben- und Formenreichtum, der grösste Prunk."

183. Qaṣr Burquʿ in the far northeast of Jordan, and apparently built or repaired by al-Walīd I when he was still *amīr*, seems to fit especially neatly into this category: Helms, *Early Islamic architecture* 19 fig. 5, 52 pl. 2.

184. Northedge, *ʿAmmān* 1.51.

185. A point also underlined by Hillenbrand, *Islamic architecture* 384.

186. Above, p. 159.

Knowing that Zayd owned a country estate (*ḍayʿa*) in the village of al-ʿArj near al-Madīna, and that he kept some girls there, his wife Sukayna insisted that he take with him the comedian (!) Ashʿab, who enjoyed her confidence, to keep an eye on him. When the pilgrimage was over, Zayd bribed Ashʿab to turn a blind eye and set off to pay the girls a nocturnal visit (this is of course only the beginning of the story).[187]

Elsewhere in the *Kitāb al-aghānī*, the poet Jarīr (d. 728) is quoted telling how he once made a journey to Syria, in the course of which he stopped off and sought hospitality at an unusually fine *qaṣr* that caught his eye in a *ḍayʿa* belonging to the Banū Numayr. Being attired as an Arab of the desert, Jarīr assumed he would not be recognized; and he expected to be lavishly entertained for two days. The anecdote that follows concerns a gaffe he made on seeing the owner's particularly beautiful daughter.[188] One gets the feeling that country estates—like monasteries—were thought of as particularly propitious places for erotic encounters, or at least for catching sight of pretty girls—one recalls also the humorous tale of al-Walīd's wooing of Salmā, when he posed as a hawker of olive oil in order to get a glimpse of her in her father's *qaṣr* at al-Faddayn.[189] Perhaps life was more relaxed in the *qaṣr* than in one's town house, and women circulated slightly more freely. Whatever the explanation, something that eventually became a bit of a literary cliché is already implicit in Quṣayr ʿAmra's paintings.

187. Iṣf. 16.154–55 (trans. Berque 321–22).
188. Iṣf. 8.88–89 (trans. Berque 253).
189. Abū 'l-Yaqẓān al-Nassāba in Bal. 2. fol. 158a = p. 315 (17 Derenk); al-Madāʾinī in Iṣf. 7.36–37 (trans. Derenk 114–15). Monasteries: Kilpatrick, *Christians* 23.

10 Umayyad Self-Representation

CONSTRUCTING A CULTURAL PERSONA

If, as was argued in chapter 5, our bath house paintings do not occupy an eccentric position in the spectrum of Umayyad art, while the whole Wādī 'l-Buṭum complex can comfortably be contextualized within the set quṣūr (chapter 9), then Quṣayr ʿAmra may reasonably be treated as representative of late Umayyad court taste. To label its frescoes "private art"[1] is too limiting. Admittedly al-Walīd, for one, was not unaware of the existence and indeed usefulness of the public/private distinction.[2] The modern tendency to dichotomize whole lives and artistic genres according to this criterion seems risky, though, when applied to absolute rulers who ultimately were responsible for everything. Such men were by definition incapable of being private for more than a few hours of repose in each day. And there is anecdotal evidence to support what common sense anyway suggests, namely that some Umayyad patrons actually wanted people to see the artistic inventions they had expended imagination and money on, and were indeed consumed with curiosity to hear their reactions.[3] It seems legitimate, then, to enquire what the court taste of which Quṣayr ʿAmra is a typical example can tell us about the broader cultural identity and aspirations of the Umayyad elite and, to the extent that that elite was representative, of the Arab conquerors generally.

An initial problem that arises in discussing any given cultural persona is how to identify its various aspects. Talk of "influences", for example, has

1. Grabar, C.A. 36 (1988) 83.
2. Above, p. 171.
3. See above, p. 271, and the similar story at Yāq. 1.530 s.v. "Al-Baydāʾ".

by and large been eschewed in this book, so as not to prejudge the question whether there was an Arab visual culture for the influences to work upon in the first place. This was not in order to espouse the extreme position of the British architectural historian Archibald Creswell, who opined that "Arabia, at the rise of Islam, does not appear to have possessed anything worthy of the name of architecture".[4] It was indeed, though, intended to reserve judgment on whether the Muslim Arabs imported any nonverbal artistic tradition of their own into Syria. Nothing we have seen suggests they did,[5] and it is highly improbable that they designed (as distinct from conceived), far less executed with their own hands, any of the projects with which we have been concerned.[6] Arab musicians and singers, who already possessed a sophisticated understanding of their art, might travel widely in order to study non-Arab traditions; or they might copy immigrant musicians.[7] Ei-

4. Creswell, *E.Is.* 1.608. The same phrase in his *Early Muslim architecture* 1.10–11, with grudging reference in n. 7 to south Arabia. On the pre-Islamic architecture of Arabia see now Lecker, *Muslims, Jews and pagans* 11–18, based on literary sources, and Finster, *A.A.* (1996), from an archaeological perspective. To be fair, the Arabic historians themselves present the early invaders as uncouth nomads and contrast them with the might and sophistication of Irān in particular (Ṭab. 1.2602 [trans. 13.186], just one among numerous similar passages; compare the quotation from Abū Nuwās above, p. 209), evidently in order to underline the irresistible power of the Muslim revelation and faith.

5. It seems proper to enter here two reservations, pending the outcome of further research. (1) There are some signs that the characteristic plan of the *quṣūr* was anticipated in pre-Islamic Arabia: Finster, *A.A.* (1996) 317–18. (2) The Arabs may have imported, at least to settlements they developed *de novo*, a dispersed type of urban agglomeration that was characteristic of Arabia, namely scattered *quṣūr* with accretions of smaller buildings and makeshift dwellings around them and substantial open space between clusters so that kin groupings could live at a safe distance from each other: compare, for example, Ibn Isḥāq, *Sīrat rasūl Allāh* 758–60 (Wüstenfeld)/3.360–62 (al-Saqqā), and L. Veccia Vaglieri, *E.Is.* 4.1138a, 1139b, on Khaybar; Morony, *Iraq* 221, 'Abd al-Ghanī, *Ta'rīkh al-Ḥīra* 28–41, and Lecomte, *Études mésopotamiennes*, on al-Ḥīra; Lecker, *Muslims, Jews and pagans* 11–18, 103–6, on al-Madīna; Whitcomb, *A.A.E.* 7 (1996), on al-Maʿbīyāt, Yathrib (al-Madīna), and al-Rabadha; and Breton, *C.R.A.I.* (2000) 854–57, on Shabwa in Yemen; with the plan of Hishām's *extra muros* development *(rabad)* at al-Ruṣāfa (see above, pp. 166–68). But the chronology of the Arabian sites is still vague; there were similarly organized preconquest Arab settlements in Syria, for example, Umm al-Jimāl; cf. de Vries, *Mediterranean archaeology* 13 (2000); while most of the Syrian *quṣūr* are single isolated structures or complexes, not extended clusters as at al-Ruṣāfa.

6. The rule is illustrated by Sayf b. 'Umar in Ṭab. 1.2492 (trans. 13.73), on the construction of the al-Kūfa mosque. Exceptions: al-Walīd b. Yazīd's singer companion 'Umar al-Wādī is called an architect *(muhandis)* by Iṣf. 7.98, without explanation. An Arab who helped a mason by carrying a stone went down in history: al-Balādhurī, *Kitāb futūḥ al-buldān* 187.

7. See above, pp. 79–80.

ther way they subjected themselves to what may properly be called "influ-
ences". But when it was a mosaic that was needed, artisans had either to be
found locally, among the subject populations, or be sent from the Roman
Empire;[8] in the latter case, we hear nothing of their training locals, let alone
Arabs of Arabia, in their skills. The tradition represented by the splendid
paintings and sculptures that have been found, especially in South Arabia,
seems by this time to have been extinct.[9] So too the Yemeni style of tower
house like the famous Ghumdān palace at Ṣanʿāʾ, whose wonders were sung
by many a poet (and ignored by Creswell).[10] These dwellings were popu-
lar in other parts of Arabia too, such as al-Madīna,[11] and there were paral-
lel architectural types even in late antique Syria.[12] But the style is not known
to have found any echo under the Umayyads. Since, then, the invaders
brought from Arabia a disposition to become patrons, but nothing in the
realm of the nonverbal arts—or even of common pottery[13]—that they cared
to teach, we had better think of their debts to other traditions as adoptions,
not influences.[14]

Ahmad Shboul has spoken of Umayyad Damascus as "the adopted city
par excellence". Although for a time its dominant culture continued to be
Greek, still the Arabs could feel at home there because "the city and its hin-
terland formed part of that traditional socio-economic continuum that had,
for a long time, extended between Syria, with its pre-Islamic Arab popula-
tion, and both the Hijaz and south Arabia".[15] Arabs—especially the better
traveled—were able to adopt Damascus as it stood because in a sense it was
already theirs, or at least extremely familiar. Before the invasions, some
Arabs of Arabia already enjoyed an identity to which cultural adoptions per-
formed in Syria had contributed. And the autochthonous Arabs of Syria,
whatever their cultural distinctiveness, were in no sense less "Syrian" than
anyone else, for Syria itself was a broad Church. It is perhaps only our ig-

8. See below, p. 298.
9. Cf. Breton, *C.R.A.I.* (2000) 874–82.
10. Serjeant and Lewcock, *Ṣanʿāʾ* 44.
11. Lecker, *Muslims, Jews and pagans* 12–13.
12. Monneret de Villard, *Introduzione* 27–29.
13. Morony, *Identity* 26–27.
14. What I call "adoption" corresponds to Ettinghausen's "transfer" (a rather
theoretical category, since he finds few instances of it) together with much of what he
calls "adoption". My "influence" corresponds to the more advanced stages of Etting-
hausen's "adoption", plus his "integration". Ettinghausen's point is that what is
adopted becomes subject, thenceforth, to new rules: one might say, adoption becomes
adaption. Needless to say, all modes of cultural reception are in reality a continuum.
See Ettinghausen, *From Byzantium to Sasanian Iran* 1–2 and passim.
15. Shboul, *ARAM periodical* 6 (1994) 102; above, p. 79, on ʿAdī b. Zayd.

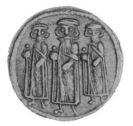

Figure 65a. Solidus/dinar of 'Abd al-Malik (685–705),
adapting a solidus of Heraclius, Heraclius Constantine,
and Heraclonas (632–38), with cross on reverse modi-
fied (no date). *Islamic coins and medals,* Auction 18
(18 February 1986) (Zurich; Spink and Son Numismat-
ics, 1986) 30 no. 87.

norance of Ghassanid art that prevents our seeing to what an extent the
Umayyads were building on foundations already set. The same goes for
Lakhmid al-Ḥīra: the shadow of al-Khawarnaq lies heavily across the pages
of early Arabic literature.[16] Nevertheless, the invasions did mean that an
Arab elite became far more intimately involved, as patrons, with the whole
spectrum of cultural productivity in Syria than had previously been the case.
After the invasions the impetus toward cultural self-representation ac-
cording to the norm that prevailed in cities such as Damascus, Homs, and
Qinnasrīn became immensely more powerful and affected far more Arabs,
including numerous immigrants such as the Umayyads themselves. It is to
this process that the present chapter addresses itself.

In what sense, then, was it possible for Arabs newly arrived from Ara-
bia to derive cultural identity from materials adopted without previous in-
teraction in any substantial breadth or depth? Especially when these adop-
tions were performed at second hand, through artisans who wanted to please
and continue being employed but knew what they knew, and no more. In
the artisans' desire to gratify,[17] and in any novel suggestions the patron
might have (like constructing a *miḥrāb* for prayer), lay seeds of develop-
ment. But the weight of the local past was bound to lie heavily at first, in-
cluding whatever "influences" had once, or still now, weighed upon it—for

16. Cf. above, pp. 143, 247.
17. One can imagine the artists' expectant air when the frescoes were unveiled
in the patron's presence—like poets who had recited their panegyrical ode and
awaited generous reward, or humiliating dismissal. Whatever the patron's role in
suggesting themes for the frescoes (cf. above, pp. 216–19), their execution was the
artists' exclusive responsibility.

Figure 65b. Dinar of 'Abd al-Malik, dated 77 A.H.
The first Islamic coinage to abandon imitation of East
Roman and Sasanian models and use only religious
texts. University of Pennsylvania Museum of Archae-
ology and Anthropology, Philadelphia (formerly
American Numismatic Society, inv. no. 1002.1.406).

at the artisan level the concept of "influence" comes more naturally than
at that of the Arab patron.[18] The weight of the past is plain to see in the his-
tory of the Umayyad coinage, for example, at least up to 'Abd al-Malik's cur-
rency reform in 697–99, since until that date mint workers went on pro-
ducing more or less the same coins they had produced for their earlier
masters, whether Sasanian or Roman. After that date, though, the substi-
tution of Islamic epigraphical types for the earlier iconic types represented
a clear case of intervention by the Arab ruling elite, probably by the caliph
himself, who now for the first time took an initiative in a question that con-
cerned—among much else—artistic patronage. Henceforth the coinage
could fairly be said to represent what the rulers had specifically requested
rather than what they had inherited and expediently continued. For the first
time, it can be treated as evidence for their own sense of identity, or at least
for what they saw fit to project publicly as their identity (fig. 65a–b).

 This did not mean that all artistic production under Umayyad patronage

18. For the distinction between the artisan who follows a "Tradition" (and, I
would add, can therefore be subject to influences), and the alien patron who can
contribute to a project only through "Rezeption", see Meinecke, *Northern Meso-
potamia* 148, though his use of "Rezeption" to refer only to revival of defunct styles
is narrower than mine of "adoption" to describe Arab patrons' relations with con-
temporary styles as well, which initially they could not control and digest the way
one does an influence. One should not, though, overemphasize the role of non-Arabs
in defining Umayyad culture. Neither influential *mawālī* like Sālim Abū 'l-'Alā' nor
a fortiori the artisans who worked at Quṣayr 'Amra would ever have been heard of
outside the employ of their Arab masters. Both Maslama and al-Ghiṭrīf, the other
two figures at the late Umayyad court noted above, p. 263, for their interest in things
Greek, were Arabs.

was now to be as different from artistic production for, say, the Christian Church, as post-reform coins were different from pre-reform coins. One has only to look at eighth-century Syrian mosaic floors—and their figural quite as much as their geometrical elements—to see that a great deal of the vocabulary continued to satisfy caliphs and bishops alike.[19] But since we know for certain that the Arab patron was now capable of taking an active role, it becomes increasingly reasonable to regard the work of the artists he employed as representing something with which he himself was positively willing to identify. Even if the end product remained close to pre-Islamic models, so that the patron appeared to be adopting alien cultural goods wholesale, while the use of the concept "influence" (with reference to the Arab patron) continues to seem inappropriate, still that adoption was the patron's conscious decision freely arrived at, and something he was prepared to be both known and judged by.

The heavy legacy of the past has indeed been a theme of this book, but an attempt has been made not to represent its workings too mechanistically. With the precision that was his hallmark, and assuming that the six kings fresco is the only one that displays Sasanid influence, Creswell calculated that it occupies less than one twentieth of Quṣayr ʿAmra's total painted surface, and that "it is only Persian in inspiration, and not in execution, so that the Persian element in the whole decoration is less than a fortieth part, perhaps about 2 per cent".[20] Without such simplemindedness, Creswell would never have covered the enormous amount of ground he did. But our aim here is to understand the mix—rather than just the constituent parts—of the Quṣayr ʿAmra recipe. And it is in the process by which this mixture was brought about that we are most likely to recognize the Arabs'—rather than their artisans'—own distinctive contribution to the Umayyad phase in late antique aesthetics. There can, furthermore, increasingly be observed, beyond the mixture, a genuine creativity too, as old images were remodeled or new ones devised, in order to meet particular needs of the Umayyad patron. Of this, we have seen striking evidence especially in the frescoes in the west aisle of Quṣayr ʿAmra's hall. When these were made, the phase of pure adoption already belonged to the past.

On balance, the mother's milk of our artists was the originally Greek art, now under Roman and, increasingly, Christian patronage, that was characteristic of the late antique East Mediterranean, and not least of Syria. The proofs are numerous and obvious: the labeled personifications in the

19. Piccirillo 47. Figural elements: Farioli Campanati, *Arte profana.*
20. Creswell 409.

east aisle, the wingless Eros in the central aisle, the bathing beauty after Aphrodite, the Adamic prince in his alcove, and the dress and pose of the six kings in the west aisle. There are at least formal resemblances between the hunting scenes and similar depictions on ivory consular diptychs and in various monuments around the Mediterranean, such as the late Roman villa at Centcelles. The apodyterium preserves further echoes of the classical, illusionist element in Greek art, especially the vault paintings and the tympanum fresco modeled on the iconography of Dionysus and Ariadne. The caldarium culminates in the thoroughly Greek zodiac painted on its dome. Elsewhere the simplified, hieratic forms of late antiquity are often a closer inspiration.

The main stream of Greek style had, though, by late antiquity flowed into many subsidiary channels and irrigated numerous provincial variations on itself. The eye of the student of Quṣayr ʿAmra is caught especially by the art of Coptic Egypt. Browsing in the plates of a recent monograph about bone plaques used to decorate relatively cheap caskets manufactured in Egypt in imitation of others made of ivory or precious metals,[21] one encounters elaborately dressed women posing in curtained arcades; naked women, dancing girls, and musicians both male and female; maidens wielding fly whisks; various personifications, some of whom hold kerchiefs weighed down with fruit; winged victories carrying crowns; hunting scenes; and mythological figures or whole scenes: Aphrodite and Dionysus are frequently sighted, and we even find Dionysus with Ariadne on their Naxian beach. We know too that al-Walīd I in particular had employed Egyptian artisans on projects in Damascus, Jerusalem, and elsewhere.[22] Beyond that, all is speculation. It is not impossible that Egyptians were employed at Quṣayr ʿAmra as well;[23] but it is perhaps wiser to dwell on the common debt shared by these two corpora of images to the clichés of the late Roman visual imagination. Nor were the Umayyads by any means the first Arabs to encounter the arts of Egypt. It is hard, for example, to imagine that the Prophet's Coptic concubine Māriya had arrived from her native land without at least one carved casket for her valuables.[24]

Evidence for Sasanian art being as deficient as that for Coptic is abundant, the Iranian element at Quṣayr ʿAmra is correspondingly elusive. Nevertheless, the possible influence of themes popular on Sasanian and post-Sasanian silverware, especially the scantily dressed dancing girls, was noted

21. Loberdou-Tsigarida, Ὀστέινα πλακίδια.
22. Above, pp. 254–55.
23. Suggested by van Lohuizen-Mulder, *BaBesch* 73 (1998).
24. On Meccan trade with Egypt, see Crone, *Meccan trade* 119–20.

in chapter 2; so too was the prominent position assigned to entertainers at both Quṣayr ʿAmra and the Sasanian court. The fact that hunting scenes were so popular in Sasanian interior decoration should be borne in mind; while the pervasive mix of female entertainers and hunting scenes is particularly suggestive of the Iranian milieu, as exemplified by Ṭāq-i Bustān. We are again reminded that forms may be East Roman but inspiration Iranian by the six kings as interpreted in chapter 7. Also suggestive of Irān are Umm al-Ḥakam reclining on her cushioned throne, and the avian procession in the princely portrait.

As for the Arab contribution, it cannot easily be isolated and catalogued, but is to be discerned in what are in fact among Quṣayr ʿAmra's most characteristic features—namely the combining of Graeco-Roman with Iranian motifs and visual styles, and the choosing of themes congenial to Arab taste and circumstance, as was exemplified by the discussion in chapter 7 of the six kings panel, and further underlined by parallels drawn with the one art form that is inalienably Arab, namely the *qaṣīda*. Nowhere did this coincidence of Quṣayr ʿAmra's emphases with those of the *qaṣīda* come out more clearly than in chapter 3 on the hunt; and one might add that, conversely, no area is more comprehensively ignored by both—while abundantly alluded to in late Roman art—than that of agricultural activity, which held no charm for Arabs. There are no calendars of months in Umayyad art. If a depiction of a basket of grapes at Quṣayr ʿAmra alludes to the vintage,[25] that is just one exception to the rule, and anyway predictable in view of the weakness of many Umayyads for wine drinking.

This Arab choosing and combining, and with it the whole Umayyad persona, is distinctively Syrian. Not that Syria had been selected as the caliphate's center and focus for the sake of its cultural potentialities; but the combining would have been done otherwise, had ʿIrāq become the seat of the caliphate earlier than the 750s. The caliphs would still have sought Constantinopolitan artisans and materials for their most prestigious projects, as the Umayyads did for the mosques of al-Madīna and Damascus,[26] but Sasanian forms would have been drawn on more extensively in both architectural and artistic production.[27] Syria, by contrast, had for centuries been part of the Greek

25. *Q.ʿA.* 121 fig. 83. For other vintage scenes in the *quṣūr*, see Creswell 600 and pl. 129 (Mushattā); *K.M.* 171 and pl. XXXVIII.

26. Flood, *Great Mosque* 20–24—though his reading of central Umayyad Damascus's mosque-palace complex as a copy of the Constantinopolitan equivalent is highly speculative.

27. As in the governor's residence at al-Kūfa (Morony, *Iraq* 73–79, and Taha, *Sumer* 27 [1971], both drawing parallels with the Sasanian palace at Kish to the north-

and then the Roman sphere. On the eve of the Arab conquest it was among the most culturally vibrant provinces of the Roman Empire, not only for its native Syriac tradition, but for its Hellenism too, as one can see from the Mādabā mosaics or from the Syriac tradition itself, which was in many aspects (not just the literary) a translation culture.[28] In the eighth century, a Theophilus of Edessa (695–785) could still be immersed in Greek astronomy and translate Homer into Syriac.[29] It was only to be expected that Syria would pass these tastes on to its Arab conquerors, and this is undoubtedly the main reason for the Hellenic spirit of Umayyad art, whatever the subsidiary contributions made by diplomatic contacts with Constantinople, imported artists and craftsmen, or prisoners of war.[30]

Once freed of Roman rule, Syria could also become more permeable to its other neighbor, that eastern civilisation of Irān, which even before Islam had always been a presence, though necessarily a discreet and even suspect one the farther west one went.[31] It is not often possible to grasp the individual human dramas that contribute to such cultural evolutions, while their artistic products are often tricky to pin down in space or time. Hence the peculiar interest of a figure such as the Iranian Mazdean soldier Magoundat from al-Rayy, who deserted the victorious Sasanian army c. 615 and installed himself at Hierapolis in the house of an Iranian Christian silversmith, whose apprentice he became. When he subsequently moved to Jerusalem to be baptized (he was the future S. Anastasius the Persian), he did so again

east), which Hillenbrand, *Islamic architecture* 391–92, rightly notes has little in common with the average Syrian *qaṣr*—at least as regards its plan.

28. On the literary side of things, Syriac and Greek, see respectively the articles by S. P. Brock and G. Cavallo, in Lapidge, ed., *Archbishop Theodore*. On mythological mosaics, see above, pp. 259–60. Cf. M. M. Mango, *East of Byzantium*, on the classical tradition in northern Mesopotamian art and architecture; also Balty and Briquel Chatonnet, *Fondation Eugène Piot: Monuments et mémoires* 79 (2000).

29. Bar Hebraeus, *Chronicon syriacum* 126–27; Pingree, *D.O.P.* 43 (1989) 236–37; Conrad, *After Bardaisan* 92–94. Had Theophilus served the Umayyads before he attached himself to the Abbasids?

30. The force, in late Umayyad times, of this locally filtered Hellenism is underestimated by Gutas, *Greek thought, Arabic culture* 18–20, who assumes that the Umayyad elite had access to Greek culture only in its Christian Constantinopolitan form, via the Greek-speaking bureaucrats of Damascus. But there was much more to Syrian Hellenism than this elite, while even Constantinople may have had more room for the ancients than Gutas allows (cf. above, p. 43 n. 25 on Ptolemy), following Av. Cameron, who has now, though, moderated her "dark" view of Constantinopolitan Hellenism at this period: *Changing cultures* XII and Addenda p. 2.

31. East Syria: M. M. Mango, *East of Byzantium* 118–19; Dorna-Metzger, *Céramique byzantine*. West Syria: Farioli Campanati, *Mosaici* 161–62; Kondoleon, *Antioch* 130–38.

under the auspices of a local silversmith, though whether of Iranian or this time Roman origin we are not told.[32] Then there was also Abū Lu'lu'a Fayrūz al-Nihāwandī, an Iranian Christian carpenter, stonemason, and smith, who was taken prisoner during Heraclius's war with Irān, and then captured in turn from the Romans during the Arab invasion of Syria. We know about him only because he went on to assassinate the caliph 'Umar (644); but in that context we learn that he was regarded as a specialist worker who earned a relatively high wage.[33] Under the aegis first of the Iranian and then of the Arab conquerors, Syrian craftsmen or immigrants like Magoundat or Abū Lu'lu'a were able to combine Roman and Iranian artistic forms from a conveniently liminal position of proximity to both traditions.

Even more than Iranian artistic style, which had anyway been more than a little tinged by Hellenism, it was the taste for luxury items—to which Magoundat, in particular, catered—that was perhaps the Umayyads' chief debt to Irān. This taste can be traced already in the vocabulary of the Qur'ān, whose loanwords having to do with luxury goods, or the furniture and other accoutrements of Paradise, are overwhelmingly Persian. Words for treasure, silver coinage (the dirham), pearls, camphor, musk, ginger, cushions, rich carpets, fine silks and silk brocade, the well-watered meadows of Paradise, the couches on which one will recline, and the ewers in which (nonalcoholic) drinks will be served—all are of Iranian origin.[34] Exactly the same cultural assumptions were at work in al-Walīd's mind when, soon after his accession, he sent the governor of Khurāsān a bulk order for short- and long-necked lutes, gold and silver ewers, female cymbal players and falcons, as well as the toughest horses he could find.[35] The numerous and detailed parallels drawn by the mid-ninth-century *Kitāb al-tāj*—wrongly attributed to al-Jāḥiẓ—between the tastes and etiquette of the Sasanian and the Umayyad as well as the Abbasid courts point in the same direction.[36]

32. *Acta martyris Anastasii Persae* 6, 8, 10; cf. the commentary in Flusin's edition, 2.226.

33. Ṭab. 1.2632 (trans. 13.216), 2722 (trans. 14.89–90). Presumably less unusual, because 'Irāq had always been part of the Sasanian world, was the case of Rūzbih b. Buzurjmihr b. Sāsān, architect of the governor's *qaṣr* at al-Kūfa. He was a *dihqān* (landowner) from Hamadhān, who had defected first to the Romans and then to the Arabs, under whose auspices he embraced Islam: Sayf b. 'Umar in Ṭab. 1.2489–95 (trans.13.70–76).

34. Jeffery, *Foreign vocabulary* 46–47, 52–53, 58–60, 129–30, 145–46, 150–51, 153–54, 179–80, 210–11, 246–47, 251, 261, 264, 281. These borrowings may have been effected in the pre-Islamic period, and via other languages such as Aramaic.

35. Ṭab. 2.1766 (trans. 26.117).

36. Note how Gutas's assertion, *Greek thought, Arabic culture* 29 (and cf., for example, 109, 191), that "the early 'Abbāsid caliphs tried to legitimize the rule of

As for nonimported, local Syrian artistic production, whether by natives or immigrants, it was characterized by both the juxtaposition and the merging of Iranian and Roman elements, as is apparent at Quṣayr ʿAmra, but even more so at Qaṣr al-Ḥayr al-Gharbī.[37] In its rawest form, juxtaposition might mean carefully allotting Rome and Irān the same weight by producing parallel imitations of their artistic styles. One thinks especially of Qaṣr al-Ḥayr al-Gharbī—not only the two princely images, Roman and Sasanian,[38] but also the pair of floor frescoes: a very East Roman personification of Earth bordered by a scroll of vine leaves and bunches of grapes (fig. 22),[39] and the Iranian hunting scene with musicians framed by floral designs within rhombuses (fig. 31),[40] reminiscent of the fresco decoration found in the governor's palace at al-Kūfa.[41] Rather than simply reflecting the artists' inability to combine styles, these juxtaposed images were probably designed "to underscore the Umayyads' role as heirs of both the great Near Eastern empires".[42] Elsewhere there is an incipient mingling of styles, observable as much at Qaṣr al-Ḥayr al-Gharbī—where the Iranian element is especially strong[43] as at Quṣayr ʿAmra, where the six kings panel and to some extent also the princely portrait and dynastic icon mix Roman and Iranian forms and ideas with some subtlety, even within one and the same panel.[44]

The same holds for the audience hall taken as a whole. Although individual elements in its decoration can be identified as either Iranian or East

their dynasty in the eyes of all the factions in their empire . . . by expanding their imperial ideology to include the concerns of the "Persian" contingent" rests purely on his examination of the "translation movement". Had he considered nonliterary materials, he would have found that imperial ideology had to a significant degree already been fertilized by Irān before 750.

37. In emphasizing the *concurrent* adoption of Roman and Iranian artistic styles by the Umayyads, I diverge from Hillenbrand's view, in *Essays in honor of K. Otto-Dorn*, that in the early eighth century (especially at Quṣayr ʿAmra) the main influence was East Rome, while by mid-century (at Mushattā) it had become Irān. The assumption of the present discussion is that both Quṣayr ʿAmra and Mushattā are to be dated toward the end of the Umayyad period. Hillenbrand's position (anticipated by Strika, *A.I.O.N.* 14 [1964] 747–49) is vitiated by his indecision about whether to assign Quṣayr ʿAmra to the early eighth century (*Essays* 73, 78, 80) or to al-Walīd II (*Art history* 5 [1982] 2).

38. Above, pp. 121–23.

39. Cf. R. Hillenbrand, *K.Is.* 172–73.

40. Cf. above, pp. 95–96 and n. 29

41. Above, p. 298 n. 27.

42. R. Hillenbrand, *K.Is.* 174–75, and cf. 164, 183.

43. Schlumberger, *Syria* 20 (1939) 347–60 (= *Q.H.G.* 21–24).

44. Note also the apparent fluctuation between an East Roman and a rather more Sasanian conception of the royal portrait in some of the Umayyads' "Arab-Byzantine" coin types: Milstein, *Israel numismatic journal* 10 (1988–89) 11.

Roman, while the overall artistic impression is more Roman than Iranian, the general concept cannot be so easily labeled: it would have made equal sense on either side of the frontier. For the chief preoccupation of both courts, when orchestrating the ruler's public appearances, was the illustration of his omnipotence in war and peace alike, what the Iranians called *razm* and *bazm. Razm* meant war and the hunt, while *bazm,* as already mentioned in chapter 2, meant the formal royal audience with its accompanying celebrations. Either might be overdone by a self-indulgent and therefore unworthy prince;[45] but neither could be dispensed with by a ruler who sought to maintain his own power, and with it the state's stability.[46] This much, at least, was the common concern of all princes. There was nothing more natural than that an Arab, caught between Irān and Rome no longer politically but certainly still culturally, should express his situation in a language whose vocabulary was taken from both sides, but whose syntax was now, beyond dispute, Arabic.

It is true that art produced under the Umayyads outside Syria might be less eclectic—post-Sasanian silverware, often hard to tell from Sasanian originals, is an obvious example. But Syria, being the metropolitan province, has yielded the overwhelming bulk of our evidence, and our best criteria for defining Umayyad style. The lines of cultural transmission that converged on Syria from every direction[47] guarantee it against any imputation of eccentricity. It is not, then, unduly limiting to characterize Umayyad art as being essentially Arab-Syrian.[48]

As if to convey the catholicity of their *imperium,* the Umayyads drew widely, even indiscriminately, on the whole spectrum of artistic models visible to them from their Syrian vantage point, regardless of date or context.[49]

45. E.g., Thomas Artsruni (ninth century), *History* 71; Mas. 595 (1.275 Dāghir); Iṣf. 2.97.

46. On *razm* and *bazm* at the Iranian court see Abka'i-Khavari, *Das Bild des Königs* 77–78, and above, pp. 131–33 on Ṭāq-i Bustān. As for the Constantinopolitan court, cf. above, pp. 53–54 (audience in the baths of Zeuxippus; receipt of booty in the Sophianai).

47. Fowden, *Empire to commonwealth* 17–18, 63–65; and cf. above, pp. 79–80.

48. Monneret de Villard, *Introduzione* 4, objected to the application of the term "Arab art" to the early Islamic period, on the grounds that its art was still late antique. The characterization "Arab-Syrian" is intended to soften this objection—the patrons were indubitably Arabs, and so were some of the artists: above, p. 257.

49. This habit has often been noted in passing with reference to the Umayyads (e.g., Schlumberger, *Syria* 20 [1939] 359–60 [= Q.H.G. 24]; Is.A.A. 49), but so far is best documented in the stucco decoration of early Abbasid al-Raqqa, which recalls Roman Palmyra and not, despite their greater proximity, the sixth-century monuments of al-Ruṣāfa: Meinecke, *Rezeption* 258–61.

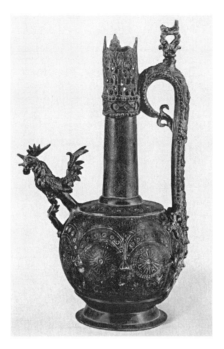

Figure 66. Ewer (bronze, c. 750?).
Museum of Islamic Art, Cairo.

That they should have contracted debts to Irān or Rome was predictable;
but we also find them imitating Palmyrene and Nabatean statuary.[50] They
were capable of showing splendid disregard for conventional relationships
between form and decoration. Examples range from a ewer found in Egypt,
of egregiously cluttered design (fig. 66),[51] to the superabundance of foliage
that threatens to burst out of its geometrical framework in the al-Aqṣā wood
carvings in Jerusalem,[52] to (again) Qaṣr al-Ḥayr al-Gharbī, where the quad-
rangular enclosure punctuated by gateway and towers and reminiscent of
a Roman fort was sheathed in a glorious abandonment of stucco decoration

50. Palmyrene: Meinecke, *Northern Mesopotamia* 143 and pl. 6c–d; Parlasca,
Rezeption 276 (commenting also on the decontextualization of Palmyrene bor-
rowings in Umayyad art); cf. above, pp. 179, 253. Nabatean: K. Brisch, *K.Is.* 185 no.
64a (Khirbat al-Mafjar); cf. above, p. 264 n. 60 (Nabatean sculptures from Khirbat
al-Dharīḥ); Monneret de Villard, *Introduzione* 30–33; Rosen-Ayalon, *Art et
archéologie* 17.
51. Cf. *Is.A.A.* 62–63.
52. Hillenbrand, *Bayt al-Maqdis*, esp. 303–8.

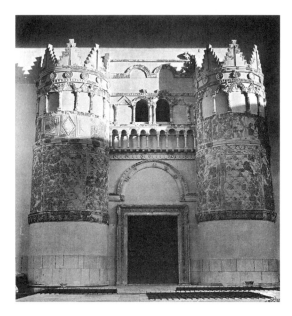

Figure 67. Qaṣr al-Ḥayr al-Gharbī, gateway
decorated in stucco. National Museum, Damascus.
G. Fowden.

(fig. 67). Although it was not unknown in the Roman East in earlier times, it seems that the Umayyads imported the habit of large-scale stucco decoration from Irān. Whether, at least on occasion, they brought the artisans too, or preferred to rely on the versatility of locals, can only finally be decided by documentary evidence which at present is not available.[53] But the stucco itself will almost certainly have struck those in a position to know as an affectation of Sasanian manners.

Undeniably, Umayyad art often seems awkward and ill digested; yet there is a chemistry, however wild, between its elements. One may even, as already suggested, go so far as to say that they tend toward an accommodation.[54] If,

53. Meinecke, *Northern Mesopotamia* 142–43, supposes Iranian artisans. For the opposite viewpoint see above, p. 256 n. 24; Kröger 263–64; Northedge, *ʿAmmān* 1.102. Bardawil, *Recherches*, is essentially a typological catalogue of geometric and vegetal motifs in the decoration of Qaṣr al-Ḥayr al-Gharbī, Khirbat al-Mafjar, and Mushattā, eschewing any historical or sociological approach.

54. Becker's formulation, *Islamstudien* 1.281, is too bald: "Die Umaijaden schufen keine neue Kultur, sondern übernahmen schlankweg das Vorgefundene." And cf., recently, Meinecke, *Northern Mesopotamia* 148, on "das uneinheitliche Er-

as at Quṣayr 'Amra, the forms are often East Roman, while some forms and some concepts too may be Iranian, there was also an Arab-Syrian synthesis struggling to emerge. This synthesis was probably brought about, in significant part, by reading Arab concepts into the adopted forms. For example, whatever the knowledge of Greek culture possessed by a few members of the Umayyad elite, it seems likely that the Greek personifications of Poetry and History on the walls at Quṣayr 'Amra will have spoken to nearly all those who saw them (and for whom the labels almost certainly had to be translated) of Imru' al-Qays rather than of Homer, of the Arabs' battle tales *(ayyām)* or stories of Iranian heroes and kings of old rather than Xenophon or even pseudo-Callisthenes' perhaps very recently translated Alexander romance. Likewise the seated prince may have been indebted to the Christian iconography of Adam; but once that allusion had been recognized the Muslim beholder's mind, however full of alien wisdoms, will have focused on the Quranic Adam, God's first caliph. Similarly the hunting scenes may, in the artist's mind, have owed something to the Roman parallels or models alluded to in chapter 3; but the quarry, nets, tents, saluki dogs, and fairly ordinary hunters, one of whom is falling off his horse, presumably all reflect what one might have seen in the environs of Quṣayr 'Amra or—at the most ambitious—have heard extolled in an impromptu panegyric such as that of Yazīd b. Ḍabba al-Thaqafī on al-Walīd b. Yazīd, his horse Sindī, and the onagers they caught together.[55] Certainly no attempt is made to rival the superhuman heroism of, for example, the Sasanian royal hunt. The dynastic icon and the Shāh-i Āfrīd panel are further examples of non-Arab visual style applied to distinctively Arab or even Umayyad subject matter.[56]

 The political events that brought the Umayyads down did not cut off this development of Arabic secular art, though of necessity it shifted tracks and became less Syrian. Our evidence from the early Abbasid period is thin, though the glass paving and remnants of floor frescoes (as at Qaṣr al-Ḥayr al-Gharbī) recently found in Hārūn al-Rashīd's capital, al-Raqqa, are at least

scheinungsbild und die stärke rezeptive Grundbehaltung der umaiyadischen Architektur". On the other hand, recent attempts to locate "a sophistication which belies the traditional image of the early Islamic period as one of cultural passivity" (Flood, *Bayt al-Maqdis* 358) have been based exclusively on religious architecture. Cf. in this connection Hillenbrand, *Bayt al-Maqdis* 281, 304, on al-Aqṣā: "a holistic context of great splendour . . . formidable integration and intensity"; "the maturity and internal consistency which late Umayyad art had attained".

 55. Iṣf. 7.114–16.
 56. Salies, *XXXV corso di cultura,* supposes a parallel development in the religious context, seeing the Damascus mosque mosaics as an adaptation of Christian symbols of Paradise to the new, Muslim vision.

suggestive.[57] After that there is nothing for several decades, until we reach the paintings Herzfeld found in the Jawsaq al-Khāqānī at Sāmarrāʾ. These, along with other aspects of the decorations at Sāmarrāʾ, are not without echoes, sometimes rather powerful ones, of the art of the Umayyad *quṣūr*.[58] Yet the influence of Irān is much increased, and a timeless formality is substituted for the movement and life that pervade the Quṣayr ʿAmra paintings.[59] This was to be the style of Arab—or perhaps we should rather by now say Islamic—painting for centuries to come.

To the process we have observed at Quṣayr ʿAmra, of cultural adoption and progressive integration of the elements adopted into a new Arab self-image, there is an analogy in the quintessentially Islamic field of Prophetic biography. At first sight this seems an improbable place to look for parallels to our bath house frescoes. But the truth is that the inhabitants of Arabia had no more seen a (successful) monotheist prophet before Muḥammad than they had been exposed to a *Badekultur* before they entered Syria. Both were new experiences and necessitated the incorporation of unfamiliar cultural goods into Arab contexts.

The construction of Muḥammad's life story has recently been studied in depth by Uri Rubin. Starting from the evident fact that many of its themes derive from biblical and in particular prophetic narratives, Rubin argues that the process by which mainly Jewish but also Christian materials were incorporated into the Prophet's life was highly self-conscious, and designed to demonstrate not only that Muḥammad was the most excellent of the prophets, but also that his community—in other words, the Islamic empire or commonwealth to which his biographers belonged—deserved to supersede all earlier traditions and civilizations. Yet those traditions could not be swallowed whole—they had to be broken up and rearranged into patterns familiar and congenial to an Arabian audience. In particular, Meccan scenery had to be provided, along with allusions to the sacred text of the Qurʾān. And inherited biographical themes that allowed for the existence of human frailties in the Prophet, however absolutely they might in the course of his life

57. Meinecke, *Mitteilungen der Deutschen Orient-Gesellschaft zu Berlin* 128 (1996) 170–71. But al-Raqqa's abundant stucco decoration does not resemble Umayyad work: Meinecke, *Rezeption* 258.

58. *Is.A.A.* 59. On the influence of Qaṣr al-Ḥayr al-Gharbī see R. Hillenbrand, *K.Is.* 175–77; M. L. Carter in Harper, *Royal hunter* 77–78. On Mushattā: Hillenbrand, *Essays in honor of K. Otto-Dorn* 74–79; Enderlein and Meinecke, *J.B.M.* 34 (1992) 148–49, 158 n. 91; Meinecke, *Northern Mesopotamia* 148, 164 fig. 14.

59. Ettinghausen, *Arabische Malerei* 42–44.

be transcended, had to be recast so as to affirm Muḥammad's ideal perfection from birth—at least if they were to be acceptable to Islamic mainstream thinking as already in process of formation by late Umayyad times.[60]

In preferring an effective rearrangement of preexisting elements, sealed by a process of appropriation to itself and denial to others, rather than some more thoroughgoing originality, early Islam was conforming to a model of transition that is common enough in cultural history. Under the Umayyads it conditioned the ideology of kingship quite as much as the biography of the Prophet. Even the specific constraints on inventiveness that operated within each of these two fields were similar. On the prophetic side there were the "facts" of Muḥammad's life story (however garbled they may have become even before his death), along with a general consensus about what was conceivable or proper, and of course the Quranic text—though this was conveniently short on biographical or historical orientation. On the kingly side, there were the tropes of kingliness already preset by Ctesiphon and Constantinople, but modified by Muslim sentiment. For example, as already noted in chapter 4, no equivalent of Ahuramazdā or Christ could be seen to invest Quṣayr ʿAmra's *amīr* with the symbols of kingship. And just as the Prophet's biographers were gradually discouraged from making indiscriminate borrowings from other prophetic *Lives,* lest Muḥammad seem less than perfect, so too the caliphs did well to imitate selectively, lest they be accused, as ʿAbd al-Malik supposedly was by his archrival Ibn al-Zubayr, of having sold out, in this case to "Kisrā".[61]

Within both the prophetic and the kingly aspects of Umayyad culture there was also a tendency—inherent perhaps in all human constructs, but acutely so in the more eclectic ones—toward confusion, inconsequence, and flat self-contradiction. The Prophet's sayings, for example, were reported, repeated, and written down, and gradually accumulated into a huge, unwieldy mass of *ḥadīth,* which could be used to justify almost anything. Quṣayr ʿAmra, for its part, has regularly been dismissed as a mere ragbag of heterogeneous images.[62]

60. U. Rubin, *Eye of the beholder,* esp. 224–25. The life and cult of ʿAlī is susceptible to the same type of analysis: cf. Ṭab. 2.701–6 (trans. 21.68–73) on ʿAlī's Chair, in conscious imitation of the Ark of the Covenant.

61. Sibṭ b. al-Jawzī reporting a tradition derived from Muḥammad b. al-Sāʾib al-Kalbī (d. 763) in Elad, *Bayt al-Maqdis* 54 (text), 35 (translation).

62. E.g., Ettinghausen, *Arabische Malerei* 29 ("ein sprunghafter Wechsel von einem Thema zum anderen . . . eine Tendenz zur Aufteilung in viele Einzelszenen"); Grabar, *Formation* 153 ("enormous bric-a-bracs of motifs and themes"), and *R.E.I.*

It can reasonably be assumed, though, that Muslim Arabs of the eighth century were capable of finding coherence—as much as they needed to—in both of these two very different cultural artifacts. During the second Muslim century, the *ḥadīth* began to be organized into the systematic collections that became the foundation of Islamic law. As for Quṣayr ʿAmra, we have no such direct way of seeing how contemporaries reacted to it. But this reaction will certainly have involved an aesthetic criterion different from those employed by many of its modern students. Of course one may question whether, even by the sort of criteria the modern observer uses, Quṣayr ʿAmra really is such a mess. It was already pointed out at the beginning of chapter 9 that the paintings do yield numerous coherences.[63] But we may also invoke for one last time the analogy of the Arabic ode, in order to suggest that, according to the aesthetic criteria of the eighth century as well, there were unities implicit in the contents of the Quṣayr ʿAmra "ragbag". Men who found coherence in the *qaṣīda* might also discover it, according to similar principles, in the paintings on their bath house wall.

The Arab poet sang of the abandoned campsite, of love, of his journeyings, and of his horse or camel. Finally, he praised either a prince or his own tribe or himself. Each part of the ode had its own character and conventions; and each part might be capable of standing alone, as an independent poem. Certainly the parts did not normally add up to what we would appreciate as a linear narrative or regard as a reasonably natural and predictable sequence of ideas. The transition from one to another might be alarmingly abrupt. Yet they were, for all that, held together by the poet's distinctive style and character, whose imprint was applied impartially throughout. And no Arab critic expected the theoretically separable parts of the ode to stand alone in practice. The *qaṣīda* was universally regarded as an autonomous and indivisible literary unit. In the same way, Quṣayr ʿAmra's frescoes were made up of numerous separate paintings, sometimes with no discernible shared subject matter to connect them with the other paintings, even those immediately adjacent. Yet all were at the same time loosely linked together by the architectural framework that contained them, and by a general theme of princely panegyric or at least celebration of the

54 (1986) 130 ("un tel mélange de thèmes et même de styles incompatibles . . . comme une espèce d'album photographique"); G. Bisheh, *O.E.A.N.E.* 4.398 ("The themes [of Quṣayr ʿAmra's paintings] are very diverse with no apparent unity or relationship to each other"). For an imaginative attempt to get beyond similar views of Khirbat al-Mafjar, see Soucek, *A.O.* 23 (1993).

63. Vibert-Guigue diss., e.g., 2.333–34, has already begun to think along these lines; but on his pursuit of a "fil conducteur" in Greek mythology see above, p. 265 n. 62.

princely life. The resemblance to the *qaṣīda* extended, in other words, beyond the shared themes of love, hunting, and panegyric that have several times been noted, to embrace also a fundamental structural affinity, which Reynold Nicholson best conveyed in his observation that "the *qaṣīda* is no organic whole: rather its unity resembles that of a series of pictures by the same hand or, to employ an Eastern trope, of pearls various in size and quality threaded on a necklace".[64] More recent critics[65] have spoken of the parts of the *qaṣīda* as "panels"—a word we have often employed for our paintings too.

There is, in this early period, no more faithful touchstone of ʿurūba, Arabism, than the *qaṣīda*.[66] If, then, we ask in what the Arabism of Quṣayr ʿAmra's frescoes consists, we may most reliably answer in the following two ways: firstly, in the congeniality of their subject matter to the Arabs' taste as manifest in their poetry; and secondly in a manner of perception shared by the hearer of the ode and the beholder of the paintings, which we may call an appreciation of the "paneled mode". This is not to imply that the paneled mode was an Arab invention. In fact it had long been one of the distinguishing features of Mediterranean art, in Greek East and Latin West alike. Sixth-century East Roman writers had emphasized the shifting vision, darting gaze, and general fragmentation of focus that characterized contemporary perception of artistic forms;[67] while right down to the eighth century the mosaic floors of churches in Jordan manage to juggle a stylistic habit of breaking any given scene into sequences of compartments or roundels each containing a single major figure,[68] with a theological intention to praise the Creator through his creatures, which implies the essential unity of the

64. Nicholson, *Literary history* 78. Abu-Deeb's exposition, *I.J.M.E.S.* 6 (1975), against Nicholson (cf. 149 n. 1), of the ode's deeper structural unities by no means dispenses with the *nasīb*, etc. (here called "formative units": 152 n. 1; cf. 182), and concedes that the structural unities themselves are often "hidden" (150). Our concern here, more modestly, is with features of the ode that were easily perceived by those whose general culture this poetry formed.

65. J. Stetkevych, *Tradition and modernity,* esp. 116 n. 5; Montgomery, *Vagaries of the qaṣīdah.*

66. Awareness of an "Arab" identity transcending tribal affiliation is already attested in the Namāra inscription of A.D. 328: Calvet and Robin, *Arabie heureuse* 265–69. The rise of Islam broadened interest in this issue by requiring converts (*mawālī*) to adopt fictive Arab genealogies, and by creating a demand for perfect command of the language of the Qurʾān. Some *mawālī* became, by this linguistic route, more Arab than the Arabs: Abiad, *Culture et éducation* 69–72.

67. Roberts, *Jeweled style* chap. 3, "Poetry and the visual arts", especially the quotations on pp. 74–75 from Procopius and Choricius of Gaza.

68. Baumann, *Spätantike Stifter* 64, 183, and pls. 5.9, 19.44.

natural world depicted.[69] That this "late antique aesthetic of discontinuity"[70] should have been so congenial to the Arabs as well, even in the inner citadel of their poetic creativity, opens up intriguing questions about the congruities of Mediterranean and pre-Islamic Arab culture—which it would be inappropriate, though, to tackle within the strictly Umayyad focus of the present study.

It may be noted, finally, that the paneled mode is also characteristic of the Qurʾān, not just in the relationship of one *sūra* to another, but within individual *sūras* too;[71] while the Arabs' taste as manifest in their poetry included, by late Umayyad times, a willingness to lace heroic pre-Islamic themes with the new Muslim piety.[72] Not unnaturally for a bath house, though, Quṣayr ʿAmra's explicit allusions to the new Arab religion are too few and restrained[73] to justify any comparison between the scripture and the frescoes. That is why it has not proved a particularly revealing field of research for scholars concerned to define a distinctively, classically "Islamic" art.[74] The frustration they have felt when pondering this anachronistic question by the banks of the Wādī 'l-Buṭum must go far toward explaining why Quṣayr ʿAmra has so long been deprived of the comprehensive contextualizing investigation it deserves. It had become all too clear that such enquiries would result in a deepened appreciation of Arab Umayyad culture but not lead to the well springs of Islamic aesthetics.

69. Ognibene, *Umm al-Rasas* 67–72.
70. Roberts, *Jeweled style* 97.
71. Donner, *Narratives* 67, 80–85.
72. Wagner, *Grundzüge* 2.1–30; Montgomery, *Vagaries of the qaṣīdah* 209–53.
73. Above, pp. 224–26.
74. In his *Formation* Grabar devotes considerable space to the *quṣūr* yet concludes: "While they are of great importance for an understanding of the eighth century and its taste, they may not be that important per se for an understanding of the formation of Islamic art" (155). "They are even more important for an understanding of pre-Islamic art than for Islamic art and it is not an accident that so many Byzantinists and even (but much more rarely) Classicists have been concerned with them" (id., *I.J.M.E.S.* 3 [1972] 222). Ettinghausen, *Islamic art and archaeology* 160, was more categorical: "Most of the repertory of Quṣayr ʿAmra . . . is purely in the late classical tradition These scenes cannot yet be called Muslim in style and iconography." On the very gradual transition from late antique to "Islamic" art, via an "early Islamic" art whose antecedents can already be traced in the sixth-century Greek East, see Allen, *Tradition and innovation.* If we are to share Hillenbrand's view, *Bayt al-Maqdis* 308–10, that the vegetal and geometric motifs of the (late Umayyad?) al-Aqṣā wood carvings, having self-confidently evolved away from their classical models, are already "Islamic", then "Islamic" ends up meaning little more than "Samarran style". Hillenbrand himself concedes, crucially, that the evolution visible at al-Aqṣā is "uncertain" and anepigraphic.

BARBARIANS IN THE BATH

"Classical" Islamic civilization was in later Umayyad times only just be-
ginning to form.[75] And as is apparent even from Ibn Hishām's early ninth-
century abridged edition of Ibn Isḥāq's *Life* of the Prophet, or—more
indirectly—from Uri Rubin's study mentioned above, it still at that time
had room for a massive amount of pre-Islamic contextualization. The clas-
sical canon was later to dispense with most of this pre-Islamic narrative; but
under the Umayyads, Islam had not yet to such an extent denied its deep
roots in late antiquity, or its debts to Jewish and Christian tradition. This
was no doubt one among many reasons why the Arabs' revelation, that
which posterity has seen as most original about the invaders, and what
marked them off from many other barbarian peoples who had pressed in
upon the charmed shores of the late antique Mediterranean, may not have
struck contemporaries as the most notable thing about them.[76] As for the
Arabs' rulers, in particular the Umayyads, they proclaimed themselves
"caliphs"—that is, "deputies of God"—and therefore inheritors in some part
of Muḥammad's religious authority. Yet outsiders—and some of their fel-
low Muslim Arabs too—perceived them as just another set of "kings"
(mulūk), a throwback (in Muslim eyes) to the bad old self-glorifying days
of pre-Islamic ignorance.[77] One begins to wonder, in short, whether the
Arabs' experience of Mediterranean inculturation was really so unique af-
ter all, far less the abrupt break in the history of these lands that later his-
torians delighted to describe. The speed with which the newcomers seized
Rome's eastern provinces had indeed been unparalleled; but this very fact
may have encouraged some of their Christian subjects to see them as just
a passing cloud[78]—like the Iranian invaders during the first two decades of
Heraclius's reign.

Precedent suggested that if they managed to hang on to their new pos-
sessions, freshly arrived barbarians were quick learners—and that the ed-
ucative process might turn out to be of as much benefit to their subjects as
themselves, since the latter desired to participate in the same way of life that
the former so earnestly wished to preserve. Indeed, to a few observers there
was something almost embarrassing about the zeal with which certain bar-

75. For this view see Sharon, *J.S.A.I.* 14 (1991) 121–34; Crone and Hinds, *God's caliph* 72–73.

76. Cf. Hoyland, *Seeing Islam* 535–38.

77. For Christian writers see the references above, p. 226 n. 117. For Muslim crit-
icisms of Umayyad inclination toward *mulk*, "kingship", see above, pp. 171–72.

78. On the apocalyptic literature see Hoyland, *Seeing Islam* chap. 8.

barians imitated civilized ways—they became a mirror suddenly held up in
front of the more self-indulgent, less manly features of the Roman elite's
behavior. Here, for example, is the sixth-century Greek historian Procopius
of Caesarea on the Vandals:

> Of all the nations which we know, that of the Vandals is the most
> luxury-loving, while that of the Moors lives in the hardest conditions.
> For the Vandals, from the time they gained possession of Libya, in-
> dulged in baths, all of them, every day, and enjoyed a table abounding
> in all things, the sweetest and best that the earth and sea produce. They
> were very given to wearing gold, and clothed themselves in Median
> garments, which now they call "Seric"; and they passed their time,
> thus attired, at the theatre and the hippodrome and in other pleasurable
> pursuits, and above all else in hunting. And they had dancers and mimes
> and all sorts of things to see and hear, music and whatever other diver-
> sions men dream up. Most of them dwelt in parks abounding in water
> and trees; and they held numerous banquets, and sought after every
> type of sexual pleasure. But the Moors for their part live in stuffy huts
> both in winter and in summer. . . .[79]

Almost everything Procopius says here could have been written by a sim-
ilarly observant Greek or Iranian about the Umayyad *quṣūr* and the life that
was lived in them. Their milieu was still that of the world of late antiquity.
In studying it, we find ourselves witnessing not so much the birth of Islamic
civilization, as another episode in that familiar late antique adjustment of
the motifs of Mediterranean or Iranian high culture to the needs of "bar-
barian" peoples eager to admire, to participate—and not be smothered.[80] By
the time Quṣayr ʿAmra was built, the Umayyad elite was so sure it was it-
self no longer "barbarous" that it could without qualms point to "the un-
couth and brutish Arab of the desert who obdurately acts at random in the
perplexity of ignorance" as a particularly noxious example of that condition.[81]

79. Procopius, *De bellis* 4.6.5–10 (based on the translation by H. B. Dewing). Cf.
the encomiastic poems by Fl. Felix, preserved in the *Anthologia latina*, on the Alianas
baths rebuilt by the Vandal king Thrasamund (496–523). For text, translation, and
commentary see Chalon, Devallet, Force, Griffe, Lassère, and Michaud, *Antiquités
africaines* 21 (1985).
80. Cf. Philostratus, *Vita Apollonii* 2.27: Phraotes, king of India, follows up his
admission to Apollonius that he can speak Greek by taking the sage to his bathing
place and gymnasium, and then to a banquet and an acrobatic display.
81. ʿAbd al-Ḥamīd al-Kātib, letter 21 p. 216 (trans. Latham, *A.L.U.P.* 168; Schönig,
Sendschreiben 18); cf. al-Balādhurī, *Kitāb futūḥ al-buldān* 424–25; and the poets
quoted by Nadler, *Umayyadenkalifen* 7–8. Note also (from a slightly later date)
Bashshār b. Burd 11–12 (Arabic), 50–51 (translation) in Beeston's selection; and the
poem of Abū Nūwās quoted above, p. 209.

The patron of Quṣayr ʿAmra would have been not a little disconcerted to learn that the frescoes with which he had adorned his bath house contained "des scènes originales de la vie nomade".[82] He would have been impressed, though, could he have foreseen the attraction his adopted way of life would continue to exercise, despite the carpings of the pious and thanks at least in part to the impetus the Umayyads gave it. The Abbasid palaces of Sāmarrāʾ, for instance, provided a setting for a courtly life whose elaboration and self-indulgence had much in common with the Umayyads', while the decoration of the buildings themselves not only echoed, as already noted, the themes of Umayyad court art, but also in at least one case the decoration of a specific Umayyad structure, Mushattā.[83] And the prestige of the Abbasid court inspired even the East Romans to imitate it.[84]

The product of this latter cultural convergence is best evoked in the Greek epic *Digenis Akritis*, where it describes the palace built on the Euphrates by the poem's hero, the son of a Muslim *amīr* who crossed over to Roman territory and was baptized for love of a Christian girl he had taken captive on a raid, and bore him Digenis. The passage may be quoted at length, for it is our only extended ancient evocation of a rural *qaṣr's* appearance and atmosphere:

> By channel from Euphrates' bank he made to flow the water,
> planted a second Paradise pleasing to all beholders,
> a grove that was incomparable, true joy to eyes it offered.
> Around the grove a wall he cast, of height just as it should be,
> each one of its four sides was made with blocks of polished marble.
> . . .
> Beneath the trees the meadow flowered, brilliant in all its glory,
> showing a range of various hues, its blooms were all a-bursting.
> . . .
> Into the meadow water flowed, copious, from all directions,
> and in there birds of various kinds enjoyed their habitation.
> . . .
> Amidst this very Paradise of wonderment and pleasure
> the valiant frontiersman raised up a truly pleasant dwelling
> of many rooms, and four-square built, its masonry cut finely,
> with stately columns up above, and likewise there were windows.
> The ceilings—every one of them—he covered in mosaic work
> of costly marbles all made up, and gleaming in their glory.
> The floor he brightened, paving it in patterns made of stone work,

82. Grabar, *Penser l'art islamique* 20.
83. Above, p. 306 n. 58.
84. A. Grabar, *L'art de la fin de l'antiquité* 1.265–90.

while inside he made upper rooms on three floors in succession.
Their height it was considerable, their vaults were many-varied,
rooms cruciform and five-domed halls, amazing to behold them,
with marble work all glittering and gleaming, full of radiance.
...
And then on each flank of his house he laid out in its side-wings
reclining rooms both long and grand, with gold-encrusted ceilings,
and thereupon the victories of olden heroes' courage
he had them show in gold mosaic that gorgeously depicted
first Samson's fight against the foe, of alien race and kindred,

and then the stories of David and Goliath, and Saul; of Achilles and Odysseus,
Bellerophon and (at length) Alexander; of Moses and the exodus of the Jews.

All these and very many more in both reclining chambers
Digenis had recorded in mosaics of golden pieces,
which gave to all who saw them there a pleasure that was boundless.[85]

Although considered a product of the twelfth century, *Digenis* preserves
echoes of the ninth- and tenth-century Roman-Arab frontier world. At least
in this milieu, a palatial style the Abbasids partly inherited from the
Umayyads had been fully assimilated not only to the Alexander romance
but also to Homer and the whole world of Greek mythology as well. The
Old Testament from which Christian and Muslim alike drew inspiration,
and to which one of Quṣayr ʿAmra's Arabic texts makes reference by in-
voking Abraham and David, was abundantly illustrated on Digenis's palace
walls. And just as the *quṣūr* allotted Islam its separate place in the mosque,
so too Digenis did not mingle the gospel story with the Hebrew and Hel-
lenic themes in his hall but built a church that stood apart in the courtyard
of his residence. The religious allegiances from which the two civilizations
of Christian Rome and the caliphate drew their specific coloring were ex-
cluded, in the *quṣūr* as in Digenis's palace, from the focus of social life.[86]

Choices such as these suggest a milieu in which soldiers and men of
action—not scholars or priests—had the last word. The days of "barbarism"
had not yet become mere historical memory. But even those soldiers and men
of action were still an elite. Procopius too clearly has in mind the Vandal rul-

85. *Digenis Akritis* 7.12–16, 23–24, 30–31, 42–52, 59–63, 99–101 (Grottaferrata version; author's translation). For further descriptive elements preserved in later versions, including reference to a bath house, and for a more detailed comparison with the *quṣūr*, see the bibliography noted in Jeffreys's edition, p. 205.

86. Cf. Brown, *Authority and the sacred* 11–12, on the exuberant art and inconspicuous Christianization of the fourth-century Roman elite. His words might be applied, with a few changes, to the Umayyads as well.

ing class, not the rank and file. We must be careful—to return to a point raised at the beginning of this chapter—not to take a bath house created by an Umayyad prince as necessarily indicative of the cultural horizons that were available to the mass of Arab fighters on whom the strength and endurance of the caliphate so directly depended. The later Umayyads derived their legitimacy, admittedly, from their ability to project themselves as rulers of an "Arab empire" *(al-dawla al-ʿarabīya)*, while denouncing their opponents and eventual supplanters as an "Iranian gang" *(al-fiʾa al-ʿajamīya)*[87]—preferring the language of race pure and simple to Wellhausen's more subtle distinction between Arab Umayyads and Muslim Abbasids.[88] Yet if we judge from the historical narratives preserved by al-Ṭabarī, for example, the austerely Arabian and Muslim cultural atmosphere of the great barrack cities of al-Baṣra and al-Kūfa, to which the conquered peoples made only limited[89] contribution, must have had little in common with that of the Syrian *quṣūr*. Even if some of these latter were also designed in part as accommodation for armed retinues, still the *buyūt* were apparently far more austere in decoration than the owner's rooms, set apart on the upper floor. Subjects of conversation below stairs are likely to have ranged from hunting to the many bloody political-religious schisms, such as Shiism and Kharijism, that were rending the Islamic community at this time, but probably did not take in the niceties of royal iconography, let alone Greek mythology. Another prominent if no longer very powerful Arab milieu was that of the refined salons of al-Madīna, famed for their poets and singers. For all its cultural distance from the barracks of ʿIrāq, though, al-Madīna will have been much less exposed than the *quṣūr* to the unique cultural mix of Syria, with its strong East Roman element. In short, whatever the usefulness of the *qaṣīda* to the interpreter of Quṣayr ʿAmra, the frescoes come nowhere near the poetry as a touchstone of Arabism. Instead, they attest a rather advanced stage of Mediterranean inculturation on the part of their Umayyad patron and his immediate circle.[90]

87. ʿAbd al-Ḥamīd al-Kātib, letter 38.
88. Wellhausen, *Das arabische Reich* 350–52.
89. But not "negligible", *pace* H. Djaït, *E.Is.* 5.350. On accounting and architecture see above, pp. 269–70, 298 and n. 27.
90. A major question that awaits an answer is the extent to which the Umayyads were inspired by the residences of the late Roman military elite in Syria. That the ordinary military *castrum* was part of the *qaṣr*'s background has already been suggested: above, p. 44. But still closer parallels are offered by the luxuriously appointed sixth-century complexes at Qaṣr ibn Wardān near Ḥamā—to whose Near Eastern as well as Constantinopolitan architectural affinities Grossmann has now drawn attention, *Da.M.* 12 (2000)—and nearby al-Andarīn, whose *castrum* turns out to have

PHILOSOPHERS IN THE BATH?

The "boundless pleasure" alluded to at the end of the quotation from *Digenis* takes us back to the way in which we began our investigation of Quṣayr ʿAmra, in chapter 2, with the "luxuries of the bath". In subsequent chapters it emerged that certain dynastic and political concerns also influenced the patron and artists who worked, in all probability together, on the bath house frescoes. These concerns, and the more hedonistic impulses that wove in and out of them, were articulated with constant reference to or at least awareness of the Arabs' poetry and history, whose personifications adorn the east aisle. But what of the third of these personifications, Inquiry or Philosophy?

Although the translation of Greek philosophy into Arabic hardly got under way until the ninth century, the same Sālim Abū 'l-ʿAlāʾ we already encountered in chapter 9 as a possible transmitter of Greek mythological themes to the Umayyad court also reveals in his *Letters of Aristotle to Alexander* some knowledge of Hermetic philosophy. When this was first realized, in the 1960s, the early date came as something of a surprise;[91] but the student of Quṣayr ʿAmra has every right to see this discovery as no more than confirmation of what his monument had already announced to the world some sixty years before Grignaschi published his researches. What exactly was it, though, that the Arabs saw as Greek philosophy's contribution to the art of bathing?

In order to answer this question, we have to resort to the writings of the physician and philosopher Muḥammad b. Zakarīyāʾ al-Rāzī, who was deeply immersed in Greek learning and died in the second quarter of the tenth century. Al-Rāzī was concerned to show that the bath caters to the mind quite as much as to the body. Quṣayr ʿAmra had by this time long since fallen into oblivion, but what al-Rāzī has to say about the decoration of bath houses reassures us that the tradition out of which Quṣayr ʿAmra had grown remained vigorous:

> When beautiful pictures also contain, apart from their subject, beautiful, pleasant colours—yellow, red, green and white—and the forms

been decorated with wall mosaics, wall paintings (nonfigural), porphyry and marble revetments, and *opus sectile:* Strube, *XXᵉ congrès international des études byzantines* 3.217. These buildings too must be part of the genealogy of Digenis's palace. My thanks to Alastair Northedge and Christine Strube for discussion of this important new perspective.

91. Grignaschi, *Bulletin d'études orientales* 19 (1965–66) 48–52; id., *Le muséon* 80 (1967) 249–52. Cf. also Gutas, *Greek thought, Arabic culture* 109.

are reproduced in exactly the right proportions, they heal melancholy humours and remove the worries to which the human soul is prone, as well as gloom of spirits. For the mind is refined and ennobled by contemplation of such pictures. The gloom in which it finds itself dissolves. He [al-Rāzī] said also: Consider only how the philosophers *(al-ḥukamā')* of old who, in the course of many years, invented the bath realised, thanks to their subtle mind and sound intellect, that a considerable part of the powers of a man who enters a bath relaxes. Their wisdom enabled them to discover through their intelligence how this can be accomplished swiftly, and they therefore had artistically made pictures, with beautiful, pleasing colours, painted in the baths. In addition, they were not content with a single subject but undertook a division into three, since they knew that the body possesses three sorts of spirits, animal, psychological and physical. Hence they arranged that each subject of a painting should serve to strengthen and increase one of the above-mentioned powers. For the animal power they have depicted battles, fights, hunts on horseback and the chase of beasts. For the psychological power they have depicted love, themes of lovers and beloved, how they accuse one another or embrace, and other scenes of this sort. And for physical power they have depicted gardens, trees pleasant to look at, a mass of flowers in charming colours. Such and similar pictures belong to first-class baths. If one asks a discerning painter why painters use only these three subjects for the painting of baths, he cannot give a reason for this; he would not remember those three qualities (of the mind) as the reason. This is due to the fact that the earliest beginnings lie so far back, and hence the cause is no longer known. (The philosophers) have not omitted anything that is correct, nor introduced anything meaningless.[92]

There could hardly be any stronger argument than this passage for the thematic unity of Quṣayr 'Amra's frescoes. It is true that al-Rāzī was a more profound student of Greek philosophy than anyone we know of who lived in the eighth century. Yet his description of the "ideal" bath corresponds so precisely to what we can still see at Quṣayr 'Amra that one can hardly doubt the Umayyad patron and his artists were following a paradigm inspired by or originally interpreted in the light of Greek philosophy, even if they themselves were unaware of that paradigm's earlier history.

If al-Rāzī was right, and it really was possible for the bath's philosophical dimension to escape the attention even of its own creators, then the student of Quṣayr 'Amra should take this as a warning and search the paintings yet again for the influence in them not only of Greek thought, but also

92. Al-Rāzī, quoted by al-Ghuzūlī, *Maṭāliʿ al-budūr fī manāzil al-surūr* 2.7–8 (trans. into English in Rosenthal, *Classical heritage* 266, here slightly emended).

of the Qur'ān and indeed generally of guiding ideas that may not have been made iconographically explicit. Besides "boundless pleasure", recreation of body and mind, and the purveying of certain cultural and political messages, were there any other major preoccupations that our patron and his artists expressed, consciously or otherwise, through their paintings? One suggestion will be offered here, in guise of conclusion.

It was argued in chapter 6 that Quṣayr ʿAmra's paintings were completed in A.H. 125–26, corresponding substantially to the years 743–44 of the Christian era and covering the whole of the brief reign of al-Walīd II. They are an unrivaled visual resource for the preoccupations of the Umayyad court milieu at this crucial and catastrophic moment, and both complement and are complemented by the later historical accounts, which for all their problems seem to be describing much the same situation. Further material evidence, likewise connected to privileged social milieux, has been coming to light in recent years in the shape of coin hoards hidden in various places in Syria, with terminal issues belonging precisely to those same years, A.H. 125–26.[93] These bear silent but eloquent witness to the collapse of confidence precipitated by the revolt during which al-Walīd was murdered, to be succeeded for a brief six months by his cousin Yazīd III. Yazīd's accession took place in an atmosphere saturated with recriminations about use of the community's wealth. In a sermon delivered at this time, Yazīd promised not to accumulate wealth *(māl)*, and to employ whatever surplus *(faḍl)* there might be in order to succour the needy.[94]

These two words, *māl* and *faḍl*, evoke an already long-standing discussion within Islam, about the proper use of economic resources belonging to Muslims. The Qur'ān does not treat possessions as in themselves bad, providing right use be made of them. "Those who treasure up gold and silver, and do not expend them in the way of God", are promised a painful chastisement;[95] but that does not mean one should reject contact with wealth as if it were intrinsically evil. Believers are exhorted to "struggle in the path of God with their possessions *(bi-amwālihim)* and their selves".[96] So there was no objection—how could there be, after the conquests?—to accumulation of wealth. What did become controversial was the use to which it ought

93. Sears, *American journal of numismatics* 12 (2000), esp. 181.
94. Ṭab. 2.1834–35 (trans. 26.194).
95. Qur'ān 9.34 (trans. Arberry).
96. Qur'ān 4.95, 49.15, 61.11; also the passages discussed by Donner, *Narratives* 73–74.

to be put. There seems to have emerged a consensus that any *faḍl* left over after all legitimate private calls on one's *māl* had been met ought to be disposed of in social and charitable works.[97]

For example, immediately after the fall of Ctesiphon, booty from Kisrā's palace was shared out, according to Arab custom, by the general Saʿd b. Abī Waqqāṣ, until there remained nothing but one gigantic carpet.

> On it were pictures of roads, and inlays like rivers; among them were pictures of houses. The edges looked like cultivated lands planted with spring vegetables, made of silk on stalks of gold. Their blossoms were of gold and silver. . . . The fruits depicted on it were precious stones, its foliage silk and its waters golden.

To sit on this carpet was to enjoy the sensation of being in a garden. Saʿd suggested it be exempted from the division of spoils and dispatched to al-Madīna, for the caliph ʿUmar to do with as he saw fit. But ʿAlī, the Prophet's cousin, argued that material things are to be used, not hoarded—so the carpet was cut up and distributed.[98]

Not just here, but throughout al-Ṭabarī's lengthy account of the Arab penetration of Sasanian Mesopotamia, this same preoccupation with right use recurs. When al-Baṣra and al-Kūfa were being founded, ʿUmar wrote and advised Saʿd not to allow his men to build houses higher than "the norm".

> "But what is this 'norm'?", they had asked. "The 'norm'", ʿUmar said, "is that which keeps you well away from wastefulness but, at the same time, won't make you lose sight of what you are aiming at"[99]

—namely securing their position and livelihood in a conquered land.

It was, predictably, under ʿUmar's successor that standards were held to have slipped. In the course of a heated debate with, among others, ʿAlī himself, the caliph ʿUthmān was said to have observed:

97. Bravmann, *Spiritual background* 229–53.

98. Sayf b. ʿUmar in Ṭab. 1.2451–54 (trans. 13.31–34 G. H. A. Juynboll). This is but one of many such edifying stories about luxury articles: Raven, *J.S.S.* 33 (1988) 214–16. For more on Arab maltreatment of Iranian carpets and cushions, see al-Balādhurī, *Kitāb futūḥ al-buldān* 303; Ṭab. 1.2270–71 (trans. 12.66–67)—though what the Arabic sources present as heroic uncouthness or noble savagery may have been a conscious imitation of long familiar ritual actions aimed at formal symbols of Sasanian authority: see above, p. 179, and (for precedent) Sebeos (attributed), *Armenian history* 79.

99. Sayf b. ʿUmar in Ṭab. 1.2488 (trans. 13.68 Juynboll). On the topos of ʿUmar's concern for simplicity and equality see Kubiak, *Al-Fustat* 122–23.

There remained a surplus *(faḍl)* of wealth *(māl)*, so why should I not do as I wish with the surplus? Why otherwise did I become imām?[100]

In similar vein, the founder of the Umayyad dynasty:

The earth belongs to God, and I am God's caliph. Whatever I take from it is mine, and what I leave for the people is a gift from me.[101]

In other words, there was a feeling growing among some of those who stood to profit by such an arrangement that the caliph ought to be allowed full discretion in disposing of the community's *faḍl*. There were various justifications that might be offered to disguise what at least in part was naked greed. The dynasty needed to be wealthy and prestigious, for the sake of the caliphal office. And anyway, what higher authority was to distinguish dynasty from caliphate? One can see how the accusation of *mulk* grew in part out of a perception that the *faḍl* element in the Umayyads' wealth was more and more treated by them as their gift not God's, and therefore as redounding to their credit and strengthening their claim to absolute authority. Even such pious investments as 'Abd al-Malik's Dome of the Rock or al-Walīd's Damascus mosque advertised the prestige of the dynasty as well.

Mu'āwiya's supposed attitude, held to have been anticipated by 'Uthmān and by those who entrusted Kisrā's carpet to 'Umar's discretion, was allowed to set the tone for the rest of the Umayyad dynasty. Already Mu'āwiya was said to have himself pointed out the contrast between his own "wallowing" in the goods of this world and the rejection of them by his predecessors Abū Bakr and 'Umar.[102] A poetess from 'Alī's camp ruefully pictured Mu'āwiya and his cronies lording it at al-Khawarnaq,[103] anticipating not only 'Abd al-Malik celebrating the fall of al-Kūfa in the same place,[104] but also his successors' growing attachment to their country residences. By the time we get to Quṣayr 'Amra it is clear that Abundance and Dynasty are felt to be complementary concepts—there is no longer anything shameful in that. Quṣayr 'Amra is indeed a veritable icon of Abundance. Of this theme the prince triumphantly enthroned with an aquatic scene beneath his footstool and flanked on the alcove's sidewalls by figures reminiscent of personifications

100. Ṭab. 1.2940 (trans. 15.144 R. S. Humphreys, slightly adjusted).

101. Al-Wāqidī in Bal. 1. fol. 349b = p. 698 (20, §63 'Abbās) (trans. Pinto and Levi della Vida 10–11, §20).

102. Ṭab. 2.211–12 (trans. 18.222), a tendentious anecdote attributed to one of Mu'āwiya's lieutenants. By the time of Hārūn al-Rashīd, cutting up an expensive carpet would occur only to "an ignorant Nabatean woman": al-Jāḥiẓ (attributed), *Kitāb al-tāj* 41; and cf. above, p. 287 n. 169, on the "Nabaṭ".

103. Hind bt Zayd b. Makhrama al-Anṣārī in Ṭab. 2.146 (trans. 18.154–55).

104. Above, p. 143.

of Earth or holding aloft a horn of plenty, or the six kings who stand for the empires of old that had yielded up so much wealth to the Arabs, or the splendid hall in which Shāh-i Āfrīd is displayed, or the voluptuous bathers with their children, are no less illustrative than the hunting scenes with their promise of succulent meat, or the noble date palms and other trees, the basket full of freshly plucked grapes or the fishes of the sea.[105] Nor is it hard to translate this artistic language into the prosaic terminology of the economic historian, who evokes—and documents from archaeological evidence—the Umayyads' infrastructural projects, their encouragement of a market economy, their monetary and administrative reforms.[106]

The atmosphere changed so radically in the round century that elapsed after the death of ʿUmar b. al-Khaṭṭāb that one wonders whether some external influence had intensified the natural instincts so obviously at work. Abundance had been one of the great themes of pre-Islamic Syrian art.[107] And there was a related nexus of ideas—creation *(ktisis)*, acquisition or possession *(ktēsis)*, and use *(chrēsis)*—so often evoked by Greek thinkers that it had become commonplace,[108] and so frequently alluded to in inscriptions applied to works of art or utility[109] that by the sixth century it was thoroughly banal. Mosaic floors both in Syria and elsewhere routinely included representations of these personifications, usually identified by Greek labels (fig. 68).[110] And when Procopius reports how the Lakhmid prince al-Mundhir (505–54) encouraged the Sasanian emperor Kawādh I (488–531) to at-

105. For the last three themes see *Ḳ.ʾA.* pl. 28; *Q.ʾA.* 61–62 figs. 33–34, 121 fig. 83, 132 fig. 88. Johns, *Bayt al-Maqdis* 84–85, connects these themes much more narrowly with the caliph's function as bringer of rain (see above, p. 124 and n. 32). For an icon of Abundance at Khirbat al-Mafjar too, see Bisheh, *Archaeology of Jordan and beyond,* esp. 63–64.

106. E.g., Walmsley, *Long eighth century* 290, 342–43.

107. Kiilerich, *Kairos.*

108. See, for example, *Corpus Hermeticum* 9.5 (creation-use); Clement of Alexandria, *Stromata* 7.11.62 (creation-use-enjoyment, on which see below); various earlier references in the Greek lexicon of Liddell, Scott, and Jones; and cf. Gnilka, *ΧΡΗΣΙΣ.*

109. *Bull. épigr.* (1972) no. 264; Dunbabin, *Papers of The British School at Rome* 57 (1989) 19; Drandaki, *Μουσείο Μπενάκη* 2 (2002) 37–53, esp. 44 (inscriptions on bath buckets etc.).

110. See also Levi, *Antioch mosaic pavements* 1.278–79, 2. pl. LXIVa (personification of *Chrēsis,* probably accompanied by *Ktisis*); also 254–56 for the more general philosophical atmosphere of certain Antiochene mosaics; Maguire, *Earth and ocean* 48–55 *(Ktisis).* Quet, *Syria* 77 (2000) 196–97, interprets a third-century mosaic depicting the Glorification of the Earth, from al-Shahbāʾ in the Ḥawrān, as an invitation to sample, as well, certain more refined and, indeed, philosophical pleasures, such as those depicted on another mosaic from the same town, mentioned above, p. 87.

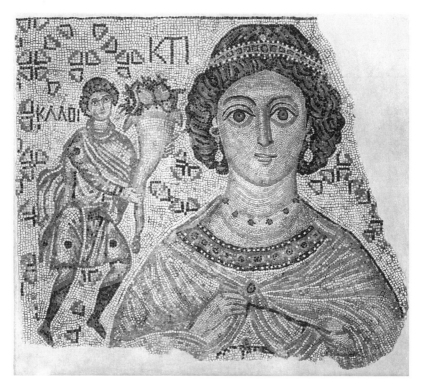

Figure 68. *Ktisis* (mosaic; c. 500–550). Metropolitan Museum of Art, New York, Harris Brisbane Dick and Fletcher Funds, 1998 (1998.69); purchase, Lila Acheson Wallace Gift, and Dodge and Rogers Funds, 1999 (1999.99).

tack Antioch because of its inhabitants' addiction to *tryphē*,[111] that luxury for which they and the Syrians generally were notorious[112] and which they commonly personified in their mosaics,[113] it is hard not to wonder about the Muslim Arabs' reaction to these same images when, just a century later, they entered the cities of Syria, having quite possibly never seen such a thing as a bath house in their life before.[114] Or, *a fortiori*, two hundred years later,

111. Procopius, *De bellis* 1.17.37.
112. Julian, *Contra Galilaeos* fr. 21.116A; Damascius, *Vita Isidori* fr. 222.
113. Levi, *Antioch mosaic pavements* 1.206, 2. pl. XLVIe.
114. Lewcock, al-Akwaʿ, and Serjeant, *Ṣanʿāʾ* 501–4; and cf. Goldziher, *Introduction* 43 n. 27; also Sayf b. ʿUmar in Ṭab. 1.2451 (trans. 13.31, with note ad loc.), and Ibn Isḥāq, *Sīrat rasūl Allāh* 733 (Wüstenfeld)/3.327 (al-Saqqā), on the lack of privies in pre-Islamic Arabian houses. But both al-Kūfa and al-Baṣra possessed bath houses from their very foundation: Morony, *Iraq* 269–70.

at the apogee of Umayyad *mulk*. They must surely have seen in these luxurious and elegant displays of wealth—indeed, of wealth personified and elevated into a semidivine sphere—a potent encouragement to their own acquisitiveness, an example of unashamed opulence set by a materially superior civilization that they had admired and envied and now controlled.

The thematic abundance of Quṣayr ʿAmra's paintings, which some have read as a sign of artistic immaturity, may then be in part a meditation on precisely this cultural encounter and economic conjuncture, a deliberate reflection of the abundance of the Arabs' inheritance and an affirmation of their right as humans, but also as conquerors, to make use *(chrēsis)* of it and to derive therefrom enjoyment *(apolausis)*—another common theme in the late antique mosaics of Syria.[115] Quṣayr ʿAmra's paintings are, in short, more than just a comment on Hishām's miserable penny-pinching, that obverse of princely generosity about which so many stories are told in al-Balādhurī's *Ansāb al-ashrāf* and by al-Ṭabarī. Hishām's behavior was considered profoundly inappropriate to the office he held, yet Qaṣr al-Ḥayr al-Gharbī had been decorated similarly to Quṣayr ʿAmra, as we saw in chapter 5. So our frescoes are not just *ad hominem*. They express a wider cultural ideal, shared to some extent by Hishām as well.

As for al-Walīd, he acquired the reputation of being a mere wastrel, whose court was a *majlis al-lahw*, an "assembly for distraction".[116] According to one of his poems, *lahw* was wine, women, and song.[117] The hedonism of his verse derives, though, from an awareness of life's brevity and death's inevitability, and from doubts (whether sincere or affected) about his own chances of Paradise, or even about the very reality of the salvation offered by Islam. That was already a theological position, however negative, and helped to earn the prince his reputation as a heretic. Such was the Iblīs aspect of his personality.

But al-Walīd well knew that, for public consumption, something more positive was required—for the sake of his sons, the dynasty, and the caliphate. Following in the footsteps of his predecessors and ancestors, he proclaimed that as God's deputy he had not merely the opportunity, but every right and indeed duty to make lavish use of creation's gifts. And so he chose Adam, the lord of creation, as the model for his portrait. In some Christian

115. Levi, *Antioch mosaic pavements* 1.305–6, 2. pl. LXVIId (personification of *Apolausis*, in a bath house); Dunbabin, *Papers of The British School at Rome* 57 (1989) 13–14, 19–20; Raeck, *Patron and pavements*, on the relation in late antique art between the themes of *chrēsis*, *apolausis*, and hunting.

116. Hishām b. al-Kalbī in Iṣf. 5.123.

117. Al-Walīd b. Yazīd no. 60/61 (trans. Hamilton 135; Derenk 98; Rotter 112); cf. Ṭab. 2.1775 (trans. 26.126–27).

contexts, including the Ḥawīrtah mosaic, the first man had been depicted in the act of naming the animals; and the same idea was taken up by the Qurʾān.[118] Through him God made manifest mankind's ideal relationship with the created world—that of a benevolent shepherd, who yet had absolute discretion, the power not only of naming but also of life or death. As God's first caliph as well, Adam provided a model that was highly appropriate—as well as convenient—to the rulers of the Arab Muslim Empire. Al-Walīd did not omit to invoke it, in the letter by which he proclaimed al-Ḥakam and ʿUthmān his heirs.[119] Quṣayr ʿAmra's irony was that it gave such explicit and self-confident expression to this Umayyad vision, on the very eve of its destruction.

118. Above, p. 136. To what extent does Quṣayr ʿAmra consciously evoke the Quranic imagery of Paradise? Apart from the patron's Adamic portrait (Eden and Paradise are identified: Qurʾān 61.12), other signs pointing in this direction are the depictions of palms and grapes (above, p. 321), not to mention women; and the explicit invocation of Paradise by a visitor to al- Walīd's court, above, p. 72 and n. 115. The traditional interpretation of the Qurʾān as promising sexual pleasures in Paradise may in its turn have been inspired by Christian images such as the Rossano Gospel's miniature of Christ in heaven with the five wise virgins: Ainalov, *Hellenistic origins* 110 fig. 54, 118.

119. Above, p. 138.

Epilogue

During one of the two visits he made to Damascus, either in 830 or else shortly before he died in 833, the Abbasid caliph al-Ma'mūn decided one day to go hunting. He took the road that led up toward Hermon, "Snowy Mountain" as the Arabs called it, and after a while the party halted at an enormous cistern shaded by four tall cypresses of surpassing beauty. Nearby had stood one of the rural retreats the Umayyad clan built in this pleasant and salubrious hill country. Al-Ma'mūn admired its picturesque ruins, then settled down to a picnic of wine and *bazmāward*, a roast meat and white bread delicacy of Iranian origin, fit for a *bazm* as its name suggests.

The *Kitāb al-aghānī*, to which we owe this evocative vignette, now comes quickly to the point, which is a resounding gaffe made by the well-known singer 'Allūya. Inexplicably, he took this oportunity to entertain the caliph with an elegy on the Umayyads:

> These things are my people's. After their peak of power and glory
> they were snuffed out. Shed a tear, else I am sick at heart.

Al-Ma'mūn was profoundly unamused, and immediately lost his appetite. "Oh, Ibn Zāniya!", he cried, "did you have to choose this moment to lament your people?" To which 'Allūya impertinently rejoined: "Yes, and I do lament them. Your client Ziryāb"—the famous scholar and cook, the greatest musician of Umayyad Spain—"is riding with them in the company of a hundred young men, while here I am, their client, dying of hunger with you."

The caliph remounted and rode off in evil mood. 'Allūya was lucky to get by with not being spoken to for three weeks—after which al-Ma'mūn relented and gave him twenty thousand dirhams, lest there be any more invidious comparisons.[1] The incident had reminded him that the Umayyads'

1. Iṣf. 4.347–48.

regal example—in the best sense—still lingered. Nostalgia for it might be stirred by the sight of an abandoned country house sheltered by ancient trees. But in the West, their kingdom still endured, and with it something of the diversity and inventiveness of late antique Syria, as it had survived even under the caliphate.

Appendix
The Value of Arabic Literary Sources

In the preface it was stated that one of the objectives of this book is to "test the literary narratives" by making the most of datable material evidence: inscriptions, coins, and papyri as well as architecture and painting. It was also suggested that, for the interpreter of a monument such as Quṣayr ʿAmra, poetry is a privileged category of literary evidence. The ten chapters that followed have, it is hoped, made as much of the material evidence as is reasonable, while coordinating it with the literary sources, and underlining the value of the poets. It remains simply to append certain remarks about the nature of our literary sources, that are more conveniently gathered together in one place than scattered distractingly throughout the text.[1]

Poems attributed to poets active before 750 have been the object of frequent allusion and are different from almost all other literary evidence—the major exception being the Qurʾān—in that they were known to the late Umayyads and therefore formed part of their cultural environment. They are not merely evidence for that environment; they actually helped mold it. Imruʾ al-Qays's *Muʿallaqa*, supposedly composed in the sixth century, well before Islam, has been proposed as a poem of central significance. And the surviving fragments of al-Walīd b. Yazīd's poetry have also been laid under contribution, on the assumption that al-Walīd was Quṣayr ʿAmra's patron (though even if he was not, they are still relevant, since al-Walīd was a prominent and trend-setting figure for much of the Umayyad dynasty's last three decades). The transmission of pre-Abbasid and especially of pre-

1. References will be given only for points of detail. Apart from *E.Is.*, further information on the writers discussed here can be sought in Duri, *Rise of historical writing*, and Khalidi, *Arabic historical thought.* See also the judicious remarks by R. S. Humphreys, *E.Is.* 10.271–76, esp. 273–74.

Islamic poetry has been one of the most debated issues in Arabic literary studies; but since Ḥammād al-Rāwiya (694–772/73), one of those most suspected of having tampered with the tradition, was an associate of al-Walīd and many other leading personalities of the 730s and 740s, one can at least be sure that the preoccupations of what passes for pre-Abbasid poetry were already familiar in the period that concerns us. Those preoccupations— bravery, endurance, and other manly virtues; hunting animals and women; praise of animals, beloved, self, and hoped-for patron; and pursuit of pleasure—match well enough with Quṣayr ʿAmra's.

Just as much Umayyad poetry has come down to us in a collection, the *Kitāb al-aghānī* or *Book of songs*, around whose intentions and reliability suspicion has flourished (see below), so too the later historians preserve a number of documents that, while purporting to be genuine Umayyad productions, must nonetheless be accounted literary rather than material or archaeological sources, as would have been the case had they been preserved on, say, papyrus. Their testimony ought not, though, to be rejected. For example, al-Walīd II's letter proclaiming his sons al-Ḥakam and ʿUthmān heirs apparent presents no self-evidently suspicious features and has been treated here as reliable evidence.[2] Likewise Yazīd III's sermon delivered shortly after al-Walīd's murder.[3]

Luckily the correspondence of ʿAbd al-Ḥamīd b. Yaḥyā al-Kātib, who was secretary to Marwān (II) b. Muḥammad while he was governor of Armenia and Azerbaijan as well as during his master's caliphate (744–50), seems not to have been tampered with, even though it too has been preserved only in the works of others. These letters are now receiving the detailed scholarly attention they deserve. Most of them are ornate in style and literary in tone, and the light they throw on Quṣayr ʿAmra is incidental; but they provide valuable insights into political ideas circulating in high places at this time. Of more specific interest—as explained in chapter 9—is the collection of *Letters of Aristotle to Alexander*, which, if indeed it was edited by Hishām's and apparently also al-Walīd's secretary Sālim Abū 'l-ʿAlāʾ, gets us very close indeed to Quṣayr ʿAmra, and by a strictly literary route.

Firsthand accounts of certain events or at least incidents were attributed, in later compilations, to various Umayyad personalities, including the aforementioned literary scholar Ḥammād al-Rāwiya. We are indebted to him for extremely colorful vignettes of life at both Hishām's court and al-Walīd's, though some stories that supposedly originated with him subsequently re-

2. Cf. Crone and Hinds, *God's caliph* 116–17.
3. See bibliography s.v. *Khuṭba Yazīd*.

ceived the same sort of cavalier treatment he himself meted out to the po-
etic tradition.[4] It is also worth noting two scholars whose main interest was
in the history of pre-Islamic times and the biography of the Prophet, but
whose contemporaneity with the Umayyads makes them valuable witnesses
to language and general cultural context. One was the polymath Wahb b.
Munabbih (654–728/32), whose testimony, notably in his *Kitāb al-tījān fī
mulūk Ḥimyar*, or *Book of crowns, concerning the kings of Ḥimyar*, was of
some value in analyzing the portrait of the enthroned prince—Wahb is
brimful of traditions about regal self-presentation, especially thrones, from
God to Kisrā by way of Adam, Iblīs, and Solomon.[5] Some two generations
later came Ibn Isḥāq (c. 704–?767), the author of the earliest biography of
Muḥammad that survives in any bulk, but also of a *Ta'rīkh al-khulafā'*, or
History of the caliphs, which covered the Umayyads as well.

Another very early attempt—likewise lost—to compile something re-
sembling a narrative history of the Umayyads is owed to Abū Mikhnaf
(c. 689–775), who not only, like Ibn Isḥāq, had himself been a contempo-
rary but had also interviewed eyewitnesses or at least informants who had
encountered eyewitnesses.[6] Unfortunately, Abū Mikhnaf's focus was on
'Irāq not Syria, and only very limited use of his surviving fragments could
be made here, mainly as sources for criticisms of the Umayyads, as one
might expect given his generally Alid orientation. By contrast, the shat-
tered state of Hishām b. Muḥammad b. al-Kalbī's historical—as distinct
from genealogical—legacy is a tantalizing loss, however palliated by ex-
tensive quotations in al-Balādhurī, al-Ṭabarī, and al-Iṣfahānī. Ibn al-Kalbī
lived from c. 737 to 819/21 and so had access to people who had lived
through the Umayyads' last decades. His main usefulness in the present
context has been as a vivid witness to Umayyad cultural life, including ma-
terial culture, though he can be quite inventive and needs to be used with
care.[7] Mention should also be made of Ibn al-Kalbī's exact contemporary
al-Haytham b. 'Adī (738–821), whose genealogically arranged *Ta'rīkh al-
ashrāf al-kabīr (Great history of the notables)* anticipated al-Balādhurī's
Ansāb al-ashrāf (Genealogies of the notables), whence most of the refer-

4. 'Aṭwān, *Al-Walīd* 146–53.

5. For a more historical perspective on this subject, see the mid-ninth-century
Kitāb al-tāj (Book of the crown) attributed to al-Jāḥiẓ, to which a number of refer-
ences have been made in the foregoing chapters. Note that not all the material in
the *Kitāb al-tījān* is by Wahb himself: Khalidi, *Arabic historical thought* 70–71.

6. Sezgin, *Abū Mikhnaf* 115 (references to reports on Abū Mikhnaf's own au-
thority or his father's), 72–81 (use of eyewitness accounts of events before his birth,
though mediated by third parties).

7. Khalidi, *Arabic historical thought* 50–54; Kilpatrick, *Book of songs* 113, 117.

ences to al-Haytham's lost work in the present book have been drawn. Al-Haytham is a useful source on al-Walīd, though not an unprejudiced or a wholly reliable one, and in general he suffers from the same affliction as all these early authorities, namely the editorial vagaries of his transmitters.[8]

Only with al-Wāqidī (748–822) and al-Madāʾinī (752–839), born respectively two years before and two years after the collapse of the Umayyads, do we reach a pair of historians whose enduring contribution to the establishment of a narrative history of the dynasty was recognized—and ultimately obfuscated—by the incorporation of outstandingly numerous quotations from their works in the classic surviving accounts by al-Balādhurī and al-Ṭabarī. Their early date, access to eyewitnesses, and generally systematic and precise approach account in significant part for the esteem in which their more famous successors are held. Of the two, al-Madāʾinī is the more extensive and synthetic—and much more frequently used in this book. He drew on his only slightly younger contemporary al-Wāqidī in order to make of his *Akhbār al-khulafāʾ al-kabīr* what—so far as one can judge—must have been a truly monumental history of the Umayyads. The references to him in the present book have been taken from al-Ṭabarī, al-Balādhurī, and al-Iṣfahānī, in descending order of quantity.

The exact historical weight that ought to be assigned to the oeuvre of al-Balādhurī (c. 810–892) is still hard to assess, since much of his genealogically arranged history of Islam, the *Ansāb al-ashrāf,* has only recently been published. His detailed accounts of Hishām and al-Walīd have been heavily exploited in the present work and provide many an illuminating personal anecdote absent from al-Ṭabarī's *History,* with its more resolutely political orientation. Al-Balādhurī's debt to to al-Haytham b. ʿAdī, who in turn was a pupil of and transmitted from Ḥammād al-Rāwiya, neatly illustrates how even a historian writing up to a century and a half after the events might not have been old enough to interview his second-generation source, yet could have met members of that source's family who had access to oral traditions or owned manuscripts and other archives (of speeches, documents or poems, for example) handed down by leading actors in the Umayyad drama.[9] As for al-Balādhurī's other major work, the *Kitāb futūḥ al-buldān (Book of the conquests of the provinces),* its focus is on the con-

8. Cf. Robinson, *Islamic historiography* 38; and ʿAṭwān, *Al-Walīd* 151–52, on al-Haytham's account of al-Walīd; also above, p. 68 n. 103.

9. On transmission of Umayyad archives and oral testimony, see Abbott, *Studies* 3.99, 105.

quest of the caliphate's various provinces, so its contribution to the study of Quṣayr ʿAmra is less direct; but still it yields a number of interesting details and sidelights on cultural and especially economic matters, even for the later Umayyad period, when most of the conquests had been completed.

The great length and inclusiveness of al-Balādhurī's work, as also his careful attention to identifying his sources through chains of authorities (*isnāds*), make him much more useful than his contemporary al-Yaʿqūbī (d. c. 905), whose brief and—from a literary point of view—elegant *History*, with reign-by-reign accounts of the Umayyads and heavy emphasis on politics, has only occasionally been referred to in these pages. In contrast, the classic history by al-Ṭabarī (839–923) has provided the backbone of such historical narrative as has been required, along with many incidental insights into the mentality and the habits—both social and individual—of the Umayyads. Al-Ṭabarī's advantage over al-Balādhurī (whom he exploits with uncharacteristic lack of acknowledgment) is a chronologcally rather than genealogically arranged narrative's ease of use; his advantage over al-Yaʿqūbī is his attention to *isnāds* and his comprehensiveness, for he often allows himself several different accounts, from different sources, of the same event, with only limited editorial intervention, so that he can hardly avoid including many telltale details that have been squeezed out of more condensed narratives. Nevertheless, his emphasis is overwhelmingly on political and military events. And from the Syrian point of view, al-Ṭabarī's heavily Iraqi and Iranian perspective is hard to forgive.

Fully deserving of mention alongside these two mighty historians, al-Balādhurī and al-Ṭabarī, are al-Masʿūdī (c. 890–956) and Abū 'l-Faraj al-Iṣfahānī (897–967), the compiler of the *Kitāb al-aghānī*. In his masterpiece, *Murūj al-dhahab*, or *The meadows of gold*, al-Masʿūdī provides a world geography as well as an outline of human history culminating in the caliphate; but from the point of view of Quṣayr ʿAmra, his usefulness is even greater when he is involved in one of his many anecdotal digressions, especially into cultural history. His interests, somewhat unusually for a Muslim writer, extended well beyond the boundaries of the caliphate.

As for the *Kitāb al-aghānī*, Musil was the first to try to make sense of Quṣayr ʿAmra by drawing on this immense biographical encyclopaedia of poets and musicians, with abundant samples of their work. Subsequent students of the "desert castles" have sometimes been quite literal in applying traditions reported by al-Iṣfahānī to the interpretation of the remains, a notable example being Robert Hamilton's explanation of certain features of the Khirbat al-Mafjar bath house by reference to al-Walīd's eccentricities

as elaborated in the *Book of songs,* for instance, his penchant for bathing in wine.[10] Al-Iṣfahānī is always on the lookout for a good story—and does not mind an obscene one. Like al-Ṭabarī, he had only moderate inclination to summarize, to compress, or to reconcile conflicting testimonies. Yet he may, as a result, preserve information that has been strained out from al-Ṭabarī's politically oriented narrative, or allow us, by comparing his versions, to catch the emergence of spin, slant, and slander.[11] Even the more skeptical reader will find much in him that illuminates the monuments. It is impossible to stand in Quṣayr ʿAmra's hall and not be carried back, in the mind's eye, to the defining event in any poet's or singer's career, the dramatic moment endlessly evoked and varied in the *Book of songs,* when the artist stands before the prince and awaits the royal command, the signal for a performance on which his immediate prosperity for sure, and perhaps his reputation and whole career, depend. Once one has accepted the substantial genuineness of the pre-Abbasid poetic corpus and perceived the similarity of those texts' subject matter to the vividly colored frescoes on the bath house walls, it is hard not to recognize the *Book of songs* as an essentially convincing guide, at least to the general atmosphere of the hall when—for however short a time—it came alive.[12]

It remains simply to note a few geographical writers—other than al-Masʿūdī—who have been of help in contextualizing Quṣayr ʿAmra, in particular Ibn Khurradādhbih (c. 820/25–c. 911), Ibn al-Faqīh, who wrote c. 903,[13] and al-Muqaddasī, who began his book in 985. Much later, Yāqūt (d. 1229) wrote his alphabetical *Dictionary of the provinces,* the *Muʿjam al-buldān,* which has been invoked frequently, not least for the sake of its generous quotations from earlier writers. But his predecessors preferred to see things for themselves, while their subject matter lacks the potential for political manipulation that is the historians' besetting temptation. As the most eminent historian of the city of Damascus, there is a sense in which Ibn

10. Hamilton 35–42. ʿAṭwān, *Al-Walīd* 189–90, questions the credibility of the story on which Hamilton bases his interpretation.

11. Cf. ʿAṭwān, *Al-Walīd* 146–53, 187–91, 200–9, showing how stories about al-Walīd b. Yazīd were doctored by supporters of Hishām or, later, the Abbasids and Shiism—or even by al-Iṣfahānī himself.

12. Cf. Blachère's characteristically balanced judgment, *Histoire* 133–38. Kilpatrick's *Book of songs* is an austerely literary analysis and wastes no sympathy on the historian's needs (13). It is interesting, though, to compare her suggestion (274–77) that al-Iṣfahānī consciously used music as a key to the unity of creation with the possibility (raised above, 316–17) that the Quṣayr ʿAmra frescoes addressed themselves to the whole man as defined by the philosophers.

13. The al-Hādī edition has now made available substantial portions of this work that were virtually unknown before. There is an informative introduction.

'Asākir (1105–76) also belongs in this company, even if most of his vast *Ta'rīkh madīnat Dimashq* takes the characteristic Muslim form of a biographical dictionary. Although only partially published, it is clear that this work devotes a lot of space to the Umayyads and goes some way toward compensating for the Iraqi historiographical tradition's indifference to Syria. Ibn 'Asākir would repay more systematic investigation than there has been time for in the context of the present project.[14]

For the historian who approaches Quṣayr 'Amra's frescoes, the ideal is the painting whose subject—if not necessarily "meaning" in the roundest sense—is uncontroversially apparent, and whose authentically Umayyad resonances do not need to be demonstrated, but may be illustrated, from the literary sources. The most convincing interpretation proceeds from picture to text; and fortunately most of Quṣayr 'Amra's stock of images—its princes, hunters, singers, dancers, bathers, and builders—can be treated in this way. Those that mystify as images are few—essentially those discussed in chapters 6 and 8—and here it was necessary, once the paintings had been carefully described, to resort to the literary sources, to see what situation or event offered the best fit. Hence the more hypothetical character of those two chapters, especially chapter 8.

It has to be borne in mind that no surviving text even once mentions Quṣayr 'Amra, or anything that resembles it. The literary sources name quite a wide variety of *quṣūr*, or at least places where there are today remnants of Umayyad installations: al-Azraq, al-Bakhrā', Bāyir, al-Faddayn, Wādī 'l-Ghadaf, al-Ḥumayma, al-Muwaqqar, al-Qasṭal, Zīzā'. Yet the major *quṣūr* still standing today, or revealed by excavation, are notable by their absence from this list: not just Quṣayr 'Amra but Qaṣr al-Ḥayr al-Gharbī, Qaṣr al-Ḥayr al-Sharqī, Qaṣr al-Ḥallābāt, Mushattā, Khirbat al-Mafjar, and the palaces at the southwest corner of al-Ḥaram al-Sharīf in Jerusalem. That the *History of the patriarchs of Alexandria* mentions one building project undertaken by al-Walīd II in the desert, without naming it, while various sources mention Hishām's residence at al-Zaytūna, which cannot be identified on the ground, still further increases the odd inconsonance of these two lists. We do not even have the option of concluding that, given the considerable depth of coverage in our literary sources, the *quṣūr* simply cannot have been very important—not just because the significance of Mushattā, in particular, is self-evident, but also because even a religious monument as notable as the

14. See especially the comments of Eisener, *Zwischen Faktum und Fiktion* 249–50; Shboul, *ARAM periodical* 6 (1994) 67–78.

Aqṣā mosque is invisible in the literary record until al-Muqaddasī, who wrote in 985 and was after all a native Jerusalemite. For all its bulk, the historical coverage that can be extracted from the literary sources is marred by considerable gaps, especially as regards Syria. What is more, not one of the references listed above—from al-Azraq to Zīzā'—is to buildings for their own sake, but merely as backdrops to events in the life of a leading political personality. People, not places, are the Arabic historians' concern; herein lies an insuperable obstacle to any truly satisfying marriage between literary sources and material evidence.

Another major obstacle to the modern historian is the hostility to the Umayyads that is such a regular feature of the Abbasid sources, and has often been commented upon. It derived in part from political animus generated by the Abbasids' long campaign of preaching against the Umayyads, followed by their violent uprising. The Abbasids not unnaturally felt the need to defame their predecessors in order to assert their own legitimacy. But beyond this essentially political propaganda there was also a religious motivation, cultivated especially by the scholarly elite, the *'ulamā'*, who were already emerging as a force to be reckoned with in the last years of the Umayyad regime, and deeply resented the Umayyads' treatment of the caliphate as a source of religious as well as political authority. Hence their constant attempts to demonstrate that the ruling dynasty was "a deviation from a sacred past . . . indifferent or even inimical to Islam".[15]

Such hostility is not, though, an entirely regular or predictable feature of our Abbasid literary sources. There are occasional flashes of sympathy for the Umayyads, and above all a recognition that this dynasty had ruled the caliphate in its formative period, and that to blacken it too much undermined the legitimacy of the whole Muslim enterprise.[16] In short, our literary sources provide us with a varied counterpoint to the material evidence that has been the primary focus of the present study. It certainly could not have been written without them.

15. Crone and Hinds, *God's caliph* 23.
16. Iṣf. 7.96.

Bibliography

ANCIENT SOURCES

Arabic names are alphabetized according to their most familiar component, e.g., Abū Dhuʾayb under his *kunya*, but al-Azraqī under his *nisba*. Where reprinted (usually Beiruti) editions of classical Arabic texts have been used, their original place and date of publication have not necessarily been noted.

ʿAbd al-Ḥamīd b. Yaḥyā al-Kātib. Edited by I. ʿAbbās, *ʿAbd al-Ḥamīd b. Yaḥyā al-Kātib wa-mā tabaqqā min rasāʾilihi wa-rasāʾil Sālim Abī ʾl-ʿAlāʾ*. Amman 1988.

Abū ʾl-Baqāʾ Hibat Allāh al-Ḥillī. *Kitāb al-manāqib al-mazyadīya fī akhbār al-mulūk al-asadīya*. Edited by S. M. Darādika and M. ʿA. Khuraysāt. Amman 1984.

Abū Dhuʾayb al-Hudhalī, Khuwaylid b. Khālid. *Marthiya*. (1) Edited and translated into English by C. J. Lyall, *The Mufaḍḍalīyāt: An anthology of ancient Arabian odes compiled by al-Mufaḍḍal son of Muḥammad according to the recension and with the commentary of Abū Muḥammad al-Qāsim ibn Muḥammad al-Anbārī*, 1.849–84, 2.355–62. Oxford; London 1918–24. (2) Edited and translated into English in *E.A.P.* 2.203–34.

Abū Nuwās. *Dīwān*. Edited by E. Wagner and E. Schoeler. Cairo; Wiesbaden 1958–.

Acta conciliorum oecumenicorum. Edited by E. Schwartz. Strasbourg; Berlin 1914–.

Acta martyris Anastasii Persae. Edited and translated into French by B. Flusin, *Saint Anastase le Perse et l'histoire de la Palestine au début du VIIᵉ siècle*, 40–91. Paris 1992.

Agapius of Manbij. *Kitāb al-ʿunwān*. Edited and translated into French by A. Vasiliev, *P.O.* 5(4), 7(4), 8(3), 11(1).

Agathias. *Historiae*. Edited by R. Keydell. Berlin 1967.

Ammianus Marcellinus. *Res gestae*. Edited by C. U. Clark. Berlin 1910–15.

Anthologia Palatina. Edited and translated into German by H. Beckby, *Anthologia graeca*. Munich n.d.[2]

Apophthegmata patrum (alphabetical series). In *P.G.* 65.71–440.

Aristophanes. Edited and translated into French by V. Coulon. Paris 1923–30.

al-Aswad b. Ya'fur al-Nahshalī. *Qaṣīda dālīya*. Edited and translated into English in *E.A.P.* 2.138–54.

al-Azdī, Yazīd b. Muḥammad. *Ta'rīkh al-Mawṣil*. Edited by 'A. Ḥabība. Cairo 1967.

al-Azraqī, Abū 'l-Walīd Muḥammad b. 'Abd Allāh b. Aḥmad. *Akhbār Makka wa-mā jā'a fīhā min al-āthār*. Edited by R. Malḥas. Beirut 1996.

Baḥshal, Aslam b. Sahl al-Razzāz al-Wāsiṭī. *Ta'rīkh Wāsiṭ*. Edited by K. 'Awwād. Beirut 1986.

al-Bakrī, Abū 'Ubayd 'Abdallāh b. 'Abd al-'Azīz. *Mu'jam mā ista'jam min ismā'i 'l- bilād wa-'l-mawāḍi'*. Edited by M. al-Saqqā. Beirut 1983.

al-Balādhurī, Aḥmad b. Yaḥyā. *Ansāb al-ashrāf* (divided into parts, folios, and pages following MS 'Āshir Efendi/Reisülküttap 597–98 [Istanbul]; for a list of contents by part and page see M. Ḥamīdullāh, *Ansāb al-ashrāf* 1 [Cairo 1959] pp. 34–53 of the prefatory matter):

Part 1, fol. 263b–345a = pp. 526–689. Edited by 'A. al-'A. Dūrī, *Ansāb al-ashrāf* 3. Wiesbaden 1978.

Part 1, fol. 345a–495a = pp. 689–989. Edited by I. 'Abbās, *Ansāb al-ashrāf* 4/1. Wiesbaden 1979. Pp. 13, §42–161, §452 of this edition translated into Italian by O. Pinto and G. Levi della Vida, *Il Califfo Mu'āwiya I secondo il "Kitāb ansāb al-ašrāf" (Le genealogie dei nobili) di Aḥmad ibn Yaḥyā al-Balāḏurī*. Rome 1938.

Part 1, fol. 555b = p. 1110–Part 2, fol. 15a = p. 29. Edited by W. Ahlwardt, *Anonyme arabische Chronik, Band XI*. Greifswald 1883.

Part 2, fol. 118a–155a = pp. 235–309. Edited by K. 'Athāmina, *Ansāb al-ashrāf* 6B. Jerusalem 1993. (References are given to folios only, as numbered by 'Athāmina in a continuous sequence from the beginning of part 1: i.e., fol. 118a–155a = 716a–753a 'Athāmina. Page references are omitted, as they are absent from 'Athāmina's edition and cannot conveniently be calculated from his numbering of the folios.)

Part 2, fol. 155a–169a = pp. 309–37. Edited by D. Derenk, *Leben und Dichtung des Omaiyadenkalifen al-Walīd ibn Yazīd: Ein quellenkritischer Beitrag*, 1–92 (Arabic section). Freiburg im Breisgau 1974.

(Because of the differing conventions adopted by the various editors of the *Ansāb al-ashrāf*, no wholly uniform system of reference is possible. For fuller lists of published sections [but omitting Derenk] see H. Kennedy and I. el-Sakkout, *Journal of the Royal Asiatic Society* 5 [1995] 410–13, and G. R. Hawting, *B.S.O.A.S.* 62 [1999] 123–24. A single edition of the whole work, by M. F. al-'Aẓm [Damascus 1997–], is under way. The Umayyads are covered in vols. 4–7. It has not been possible to take account of this edition in the present book.)

———. *Kitāb futūḥ al-buldān*. Edited by M. J. de Goeje. Leiden 1866. Trans-

lated into English by P. K. Hitti and F. C. Murgotten, *The origins of the Islamic state.* New York 1916–24.

Bar Hebraeus. *Chronicon syriacum.* Edited by P. Bedjan. Paris 1890. Translated into English by E. A. W. Budge, *The chronography of Gregory Abû'l Faraj.* London 1932.

Bashshār b. Burd. *Dīwān* (selection). Edited and translated into English by A. F. L. Beeston, *Selections from the poetry of Baššār.* Cambridge 1977.

Book of deeds of Ardashir son of Papak (Kārnāmag-ī Ardašīr-ī Pābagān). Edited and translated into English by D. P. Sanjana. Bombay 1896.

Chronicon ad annum Christi 1234 pertinens. Edited by J.-B. Chabot. Louvain 1916–20. Translated into Latin and French by J.-B. Chabot and A. Abouna. Louvain 1937–74.

Chronicon anonymum pseudo-dionysianum vulgo dictum. Edited by J.-B. Chabot. Louvain 1927–33. Translated into Latin and French by J.-B. Chabot and R. Hespel. Louvain 1949–89.

Chronicon maroniticum. Edited by E. W. Brooks, *Chronica minora* 2 (editio). 43–74. Translated into Latin by J.-B. Chabot, *Chronica minora* 2 (interpretatio). 35–57. Paris 1903–7.

Clement of Alexandria. *Stromata.* Edited by O. Stählin and L. Früchtel. Berlin 1985⁴ (vol. 1), 1970² (vol. 2).

Constitutiones apostolorum. Edited and translated into French by M. Metzger. Paris 1985–87.

Corippus, Flavius Cresconius. *In laudem Iustini Augusti minoris.* Edited and translated into English by Av. Cameron. London 1976.

Corpus hermeticum. Edited and translated into French by A. D. Nock and A. J. Festugière. Paris 1946–54.

Cyril of Scythopolis. *Vita Euthymii.* Edited by E. Schwartz, *Kyrillos von Skythopolis,* 3–85. Leipzig 1939.

Damascius. *Vita Isidori.* Edited by C. Zintzen. Hildesheim 1967.

Denḥā. *History of Mārūthā of Takrīt.* Edited and translated into French by F. Nau, *P.O.* 3 (1). 52–96.

Digenis Akritis. Edited and translated into English by E. Jeffreys, *Digenis Akritis: The Grottaferrata and Escorial versions.* Cambridge 1998.

Dio Chrysostom. *Orationes.* Edited by G. de Budé. Leipzig 1916–19.

Ephraem the Syrian. *Hymns on the Nativity.* Edited and translated into German by E. Beck. Louvain 1959.

Epic of Gilgamesh. Translated into English by M. G. Kovacs. Stanford 1989.

Eustathius of Thessalonica. *Interpretatio hymni pentecostalis Damasceni.* In *P.G.* 136.501–754.

Eutychius of Alexandria: see Saʿīd b. al-Biṭrīq.

al-Farazdaq. *Dīwān.* Edited by K. al-Bustānī. Dār Ṣādir edition. Beirut 1960.

Firdawsī. *Shāhnāma.* Translated into English by (1) A. G. and E. Warner. London 1905–25. (2) R. Levy, *Ferdowsi: The epic of the kings.* Costa Mesa, Calif., 1996² (abridged).

al-Ghiṭrīf b. Qudāma al-Ghassānī. *Kitāb ḍawārī al-ṭayr.* Edited by D. Möller, *The book on birds of prey.* Frankfurt am Main 1986.

al-Ghuzūlī, ʿAlāʾ al-Dīn. *Maṭāliʿ al-budūr fī manāzil al-surūr.* Cairo 1882–83.

Ḥadīth Dāwūd (papyri Schott-Reinhardt, Universitätsbibliothek Heidelberg, Arab. 23). Edited and translated into German by R. G. Khoury, *Wahb b. Munabbih,* 33–115. Wiesbaden 1972.

Ḥamza b. al-Ḥasan al-Iṣfahānī. *Taʾrīkh sinī mulūk al-arḍ wa-'l-anbiyāʾ.* Dār Maktaba al-Ḥayāt edition. Beirut n.d.

Ḥassān b. Thābit. *Dīwān.* Edited by W. N. ʿArafat. London 1971.

Heliodorus. *Aethiopica.* Edited by A. Colonna. Rome 1938.

Heraclides of Cyme. *Persica.* In *F.Gr.H.* 689.

Historia Augusta. Edited by E. Hohl and revised by C. Samberger and W. Seyfarth. Leipzig 1965; reprint with corrections 1971.

History of the Patriarchs of Alexandria. Edited and translated into English by B. Evetts, *P.O.* 1 (2, 4), 5 (1), 10 (5).

Homer. *Odyssea.* Edited by T. W. Allen. Oxford 1917–19².

Ibn ʿAbd al-Ḥakam, Abū 'l-Qāsim ʿAbd al-Raḥmān b. ʿAbd Allāh. *Futūḥ Miṣr wa-akhbāruhā.* Edited by C. C. Torrey, *The history of the conquest of Egypt, North Africa and Spain known as the Futūḥ Miṣr.* New Haven 1922.

Ibn ʿAbd Rabbihi, Aḥmad b. Muḥammad. *Al-ʿiqd al-farīd.* Edited by A. Amīn, A. al-Zayn, and I. al-Abyārī. Cairo 1940–53.

Ibn ʿAsākir, ʿAlī. *Taʾrīkh madīnat Dimashq.*
> Vol. 2 (1). Edited by S. al-D. al-Munajjid. Damascus 1954. Translated into French by N. Elisséeff, *La description de Damas d'Ibn ʿAsākir.* Damascus 1959.
> *Tarājim al-nisāʾ.* Edited by S. al-Shihābī. Damascus 1981.
> Selection of passages on the Umayyads: *Muʿjam Banī Umayya.* Edited by S. al-D. al-Munajjid. Beirut 1970.

Ibn al-Athīr, ʿIzz al-Dīn ʿAlī. *Al-kāmil fī 'l-taʾrīkh.* Edited by ʿA. Shīrī. Beirut 1989–92.

Ibn al-Balkhī. *Fars-nāma.* Edited by G. Le Strange and R. A. Nicholson. London 1921.

Ibn al-Faqīh, *Kitāb al-buldān.* Edited by Y. al-Hādī. Beirut 1996. (This edition includes [1] partially preserved original text from MS Mashhad 5229; [2] partially preserved abridgement by Abū 'l-Ḥasan ʿAlī b. Jaʿfar b. Aḥmad al-Shayzarī, translated into French by H. Massé. Damascus 1973.)

Ibn Ḥazm, Abū Muḥammad ʿAlī b. Aḥmad b. Saʿīd. *Jamharat ansāb al-ʿarab.* Dār al-Kutub al-ʿIlmīya edition. Beirut 1983.

Ibn Isḥāq b. Yasār, Muḥammad. *Sīrat rasūl Allāh.* (A) Transmission *(riwāya)* of Ziyād al-Bakkāʾī, in the abridged edition by ʿAbd al-Malik b. Hishām. Edited by (1) F. Wüstenfeld. Göttingen 1858–60. (2) M. al-Saqqā, I. al-Abyārī, and ʿA. Shalabī. Cairo 1936; reprint, Beirut 1994 (the edition used here). Translated into English (with Wüstenfeld's pagination in the margins) by A. Guillaume, *The life of Muhammad.* London 1955. (B) Transmission of Yūnus b. Bukayr. Edited by (1) M. Ḥamīdullāh. Rabat 1976. (2) S. Zakkār. Damascus

1978. Summarized by A. Guillaume, *New light on the life of Muhammad.* Manchester n.d. (Discussed by G. Schoeler, *Écrire et transmettre dans les débuts de l'Islam,* 76, 85. Paris 2002.)

Ibn Khaldūn, ʿAbd al-Raḥmān. *Muqaddima.* Edited by E. Quatremère. Paris 1858. Translated into English by F. Rosenthal. Princeton 1967[2].

Ibn Khallikān, Shams al-Dīn. *Wafayāt al-aʿyān wa-anbāʾ abnāʾ al-zamān.* Edited by I. ʿAbbās. Beirut 1968–72. Translated into English by MacGuckin de Slane, *Ibn Khallikan's biographical dictionary.* Paris 1842–71.

Ibn Khurradādhbih, Abū ʾl-Qāsim ʿUbayd Allāh b. ʿAbd Allāh. *Kitāb al-masālik wa-ʾl-mamālik.* Edited and translated into French by M. J. de Goeje, *B.G.A.* 6.

Ibn al-Nadīm, Abū ʾl-Faraj Muḥammad b. Abī Yaʿqūb Isḥāq. *Kitāb al-fihrist.* Edited by R. Tajaddud. Teheran 1971. Translated into English by B. Dodge. New York 1970.

Ibn Qutayba, Abū Muḥammad ʿAbd Allāh b. Muslim. *Al-imāma wa-ʾl-siyāsa.* Maktaba Muṣṭafa al-Bābī al-Ḥalabī edition. Cairo 1969.

———. *Kitāb al-shiʿr wa-ʾl-shuʿarāʾ.* Dār al-Thaqāfa edition. Beirut n.d.

———. *ʿUyūn al-akhbār.* Edited by Y. ʿA. Ṭawīl. Beirut 1998.

Ibn Rusta, Abū ʿAlī Aḥmad b. ʿUmar. *Kitāb al-aʿlāq al-nafīsa.* Edited by M. J. de Goeje, *B.G.A.* 7.

Imruʾ al-Qays b. Ḥujr. *Muʿallaqa.* Edited and translated into English in *E.A.P.* 2.52–86.

al-Iṣfahānī, Abū ʾl-Faraj. *Kitāb al-aghānī.* Edited by ʿA. ʿA. Muhannā and S. Jābir. Beirut 1982. Excerpts translated into French by J. Berque, *Musiques sur le fleuve: Les plus belles pages du Kitâb al-aghâni.* Paris 1995. Excerpts translated into German by G. Rotter, *Abu l-Faradsch: Und der Kalif beschenkte ihn reichlich. Auszüge aus dem "Buch der Lieder".* Tübingen 1977. (For a fuller account of editions and translations, see H. Kilpatrick, *Making the great Book of songs: Compilation and the author's craft in Abū l-Faraj al-Iṣbahānī's Kitāb al-aghānī,* 2–7, 412–13. London 2003. The indices of the more widely available Cairo edition usually serve to locate in it references to the Muhannā-Jābir edition, given that variations often do not exceed 10 to 15 pages.)

———. *Al-qiyān.* Edited by J. ʿAṭīya. London 1989.

——— (attributed). *Kitāb adab al-ghurabāʾ.* Edited by Ṣ. al-D. al-Munajjid. Beirut 1972. Translated into English by P. Crone and S. Moreh, *The book of strangers: Mediaeval Arabic graffiti on the theme of nostalgia.* Princeton 2000. (Kilpatrick, *Book of songs* 27–28, takes this to be a genuine work by al-Iṣfahānī.)

al-Jāḥiẓ. *Risālat al-qiyān.* Edited and translated into English by A. F. L. Beeston, *The epistle on singing-girls of Jāḥiẓ.* Warminster 1980.

——— (attributed). *Kitāb al-tāj fī akhlāq al-mulūk.* Edited by Aḥmad Zakī Bāshā. Cairo 1914. Translated into French by C. Pellat, *Le livre de la couronne.* Paris 1954. (Correct attribution: G. Schoeler, *E. Is.* 10.434.)

al-Jahshiyārī, Abū ʿAbdallāh Muḥammad b. ʿAbdūs. *Kitāb al-wuzarāʾ wa-ʾl-kuttāb.* Edited by M. al-Saqqāʾ, I. al-Abyārī, and ʿA. al-Ḥ. Shalabī. Cairo 1938.

Partially translated into German by J. Latz, "Das Buch der Wezire und Staatssekretäre von Ibn ʿAbdūs al-Ǧahšiyārī: Anfänge und Umaiyadenzeit." Diss., Bonn 1958. (Note especially VIII on pagination.)

Jarīr b. ʿAṭīya. *Dīwān*. Edited by M. I. al-Ṣāwī. Beirut 1960.

Jarīr b. ʿAṭīya, and al-Farazdaq. *Naqāʾid*. Edited by A. A. Bevan, *The Naḳāʾiḍ of Jarīr and al- Farazdaḳ*. Leiden 1905–12.

John Bar Penkāyē (John of Phenek). *Rīš Mellē*. Edited by A. Mingana, *Sources syriaques* 1 (Leipzig 1908) 1*–171* (with book 15 translated into French, pp. 172*-97*). End of book 14 and parts of book 15 translated into English by S. P. Brock, "North Mesopotamia in the late seventh century. Book XV of John Bar Penkāyē's *Rīš Mellē*", *J.S.A.I.* 9 (1987) 51–75.

John Chrysostom. *De inani gloria et de educandis liberis*. Edited and translated into French by A.-M. Malingrey, *Jean Chrysostome: Sur la vaine gloire et l'éducation des enfants*. Paris 1972.

———. *Homiliae in Genesin*. In *P.G.* 53–54.

John of Ephesus. *Historia ecclesiastica*. Edited and translated into Latin by E. W. Brooks. Louvain 1935–36.

John Malalas. *Chronographia*. Edited by I. Thurn. Berlin 2000.

John of Nikiu. *Chronicle*. Edited and translated into French by H. Zotenberg. Paris 1883. Translated into English by R. H. Charles. London 1916.

Josephus. *Antiquitates Iudaicae*. Edited by B. Niese, *Flavii Iosephi opera*, 1–4. Berlin 1885–95.

Julian. *Contra Galilaeos*. Edited and translated into Italian by E. Masaracchia. Rome 1990.

Khuṭba Yazīd b. al-Walīd baʿda qatlihi al-Walīd (Sermon of Yazīd III after the murder of al-Walīd II, 744). In (1) Ibn Qutayba, *ʿUyūn al-akhbār*, 2.270–71. (2) Bal. 2. fol. 168a = p. 335 (65–66 Derenk) (summary). (3) Ṭab. 2.1834–35 (trans. 26.193–95). Etc. (cf. J. van Ess, *Theologie und Gesellschaft im 2. und 3. Jahrhundert Hidschra: Eine Geschichte des religiösen Denkens im frühen Islam* [Berlin 1991–97] 1.86 n. 1).

al-Kindī, Abū ʿUmar Muḥammad. *Taʾrīkh Miṣr wa-wulātihā*. Edited by R. Guest, *The governors and judges of Egypt, or Kitâb el ʾUmarâʾ (El Wulāh) wa Kitâb el Quḍâh of el Kindî, together with an appendix derived mostly from Rafʿ el Iṣr by Ibn Ḥajar*, 3–298 (Arabic pagination). Leiden 1912.

Kitāb al-ʿuyūn wa-ʾl-ḥadāʾiq fī akhbār al-haqāʾiq. Edited by M. J. de Goeje, *Fragmenta historicorum arabicorum*. Leiden 1871. (Cf. O. Saïdi, *Kitāb al-ʿuyūn wa-l-ḥadāʾiq fī aḫbār al-haqāʾiq: Chronique anonyme* 4· 256/870 -350/961 [Damascus, 1972–73] 1.IX–XLVIII.)

Kuthayyir ʿAzza. *Dīwān*. Edited by I. ʿAbbās. Beirut 1971.

Labīd b. Rabīʿa. *Muʿallaqa*. Edited and translated into English in *E.A.P.* 2.164–202.

Łazar Pʿarpecʿi. *History*. Translated into English by R. W. Thomson. Atlanta 1991.

Leo Grammaticus. *Chronographia*. Edited and translated into Latin by I. Bekker. Bonn 1842.

Leontius of Neapolis. *Vita Ioannis Eleemosynarii.* Edited by H. Gelzer, *Leontios' von Neapolis Leben des Heiligen Iohannes des Barmherzigen, Erzbischofs von Alexandrien.* Freiburg 1893.

―――. *Vita Symeonis Sali.* Edited and translated into French by L. Rydén and A. J. Festugière. Paris 1974.

Letter of Tansar. Edited by M. Minovi. Teheran 1932. Translated into English by M. Boyce. Rome 1968.

Liudprand of Cremona. *Antapodosis.* Edited by J. Becker, *Die Werke Liudprands von Cremona,* 1–158. Hanover 1915³.

al-Masʿūdī, ʿAlī b. al-Ḥusayn. *Kitāb al-tanbīh wa-ʾl-ishrāf.* Edited by M. J. de Goeje, *B.G.A.* 8. Translated into French by B. Carra de Vaux, *Maçoudi: Le livre de l'avertissement et de la revision.* Paris 1896.

―――. *Murūj al-dhahab.* (1) Edited with French translation by C. Barbier de Meynard and J.-B. Pavet de Courteille, *Maçoudi: Les prairies d'or.* Paris 1861–77. Revised by C. Pellat. Beirut 1966–79 (text); Paris 1962– (translation). (2) Edited by Y. A. Dāghir. Beirut 1956–66.

Megasthenes. *Indica.* In *F.Gr.H.* 715.

Michael the Syrian. *Chronicle.* Edited and translated into French by J.-B. Chabot. Paris 1899–1910.

Mozarabic chronicle of 754. Edited and translated into Spanish by J. E. L. Pereira, *Crónica mozárabe de 754.* Zaragoza 1980. Translated into English by K. B. Wolf, *Conquerors and chroniclers of early medieval Spain,* 111–58. Liverpool 1990.

Mujīr al-Dīn al-ʿUlaymī. *Al-uns al-jalīl bi-taʾrīkh al-Quds wa-ʾl-Khalīl.* Cairo 1866/67. Translated into French by H. Sauvaire, *Histoire de Jérusalem et d'Hébron depuis Abraham jusqu'à la fin du XVᵉ siècle de J.-C.* Paris 1876.

al-Muqaddasī, Shams al-Dīn Muḥammad b. Aḥmad. *Aḥsan al-taqāsīm fī maʿrifat al-aqālīm.* Edited by M. J. de Goeje, *B.G.A.* 3 (corrected reprint 1906). Translated into English by B. Collins. Reading 1994.

al-Nābigha al-Shaybānī. *Dīwān.* Edited by A. Nasīm. Cairo 1932.

Nicephorus of Constantinople. *Breviarium.* Edited and translated into English by C. Mango. Washington, D.C., 1990.

Niẓāmī Ganjawī, Jamāl al-Dīn. *Haft paykar.* Translated into English by J. S. Meisami. Oxford 1995.

Nonnus, Pseudo-. *In IV orationes Gregorii Nazianzeni commentarii.* Edited by J. Nimmo Smith. Turnhout 1992. Syriac translation edited and translated into English by S. Brock, *The Syriac version of the Pseudo-Nonnus mythological scholia.* Cambridge 1971.

Oppian of Apamea. *Cynegetica.* Edited by M. Papathomopoulos. Munich 2003. Translated into English by A. W. Mair. London 1928.

Parastaseis syntomoi chronikai. Edited by T. Preger, *Scriptores originum Constantinopolitanarum,* 19–73. Leipzig 1901–7.

Philostratus. *Vita Apollonii.* Edited by C. L. Kayser. Leipzig 1870.

Pisentius of Coptos. *Encomium on S. Onophrius.* Edited and translated into

French by W. E. Crum, "Discours de Pisenthius sur Saint Onnophrius", *Revue de l'Orient chrétien* 20 (1915–17) 38–67.

Plato. Edited by J. Burnet. Oxford 1900–1907.

Procopius. *De aedificiis*. Edited by J. Haury; revised reprint edited by G. Wirth. Leipzig 1964.

———. *De bellis*. Edited by J. Haury; revised reprint edited by G. Wirth. Leipzig 1962–63.

Ptolemy. *Tetrabiblos*. Edited by W. Hübner. Stuttgart 1998.

al-Qazwīnī, Zakarriyāʾ b. Muḥammad b. Maḥmūd Abū Yaḥyā. *Āthār al-bilād*. Dār Ṣādir edition. Beirut n.d.

Quintus Curtius Rufus. *Historiae Alexandri Magni*. Edited and translated into French by H. Bardon. Paris 1961–65².

al-Qurʾān. Official Egyptian edition. Cairo 1924. Translated into English by A. J. Arberry. London 1955. Translated into German by R. Paret. Stuttgart 1996⁷. (Paret's version is easier to use, the numbering of its verses corresponding to that of the official Egyptian edition.)

Saʿīd b. al-Biṭrīq. *Kitāb al-taʾrīkh al-majmūʿ ʿalā ʾl-taḥqīq wa-ʾl-taṣdīq*. Edited by L. Cheikho, B. Carra de Vaux, and H. Zayyat, *Eutychii Patriarchae Alexandrini annales*. Beirut 1906–9. Translated into Italian by B. Pirone, *Eutichio: Gli annali*. Cairo 1987.

Sebeos (attributed). *Armenian history*. Translated into English by R. W. Thomson. Liverpool 1999.

al-Shābushtī, Abū ʾl-Ḥasan ʿAlī b. Muḥammad. *Kitāb al-diyārāt*. Edited by K. ʿAwwād. Baghdad 1966².

Sidonius Apollinaris. Edited and translated into French by A. Loyen. Paris 1960–70.

Simeon of Beth-Arsham. *Letter G*. Edited and translated into English by I. Shahîd, *The martyrs of Najrân: New documents*, I–XXXII, 43–64. Brussels 1971.

Stephanus the Philosopher. *De arte mathematica*. Edited by F. Cumont, in *Catalogus codicum astrologorum graecorum*, edited by F. Cumont et al., 2.181–86. Brussels 1898–1936.

Stephen the Deacon. *Vita Stephani Iunioris*. Edited and translated into French by M.-F. Auzépy, *La vie d'Étienne le Jeune par Étienne le Diacre*. Aldershot 1997.

al-Ṭabarī, Abū Jaʿfar Muḥammad b. Jarīr. *Taʾrīkh al-rusul wa-ʾl-mulūk*. Edited by (1) M. J. de Goeje et al. Leiden 1879–1901. (2) M. A. Ibrāhīm. Cairo 1960–69. Translation into English edited by E. Yar-Shater, *The history of al-Ṭabarī*. Albany 1985–. Partially translated into German by T. Nöldeke, *Geschichte der Perser und Araber zur Zeit der Sasaniden: Aus der arabischen Chronik des Tabari übersetzt*. Leiden 1879. (References are to the Leiden edition whose pagination, noted in the margins of the Cairo edition, is divided into three series: 1.1–3476 = vols. 1–17 of the English translation; 2.1–2017 = vols. 18–27, p. 123; 3.1–2294 = vol. 27, p. 124–vol. 38; these references are followed in brackets by the volume and page number of the English translation or

Nöldeke's. Quotations from the English version are attributed to the translator responsible for the volume in which the passage in question occurs.)

Ṭarafa b. al-ʿAbd al-Bakrī. *Muʿallaqa*. Edited by ʿA.F. al-Ṭabbāʿ, *Dīwān Ṭarafa ibn al-ʿAbd*, 21–43. Abu Dhabi n.d. Translated into English by A. J. Arberry, *The seven odes: The first chapter in Arabic literature*, 83–89. London 1957.

Tertullian. *De virginibus velandis*. Edited and translated into French by E. Schutz-Flügel and P. Mattei, *Tertullien: Le voile des vierges*. Paris 1997.

al-Thaʿālibī, Abū Manṣūr ʿAbd al-Malik b. Muḥammad. *Al-ghurar fī siyar al-mulūk*. Partially edited and translated into French by H. Zotenberg, *Al-Thaʿālibī: Histoire des rois des Perses*. Paris 1900.

———. *Thimār al-qulūb fī 'l-muḍāf wa-'l-mansūb*. Edited by M. A. Ibrāhīm. Cairo 1965.

Theophanes. *Chronographia*. Edited by C. de Boor. Leipzig 1883–85.

Thomas Artsruni. *History of the House of the Artsrunikʿ*. Translated into English by R. W. Thomson. Detroit 1985.

Vita S. Theophano. Edited by E. Kurtz, *Zwei griechische Texte über die Hl. Theophano, die Gemahlin Kaisers Leo VI*, 1–24. St. Petersburg 1898.

Wahb b. Munabbih. *Kitāb al-tījān fī mulūk Ḥimyar*. Sanʿāʾ 1979.

———: see under *Ḥadīth Dāwūd*.

al-Walīd b. Yazīd. *Dīwān*. Edited by (1) F. Gabrieli, "Al-Walīd ibn Yazīd, il califfo e il poeta." *Rivista degli studi orientali* 15 (1934) 1–64 (variants and additions in Derenk 10–26). (2) Ḥ. ʿAṭwān. Beirut 1998. (References are given in this order to both editions, e.g., no. 96/102.)

al-Wāqidī, Abū ʿAbd Allāh Muḥammad. *Kitāb al-maghāzī*. Edited by M. Jones. London 1966.

Xenophon. *Cynegeticus*. Edited and translated into French by E. Delebecque. Paris 1970.

———. *Cyropaedia*. Edited by W. Gemoll; revised by J. Peters. Leipzig 1968.

al-Yaʿqūbī, Aḥmad b. Abī Yaʿqūb b. Wāḍiḥ. *Kitāb al-buldān*. Edited by M. J. de Goeje, *B.G.A.* 7. Translated into French by G. Wiet, *Les pays*. Cairo 1937.

———. *Al-taʾrīkh*. Dār Bayrūt edition. Beirut n.d.

Yāqūt al-Rūmī, Shihāb al-Dīn al-Ḥamawī. *Muʿjam al-buldān*. Beirut 1955–57.

Zosimus. *Historia nova*. Edited and translated into French by F. Paschoud. Paris 1971–89; 2000² (vol. 1).

SECONDARY LITERATURE

Articles in encyclopaedias and items found in the list of abbreviations have not been included.

ʿAbbās, I. *ʿAbd al-Ḥamīd b. Yaḥyā al-Kātib wa-mā tabaqqā min rasāʾilihi wa-rasāʾil Sālim Abī 'l-ʿAlāʾ*. Amman 1988.

Abbott, N. *Studies in Arabic literary papyri*. Chicago 1957–72.

———. "Women and the state in early Islam." *J.N.E.S.* 1 (1942) 106–26, 341–68.

ʿAbd al-Ghanī, ʾA. *Ta'rīkh al-Ḥīra fī 'l-jāhilīya wa-'l-islām.* Damascus 1993.

Abiad, M. *Culture et éducation arabo-islamiques au Šām pendant les trois premiers siècles de l'Islam, d'après "Tārīḫ Madīnat Dimašq" d'Ibn ʿAsākir (499/1105– 571/1176).* Damascus 1981.

Abkaʿi-Khavari. *Das Bild des Königs in der Sasanidenzeit: Schriftliche Überlieferungen im Vergleich mit Antiquaria.* Hildesheim 2000.

Abu-Deeb, K. "Towards a structural analysis of pre-Islamic poetry." *I.J.M.E.S.* 6 (1975) 148–84.

Abujaber, R. S. *Pioneers over Jordan: The frontier of settlement in Transjordan, 1850–1914.* London 1989.

Acconci, A. "Su alcuni lacerti pittorici di Umm er-Rasās—Kastron Mefaa." In *Bisanzio e l'Occidente: Arte, archeologia, storia. Studi in onore di Fernanda de'Maffei,* 193–205. Rome 1996.

Adontz, N. *Armenia in the period of Justinian: The political conditions based on the naxarar system.* Translated and revised by N. G. Garsoian. Lisbon 1970.

Afinogenov, D. "The bride-show of Theophilos: Some notes on the sources." *Eranos* 95 (1997) 10–18.

Ahsan, M. M. *Social life under the Abbasids 170–289 AH, 786–902 AD.* London 1979.

Ainalov, D. V. *The Hellenistic origins of Byzantine art.* Translated by E. Sobolevitch and S. Sobolevitch. New Brunswick, N.J., 1961.

Åkerström-Hougen, G. *The calendar and hunting mosaics of the Villa of the Falconer in Argos: A study in early Byzantine iconography.* Stockholm 1974.

Allen, M. J. S., and G. R. Smith. "Some notes on hunting techniques and practices in the Arabian peninsula." *Arabian studies* 2 (1975) 108–47.

Allen, T. "The arabesque, the beveled style, and the mirage of an early Islamic art." In *Tradition and innovation in late antiquity,* edited by F. M. Clover and R. S. Humphreys, 209–44. Madison 1989.

Almagro, A. "Remarks on building techniques during Umayyad times." *S.H.A.J.* 5 (1995) 271–75 .

Almagro, A., P. Jiménez, and J. Navarro. "Excavation of building F of the Umayyad palace of Amman: Preliminary report." *A.D.A.J.* 44 (2000) 433–57.

Altheim, F., and R. Stiehl. *Die Araber in der alten Welt.* Berlin 1964–69.

Anderson, J. C. "Cod. Vat. gr. 463 and an eleventh-century Byzantine painting center." *D.O.P.* 32 (1978) 175–96.

Anderson, J. K. *Hunting in the ancient world.* Berkeley 1985.

Antoun, R. T. *Muslim preacher in the modern world: A Jordanian case study in comparative perspective.* Princeton 1989.

Arberry, A. J. *The seven odes: The first chapter in Arabic literature.* London 1957.

Arnold, T. W. *Painting in Islam: A study of the place of pictorial art in Muslim culture.* Oxford 1928.

L'Asie des steppes d'Alexandre le Grand à Gengis Khân. Paris 2000.

Asimakopoulou-Atzaka, P. *Τὸ ἐπάγγελμα τοῦ ψηφοθέτη κατὰ τὴν ὄψιμη ἀρχαιότητα (3ος–7ος αἰώνας).* Athens 1993.

ʿAthamina, K. "The tribal kings in pre-Islamic Arabia: A study of the epithet *malik* or *dhū al-tāj* in early Arabic traditions." *Al-qanṭara* 19 (1998) 19–37.

ʿAṭwān, Ḥ. *Al-Walīd b. Yazīd: ʿArḍ wa naqd.* Beirut 1981.

Auzépy, M.-F. "Le Christ, l'empereur et l'image (VIIe-IXe siècle)." In *EYΨYXIA: Mélanges offerts à Hélène Ahrweiler,* 35–47. Paris 1998.

Avner, T. "Early Byzantine wall-paintings from Caesarea." In *Caesarea papers,* edited by K. G. Holum, A. Raban, and J. Patrich, 2.108–28. Portsmouth, R.I., 1999.

Avner, U., and J. Magness. "Early Islamic settlement in the southern Negev." *B.A.S.O.R.* 310 (1998) 39–57.

Awn, P. J. *Satan's tragedy and redemption: Iblīs in Sufi psychology.* Leiden 1983.

Azarnoush, M. "Hadjiabad: Résidence sassanide dans le Fârs." *D.A.* 243 (1999) 50–51.

al-Azmeh, A. *Muslim kingship: Power and the sacred in Muslim, Christian, and pagan polities.* London 1997.

Bacharach, J. L. "Marwanid Umayyad building activities: Speculations on patronage." *Muqarnas* 13 (1996) 27–44.

Baer, E. "Female images in early Islam." *Da.M.* 11 (1999) 13–24.

———. "A group of North Iranian craftsmen among the artisans of Khirbet el-Mefjer?" *I.E.J.* 24 (1974) 237–40.

Bagg, A. M. *Assyrische Wasserbauten: Landwirtschaftliche Wasserbauten im Kernland Assyriens zwischen der 2. Hälfte des 2. und der 1. Hälfte des 1. Jahrtausends v. Chr.* Mainz am Rhein 2000.

Bahat, D. "The physical infrastructure." In *The history of Jerusalem: The early Muslim period, 638–1099,* edited by J. Prawer and H. Ben-Shammai, 38–100. Jerusalem 1996.

Bakirer, O. "The story of three graffiti." *Muqarnas* 16 (1999) 42–69.

Balty, Janine. *La mosaïque de Sarrîn (Osrhoène).* Paris 1990.

———. *Mosaïques antiques du Proche-Orient: Chronologie, iconographie, interprétation.* Paris 1995.

Balty, Janine, and F. Briquel Chatonnet. "Nouvelles mosaïques inscrites d'Osrhoène." *Fondation Eugène Piot: Monuments et mémoires* 79 (2000) 31–72.

Baramki, D. C. "Excavations at Khirbet el Mefjer. III." *Q.D.A.P.* 8 (1939) 51–53.

Barbet, A., and C. Vibert-Guigue. *Les peintures des nécropoles romaines d'Abila et du nord de la Jordanie.* Paris 1988–94.

Bardawil, F. al-T. "Recherches sur le décor sculpté dans l'architecture civile omeyyade de Syrie (661–750)." Diss., Paris, 1995.

Barnett, R. D. *Sculptures from the North Palace of Ashurbanipal at Nineveh (668–627 B.C.).* London 1976. .

Bashear, S. "Apocalyptic and other materials on early Muslim-Byzantine wars: A review of Arabic sources." *Journal of the Royal Asiatic Society* 1 (1991) 173–207.

———. *Arabs and others in early Islam.* Princeton 1997.

Bates, M. L. "Byzantine coinage and its imitations, Arab coinage and its imitations: Arab-Byzantine coinage." *ARAM periodical* 6 (1994) 381–403.

———. "History, geography and numismatics in the first century of Islamic coinage." *Schweizerische Numismatische Rundschau* 65 (1986) 231–63.

Bauer, K. J. *Alois Musil: Wahrheitssucher in der Wüste*. Vienna 1989.

Baumann, P. *Spätantike Stifter im Heiligen Land: Darstellungen und Inschriften auf Bodenmosaiken in Kirchen, Synagogen und Privathäusern*. Wiesbaden 1999.

Baur, P. V. C. "The fragment of a painting of Aphrodite." In *The excavations at Dura Europos conducted by Yale University and the French Academy of Inscriptions and Letters: Preliminary report of sixth season of work, October 1932–March 1933*, edited by M. I. Rostovtzeff, A. R. Bellinger, C. Hopkins, and C. B. Welles, 279–82. New Haven 1936.

Bayer, I. "Architekturzeichnungen auf dem Boden der Basilika." In *Resafa*. Vol. 2, *Die Basilika des Heiligen Kreuzes in Resafa-Sergiupolis*, edited by T. Ulbert, 155–59. Mainz am Rhein 1986.

Beck, H.-G. *Byzantinisches Erotikon*. Munich 1986.

Becker, C. H. *Islamstudien: Vom Werden und Wesen der islamischen Welt*. Leipzig 1924–32.

Behrens-Abouseif, D. "The lion-gazelle mosaic at Khirbat al-Mafjar." *Muqarnas* 14 (1997) 11–18.

Bell, G. *The Arabian diaries, 1913–1914*. Edited by R. O'Brien. Syracuse 2000.

Bell, H. I. *Greek papyri in the British Museum: Catalogue, with texts*. Vol. 4, *The Aphrodito papyri*. London 1910.

Berchem, M. van. "Aux pays de Moab et d'Edom." *Journal des savants* (1909) 293–309, 363–72, 401–11.

Berger, A. *Das Bad in der byzantinischen Zeit*. Munich 1982.

Besnier, M.-F. "La conception du jardin en Syro-Mésopotamie à partir des textes." *Ktema* 24 (1999) 195–212.

Bettini, S. "Il castello di Mschattà in Transgiordania nell'ambito dell' "arte di potenza" tardoantica." In *Anthemon: Scritti di archeologia e di antichità classiche in onore di Carlo Anti*, 321–66. Florence 1955.

Betts, A. V. G. "Graffiti from Qusayr 'Amra: A note on dating of Arabian rock carvings." *A.A.E.* 12 (2001) 96–102.

Bieberstein, K., and H. Bloedhorn. *Jerusalem: Grundzüge der Baugeschichte vom Chalkolithikum bis zur Frühzeit der osmanischen Herrschaft*. Wiesbaden 1994.

Bienkowski, P., ed. *The art of Jordan: Treasures from an ancient land*. Stroud 1991.

Bischoff, B., and M. Lapidge, eds. *Biblical commentaries from the Canterbury School of Theodore and Hadrian*. Cambridge 1994.

Bisheh, G. "From castellum to palatium: Umayyad mosaic pavements from Qasr al-Hallabat in Jordan." *Muqarnas* 10 (1993) 49–56.

———. "Ḥammām al-Ṣarāḥ in the light of recent excavations." *Da.M.* 4 (1989) 225–30.

———. "An iconographic detail from Khirbet al-Mafjar: The fruit-and-knife motif." In *The archaeology of Jordan and beyond: Essays in honor of James A. Sauer*, edited by L. E. Stager, J. E. Greene, and M. D. Coogan, 59–65. Winona Lake, Ind., 2000.

. "Mulāḥaẓāt mutafarriqa ḥawla iktishāfāt umawīya hadītha." *A.D.A.J.* 30 (1986) 7–14 (Arabic section).

. "Qasr al-Hallabat: An Umayyad desert retreat or farm-land." *S.H.A.J.* 2 (1985) 263–65.

. "Qasr al-Mshatta in the light of a recently found inscription." *S.H.A.J.* 3 (1987) 193–97.

. "Qasr Mshash and Qasr ʿAyn al-Sil: Two Umayyad sites in Jordan." In *The fourth international conference on the history of Bilād al-Shām during the Umayyad period. Proceedings of the third symposium, English section* 2, edited by M. A. Bakhit and R. Schick, 81–103. Amman 1989.

. "Two Umayyad mosaic floors from Qastal." *Liber annuus* (Studium Biblicum Franciscanum, Jerusalem) 50 (2000) 431–38.

. "The Umayyad monuments between Muwaqqar and Azraq: Palatial residences or caravanserais?" In *The Near East in antiquity: German contributions to the archaeology of Jordan, Palestine, Syria, Lebanon and Egypt,* edited by S. Kerner, 3.35–41. Amman 1990–94.

Bisheh, G., T. Morin, and C. Vibert-Guigue. "Rapport d'activités à Quṣayr ʿAmra." *A.D.A.J.* 41 (1997) 375–93.

Bivar, A. D. H. "The royal hunter and the hunter god: Esoteric Mithraism under the Sasanians?" In *Au carrefour des religions: Mélanges offerts à Philippe Gignoux,* edited by R. Gyselen, 29–38. Bures-sur-Yvette 1995.

Blachère, R. *Analecta.* Damascus 1975.

. *Histoire de la littérature arabe des origines à la fin du XVᵉ siècle de J.-C.* Paris 1952–66.

Blair, S. "What is the date of the Dome of the Rock?" *Bayt al-Maqdis* 1.59–87.

Blankinship, K. Y. *The end of the jihād state: The reign of Hishām Ibn ʿAbd al-Malik and the collapse of the Umayyads.* Albany 1994.

Blazquez, J. M. "La pintura helenística de Qusayr ʿAmra. II." *Archivo español de arqueologia* 56 (1983) 169–212 .

."Las pinturas helenísticas de Qusayr ʾAmra (Jordania) y sus fuentes." *Archivo español de arqueologia* 54 (1981) 157–202.

Boardman, J. *Classical art in eastern translation.* Oxford 1993.

Bothmer, H. C. von, K.-H. Ohlig, and G.-R. Puin. "Neue Wege der Koranforschung." *Magazin Forschung: Universität des Saarlandes* (1999, fasc. 1) 33–46.

Bowersock, G. W. *Selected papers on late antiquity.* Bari 2000.

Brands, G. "Anmerkungen zu spätantiken Bodenmosaiken aus Nordsyrien." *Jahrbuch für Antike und Christentum* 45 (2002) 122–36.

. "Der sogenannte Audienzsaal des al-Mundir in Resafa." *Da.M.* 10 (1998) 211–35.

Braun, J. *Das christliche Altargerät in seinem Sein und in seiner Entwicklung.* Munich 1932.

Bravmann, M. M. *The spiritual background of early Islam: Studies in ancient Arab concepts.* Leiden 1972.

Breckenridge, J. D. *The numismatic iconography of Justinian II (685–695, 705–711 A.D.).* New York 1959.

Brentjes, B. "Ein "syrisches Wüstenschloss" der Umaiyadenzeit am Talas in Kasachstan." In *Syrien: Von den Aposteln zu den Kalifen,* edited by E. M. Ruprechtsberger, 347–49. Mainz 1993.

Breton, J.-F. "Shabwa (Yémen): Traditions sémitiques, influences extérieures (IIIe s. av.—IIIe ap. J.C.)." *C.R.A.I.* (2000) 849–82.

Brilliant, R. *Gesture and rank in Roman art: The use of gestures to denote status in Roman sculpture and coinage.* New Haven 1963.

Brisch, K. Review of *A short account of early Muslim architecture,* by K. A. C. Creswell (revised by J. W. Allen). *Oriens* 33 (1992) 448–56.

Brock, S. *Syriac perspectives on late antiquity.* London 1984.

Brown, F. E. "Block F3" and "The Roman baths." In *The excavations at Dura-Europos conducted by Yale University and the French Academy of Inscriptions and Letters: Preliminary report of sixth season of work, October 1932—March 1933,* edited by M. I. Rostovtzeff, A. R. Bellinger, C. Hopkins, and C. B. Welles, 49–105. New Haven 1936.

Brown, K. R. *The gold breast chain from the early Byzantine period in the Römisch-germanisches Zentralmuseum.* Mainz 1984.

Brown, P. *Authority and the sacred: Aspects of the Christianisation of the Roman world.* Cambridge 1995.

———. *The body and society: Men, women and sexual renunciation in early Christianity.* New York 1988.

Brubaker, L., and J. Haldon. *Byzantium in the iconoclast era (ca 680–850): The sources, an annotated survey.* Aldershot 2001.

Brünnow, R. "Über Musils Forschungsreisen." *Wiener Zeitschrift für die Kunde des Morgenlandes* 21 (1907) 353–74.

———. Review of Ḳ.ʿA. *Wiener Zeitschrift für die Kunde des Morgenlandes* 21 (1907) 268–96.

Brunet, J.-P., R. Nadal, and C. Vibert-Guigue. "The fresco of the cupola of Qusayr ʿAmra." *Centaurus* 40 (1998) 97–123.

Bujard, J. "Umm al-Walid: Chateaux et mosquées d'époque omeyyade." *D.A.* 244 (1999) 84–89.

Bujard, J., and W. Trillen. "Umm al-Walīd et Khān az-Zabīb, cinq quṣūr omeyyades et leurs mosquées revisités." *A.D.A.J.* 41 (1997) 351–74.

Busse, H. "Zur Geschichte und Deutung der frühislamischen Ḥarambauten in Jerusalem." *Z.D.P.V.* 107 (1991) [1992] 144–54.

Calvet, Y., and C. Robin. *Arabie heureuse, Arabie déserte: Les antiquités arabiques du Musée du Louvre.* Paris 1997.

Cameron, Al. "The funeral of Junius Bassus." *Zeitschrift für Papyrologie und Epigraphik* 139 (2002) 288–92.

Cameron, Av. *Changing cultures in early Byzantium.* Aldershot 1996.

Canivet, P., and M. T. Canivet. *Ḥūarte, sanctuaire chrétien d'Apamène (IVe-VIe s.).* Paris 1987.

Carlier, P., and F. Morin. "Qaṣtal: Un site umayyade complet." *Archiv für Orientforschung* 33 (1986) 187–206.

———. "Recherches archéologiques au chateau de Qaṣṭal (Jordanie)." *A.D.A.J.* 28 (1984) 343–83.

Cecchelli, C., I. Furlani, and M. Salmi, eds. *Evangeliarii syriaci, vulgo Rabbulae, in Bibliotheca Medicea-Laurentiana (Plut. I,56) adservati ornamenta.* Olten 1959.

Chalon, M., G. Devallet, P. Force, M. Griffe, J.-M. Lassère, and J.-N. Michaud. "Memorabile factum: Une célébration de l'évergétisme des rois vandales dans l'Anthologie latine." *Antiquités africaines* 21 (1985) 207–62.

Charpentier, G. "Les bains de Sergilla." *Syria* 71 (1994) 113–42.

———. "Les petits bains proto-byzantins de la Syrie du nord." *ΤΟΠΟΙ* 5 (1995) 219–47.

Chateaux omayyades de Syrie: Collections du Musée National de Damas, 16 septembre 1990–17 mars 1991. Institut du Monde Arabe. Paris 1990.

Chehab, H. Z. "On the identification of 'Anjar ('Ayn al-Jarr) as an Umayyad foundation." *Muqarnas* 10 (1993) 42–48.

Chokr, M. *Zandaqa et zindīqs en Islam au second siècle de l'Hégire.* Damascus 1993.

Choksy, J. K. "Gesture in ancient Iran and Central Asia I: The raised hand." *Iranica varia: Papers in honor of Professor Ehsan Yarshater*, 30–37. Acta iranica 30. Leiden 1990.

Christensen, A. *L'Iran sous les Sassanides.* Copenhagen 1944².

Clarke, J. R. *Looking at lovemaking: Constructions of sexuality in Roman art 100 B.C.–A.D. 250.* Berkeley 1998.

Colledge, M. A. R. *The art of Palmyra.* London 1976.

Collins, R. *The Arab conquest of Spain, 710–797.* Oxford 1989.

Conrad, L. I. "The conquest of Arwād: A source-critical study in the historiography of the early medieval Near East." *B.E.I.N.E.* 1.317–401.

———. "Epidemic disease in central Syria in the late sixth century: Some new insights from the verse of Ḥassān ibn Thābit." *Byzantine and modern Greek studies* 18 (1994) 12–58.

———. "Historical evidence and the archaeology of early Islam." In *Quest for understanding: Arabic and Islamic studies in memory of Malcolm H. Kerr*, edited by S. Seikaly, R. Baalbaki, and P. Dodd, 263–82. Beirut 1991.

———. "The *quṣūr* of medieval Islam: Some implications for the social history of the Near East." *Al-abhath* 29 (1981) 7–23.

———. "Varietas syriaca: Secular and scientific culture in the Christian communities of Syria after the Arab conquest." In *After Bardaisan: Studies on continuity and change in Syriac Christianity in honour of Professor Han J. W. Drijvers*, edited by G. J. Reinink and A.C. Klugkist, 85–105. Leuven 1999.

Conticello, V. S. "Jean Damascène." In *Dictionnaire des philosophes antiques*, edited by R. Goulet, 3.989–1012. Paris 1989–.

Cook, M. *Early Muslim dogma: A source-critical study.* Cambridge 1981.

Cosentino, A. "Adamo in trono." http://utenti.lycos.it/augustocosentino/Viaggistorici.htm.

Crone, P. *Meccan trade and the rise of Islam.* Oxford 1987.

———. *Slaves on horses: The evolution of the Islamic polity.* Cambridge 1980.

Crone, P., and M. Hinds. *God's caliph: Religious authority in the first centuries of Islam.* Cambridge 1986.

Daems, A. "The iconography of pre-Islamic women in Iran." *Iranica antiqua* 36 (2001) 1–150.

Dagron, G. *Constantinople imaginaire: Études sur le recueil des Patria.* Paris 1984.

———. *Empereur et prêtre: Étude sur le "césaropapisme" byzantin.* Paris 1996.

Dalton, O. M. *Byzantine art and archaeology.* Oxford 1911.

Daniel, R. W. "P. Petra inv. 10 and its Arabic." In *Atti del XXII congresso internazionale di papirologia,* edited by I. Andorlini, G. Bastianini, and G. Menci, 331–41. Florence 2001.

Deichmann, F. W. *Ravenna: Hauptstadt des spätantiken Abendlandes.* Wiesbaden; Stuttgart 1969–89.

Delmont, E., ed. *Jordanie: Sur les pas des archéologues.* Paris 1997.

Dentzer, J.-M. "Khāns ou casernes à Palmyre? A propos de structures visibles sur des photographies aériennes anciennes." *Syria* 71 (1994) 45–112.

De Vries, B. "Continuity and change in the urban character of the Southern Hauran from the 5th to the 9th century: The archaeological evidence at Umm al-Jimal." *Mediterranean archaeology* 13 (2000) 39–45.

———. "Research goals and implementation" and "Towards a history of Umm el-Jimal in late antiquity." In *Umm el-Jimal: A frontier town and its landscape in northern Jordan 1: Fieldwork 1972–1981,* edited by B. de Vries et al., 15–26. Portsmouth, R.I., 1998.

Dirven, L. "The arrival of the goddess Allat in Palmyra." *Mesopotamia* 33 (1998) 297–307.

Di Segni, L. "The Greek inscriptions of Hammat Gader." In *The Roman baths of Hammat Gader: Final report,* by Y. Hirschfeld, 185–266. Jerusalem 1997.

Dodd, E. C. "The monastery of Mar Musa al-Habashi, near Nebek, Syria." *Arte medievale* 6 (1992) 61–132.

Donceel-Voûte, P. *Les pavements des églises byzantines de Syrie et du Liban: Décor, archéologie et liturgie.* Louvain-la-Neuve 1988.

Donner, F. M. *The early Islamic conquests.* Princeton 1981.

———. *Narratives of Islamic origins: The beginnings of Islamic historical writing.* Princeton 1998.

Dorna-Metzger, F. "Céramique byzantino-sassanide de Nisibe: Étude préliminaire." In *La céramique byzantine et proto-islamique en Syrie-Jordanie (IVᵉ-VIIIᵉ siècles apr. J.-C.),* edited by E. Villeneuve and P. M. Watson, 13–22. Beirut 2001.

Doughty, C. M. *Travels in Arabia deserta.* London 1936³.

Dow, M. *Islamic baths of Palestine.* Oxford 1996.

Dozy, R. *Dictionnaire détaillée des noms des vêtements chez les arabes.* Amsterdam 1843.

———. *Supplément aux dictionnaires arabes.* Leiden 1881.

Drandaki, A. "*"ΥΓΙΕΝΩΝ ΧΡΩ ΚΥΡΙ(Ε)*" A late Roman brass bucket with a hunting scene." *Μουσείο Μπενάκη* 2 (2002) 37–53.

Duchesne-Guillemin, M. *Les instruments de musique dans l'art sassanide.* Gent 1993.

Dunbabin, K. M. D. "Baiarum grata voluptas: Pleasures and dangers of the baths." *Papers of The British School at Rome* 57 (1989) 6–46.

———. *The mosaics of Roman North Africa: Studies in iconography and patronage.* Oxford 1978.

Duri, A. A. *The rise of historical writing among the Arabs.* Edited and translated by L. I. Conrad. Princeton 1983.

Dvořák, M. "Alois Riegl." *Mitteilungen der k.k. Zentralkommission für Erforschung und Erhaltung der Kunst- und historischen Denkmale* 3ᵉ Folge, 4 (1905) 255–76.

Eberlein, J. K. *Apparitio regis-revelatio veritatis: Studien zur Darstellung des Vorhangs in der bildenden Kunst von der Spätantike bis zum Ende des Mittelalters.* Wiesbaden 1982.

Egan, V., and P. Bikai. "Archaeology in Jordan." *American journal of archaeology* 103 (1999) 485–520.

Eisener, R. *Zwischen Faktum und Fiktion: Eine Studie zum Umayyadenkalifen Sulaimān b. ʿAbdalmalik und seinem Bild in den Quellen.* Wiesbaden 1987.

Elad, A. *Medieval Jerusalem and Islamic worship: Holy places, ceremonies, pilgrimage.* Leiden 1995.

———. "Why did ʿAbd al-Malik build the Dome of the Rock? A re-examination of the Muslim sources." *Bayt al-Maqdis* 1.33–58.

Elsner, J. "The birth of late antiquity: Riegl and Strzygowski in 1901." *Art history* 25 (2002) 358–79.

Enderlein, V. "Syria and Palestine: The Umayyad Caliphate." In *Islam: Art and architecture,* edited by M. Hattstein and P. Delius, 58–87. Cologne 2000.

Enderlein, V., and M. Meinecke. "Graben-Forschen-Präsentieren: Probleme der Darstellung vergangener Kulturen am Beispiel der Mschatta-Fassade." *J.B.M.* 34 (1992) 137–72.

Esin, E. "The Turk al-ʿĀğam of Sāmarrā and the paintings attributable to them in the Ğawsaq al-Ḫāqānī." *Kunst des Orients* 9 (1973–74) 47–88.

Ess, J. van. *Theologie und Gesellschaft im 2. und 3. Jahrhundert Hidschra: Eine Geschichte des religiösen Denkens im frühen Islam.* Berlin 1991–97.

Ettinghausen, R. *Arabische Malerei.* Geneva 1962.

———. *From Byzantium to Sasanian Iran and the Islamic world: Three modes of artistic influence.* Leiden 1972.

———. *Islamic art and archaeology: Collected papers.* Edited by M. Rosen-Ayalon. Berlin 1984.

Farioli Campanati, R. "Città, edifici e strutture architettoniche nei mosaici pavimentali del Vicino Oriente: Giordania e Siria." *Felix Ravenna* 145–48 (1993–94) [1999] 259–91.

———. "Considerazioni sui pavimenti musivi cristiani della Giordania." In *I mosaici di Giordania,* edited by M. Piccirillo, 157–62. Rome 1986.

———. "Decorazioni di origine tessile nel repertorio del mosaico pavimentale protobizantino del Vicino Oriente e le corrispondenze decorative parietali di Ravenna, Salonicco, Costantinopoli e Qusayr 'Amra." *XXXIX corso di cultura sull' arte ravennate e bizantina* (1992) 275–95.

———. "Il mosaico pavimentale d'epoca umayyade della chiesa di S. Giorgio nel Deir al-Adas (Siria)." In *Arte profana e arte sacra a Bisanzio,* edited by A. Iacobini and E. Zanini, 257–69. Rome 1995.

Fernández-Puertas, A. "La inscripción cúfica sobre la ventana del testero de la nave derecha del gran salón." *Q.'A.* 149–51.

Fiey, J. M. "Les "Nabaṭ" de Kaskar-Wāsiṭ dans les premiers siècles de l'Islam." *Mélanges de l'Université Saint-Joseph* 51 (1990) 51–87.

Finster, B. "Arabien in der Spätantike: Ein Überblick über die kulturelle Situation der Halbinsel in der Zeit von Muhammad." *A.A.* (1996) 287–319.

———. "Probleme der Antikenrezeption in der umayyadischen Kunst." In *Die Gegenwart des Altertums: Formen und Funktionen des Altertumsbezugs in den Hochkulturen der Alten Welt,* edited by D. Kuhn and H. Stahl, 373–89. Heidelberg 2001.

Finster, B., and J. Schmidt. "Sasanidische und frühislamische Ruinen im Iraq." *Baghdader Mitteilungen* 8 (1976).

Flood, F. B. *The Great Mosque of Damascus: Studies on the makings of an Umayyad visual culture.* Leiden 2001.

———. "Light in stone: The commemoration of the Prophet in Umayyad architecture." *Bayt al-Maqdis* 2.311–59.

Flusin, B. "L'esplanade du Temple à l'arrivée des Arabes, d'après deux récits byzantins." *Bayt al-Maqdis* 1.17–31.

Fontana, M. V. "Ancora sulla caccia di Bahrām Gūr e Āzāda." In *Haft qalam: Cento pagine in onore di Bianca Maria Alfieri da parte dei suoi allievi,* 15–37. Naples 2000.

———. *La leggenda di Bahrām Gūr e Āzāda: Materiale per la storia di una tipologia figurativa dalle origini al XIV secolo.* Naples 1986.

Forsyth, G. H. "The monastery of St. Catherine at Mount Sinai: The church and fortress of Justinian." *D.O.P.* 22 (1968) 3–19.

Forsyth, G. H., and K. Weitzmann. *The monastery of Saint Catherine at Mount Sinai: The church and fortress of Justinian. Plates.* Ann Arbor n.d. [1973].

Foss, C. "Syria in transition, A.D. 550–750: An archaeological approach." *D.O.P.* 51 (1997) 189–269.

Fowden, E. K. "An Arab building at al-Ruṣāfa-Sergiopolis." *Da.M.* 12 (2000) 303–24.

———. *The Barbarian Plain: Saint Sergius between Rome and Iran.* Berkeley 1999.

Fowden, G. "'Desert kites': Ethnography, archaeology and art." In *The Roman and Byzantine Near East.* Vol. 2, *Some recent archaeological research,* edited by J. H. Humphrey, 107–36. Portsmouth, R.I., 1999.

———. *Empire to commonwealth: Consequences of monotheism in late antiquity.* Princeton 1993.

Fowler, D. *Roman constructions: Readings in postmodern Latin.* Oxford 2000.

Franklin, S. *Byzantium-Rus-Russia: Studies in the translation of Christian culture.* Aldershot 2002.

Gabrieli, F. *Il califfato di Hishâm: Studi di storia omayyade.* Alexandria 1935.

Gall, H. von. "Entwicklung und Gestalt des Thrones im vorislamischen Iran." *A.M.I.* 4 (1971) 207–35.

———. "Die Mosaiken von Bishapur und ihre Beziehung zu den Triumphreliefs des Shapur I." *A.M.I.* 4 (1971) 193–205.

Gatier, P.-L. "Les inscriptions grecques d'époque islamique (VIIᵉ—VIIIᵉ siècles) en Syrie du sud." *S.Byz.Is.* 145–57. Updated version: "Le témoignage des inscriptions grecques de l'époque islamique au Proche-Orient (VIIᵉᵐᵉ–VIIIᵉᵐᵉ s.)." Unpublished paper submitted to the Central European University Humanities Center and Maison des Sciences de l'Homme colloquium "Islam and late antiquity," Budapest, 24–26 January 2003.

———. "Un moine sur la frontière, Alexandre l'Acémète en Syrie." In *Frontières terrestres, frontières célestes dans l'antiquité*, edited by A. Rousselle, 435–57. Paris 1995.

Gaube, H. "ʿAmmān, Ḥarāne und Qasṭal: Vier frühislamische Bauwerke in Mitteljordanien." *Z.D.P.V.* 93 (1977) 52–86.

———. *Ein arabischer Palast in Südsyrien: Ḥirbet el-Baiḍa.* Beirut 1974.

———. "An examination of the ruins of Qasr Burquʿ." *A.D.A.J.* 19 (1974) 93–100.

———. "Die syrischen Wüstenschlösser: Einige wirtschaftliche und politische Gesichtspunkte zu ihrer Entstehung." *Z.D.P.V.* 95 (1979) 182–209.

Genequand, D. "Une mosquée à Qusayr ʿAmra." *A.D.A.J.* 46 (2002) 583–89.

Gerstinger, H. *Dioscurides: Codex Vindobonensis Med. Gr. 1 der Österreichischen Nationalbibliothek.* Graz 1970.

Geyer, B. "Des fermes Byzantines aux palais omayyades ou l'ingénieuse mise en valeur des plaines steppiques de Chalcidique." In *Aux origines de l'archéologie aérienne: A. Poidebard (1878–1955)*, edited by L. Nordiguian and J.-F. Salles, 109–22. Beirut 2000.

Geyer, R. "Musil und die Beduinen." *Memnon* 1 (1907) 194–206.

———. "Das Wüstenschloss ʿAmra." *Deutsche Literaturzeitung* 28 (1907) 2053–56.

Ghanimati, S. "New perspectives on the chronological and functional horizons of the Kuh-e Khwaja in Sistan." *Iran* 38 (2000) 137–50.

Ghirshman, R. *Bîchâpour.* Paris 1956–71.

———. *Iran: Parther und Sasaniden.* Munich 1962.

———. "Notes iraniennes V: Scènes de banquet sur l'argenterie sassanide." *Artibus asiae* 16 (1953) 51–76.

Gil, M. *A history of Palestine, 634–1099.* Translated by E. Broido. Cambridge 1992.

Gillon, J.-Y. *Les anciennes fêtes de printemps à Ḥomṣ.* Damascus 1993.

Gnilka, C. *XPHΣIΣ/CHRESIS: Die Methode der Kirchenväter im Umgang mit der antiken Kultur.* Basel 1984–93.

Göbl, R. *Sasanidische Numismatik*. Braunschweig 1968.

Goldman, B. "The later pre-Islamic riding costume." *Iranica antiqua* 28 (1993) 201–46.

———. "Women's robing in the Sasanian era." *Iranica antiqua* 32 (1997) 233–300.

Goldziher, I. *Introduction to Islamic theology and law*. Translated by A. Hamori and R. Hamori. Princeton 1981.

———. *Muslim studies*. Edited by S. M. Stern and translated by C. R. Barber and S. M. Stern. London 1967–71.

———. *Tagebuch*. Edited by A. Scheiber. Leiden 1978.

Gombrich, E. H. *Art and illusion: A study in the psychology of pictorial representation*. New York 1961².

———. *The sense of order: A study in the psychology of decorative art*. London 1984².

Grabar, A. *L'art de la fin de l'antiquité et du moyen age*. Paris 1968.

———. *L'empereur dans l'art byzantin: Recherches sur l'art officiel de l'empire d'Orient*. Paris 1936; reprinted with additions, London 1971.

———. *Le premier art chrétien (200–395)*. Paris 1966.

Grabar, O. "L'art omeyyade en Syrie, source de l'art islamique." *S.Byz.Is.* 187–93.

———. "The date and meaning of Mshatta." *D.O.P.* 41 (1987) 243–47.

———. *The formation of Islamic art*. Rev. ed. New Haven 1987.

———. "Notes sur les cérémonies umayyades." In *Studies in memory of Gaston Wiet*, edited by M. Rosen-Ayalon, 51–60. Jerusalem 1977.

———. "Note sur une inscription grecque à Qusayr ʿAmrah." *Revue des études islamiques* 54 (1986) 127–32.

———. "The painting of the six kings at Quṣayr ʿAmrah." *A.O.* 1 (1954) 185–87.

———. "The paintings." In *K.M.*, 294–326.

———. "The paintings at Qusayr Amrah: The private art of an Umayyad prince." Unpublished typescript, 1975.

———. *Penser l'art islamique: Une esthétique de l'ornement*. Paris 1996.

———. "La place du Qusayr Amrah dans l'art profane du Haut Moyen Age." *C.A.* 36 (1988) 75–83.

———. *The shape of the holy: Early Islamic Jerusalem*. Princeton 1996.

———. "A small episode of early ʿAbbāsid times and some consequences." *Eretz-Israel* 7 (*L. A. Mayer memorial volume (1895–1959)*) (1964) 44*–47*.

———. *Studies in medieval Islamic art*. London 1976.

———. "Umayyad palaces reconsidered." *A.O.* 23 (1993) 93–108.

———. Review of Creswell, *I.J.M.E.S.* 3 (1972) 217–22.

Graf, D. F. *Rome and the Arabian frontier: From the Nabataeans to the Saracens*. Aldershot 1997.

Graf, D. F., with E. L. Dreyer. "The Roman East from the Chinese perspective." *A.A.A.S.* 42 (1996) 199–216.

Gregory, S. *Roman military architecture on the eastern frontier*. Amsterdam 1995–97.

———. "Was there an eastern origin for the design of late Roman fortifications? Some problems for research on forts of Rome's eastern frontier." In *The Roman army in the East,* edited by D. L. Kennedy, 169–209. Ann Arbor 1996.

Grierson, P. *Catalogue of the Byzantine coins in the Dumbarton Oaks collection and in the Whittemore collection.* Vol. 2, *Phocas to Theodosius III, 602–717.* Washington, D.C., 1968.

Griffith, S. H. *Arabic Christianity in the monasteries of ninth-century Palestine.* Aldershot 1992.

———. "From Aramaic to Arabic: The languages of the monasteries of Palestine in the Byzantine and early Islamic periods." *D.O.P.* 51 (1997) 12–31.

Grignaschi, M. "Les "Rasāʾil ʾAristāṭālīsa ʾilā-l-Iskandar" de Sālim Abū-l-ʿAlāʾ et l'activité culturelle à l'époque omayyade." *Bulletin d'études orientales* 19 (1965–66) 7–83.

———. "Le roman épistolaire classique conservé dans la version arabe de Sâlim Abû-l-ʿAlâʾ." *Le muséon* 80 (1967) 211–64.

———. "Un roman épistolaire gréco-arabe: La correspondence [sic] entre Aristote et Alexandre." In *The problematics of power: Eastern and western representations of Alexander the Great,* edited by M. Bridges and J. C. Bürgel, 109–23. Bern 1996.

Grohmann, A. *Arabische Paläographie.* Vienna 1967–71.

———. "Beiträge zur arabischen Epigraphik und Papyruskunde." *Islamica* 2 (1926) 219–32.

———. *Expédition Philby-Ryckmans-Lippens en Arabie.* Pt. 2, *Textes épigraphiques,* vol. 1, *Arabic inscriptions.* Louvain 1962.

Grossmann, P. "Zu den Bogen und Gewölben in dem Wüstenpalast von Qaṣr ibn Wardān." *Da.M.* 12 (2000) 291–302.

Grotzfeld, H. *Das Bad im arabisch-islamischen Mittelalter: Eine kulturgeschichtliche Studie.* Wiesbaden 1970.

Gutas, D. *Greek thought, Arabic culture: The Graeco-Arabic translation movement in Baghdad and early ʿAbbāsid society (2nd–4th/8th–10th centuries).* London 1998.

Gyssens, J. C., and F. al-Khraysheh. "Preliminary report of reconnaissance survey in the region of Wādī Bāyir." *A.D.A.J.* 39 (1995) 355–64.

Haase, C.-P. "Is Madinat al-Far, in the Balikh region of northern Syria, an Umayyad foundation?" *ARAM periodical* 6 (1994) 245–57.

———. "Untersuchungen zur Landschaftsgeschichte Nordsyriens in der Umayyadenzeit." Diss., Hamburg, Kiel 1975.

Haddad, R. "La phonétique de l'arabe chrétien vers 700." *S.Byz.Is.* 159–64.

Hamarneh, B. *Topografia cristiana ed insediamenti rurali nel territorio dell' odierna Giordania nelle epoche bizantina ed islamica, V–IX sec.* Vatican City 2003.

Hamilton, R. W. *The structural history of the Aqsa mosque: A record of archaeological gleanings from the repairs of 1938–1942.* Jerusalem 1949.

———. "Who built Khirbat al Mafjar?" *Levant* 1 (1969) 61–67.

Hanisch, L., ed. *Islamkunde und Islamwissenschaft im Deutschen Kaiserreich: Der Briefwechsel zwischen Carl Heinrich Becker und Martin Hartmann (1900–1918).* Leiden 1992.

Harper, P. O. *The royal hunter: Art of the Sasanian Empire.* New York 1978.

———. *Silver vessels of the Sasanian period.* Vol. 1, *Royal imagery.* New York 1981.

———. "Sources of certain female representations in Sasanian art". In *Atti del convegno internazionale sul tema: La Persia nel medioevo,* 503–15. Rome 1971.

———. "Thrones and enthronement scenes in Sasanian art." *Iran* 17 (1979) 49–64.

Harrison, D. L., and P. J. J. Bates. *The mammals of Arabia.* Sevenoaks 1991².

Hartel, W. von, and F. Wickhoff. *Die Wiener Genesis.* Vienna 1895. (Partially translated into English by S. A. Strong, in *Roman art: Some of its principles and their application to early Christian painting* [London 1900].)

Hauben, H. ""Onagres" et "hémionagres" en Transjordanie au III^e siècle avant J.-C." *Ancient society* 15–17 (1984–86) 89–111.

Hebbo, A. I. "Die Fremdwörter in der arabischen Prophetenbiographie des Ibn Hischam (gest. 218/834)." Diss., Heidelberg, 1970.

Helms, S. *Early Islamic architecture of the desert: A bedouin station in eastern Jordan.* Edinburgh 1990.

Herzfeld, E. "Die Genesis der islamischen Kunst und das Mshatta-Problem." *Der Islam* 1 (1910) 27–63, 105–44.

———. "Khusrau Parwēz und der Ṭāq i Vastān." *A.M.I.* 9 (1938) 91–158.

———. "'Die Könige der Erde.'" *Der Islam* 21 (1933) 233–36.

———. *Die Malereien von Samarra.* Berlin 1927.

———. "Mshattâ, Ḥîra und Bâdiya: Die Mittelländer des Islam und ihre Baukunst." *Jahrbuch der Preuszischen Kunstsammlungen* 42 (1921) 104–46.

Hillenbrand, R. "Creswell and contemporary Central European scholarship." *Muqarnas* 8 (1991) 23–35.

———. "*La dolce vita* in early Islamic Syria: The evidence of later Umayyad palaces." *Art history* 5 (1982) 1–35.

———. *Islamic architecture: Form, function and meaning.* Edinburgh 1994; corrected reprint 2000.

———. "Islamic art at the crossroads: East versus West at Mshattā." In *Essays in Islamic art and architecture in honor of Katharina Otto-Dorn,* edited by A. Daneshvari, 63–86. Malibu 1981.

———. "Qasr Kharana re-examined." *Oriental art* 37 (1991) 109–13.

———. "Umayyad woodwork in the Aqṣā mosque." *Bayt al-Maqdis* 2.271–310.

Holum, K. G. "The temple platform: Progress report on the excavations." In *Caesarea papers,* edited by K. G. Holum, A. Raban, and J. Patrich, 2.12–34. Portsmouth, R.I., 1999.

Honeyman, A. M. "The Hombrechtikon plaque." *Iraq* 16 (1954) 23–28.

Horovitz, J. "ʿAdi ibn Zeyd, the poet of Hira." Translated by M. Pickthall. *Islamic culture* 4 (1930) 31–69.

Hourani, A. H. *Islam in European thought.* Cambridge 1991.

Hoyland, R. G. "The content and context of early Arabic inscriptions." *J.S.A.I.* 21 (1997) 77–102.

———. *Seeing Islam as others saw it: A survey and evaluation of Christian, Jewish and Zoroastrian writings on early Islam.* Princeton 1997.

Humbert, J.-B. "El-Fedein/Mafraq." In *Contribution française à l'archéologie jordanienne*, 125–31. Amman 1989.

———. "El-Fedein/Mafraq." *Liber annuus* (Studium Biblicum Franciscanum, Jerusalem) 36 (1986) 354–58.

Humbert, J.-B., and A. Desreumaux, eds. *Fouilles de Khirbet es-Samra en Jordanie.* Vol. 1, *La voie romaine, le cimetière, les documents épigraphiques.* Turnhout 1998.

Hunt, L.-A. "The Byzantine mosaics of Jordan in context: Remarks on imagery, donors and mosaicists." *P.E.Q.* 126 (1994) 106–26.

Hurgronje, C. S. *Mekka.* The Hague 1888–89.

Ihm, C. *Die Programme der christlichen Apsismalerei vom 4. Jahrhundert bis zur Mitte des 8. Jahrhunderts.* Stuttgart 1992[2].

Iliffe, J. H. "Imperial art in Transjordan: Figurines and lamps from a potter's store at Jerash." *Q.D.A.P.* 12 (1946) 1–26.

Imbert, F. "Le Coran dans les graffiti des deux premiers siècles de l'Hégire." *Arabica* 47 (2000) 381–90.

———. *Un corpus des inscriptions arabes de Jordanie du nord.* Damascus, forthcoming.

———. "La nécropole islamique de Qasṭal al-Balqāʾ en Jordanie." *Archéologie islamique* 3 (1992) 17–59.

Jabbur, J. S. *The bedouins and the desert: Aspects of nomadic life in the Arab East.* Edited by S. J. Jabbur and L. I. Conrad and translated by L. I. Conrad. Albany 1995.

Jamil, N. "Caliph and quṭb. Poetry as a source for interpreting the transformation of the Byzantine cross on steps on Umayyad coinage." *Bayt al-Maqdis* 2.11–57.

Jayyusi, S. K. "Umayyad poetry." *A.L.U.P.* 387–432.

Jeffery, A. *The foreign vocabulary of the Quran.* Baroda 1938.

Jenkins, J., and P. R. Olsen. *Music and musical instruments in the world of Islam.* London 1976.

Johansen, B. "The valorization of the human body in Muslim Sunni law." In *Law and society in Islam*, edited by D. J. Stewart, B. Johansen, and A. Singer, 71–112. Princeton 1996.

Johns, C. *The jewellery of Roman Britain: Celtic and classical traditions.* London 1996.

Johns, J. "The 'House of the Prophet' and the concept of the mosque." *Bayt al-Maqdis* 2.59–112.

Johnson, D. W. "Dating the *Kebra Nagast*: Another look." In *Peace and war in Byzantium: Essays in honor of George T. Dennis, S.J.*, edited by T. S. Miller and J. Nesbitt, 197–208. Washington, D.C., 1995.

Jones, L. "The visual expression of power and piety in medieval Armenia: The palace and palace church at Aghtamar." In *Eastern approaches to Byzantium,* edited by A. Eastmond, 221–41. Aldershot 2001.

Journeys through desert and time: Historical photographs of this country and its people by Alois Musil. Amman [1999].

Justi, F. *Iranisches Namenbuch.* Marburg 1895.

Kádár, Z. "La *ΧΑΡΙΣ*" nei ritratti dei giovani santi di Cipro sui mosaici di S. Giorgio a Salonicco." *Acta antiqua Academiae Scientiarum Hungaricae* 40 (2000) 205–11.

———. *Survivals of Greek zoological illuminations in Byzantine manuscripts.* Budapest 1978.

Karabacek, J. [von]. "Datierung und Bestimmung des Baues." *K.A.* 1.213–38.

———. "Über die Auffindung eines Chalifenschlosses in der nordarabischen Wüste." *Almanach der Kaiserlichen Akademie der Wissenschaften* 52 (1902) 339–61.

Karev, Y. "Nouvelles recherches dans la citadelle de l'ancienne Samarkand." *Bulletin: Fondation Max van Berchem* 15 (2001) 1–4.

———. "Un palais islamique du VIII^e siècle à Samarkand." *Studia iranica* 29 (2000) 273–96.

Kawami, T. S. "Kuh-e Khwaja, Iran, and its wall paintings: The records of Ernst Herzfeld." *Metropolitan Museum journal* 22 (1987) 13–52.

Kazhdan, A., with L. F. Sherry and C. Angelidi. *A history of Byzantine literature (650–850).* Athens 1999.

Keall, E. J., M. A. Leveque, and N. Willson. "Qal'eh-i Yazdigird: Its architectural decorations." *Iran* 18 (1980) 1–41.

Kellner-Heinkele, B. "Ruṣāfa in den arabischen Quellen." In *Resafa.* Vol. 4, *Die Grosse Moschee von Resafa-Ruṣāfat Hišām,* edited by D. Sack, 133–54. Mainz 1996.

Kennedy, C. A. "The development of the lamp in Palestine." *Berytus* 14 (1961–63) 67–115.

Kennedy, D. L. "Ancient Jordan from the air." *ARAMCO world* 51(3) (2000) 36–46.

———. *Archaeological explorations on the Roman frontier in north-east Jordan: The Roman and Byzantine military installations and road network on the ground and from the air.* Oxford 1982.

———. "Relocating the past: Missing inscriptions from Qasr el-Hallabat and the air photographs of Sir Aurel Stein for Transjordan." *P.E.Q.* 132 (2000) 28–36.

———. *The Roman army in Jordan.* London 2000.

Kennedy, H. *The Prophet and the age of the caliphates: The Islamic Near East from the sixth to the eleventh century.* Harlow 2004².

Kennedy, P. F. *The wine song in classical Arabic poetry: Abū Nuwās and the literary tradition.* Oxford 1997.

Kessler, C. "The floor mosaics of Quṣayr 'Amra." In Creswell, 416–23.

Khairy, N. I., and A.-J. A. ʿAmr. "Early Islamic inscribed pottery lamps from Jordan." *Levant* 18 (1986) 143–53.

Khalidi, T. *Arabic historical thought in the classical period.* Cambridge 1994.

Khamis, E. "A bronze weight of Saʿīd b. ʿAbd al-Malik from Bet Shean/Baysân." *Journal of the Royal Asiatic Society* 12 (2002) 143–54.

———. "Two wall mosaic inscriptions from the Umayyad market place in Bet-Shean/Baysān." *B.S.O.A.S.* 64 (2001) 159–76.

Khan, M., and A. Al-Mughannam. "Ancient dams in the Tāʾif area 1981 (1401)." *Atlal* 6 (1982) 125–35.

Khoury, N. N. N. "The mihrab: From text to form." *I.J.M.E.S.* 30 (1998) 1–27.

Khoury, R. G. *Wahb b. Munabbih.* Wiesbaden 1972.

Khraysheh, F. H. "New Safaitic inscriptions from Jordan." *Syria* 72 (1995) 401–14.

Kiilerich, B. "The abundance of nature—the wealth of man: Reflections on an early Byzantine seasons mosaic from Syria." In *Kairos: Studies in art history and literature in honour of Professor Gunilla Åkerström-Hougen,* edited by E. Piltz and P. Åström, 22–36. Jonsered 1998.

Kilpatrick, H. *Making the great Book of songs: Compilation and the author's craft in Abū l-Faraj al-Iṣbahānī's Kitāb al-aghānī.* London 2003.

———. "Monasteries through Muslim eyes: The *diyārāt* books." In *Christians at the heart of Islamic rule: Church life and scholarship in ʿAbbasid Iraq,* edited by D. Thomas, 19–37. Leiden 2003.

King, G. R. D. "The distribution of sites and routes in the Jordanian and Syrian deserts in the early Islamic period." *Proceedings of the seminar for Arabian studies* 17 (1987) 91–105.

———. "Islam, iconoclasm, and the declaration of doctrine." *B.S.O.A.S.* 48 (1985) 267–77.

———. "Preliminary report on a survey of Byzantine and Islamic sites in Jordan 1980." *A.D.A.J.* 26 (1982) 85–95.

———. "Settlement patterns in Islamic Jordan: The Umayyads and their use of the land." *S.H.A.J.* 4 (1992) 369–75.

———. "The Umayyad qusur and related settlements in Jordan." In *The fourth international conference on the history of Bilād al-Shām during the Umayyad period. Proceedings of the third symposium, English section* 2, edited by M. A. Bakhit and R. Schick, 71–80. Amman 1989.

King, G. R. D., C. J. Lenzen, A. Newhall, J. L. King, J. D. Deemer, and G. O. Rollefson. "Survey of Byzantine and Islamic sites in Jordan, third preliminary report (1982): The Wādī ʿArabah (part 2)." *A.D.A.J.* 33 (1989) 199–215.

King, G., C. J. Lenzen, and G. O. Rollefson. "Survey of Byzantine and Islamic sites in Jordan: Second season report (1981)." *A.D.A.J.* 27 (1983) 385–436.

Kislev, M. E. "Reference to the pistachio tree in Near East geographical names." *P.E.Q.* 117 (1985) 133–38.

Kiss, E. "Σύνολο πλακιδίων που συνθέτουν το "Στέμμα του Μονομάχου"." In *Το Βυζάντιο ως οικουμένη,* 78–83. Athens 2001.

Kister, M. J. ""Exert yourselves, O Banū Afrida!": Some notes on entertainment in the Islamic tradition." *J.S.A.I.* 23 (1999) 53–78.

———. *Studies in Jāhiliyya and early Islam.* London 1980.

Kleemann, I. *Der Satrapen-Sarkophag aus Sidon.* Berlin 1958.

Kleinbauer, W. E. "The double-shell tetraconch building at Perge in Pamphylia and the origin of the architectural genus." *D.O.P.* 41 (1987) 277–93.

Kleiss, W. "Die sasanidische Brücke und das Paradeisos." In *Bisutun: Ausgrabungen und Forschungen in den Jahren 1963–1967,* edited by W. Kleiss and P. Calmeyer, 99–113. Berlin 1996.

Kondoleon, C. *Antioch, the lost ancient city.* Princeton 2000.

Kourkoutidou-Nikolaïdou, E., and A. Tourta. Περίπατοι στή Βυζαντινή Θεσσαλονίκη. Athens 1997.

Kraemer, C. J. *Excavations at Nessana.* Vol. 3, *Non-literary papyri.* Princeton 1958.

Krautheimer, R. *Early Christian and Byzantine architecture.* Revised by R. Krautheimer and S. Ćurčić. Harmondsworth 1986⁴.

Kropáček, L. "Alois Musil on Islam." *Archív orientální* 63 (1995) 401–9.

Kubiak, W. B. *Al-Fustat: Its foundation and early urban development.* Cairo 1987.

Küchler, M. "Moschee und Kalifenpaläste Jerusalems nach den Aphrodito-Papyri." *Z.D.P.V.* 107 (1991) [1992] 120–43.

Lammens, H. "Ajā'ib bilād Mu'āb." *Al-Mashriq* 10 (1907) 577–81.

———. "Aqdam athar li-Banī Ghassān aw akhribat al-Mushattā." *Al-Mashriq* 1 (1898) 481–87, 630–37.

———. *Études sur le siècle des Omayyades.* Beirut 1930.

Lampe, G. W. H., ed. *A patristic Greek lexicon.* Oxford 1961.

Lane, E. W. *An account of the manners and customs of the modern Egyptians written in Egypt during the years 1833–1835.* London 1836.

———. *An Arabic-English lexicon.* London 1863–93.

Lankester Harding, G. "The cairn of Hani'." *A.D.A.J.* 2 (1953) 8–56.

Lapidge, M., ed. *Archbishop Theodore: Commemorative studies on his life and influence.* Cambridge 1995.

Lapidus, I. M. "Arab settlement and economic development of Iraq and Iran in the age of the Umayyad and early Abbasid caliphs." In *The Islamic Middle East, 700–1900: Studies in economic and social history,* edited by A. L. Udovitch, 177–208. Princeton 1981.

Latham, J. D. "The beginnings of Arabic prose literature: The epistolary genre." *A.L.U.P.* 154–79.

Lavin, I. "The hunting mosaics of Antioch and their sources: A study of compositional principles in the development of early mediaeval style." *D.O.P.* 17 (1963) 179–286.

Lawrence, T. E. *Seven pillars of wisdom: A triumph.* London 1935.

Lecker, M. "The estates of 'Amr b. al-'Āṣ in Palestine: Notes on a new Negev Arabic inscription." *B.S.O.A.S.* 52 (1989) 24–37.

———. *Muslims, Jews and pagans: Studies on early Islamic Medina.* Leiden 1995.

Lecomte, O. "Les Lakhmides d'al-Ḥīrā: Des arabes en basse Mésopotamie (IIIᵉ–VIIᵉ siècles apr. J.-C.)." In *Études mésopotamiennes: Recueil de textes offert à Jean-Louis Huot,* edited by C. Breniquet and C. Kepinski, 315–21. Paris 2001.

Lee, J. L., and F. Grenet. "New light on the Sasanid painting at Ghulbiyan, Faryab Province, Afghanistan." *South Asian studies* 14 (1998) 75–85.

Lenoir, M. "Dumayr, faux camp romain, vraie résidence palatiale." *Syria* 76 (1999) 227–36.

Levi, C. *Christ stopped at Eboli.* Translated into English by F. Frenaye. London 1982.

———. *Cristo si è fermato a Eboli.* Turin 1990.

Levi, D. *Antioch mosaic pavements.* Princeton 1947.

Lewcock, R., I. al-Akwaʿ, and R. B. Serjeant. "The public bath." In *Ṣanʿāʾ: An Arabian Islamic city,* edited by R. B. Serjeant and R. Lewcock, 501–24. London 1983.

Lewis, B. *Studies in classical and Ottoman Islam (7th–16th centuries).* London 1976.

Lewis, N. N. *Nomads and settlers in Syria and Jordan, 1800–1980.* Cambridge 1987.

Lichtenberger, A. *Die Baupolitik Herodes des Grossen.* Wiesbaden 1999.

Linant de Bellefonds, P. "Prolongements tardifs de l'iconographie classique en Syrie et en Jordanie." In *Ο Ελληνισμός στην Ανατολή,* 231–43. Athens 1991.

Littmann, E. "Muḳauḳis im Gemälde von Ḳuṣair ʿAmra." *Z.D.M.G.* 105 (1955) 287–88.

Loberdou-Tsigarida, A. *Οστέινα πλακίδια: Διακόσμηση ξύλινων κιβωτιδίων από τη χριστιανική Αίγυπτο.* Athens 2000.

Lohuizen-Mulder, M. van. "Frescoes in the Muslim residence and bathhouse Qusayr ʿAmra: Representations, some of the Dionysiac cycle, made by Christian painters from Egypt." *BaBesch* 73 (1998) 125–51.

L'Orange, H. P. *Studies on the iconography of cosmic kingship in the ancient world.* Oslo 1953.

Luxenberg, C. *Die syro-aramäische Lesart des Koran: Ein Beitrag zur Entschlüsselung der Koransprache.* Berlin 2000.

Madelung, W. "Apocalyptic prophecies in Ḥimṣ in the Umayyad age." *J.S.S.* 31 (1986) 141–85.

Mader, E. *Mambre: Die Ergebnisse der Ausgrabungen im heiligen Bezirk Râmet el-Ḫalîl in Südpalästina 1926–1928.* Freiburg im Breisgau 1957.

Magdalino, P. "The Bath of Leo the Wise and the "Macedonian Renaissance" revisited: Topography, iconography, ceremonial, ideology." *D.O.P.* 42 (1988) 97–118.

Maguire, H. *Earth and ocean: The terrestrial world in early Byzantine art.* University Park, Pa., 1987.

———. *Rhetoric, nature and magic in Byzantine art.* Aldershot 1998.

Maʿīnī, ʿA. al-Ḥ. "Al-amākin al-urdunīya fī shiʿr al-ʿaṣr al-umawī." *Al-Balqāʾ* (Amman University) 1 (1992) 141–85.

————. "Al-Muwaqqar fī 'l-shiʿr al-umawī." *Abḥāth al-Yarmūk* 9 (1991) 107–38.

Mango, C. "Greek culture in Palestine after the Arab conquest." In *Scritture, libri e testi nelle aree provinciali di Bisanzio,* edited by G. Cavallo, G. De Gregorio, and M. Maniaci, 149–60. Spoleto 1991.

————. "The Temple Mount AD 614–638." *Bayt al-Maqdis* 1.1–16.

Mango, M. M. "The continuity of the classical tradition in the art and architecture of northern Mesopotamia." In *East of Byzantium: Syria and Armenia in the formative period,* edited by N. G. Garsoïan, T. F. Mathews, and R. W. Thomson, 115–34. Washington, D.C., 1982.

————. "Excavations and survey at Androna, Syria: The Oxford team 1999." *D.O.P.* 56 (2002) 307–15.

Manzalaoui, M. "The pseudo-Aristotelian *Kitāb sirr al-asrār:* Facts and problems." *Oriens* 23–24 (1974) 147–257.

Maranci, C. "Byzantium through Armenian eyes: Cultural appropriation and the church of Zuartʿnocʿ." *Gesta* 40 (2001) 105–24.

Marchand, S. *Down from Olympus: Archaeology and philhellenism in Germany, 1750–1970.* Princeton 1996.

Markwart, J. *Südarmenien und die Tigrisquellen nach griechischen und arabischen Geographen.* Vienna 1930.

Mars(c)hak, B. "Le programme iconographique des peintures de la "Salle des ambassadeurs" à Afrasiab (Samarkand)." *Arts asiatiques* 49 (1994) 5–20.

————. *Silberschätze des Orients: Metallkunst des 3.-13. Jahrhunderts und ihre Kontinuität.* Translated by L. Schirmer. Leipzig 1986.

————. "La thématique sogdienne dans l'art de la Chine de la seconde moitié du VIᵉ siècle." *C.R.A.I.* (2001) 227–64.

Martinelli, P. A., ed. *La basilica di San Vitale a Ravenna (Testi; Atlante).* Modena 1997.

Matzulewitsch, L. *Byzantinische Antike: Studien auf Grund der Silbergefässe der Ermitage.* Berlin 1929.

Mayerson, P. "Some observations on the Negev archaeological survey." *I.E.J.* 46 (1996) 100–107.

Meehan, B. *The Book of Kells: An illustrated introduction to the manuscript in Trinity College Dublin.* London 1994.

Meinecke, M. "ʿAbbāsidische Stuckdekorationen aus ar-Raqqa." In *Bamberger Symposium: Rezeption in der islamischen Kunst,* edited by B. Finster, C. Fragner, and H. Hafenrichter, 247–67. Beirut 1999.

————. "Die frühislamischen Kalifenresidenzen: Tradition oder Rezeption?" In *Continuity and change in northern Mesopotamia from the Hellenistic to the early Islamic period,* edited by K. Bartl and S. R. Hauser, 139–64. Berlin 1996.

————. "ar-Raqqa am Euphrat: Imperiale und religiöse Strukturen der islamischen Stadt." *Mitteilungen der Deutschen Orient-Gesellschaft zu Berlin* 128 (1996) 157–72.

Melikian-Chirvani, A. S. "From the royal boat to the beggar's bowl." *Islamic art* 4 (1990–91) 3–111.

———. "The Iranian *bazm* in early Persian sources." In *Banquets d'Orient*, edited by R. Gyselen, 95–120. Bures-sur-Yvette 1992.

———. "The Iranian wine horn from pre-Achaemenid antiquity to the Safavid age." *Bulletin of The Asia Institute* 10 (1996) 85–139.

Mémoires d'Euphrate et d'Arabies: Photographies Jean-Louis Nou. Paris 1991.

Mentzu-Meimare, K. "Der "χαριέστατος Μαϊουμᾶς."" *Byzantinische Zeitschrift* 89 (1996) 58–73.

Mielich, A. L. "Die Aufnahme der Malereien." *Ḳ.ʿA.* 1.190–99.

Migeon, G. "Qesejir Amra." *Revue biblique* 11 (1914) 392–401.

Miles, G. C. "The earliest Arab gold coinage." *Museum notes (American Numismatic Society)* 13 (1967) 205–29.

Milstein, R. "A hoard of early Arab figurative coins." *Israel numismatic journal* 10 (1988–89) 3–26.

Mitchell, S. "Inscriptions of Ancyra." *Anatolian studies* 27 (1977) 63–103.

Mode, M. *Sogdien und die Herrscher der Welt: Türken, Sasaniden und Chinesen in Historiengemälden des 7. Jahrhunderts n. Chr. aus Alt-Samarqand.* Frankfurt am Main 1993. Translated into English and revised, with numerous illustrations, as *Court art of Sogdian Samarqand in the 7th century AD: Some remarks to an old problem.* 2002. http://mlucom6.urz.uni-halle.de/orientarch/ca/afras/index.htm.

Möller, D. *Studien zur mittelalterlichen arabischen Falknereiliteratur.* Berlin 1965.

Monneret de Villard, U. "'Aksūm e i quattro re del mondo." *Annali Lateranensi* 12 (1948) 125–80.

———. *Introduzione allo studio dell' archeologia islamica: Le origini e il periodo omayyade.* Venice 1966.

Montgomery, J. E. *The vagaries of the qaṣīdah: The tradition and practice of early Arabic poetry.* London 1997.

Moraitou, M. "Umayyad ornament on early Islamic woodwork: A pair of doors in the Benaki Museum." *Μουσείο Μπενάκη* 1 (2001) 159–72.

Mordtmann, A. D. "Neue Beiträge zur Kunde Palmyra's." *Sitzungsberichte der philosophisch-philologischen und historischen Classe der k.b. Akademie der Wissenschaften zu München* (1875, fasc. 2.4 with separate pagination).

Morelli, F. "Legname, palazzi e moschee: P. Vindob. G 31 e il contributo dell' Egitto alla prima architettura islamico." *Tyche* 13 (1998) 165–90.

Morin, T., and C. Vibert-Guigue. "Une structure d'accueil des visiteurs à l'entrée de Quṣayr ʿAmra." *A.D.A.J.* 44 (2000) 581–91.

Morony, M. G. *Iraq after the Muslim conquest.* Princeton 1984.

———. "Material culture and urban identities: The evidence of pottery from the early Islamic period." In *Identity and material culture in the early Islamic world,* edited by I. A. Bierman, 1–45. Los Angeles 1995.

Motzki, H. *The origins of Islamic jurisprudence: Meccan fiqh before the classical schools.* Translated by M. H. Katz. Leiden 2002.

Mountfort, G. *Portrait of a desert: The story of an expedition to Jordan.* London 1965.

Mouterde, P. "Inscriptions en syriaque dialectal à Kāmed (Beqʿa)." *Mélanges de l'Université Saint Joseph* 22 (1939) 71–106.

———. "Trente ans après: Les inscriptions de Kamed." *Mélanges de l'Université Saint-Joseph* 44 (1968) 21–29.

Müller, D. H. "Vorwort." *K̇.Ȧ.* 1.I–VIII.

Müller, D. H., and J. von Schlosser. *Die Haggadah von Sarajevo: Eine spanisch-jüdische Bilderhandschrift des Mittelalters.* Vienna 1898.

al-Muheisen, Z., and D. Tarrier. "La période omeyyade dans le nord de la Jordanie: Continuité et rupture." *ARAM periodical* 6 (1994) 333–41.

Munro-Hay, S. *Aksum: An African civilisation of late antiquity.* Edinburgh 1991.

Muratore, G., ed. *Da Ebla a Damasco: Diecimila anni di archeologia in Siria.* Milan 1985.

Museum für Islamische Kunst: Staatliche Museen zu Berlin, Preussischer Kulturbesitz. Mainz am Rhein 2001.

Musil, A. *Arabia deserta: A topographical itinerary.* New York 1927.

———. *Arabia petraea.* Vienna 1907–8.

———. "Ḳuṣejr ʿAmra." *K̇.Ȧ.* 1.1–183.

———. *Ḳuṣejr ʿamra und andere Schlösser östlich von Moab: Topographischer Reisebericht.* Sitzungsberichte der philosophisch-historischen Classe der kaiserlichen Akademie der Wissenschaften 144, fasc. 7. Vienna 1902.

———. *The manners and customs of the Rwala Bedouins.* New York 1928.

———. *The Middle Euphrates: A topographical itinerary.* New York 1927.

———. *Northern Arabia.* New York 1928.

———. *Palmyrena: A topographical itinerary.* New York 1928.

———. *Pán Amry.* Prague 1948.

———. *Po prve v pousti.* Prague 1932.

———. "Riḥla ḥadītha ilā bilād al-bādiya." *Al-Mashriq* 1 (1898) 625–30.

———. *Tajemná Amra.* Prague 1932.

———. "Topographie und Geschichte der Gebiete von ʿAmra bis zum Ausgange der Omajjâden" (summary). *Anzeiger der kaiserlichen Akademie der Wissenschaften, Philosophisch-historische Klasse* 42 (1905) 40–46.

Muth, S. *Erleben von Raum—Leben im Raum. Zur Funktion mythologischer Mosaikbilder in der römisch-kaiserzeitlichen Wohnarchitektur.* Heidelberg 1998.

Muthesius, A. *Byzantine silk weaving, AD 400 to AD 1200.* Edited by E. Kislinger and J. Koder. Vienna 1997.

Nadler, R. "Die Umayyadenkalifen im Spiegel ihrer zeitgenössischen Dichter." Diss., Erlangen-Nürnberg, 1990.

Najjar, M., H. Azar, and R. Qusous. "Taqrīr awwalī ʿan natāʾij al-tanqībāt al-athariya fī baldat al-Muwaqqar." *A.D.A.J.* 33 (1989) 5–12 (Arabic section).

Nasrallah, J. *Histoire du mouvement littéraire dans l'Église Melchite du Ve au XXe siècle: Contribution à l'étude de la littérature arabe chrétienne.* Louvain 1979–.

Nau, F. "Un colloque du Patriarche Jean avec l'émir des Agaréens." *Journal asiatique* 5 (1915) 225–79.

Negev, A. *The architecture of Oboda: Final report.* Jerusalem 1997.

Nicholson, R. A. *A literary history of the Arabs.* Cambridge 1930.

Nicolle, D. "Arms of the Umayyad era: Military technology in a time of change." In *War and society in the eastern Mediterranean, 7th–15th centuries,* edited by Y. Lev, 9–100. Leiden 1997.

Niehoff-Panagiotidis, J. *Koine und Diglossie.* Wiesbaden 1994.

Nielsen, I. *Thermae et balneae: The architecture and cultural history of Roman public baths.* Aarhus 1993².

Nöldeke, T. Review of *K.'A. Z.D.M.G.* 61 (1907) 222–33.

Nordenfalk, C. *Studies in the history of book illumination.* London 1992.

Nordhagen, P. J. *The frescoes of John VII (A.D. 705–707) in S. Maria Antiqua in Rome.* Rome 1968.

Northedge, A. "Archaeology and new urban settlement in early Islamic Syria and Iraq." *B.E.I.N.E.* 2.231–65.

———. "Entre Amman et Samarra: L'archéologie et les élites au début de l'Islam (VIIe-IXe siècle)." Unpublished dissertation, Habilitation à diriger les recherches, Université de Paris I, 2000.

———. *Studies on Roman and Islamic 'Ammān.* Oxford 1992–.

———. "Thoughts on the introduction of polychrome glazed pottery in the Middle East." In *La céramique byzantine et proto-islamique en Syrie-Jordanie (IVᵉ-VIIIᵉ siècles apr. J.-C.),* edited by E. Villeneuve and P. M. Watson, 207–14. Beirut 2001.

Northedge, A., T. J. Wilkinson and R. Falkner. "Survey and excavations at Sāmarrā' 1989." *Iraq* 52 (1990) 121–47.

Oddy, A. "Arab imagery on early Umayyad coins in Syria and Palestine: Evidence for falconry." *Numismatic chronicle* 151 (1991) 59–66.

Ognibene, S. *Umm al-Rasas: La chiesa di Santo Stefano ed il "problema iconofobico".* Rome 2002.

Oleson, J. P., K. 'Amr, R. Foote, J. Logan, M. B. Reeves, and R. Schick. "Preliminary report of the al-Ḥumayma excavation project, 1995, 1996, 1998." *A.D.A.J.* 43 (1999) 411–50.

Oliverius, J. "Alois Musils Reisebücher." *Archív orientální* 63 (1995) 410–18.

Olmos, R. "El amor del hombre con la estatua: De la Antigüedad a la Edad Media." In *Kotinos: Festschrift für Erika Simon,* edited by H. Froning, T. Hölscher, and H. Mielsch, 256–66. Mainz am Rhein 1992.

Les Omeyyades: Naissance de l'art islamique. Aix-en-Provence 2000.

Ostrogorsky, G. *Zur byzantinischen Geschichte: Ausgewählte kleine Schriften.* Darmstadt 1973.

Otto-Dorn, K. "Grabung im umayyadischen Ruṣāfah." *A.O.* 2 (1957) 119–33.

Oxus: Tesori dell' Asia Centrale. Rome 1993.

Pächt, O. "Anhang." In *Spätrömische Kunstindustrie,* by A. Riegl, 406–12. Reprint, Vienna 1927.

Palmer, A. *The seventh century in the West-Syrian chronicles.* Liverpool 1993.

Pantke, M. *Der arabische Bahrām-Roman: Untersuchungen zur Quellen- und Stoffgeschichte.* Berlin 1974.

Paret, R. *Der Koran: Kommentar und Konkordanz.* Stuttgart 1993⁵.

Parlasca, K. "Palmyra und die arabische Kultur: Tradition und Rezeption." In *Bamberger Symposium: Rezeption in der islamischen Kunst,* edited by B. Finster, C. Fragner, and H. Hafenrichter, 269–80. Beirut 1999.

Pausz, R.-D., and W. Reitinger. "Das Mosaik der gymnischen Agone von Batten Zamour, Tunesien." *Nikephoros* 5 (1992) 119–23.

Pentz, P. *The invisible conquest: The ontogenesis of sixth and seventh century Syria.* Copenhagen 1992.

Piccirillo, M. "I mosaici del complesso di Santo Stefano," and "Le iscrizioni di Kastron Mefaa." In *Umm al-Rasas—Mayfa'ah.* Vol. 1, *Gli scavi del complesso di Santo Stefano,* M. Piccirillo and E. Alliata, 121–64, 241–69. Jerusalem 1994.

Pingree, D. "Classical and Byzantine astrology in Sassanian Persia." *D.O.P.* 43 (1989) 227–39.

———. "The Greek influence on early Islamic mathematical astronomy." *Journal of the American Oriental Society* 93 (1973) 32–43.

Polat, M. *Der Umwandlungsprozess vom Kalifat zur Dynastie: Regierungspolitik und Religion beim ersten Umayyadenherrscher Mu'āwiya Ibn Abī Sufyān.* Frankfurt am Main 1999.

Pollak, J., and F. Wenzel. "Die chemische Analyse der Farben." *Ḳ.'A.* 1.200–202.

al-Qāḍī, W. "Early Islamic state letters: The question of authenticity." *B.E.I.N.E.* 1.215–75.

———. "The religious foundation of late Umayyad ideology and practice." In *Saber religioso y poder político en el Islam: Actas del simposio internacional,* 231–73. Madrid 1994.

———. "The term 'khalīfa' in early exegetical literature." In *Gegenwart als Geschichte: Islamwissenschaftliche Studien Fritz Steppat zum fünfundsechzigsten Geburtstag,* edited by A. Havemann and B. Johansen, 392–411. Leiden 1988.

Qedar, S. "Copper coinage of Syria in the seventh and eighth century A.D." *Israel numismatic journal* 10 (1988–89) 27–39.

Quet, M.-H. "Le Triptolème de la mosaïque dite d'*Aiôn* et l'affirmation identitaire héllène à Shahba-Philippopolis." *Syria* 77 (2000) 181–200.

Raban, A., and K. G. Holum, eds. *Caesarea Maritima: A retrospective after two millennia.* Leiden 1996.

Raby, J. "In vitro veritas: Glass pilgrim vessels from 7th-century Jerusalem." *Bayt al-Maqdis* 2.113–90.

Raeck, W. "Mythos und Selbstdarstellung in der spätantiken Kunst: Das Beispiel der Meleagersage." In *Patron and pavements in late antiquity,* edited by S. Isager and B. Poulsen, 30–37. Odense 1997.

Rasmussen, M. B. "Fragment of a floor mosaic with Adam in the Garden of Eden." In *Byzantium: Late antique and Byzantine art in Scandinavian collections,* edited by J. Fleischer, Ø. Hjort, and M. B. Rasmussen, 63–65. Copenhagen 1996.

Raven, W. "Some early Islamic texts on the Negus of Abyssinia." *J.S.S.* 33 (1988) 197–218.

Reenen, D. van. "The *Bildverbot,* a new survey." *Der Islam* 67 (1990) 27–77.

Reeth, J. M. F. van. "La représentation du ciel et du zodiaque dans le palais omayyade de 'Amrā." In *Le ciel dans les civilisations orientales,* 137–50. Brussels 1999.

———. "Die Transfiguration Walīd b. Yazīds." In *Studies in Arabic and Islam. Proceedings of the 19th Congress, Union Européenne des Arabisants et Islamisants,* Halle 1998, edited by S. Leder, 501–11. Leuven 2002.

Reinach, S. *Répertoire de peintures grecques et romaines.* Paris 1922.

Reinink, G. J. "The Romance of Julian the Apostate as a source for seventh century Syriac apocalypses." *S.Byz.Is.* 75–86.

Richardson, H. "The jewelled cross and its canopy." In *From the isles of the north: Early medieval art in Ireland and Britain,* edited by C. Bourke, 177–86. Belfast 1995.

Riegl, A. *Spätrömische Kunst-Industrie nach den Funden in Österreich-Ungarn.* Vienna 1901.

———. *Stilfragen: Grundlegungen zu einer Geschichte der Ornamentik.* Berlin 1893.

al-Rīhāwī, A. al-Q. "Zāwiya al-muktashafāt al-athariȳa." *A.A.A.S.* 11–12 (1961–62) 99–106 (Arabic section), 207–11 (extracts in French).

Roberts, M. *The jeweled style: Poetry and poetics in late antiquity.* Ithaca, N.Y., 1989.

Robin, C. "Du paganisme au monothéisme." *Revue du monde musulman et de la Méditerranée* 61 (1991) 139–55.

Robinson, C. F. *Empire and elites after the Muslim conquest: The transformation of northern Mesopotamia.* Cambridge 2000.

———. *Islamic historiography.* Cambridge 2003.

Rösch, G. *ΟΝΟΜΑ ΒΑΣΙΛΕΙΑΣ: Studien zum offiziellen Gebrauch der Kaisertitel in spätantiker und frühbyzantinischer Zeit.* Vienna 1978.

Rogers, J. M. "Architectural history as literature: Creswell's reading and methods." *Muqarnas* 8 (1991) 45–54.

Rosen-Ayalon, M. *Art et archéologie islamiques en Palestine.* Paris 2002.

———. "Return to Quṣayr 'Amra." *Archív orientálni* 63 (1995) 455–70.

Rosenthal, F. *The classical heritage in Islam.* London 1975.

———. *Humor in early Islam.* Leiden 1956.

Rossiter, J. J. "Houses in Roman Britain." *J.R.A.* 15 (2002) 625–29.

Rostovtzeff, M. I. "Dura and the problem of Parthian art." *Yale classical studies* 5 (1935) 157–304.

Roueché, C. *Aphrodisias in late antiquity.* London 1989.

Rubin, M. "Arabization versus Islamization in the Palestinian Melkite community during the early Muslim period." In *Sharing the sacred: Religious contacts and conflicts in the Holy Land, first–fifteenth centuries CE,* edited by A. Kofsky and G. G. Stroumsa, 149–62. Jerusalem 1998.

Rubin, U. *The eye of the beholder: The life of Muḥammad as viewed by the early Muslims: A textual analysis.* Princeton 1995.

———. "Prophets and caliphs: The biblical foundations of the Umayyad authority." In *Method and theory in the study of Islamic origins,* edited by H. Berg, 73–99. Leiden 2003.

Russell, A. *The natural history of Aleppo.* London 1794.

Rypka, J. "Alois Musil June 30th, 1868–June 30th, 1938." *Archív orientální* 10 (1938) 1–34.

———. "†Alois Musil." *Archív orientální* 15 (1946) I–VIII.

Sack, D. "Resafa: Das Umland." In *Zehn Jahre Ausgrabungen und Forschungen in Syrien 1989–1998,* 89–93. Deutsches Archäologisches Institut. Damascus 1999.

Sack, D., and H. Becker. "Zur städtebaulichen und baulichen Konzeption frühislamischer Residenzen in Nordmesopotamien mit ersten Ergebnissen einer Testmessung zur geophysikalischen Prospektion in Resafa—Ruṣāfat Hišām." In *Stadt und Umland: Neue Ergebnisse der archäologischen Bau- und Siedlungsforschung,* edited by E. L. Schwandner and K. Rheidt, 270–86. Mainz am Rhein 1999.

Sadan, J. *Le mobilier au Proche Orient médiéval.* Leiden 1976.

Salies, G. H. "Die Mosaiken der Grossen Moschee von Damaskus." *XXXV corso di cultura sull' arte ravennate e bizantina* (1988) 295–313.

Sauvaget, J. "Chateaux umayyades de Syrie: Contribution à l'étude de la colonisation arabe aux Ier et IIe siècles de l'Hégire." Edited by J. Sourdel-Thomine and D. Sourdel. *R.E.I.* 35 (1967) 1–52.

———. "Les inscriptions arabes de la mosquée de Bosra." *Syria* 22 (1941) 53–65.

———. "Notes de topographie omeyyade." *Syria* 24 (1944–45) 96–112.

———. "Remarques sur les monuments omeyyades." *Journal asiatique* 231 (1939) 1–59.

———. "Les ruines omeyyades du Djebel Seis." *Syria* 20 (1939) 239–56.

Saxl, F. "The zodiac of Quṣayr ʿAmra." In Creswell, 424–31.

Scarrocchia, S. *Alois Riegl: Teoria e prassi della conservazione dei monumenti. Antologia di scritti, discorsi, rapporti 1898–1905, con una scelta di saggi critici.* Bologna 1995.

Schacht, J. *The origins of Muhammadan jurisprudence.* Oxford 1950; reprinted with corrections and additions 1967.

Schaeder, H. H. "Über das 'Bilderbuch der Sasaniden-Könige.'" *Jahrbuch der preuszischen Kunstsammlungen* 57 (1936) 231–32.

Schick, R. *The Christian communities of Palestine from Byzantine to Islamic rule: A historical and archaeological study.* Princeton 1995.

———. "The settlement pattern of southern Jordan: The nature of the evidence." *B.E.I.N.E.* 2.133–54.

Schiøler, T. *Roman and Islamic water-lifting wheels.* Odense 1973.

Schlumberger, D. "Deux fresques omeyyades." *Syria* 25 (1946–48) 86–102.

———. "Les fouilles de Qasr el-Heir el-Gharbi (1936–1938): Rapport préliminaire." *Syria* 20 (1939) 195–238, 324–73.

————. "La représentation frontale dans l'art des sassanides." In *La Persia e il mondo greco-romano*, 383–93. Rome 1966.

Schlunk, H. *Die Mosaikkuppel von Centcelles*. Edited by A. Arbeiter. Mainz am Rhein 1988.

Schmidt-Colinet, A. "'Velum und Kolpos': Ein paganer Bildtopos und seine *interpretatio christiana*." *Mitteilungen zur spätantiken Archäologie und byzantinischen Kunstgeschichte* 1 (1998) 29–46.

Schnapp, A. *Le chasseur et la cité: Chasse et érotique en Grèce ancienne*. Paris 1997.

Schoeler, G. *Écrire et transmettre dans les débuts de l'islam*. Paris 2002.

Schönig, H. *Das Sendschreiben des ʿAbdalḥamīd b. Yaḥyā (gest. 132/750) an den Kronprinzen ʿAbdallāh b. Marwān II*. Stuttgart 1985.

Schwabe, M. "Khirbat Mafjar. Greek inscribed fragments." *Q.D.A.P.* 12 (1946) 20–30.

Scott-Meisami, J. "The palace-complex as emblem. Some Samarran qaṣīdas." In *A medieval Islamic city reconsidered: An interdisciplinary approach to Samarra*, edited by C. F. Robinson, 69–78. Oxford 2001.

Sears, S. D. "An ʿAbbasid revolution hoard from the western Jazira (al-Raqqa?)." *American journal of numismatics* 12 (2000) 171–93.

Segert, S. "Alois Musil—Bible scholar." *Archív orientální* 63 (1995) 393–400.

Sénac, P. "Les ḥuṣūn du Ṭaġr al-Aqṣā: À la recherche d'une frontière septentrionale d'al-Andalus à l'époque omeyyade." In *Castrum*. Vol. 4, *Frontière et peuplement dans le monde méditerranéen au moyen âge*, edited by J.-M. Poisson, 75–84. Rome 1992.

Serjeant, R. B. *South Arabian hunt*. London 1976.

Serjeant, R. B., and R. Lewcock, eds. *Ṣanʿāʾ: An Arabian Islamic city*. London 1983.

Severin, H.-G. "Zur Skulptur und Malerei der spätantiken und frühmittelalterlichen Zeit in Ägypten." In *Ägypten in spätantik-christlicher Zeit: Einführung in die koptische Kultur*, edited by M. Krause, 295–338. Wiesbaden 1998.

Sezgin, U. *Abū Miḥnaf: Ein Beitrag zur Historiographie der umaiyadischen Zeit*. Leiden 1971.

Shahîd, I. *Byzantium and the Arabs in the fifth century*. Washington, D.C., 1989.

Shaked, S. "From Iran to Islam: On some symbols of royalty." *J.S.A.I.* 7 (1986) 75–91.

Sharon, M. *Black banners from the East: The establishment of the ʿAbbāsid state—Incubation of a revolt*. Jerusalem 1983.

————. "Five Arabic inscriptions from Reḥovoth and Sinai." *I.E.J.* 43 (1993) 50–59, 252.

————. "The Umayyads as *ahl al-bayt*." *J.S.A.I.* 14 (1991) 115–52.

Shboul, A. "Arab attitudes towards Byzantium: Official, learned, popular." In *ΚΑΘΗΓΗΤΡΙΑ: Essays presented to Joan Hussey for her 80th birthday*, 111–28. Camberley 1988.

————. "Change and continuity in early Islamic Damascus." *ARAM periodical* 6 (1994) 67–102.

————. "On the later Arabic inscription in Qaṣr Burquʿ." *A.D.A.J.* 20 (1975) 95–98.

Shboul, A., and A. Walmsley. "Identity and self-image in Syria-Palestine in the transition from Byzantine to early Islamic rule: Arab Christians and Muslims." *Mediterranean archaeology* 11 (1998) 255–87.

Shepard, J. "The uses of 'history' in Byzantine diplomacy: Observations and comparisons." In *Porphyrogenita: Essays on the history and literature of Byzantium and the Latin East in honour of Julian Chrysostomides*, edited by C. Dendrinos, J. Harris, E. Harvalia-Crook, and J. Herrin, 91–115. Aldershot 2003.

Shepherd, D. "Sasanian art." In *The Cambridge history of Iran*, edited by W. B. Fisher et al., 3.1055–112. Cambridge 1968–91.

Simon, R. *Ignác Goldziher: His life and scholarship as reflected in his works and correspondence*. Budapest 1986.

Sinclair, T. A. *Eastern Turkey: An architectural and archaeological survey*. London 1987–90.

Sörries, R. "Das Bild des Christus-Rex in der Sarkophagplastik des vierten Jahrhunderts: Überlegungen zum dogmatischen Hintergrund einer ikonographischen Idee." In *Studien zur frühchristlichen Kunst*, edited by G. Koch, 2.139–59. Wiesbaden 1986.

————. *Christlich-antike Buchmalerei im Überblick*. Wiesbaden 1993.

Soler, A., and J. Zozaya. "Castillos omeyas de planta cuadrada: Su relación funcional." In *III congreso de arqueología medieval española, Actas.* Vol. 2, *Comunicaciones*, 265–74. Oviedo 1989–92.

Sotiriou, G., and M. Sotiriou. Ἡ βασιλικὴ τοῦ Ἁγίου Δημητρίου Θεσσαλονίκης. Athens 1952.

Soucek, P. P. "Solomon's throne/Solomon's bath: Model or metaphor?" *A.O.* 23 (1993) 109–34.

Sourdel-Thomine, J., and D. Sourdel. "À propos des documents de la Grande Mosquée de Damas conservés à Istanbul: Résultats de la seconde enquête." *R.E.I.* 33 (1965) 73–85.

Spetsieri-Choremi, A. "Eine überlebensgrosse Nike-Statue in Athen." *Mitteilungen des Deutschen Archäologischen Instituts, Athenische Abteilung* 111 (1996) 363–90.

Splendeur des Sassanides: L'empire perse entre Rome et la Chine [224–642]. Brussels 1993.

Sprengling, M. "From Persian to Arabic." *American journal of Semitic languages and literatures* 56 (1939) 175–224, 325–36.

Spycket, A. ""Le carnaval des animaux": On some musician monkeys from the ancient Near East." *Iraq* 60 (1998) 1–10.

Stein, A. *Limes report*. Edited by S. Gregory and D. Kennedy. Oxford 1985.

Stetkevych, J. "The hunt in classical Arabic poetry: From Mukhaḍram *qaṣīdah* to Umayyad *ṭardiyyah*." *Journal of Arabic literature* 30 (1999) 107–27.

————. "The hunt in the Arabic *qaṣīdah:* The antecedents of the *ṭardiyyah*."

In *Tradition and modernity in Arabic language and literature,* edited by
J. R. Smart, 102–18. Richmond 1996.

Stetkevych, S. P. *The mute immortals speak: Pre-Islamic poetry and the poet-
ics of ritual.* Ithaca, N.Y., 1993.

———. "Umayyad panegyric and the poetics of Islamic hegemony: al-Akhṭal's
Khaffa al-qaṭīnu ("Those that dwelt with you have left in haste")." *Journal
of Arabic literature* 28 (1997) 89–122.

Strelkoff, A. "Īrān and the pre-Islamic art of West Turkistān." In *A survey of
Persian art from prehistoric times to the present,* edited by A. U. Pope and
P. Ackerman, 449–58. London 1938–39; reprinted with corrections and ad-
ditions 1964–65.

Strika, V. "Alcune questioni su Quṣayr 'Amrah." *A.I.O.N.* 17 (1967) 343–
48.

———. "La formazione dell' iconografia del califfo nell' arte ommiade." *A.I.O.N.*
14 (1964) 727–57.

———. "I madīḥ di Ǧarīr per Hishām ibn 'Abd al-Malik." *A.I.O.N.* 30 (1970)
483–510.

———. "Note sull'evoluzione della maestà califfale." *A.I.O.N.* 16 (1966) 105–35.

Strommenger, E., and J. Bollweg. "Onager und Esel im alten Zentralvorder-
asien." In *Collectanea orientalia: Histoire, arts de l'espace et industrie de la
terre: Études offertes en hommage à Agnès Spycket,* edited by H. Gasche
and B. Hrouda, 349–66. Neuchâtel 1996.

Strube, C. "Excavations and survey at el Anderin/Androna, Syria: The work of
the German team." In *XXᵉ congrès international des études byzantines: Pré-
actes,* 3.217. Paris 2001.

Strzygowski, J. "Amra als Bauwerk." *Zeitschrift für Geschichte der Architek-
tur* 1 (1907) 57–64.

———. *Catalogue général des antiquités égyptiennes du Musée du Caire, Nᵒˢ
7001–7394 et 8742–9200: Koptische Kunst.* Vienna 1904.

———. *Orient oder Rom: Beiträge zur Geschichte der spätantiken und früh-
christlichen Kunst.* Leipzig 1901.

Taha, M. Y. "A mural painting from Kufa." *Sumer* 27 (1971) 77–79.

Talbot Rice, D., ed. *The Great Palace of the Byzantine emperors: Second report.*
Edinburgh 1958.

Trempelas, P. N. Αἱ τρεῖς λειτουργίαι κατὰ τοὺς ἐν Ἀθήναις κώδικας. Athens 1935.

Troupeau, G. "Le mot miḥrâb chez les lexicographes arabes." In *Le miḥrâb dans
l'architecture et la religion musulmanes,* edited by A. Papadopoulo, 60–64.
Leiden 1988.

Trümpelmann, L. "Die Skulpturen von Mschatta." *A.A.* (1965) 235–76.

———. "Die Terrasse des Ḫosrow." *A.A.* (1968) 11–17.

Tsafrir, Y., and G. Foerster. "Bet Shean excavation project—1988/1989." *Exca-
vations and surveys in Israel* 9 (1989–90) 120–28.

———. "Urbanism at Scythopolis—Bet Shean in the fourth to seventh cen-
turies." *D.O.P.* 51 (1997) 85–146 .

Ṭūqān, F. A. *Al-ḥāʾir: Baḥth fī 'l-quṣūr al-umawīya fī 'l-bādiya.* Amman 1979.
———. "Al-quṣūr al-umawīya al-ṣaḥrāwīya, li-mā-dhā ubtuniyat?" *A.D.A.J.*
14 (1969) 4–25 (Arabic section).
Tyan, E. *Institutions du droit public musulman.* Paris 1954–56.
Tyler-Smith, S. "Coinage in the name of Yazdgerd III (AD 632–651) and the
Arab conquest of Iran." *Numismatic chronicle* 160 (2000) 135–70.
Ulbert, T. "[Al-Ḥulla:] Die umayiadische Anlage." In *Resafa.* Vol. 5, *Der spätrö-
mische Limes in Syrien: Archäologische Untersuchungen an den Grenz-
kastellen von Sura, Tetrapyrgium, Cholle und in Resafa,* edited by M. Kon-
rad, 19–22. Mainz 2001.
———. "Ein umaiyadischer Pavillon in Resafa-Ruṣāfat Hišām." *Da.M.* 7 (1993)
213–31.
Urbach, E. E. *The sages: Their concepts and beliefs.* Translated by I. Abrahams.
Cambridge, Mass., 1979².
Urice, S. K. *Qasr Kharana in the Transjordan.* Durham, N.C., 1987.
Vasiliev, A. A. "The iconoclastic edict of the Caliph Yazid II, A.D. 721." *D.O.P.*
9–10 (1956) 23–47 .
Vaux, R. de. "Sur le voile des femmes dans l'Orient ancien." *Revue biblique* 44
(1935) 397–412.
Vernoit, S. "The rise of Islamic archaeology." *Muqarnas* 14 (1997) 1–10.
Vibert-Guigue, C. "Le projet franco-jordanien de relevé des peintures de Qu-
seir ʿAmra." *ARAM periodical* 6 (1994) 343–58.
———. "Qusayr ʿAmra: Peinture omeyyade et vocation picturale." *D.A.* 244
(1999) 90–94.
———. "Le relevé des peintures de Quṣayr ʿAmra." *S.H.A.J.* 5 (1995) 105–10.
Vibert-Guigue, C., and G. Bisheh. *Les peintures de Qusayr ʿAmra.* Institut
Français d'Archéologie du Proche-Orient and Department of Antiquities of
Jordan, forthcoming.
Vickers, M., ed. *Pots and pans: A colloquium on precious metals and ceramics in
the Muslim, Chinese and Graeco-Roman worlds, Oxford 1985.* Oxford 1986.
Violet, B. "Ein zweisprachiges Psalmfragment aus Damascus." *Orientalistische
Litteratur-Zeitung* 4 (1901) 384–403, 425–41, 475–88.
Vogüé, M. de. *Syrie centrale: Inscriptions sémitiques.* Paris 1868–77.
La voie royale: 9000 ans d'art au royaume de Jordanie. Paris 1986.
Volbach, W. F. *Elfenbeinarbeiten der Spätantike und des frühen Mittelalters.*
Mainz am Rhein 1976³.
Wagner, E. *Abū Nuwās: Eine Studie zur arabischen Literatur der frühen ʿAb-
bāsidenzeit.* Wiesbaden 1965.
———. *Grundzüge der klassischen arabischen Dichtung.* Darmstadt 1987–88.
———. "Die Überlieferung des Abū Nuwās-Dīwān und seine Handschriften."
*Akademie der Wissenschaften und der Literatur in Mainz, Abhandlungen
der Geistes- und Sozialwissenschaftlichen Klasse* (1957) 303–73.
Waheeb, M. "Al-Mawsim al-thānī li 'l-tanqībāt al-athārīya fī 'l-Muwaqqar:
Taqrīr awwalī." *A.D.A.J.* 37 (1993) 5–22 (Arabic section).
Walmsley, A. "Production, exchange and regional trade in the Islamic East

Mediterranean: Old structures, new systems?" In *The long eighth century,* edited by I. L. Hansen and C. Wickham, 265–343. Leiden 2000.

———. "Turning east: The appearance of Islamic Cream Ware in Jordan: The "end of antiquity"?" In *La céramique byzantine et proto- islamique en Syrie-Jordanie (IVᵉ-VIIIᵉ siècles apr. J.-C.),* edited by E. Villeneuve and P. M. Watson, 305–13. Beirut 2001.

Ward-Perkins, B. Review of *Studies on Roman and Islamic ʿAmmān,* by A. Northedge. *Levant* 28 (1996) 221–24.

Ward-Perkins, J. B., and J. M. C. Toynbee. "The Hunting Baths at Lepcis Magna." *Archaeologia* 93 (1949) 165–95.

Watson, A. M. *Agricultural innovation in the early Islamic world: The diffusion of crops and farming techniques, 700–1100.* Cambridge 1983.

Watson, R. P., and G. W. Burnett. "On the origins of Azraq's "Roman wall"." *Near Eastern archaeology* 64(1–2) (2001) 72–79.

Weisweiler, M. *Arabesken der Liebe: Früharabische Geschichten von Liebe und Frauen.* Leiden 1954.

Wellhausen, J. *Das arabische Reich und sein Sturz.* Berlin 1902.

Wheatley, P. *The places where men pray together: Cities in Islamic lands, seventh through the tenth centuries.* Chicago 2001.

Whelan, E. "The origins of the *miḥrāb mujawwaf:* A reinterpretation." *I.J.M.E.S.* 18 (1986) 205–23.

Whitcomb, D. "Amṣār in Syria? Syrian cities after the conquest." *ARAM periodical* 6 (1994) 13–33.

———. "Ḥesban, Amman, and Abbasid archaeology in Jordan." In *The archaeology of Jordan and beyond: Essays in honor of James A. Sauer,* edited by L. E. Stager, J. A. Greene, and M. D. Coogan, 505–15. Winona Lake, Ind., 2000.

———. "Khirbet al-Mafjar reconsidered: The ceramic evidence." *B.A.S.O.R.* 271 (1988) 51–67.

———. "Umayyad and Abbasid periods." In *The archaeology of Jordan,* edited by B. MacDonald, R. Adams, and P. Bienkowski, 503–13. Sheffield 2001.

———. "Urbanism in Arabia." *A.A.E.* 7 (1996) 38–51.

Wickhoff, F. "Der Stil der Malereien" and "Erklärung der Tafeln." *K.A.* 1.203–7, 208–12.

Williams, J. H. C. "Septimius Severus and Sol, Carausius and Oceanus: Two new Roman acquisitions at the British Museum." *Numismatic chronicle* 159 (1999) 307–13.

Wilson, J., and M. Saʿd. "The domestic material culture of Nabataean to Umayyad period Buṣrā." *Berytus* 32 (1984) 35–147.

Winkler-Horacek, L. "Dionysos in Quṣayr ʿAmra—Ein hellenistisches Bildmotiv im Frühislam." *Da.M.* 10 (1998) 261–90.

Wolf, K. B. *Conquerors and chroniclers of early medieval Spain.* Liverpool 1990.

Wright, O. "Music and verse." *A.L.U.P.* 433–59.

Würsch, R. "Das Schloss H̲awarnaq nach arabischen und persischen Quellen." *Wiener Zeitschrift für die Kunde des Morgenlandes* 88 (1998) 261–79.

Yegül, F. K. *Baths and bathing in classical antiquity.* New York 1992.

————. "The Roman baths at Isthmia in their Mediterranean context." In *The Corinthia in the Roman period,* edited by T. E. Gregory, 95–113. Ann Arbor 1993.

Zimmer, G. *Römische Berufsdarstellungen.* Berlin 1982.

Index

Murjiʾa, 171
Mūsā b. Nuṣayr, governor of Africa, 144
Mushatta, 18 fig. 3, 54, 158–59 and n. 100, 161, 163, 246, 333; construction, 35, 161; date, 25–26, 158 n. 96, 301 n. 37; decoration, 59, 158–59 and n. 96, 181 n. 23, 255 n. 19, 304 n. 53; imitation by Abbasids, 306 n. 58, 313; orientation, 141, 159 n. 96; removal of facade, 17
musical instruments, 80, 174; cymbals, 300; flute, 67, 103, 104, 169 n. 144; harp, 109; lute, 64, 67 and n. 101, 68, 69, 80, 103, 169 and n. 144, 242, 300; lyre, 110; tambourine, 69, 83 and nn. 155–56
music, musicians, 80, 89, 103, 109, 166, 297, 300. *See also* Makka: musical life; *mukhannathūn*; musical instruments; Quṣayr ʿAmra frescoes: entertainers; singing girls
Musil, A., xxi, 4–21, 7 fig. 2, 29–30, 170, 198, 203–4, 258, 264, 278 and n. 119, 331
Muslim b. Ṣubayḥ, traditionist, 199
al-Muwaqqar, 21 and n. 50, 33, 38 n. 12, 151–52 and n. 54, 153, 274 n. 107, 276, 277 n. 115, 280 n. 123, 283, 333

Nabaṭ, 286 n. 169, 320 n. 120
Nabatean art, 264 n. 60, 303
al-Nābigha al-Dhubyānī, poet, 64
al-Nābigha al-Shaybānī, poet, 268
al-Naḍr b. al-Ḥārith, storyteller, 111
Namāra inscription, 178 n. 4, 309 n. 66
Nawār, singing girl, 149–50
Nawrūz, Iranian festival, 56 n. 63, 82, 239
Nebo, Mount: mosaic, 123 n. 23, 268
necklaces, 230 and n. 10
Negus (Aksumite ruler), 204–6, 211–13 and n. 71, 215, 221, 223–24, 225
Nessana papyri, 266, 269 n. 85
Nile, 123, 125 n. 33, 198; Nilotic scenes, 123
Nineveh, 101, 109

Niẓāmī, poet, 247
Nöldeke, T., 25, 197 and n. 1
Nonnus, pseudo-, *In IV orationes Gregorii Nazianzeni commentarii*, 260–61
Nubia, 211
nudity, 57–64, 75, 77–78, 81, 97, 104, 136, 241 and n. 43, 244, 297. *See also* Quṣayr ʿAmra frescoes: nudity
al-Nuʿmān (I) b. Imruʾ al-Qays, king of al-Ḥīra, 125
al-Nuʿmān (III) b. al-Mundhir, king of al-Ḥīra, 64, 209
nymphs, 59–60

ode, Arabic. *See* poetry/poets: ode
Oppian of Apamea, *Cynegetica*, 104–5
ostrich, 86
owl, 9, 10

Palmyra, 16–17, 61 n. 88, 283; Umayyad/Abbasid interest in Palmyrene art, 180, 253, 302 n. 49, 303 and n. 50
panegyric. *See* poetry/poets: panegyric
Panjikent, 60 n. 79, 96 n. 29, 222 n. 103
paradeisos. See hunting enclosures
peacock, 139, 181, 185
Persian, Middle, 269
personifications in art, 297. *See also* Abundance; Acquisition; Creation; Earth; Enjoyment; History; Luxury; Philosophy; poetry/poets: personification of; Quṣayr ʿAmra frescoes: personifications; Use; Victory
Perugia: *ciborium*, 139
Pharaoh: in Qurʾān and tradition, 173; "Pharaoh's phallus", drinking bowl, 83 n. 154, 173 n. 163
Philippicus, East Roman emperor, 53–54
Philosophy (Skepsis), personification, 87–88, 261
pilgrimage *(ḥajj)*, 284. *See also* Makka; Pilgrim Road; Zīzāʾ
Pilgrim Road *(ḍarb al-ḥajj)*, 6, 7, 8, 140 n. 89, 160, 283–84

Compositor:	Integrated Composition Systems
Text:	General, 10/13 Aldus; Greek, Porson
Display:	Aldus
Printer and binder:	Edwards Brothers, Inc.